The
Obstacle
Race

Definitio est
negatio.
Best wishes to Rosemary
Courtney.
Germaine Greer

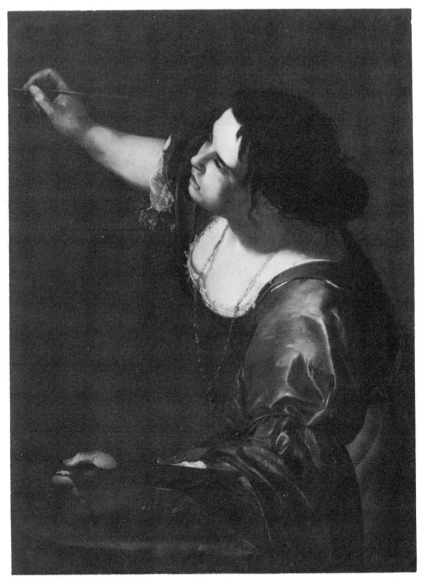

Artemisia Gentileschi, *Self-Portrait as 'The Art of Painting'*

The Obstacle Race

The Fortunes of Women Painters and Their Work

GERMAINE GREER

FARRAR STRAUS GIROUX

New York

Contents

A healthy artistic climate does not depend solely on the work of a handful of supremely gifted individuals. It demands the cultivation of talent and ability at all levels. It demands that everyday work, run-of-the-mill work, esoteric and unpopular work should be given a chance; not so much in the hope that genius may one day spring from it, but because, for those who make the arts their life and work, even modest accomplishment is an end in itself and a value worth encouraging. The pursuit of excellence is a proper goal, but it is not the race itself . . .

Gough Whitlam, Prime Minister of Australia 1973–4

Introduction

The artist does not yet know what reality is, let alone how to affect it. Paper cups lined up on the street, pieces of paper thrown into an empty lot, no matter how many ponderous reviews they get in Art News, *are a waste of time. If these clumsy attempts are at all hopeful, it is only in so far as they are signs of the break-down of 'fine art'.*

Shulamith Firestone, *The Dialectic of Sex*, 1972

On 1st December 1976 an exhibition entitled 'Women Painters: 1550–1950' opened at the Los Angeles County Museum. The gathering of a hundred and fifty works to represent four hundred years of struggle, half of them from the century 1850–1950, seemed to most of the visitors, of whom there were throngs all day and every day, to be something of a pioneering achievement. They might have been surprised to learn that seventy years before, in the Hôtel du Lycéum France, *Une Exposition retrospective d'Art féminin* had covered some of the same ground.[1] By no means all of the paintings exhibited there can still be traced; the feminist consciousness that prompted the enterprise could not so inoculate the old stock of the art establishment that it would abandon its normal practices and begin to search out minor artists and clarify their relation to better known artists, a laborious practice at any time, but, more significantly, a process which actually takes money out of the pockets of the art merchants and never puts it back.

Women are consumers of art; they are also art historians, but they have not so passionately espoused their own cause that they have become a market which will impose its own values. They did not as a result of the 1906 exhibition begin

1

to haunt the salerooms on the *qui vive* for any scent of an Artemisia Gentileschi; they did not force the prices of women's work up by bidding at auctions. That exhibition was not the preliminary to systematic studies of individual women artists, or to groups of women artists. There were subsequent exhibitions of women painters of certain periods and regions, but the subject did not mature into a respectable section of the history of art. Appallingly, some of the pictures exhibited in 1906 have since disappeared. The women who worked on the Los Angeles exhibition, which travelled to Austin, Texas, Pittsburgh, Pennsylvania and closed at the Brooklyn Museum in New York, had to start virtually from scratch. The catalogue, compiled by Linda Nochlin and Ann Sutherland Harris with the help of specialist contributors, takes the study of women's art to a new level of thoroughness and respectability, and it is to be hoped that art historians coming after them will carry on from where they leave off, and not that the exhibition that they put together has both re-opened and closed the subject.

There has always been a degree of fairly desultory interest in women artists as varieties of natural prodigies. Painting is allegorically presented always as a female and the legend of the birth of the graphic arts attributes their invention to Kora, the virgin of Corinth, also known as Callirhoe, who seeing her beloved's profile cast upon the wall by the firelight seized a spent coal and drew an outline around it.

When Giorgio Vasari came to discuss the achievements of women in the second edition of the *Vite*, published in 1568, he prefixed his article on Properzia de'Rossi, the sculptor, with a general eulogy of women.[2] He might have found the precedent for it in Book 35 of Pliny's *Historia Naturalis*, one of the first ever best-sellers. Among all the other freakish circumstances, most of them imaginary, listed by Pliny, there were six female painters of whom three, Timarete, whose picture of Diana was hung at Eleusis, Helena and Aristarete were the daughters of painters, while Lala of Cizicus, Marsia, the most successful portraitist of her time, and Olympia were not. Pliny's rather cursory account, which may no more be trusted than his confidence that eagles can fly into the sun and phoenixes rise from their own ashes and salamanders live in fire, gives the impression that the women painters were perfectly free to compete with men even for important temple commissions, and might surpass them as Marsia did Sopylus and Dionysus, her contemporaries, or teach them, as Olympia taught Autibolus.[3]

As a humanist scholar and a gentleman, Vasari could not be seen to be inferior to Pliny, but there is a touch of Pliny's hyperbole and his egregious credulity in the tone of Vasari's writing about women which he would scorn to adopt for any other topic. He quotes Ariosto:

> Le donne sono venute in eccellenza
> Di ciascun'arte ov'hanno posto cura ...
>
> (Women have come into excellence
> in every skill where they have taken pains.)[4]

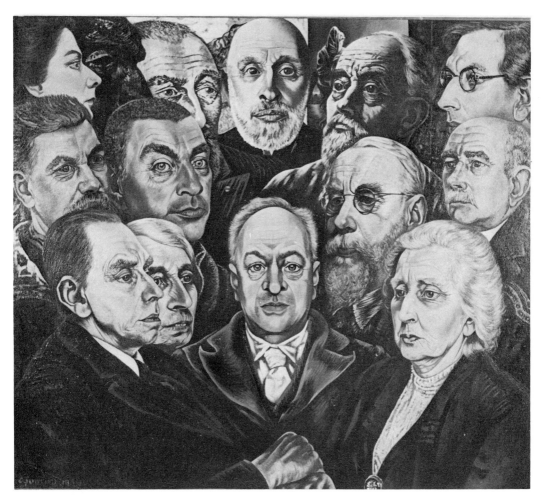

Charley Toorop, *H. P. Bremmer and his wife with the artists of his time*
A woman's view of her role in the artists' confraternity. Charley Toorop's own
profile gazes sightlessly in from the upper left. The bust of her father, the
symbolist Jan Toorop, dwarfs her finer features.

His successors as chroniclers of art followed his gallant example, listing
rather haphazardly selected women and refraining from any serious criticism of
their achievement, sometimes even repeating the quotation from the *Orlando
Furioso*. Vasari includes Suor Plautilla, Lucrezia Quistelli della Mirandola,
Sofonisba Anguissola and her sisters, Irene di Spilimbergo, and Barbara
Longhi, as well as five female miniaturists.[5] Before even a hundred years had
passed, Ridolfi in his *Meraviglie dell'Arte* (1648), besides his obligatory mention
of the women artists of classical antiquity, mentions only one of Vasari's
women artists, Irene di Spilimbergo, whose output was slight and probably
juvenile, for she died before she was twenty, and three new ones, Lavinia
Fontana, Chiara Varotari and Giovanna Garzoni.[6]

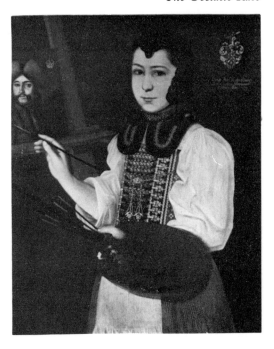

Anna Waser, *Self-Portrait*, 'Durch Ana
Waser ū Zürich im 12 jarihres Alters
gemâlt Anno 1691'
 An infant prodigy among prodigies,
Anna Waser was put by her father to
study art with the miniaturist Werner.
With this larger portrait she advertised
her abilities at this early stage in her
career: she was to win commissions
from all the German courts and from
as far away as England and Holland.
She died, evidently accidentally, at the
age of twenty-four.

In Northern Europe, the earliest commentary, *Het Schilder Boeck* of Karel
van Mander (1604), did not even include the five Netherlandish women
mentioned by Vasari.[7] Joachim von Sandrart accepts the existence of women
painters, and Arnold Houbraken went so far as to call his *Groote Schouburgh* the
story of Netherlandish painters *and paintresses*, because he included more than
twenty women.[8] None of them mentioned Mechteld toe Boecop, a much more
considerable artist than some of those who were included, for she painted
religious pictures in large format for thirty years, while other women are better
known to history for a few sheets of scissorwork and portrait-drawing.[9]

The unreliability of the classic references when it comes to women's work is
the consequence of the commentators' condescending attitude. Any work by a
woman, however trifling, is as astonishing as the pearl in the head of the toad. It
is not part of the natural order, and need not be related to the natural order.
Their work was admired in the old sense which carries an undertone of
amazement, as if they had painted with the brush held between their toes. In a
special corner reserved for freaks they were collected and disposed of, topped
and tailed with compliment. By the time the next commentators came around,
no one could remember why they had ever been included. They appear and
disappear, leaving the serious student baffled to know whether there ever were
any considerable works, let alone where they have since disappeared to. In
including in the early parts of this discussion every single woman about whom
anything could be found, the intention has been not to flatter long dead

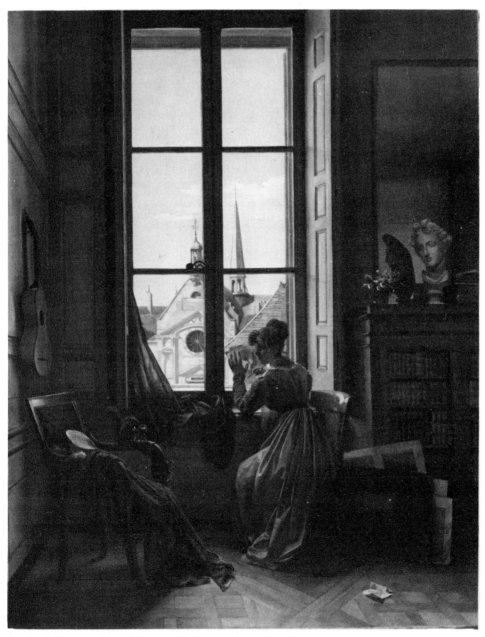

Louise Adéone Drolling, *Interior with Young Woman Tracing a Flower,* 1824
 Adéone Drolling was the daughter of the German interior and genre painter
 Martin Drölling who came to Paris to study at the Ecole des Beaux-Arts. Like her
 brother, Michel Martin, she was trained by her father, but whereas he won the
 Prix de Rome and became a member of the Académie, she is virtually unknown.
 This ironic little painting vividly conveys the nature and conditions of much
 women's work. It was exhibited at the Salon in 1824 and bought by the Duchesse
 de Berry.

individuals or to distort the shape of art history, but to build up a realistic picture of what women were actually up to, while the great monuments of European painting were being created.

Partial lists of twenty or thirty women can only ultimately discourage and confuse people with a genuine interest in women's contribution to the graphic arts for, while implying that there are no significant obstacles to the emergence of excellence by exaggerating the achievements of an arbitrarily chosen group, they account for the actual contribution of women in an insultingly small space. The struggle of half the population over centuries is worth a single book, a single exhibition and the subject is drained of all interest until it may be done again for another, equally ignorant generation. At every listing, old names are omitted and new names included; the representation is as arbitrary as the eighteenth-century limitation of the number of women in the Académie Royale de la Peinture et de la Sculpture to four at any one time.

This book would have to take its place in the succession of insults, were it not for the fact that the present writer has tried inexpertly to address the question of women's participation in the fine arts, not so much by repeating the legends which have grown up around single figures as by attempting to rejoin those freaks to the body of women from whom they have been separated, and by placing these women in some sort of a social and cultural background. The intention is to show women artists not as a string of over-rated individuals but as members of a group having much in common, tormented by the same conflicts of motivation and the same practical difficulties, the obstacles both external and surmountable, internal and insurmountable of the race for achievement.

It is devoutly to be wished that this book and the 'Women Painters: 1550–1950' exhibition are the last of their kind, for they are introductory. They simply raise the true questions contained in the false question, 'Why were there no great women painters?' The real questions are 'What is the contribution of women to the visual arts?', 'If there were any women artists, why were there not more?', 'If we can find one good painting by a woman, where is the rest of her work?', 'How good were the women who earned a living by painting?' The real questions are based not in the notions of great art entertained by the 'layman', which are essentially prejudices, but in the sociology of art, an infant study still in the preliminary stages of inventing a terminology for itself.

The present writer's only excuse for attempting this book is that it would not have done to have waited another seventy years for it. The nature of the art establishment is revealed by the struggles of a minority to enter it; by understanding the relationship of groups like Jews, Protestants and women to the patronage system, we understand also the nature of our so-called heritage and can cease making of it a rod to beat our own backs. It must never be forgotten that female competitors for excellence in painting were not the only women motivated to express themselves artistically. Their fortunes do not demonstrate

the innate artistic ability of women as a sex, any more than trotting races show how fast a horse can run.

Even if it is not great female art, women's painting reveals much that is of interest and concern both to the feminist and to the student of art, whether it shows the impoverishment of the oppressed personality, the sterile archetypes of self-censorship, the grimace of narcissistic introversion or the occasional flicker of rebellion in its latent content, or all of these. What it does not and cannot show is the decisive evidence of female creative power, for by far the greater proportion of that was never expressed in painting, but in the so-called minor arts.

Why portable paintings have acquired such prestige is not immediately obvious, especially because we have all grown up taking their prestigiousness for granted and calling other art forms, including the massive ones of architecture and gardening, *minor* arts. In financial terms, portable paintings are, like rare stamps, small repositories of enormous value. This value is not primarily or even secondarily related to aesthetic values. The same painting may be worth a hundred times as much when attributed to one painter as it is when attributed to another. Authenticity is the highest index of value, rarity the second. Surviving portable paintings by women are rarely found, but their rarity seldom suffices to counteract the obscurity of their authors.

The great connoisseurs, who by their concurrence in seeking works by the great masters create such enormous value in the salerooms, are members of the ruling class as it is constituted at any one time. The great painters were seldom aristocrats and never plutocrats, but they did express the concerns of the ruling class and in many cases became *ex officio* members of it by recognition. The painter who was clearly a Jew in Christian society, or a Protestant in Catholic society, had either to suppress or to change this aspect of himself.[10] Often, painters like Rembrandt and Vermeer, who could not be recognised by the ruling class of their own times, were recognised by that of a subsequent era which wished to elevate the characteristics of their work as illuminative of its own preoccupations. So the nineteenth century created the artist as self-made man in its own upstart image.

Women then like Jews and Protestants entered the lists of painters under false colours. Often they simply took over the preoccupations of their masters together with their styles and worked on without perceptible stress, unless it can be discerned in the conservatism and timidity usually to be found in their work. As painting became more abstract, we might expect that some of the contradictions in their situation are eased by the bleaching out of overt literary content and women painters feel freer to express their real selves. Among the pioneers of cubism and futurism and abstraction we find women whose achievements are undeniable, but even in these cases the sacrosanct medium of fine art fails to absorb them completely. Unmoved by its prestige and the enormous value which easel paintings generate, women like Goncharova,

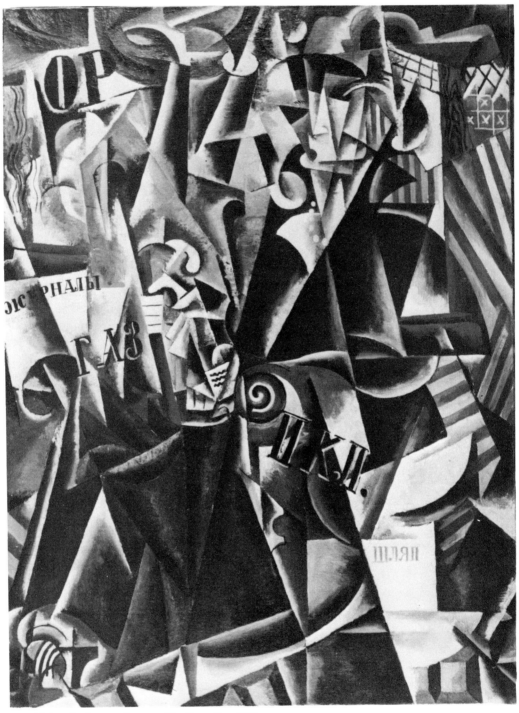

Liubov Serbeevna Popova, *The Traveller*, 1915
This remarkable cubo-futurist composition is impressive by any standards but
Popova abandoned easel painting for good three years after this was painted.

Exter, Udaltsova, Rozanova, Popova and Stepanova kept wandering away from fine art into the minor arts. Even as they demonstrated their complete grasp of the loftiest versions of the arcane language of modern art, they realised that art had to be emancipated from the prison of the picture frame and the charnel house of the museum.

The atmosphere in which they learned to paint was unique in the history of women artists. In the brave new world which Russian intellectuals were fashioning, all individuals would come into their own, including women. Working side by side with their male colleagues in an atmosphere of dizzy optimism and excitement, they seized upon the new statements of the French post-impressionists and carried them to their logical conclusion, further than anyone had ever dared, into the realms of abstract constructivism. Even in the midst of their excitement, however, they could not ignore the pressure of the need of the masses. They could not put behind them the art of the oppressed.[11]

Natalia Sergeevna Goncharova (1881–1962), unlike her inseparable companion, Larionov, who stuck to rayonist easel painting, made her own versions of the folk forms of the *lubok* and the icon (see Pl. 27). She moved onward and outward into the kinetic and ephemeral world of the ballet, studying movement, costume, textiles and music.[12] Alexandra Exter (1882–1949) introduced French cubism to Russia and Russian art to Paris. By 1912, she was already working in mixed media and collages (see Pl. 28); later she worked in the anti-realist theatre with Tairov, in the Moscow Atelier of Fashions and the Moscow Children's Theatre, as well as designing a science fiction film, *Aelita*.[13] Nadezhda Andreevna Udaltsova (1886–1961) participated in the *0.10* exhibition, optimistically subtitled 'The Last Futurist Painting Exhibition'.[14] The manifesto of the exhibition *5×5=25*, in which Varvara Stepanova (1894–1958) participated with Exter and Popova, stated their rejection of easel painting quite clearly:

> Composition is the contemplative approach of the artist in his work. Technique and industry have confronted all with the problem of construction as an active process and not a contemplative reflection. The 'sanctity' of the work as a single entity is destroyed. The museum which is the treasury of this entity is now transformed into an archive.[15]

So faithfully did Olga Vladimirovna Rozanova (1886–1918) serve the constructivist ideal, throwing herself wholeheartedly into the exhausting business of organising art for the masses, she gave her life for it. She collapsed while putting up posters in an aerodrome, to mark the first anniversary of the October Revolution.[16] Liubov Popova (1889–1924) did not live to see the final betrayal of their great ideal either. She gave up painting for teaching and teaching for utilitarian design, both in the theatre and in textiles. The catalogue of her posthumous exhibition in 1924 quoted her as saying:

> No artistic success has given me as much pleasure as the sight of a peasant buying a length of material designed by me.[17]

Olga Vladimirovna Rozanova,
Abstract Composition, c. 1916
 This dynamic composition, which
 looks forward to the
 developments of the twenties, is
 among the last easel paintings of
 Rozanova.

Another great woman artist who eschewed easel painting was Käthe Kollwitz (1867–1945) whose countless studies and drawings were carried out as preparation for prints. For her, beauty was inseparable from political and moral function: her extraordinary achievement is relevant to a study of women's artistic capability, but not to a book about women's painting.[18]

The rejection of easel painting by these highly gifted women is being continued in our own time by artists of both sexes. Nevertheless, while recognising that there is more to art than easel painting, there is some point in studying the achievements of those women who chose to be painters. Firstly, it is intolerable that their work is gradually succumbing to decay and all trace of their struggles will soon be lost. Secondly it is even more intolerable that so much of what they did has been recorded as the achievement of others. The concept of art history which treats it as the story of a select group of extraordinary personalities is philistine and misleading: art could only benefit by a concerted attempt to repeople the historical artscape.

This book may therefore seem to have a rather perverse bias. The normal approach is to discuss the women with the most considerable oeuvre rather than to marshal a whole crowd of women, some of whom have left a single good work, some no work at all and more a patchy, poorly preserved cluster of forgotten effort. The reasons for such a proceeding include first of all the desire to give some impression of women painters as a group, secondly to avoid duplicating information which may easily be come by in other places and even in single full-length studies which are far more informative than a notice in this context would be. So well-known painters like Marie Laurencin, Berthe Morisot and Mary Cassatt are assumed as part of the background of the discussion of the others (see Pls. 29, 20 and 21 for examples of their work). Part of the function of this book is to stimulate the curious reader into making his own enquiries.

Books are finite; the story of women painters has no end – indeed it may be said to be just beginning – but a book must stop somewhere. The decision to discuss no living women painters was prompted by the impossibility of doing them justice in such a format, even supposing it had been possible to include all the women working now or to select them by any method which would not be invidious. They do not need to be discovered, for they are forcing the world to notice them on their own behalf and on their own terms. It is quite inappropriate in such a volatile situation to attempt any evaluation of their achievement.

If we look fearlessly at the works of dead women and do not attempt to erect for them a double standard in the mistaken notion that such distortion of the truth will benefit women living and working today, we will understand by analogy a good deal about our own oppression and its pathology. We will see all the signs of self-censorship, hypocritical modesty, insecurity, girlishness, self-deception, hostility towards one's fellow-strivers, emotional and sexual dependency upon men, timidity, poverty and ignorance. All these traits of the oppressed personality are only to be expected; the astonishing and gratifying thing is that so many women conquered all of these enemies within some of the time, most often when they were young, before marriage and childbirth or poverty and disillusionment took their toll. Their defeats can teach us about the nature of the struggle; their successes assure us that we too can do it.

I

Family

The love of fame in men is encouraged by education and opinion: to 'scorn delights and live laborious days' for its sake is accounted the part of 'noble minds', even if spoken of as their 'last infirmity', and is stimulated by the access which fame gives to all the objects of ambition, including even the favour of women; while to women themselves all these objects are closed, and the desire of fame itself considered daring and unfeminine. Besides, how could it be that a woman's interests should not be all concentrated upon the impressions made on those who come into her daily life, when society has ordained that all her duties should be to them, and has contrived that all her comforts should depend on them?

John Stuart Mill, *On the Subjection of Women*, 1906

The single most striking fact about the women who made names for themselves as painters before the nineteenth century is that almost all of them were related to better-known male painters, while the proportion of male painters who were *not* related to other painters is nearly as high as the proportion of women who were. The reason might be obvious, but it is also highly significant; for a woman in whose family circle painting was not practised there was no possibility of access to training, except in very unusual circumstances, as in the case of Sofonisba Anguissola whose widowed father placed her and her sister *en pension* in an artist's household in the sixteenth century.[1]

The undeniable corollary of the fact that nearly all pre-nineteenth-century women painters were related to male painters is the exclusion from the practice of the art of women who were not in that situation. As long as the great mass of women had no conception of seeking vocational training in response to their own creative impulse and no practical opportunity of finding such training, we might as well assume that *the great number of male painters who were not members of painting dynasties could have been equalled by as great a number of women who actually never painted a stroke.* It is foolish to say that women gifted for the visual arts

must have given evidence of such gifts; if they did, they were obliged to do so in the way they clothed themselves and their families and created the environments which inspired painters. They could not even be seen to draw, because drawing as a common pursuit is relatively modern. Paper and drawing materials were not easily available until the eighteenth century, when the number of women active in the graphic arts began to increase rapidly, and reluctant masters found themselves pressured into admitting women to their studios.

Any student of women painters therefore finds that he is actually studying the female relatives of male artists, a curious study in itself, and one which must take account of certain basic factors, some of which, such as the legal status of female relatives, the opportunity that male relatives have to confine and repress women, are obvious, while others, like the effect of filial status upon the self-image of the artist, are insidious. As far as the development of the artistic personality is concerned, the internalised factors are the most crucial.

It would be crass to suppose that the female relatives who copied, imitated, etched, and engraved the works of their better-known menfolk were all much better artists prevented by naked tyranny from making their own designs or accepting their own commissions. Their participation in the graphic arts was probably a filial and submissive response to the family environment and family pressure. Such motivation springs from a desire to conform and please others, and has little to do with the self-generated determination to produce great art. In the conforming, obedient personality which finds its fulfilment and gratification through pleasing others, the super-ego has the id thoroughly muzzled. In man or in woman, such a posture may produce good art but it cannot fling a bridge across to the subconscious and tap the wells of human creativity. Women artists before the nineteenth century seldom expressed their own creativity: they imitated the modes of self-expression first forged by integrated, self-regulating (male) genius, most often when they were already weakened by eclecticism and imitation.

If an influential male artist had a strongly motivated and highly talented daughter, the likelihood is that she would have shown herself an unsatisfactory collaborator, in that her own modes of perceiving and of translating her perceptions would have seemed to her father's overriding artistic ego incompetent because they did not resemble his own. He would have encouraged her as long as she mirrored himself and found her a bad pupil when she ceased to do so. Some extraordinary circumstance would have had to liberate her from her father's interference if the young woman artist was ever to find her own style and subject matter. Until the nineteenth century liberation from the overwhelming and ubiquitous artist father would also have meant cessation of all technical training.

When Elisabetta Sirani set up a school for women in Bologna in the mid-seventeenth century, most of the women who came to her to learn to paint were

not members of painting families.[2] If she had lived longer, her school might have set a precedent. Women might not have had to wait until the late eighteenth century for art training, and the proportion of women painters who were related to better-known men might have been much lower. When public art schools were set up in the nineteenth century, hundreds of women began to study painting, despite the relative impropriety of an artist's peripatetic existence.

All but the most autocratic of fathers encouraged their sons to broaden their acquaintance with the world. It was not complimentary to say of a son that he devoted himself to his family, but it was derogatory to say anything else of a daughter. Sanzio saw that his son Raffaello had greater talent than he, so he sent him away to a better master than himself. For a daughter, such action was impractical and unthinkable. However much her talent for painting might be valued, her other contributions to the nurturing activities of the family were deemed more important. A father might with impunity forbid his daughter to sign paintings in her own style, for publicity was considered immodest, but often such prohibition was unnecessary. Daughters were ruled by love and loyalty; they were more highly praised for virtue and sweetness than for their talent, and they devalued their talent accordingly. Anne Louise (1690–1747), the eldest daughter of Lodowyck de Deyster, is a typical case. She copied her father's work so expertly and faithfully that the copies could not be distinguished from the originals; her original compositions were conceived and carried out in her father's manner and when he died she was his biographer.[3]

Jacopo Robusti, the *terribile maestro*, Tintoretto, was deeply attached to his eldest daughter, Marietta (1560–90). He took her everywhere with him, dressed as a boy, until she was too old. She learned the techniques of painting in the rough and tumble of his studio along with her brothers. Like her brother, Domenico, she learned to paint portraits in Tintoretto's grand manner, which was very popular with the dignitaries who flocked to Venice. When she came of marriageable age, she bleached her hair and wore it crimped around her face like the other fashionable Venetian ladies, whose dark eyes look out of rouged and powdered faces in the portraits from her father's *bottega*. She had become an accomplished musician whose singing and playing delighted her father when he rested in the evenings.

Her fame spread to the courts of Spain and Austria. The Emperor Maximilian and Philip II both asked her father if she might come to work in their courts, but he refused. Instead, he found her a husband, Jacopo d'Augusta, head of the silversmiths' guild, who accepted the condition imposed by Tintoretto, that Marietta should not leave his household in his lifetime. There, four years later, she died in childbirth.

What she thought and felt about her life will never be known, for she furnishes no more than a paragraph or two in biographies of her father. Those tantalised by these cursory references have been only too eager to identify

portraits of Venetian women of this period as self-portraits by Marietta and their misguided chivalry has simply fogged the issue with frivolous attributions. Modern scholars attribute none of the work of the Tintoretto *bottega* to her, although she worked there more or less full time for fifteen years. In the last years of her life, she is said to have portrayed all her husband's colleagues for the silversmiths' guild and it is unthinkable that all these paintings can have perished, rather they have been submerged in the oceanic muddle of Tintoretto attribution.[4]

Marietta Robusti seems to have been treated as a female prodigy, and to have been happy in that rôle, as far as anyone can judge. It is tempting to think that she was destroyed by her father's notorious egotism, but it is begging the question. Her talent might have after all been for being a daughter, rather than a painter. She may have been as dependent upon her father as her brother Domenico was. Without Tintoretto, perhaps neither would have painted a stroke.

However little we know of Marietta or La Tintoretta as she used to be known, we know even less of the daughter of Paolo Uccello, Antonia (1456–91); simply that she 'knew how to draw', became a Carmelite nun and was called on her death certificate '*pittoressa*'.[5]

Carlo Dolci taught his daughter, Agnese (d. 1689), to paint in his own style. Judging from her copy of his *Virgin adoring the Infant Jesus* (Rome, Galleria Corsini) she achieved a considerable degree of expertise. The Louvre has an

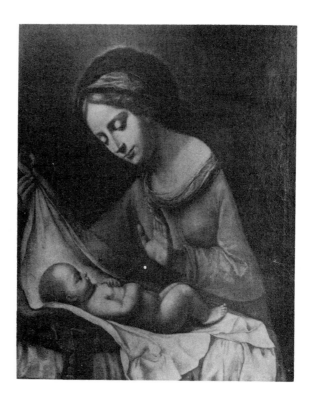

Agnese Dolci, *Madonna and Child*
The copy is not slavish: in fact Carlo Dolci's daughter has deliberately eliminated many sensuous elaborations, simplified the shape and striven for a more austere effect.

original composition by her, *Christ Breaking Bread*, but in general attributions to her are unreliable. She eventually married a silk weaver called Bacci, and probably continued to paint with commercial success in her father's manner. Her work is now engulfed in the floods of contemporary Dolci copies which yearly inundate the salerooms.[6]

Vittoria Farinato copied the works of her father Paolo (*c.* 1524–1606) and as her reward was named as his heir, on condition that all her brothers and their issue pre-deceased her. Rosalia Novelli was the daughter, pupil and copyist of Pietro Il Monrealese (1603–after 1647). Donato Creti (1671–1749), Carlo Maratta (1625–1713), Giovanni Battista Lanceni (*c.* 1660–1737) all had daughters who painted but whose works are unknown.[7]

Vicente Juan Macip had two daughters who collaborated with him, Dorotea Joanes (d. 1609) and Margarita Joanes (d. 1613). It is now quite impossible to distinguish their hands in their father's work. Dorotea's only authenticated work, a *Crucifixion* in the Church of Santa Cruz, Valencia, was demolished with the church in 1869.[8] A similar fate befell the daughter of Mateo Gilarte (d. *c.* 1680) who painted in the cloisters of Murcia, Toledo and Madrid.[9] Isabel Sanchez Coello (1564–1612) followed in her father's footsteps as a portraitist in his style and copyist of his court portraits, which were often ordered in bulk.[10] This kind of drudgery was most often left to the painter's workshop and his family, who had of necessity to remain indistinguishable and anonymous.

The great Dutch painter, Gerard ter Borch the Elder, taught his three

Gesina ter Borch, a page from the album of sketches in the Rijksmuseum
Her sharp but sympathetic observation of animals and people meeting on a visit owes nothing to the muted interiors painted by her father. The purpose of such a sketch was probably simply commemorative, but the talent shown in composition and drawing reveals Gesina as capable of much more.

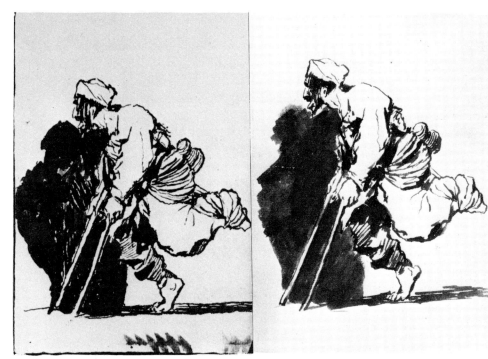

Francisco Goya (and Rosario Weiss), Rosario Weiss, *A Lame Beggar*
A Lame Beggar
 In the process of composition Goya has simply blocked out a second figure.
Rosario Weiss copies the drawing as exactly as she can including the shadow,
although she disentangles the ends of the crutches. The emphasis and thrust of
the drawing is slightly weakened because she is drawing a drawing and not a
figure. Some signs of retracing may be seen on the original.

children, Gerard the Younger, Gesina (1633–90) and Maria, to paint. Gesina had
considerable skill and sympathy in depicting lively scenes of family life, both
indoors and out, and it is tempting to see her hand in much of her father's work,
but no detailed study of her contribution has ever been made. The album of
sketches preserved in the Rijksmuseum is her only authenticated work.[11]

Sir Anthony Van Dyck's daughter, Justina, born in London in 1641, is
recorded by Vertue as the painter of a *Christ on the Cross with Four Angels
gathering the Precious Blood*, but the painting has never been identified. She
married Sir John Stepney when she was twelve years old and received a pension
from Charles II.[12]

Frans Xaver Hendrik Verbeeck (1686–1755) married the daughter of his
teacher Peter Casteels II, and taught his own daughters, Elisabeth (b. 1720) and
Anne (b. 1727), to paint, but no works by either are known.[13]

When Francisco Goya left Spain for political reasons in 1824 and settled in
Bordeaux, he was joined by his friend, Doña Leocadia Zorilla de Weiss, and her
ten-year-old daughter, Maria del Rosario, who was, 'as a result of the misfor-
tunes suffered by her family', entrusted to his care. Goya may have been her

real parent; at all events he was *in loco parentis* and he treated the gifted little girl as many a proud father had done in the past. He set himself to teach her to draw without boring her, by making vignettes of droll and interesting subjects which she would copy over and over again until she had mastered his style. He was immensely proud of her facility:

> This astonishing child wishes to learn miniature painting and I also wish her to do so, for she is probably the greatest phenomenon of her age in the world, doing what she does . . .[14]

but his attempts to find her a teacher in Paris were unsuccessful. She continued her studies under Lacour who also taught by getting his students to copy. When Goya died Maria del Rosario became a faker in league with a crooked dealer. After she had copied colour sketches by Velàzquez in the collection of the Duchess of San Fernando, the Duchess quickly bought the paintings and refused to allow her to copy any more of her collection. In 1841 she was made a member of the Academia de San Fernando, and in 1842 became the teacher of little Queen Isabel II. In 1843 she died, aged twenty-nine.

In the collections of drawings by the hands of Goya and Rosario Weiss can be seen all the drama of the invasion of a talented little girl's mind by a more powerful artistic personality. In choosing to spend hours over Goya's motifs, she tacitly assumed the focus of his interest. More insidiously she took over his modes of translating ideas into lines and masses, adopting therefore the graphic language of Goya's subconscious, the rhythm and stress of another's response to reality. We do not know what means Goya used to control her imagination: little coercion is needed when the emulation is prompted by filial love. When the old man embraced her and praised her to the skies she must have been utterly content. When the object of that love was taken from her, she simply filled the void by allowing other painters to take his place, and became a mere counterfeiter.

The most striking instances of women dragooned into the practice of painting by family pressure are possibly those groups of sisters exhibited by their trainer-manager fathers as wonders of the earth, ready-made covens of muses. Angelica, Anna, Clorinda and Lucrezia, the 'beautiful' daughters of the Flemish Nicolas Regnier (*c.* 1590–1667), who worked in Italy, were all instructed in the techniques of painting by their papa. The chivalrous *accademici* of Venice assure us that the male painters of the time gnashed their teeth in envy of their brilliance, but no work from the hand of any of them survives to give substance to such compliments. Lucrezia married the Flemish painter Daniel van den Dyck, and Clorinda, Pietro della Vecchia.[15]

The Neapolitan Paolo de Matteis (1662–1728) taught his three daughters to paint. Mariangiola devoted herself to portraiture, Felice was an amateur painter of small religious pictures, and Emanuella copied historical and mythical subjects.[16]

George Lisziewski trained two daughters: Anna Rosina (1716–83) was to

Jane Nasmyth, *Furness Abbey with a distant view of Morecambe Bay*, 1849
As Alexander Nasmyth's eldest daughter, Jane had perforce to spend most of her time working as his collaborator. Few indeed are the works which she managed to sign as all her own work. Her sister, Barbara (b. 1790), worked 'with success and much respect' in London after their father's death.

have a great success in her widowhood, after 1755, and, as Madame Matthieu, to be invited to Brunswick for royal commissions, and be named a member of the Dresden Academy; Anna Dorothea (1721–82) was to hold court appointments in Prussia and in Russia, and become a member of both the Berlin and Paris academies. Their brother was so impressed that he in turn trained two daughters, Julie (1767–1837), and Frederica Julia (b. 1772), who also became a member of the academy at Berlin.[17]

Alexander Nasmyth, the Scottish water-colourist, trained all his five daughters to follow his calling, an easy matter enough, seeing that a large part of his time was spent in teaching the taking of water-colour views to ladies. His most successful pupil was his eldest daughter, Jane, whose work could hardly be distinguished from her father's. Some insight into the probable relationship of earlier fathers and daughters for whom we lack documentary evidence might be gained from a letter that he wrote to accompany a batch of paintings to London, in which it appears that four of the five paintings were actually by Jane. Alexander, a canny Scot, is careful not to devalue them too far: he muddles the whole matter by remarking: 'This picture is likewise by Miss Jane, with some of my own painting on it, as is the case with all of them.'[18]

Alexander Nasmyth's clever daughter was only raised above the rank of the nameless members of a *bottega* because he chose to acknowledge her. Working under such close supervision would have stifled the expression of Jane's own artistic vision, if she had had one, and rendered quite impossible the imposition of her own personality. Jane had learned a method of taking views, following the mode of perception of another and subjecting herself to his version of the experience, so that he might take her work and transform it by adding the 'finishing touches'. Her own attitude must have been analytic and reductive. While the greatest artists have been able to make for themselves extra pairs of hands, none of the successful extra pairs of hands has ever belonged to a great artist, for an artist who is dazzled by his own interior vision cannot put on the perceptual mode of another.

Rosa Bonheur (1822–99) is the most striking example of a painter who, while practising the same genre as her father, outstripped him absolutely (see Pl. 18). All Raymond Bonheur's children were taught to paint, perhaps as a result of the extraordinary application of their elder sister, who was at first apprenticed to a dressmaker and had to struggle to be allowed to study painting seriously.

Charlotte Nasmyth, *A Wooded Landscape with Travellers on a Path*, 1813
 After Margaret (b. 1791), Elizabeth (b. 1793) and Anne (b. 1798), considered to be
 at her best the best painter of the whole Nasmyth family, came Charlotte, whose
 birthdate (1804) may have to be revised, unless the signature and/or the date on
 this painting are/is forged.

Except for Rosa, none of the Bonheurs achieved anything of importance. Juliette (1830–91), Rosa's junior by eight years, painted sentimental studies of pet animals, with a degree of commercial and some academic success. She played a typically sisterly rôle at the girls' school in the Rue Dupuytren from 1849 until 1860, when her second son was born, for Rosa visited the school for a short time once a fortnight, while Juliette attended to the daily needs of the pupils. The girls found Madame Peyrol 'very nice' and her pictures were 'considered by them worthy of emulation', a fact which might explain why no stream of female artists issued forth.[19]

It is an important factor in the development of Rosa Bonheur's talent that she did not continue to live in the bosom of her family, as a maiden aunt whose time was at their disposal. She was befriended and supported by an old friend of her mother, Madame Micas, with whom she went to live until Madame Micas died when she continued to live with Mademoiselle Micas. In their household she was no longer a junior or a menial, but their head and their idol. Madame Micas kept house for her and Nathalie Micas, herself a painter, provided the supportive friendship that the artist needed, creating for her a fostering environment, almost unique in the annals of gifted unmarried women, most of whom were incessantly called from their work to nurse the sick and dying, to care for sisters in childbed and their children, to mother the motherless, and the like.[20]

Besides copying, preparing and engraving her father's work, an artist's daughter could offer another service: she could bind his best students to him by marriage. For an ambitious student the move had obvious advantages: the girl did as she was told. Quintilia Amalteo's father had married the daughter of his master, Pordenone; in turn, he married his own daughter (*c.* 1572–after 1611), known to history as a painter, to Guiseppe Moretto.[21]

Such marriages founded veritable art dynasties which could run on for generations. In most of these dynasties the rôle of women is obscure: they are the mortar that holds the male bricks together. In others, the Christian names of the women are known, and even some notion of the kind of artistic activity that they were interested in. While maternity was a hazardous business, and high infant mortality made married life one continuous pregnancy, few of the womenfolk in painter families had any chance to leave even their names to posterity. Their participation in the family business was usually sporadic and menial. Fashion also played its part: some generations gloried in their women's participation, others were ashamed of it.

Dammes Claesz de Hoey chose Marijtgen, the daughter of Lucas van Leyden, to help him found a painting dynasty. Of their four sons, two became painters and moved from Leyden to Fontainebleau to work for Henri IV. Jean I (1545–1615) married a granddaughter of Domenico del Barbiere, Maria Ricoveri, who as well as sons gave him four daughters, three apparently with the same name: Françoise I did not marry a painter, but her son, Simon de Laminois, became a successful painter of battle scenes, working in

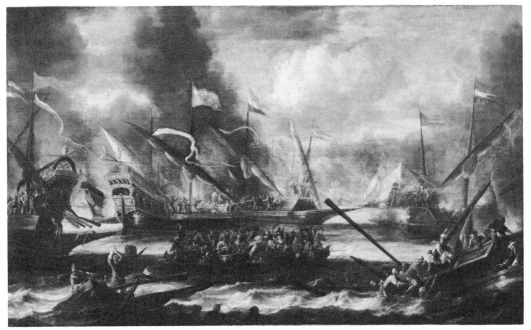
Catharina Peeters, *Sea-Battle*, 1657
The theme is here subordinated to the play of criss-cross lines and alternating
bands of light and shade, action transmuted into pattern, two hundred years
after Uccello's *Battle of San Romano*.

Fontainebleau, Venice and Paris, where he was received into the Académie
Royale in 1663; Françoise II married the painter Martin de Fréminet, who
already had two sons by the sister of the painter Maugras. She gave him two
painter sons, Martin and Paul, before her death in 1615, when her husband
married, as third wife, her sister, also called Françoise, widow of the painter
Ambroise Dubois (1543–1614), director of painting in the Château de Fon-
tainebleau. This marriage yielded two painter sons, Jean and Louis, and Jean
was to father two painters, also called Jean and Louis. One of Maria Ricoveri de
Hoey's sons, Claude, succeeded Jean de Hoey as *peintre et valet de chambre* in
1603, and in 1621 married Gabrielle Tabouret, granddaughter of Ruggiero dei
Ruggieri.

We cannot be sure that simply because no artistic activity by the women has
been recorded, that they were chosen simply for their blood-lines. Young
Simon de Laminois must have been steered towards painting by his mother, for
she was bringing him up far from her own family, in Noyon.[22]

Netherlandish painting has always been a family business and we may
perhaps trace the rise and fall of Netherlandish influence in the promotion of
women's participation in other countries. The Antwerp family of marine
painters, the Peeters, were apparently happy to have Catharina (1615–76) sign
works, alongside Gilles, Bonaventura and Jan, for the Liechtenstein Collection
in Vaduz has a signed painting of a sea-battle in her brothers' manner.
Catharina's niece Isabella Josina Peeters (1662–?) was also a painter.[23]

The women of the dynasty founded by the French landscape painter, Antoine Hérault (*fl.* 1631) succeeded in carrying out some independent artistic activity, within rather strict limits. Of Hérault's twelve children by Madeleine Bruiant, a daughter Madeleine (1635–82) married her father's friend and colleague, Noël Coypel (1628–1707), and contributed to the family fortunes by working as a copyist, as well as producing a son, Antoine (1661–1722), a distinguished painter who became Rector of the Académie des Beaux-Arts in 1716. His son Charles Antoine became a painter-engraver. When Madeleine died, Noël Coypel married another painter, Anne Françoise Perrin, who bore him another painter son, Noël Nicolas. When Coypel died, Anne Françoise married another painter, François Bonart. Madeleine's younger sister, Antoinette, who excelled in making miniature copies of the works of the great masters, married the successful engraver Guillaume Chastel (1635–83), to whom her talent would have been decidedly useful, for engravings are usually made from small-scale copies of larger works, it being impractical to bring huge canvases into the workshop. Upon her husband's death, she married the court painter and engraver, Jean-Baptiste Bonnart.[24]

One of Antoine Hérault's sons, Charles Antoine (1644–1718), himself a painter, married another member of a painting dynasty, Marie Geneviève de Lens, who gave him three sons and six daughters 'toutes belles et sachant bien habilement manier le pinceau'.[25] Marie Cathérine (1680–1743) married Louis Silvestre le Jeune, himself the grandson of a glass painter who married his master's daughter, and the son of a painter. Twelve years after their marriage, she accompanied him to Dresden, where he had been appointed court painter to Augustus II and helped him in the drudgery of painting copies of his official

Maria Tibaldi Subleyras, *Supper in the House of the Pharisee*, 1798
Three of the women in Pierre Subleyras' household were miniaturists, Felicita, his wife (1707–70), Clementina, his daughter (*fl. c.* 1784) and Maria, who may have been a sister-in-law or a daughter. Such copies of larger works were highly prized.

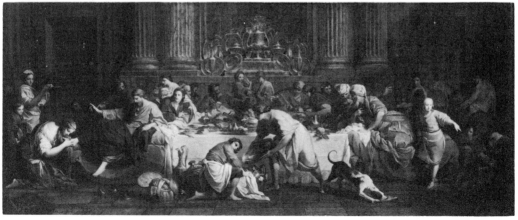

portraits. Their son François Charles distinguished himself as a painter in Dresden where he became Director of the Academy in 1748. Apparently Marie Cathérine Silvestre accepted commissions on her own behalf: ten pastel portraits of Polish nobility in the Museum at Capodimonte are attributed to her. A daughter of Marie Cathérine, Marie Maximilienne (1708–97), helped in copying her father's portraits and became the drawing teacher of Marie Josephe de Saxe, later Dauphine of France.

Madeleine, the second daughter of Charles Antoine Hérault, married the painter, Jean Bérain le Jeune, whose nephew was a student of her brother-in-law, Louis Silvestre. In 1712, Geneviève Hérault married the history painter Pierre Dulin, and her three sons all became famous artists. Anne Auguste Hérault, elected to the Académie de Saint-Luc in 1721, was wife of François Hutin, painter to the King of Poland (which suggests another attribution for the Capodimonte pastel portraits).

Cathérine Hérault (b. 1691) married the King's medallist, Joseph Charles Roettiers, himself a member of a huge art dynasty in which the women did not figure as active artists. The son, Charles Roettiers, succeeded his father as medallist to the King.

Clearly, the amount of independent artistic activity that a female member of a painting dynasty could lay claim to was largely determined by the heads of the family. Unmarried women in painting families were seldom encouraged to undertake independent works on the same scale as their brothers or to accept independent commissions, but they were not allowed to remain idle either. By making miniature copies of their menfolk's work they increased its fame and therefore its value, for there was a separate market for miniature copies as collectibles and *aides-mémoires*.

Oil painting is a slow and continuous labour, not much of which is directly concerned with the fine points of design and composition, and women not employed in other household tasks must have been called in to help. Whether the family publicly acknowledged the participation of its womenfolk was entirely up to the individuals; there was no public pressure working upon them. If anything, public pressure worked against the publicising of women's contribution to the work of famous family *ateliers*.

Charles Willson Peale decided to commandeer the position of head of a cultural dynasty in North America while the post remained vacant. By his first wife, Rachel Brewer, as well as boys called Raphaelle, Rembrandt, Titian and Rubens, he had a daughter Angelica Kauffmann Peale (1775–1853) whom he portrayed as his successor, taking the brush from his hand, but she gave up painting after her marriage; two other daughters, who died in infancy, were called Sofonisba Anguisciola and Rosalba Carriera. His second wife, Elizabeth de Peyster, bore him a Titian and a Vandyke but no daughters.[26]

C. W. Peale's brother James married the daughter of a painter. Their five surviving daughters all painted: Jane Ramsay, Maria, Anna Claypoole,

Sarah Miriam Peale, *Self-Portrait, c.*
1830
 This bland portrait is typical of the
 likenesses by which Sarah Miriam
 earned her living.

Margaretta Angelica, who was a founder member of the Pennsylvania Academy of Fine Arts, and the best known of the Peale women, Sarah Miriam. It seems that proficiency in painting was not the attraction to prospective husbands in early nineteenth-century Maryland that it had been in pre-revolutionary Europe. Maria, Margaretta Angelica and Sarah Miriam all died unmarried. Sarah Miriam seems to have been something of a pioneering rebel, for she left her father's house in 1831, and went to live and work on her own in Baltimore. She died in St Louis, having supported herself all her life by her own work.

The third generation of Peales produced a daughter of Rubens, Mary Jane (1827–1902), who is perhaps unique in that she instructed her father at the age of seventy-one in the art of still-life painting which he practised with marvellous results. Although Rembrandt Peale married a painter, Harriet Cany (c. 1800–69), he did not thereby advance the dynasty. His cousin, Jane Ramsay Peale, had a daughter, Mary Jane Simes, who practised as a miniaturist.

Ironically perhaps for a would-be art patriarch, Charles Willson Peale believed passionately that artistic talent was not inborn. The point of training all his and his brother's children as artists was to disprove any idea that talent is hereditary. He must have felt some discouragement when he reflected upon the environmental factors which would work upon the children, from which

artistic discrimination and economic encouragement were notably absent. The training they could get was severely limited, but even so it is chilling to observe that in a long professional career as a portrait painter, Sarah Miriam Peale never altered her formula. She painted a dull succession of busts, on the same models as her contemporaries, the itinerant portraitists, usually without hands for reasons that are apparent when hands are included, in creamy, opaque swirling brushwork, broadly modelled masses contrasting with the finicking linear detail of lace and Kashmir shawls. Her smooth cosmetic approach is thoroughly commercial, non-committal and uninteresting.

Families cemented together and enriched by the activities of women must also have been profoundly under their influence in that they were the first teachers of all the children. Usually the recorded master of a painter from an art dynasty is his father, regardless of his mother's rôle in his earliest motivation and training, but there are cases where a woman has been specifically named as the teacher of her sons and daughters.

Marie Bessemers (*c.* 1520–*c.* 1600) was a miniaturist, and, according to Guicciardini,[27] one of the five best known Netherlandish women painters of her time. She married Pieter Coeck van Aelst, the painter, designer, sculptor, engraver, writer and publisher, and is more usually known as Mayken Verhulst. No work can be attributed to her with certainty, although Simone Bergmans tries hard to build a case for her identification with the Monogrammatist of Brunswick.[28] One of her daughters, Marie, married Pieter Breughel the Elder, and brought her two boys to live with their grandmother when her husband died in 1569. Jan, better known as Velvet, Breughel was only one year old, and his grandmother is usually credited with being his first teacher.

She married her other daughter, Katharine, to her husband's successor as doyen of art publishing in Brussels, Hubert Goltzius. Her great-grandson, Jan Breughel II, married Anna (*fl.* 1645–68), the daughter of his fellow flower-painter, Abraham Janssens. Another Anna, Mayken Verhulst's great-granddaughter, married David Teniers the Younger. Two other great-granddaughters married painters, Hieronymus van Kessel and Jan Baptist Borrekens.

There are relatively few examples of women painters training their daughters to follow in their footsteps. One of the earliest cases documented is that of Cecilia Morillas Sobrino (1538?–81) whose nine children were all famous. She taught painting to two of her daughters, one of whom, taking the name Cecilia del Nacimiento in religion, worked as an artist in her convent at Valladolid.[29] Artemisia Gentileschi taught at least one daughter to paint, but showed rather more concern in finding a good husband for her, understandably enough in the light of her own insecure and laborious existence.[30] Teresa del Po (d. 1716), a miniaturist and copper-plate engraver, trained her daughter, Vittoria, who married the engraver Patin.[31] Maria Caterina Prestel (1747–94) is not usually given the credit for training her daughter Ursula Magdalena (1777–1845) who

Giovanna Fratellini, *Self-Portrait*
Giovanna Fratellini (née
Marmocchini-Cortesi) was
presented to the Grand Duchess
of Tuscany by her uncle, her
aiutante di camera; she was
educated with the women in the
Duchess's service and became
an accomplished portraitist,
carrying out commissions for
Cosimo III, Ferdinando de'Medici
and Violante Beatrice of Bavaria,
in miniature, oil, pastel and
enamel, but she regarded her
son as her masterpiece.

made her name with portraits, flower paintings and engravings, but as the
sixteen-year-old girl accompanied her mother when the latter left her husband
in 1786, and travelled with her to London, it seems likely that mother and
daughter were working together.[32]

Examples of women painters who trained their sons are much more readily
found. Giovanna Fratellini (1666–1731) was immensely proud of her son,
Lorenzo; his early death was the great grief of her life. Mary Beale (1632–97)
gloried as much in the achievement of her son Charles as she did in her own.
The enormously successful Ary Scheffer (1795–1858) owed everything to his
mother, the painter Cornelia Lamme (1769–1839), who took her two sons to
Paris after the death of her husband, so that they could train with the painter
Guérin.[33] Maurice Utrillo's debt to his mother, Suzanne Valadon, is well
documented. Van Gogh's first paintings were copies of the works of his
mother, Anna Carbentus.[34]

Few painters actually bothered to acknowledge the women who guided their
first efforts. A shining exception is the Umbrian, Ignazio Danti, who went out
of his way to acknowledge his indebtedness to his gifted aunt, Teodora
(1536–86).[35]

Rolinda Sharples, *Rolinda Sharples and Her Mother*
Rolinda Sharples (1794–1838) was encouraged to take up painting seriously by her mother, the miniaturist Ellen Sharples, who used her talent to support them in the United States. She earned her first fee at thirteen. Upon returning to England, her mother sought out further teachers for her; she became an honorary member of the Society of British Artists in 1827.

It is a sad reflection of the obliteration of the contribution of women to the great art dynasties that often we do not learn the names of any female members until the dynasty has died out, leaving them exposed like pebbles at low tide. The last descendant of the Holbein family was a woman and an artist, Therese Holbein von Holbeinsberg, who died in 1859.[36] The last artist of the great degli Erri family, famous in Modena since the beginning of the fifteenth century, Ippolita degli Erri, died in the convent of San Marco in 1661.[37] The Huygens family, which produced many gifted amateurs, died with Susannah, great-granddaughter of Constantijn the Elder, in 1785.[38] The last members of the van Huysum family were three sisters, Francina Margareta, Anna and Magdalena. There is a rumour that they had a gifted aunt, Maria van Huysum, but no proof of her existence has ever been found.[39] Women artists appear only in the last generation of the Parrocel family, which had originated in Montbrison in the seventeenth century.[40]

In the patriarchal family system, brothers have almost as much ascendancy over sisters as fathers over daughters, especially if a brother has taken a father's place as head of the family. Art history abounds with the names of sisters who worked with or for their brothers, not only painting for them, but copying and engraving their works, travelling with them and keeping house for them.

Perhaps the most tantalising sister is the shadowy Margarethe van Eyck, sister of Jan and Hubert. She may have been first mentioned in L. de Heere's 'Ode on the Ghent Altarpiece', supposedly written in 1559, though the extant version is probably an eighteenth-century forgery.[41] In 1569, M. van Vaernewyck recorded that she never married, worked and lived with her brother Hubert beside whom she was buried in the church of St Bavon in Ghent.[42] Hubert and Margarethe stayed in Ghent, while Jan travelled in the service of the Duke of Burgundy and it is probably safe to assume that Margarethe died at about the same time as her brother, whose burial is recorded in 1426. While her brothers occasionally signed their work, and other work can be attributed to Jan by documentation, Margarethe neither signed nor was associated by contemporary tradition with any work. Many romantic feminists have seized upon the conundrum and ascribed paintings to this shadowy figure, for example, *The Virgin and Child* and the *Mystic Marriage of St Catherine* in the National Gallery, London, which have both been ascribed to her at different times.

Not all sisters have been as effectively hidden from history as Margarethe van Eyck, but most have shared the fate of Cecilia Riccio (1549–93), the daughter of Il Brusasorci, whose work is nearly always confused with that of her brother Felice.[43] Chiara Varotari, the sister of Il Padovanino, devoted her life to him. Although she was sufficiently aware of her own individuality to write a

Chiara Varotari, *Self-Portrait*
Despite the ravaged condition of this self-portrait its impact is still dramatic. The stern expression and averted gaze of a woman who refuses to enter into any coquetry with the beholder are belied by the blood-red flower in her dark hair.

feminist tract and to send her self-portrait to the Grand-ducal collection in the
Uffizi, there are too few works attributed to her nowadays. The sisters of
Godfried Schalcken (1643–1706), Pietro Damini da Castelfranco (1592–1631),
Antonio Triva (1626–99), and Herman van der Mijn (1684–1741) are known to
have collaborated with them, but no independent works are recorded.[44]

Jeanne Natoire and Theresa Concordia Mengs accompanied their better-
known brothers to Rome in the mid-eighteenth century, doubtless so that they
might continue to give their valuable collaboration. Unmarried women, like
Lucia Ricci who worked with her uncle Ubaldo (*c.* 1650), and Elisabetta
Lazzarini (1662–1729), who helped her brother Gregorio until she went blind,
have left no recorded protest against the sacrifice of their lives. Women like
Claudine Bouzonnet (1636–97), whose 'existence retirée et labourieuse' drew
such praise from Fidière, engraved her father's work, as well as Poussin's; and
Jessica Landseer (1810–1880) was happy to engrave her more famous brother's
work.[45]

When the Reynolds children were small, they used to draw with charcoal

Agatha van der Mijn, *Dead Hare*
 It is no great surprise to learn that the painter of this dead hare was the sister of
 the painter of fruit, flowers and dead birds, Herman van der Mijn, whom she
 accompanied to England in 1719. She became a member of the Free Society of
 Artists and exhibited for the last time in 1768.

Marie Amélie Cogniet, *Portrait of Madame Adélaïde d'Orléans*
Marie Amélie was the student of her brother, Léon. She did not begin to exhibit until 1831, when she was thirty-three, and evidently gave up in 1843. This painting is closely related to her brother's portrait of the same sitter in the same pose in the Museum at Orléans.

upon a whitewashed wall; of the eleven (or twelve) of them, Joshua, the seventh child, was not the most successful. Among those whose facility surpassed his was his little sister, Frances (1729–1807). When the decision had been taken that Joshua should become a portrait painter rather than an apothecary, he was duly apprenticed while Frances continued her artistic activities without systematic training. When her brother came to London in 1752 and began to make a name for himself, Frances kept house for him for many years. It was then that she met Dr Johnson who became very fond of 'Renny' as he called her. 'Madame, I would rather sit with you than on a throne,' he would say when he came to take a dish of tea with her years later, when she was living on her own.[46]

Sir Joshua (he was knighted in 1768) did not treat his gifted sister well. Her miniature copies of his own work, which unwittingly betrayed all his weaknesses in drawing, made others laugh and him cry, he said. Her known work is solidly conservative, neither comic nor lamentable. The man who was famous for his kind heart and his encouragement of young people never instructed his sister in painting (as he confessed to Northcote), and gradually refused to speak to her at all. Fanny Burney seeks to explain this sad circumstance in a characteristically condescending way:

> [Frances] unfortunately for herself, made throughout life the great mistake of nourishing a singularity which was her bane, as it had been her greatest blessing ... it was that of living in an habitual perplexity of mind, and irresolution of conduct, which to herself was restlessly tormenting, and to all around her was teasingly wearisome.[47]

Against this description of a silly woman must be put the friendship of Dr Johnson, who was not noted for bearing fools gladly. He was happy to sit for Frances to paint him in miniature on many occasions. She painted his blind friend, Mrs Withams, and Hoole, the translator of Ariosto, but most of all, it seems, she painted nothing at all. In 1767, when Sir Joshua was at the high point of his career, he sent her away from his house, which was henceforth kept for him by his pretty nieces, Mary and Theophila Palmer. Frances, still unmarried, could not have lived in London anywhere else but in her brother's house without causing a scandal. As she was his dependant, she was at his mercy and could only protest helplessly at her banishment to Windsor. Dr Johnson drafted her letter of protest to her brother.[48]

In her Commonplace Book, to which she had confided her fears about her brother's irreligion and the single-mindedness of his ambition, she wrote sadly:

> I am incapable of painting; my faculties are all becalmed in the dead region of Torrington. I want some grateful gale of praise to push my bark to sea, some incentive to emulation to awake my slumbering powers ...[49]

She struggled not to vegetate in her seclusion, writing poems and even a tract on aesthetics, 'An Enquiry concerning the Principles of Taste and the Origins of Our Ideas of Beauty'. Her brother's rejection paralysed her, for she could not be seen to be at odds with him, for his sake as well as her own.

> As the mind must have some pursuit and I unhappily have none that is so satisfactory, or that appears to me so praiseworthy as painting, and having been thrown out of the path nature had in a peculiar manner fitted me for, and as it is natural to endeavour to excel in something, I confess I can't help pleasing myself in the hope that I might arrive at a tolerable degree of perfection in these little pictures, could I refresh imagination and improve my ideas by the sight of pictures of that sort, and by the judgment of connoisseurs. But I must beg you to believe that nothing but the greatest necessity should prompt me to take any advantage of them in a manner unsuitable to the character of a gentlewoman, both for my own sake as well as my brother's ... The height of my desire is to be able to spend a few months in the year near the arts and sciences, but if you think it will bring my character in question, for my brother to be in London, and I not at his house, I will content myself with residing at Windsor.[50]

When her brother died in 1792, Frances Reynolds took a large house in Queen's Square, Westminster, where she exhibited her own works until her death in 1807, hardly the behaviour of a woman who suffered from chronic indecision.[51] There is, alas, nothing surprising in the fact that a man who genuinely cared about painting and the nurturing of young, and female, talent, should have been unable to tolerate it in his own little sister, whom he sought to treat as a domestic. Whatever facility she had reflected tamely upon his own ability, which he wished to show as prodigious. He was, in a word, frightened of her, the little sister who had laughed at his own childish attempts to draw. From his pinnacle as founding president of the Royal Academy he could extend

Guglielmo and Orsola Maddalena Caccia,
The Martyrdom of St Maurice
　Modern scholars believe that Orsola
　Maddalena painted the upper part of this
　work, partly on internal evidence of weakness
　in drawing and colouring.

largesse to strangers, but there is no condescending to members of one's own family.

Until a hundred years ago, the only alternative to family life for women was the convent. A woman stifled by the expectations of her kin, and unthinkingly obscured by those she loved, could not simply set off to earn her fortune on her own, or present herself as an apprentice to masters outside her household, but if she hoped for creative opportunity and freedom within the convent, she was often sadly mistaken. There she simply exchanged the duty of obedience to her father for obedience to her superiors in religion. She might as a nun secure important public commissions for the Church, but even then, the Church was not blind to the fact that she was related to a famous artist; she might even have been accepted without a dowry if she could guarantee the help of her kinsmen in beautifying Church property. Such, it seems, was the lot of Suor Lucrina Fetti.[52]

Giustina Fetti came to Mantua with her family, including her brother, the painter Domenico, at the invitation of the Duke Ferdinando Gonzaga in 1614. The Duke gave her a hundred and fifty scudi towards her dowry when she became Suor Lucrina at the Ursuline convent. A series of eight scenes from the New Testament, all inscribed S.L.F.R.F.S.O. 1629, rendered as *Suor Lucrina Fetti Romana fece in Sant'Orsola 1629*, seems clearly inferior to the group of portraits of the patronesses of the convent usually ascribed to her, while a third group of paintings represents the work of several different hands. On a painting of St Barbara, in a private collection in Rome, the inscription LUCRINA FETTI FECI L'ANNO 1619 appeared after cleaning had removed Domenico's name. This may be one of two paintings that she carried out for the chapel of Santa Margaretta in the public church attached to the convent of Sant'Orsola. It is also closer to her brother's style, manner of execution and colour range than

any other work attributed to her. The case of Lucrina Fetti, it seems, provides one example where the shadow of a famous brother fell across the work of a sister, even within the cloister.

A more extraordinary example of the power of a male kinsman to affect the destiny of women even after his death was the foundation of a monastery by the painter Guglielmo Caccia, in his home town of Moncalvo. There he placed his five daughters, two of whom are known to us as painters. The eldest, Orsola, was trained to be her father's assistant, and scholars are only now setting about the arduous task of distinguishing her work from her father's. Occasionally she identified herself by a small emblem, a flower, but more often she was entrusted with the colouring of her father's designs, to which he added the final touches, so that very little in the way of definitive attribution may be expected. Orsola's independent working life lasted until 1666; she lived to have assistants and pupils of her own.[53] Francesca, who died in 1627 at the age of nineteen, was deemed so excellent a painter that 'her works may not be distinguished from her father's' unless signed with her emblem of a bird.

Blanche Hoschédé, *The House of Sorel-Moussel*
It was Blanche Hoschédé who gave Monet the courage to survive the Great War, and to take up painting again. She kept his household together and invited his friends to stay as his mother had done. Whether she would have painted at all in different circumstances, or developed an artistic personality of her own, can never be known.

Although there are many examples like that of Edvard Munch, who asked that his sister's paintings not be exhibited because it excited her too much,[54] it must not be supposed that the chief element in the eclipse of artists' kinswomen was any such crass persecution. In allowing their daughters and sisters to practise as artists, the male artists treated them in a paternalist fashion, allowing them to learn only as much as was useful, but there are very few examples of the women protesting against such treatment. A man like John Flaxman, who encouraged his half-sister Mary Ann Flaxman (1768–1833) and his young sister-in-law Maria Denman (d. 1860), who took his name, was not promoting women at his own expense, but earning golden opinions for his enlightened attitude. The women, for their part, underlined his own greatness and superiority in every line they drew.[55]

The feminist art historian must deal with the phenomenon of willing self-sacrifice, like Blanche Hoschédé (1865–1947) who, when her husband died, devoted herself to her father-in-law, Edouard Monet, 'running his house, accompanying him on his walks, painting at his side in the garden at Giverny'.[56] It is true of women painters as it is true of women in all walks of life that human relationships are more important to them than ambition for personal success. The artistic ego is to most women repulsive for themselves, and compelling in men.

Whether daughters or sisters, these painters were ruled by love and admiration, not by the exigencies of their own talent and creativity; they tendered the sincerest flattery of their menfolk, faithful imitation, in which we search in vain for evidence of an independent artistic personality. Whether we hope to find it in the unconscious patterning of the brushwork, a difficult matter since they have learned even that from the loved source, or in a subtle treatment of the overt content of the paintings, it is rarely apparent. Attempts, however scholarly, to separate the hands of father or brother from the contribution of a female relative involve a certain amount of assumption which entails what is then proved, that most daughters and sisters are distinguished by weaker drawing or a narrower range of technical skill. Feminists might insist that paintings made by men and women ought to be exhibited bearing the names of all the collaborators but such a procedure would bring forward more men than women and more anonymous workers than known collaborators of either sex.

When art appears to a woman in the person of a loved male, her attitude to it necessarily partakes of the nature of her relationship to men. If male relatives exercise dominion over the minds and hearts of their womenfolk, unrelated males who are love objects exercise more destructive power still. Many women escaped the family pitfall only to be betrayed by sexual love.

II

Love

They engage very little in warfare, they permit themselves to be blackmailed and bullied and intimidated and bribed by their more aggressive neighbours; they admire so deeply the artistic products of others that they have developed practically no art of their own.

Margaret Mead on the Arapesh male, *Male and Female*, 1967

As the body of Greuze lay in church, a 'young person, whose emotion and tears could be seen beneath the veil which covered her face' came up to the coffin, put a bouquet of *immortelles* upon it and withdrew. She was Constance Mayer who, with Anne Geneviève Greuze, Caroline de Valory, Madame Junot and Philiberte Le Doux, was part of the group of young women who surrounded the old painter in his declining years. 'He painted virtue, friendship and innocence, and his soul breathes through his pictures' it said upon the gravestone that his daughters put up to him.[1] He is more famous for painting damaged child-women, with the emblems of their own vulnerability, *cruches cassées*, dead birds and broken mirrors, *aux regards noyés* and with dishevelled hair, one rose-petal breast peeping through their disarranged corsage. What passed for 'innocence' was simply the image of woman as victim, the innocence was defiled, self-conscious, a source of erotic appeal. The stereotype appealed to women themselves, not all of whom, like Vigée-Le Brun, knew what to take and what to leave behind. Constance Mayer drank deep of his polluted well. She copied his manner so well that several heads, actually by her, appeared upon the art market as the work of Greuze.[2] After his death in 1805 she went to his successor as chief painter of sentimental erotica, Pierre-Paul Prud'hon.

In 1798, Citoyenne Mayer exhibited five works, among them a self-portrait which, if we could find it, might give us some impression of how the painter saw herself before she was so submerged in the men in her life that they dictated even her physical image.[3] A rather dry conversation piece, exhibited in 1801, shows the artist, much idealised as a tall woman with a noble profile showing through her Grecian curls, gazing upon the bust of Raphael. This view of herself is fundamentally different from the gamine self-portraits she painted later from sketches by Prud'hon. In this picture, she shows herself as an imposing, free-standing figure, intent upon the honourable pursuit of art. In life it was love that claimed her art and ultimately her life.

Like Greuze's, Prud'hon's life was complicated by the existence of a wife, who was eventually incarcerated by Imperial order, because she dared to implicate in one of her jealous scenes the Empress Joséphine, whose portrait Prud'hon was painting. Their five children were to be cared for and brought up by Constance Mayer who, when she had time, worked in Prud'hon's *atelier* under the direction of her master.[4] Works attributed to her are few, and preparatory sketches for them in Prud'hon's hand exist in large numbers. On the other hand, her contribution to the larger output of her master, apart from the unseen contribution of running his domestic affairs, was also great.

Constance Mayer, *The Dream of Happiness*
Constance Mayer's icon of bliss, in which the boat reminds us of the Empire beds *en bateau*, shows herself as Fortune, the dark guardian of a blond felicity she never enjoyed.

The ideal of nacreous, exiguous carnality and limitless, glowing oceans of palpitating emotion was what Constance Mayer lived by. She may have been as virgin as the legendary Madame Récamier herself, but her whole life was a delicate, incessant *effleurage* of appetite. Together Prud'hon and Mayer worked upon the imagery of a sexual idyll, culminating in Mayer's masterpiece, *The Dream of Happiness*, which Prud'hon designed and for which he executed preliminary studies. The subject is the original dreamboat of vulgar parlance: in a punt gliding in glimmering waters, a young mother lies safely asleep within the protecting arms of her angelically beautiful husband. Her baby slumbers on her milky breast. All is bathed in dim refulgence, except for the shadowy countenance of the woman at the other end of the boat, who gazes at the icon of fulfilment which lies before her.

The intricate enlacement of the careers of both painters is in the process of unravelment, as drawings are carefully matched to oil sketches and finished work. Some paintings, like the steamy *Sleep of Venus and Cupid* in the Wallace Collection, have been disputed as to whether by Prud'hon or Mayer, when the facts are clearly that the painting is by both. The Empress Joséphine had commissioned it from Mayer, but there is a finished study in oils by Prud'hon at Chantilly, and a chalk drawing for it by him in the Louvre. In the Salon of 1818 it was pendant to the *Torch of Venus* by Prud'hon. Mayer's *The Happy Mother* is based upon a finished oil study by Prud'hon which hangs in the Wallace Collection. In other cases, she is thought to have supplied the original ideas for the composition. *Love seduces Innocence, Pleasure ensues, Penitence follows* was begun by her.[5]

Constance Mayer, *The Happy Mother*
A comparison of this painting with the preparatory oil sketch for it by Pierre-Paul Prud'hon is not at all to Mayer's advantage. Prud'hon's palette is more sparkling, his brushwork far more expressive, the forms not only more voluptuous but more correct.

The engulfment of Constance Mayer in Pierre-Paul Prud'hon is then not a simple matter of her work being misattributed to him. In fact, the traffic went the other way: Prud'hon had far too much to do with work commissioned from and attributed to Mayer. Occasionally, as in the case of the portrait of Madame Tastu at the time of her marriage, Mayer's work was called Prud'hon's, and there is no record of any protest from her. It was her dearest wish to merge herself with Prud'hon; she willingly became his alter ego. She was a woman invaded by another's vision of life, utterly given up to a relationship of the most binding intimacy. In 1810 she went to live in the Sorbonne, in a tiny apartment close to Prud'hon's. 'He ate at her house, and, absorbed as he was by his art, he left the care of all else to his friend.'[6]

As Prud'hon's children grew up they grew away from their father's friend. The youngest daughter turned against her and spoke evilly of her rôle in the break-up of the family, even though Mayer gave the girl a dowry of twenty thousand francs at her wedding. When Madame Prud'hon was reported to be in poor health, Mayer asked Prud'hon if he would ever marry again. 'Ah! Jamais!' he replied. She came upon a preparatory sketch of a client's wife, depicted in Prud'hon's usual voluptuous fashion, and destroyed it. Her fortieth birthday had come and gone. The youth that she and Prud'hon had celebrated in all their work had withered. She was no longer the Correggio cherubim he had drawn in 1806. 'I am ugly!' she screamed. Prud'hon took her away from Paris for a holiday; melancholy had begun to menace her health.

On their return they learned that all artists had to give up their apartments in the Sorbonne. Mayer was beside herself. Prud'hon tried to calm her by saying that they would continue to live as they had in the Sorbonne, but she would not listen.

Emotionally bankrupt and desperate, Constance Mayer had lost the qualities that endeared her to Prud'hon, or at any rate thought she had. She was publicly humiliated by the fact that marriage was now possible and was not forthcoming. The dream of love upon which their whole life together had been based seemed a lie.

On 27th May 1821, her pupil Sophie Duprat left her at eleven. Mayer went into Prud'hon's room, took his razor and cut her hand with it. Finding it sharp enough she took aim in a looking-glass, and struck at her neck. The blow cut her throat through to the cervical vertebra. She fell on her back, her feet towards the connecting door, dead in a bath of blood. Prud'hon, who had been happily working in the neighbouring *atelier*, rushed past his friends and threw himself upon the body, trying to hold the edges of the appalling wound together. When they took him away he was drenched in her blood.

When he recovered from his frenzy of grief, Prud'hon finished the work, *The Death of the Worker*, that Constance Mayer had begun in her depression. Much of his energy was spent in arranging the retrospective exhibition of her work in the Salon of 1822. In February 1823, he died. The dream of love had claimed its other victim.[7]

Constance Mayer's act of physical self-destruction is the outward expression of the self-annihilation of literally hundreds of women artists for love. Too often women must love where they admire, and admiring emulate, and by emulation are absorbed into the myth of the master, in which they are the most fervent believers. Only if the woman artist begins to count the cost, to jeopardise her sexual happiness by restless competition or struggles for freedom, does the outside world even guess that an individual talent is at stake. Women are conditioned to place their love first, to value it above all other forms of satisfaction that life may offer. For every woman artist who struggled to assert herself against the power of love, there are literally hundreds who submerged themselves so willingly that their activity has left no perceptible trace. The phenomenon is as old as painting itself.

The devotion of Anella de Rosa (1602–c. 1649) to her master the Cavaliere Stanzione proved fatal in every sense. She was his willing collaborator, transferring his sketches to the canvas, often doing nearly all the painting, leaving to him only the finishing touches to faces and hands, especially if the work in question was a private commission, and not a major, public work upon which the Cavaliere's reputation would rest. She was married to another pupil of Stanzione, Agostino Beltrano.

Despite the demands of the work that she carried out for Massimo Stanzione, Anella de Rosa also accepted commissions on her own behalf. According to De' Dominici, the Neapolitan art gossip, she accepted one such in 1649. The Cavaliere came to see it, and was so impressed with her work, that he embraced her. This being seen by an ill-disposed servant maid, she ran to fetch Beltrano, who was already chagrined by the favour which his wife enjoyed in their master's eyes. He came into her workroom and witnessed the unseemly intimacy, whereupon he stabbed his wife to death.[8]

The story is plainly nonsense. Anella de Rosa had already painted two big commissions for the church of Santa Maria de'Turchini, a *Birth of Christ* and a *Death of the Virgin*, which had won for her considerable fame. A friendly expression of joy and esteem can hardly have lasted as long as it took the wicked servant (a favourite resort of gossip) to fetch her employer. De' Dominici explains the fact that Anella's family took no revenge on Beltrano by saying that he fled to France until he heard that it was safe to return to Naples because Anella's relatives had been wiped out by the plague.

Nowadays, scholars reject out of hand the version of De' Dominici, thus leaving him guilty of not just his usual brand of twaddle, but of criminal libel, without deigning to say why. The tradition persists not only that Anella de Rosa was murdered, but that Massimo Stanzione eulogised her as *his* Anella, his highest praise being that she had equalled himself. When a niece of his, Mariangiola Criscuolo, the daughter of a painter and wife of another, achieved a reputation for religious paintings, he belittled her achievement by contrast with the work of his dead devotee.[9]

In 1638 an explosion at Castel Nuovo brought down the roof of Santa Maria de'Turchini, and Anella's only authenticated work was destroyed.[10]

Most often the truth that lies behind the mere mention of some well-known male painter's wife 'who also painted' is of a lesser talent drawn into the vortex of an artist's ego, and there seems no more point in lamenting the submergence of such women than one would seriously lament the fact that Nathalie Micas, who occasionally painted, spent most of her time and energy making a home for Rosa Bonheur. However, we have no way of knowing whether all the talents obscured by marriage to an artist were equally negligible. Occasionally, as in the case of those wives who blossomed once their husbands were dead, we have definite evidence of a considerable talent smothered by the exigencies of domestic life, in particular, the necessity of protecting the male ego. The wife of Hendrik van Steenwijk the Younger (c. 1580–c. 1649) did not emerge as a painter until after her husband's death, when her individual achievement was considerable.[11] Marie Jeanne Buseau only began to exhibit after the death of her husband Boucher in 1770.[12] Even Sonia Delaunay, born in a very different era, did not show paintings during her husband's lifetime.[13]

Maria Hadfield had distinguished herself to such a degree while still at school that she was made a member of the Accademia delle Belle Arti in Florence when she was only nineteen. In Rome she was the pupil of Batoni, Mengs, Fuseli and Wright of Derby. When her father died, she expressed her wish to enter a convent but at Angelica Kauffmann's entreaty the family moved to London, where the pretty Maria, who was, like Angelica, gifted with a good voice and some musical ability, quickly became the toast of the town. In 1781 she married the eccentric and highly successful miniaturist Richard Cosway. Even the most serious accounts of her life are marred by insinuation: some say that Cosway kept her secluded until she had mastered English and the other requirements for playing the grand hostess in polite society. She continued to paint, but Cosway had more use for her as the crowning ornament of his extravagantly luxurious drawing-rooms than as a rival. He forbade her to accept payment for her work, and made sure that her time was taken up in elegant dissipation.[14]

Until a serious study is undertaken of this good artist, we shall not know what Maria Cosway made of all this. In the series of engravings that she prepared for the verses written by Perdita Robinson as she lay impoverished and dying, which were published by Ackermann in 1800, we may see Maria's own version of the fashionable life, heated, crowded, noisy, confused gatherings, replete with malice and discontent, while in her self-portrait, which was engraved by Valentine Green in 1787, we see a serious woman, her arms folded solemnly over her bosom as if to eschew all coquetry, and a heavy cross hanging from a heart at her neck.

She began to absent herself from her husband's fashionable establishment, while she travelled for health reasons. The second time she went to the Continent, she stayed three years. Her religious aspirations had not weakened with

the passage of time, although she remained a dutiful and affectionate wife, many of whose prayers were for the birth of a living child. She set up a convent in Lyon in 1801, and in 1812 the Collegio delle Grazie at Lodi, where after the death of her only child and her husband, she went permanently to live as a nun.

As is inevitable in the case of such an interesting personage, a muddle of silly attributions clings to Maria Cosway, most of them supposed self-portraits. Her actual achievements number very few paintings, some miniatures, illustrations to the poets, and some brilliant drawings, most of a serious didactic or votive character, and a massive book of engravings from her drawings of the works in the Louvre. Until the documentation of her life in Lodi, Florence, London and Rome is properly sifted, she must remain a moving conundrum, the serious woman whose social duty was frivolity.[15]

From the first instances of men teaching women to paint, we may be sure that their pupils fell in love with them. As long as the relationship was ruptured, and the period of dazzlement forcibly brought to a close, the female artists might recover their individuality. If the relationship developed, even when the man in question strove to stimulate and preserve the independence of his loving pupil, the woman's love often absorbed her completely. It is Gabriele Münter (1877–1962) who tells us glowingly that Kandinsky 'explained things in depth and looked at me as if I was a human being, consciously striving, a being capable of setting tasks and goals'.

> 'As a pupil you are hopeless – nothing can be taught you. You can only create that which grew inside you. What I can do for you is merely to guard your talent, to nurse it, and to make sure that nothing false touches it,' he used to say.[16]

Unfortunately for Gabriele, Kandinsky also fell in love with her. At first he refused her entry into his classes, but his resolution failed and in 1903 he left his wife and they began a public liaison which lasted until 1916, the years of Kandinsky's greatest creativity. Gabriele's artistic ego was probably her salvation from complete engulfment in the life of Kandinsky, who, despite his often stated promise to marry Münter, married a younger woman in 1917. The pain of the severance was intense and for more than ten years Gabriele Münter found that she could hardly work at all, until, in fact, she found her own helpmate and supporter, Johannes Eichner. To her relationship with Kandinsky she had sacrificed, if not her artistic independence, her time and energy.

> I held to Kandinsky. I gave myself no worth next to him. He was a holy man.[17]

The world of men still thanks her more for the hundred and twenty Kandinskys that she presented to the city museum of Munich than for her own life's work.

It is customary to take for granted that in an artistic partnership like those of Münter and Kandinsky, Sonia Terk and Robert Delaunay, Sophie Tauber and

Jean Arp, Kay Sage and Yves Tanguy, the male was always the predominating figure, the innovator and the initiator, with the woman following as his emulator. Often the similarity between the works of both partners leads inevitably to this conclusion, but does not in fact constitute very good grounds for it. In the case of Kandinsky and Münter, the superficial observer might suppose that Münter's style remained all her life a version of the style of Kandinsky in the years of their greatest intimacy: the correction of this basically false impression is not helped by the facts that Münter never stinted in her praise of Kandinsky and remained obsessed with him all her life, while Kandinsky never mentioned her or her work. Until a detailed examination of the chronology and iconography as well as the stylistic developments of the work of both during the period of their greatest intimacy has been made, the present writer can only suggest that Kandinsky owed a great deal to Münter's way of seeing and her vigorous and typical condensation of diffuse shapes into simple, expressive forms. (See Pl. 25.)

The correct assessment of the value of the woman's part in these male–female artistic collaborations is not helped by the adoption by the woman of 'minor' or at any rate, voluntarily limited modes. Kay Sage's range of imagery is narrower than Tanguy's, her development towards intensity and profundity rather than to scope or sweep. Her self-confinement is deliberate, representing a journeying inwards rather than outwards, and it has been interpreted as taking a subjugated position beside her husband's more clamorous genius. In terms of motivation, such a judgment may be apt enough, but in terms of evaluation, especially when the divergence is taken to justify exaggerated denigration, it is philistine. Kay Sage is another female artist whose reputation has suffered because she strove for excellence rather than importance, for integrity rather than effect.

Sophie Tauber-Arp and Sonia Terk-Delaunay were both as strongly attracted by so-called minor art forms or decorative arts as they were by the 'major' form of painting. Often their working out of abstract motifs in painting seems to have been the initial development of themes which would be used rhythmically in environments and kinetic structures. Arp the sculptor and Delaunay the painter are both treated as more significant figures than their wives, although it is perfectly well known that the innovative qualities of their work owed a great deal to the fruitful vision of their womenfolk, who poured out original ideas in all kinds of media with almost wanton and certainly ingenuous prodigality. One views with amazement the range of media to which Sophie Tauber-Arp adapted her decorative genius, whether it be at l'Aubette, in her weaving, embroidery, marionettes, stage décor, furniture design, stained glass, collage, wood reliefs, or even in dancing and publishing.

Ever since male painters have taught females to whom they were not related, art students have been marrying their teachers. Jean-Baptiste Oudry (1686–1755) married his pupil, Marie Marguerite Froissé in 1710. Apollonie de

Forgue (1767–1840) married her teacher, Jacob Crescentius Seydelmann, in 1788 and went with him to Rome. The filial status of such wives is sometimes emphasised by an age difference: Julienne Marie Boussuge (b. 1777) was seventeen years younger than her husband, André Claude Boissier, Augustine Dufresne (1789–1842) eighteen years younger than her husband, Baron Gros, while Achille Chaine married a student, Joséphine Olivier (1847–82), fully thirty-three years younger than himself, and outlived her.[18]

The advantages of marrying a pupil are obvious, even when she is not an heiress, as was Elisabeth Boswell of Balmuto who eloped with her drawing-master, Patrick Syme (1774–1845) and elected to spend the rest of her life working with him at painting flowers and insects.[19] In the nineteenth-century art-schools, where art-struck women flocked to pay inflated prices for inferior teaching, the dashing young masters could pick and choose. The most success-ful art-school entrepreneur, the ex-wrestler Rodolphe Julian, married Amalie Beaury-Saurel (b. 1856) whose love-sickness had infuriated Marie Bashkirtseff when they were obliged to work together.[20] Léon Cogniet married the nineteen-years-younger Caroline Thévenin, who continued to exhibit under her maiden name,[21] as did Adrienne Marie Louise Grandpierre-Deverzy

Adrienne Marie Louise Grandpierre-Deverzy, *The atelier of Abel Pujol*, 1822
 The earlier ateliers for women students seem to have been more comfortable and
 better run than those of the nineties, where the master, who came once a week,
 would criticise more than a hundred and fifty works in two hours.

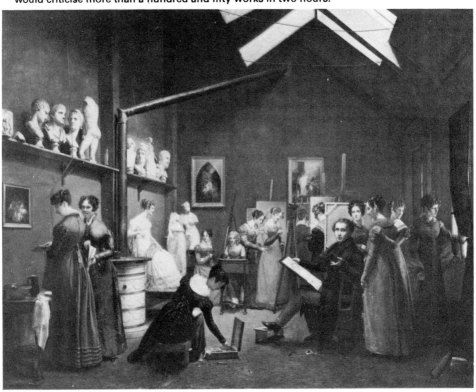

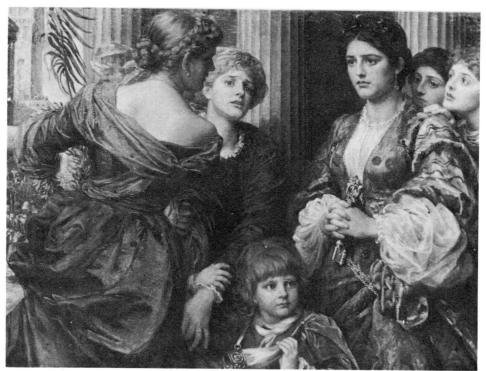

Anna Lea Merrit, *War*, 1883
The theme is heroic but the values of this extremely eclectic painting are primarily sensual. The reference may be to the Egyptian campaigns in which Gordon was to fall at Khartoum, but the appeal of the picture lies in its combination of the sentimental and the aesthetic.

(1798–after 1855) who married her teacher, Abel de Pujol.[22] In Mme Cogniet's paintings of her husband enthroned in his *atelier*, surrounded by his female pupils, we may get some idea of the atmosphere in which these young women fell in love.

Laura Epps (1852–1909) did not just bring youth and a cloud of red-gold hair to her husband, Laurens (later Sir Lawrence) Alma-Tadema. She was also rich, for her father was a successful Dutch cocoa-merchant. She entered Alma-Tadema's studio when she was eighteen and he thirty-four. She continued to work after marriage, signing her work as he did, L. Alma-Tadema (but without an opus number), combining her husband's technique and treatment with a suitably feminine and domestic choice of subjects.[23] The partnership was not unique: the Stanhope Forbeses, Young-Hunters, Kenyon Coxes, and Albert and Mary Stevens worked in a similarly complementary fashion.[24] Victoria Dubourg (b. 1840), who married Fantin-Latour, painted flowers 'in his second best manner', signing with her maiden name. Elizabeth Boott (1846–*fl.* 1886) married Frank Duveneck with whom she had studied in Paris. Alice Preble Tucker, the marine painter, married her teacher M. F. H. De Haas (1832–95). Henry A. Loop married a student, Jeannette Shepperd Harrison (1840–1909), usually known only as Mrs Henry A. Loop.[25]

One of the most extraordinary cases of pupil infatuation is that of the American painter Anna Lea (1844–1930) with the picture restorer, Henry Merritt: she worked with him for more than five years, before he agreed to marry her, dying only weeks later. In her memoir of him, she describes her feelings as their relationship developed:

> Every impulse I had previously felt driving me to become an artist was now merged in the great wish to please my master . . . how he scolded me; how ruthlessly he rubbed out again and again, the work of days, bidding me do it better; what pains he took to make me appreciate true points of excellence! When my work was dry and had lain awhile, he would sketch upon it in crayon, designing backgrounds, trying various effects of chiaroscuro . . . Often he would work thus for a couple of hours, transforming my dull study of a model into a vision . . . I used to stand behind him, breathless with excitement . . . The lesson over, I was often permitted to go with him to the window, to fill his pipe . . .[26]

As Anna Lea was several times called back to the United States by the duties of an unmarried elder sister, much of their relationship was conducted by letter, in which Merritt varied his usual form of address, 'little girl', with 'little pupil'. Eventually he did say to her, 'Little pupil, we shall be married.'[27] Although on her own admission, she 'always felt in his company like a child on good behaviour', Anna Lea Merritt (as she was thenceforth known) remembered her time with a man old enough to be her father as one of intense happiness and fulfilment.

The archetypal teacher–lover, who exploited his female students to the limit, was Walter Richard Sickert (1860–1942). His class in Camden Town in 1911 has been described for us by one of the pupils, Enid Bagnold, better known as novelist and playwright:

> Sylvia Gosse was a pupil. Harold Gilman worked there too, coming in and out, not exactly a pupil. McEvoy the same. The rest were women, devoted and dull. Sickert liked his pupils as the Old Masters, protective, disrespectful, chiding, kind and half contemptuous. 'My flock – poor creatures.' He hammered their heads with his wit . . . He was such a teacher as would make a kitchen-maid exhibit once.[28]

Even the clear-eyed Bagnold was drawn to work for Sickert at Red Lion Square, preparing, waxing and smoking his copperplates. In return she received the first pulls of some of the etchings and notes like this:

> Dear delightful and amazing,
> Do you ever sleep in London? If so would you breakfast here at 9 sharp? Any day including Sunday.
> I should then get you alone for which I thirst – and have always thirsted – and shall continue to thirst.
> Yours in gratitude for your radiant existence and your dear warm friendship.
>
> W.S.[29]

Such heady stuff was not squandered on the undistinguished pupils, who saw him once a fortnight for perhaps four minutes. Only the best students were worth side-tracking in this fashion.

Wendy Baron, in the introduction to an exhibition catalogue of 1974, taste-lessly entitled *The Sickert Women and the Sickert Girls*, wrote:

> Sickert, handsome, witty, gallant, charming, with an intuitive understand-ing of women, particularly women with latent artistic talents, possessed an enormous appeal for the opposite sex. Many of his pupils could not help loving him and Sickert, too obsessed with his work to form deep emotional attachments, was happy to accept their devotion and repay it by taking their work seriously, generously giving them his advice and criticism, and thus endowing their efforts with meaning and direction. As a critic of contem-porary and past art Sickert always found promise and praiseworthy qualities in the most unexpected places. Moreover many of Sickert's lady pupils had real talent, and some possessed a strong enough individual temperament to withstand the impact of Sickert.[30]

It does not require either a vivid imagination, or an excessively soured one, to picture the master encouraging slight emotional attachments, affairs and adora-tion in place of the deeper ones he had no time for, and using his only too willing worshippers as drudges. As his most recent biographer, Denys Sutton, put it, 'he had the happy knack of making the women who either loved or liked him undertake his chores'.[31] One of the 'Sickert girls' has told us in her own words how this might come about: Wendela Boreel had been allowed to attend life classes at the Westminster School of Art, but was afraid that she might not be able to draw well enough to be allowed to stay:

> One evening Sickert said to me, 'I want to see you in my office afterwards.' I was very frightened and did not want to stop going to the classes. To my surprise he said: 'Your drawing is far too good for here. I'll install you in a studio in Mornington Crescent, where you will paint each morning and come to me in the afternoons': so I became Sickert's *petit nègre*, to do all and to be at his beck and call.[32]

Nina Hamnett (b. 1890) was another young artist invited to breakfast by Sickert, who, although she was sexually attracted to him and went to Bath with him, was not a great admirer of his work, and found his compulsion to behave towards her in a paternal and teacherly fashion bullying and misguided. She wrote to a friend during her lonely and dull sojourn in Bath:

> My picture is nearly finished, it is très loin de Sickert. He by the way spends at least two hours daily at tea-time in holding forth. I always say yes and go home and do the opposite.[33]

After an unsuccessful first marriage, Sickert married Christine Angus, one of his students and twenty years younger than he. Her adoption of a wifely rôle may not have been a great loss to art, any more than one would insist that the time spent by another student, Mrs Crewe Clements, in preparing and squaring

his canvases was not well spent. When it comes to his effect upon the lives of the important painters, Thérèse Lessore and Sylvia Gosse, one would be more justified in resenting both the time he took from them and the disproportionate influence that he wielded over them.

Thérèse Lessore (1884–1945) had been the wife of W. B. Adeney, President of the London Group from 1918 until 1922. She and Sickert and Sylvia Gosse had all been working in Fitzroy Street, where it seems that Sickert, impressed with the economy and grace of Lessore's work, came for a short period under her influence. Two years after the death of his wife Christine, Lessore married him and thenceforward identified completely with his interests. According to another of the 'Sickert girls', Marjorie Lilly,

> ... her pictures lost their special flavour because she was so much with Sickert. She withstood his influence at first but gradually it gained upon her; by degrees her fey quality disappeared and like so many others who came beneath the Sickert spell she began to turn out echoes of him rather than her strange little interiors.[34]

Sylvia Gosse, *The Printer*, 1915–16
This is apparently not a portrait of Gosse herself slaving away at Sickert's prints. According to information supplied by Anthony d'Offay she was part owner of the press, the figure was posed by a model and the prints on the line are Gosse's own.

Not everyone agrees with this assessment of Thérèse Lessore's career; other critics can be found who insist that she kept her individuality to the last, and it must be admitted that as a critic Sickert did praise those qualities in Lessore's work which were not to be found in his own. However, the effect of regularly laying in his paintings for him and of preparing and squaring his canvases, must have been considerable, if only in terms of the time that it took from her own work.

The credit for the emergence of the incredibly shy Sylvia Gosse (1881–1968) as a painter has been put down to the encouragement and support given her by Sickert, but she certainly repaid it a hundredfold. She ran the school at Rowlandson House for him, tended him during the dark days after the death of his faithful and uncomplaining Christine, saw to it that he went back to work, and, like Lessore, relieved him of some of the studio drudgery.[35]

Not one of the women who served Sickert begrudged a second of her time. Only Nina Hamnett, in her letters, has repined about the effect that he had upon their work and independent development. Perhaps that was why, when Wendela Boreel expressed a desire to meet Hamnett, whose work she admired, the great man said, 'It's a waste of time', and told her not to visit her.[36]

When Paula Becker (1876–1907) married Otto Modersohn, one of her teachers in the artists' colony of Worpswede, she had already progressed beyond what Worpswede could offer. On the last day of the nineteenth century she had travelled to Paris and in Vollard's gallery had seen the work of Cézanne, which struck her like a great wind. Modersohn pressed his claim on her and she yielded, taking over the running of his household and the care of his young daughter by a previous marriage. In 1903 she left for Paris again, only to return again. She made another attempt to escape into art, but Modersohn followed her, with the promise of a big new studio of her own. For the last time she weakened and returned, pregnant, to Worpswede.

She would not have done so merely as a capitulation to external pressure. She would not have been the painter she was if she had not given great importance to the life of feeling and of family feeling in particular. Over and over she reworked intense images of motherhood, of nurturing and simple piety. Her deep respect for the simplicity of peasant life was also her respect for these primary relationships which she depicted as monumental and noble. When Otto and her family put pressure on her to return, she answered in terms that revealed her own susceptibility to their pleading:

> My dearest Mother . . .
> I am beginning a new life. Don't intrude on it . . . let me be. It is beautiful. Last week I lived like I was drunk. I think I created things that are good.
> Don't be sad about me. If my life won't take me back to Worpswede, that does not mean that the eight years that I spent there were not good.
> I found Otto very touching. This, and thoughts of you, make my path a difficult one.[37]

Paula Modersohn-Becker,
Self-portrait, 1906
Like many other women painters,
Paula Modersohn-Becker painted
many self-portraits, depicting not
only the stages in her life as
woman, but the artist thrown
upon her own resources.

Rilke wrote, in her *Requiem*, referring perhaps to the self-portrait of 1906, 'And finally you saw yourself as fruit, Lifted yourself out of your clothes, and carried that self before the mirror, let it up to your gaze; which remained large, in front, and did not say: *that's me*; no, but *this is*.'[38]

Her resistance to Otto's pleading was not helped by the fact that of all her two hundred and fifty-nine paintings she only ever sold one. Throughout her pregnancy she worked, producing her greatest paintings, but when the day came to rise from childbed after a difficult birth, she suffered an embolism and died. She was thirty-one.

Paula Modersohn-Becker was an exceptionally gifted woman, and an exceptionally strongly motivated one, but her independence was made her bane. She was isolated and undervalued in Worpswede, and would have been much happier living like a gypsy in Paris. As she wrote to her sister during her illusory escape in 1906, 'I am experiencing the most intense, happiest time of my life,' but childbearing proved too seductive and she put that happiness behind her.[39] Her friend, the sculptor Clara Westhoff, had drifted away from her when she married Rainer Maria Rilke. While Modersohn understood that his wife was a

great painter, he did not understand what she was doing. Alone, she tried to invent her own form of truth, and in great measure succeeded, but the price was too high.

Generally speaking, long-lived husband and wife teams were dominated by the artistic personality of the husband, especially where the wife was much younger and had actually worked in a filial manner under her husband's direction from an early age. An interesting description of the power of the beloved artist to influence his younger admirer can be found in Laura Knight's autobiography:

> The broadcasting of talent in the fine arts is not nature's daily practice. Harold Knight was the one student whose work leaped beyond all others . . . Whenever possible I fixed my easel close to his; if he started the drawing of a head by first blocking in the outline, I did the same; if he first of all drew detail of an eye, I copied that method – though never to attain his subtle realisation of the whole head.[40]

Throughout her life, Laura Knight (1877–1970) treated Harold Knight as a greater genius than herself, despite the fact that her career advanced far beyond his. She always deferred to him in matters of taste, praising his wit and taciturn wisdom. She generously acknowledged him as the controlling influence in her

Laura Knight, *The Nuremberg Trial*, 1946
Women were employed as Official War Artists on both sides in both World Wars. In this study of the Nuremberg Trial, Knight was obliged to depart from her usual style and preferences.

life, at the same time as she insisted upon the difference of their aesthetic approach. While admiring his building up of dense images she herself tended more and more to the 'magic of a single line'.[41] By such sensitive balancing of motivation, she achieved the almost impossible, a long happy married life with another artist and the realisation of an independent artistic career.

Frida Kahlo (1910–54) was only thirteen when she decided that her ambition in life was to have a child by Diego Rivera. As it did for so many women, a desire for art led her to the artist; creativity was personified in the master and she was prepared to build her life around him and dedicate her art to her love. She learned to paint when her body was crushed in a street accident, and, naturally, she took her first three paintings to Diego Rivera. When she was nineteen she married him.[42]

In her painting, which remained steadfastly independent of her husband's style, strongly rooted in peasant and votive art, she worked out the drama of her love for a man who was incapable of any such feeling, a love which remained generous and constant through all her physical pain, her despairing miscarriages and Rivera's infidelities, a divorce and a remarriage. It was a love not unmixed with hostility and contempt, but it was the central reality of her life. In the intensity and sharp irony of her depiction of her battered existence, Frida Kahlo showed an honesty which wears better than her husband's rhetoric.[43]

In 1892, Ida Nettleship (1877?–1907) followed in the footsteps of her father, the animal painter and author, J. T. Nettleship, to the Slade. There she became one of a group of brilliant women students, all of whom, save one, were to sacrifice their art to love. Diana Holman-Hunt has said that at this time Ida Nettleship responded more to women than to men.[44] In the period of her greatest achievement, she was emotionally, if not sexually, homophile. In 1894, Augustus John came to the Slade. We know little of his wooing of Ida Nettleship, who continued to distinguish herself until she took up a travelling scholarship which she had won in 1895, and went to Italy in 1897. For some reason, unexplained by Ida or Augustus, she was quite unable to work in Italy. Perhaps the rigorous discipline of the Slade, from which the female students might not find the same relief in boisterousness that the men might, had crushed the energy from her. In October 1900 she secretly married Augustus John.

The sacrifice of her life was pointless; she was not able even to satisfy the man she had given up her work for: he was uproariously unfaithful to her before their marriage and more so afterwards. Ida was the mother of the children he found a harassment; he required not responsibility but inspiration, a model, in short, so Dorothy McNeill alias Dorelia John came to make up the *ménage à trois*. In time she too had children: Augustus made love to whichever woman was not more taken up with a new-born baby. In 1907, Ida, dealing with her fifth pregnancy alone in Paris, felt the beginnings of labour and walked by herself to hospital where she died a few days later.

The sacrifice she made was total; although her last months of life were tormented with guilt and depression, she never allowed herself to utter a single complaint of John's selfishness and neglect.[45] Probably she thought, as did everyone who knew him, that because he was a brilliant draughtsman, he was also a great artist and that she could contribute more to art by being a good wife to him than by developing her own talent. This came to mean giving him as little trouble as possible, by crushing herself and stifling her own demands. In the event, she meant less to him in every way than Dorelia.

Perhaps something similar befell her friend, Gwendolen Salmond, who in 1912 married the man she had seen repeatedly humiliated by Henry Tonks at the Slade, the frail, timid Matthew Smith. We hear nothing more of her. Of him we read:

> Early in the twenties the normal shortcomings of his health allied with the sense of something unfulfilled in his personal life to produce a serious breakdown; and it was not until he found in Vera Cunningham the ideal model for his art that he recovered and, indeed, redoubled his ability to work.

What became of Gwendolen's ability to work is of no concern. She lived on until 1958.[46]

Another of the brilliant Slade girls, Edna Waugh, virtually abandoned painting at nineteen, when she married Clarke Hall.[47]

In 1918 the English artist Stella Bowen fell in love with the novelist Ford Madox Ford. For eight years she devoted herself to him.

> My painting had been hopelessly interfered with by the whole shape of my life, for I was learning the technique of quite a different rôle: that of consort to another and more important artist, so that although Ford was always urging me to paint, I simply had not got any creative vitality to spare after I had played my part towards him and Julie [her daughter] and struggled through the day's chores ...
> Ford never understood why I found it so difficult to paint when I was with him. He thought I lacked the will to do it. That was true but he did not realise that if I *had* the will to do it at all costs, my life would have been oriented quite differently. I should not have been available to nurse him through the strain of his daily work; to walk and talk with him whenever he wanted, and to stand between him and circumstances. Pursuing an art is not just a matter of finding the time – it is a matter of having a free spirit to bring it on ... I was in love, happy and absorbed, but there was no room for me to nurse an independent ego ...
> ... a man writer or painter always managed to get some woman to look after him and make his life easy and since female devotion, in England anyhow, is a glut on the market, this is not difficult. A professional woman, however, seldom gets this cushioning, unless she can pay money for it.[48]

The eventual outcome of the story is the familiar one. Ford, the artist, needed new stimulus: he proposed to divide his attention between Bowen and a series

of other women, but Bowen was no Nettleship. She knew what the rewards of such self-sacrifice were: in 1941 she came to this then very unfashionable conclusion:

> Every day I see dozens of middle-aged, dowdy, deprecating, slightly daft females pottering about in shops and buses, every lineament depicting a fatal sense of inferiority. They are utterly incapable of effective independent action. I see others, more intelligent and more embittered, who on emerging from their private world seeking independence in work find all doors closed against them. Only the girl who has trained for a job and has never stopped working has the privilege of continuing to work when she's mature.[49]

Bowen learned her own lesson. After weathering one of Ford's affairs, she began to feel the 'exhilaration of falling out of love'. When he announced another emotional entanglement in 1927, she went quietly off to see a lawyer.

The saddest part of the irony of the situation is that the loving woman's assessment of the artistic genius of her mate has not been shared by posterity. Strong sexual attraction does not lend discernment: this is the factor that compromises nearly all the women who were admitted to fashionable art schools in the nineteenth century: the effect of such sexual attraction is actually reinforced by repression.

There can be no doubt that artists like other people need emotional fulfilment, but men and women are very differently placed when it comes to finding that fulfilment. The wise artist seeks out a personality that will complement and nourish his own: the cliché that the artist relates primarily to his muse-model has some truth in it. This relationship between artist and catalytic love-object crosses the boundaries of sex. Men have fulfilled the rôle for other men and we could find examples of men doing it for women, but generally speaking, artistic women tend to marry not for support and comfort but for esteem. They marry 'upward'. A female artist almost always seeks love where she feels admiration, from another artist, her senior and her superior, at least in her eyes.

Dora Carrington's (1893–1932) progress away from the home of her parents and into the world of the Slade was a movement away from domesticity and all the thoughtless carnality and spiritual narrowness that she associated with it. Intellectually battered by the sex-in-the-head of the Bloomsbury Group, she accepted the idea that sex was good for her, whether she liked it or not, but all her relationships with men were a desperate struggle to keep her intellectual integrity which ended in various kinds of stalemate.[50]

Her repugnance for sexual contact increased as she struggled to force herself to endure it. Her honey hair and skin and her lovable manners seduced most of the men around her, some of whom badgered her for years. She needed their affection and emotional closeness to them and their work, but the sexual element in all these relationships, most importantly with Mark Gertler, filled her with shame and uneasiness. The struggle between the male artist, who saw

Dora Carrington, *The Mill at Tidmarsh*, 1918
In the house on the left, Carrington lived at first alone and happily with Strachey,
then with Ralph Partridge whom she married and made unhappy, while having an
affair with Gerald Brenan and making him just as unhappy. The Mill House was
one of the two great artefacts inspired by her true love for Strachey. Ham Spray
was the other.

her primarily as a beautiful woman and desired her subjection to his will, and
the woman painter trying to re-invent the relationship between men and
woman according to her sensibility was veritably heroic. Well might Gertler
write in a rage after a particularly frustrating meeting:

> I don't think that often these last few times I love you as much as I used to. I
> have suddenly begun to think that you simply use me as a help to your work
> and for myself you don't care a scrap . . .
> I have just had a letter from a Jewish girl I once knew. A girl that is simple
> and beautiful, who is, thank God, not 'arty' and of my own class. She will
> not torment my life.[51]

Five years later the torment was still going on: Gertler could not understand
the contradictions in Carrington's behaviour, while she could not clear a space
in which they might be able to cohabit without her going under.

> Yes, it is my work that comes between us, but I cannot put that out of my
> life because it is too much myself now. If I had not my love for painting I
> should be a different person.
> I understand, but I think a few months spent together a year is worth it –
> but you do not think so . . . I really am certain that I could never live with you
> sexually day after day . . . I at any rate could not work at all if I lived with you
> every day.[52]

Mark Gertler was not the only man to assail Carrington's aloofness. Her heart was full of loving which was to be the more disastrous in its effect because she was incapable of sexual fulfilment. In 1917 she devoted herself entirely to a man thirteen years older than she, Giles Lytton Strachey, who accepted her love in the same spirit of light-hearted benevolence that he accepted her cooking and sewing and housekeeping, with temperate thanks and judicious signs of affection. After a brief attempt at a sexual relationship he reverted to his usual homosexual activities. His grand friends like Margot Asquith and Lady Cunard never thought to invite his female companion to their soirées. It must have shocked them profoundly when, six weeks after Strachey's death from an undiagnosed cancer in 1932, Carrington shot herself in the head with a borrowed gun.

Her work had dwindled steadily since 1917. She helped Roger Fry in the Omega Workshop, took years making woodcuts for the Hogarth Press, painted inn-signs and china, and decorated rooms for her friends, rarely finishing any of them. Her masterpieces were the two houses she made for Lytton Strachey, the Mill House in Tidmarsh and Ham Spray. Like most of women's artistic activity they were intricate, kinetic structures, relying as much upon the smell of quince cheese in season as the sunlight on the walls that she painted, the rhythm and ease that she created out of chaos. When Lytton Strachey died, the structure fell apart. It exists only in its literary monument, the letters and diaries of Carrington, which show beyond doubt that she succeeded in creating a great love, instead of great painting.

Perhaps a talent which is so easily overcome is a slight talent at best. Carrington was always distracted, primarily by the heterosexual men, Mark Gertler, Ralph Partridge and Gerald Brenan, who loved her and tormented her with their peremptory desire. Lytton Strachey gave her a responsive, generous, diffident love, full of apologies and emotional impotences. He tried to be interested in her work, and made her a present of a new studio at Ham Spray, but he also accepted the loving care and attention which kept her out of her studio. When he was writing she did not dare to enter his room even to find her pen, for fear he should be disturbed. No one in her life ever showed her similar consideration.

A sexual relationship with a woman might have solved the conflicts that obsessed Carrington all her life. Her nature was deeply sensual and her rejection of men's sexual advances in no way a failure to respond to male appeal. She is usually described as revolted by her womanly functions, about which she certainly complained, but she was rather more revolted by the specificity of heterosexual relations. She was capable of responding sexually to a woman and during a brief period in her life made advances to a number of women. With one woman, Henrietta Bingham, she had a relationship of some intimacy and a little ecstasy.

The difference between what a man might expect in the way of support from

a woman, and the most a woman can expect, even from a man who does not impose upon her, may be seen in the fact that in 1931 Carrington won a prize from the *Weekly Review* for an obituary of Lytton Strachey written in his own style.[53] No matter how conscientiously Strachey saw to it that she had a room of her own, he could never have responded to her genius as profoundly as she to his. Because he could feel no deep interest, she became bored with her work, turned away from it and shrank from pretension to any but occasional pieces. She saw her life as a continuity with other lives; hers was not the ego of the artist. Her talent was considerable but she lacked ruthlessness in asserting it. What Ruskin said to another man might have been said to her with equal justice: 'Had you been a little less gently made you would have been a great painter.'

If Carrington had had a friend and collaborator like the one Vanessa Bell found in Duncan Grant, she might have become reconciled both to her sexuality and to the exigencies of her art. The relationship between Grant, who had been for many years the lover of Maynard Keynes, and Vanessa Bell was meticulously adjusted to allow both the fullest expression of their creativity. The story has yet to be told: it was not simply an asexual partnership, for Grant was the father of Vanessa Bell's child, Angelica, but it was not unbalanced by its sexual component. Grant managed to respect Bell's individual stature at the same time that he responded to her sexuality. He rescued her from the pressure of her marriage with Clive Bell and freed her to work. Theirs may be one of the greatest love stories of our time. The relationship between them both as artists is a complex one. Vanessa Bell had the stronger personal style, while Grant was more eclectic. Both of them were as interested in creating environment as they were in easel painting, and shared the common female irreverence for monuments.[54] (See Pl. 26.)

Rosa Bonheur may have shared Carrington's fear of the marauding activities of heterosexual men. On many occasions she announced her dislike of men, joking that the only males who attracted her were the bulls she painted. If Carrington had been able to find the love that Rosa Bonheur found in Nathalie Micas, her story would have been very different.

Rosa Bonheur had known Nathalie Micas since they were both children, when Nathalie's mother sold animal-skins to Madame Bonheur to make shuttlecocks. They became re-acquainted in 1844 when both were in their twenties, and lived together until Nathalie's death. Although Bonheur herself refers to mudslinging and the 'mortifications and stupidities' that they suffered at the hands of 'silly, ignorant, low-minded people', historians' accounts of their relationship breathe no slander or innuendo upon it. This may have been because the household was presided over by Nathalie's mother until her death, although it seems odd that the mere fact of such chaperonage should counterbalance Nathalie Micas' melodramatic and at times absurdly jealous behaviour and the public phenomenon of Rosa Bonheur's cross-dressing.[55]

From her childhood, Rosa Bonheur had preferred a fairly masculine style of

dress: in 1857 she gained police permission to wear men's dress in public places, apparently so that she would not be molested when working. In fact, she wore men's dress at home and in the country at all times, only donning a skirt to go out in the streets of Paris or for official occasions. Her cross-dressing was distinguished from that of the notorious George Sand, on no very good grounds, for Bonheur deeply admired Sand and frequently spoke in her praise and in her defence. She spoke often of her friendship with Nathalie Micas too:

> I am a painter, I have earned my living honestly. My private life is nobody's concern. I have only to thank God for the protection he has always granted me by giving me a guardian angel in my friend.[56]

There was nothing titillating about the full trousers and painters' smocks that Bonheur wore: she managed to convey an impression of sexlessness which may have been reinforced by nineteenth-century ignorance about lesbianism or by the possibility that her relationship with Nathalie Micas was not carnal. The notion of an *amitié sentimentale* was much more plausible to people who grew up in the 1830s than it is to us; prurient speculation would have arisen when

Madame Achille Fould, *Rosa Bonheur in her studio,* 1893
 The painter is shown at the zenith of her career, composed, confident and
 working sitting down. The figurines and bric-à-brac and the general air of luxury
 do not actually enhance the depiction.

Bonheur was an older and extremely eminent woman but may have been relatively easy to quell. The Empress Eugénie, meanwhile, had found nothing improper in the fact that, when she called upon the painter, Nathalie Micas was taking a bath in a room opening off the studio, of which Bonheur had kicked the door hastily shut as she entered. In her correspondence, Bonheur makes nothing of the fact that when she and Nathalie were travelling they often shared a bed, except to complain of its narrowness, for most of her unmarried female contemporaries did not sleep alone.

However much sex there was in their relationship, there was no dearth of love. The Micas women not only paid off Raymond Bonheur's debts when he died, but gave over their whole lives to the service and support of Rosa's genius. All the cares of housekeeping and financial management were taken off her shoulders, and she was left as few women have been, free to work. Some observers, like Paul Chardin, spoke slightingly of Nathalie's influence on her beloved Rosa:

> As Rosa Bonheur's friend, Nathalie Micas conceived a taste for painting. She used in preference to paint cats, one picture in particular I remember represented some kittens playing with a ball of wool. It was an awful daub; yet Rosa Bonheur, with that naïve goodness so characteristic of her, took the trouble to advise Nathalie and even to add a few touches to the wretched canvas. At times she would encourage her and say: 'Well, my old Ines, and what have you done today? Come, that's not bad.' Whereupon Nathalie, greedily swallowing the flattering words, would return the compliment and, sticking herself in front of Rosa's easel, would launch into congratulations and critical remarks quite like a connoisseur.[57]

Nathalie Micas seems to have been a rather ridiculous personage in many ways, with her pretensions to medical and veterinary knowledge, her inventions, and her preference for passing herself off as some sort of flamenco gypsy, but her devotion to Rosa Bonheur was real and the painter was glad of it. 'She alone knew me,' she said proudly, 'and I, her only friend, knew what she was worth.' When Nathalie died Bonheur was not only inconsolable, but desolate and afraid for the future. Perhaps Princesse Stirbey saw the relationship more clearly: 'Nathalie made herself small, ungrudgingly, so that Rosa might become greater.'[58]

In her later years, Bonheur used jokingly to call herself Princesse Stirbey's 'grandson'. She wrote about marriage in a revealing way:

> Your Consuelo [Consuelo Fould, a painter and Marquise de Grasse] has made famous progress in her art, and as for Princesse Achille [Fould] she too is getting tremendously clever with her brush. She's right to prefer art to marriage, which more often than not takes a girl in. However I don't despise this natural institution among the animals, and so useful to men, who would mope to death without wives.
>
> Our artist household is getting on very well. My wife has much talent and the children don't prevent us from painting pictures.[59]

The new wife, who sweetened the last months of Rosa Bonheur's life and was her sole legatee, was the American painter, Anna Klumpke.

An interesting parallel to the retired existence of Rosa Bonheur and Nathalie Micas is the life led by Mary Ann Wilson and Miss Brundage, who travelled to Green County in New York State in 1810, so that they might live together without harassment. Mary Ann Wilson's primitive paintings were carried out on the backs of used papers, with colours that she made herself from the juices of berries and plants, to sell for twenty-five cents.[60]

If Rosa Bonheur dressed as a man to escape notice, her fellow Légionnaire d'Honneur, Louise Abbéma (1858–1927), did it for the opposite reason. She also claimed to be descended from Louis XIV *'par le Parc aux Cerfs'*, a claim that was taken seriously by some. She did not dress like a labourer as Bonheur did, but as a young captain of dragoons, with a large bicorned hat on her head; this dress and her strangely hooded eyes earned her the title of 'the old Japanese general' from her friend Sarah Bernhardt. Besides the rank of Chevalier of the Legion, she won many prizes and was named also 'Officier de l'Académie de Cambodge, du Mérit Agricole, du Nicham-Iftikar, Commander de l'Etoile noire de Bénin er du Dragon d'Annam', in recognition of her services to art of a thoroughly commercial, academic type. She was not without talent as her early *Lunch in the Hothouse* in the Museum at Pau shows, but she did not develop any further as an artist. Instead she settled for the fashionable limelight that her flamboyant behaviour attracted.[61]

She first painted Sarah Bernhardt's portrait in 1876 when she was eighteen, and last in 1922. It is doubtful whether this relationship, although highly emotional, was actually sexual. It cannot have been a calming and supportive influence, for Bernhardt was a demanding personality herself. Abbéma joined her retinue and became a part of Bernhardt's self-publicising machine, and as such she is chiefly remembered.

Nothing can have been less like the calm domestic routine of Rosa Bonheur's household than the frenetic emotional life of another Légionnaire d'Honneur, Romaine Brooks (1873–1970). Although her relationship with Natalie Barney lasted fifty years, like Abbéma's with Bernhardt it was a background to other encounters, passionate affairs with other women, *amitiés amoureuses* with men, and Barney's hectic life as the doyenne of a literary-artistic coterie.[62] To the effects of a life of emotional insecurity must be added those of heredity, upbringing and great wealth. Some of the obsessive patterns were worked out in continuous line drawings of which she carried out thousands; her developed portraiture is stylish, cold, mocking and repressive, even while it is erotic. The cross-dressing that Brooks and her friends went in for was titillating, like the lipstick and pearl earrings that Una, Lady Troubridge, wore for her portrait by Brooks. Gluck (1895–1978), the daughter of Gluckstein, millionaire owner of a London restaurant chain, who was painted by Brooks, and a very serious painter, detested the life led by the Barney coterie. Her cross-dressing was a part

Romaine Brooks, *Una, Lady Troubridge*, 1924
This wonderfully stylish portrait caused a
sensation when it was exhibited recently in
London. Lady Troubridge was Radclyffe
Hall's lover and biographer; Brooks sees
her from outside as a perverse combination
of elegance, cruelty and sentimentality.

of her intense virginal fastidiousness and utterly without coquetry. She seems to have lived and worked completely independently, to the point of isolating herself even from movements in art, in an unremitting search for purity.[63]

Many nineteenth-century women grew up believing that the fulfilment of their sexuality was inimical to the achievement of excellence in art, not simply because of the rôles that women are expected to play as wives and mothers, but because they held to a crude theory of sublimation. The notion that repressed sexual energy fuels the artist's creativity is actually wrong; as Freud was eventually to explain, the energy spent in rigorous self-repression is not available for other activities. Some of the pressure upon art-education establishments to train women came from the dismal fact that there were not enough men to go round; many of the students regarded their artistic activities as a second string. Another group insisted on distinguishing itself as professional and deliberately eschewed the courtship race. The list of single women who distinguished themselves as artists grew longer and more conspicuous as the century advanced, culminating in Cecilia Beaux (1855?–1942), who was called 'the best woman painter who ever lived'.[64]

Contradictory demands tugged women like Fidelia Bridges, Emily Sartain, Lucy Kemp-Welch, Louise Breslau, Katharine Augusta Carl, Jenny Fontaine, Isobel Gloag, Adele Kindt, Dora Hitz, Wally Moes, and even Mary Cassatt, both ways. On the one hand they liked to give the impression that they had sacrificed all to art and on the other they were obliged to show that they were real, natural, tender, maternal women. They could not be heard to speak slightingly of the vocation of wife and mother, even by implication in glorying in their own choice. Cecilia Beaux, not otherwise troubled by false modesty, deprecated her own rôle when speaking in public to a predominantly female audience.[65] For hundreds of women artists, the abandonment of a domestic rôle was expiated by the daily depiction of idyllic domestic scenes.

The life of the unmarried female artist was not an easy one. If she had not the support of her family, she could easily find herself struggling in a cheap, shabby studio, trying to keep up appearances and at the same time work as much as was humanly possible. Few young women in such a situation could afford domestic help; just keeping the studio fire alight could become an unwanted complication in the day's routine, let alone preparing food and caring for clothes, all activities immensely more time-consuming than we can now well imagine.

The solution for such women was, as it has always been, to band together in mutual support. The old cloister had afforded some sort of refuge for the gifted woman by providing her with the necessary support systems. This proved so attractive to one woman, Anne-Marie Strésor (1651–1713), that, despite the fact that she had been received into the Académie Royale in 1676 as a miniaturist, she accepted the conditions imposed by a Visitandine convent in Paris, namely that she would have to learn to paint in oils if they agreed to receive her without dowry. The convent needed edifying altarpieces, not vain mementoes and jewels: it seems Strésor found the bargain a good one, although no work in large format is known to us, but some are recorded.[66]

Literally hundreds of women worked in the convents of Italy, Spain and Portugal in the seventeenth and eighteenth centuries. Not all of them would have been primarily attracted by the possibilities of working as artists in the cloister; once in the convent the fact that religion came before art would have been daily borne before them, and the more they resisted accepting this order of things, the less they would have been permitted by their superiors to work. It would be wonderful if great masterpieces were mouldering inside the convents where Ortensia Fedeli (*fl.* 1620), Suor Aurelia Fiorentini (1587–1675), Ippolita degli Erri (d. 1661), Angela Veronica Airola (d. 1670), Luisa Capomazzo (d. 1646), Caterina Ginnasi (1590–1660), Maria De'Dominici (1650–1703), Maria Chiara Baldelli (d. 1805), Michelangela Lanceni (*fl.* 1718) and Giacinta Sacchetti (*fl.* 1734) lived and worked, but the convents themselves have perished, or lost track of the women's work. One of the more gifted was Plautilla Bricci (*fl.* 1650 and 1664) whose altarpiece of *St Louis* may still be seen in the Roman church of San Luigi dei Francesi. Bricci was also an architect and designed the

chapel as well as other buildings.[67] The painting of St Louis, flanked by two female saints, with *angioletti* dropping roses on him, is graceful and competent.

A modern, secular analogue of the cloister was the household which surrounded the distinguished American muralist Violet Oakley (1874–1961), first at her Chestnut Street Studio in Philadelphia where she was joined by Jessie Willcox Smith and Elizabeth Shippen Green in 1897. Their household augmented by the arrival of Oakley's mother, Green's parents and a gardener, Henrietta Cozens, they moved to the country, to an estate called Red Rose. Evicted in 1905, they moved to Cogslea. Green married and moved away, Smith built her own house on a different part of the estate, and Violet Oakley, joined by her apprentice Edith Emerson, lived on at Cogslea until 1961.[68] All three were immensely successful in their own lifetimes; although Oakley's eighteen murals for the state capitol at Harrisburg are not now highly esteemed,

Gwen John, *Chloë Boughton Leigh, c.* 1907
Of all the brilliant young women at the Slade in the 1890s, Gwen John, not among the most conspicuous, became the only utterly single-minded and ultimately great painter.

in her own time she was thought to have made art history, and became the second woman to receive the Gold Medal from the Pennsylvania Academy of Fine Arts (Cecilia Beaux was the first).

The secular cloister of Cogslea was a cheerful and comfortable place. Prudence Heward's home on the St Lawrence provided a similar background for her friend Sarah Robertson, who lived and worked there with her in the summertime during the 1920s and 1930s.[69]

A passionate love for another woman did not always work to the artist's advantage. Much depended upon the woman in question, her sensitivity and her capacity to return the affection. Gwen John (1876–1939) moved to a shack in the Parisian suburb of Meudon in order to be closer to Maritain's sister-in-law, Vera Oumançoff, who was a member of the philosopher's household. Her feelings, though pure, were so intense that Oumançoff was distressed by them, and so it was arranged by their mutual friends that Gwen should only visit for half an hour on Mondays to take tea. To Gwen, this was an agonising situation:

> I think that the souls in Purgatory must feel a little as I do. I do not live calmly like you and everybody else. When you leave me, for you there will be tomorrow and the day after, all the other days of the week after all, and that indeed is what happens. For me, that is the last day. I don't see any others: I do not look ahead ...

Oumançoff replied in pious vein:

> Do you really need to write to me every day? I don't think so – and I even think that it is bad for your soul – for you are too attached to a creature, without ever knowing it, so to speak. I am well aware that you have great sensitivity, but you must direct it towards Our Lord, towards the Blessed Virgin.[70]

It is one of the more galling ironies of history that the hundreds of drawings and paintings that Gwen John brought to Vera Oumançoff on Mondays, when they were simply thrown into a drawer and forgotten, are being sold off piecemeal to finance the Centre des Etudes Maritain. (See Pl. 24.)

All the models of male and female interaction among artists were overturned by the woman who has been called, by herself among others, the best French woman painter, Suzanne Valadon (1865?–1938). Although physically diminutive, she radiated a kind of lawless, sexual energy that impressed all those who had any dealings with her, and won for her a respect that less outrageous women never earned. Although without formal training, she drew, instinctively, very well, so well that Degas used to wheedle drawings out of her in a most uncharacteristic fashion, describing them, correctly, as 'hard', 'graceful', 'malign'. He accepted her as he never accepted Mary Cassatt, as 'one of us'. As for Valadon, she gave little sign of caring whether he accepted her or not.[71]

Although she observed and understood the work of Puvis de Chavannes, Toulouse-Lautrec (who gave her the name Suzanne instead of her baptismal

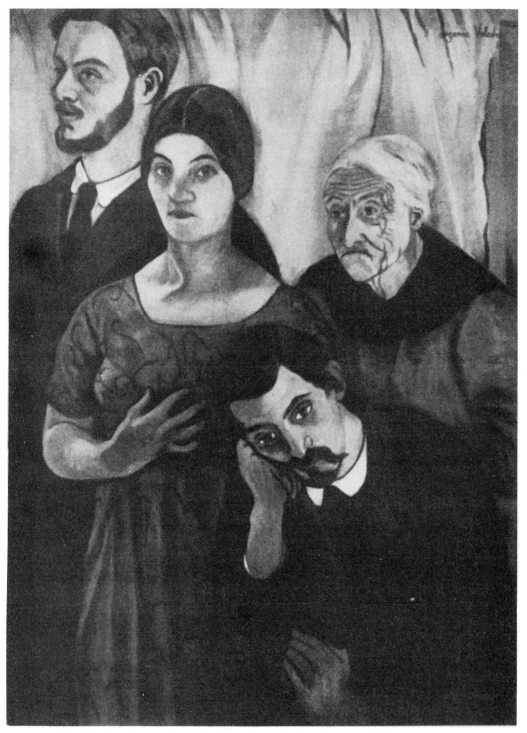

Suzanne Valadon, *Family Portrait: André Utter, Suzanne, Grand'mère and Maurice Utrillo*, 1912
　　Conscious of her own power, the painter gazes levelly at the beholder, aware too of the energy field in which the two young men move and are overcome.

Frida Kahlo, *Frida and Diego*
Frida Kahlo's stylistic
independence is obvious in this
ironic version of a folk bridal
portrait. Her small hand, placed
over Rivera's rather than in it,
moors him like a baby-shaped
balloon to her figure.

name Marie Clémentine), Renoir, Degas, Van Gogh and Gauguin, she was not
so impressed that she abandoned her individual and highly charged modes of
representation for any current -ism. Even the debt to Degas in her drawings has
been exaggerated: her line is, as he would have said himself, harder, less
sentimental, more decisive than his. Boldness was her hallmark, boldness of
conception, boldness of design and boldness of execution, and she lived with
the same uncompromising boldness. A fierce emotional sensuality lights up the
most banal subject in her hands. (See Pl. 23.)

Throughout her life she exercised both immediate and enduring appeal for
men, but the man who fell most irrevocably under her spell was her son,
Maurice Utrillo. From his earliest childhood, when he lived on the fringe of her
hectic life, Maurice adored his mother, the more because he was the unsuccess-
ful rival of her lovers. The result was deep sexual disturbance, such that the
sight of a pregnant woman would bring on terrible seizures, alcoholic crises and
subsequent dependence upon his mother for everything. As an artist, the
growing boy was in the same situation as many women who fall in love with
senior and admired painters. He was invaded by his mother's artistic personali-
ty, so that an observer of an exhibition of the work of mother and son in the

years 1910–12 could say, 'the same organisation, the same materials, the same method, the same harmonies ... only the subjects, the motifs differ'. (And Suzanne replied, 'Of course. And it is the Valadon palette.')[72] Ironically, Maurice became famous in the years of his decline, when with little inspiration and great labour he ground out crusty white Paris scenes, which were astutely marketed by his mother's young husband, André Utter.

At least Maurice Utrillo continued to paint. His friend André Utter met Suzanne Valadon when she was forty-three and he was twenty-two, three years younger than Maurice. For him, she left her husband, the businessman Paul Mousis, and returned to Paris to paint full time, in a notorious *ménage à trois* with her two young adorers. This was the period of her greatest achievement, but Utter, disoriented by his military service in 1914–18, but more significantly eclipsed by Suzanne's artistic personality, gradually lost his bearings, began to imitate Suzanne, and eventually gave up painting altogether, as many a wife had done before him. The relationship endured for more than twenty years and Utter was never able to dissociate himself entirely from Valadon and Utrillo, but became their dealer.

In Valadon's work we may see the expression of a female genius which was not compressed into smallness and modesty. Growing up as a gamine in Paris, she had kept her libido intact, for she needed all her audacity and courage to tear any small satisfaction from the grim life of the streets. The advice that Degas gave her, 'Il faut avoir plus d'orgueil', was unnecessary: Valadon's self-confidence amounted to arrogance. She seized what she wanted from art and life, and tore it free with both hands, making it irrevocably her own. Her strong decorative sense as a painter was not a matter of prettiness or of imposing acceptability upon her subjects, but a rhythmic expression of her emotional energy. The sensuous female bodies that she loved to paint have solidity and strength flowing through their heavily defined contours, which still carry the force and nervousness which so impressed Degas. The bodies that she liked best are used, ample, pregnant with sexual power, innocent of idealisation or sentimentality. Her curious life shows that the common patterns of female subjugation that one finds in the careers of artists are not primarily or intrinsically sexual, but reflections of the relative social rôles of men and women. A woman who breaks the mould may make her own normality.

III

The Illusion of Success

Success achieved by the most contemptible means cannot but destroy the soul ... It helps to cover up the inner corruption and gradually dulls one's scruples, so that those who begin with some high ambition cannot, even if they would, create anything out of themselves.

Emma Goldman, 'Intellectual Proletarians', *Mother Earth*, February 1914

The story of women painters is not simply the story of gifted women struggling against crass male envy and direct persecution. If it had been, the actual achievements of women might have been more worthwhile, although their lives might have been more miserable. A young, pretty woman, with obliging manners, who also painted reasonably well, had no need to fear destructive criticism, unless she was one of a band too numerous to have the charm of novelty, which could not be said until the nineteenth century. She had much more to fear from poisonous praise.

Even men who regarded themselves as responsible critics felt no shame in debasing all their standards in order to flatter a woman's work. They talked and wrote fulsome nonsense with impunity, as long as a woman was its subject, for compliment is the recognised commerce between the sexes.

When men begin to persecute and exclude women, they acknowledge their own insecurity. When they patronise and flatter them they assert the unshakability of their own superiority. It is expecting too much to hope that a young woman, with patchy training and an overpowering desire for the approval of others, would see through the rainbow clouds of adulation to the arduous

Unknown, *Marsia* from Boccaccio's *De Casibus Virorum Illustrorum*
The only source details of the life of the painter Marsia is, alas, Pliny's *Historia Naturalis* – which is full of falsehoods, deliberate and unwitting. It is thought by some that this manuscript is in fact illustrated by the famous Anastaise.

pursuit of real excellence. Gallant praise was not a stimulus to further effort, but a siren song calling her to desist from her labours. Few women who were exposed to it had the forethought to deafen themselves to it. They were, after all, competing with men in a male province: by graciously conceding victory and loading the novice women with trophies, the men disarmed them. The female artists were led out of the race with false prizes, unaware of their defeat.

Even Vasari adopted a double standard when writing of the works of women, for he exercised a kind of gallantry in dealing with them which did not inhibit his judgments when dealing with men. He was more interested in Sofonisba Anguissola and her sisters as prodigies of nature than he was in assessing their contribution to art. Sofonisba's drawing 'si rende piú meravigliosa in una donzella'. In speaking of women at all he was fulfilling the demands of humanist chivalry, summarised in the quotation from Ariosto that he used to preface his remarks on Properzia de'Rossi (see p. 2).

The praise of women like the Anguissolas could not be limited only to their proficiency in art: as women there were other irrelevant but more important

demands to be made of them. The praise of painter and of person became confounded; *bella pittrice* means not only *painter of beautiful things* but *beautiful woman; dotata di ogni virtu* meant not only that she had all the necessary talents but that she was extraordinarily virtuous. These interpenetrations of meaning were all part of the neo-platonic world view and were theoretically equally applicable to men except that in men the application might be expected to be figurative. In women it was expected to be the literal truth. This, when we might expect to hear more of Sofonisba Anguissola's innovative techniques, we are told instead of her piety and humility.[1]

Vasari joined in the praises of Irene di Spilimbergo, whose untimely death in 1561 together with her noble birth would be sufficient explanation of the eulogies that were addressed to her by all the *accademici* of the Veneto (including a large number of very distinguished women, like Laura Battiferri, Laura Terracina, Lucia Albana Avogadra and Lucia Bertana), whether she had attained proficiency as a painter or not. For the most part, the *accademici* are content to elaborate their own conceits upon the occasion of the death of one of their number: Irene di Spilimbergo's painting is just one of the accomplishments of a woman who was 'veramente divina'. Lodovico Dolce was of the opinion that

> With learned verses and with sweet singing she surpassed
> Phoebus and the Muses: and Zeusis when compared with her
> Loses all esteem.[2]

Mary Moore, *Thomas Cromwell, Earl of Essex*
This rather undistinguished copy of an earlier portrait merits for its painter a mention by Walpole in a very select list of artists.

Arcangela Paladini, *Self-Portrait*
Arcangela Paladini, the daughter of a painter, was a typical female prodigy. She was famous at the age of fifteen for singing and versifying and embroidery as well as painting. This stunningly simple and commanding self-portrait was commissioned by the Archduchess Maria Maddalena, who called her to the court of Cosimo II. At seventeen she married Jan Broomans of Antwerp but died six years later in 1622 and was buried in the church of Santa Felicità in Florence.

Another stated that

> She surpassed in song the harmony of heaven,
> With her needle and the brush, Pallas and Apelles:
> and with her lovely eyes the goddess, mother of love[3]

All we can glean from such hyperbole is that Irene di Spilimbergo practised versifying, singing, needlework and painting. Even if we knew the painting of Zeusis and Apelles, it would hardly inform us of the quality of the young woman's efforts. The offering of her teacher, the great Titian himself, does not help us to form any clearer notion of the kind of teaching that she was getting or the quality of her response to it, for it is a complex *jeu d'esprit* on her namesake, the nymph beloved of Ausonias.[4]

Giulio Cesare Croce was not ashamed to apply the same extravagant praises that were heaped on the dead Irene di Spilimbergo upon the industrious and long-lived matron, Lavinia Fontana. She was not only the 'glory of woman-kind, come upon earth like the phoenix', she painted so well

> That she equalled Apollodorus, Zeusis and Apelles,
> Michelangelo among others as excellent,
> Correggio, Titian and Raphael ...[5]

It is not easy to decide how such fulsome compliment was meant to be taken: to a serious painter it must have seemed mocking and insulting, as if she was assumed to be so vain and so gullible that she did not know the quality of the achievement of the great masters and that she was being humoured in her pretentiousness.

Part of the problem seems to stem from the very concept of female talent which chivalrous men entertained. It was obvious that women were hampered in their struggle for artistic training and yet also obvious that an occasional woman demonstrated great and almost untutored talent at an early age. To her friends and supporters this phenomenon seemed prodigious, beyond the natural, and so they stressed the gratuitousness of her appearance, its almost supernatural character. Like Irene di Spilimbergo, Elisabetta Sirani gave further credibility to the idea that she was a freak, by showing many-sided talents as well as a dazzling piety. She painted as swiftly as Marsia with so little effort that she seemed 'gracefully joking', and wrote verse, sang and played the harp.[6]

The feminist art-lover might now regret the tendency of so many women painters to diversify, showing a little talent in many fields, like jacks of all trades, but it is a syndrome which is repeated in the young female prodigy time and time again. Marietta Robusti, Teresa Muratori, Angelica Kauffmann and Maria Cosway all divided their precious time between music and painting.

Death was no deterrent to flatterers. On the tombstone of Arcangela Paladini in the loggia of Santa Felicità in Florence, we may read that she equalled Pallas and Apelles in her use of colours, and the Muses with her singing:

SPARSE ROSIS LAPIDEM COELESTI INNOXIA CANTU
THUXA JACET SIREN ITALA MUSA JACET

As the chief source of inspiration to male painters, the beauty of women had condemned them to the passive rôle. Women artists were not as men struggling to find the means of giving aesthetic expression to visions of an object of universal desire, they were themselves the objects of aesthetic desire. The young woman who gave evidence of talent was not an artist, but a muse. Her work was not evidence of what she could do, but of what she was. Boschini says of the women painters he is about to list in the *Carta del Navegar*,

> I can well call them bright stars
> Of heaven and of painting, or new Muses,
> Who shine thus, as also shone
> In Parnassus the nine sisters ...[7]

Possibly the most obvious case of the muse syndrome is that of Elisabeth Sophie Chéron (1648–1711), the daughter of the miniaturist, Henri Chéron, who was her first teacher. In 1672 she presented a self-portrait among other works to the Académie Royale, which 'estimant cet ouvrage fort rare, excédant

Pl. 1 Sibylla de Bondorff, *St Francis kneeling at prayer*, 1478

Pl. 2 Andriola de Baracchis, *The Madonna and Child Enthroned*, 1489

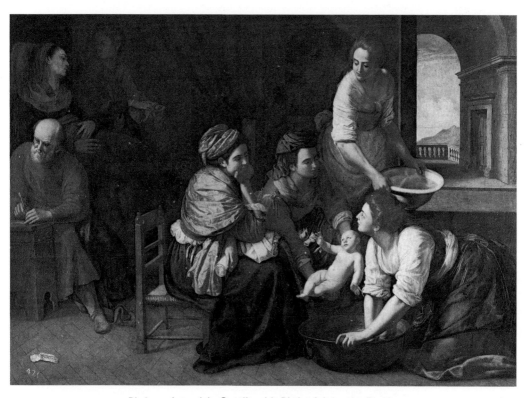

Pl. 3 Artemisia Gentileschi, *Birth of John the Baptist*

Pl. 4 Lavinia Fontana, *The Visit of the Queen of Sheba*

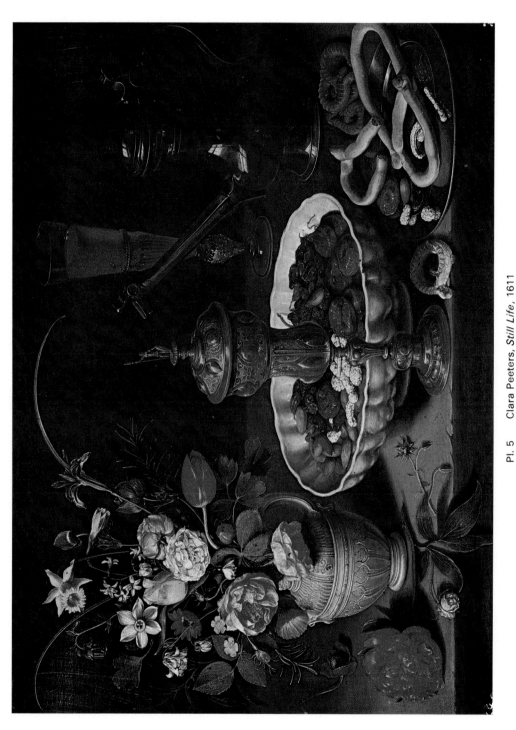

Pl. 5 Clara Peeters, *Still Life*, 1611

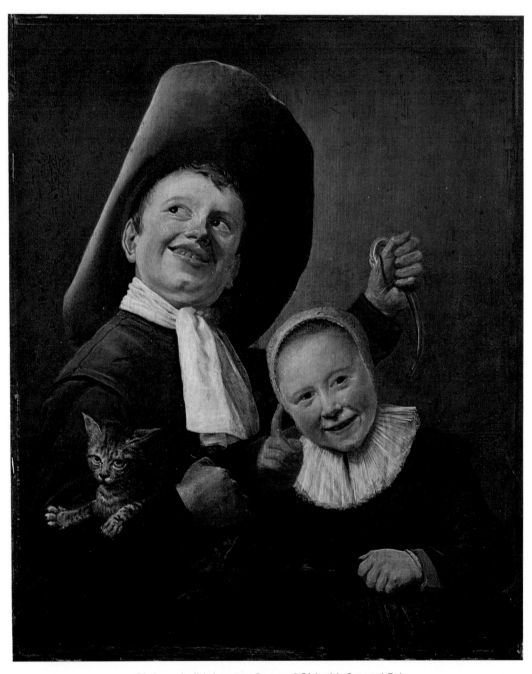

Pl. 6 Judith Leyster, *Boy and Girl with Cat and Eel*

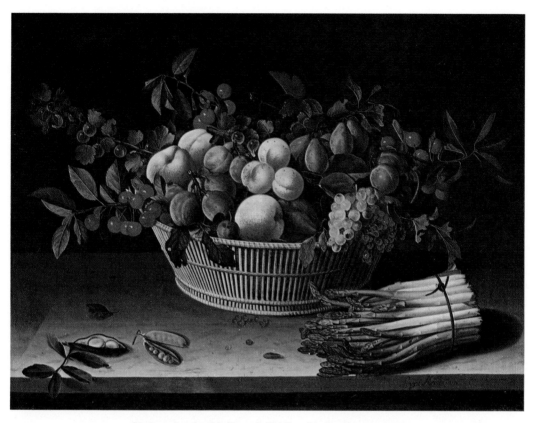

Pl. 7 Louise Moillon, *Still Life with Asparagus*, 1630

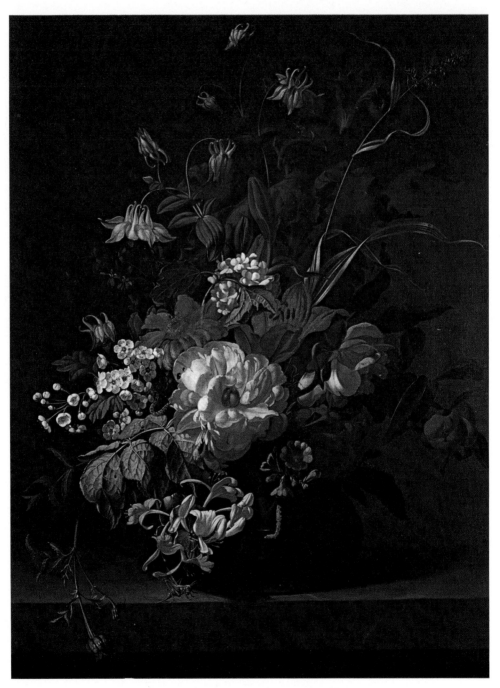

Pl. 8 Rachel Ruysch, *Flowers in a Vase*

Elisabeth Sophie Chéron, *Self-Portrait*
It was for just such a self-portrait that
Chéron gained entry to the Académie
Royale. Her image was her genius, and
her versions of it were engraved many
times.

mesme la force ordinaire du sexe' received her as a member.[8] The self-portrait
shows us a pretty young woman with an air of softness and grace, holding an
ambiguous parchment, stressing as usual the many facets of her talents. One De
Vertron designed a device for her of a quill and a paintbrush interlaced, with this
motto:

> When Chéron takes up her brush
> Without effort she would make that of Apelles tremble:
> And when her mind in some new transport
> Abandons itself to the work to which the Muse calls her,
> One wonders who of the Gods, Apollo or she herself,
> Uses a more beautiful language,
> Chéron, without being a painter, I make a picture of you.[9]

To imply that Chéron worked without effort removes her from the ranks of
earthly artists. As well as being a painter, enamellist and engraver, and a poet
whose translation of the Psalms was published with illustrations by her
younger brother Louis, Elisabeth Sophie Chéron was an accomplished musi-
cian and noted *femme d'esprit*. She had been responsible for the support of her
family since her father abandoned them. In order to continue enjoying royal
patronage they had to renounce their Huguenot religion, so Sophie and her
sister, the miniaturist Marie Anne Chéron who married Alexis Simon Belle,
became Catholics while their brother fled to England. Elisabeth Sophie worked

Elisabeth Sophie Chéron,
Self-Portrait
 The extraordinary contrast
 between the harsh realism and
 puritanical garb and posture of
 this portrait compared with
 Chéron's better known self-portrait
 suggest that it may date from an
 earlier period when the artist's
 attachment to her Huguenot faith
 had not been entirely repressed.

as a portraitist under royal patronage and also executed various religious and mythical subjects, some landscapes, and a large number of self-portraits.[10]

However many self-portraits Elisabeth Sophie Chéron actually did paint, they would never have sufficed to satisfy the demand. As the Muse herself is the crowning work of divine art, the most appropriate employment of her time is the taking of her own likeness. The Louvre and Versailles both have self-portraits by Chéron, and three more were listed by Bénézit as having appeared on the art market in the nineteenth century. The interest in the painter as a prodigy has not waned even into our own time, when the number of self-portraits ascribed to female painters still exceeds the bounds of probability.

Chéron continued to follow the kind of career that befits a prodigy. She was received into the Académie as a poet in 1676, and into the Accademia dei Ricoverati in Padua in 1699, with the name Erato, a clear tribute to her as a Muse. In 1692, when she was forty-four, she abandoned the virginal state befitting her musehood and married Jacques le Hay, the King's engineer.

Although few critics nowadays would fall down and worship female painters as young prodigies and muses incarnate, the tendency to compliment and flatter women rather than deal straightforwardly with their work dies hard. The whole tone of books about women artists, especially when they are written or compiled by men like Walter Shaw Sparrow,[11] is condescending. Painters are commended because of the womanly nature that their works express, for

charm, freshness, sweetness, grace and delicacy. The most cloying sentimental-
ity was expected from women throughout the nineteenth century and it was
supplied. Women like Rosa Brett and Antonietta Brandeis were so sickened by
the double standard that they signed some works as men. Other painters, like
Gluck, did their best to conceal their femaleness under sexless names. Kathleen,
Lady Scott, although herself a sneering anti-feminist, wrote crossly:

> Nothing is expected of a woman in my class, neither brains, energy, nor
> initiative; and you have only to display a modicum of these things to get
> fantastic praise.[12]

Marie Bashkirtseff was avid for praise, but she did not wish to win it unfairly,
nor did she want the kind of praise that was meted out to women.

> I have made Julian come for my statue, which is finished as a sketch. He is
> entranced and says, 'Very good, exquisite, charming, captivating.' Which
> means I no longer esteem Julian.[13]

While Bashkirtseff rightly objected to being praised in these terms, she might
have been seduced by the other kind of praise, which denigrates all other
women in praising one. One of the earliest examples, if one discounts Dürer's
astonishment at the fact that Susannah Horenbout could draw at all, is to be
found in the eulogy of Elisabetta Sirani, in which we are told

> She was born a woman, but about her there was nothing effeminate, except
> the husk of a name . . .[14]

Many women found themselves impaled on the horns of this kind of
dilemma. To be truly excellent in art was to be de-sexed, to be a woman only in
name, to inhabit a special realm that no other women could enter, to be
separated from all other women, or it was to express true femininity in grace,
delicacy, sweetness and so forth, and be condemned to the second rank. So
Marie Bashkirtseff, tormenting herself by the contemplation of the work of
Louise Breslau, notes bitterly 'she does not draw at all like a woman'. Bashkirt-
seff found nothing repugnant in the idea that good drawing was to be virile, but
many women in her circumstances would have done.

Few women could see through the other kind of false praise, which is meted
out to token women, single individuals whose recognition is taken to absolve
the observer from a charge of prejudice and to give him licence to denigrate or
ignore all the other women in the same category. Rosa Bonheur was called the
'best female painter who ever lived', without the men who so named her feeling
any obligation to compare her with other women, or even to inform them-
selves about the other women who had lived and worked as painters.[15] The
effect of such praise is to humiliate and discourage other women.

Both Rosa Bonheur and Cecilia Beaux had considerable commercial success,
the kind of success that results from a nice coincidence of the work with the

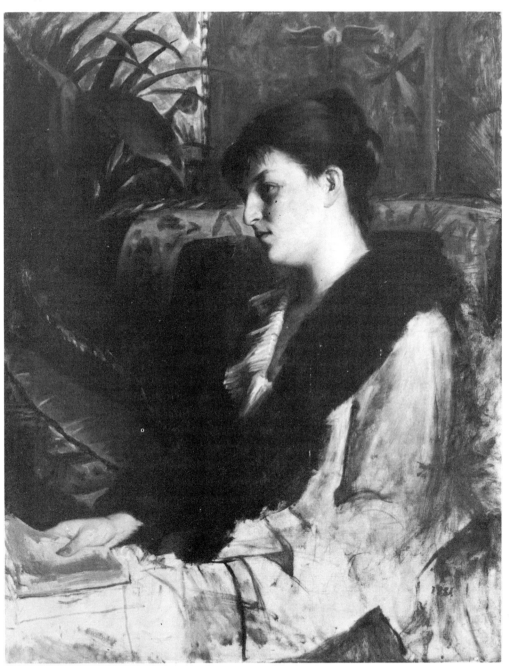

Marie Bashkirtseff, *The Painter's Sister-in-Law*, 1881
 The dashing aproach to a conventional subject from a student of twenty-one
 promised great things for Bashkirtseff whose attitude to her teachers was
 ironically summed up in her picture of *Criticism Day at the Académie Julian* in the
 Hermitage.

tastes and preoccupations of the time. In 1888 a Rosa Bonheur painting fetched £4,200 at Christie's, but in 1929 the same painting was sold for £46.[17] The eclipse of Rosa Bonheur's fame in less than forty years is a direct result of the original over-valuation. Both painters were earnest, hard-working and self-assured, but the criteria applied to their work, and to some extent internalised by them, were false and misleading. Both must now be re-evaluated, for both had real genius which was revealed in patches, especially when they were not working under public pressure. No amount of re-evaluation, however, will disguise the disproportion of contemporary praise to the actual achievement. (See Pls. 18 and 22.)

Because their sex made art training virtually inaccessible until the nineteenth century, the few women who did acquire some skill found dazzling possibilities opening before them because of their sex, a double irony. Court portraits, in the age before photography, were a constant necessity; young female members of royal houses could be closeted for days at a time with artists recording their features for the public outside the court; so much the better if the person thus thrown into propinquity with them were herself female. She could also double as the ladies' instructor in the gentle arts of water-colour painting. Because then of the lack of competition, women of fairly slender achievement gained court appointments which men might have envied.

Often, as in the case of Isabella Maria del Pozzo, the invitation to work at court came from a female member of the ruling family. The Archduchess Henriette Adelaide invited del Pozzo to Munich in 1674, as can be verified by an entry for her colours in the court accounts of that year. In 1677 she was granted a pension of four hundred florins to be paid in wine, beer and bread. In 1696 the Archduke gave her a gift of thirty florins. After she went blind, in 1697, she was granted an annual pension of two hundred florins, which her husband claimed after her death, without success. Virtually nothing but those notices remains of twenty years' work in the court at Munich.[18]

Even more mysterious is the career of the many-sided amateur, Johanna Koorten or Koerten (1650–1715), who embroidered, paperworked, designed on goblets, drew and sang her way around the courts of Europe. Peter the Great honoured her and the Emperor Leopold and Queen Mary of England enjoyed her performances. She is usually described as an amateur, although presumably she stayed at the courts of Russia, Belgium and England at the expense of her hosts.[19] The status of many women who worked as court artists can be compared to hers in that they were often obliged to perform as ornaments to royal society: elegance, fashionable manners and a measure of beauty were even more important than artistic ability, and this explains why so many women called to royal appointments were so young. All royal patrons required, apparently, was the word that a pretty and accomplished woman was at their disposal: there was seldom any question of professional competence, let alone distinction. Henrietta Wolters (1692–1741), the daughter and pupil of

Theodorus van Pee, a very accomplished miniaturist who was helped by her husband, Hermann, in the way most male artists are helped by their wives, refused to go to Russia at Peter the Great's request, or to Prussia at the invitation of Friedrich Wilhelm. Perhaps we may see in this a highly professional woman's scorn for the dilettante atmosphere of the autocratic courts and even a distrust of the monarchs' motives.[20]

Female royalty was often seriously interested both in art and in the woman question. Time and again we read of women like the Grand Duchesses of Tuscany seeking out female talent and providing it with protection and support. The Grand Duchess Vittoria della Rovere took Giovanna Marmocchini-Cortesi as a child to be educated among the women in her service, so that she learned miniature painting under Galantini with them, then with Gabbiani, and then pastel painting with Domenico Tempesti. As a result she could accept commissions from Cosimo III, Ferdinando de' Medici and Violante Beatrice of Bavaria.[21]

The tradition of royal appointments from women continued until quite recently; the royal patroness *par excellence* was probably Queen Victoria, who gave dozens of commissions to women, most of them insignificant, being to copy her Winterhalters and chores of that kind meant to encourage young women, but many of them lucrative. The best known of the women who worked for her, Mrs E. M. Ward (1832–1924), Mary Severn (1832–66), Josephine Swoboda (1861–1924), Emily Mary Osborn (1834–after 1893), the limbless Sara Biffin (1784–1850), and the portraitists of the royal pets, Maud Earl (*fl.* 1884–1934) and Gertrude Massey (1868–1957), managed on the strength of royal patronage to build up very good practices, but posterity is virtually unaware that they ever existed.[22]

One of the most extraordinary stories of court success is that of Christina Jane Robertson (*fl.* 1823–50), who became the favourite portraitist of the Russian nobility and the royal family at St Petersburg where she was made a member of the Imperial Academy in 1841. She was well known in London from the 1820s as a miniaturist, but her brushless style was so successful that in Russia she turned to oil portraiture and is represented in most of the major Russian collections, although not hung in any public rooms at present.[23]

In the nineteenth century commercial success often went hand in hand with academic success, which had an even more tenuous relation to enduring artistic value. As soon as they were admitted to art schools women showed themselves to be born prize-winners, perhaps because they were more dependent upon external guarantees of the value of their work than more assured artists. The hundreds of women who followed exhibition careers for twenty and thirty years were in competition for hundreds of medals, gold, silver and bronze, Honourable Mentions, *Palmes académiques*, cash prizes, scholarships and special commissions; at art schools, women, who quickly became the majority of students took an even larger share of the spoils, with the exception of the great

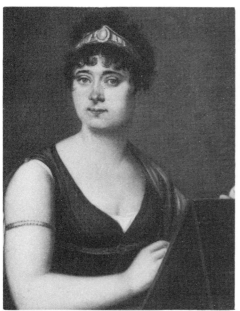

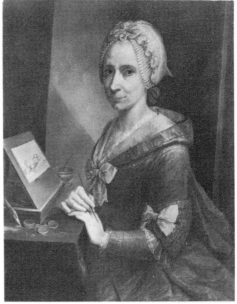

Mariana Valdestein, Marquesa de Santa Cruz, *Self-Portrait*, 1772
This intriguing personage was deemed to have merited inclusion in the Grand Ducal collection of self-portraits in the Uffizi on somewhat unsubstantial grounds. In 1771, a year before this self-portrait, she was named honorary director of the Academia de San Fernando.

Anna Bacherini Piattoli, *Self-Portrait*
It is interesting to compare this portrait of a woman whose features are drawn by resignation and overwork with the idyllic pastel portrait made by her husband at the beginning of their partnership when he was her teacher. Of a lifetime of hard work (1720–88) little besides this portrait remains, although the Grand Dukes of Tuscany thought her distinguished enough to join their collection of self-portraits.

travelling scholarships, but no one now remembers Jane Mary Dealy, who got a prize at the Royal Academy Schools for the best drawing of the year, or Emmeline Halse who got two silver medals and a cash prize of thirty pounds.[24]

Governments followed the lead of the academies and art unions and began to award decorations to women painters. Few would quarrel with the conferring of the rank of Chevalier de la Légion d'Honneur on Rosa Bonheur, and perhaps not even to Romaine Brooks and Louise Abbéma, but Virginie Demont-Breton (1859–1935), who got an honourable mention at the Salon of 1880, medals in 1881 and 1883, the gold medal at the Exposition Universelle in Amsterdam, 1883, and at the Paris Expositions of 1889 and 1900, the medal of honour at Antwerp, and the Order of Leopold as well as her Légion d'Honneur, is now quite forgotten. Bashkirtseff's great rival, Louise Breslau (b. 1856), was a Chevalier de la Légion and a multiple medallist, as were Katharine Carl (d. 1933), who was commissioned to paint a portrait of the Empress of China, Cecile de Wentworth (an American who assumed her particle as well as her red ribbon), Henriette Mankiewicz (1854–1906) and Madeleine Lemaire (1845–1928).[25]

One of the indices for the success of any painting is whether or not it is engraved. Publication meant both fame and money for the painter, and many women were gratified to see their works find favour in this way. Few painters of either sex can have been more successful than Angelica Kauffmann, whose work was engraved more than six hundred times. Moreover, her designs were used in all conceivable kinds of media, on fans, painted furniture, flower vases, chocolate cups, snuff-boxes, wine-coolers, tea-sets, and even as the basis for porcelain figure groups, from Worcester to the Wiener Porzellan Manufaktur.

The price that Angelica Kauffmann paid for being the rage was a very high one. Constable associated her with all that was decadent and advised the English to forget her[26] which, in the heat of reaction, they promptly did, for they failed to see her influence in the continuing tradition of history painting as it developed in the nineteenth century, an influence which, if it had been better understood, might have steered the Victorians away from their vulgarity and pompousness. She was a marvellous hybrid: free from the overwhelming influence of any single master, she had sipped and plundered from the Venetians, from Correggio and Domenichino, from her contemporaries Anton Raphael Mengs and Pompeo Batoni. The transparent brushwork and rich, romantic colour of the Venetians, the grand language of the neo-classicists and the voluptuousness of Correggio were steeped in her particular medium in which they all became lighter, more reserved, more elegant, less rhetorical, less hectoring. Her neo-classicism was witty and worldly, easier to live with than the solidity of her rival as a painter of mythological subjects in England, Benjamin West, and far more painterly than the sculptural works of her successor, David. Her painting has the same sort of understated but enduring appeal that she had herself; once one has learned to appreciate the depths that glimmer under her reserve, one finds her unmistakable and irresistible. She began by being ahead of her time: she may have finished behind it, but in the gentle development of her visual language there is a fine consistency; her separateness is explained rather by a rejection of the aggressive neo-classicism of her younger contemporaries than by an ignorance of it.

Her influence upon her contemporaries was greater than is commonly acknowledged. While she learned much from Reynolds, she also showed him a wider range of colour and emotion. Gavin Hamilton paid her the sincerest compliment of emulation. While the subtlety of English light and landscape was something she responded to with alacrity, she painted her own free and vivid version of it, which influenced the later landscapists who condemned her. In Europe where there was a tradition of history painting she was more highly respected than in England where there was none. It is sobering to reflect that her most ambitious works were undertaken without patronage, in the intervals of painting decorative panels for great houses.

The most telling evidence of her influence comes from an unlikely source. The arrogant and independent Vigée-Le Brun, after her meeting in Naples with

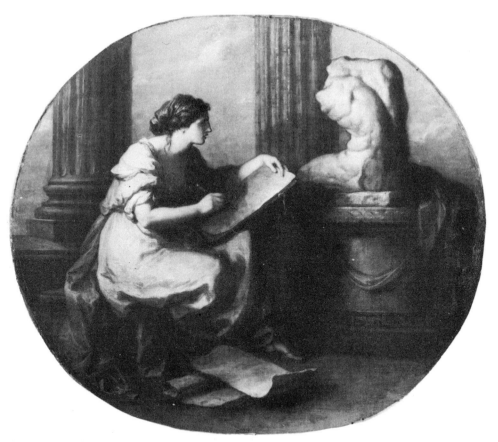

Angelica Kauffmann, *Design*
This elegant decoration was removed by the Royal Academy from its original
location and replaced in the Central Hall of Burlington House. Not all of
Kauffmann's decorative panels have been so carefully treated.

Angelica, chose to paint Lady Hamilton as the Persian Sybil in the Kauffmann
manner. She had tried her hand at mythological and allegorical subjects before,
but she was too gregarious a creature to inhabit Kauffmann's imaginary world
for long. Her genius was all communication and sociability, and portrait-
painting her métier, nevertheless her dramatised portrait of Lady Hamilton in
burning scarlet draperies impressed her so much that she refused to part with it,
but had it unrolled and set up in her painting rooms as she travelled about
Europe, to remind her of what she was capable. The influence of Kauffmann
flows through the best of her Russian portraits as well, especially the staggering
portrait of Varvara Ivanovna Narishkine which was exhibited at the 'Women
Painters: 1550–1950' Exhibition.[27]

The re-evaluation of neo-classicism continues apace; the re-evaluation of
Angelica Kauffmann was begun by the exhibition 'Angelika Kauffmann und
ihre Zeitgenossen' in Bregenz in 1968. Unfortunately the exhibition travelled
no further than Vienna: the work of rediscovery of Angelica Kauffmann has
stood still since then, especially in England.

The assessment made by the present writer of Angelica Kauffmann's achievement may be more enthusiastic than what is usually written about her, but it is positively lukewarm compared to the panegyrics of her contemporaries. She became a slave to the fashion that she herself had created. Her unenviable economic situation was one cause of her having to work swiftly, imitating her own style with unavoidable facility, but her public demanded nothing else from her.

> 'her male and female figures never vary in form, feature or expression from the favourite ideal in her own mind. Her heroes are all the man to whom she thought she could have submitted ... her heroines are herself, and while suavity of countenance and alluring graces shall be able to divert the general eye from the sterner demands of character and expression, she can never fail to please,' wrote Henry Fuseli, rather jealously.[28]

In fact, Angelica Kauffmann had no conception of failing to please and could not have afforded to fail to please. Her success was thoroughly commercial, and though we may nowadays deplore the restricting effects of popularity upon Kauffmann's work, we ought also to see its lasting value, even while we wonder how she would have developed had her work met with more judicious criticism.

In 1874, Elizabeth Thompson sent her large painting *Calling the Roll before an Engagement – the Crimea* to the hanging committee at the Royal Academy and went off to the Isle of Wight for a holiday. The painting had been commissioned by a manufacturer from Manchester for a hundred pounds. When the committee saw it, they lifted their hats and gave it and the young artist 'a round of huzzas'. On varnishing day she came to re-paint a fallen Prussian helmet in the foreground, and found her work hanging 'on the line' in pride of place, already surrounded by a throng of admiring viewers. The Crimean War was fading in the memories of the British people by that time, but Miss Thompson's painstaking researches and accurate observation had re-created every detail so vividly, that some who saw the picture went away in tears.[29]

Queen Victoria had the picture sent to Buckingham Palace to see for herself, and then to Windsor to show it to the Tsar. When the Exhibition opened to the public, a policeman had to stand by the painting to control the crowds. When it closed, the painting was taken to Florence Nightingale's bedside, so she might relive her memories of the Crimea. The Queen wanted to buy the picture; the manufacturer refused at first, then gave in, on condition that he have copies of the reproductions and a new picture from Miss Thompson for the same money, although by then her prices had increased ten-fold.

Elizabeth Thompson's father had had no sons; he himself undertook the formal education of Elizabeth (1844/51–1933) and her sister Alice, who became the poet, Alice Meynell. Their mother was a musician, who saw to it that after their brief sessions in the schoolroom, the girls were kept stimulated and inspired. There was no attempt to break down Elizabeth's fixation upon matters military

and equine. The beginning of her formal art training at the elementary class at the South Kensington School was dreary and stifling, so her parents wisely took her away until she might join the 'antique' and 'life' classes. During the holidays they took her upon a study tour of Italy, taking studios and teachers in Florence and Rome. She responded to their support and confidence and became not only a famous painter but a warm, witty and wise woman, whose account in her autobiography of life-classes for girls at South Kensington still raises guffaws.[30]

Elizabeth Thompson (known as Lady Butler after her marriage to a soldier in 1877) had kept the copyright of *The Roll-Call* to herself. It was sold for twelve hundred pounds and the picture became famous through all England, as were many of her more important works, *Steady the Drums and Fifes*, *The Charge of the Light Brigade* and *Scotland Forever!* In 1915, a German prisoner was taken with a New Year's Greeting Card in his pocket. On it was reproduced Lady Butler's *Scotland Forever!* with the soldiers *travestis* as Prussians.[31] (See Pl. 19.)

Lady Butler's achievement is not solely to be measured in terms of popularity. She recalled that another painter said when he saw *The Roll-Call*, 'What an absurdly easy picture!'[32] To be sure, there is only one plane of action, with the men standing huddled in greatcoats, the background blotted out by snow and mist, the figures dark against the snowlight. If she avoided one kind of problem, she delighted in solving others: she was proud that she was among the first painters ever to get the movement of a horse's legs right, in the officer's mount on the left of the picture.[33]

Elizabeth Thompson, Lady Butler, *Quatre Bras*, 1815
In order to depict this incident in the Battle of Waterloo, Lady Butler called upon the Royal Engineers to re-create the scene. Every part of the composition was studied from the life, including the field of trampled rye which her mother bought for the purpose.

The year after the exhibition of *The Roll-Call*, she showed *Quatre Bras* of which Ruskin wrote:

> I never approached a picture with more iniquitous prejudice against it than I did Miss Thompson's 'Quatre Bras' – partly because I always said that no woman could paint, and secondly because I thought what the public made such a fuss about *must* be good for nothing. But it is Amazon's work this, no doubt of it, and the first fine pre-Raphaelite picture of battle we have had; profoundly interesting and showing all manner of illustrative and realistic faculty ... The sky is most tenderly painted, and with the truest outline of cloud in all the Exhibition; and the terrific piece of gallant wrath and ruin on the extreme left, when the cuirassier is catching round the neck of his horse as he falls, and the convulsed fallen horses, seen through the smoke below, is wrought through all the truth of its frantic passion with gradations of colour and shade which I have not seen the like of since Turner's death.[34]

However arbitrary Ruskin's collaring of a painter so clearly influenced by the school of Meissonnier for the pre-Raphaelite confraternity, he is only fair to her in his appreciation of her technical skill. She was an innovative painter not only in her faith in her own observation but in the manner in which she transferred what she saw to the canvas. In the detail of *Quatre Bras* we may see the economy and expressiveness of her brushwork, as individual as a fingerprint.

If achievement is to be measured in terms of the judgment of posterity, it is perhaps significant that no public gallery in England has a Lady Butler hanging in a public room (*The Roll-Call* is in the Museum of the Military Academy at Sandhurst). In 1879, she failed by two votes to be elected to the Royal Academy: in 1922, she simply said, 'Since then the door, I think, has been closed and wisely.'[35] (That year, however, Mrs Annie Swynnerton was elected A.R.A.) Her work was essentially monumental in its intention, and finished either in Royal hands or in the possession of public institutions, so little ever appears in the art market. Her eclipse is as much due to the downfall of her subject matter as to any aspect of her handling of it. Many modern painters would envy her success; she is perhaps the last European painter to catch the imagination of the masses.

The success story of Cornelia Adèle Fassett (1831–98) is in its way as impressive as that of Lady Butler. Mrs Fassett was one of the earlier American students abroad, for she went to Paris in the 1850s to study under world famous masters. Her best known work was the *Electoral Commission in Open Session*, in which she incorporated two hundred and fifty-eight portraits of notables, which was hung in the U.S. Capitol in 1876, presumably as part of the centennial celebrations. For another painting of the Florida case before the electoral commission in 1877, Congress paid her no less than fifteen thousand dollars. When one remembers that she had eight children, such success seems verily miraculous.[36]

The consumers of fine art nowadays are a small incestuous group, who with

Henriette Ronner-Knip, *Three to One*
As a result of Henriette Ronner-Knip's success, itself an odd outgrowth of the Bonheur craze, for Bonheur also quite seriously painted pet portraits, a whole generation of animal portraitists grew up in Europe and America.

the best intentions in the world cannot fire the imagination of millions about the beauty of the works they praise. Even David Hockney, who has saturated the market to its limit with prints and designs as well as highly priced paintings, cannot boast the kind of penetration achieved by Kate Greenaway or Lady Butler. Alas, while we deprecate the hermetic nature of the patrician art establishment, we cannot exalt popular taste as any sort of corrective. Two women painters whose success in their own time was phenomenal, and who still tyrannise in the salerooms to the delight of these on commission, displayed talents of the slightest. Their success lay in their happy choice of subject matter. As the auctioneers say, any picture of a horse will sell well. Maud Earl demonstrated the principle with dogs, Henriette Ronner with cats.

Henriette Ronner (1821–1909) was the daughter of two painters, Johann August Knip, who taught her to paint, and Pauline de Courcelles, a distinguished botanical illustrator who had left Knip when Henriette was three. Henriette made her name as a painter of animals with a picture called *Friend of Man* which was exhibited in 1860. After 1870, she began to devote herself to pictures of cats, and not simply cute genre scenes, but portraits of real animals, brought to sit for her in Holland from all over Europe, in the days before quarantine. Her success lasted beyond the end of her long life, for her cat pictures still fetch high prices at auction. She trained a son and a daughter to

Maud Earl, *The Ace of Hearts*
 Animal genre had its beginnings in the studies of children and animals exhibited
 at the Paris Salons in the first decade of the nineteenth century. Maud Earl's
 dexterity in portraying animal character chimes rather oddly with the forced
 cuteness of the pose.

follow in her footsteps. Her success was not simply commercial. Her works
were praised in the highest terms, and she was called a glory of Dutch painting,
and a rival to – Rosa Bonheur.[37]

Maud Earl painted dog portraits for Queen Victoria and for King George V,
exhibiting work in America as well as in England. Her subject pictures, as *Ace of
Hearts*, which shows two poodles, one white and one black with his paw on the
card, were reproduced in all kinds of media.[38]

When it comes to saturation by an artist, one woman probably holds the
field. Kate Greenaway (1846–1901) quite literally designed a generation. Her
drawings influenced the style of children's dress, of nursery furniture, book
illustration and card design not only in England but in America and France and
Germany. *Under the Window*, published in 1879, sold a hundred and fifty
thousand copies. For four other children's books she was paid sixteen thousand
pounds. It is now a hundred years since her works became known and her
influence continues.[39] Beatrix Potter's vision of the animal world is still dear to
every middle-class child of whatever age. Perhaps in the unassuming genius of

these two women we can find a clue to the pervasive influence of mothers upon children's ways of seeing from the beginnings of our culture.[40]

The kinds of success that women have enjoyed may be regarded as illusory or secondary, popular or commercial; they may have decoyed women from the true preoccupations of fine art, or they may have indicated other rôles for art, which women, with their greater allegiance to life, were happier to play. If we sneer at these modest achievements we may be making a mistake in that we apply the criteria of the establishment which excluded these women. It is hard for the feminist art historian to decide what is a doubling of standards and what is abandonment of prejudicial discrimination.

One thing is clear, however: the success which is popular and commercial may blind an artist to other kinds of failure. It is more likely to do so when the artist has never been able to find herself, or suspected that there was a self to find, but has always been directed by praise and reward. It is too simple to complain that women artists were obstructed, although many were. Too often, they were adversely affected by promotion. Moreover the possibility always exists where tokenism is practised, that the wrong women are singled out for praise. Ruskin, the most influential critic of his day, had irrational preferences for his 'pets', young, pretty and usually blonde artists (Greenaway being the exception), about some of whom, like Francesca Alexander, he behaved absurdly. He praised some women, like Mrs Allingham, inordinately while ignoring others. The masculine art establishment was, in this respect, made in his likeness.[41]

IV

Humiliation

Was it simply her own imagination, or could there be any truth in this feeling that waiters – waiters especially and hotel servants – adopted an impertinent, arrogant and slightly amused attitude towards a woman who travelled alone? Was it just her wretched female self-consciousness? No, she really did not think it was. For even when she was feeling at her happiest, at her freest, she could become aware, quite suddenly, of the 'tone' of the hotel servant. And it was extraordinary how it wrecked her sense of security, how it made her feel that something malicious was being plotted against her and that everybody and everything – yes, even to inanimate objects like chairs and tables – was secretly 'in the know', waiting for that ominous infallible thing to happen to her, which always did happen, which was bound to happen, to every woman on earth who travelled alone!

Katherine Mansfield, 'Travelling Alone', *Journal* 1915

The price eventually paid for the immoderate praise of young woman artists is high. Young women grow old; their precocious achievements often stagnate and are seen for what they are, when the glamour of youth and beauty have worn off. If the female painter shows herself a serious rival to men, committed to advancing her own career and not simply playing, she may expect opposition to harden against her. The better she is, the prouder and more serious, the more implacably the ranks close against her.

Anna Dorothea Lisziewska (1721–82) married in 1745, when she was twenty-four and already active as a painter. In 1761, she reappeared on the scene when she was invited to the court of the Duke Karl Eugen in Stuttgart, an astonishing success for a woman who had been buried in her family for fifteen years. She was also invited to the court of the Elector of Mannheim where she

carried out ambitious projects. Unwisely, she decided to try her fortunes in the centre of European culture, Paris, where she was admitted to the Académie Royale in 1767, at which point her triumphant progress came to an abrupt halt. Diderot explains why:

> It was not charm that she lacked in order to create a great sensation in this country, for she had that in any case, it was youth, beauty, modesty, coquetry, one must go into ecstasies over the works of our great male artists, take lessons from them, have a good bosom and buttocks, and succumb entirely to one's teachers.[1]

In her forties, and never a beauty, proud, hard-working and passionate about her work, Lisziewska could not and would not ingratiate herself with the art establishment in France. In 1768, she gave up the struggle and retreated to the Netherlands, leaving numerous debts. Even Diderot found her behaviour unreasonable, in that she blamed him for her failure to win commissions from the court of Louis XV, and his enlightened patience gave out.

Another man, the Abbé Conti, explained the troubled career of another plain, hardworking, middle-aged woman artist, the great Giulia Lama (*c.* 1685–after 1753):

> The poor woman is persecuted by painters, but her talent triumphs over her enemies. It is true she is as ugly as she is intelligent, but she speaks with grace and polish, so that one easily pardons her face. . . . She lives, however, a very retired life.[2]

Giulia Lama, *Self-Portrait*
Snub-nosed, with the suggestion of a hare-lip, her hair unbecomingly dressed in two downward curving horns, Giulia Lama has here asserted her plainness with a kind of humorous defiance. So literal a likeness has little in common with her usual style.

Her own self-portrait exaggerates her plainness, for she poses herself squarely facing the front, with a harsh light falling on her snub features from above, as if to defy the onlookers to flatter her.

It is obviously essential for any greatly gifted artist that he prize his independence and pursue his own path beyond the myopia of public and academic taste, but the few women who did that, as Lama did, could expect to be regarded with horror, as unnatural phenomena, for modesty was until very recently taken as a female sexual characteristic. It is hard for us now to comprehend the astonishment caused by the diaries of Marie Bashkirtseff, which were taken to illustrate the appalling consequences of admitting women to higher education. Even her death at twenty-four was put down by some to the unhealthy effects of her overweening ambition.[3] Even if she had concealed her exuberant feelings and manipulated the male artists around her with more skill, she would still have had to face the most enduring calumny of all, the universal imputation to women artists, who do not render themselves repulsive by other means, of promiscuity and the abuse of their sexual charms in the race for success.

It is inevitable, perhaps, that a woman who will only be tolerated by an all-male group as long as she is attractive, will be accused of exploiting her sexuality. What is more disgusting than the fact of the calumny is that it could also damage a woman's career. It is of no consequence whether a male artist leads a truly debauched sexual life: if a woman artist is convicted of any sexual irregularity the stigma clings to her for ever.

Although very few painters are mentioned by the authors of the *Cimiterio* (a collection of satirical epitaphs) of 1654, Artemisia Gentileschi appears not once but twice:

> Painting the faces of this one and that one
> In the world I won infinite merit:
> For carving out horns for my husband
> I laid down the brush and took up the chisel.

> Sweet bait of the hearts of those who could see me
> Was I always in the blind world:
> Now between these marble slabs am I hidden,
> Become the sweet bait of the worms.[4]
> [Gentil' esca, sweet bait, is a pun on Artemisia's name.]

Those historians who recorded Artemisia Gentileschi's reputation did not take the hint from the epitaph that her *merit* as a painter was *infinite*. Their version of the calumny was that she was as famous for her loves as her painting. Even the most judicious modern commentators repeat the denigration of her character, imputing her rape and her abandonment by her husband to her own fault, and then, more horribly, finding evidence of a coarse and debased character in her work itself.

When the wife of the English ambassador brought Angelica Kauffmann

home with her from Venice in 1766, she knew that this brilliant young person-age could not fail to enhance her own social reputation. She sang beautifully, painted portraits as well as anyone, and was equipped with a brand of charm which few could resist. The young person's ageing parent, who lacked all her accomplishments, had been left behind. There was to be no drag upon Angelica's progress as a society painter and drawing-room prodigy.

She was, of course, a serious and greatly gifted painter, who had taken to heart the lessons of Winckelmann on taste and even more the example of the great Italian painters whose work she had seen in her travels with her father. She wore her seriousness lightly: her patrons were no longer clerics like the Bishop who had given her her first commission when she was eleven. As well as being a good painter she had to be an ornament to society as Rosalba had been. Society belles do not wish to be closeted with a gorgon for the long hours that sitting required, society beaux still less. A studio was also a salon.

Her reputation had preceded her; her seductiveness and her success added fuel to the fires of envy. Traducement of her character was an occupational hazard which she could not have avoided if she had tried. There was nothing for it but to stand boldly in the limelight and let pettiness and covetousness do their worst. She could not emerge unscathed. Her art suffered because she was the rage and her spirit was worn down by the falseness of her situation. The central reality of her youth in London was hard work and penny-pinching in poor lodgings, struggling to work in the short dark days of the season. The myth was that she was a flibbertigibbet who spent most of her time flirting. The conflict between the public image and the private reality could not continue without affecting her personality and her painting.

She had known carping since she was a little girl in the Valtellina. On her study tour she had soon found that as a female she could only work in the galleries under the patronage and protection of some great name, and so she learned to ingratiate herself. The swiftness of her rise was partly a result of her personal charm, and the circumstance was neither forgotten nor pardoned. Recollected in tranquillity, the gossip became if anything more vicious. J. T. Smith in his life of Nollekens describes her at this time as being

> ridiculously fond of displaying her person and being admired, for which purpose she one evening took her station in one of the most conspicuous boxes of the theatre accompanied by Nathaniel Dance and another artist, both of whom as well as many others were desperately enamoured of her . . . while she was standing between her two beaux, and finding an arm of each most lovingly embracing her waist, she contrived, whilst her arms were folded before her on the front of the box over which she was leaning, to squeeze the hand of both, so that each lover concluded himself beyond all doubt the man of her choice.[5]

Angelica Kauffmann's biographers are to this day obliged to spend far too much time pondering the mystery of her relationship with the inferior painter,

Angelica Kauffmann, *Lady Elizabeth Foster*
The sitter became the Duchess of Devonshire after being her predecessor's
confidante and the Duke's mistress. Perhaps Kauffmann alludes to this odd
situation in the portrait medallion about the sitter's neck. Otherwise the picture is
a perfect Romantic idyll, and thoroughly English, although Lady Elizabeth wears a
robe en gaulle like Vigée-Le Brun's sitters.

Nathaniel Dance. The historic certainty is that Dance sketched her maliciously once and painted her beautifully once. The gossip is that she deserved his malice: its source is the diary of Joseph Farington, written forty years after the supposed event.

If Angelica Kauffmann had been a man, her friendship with Sir Joshua Reynolds would have seemed inevitable and right. As she was a woman, the most fastidious biographers cannot resist speculation about possible marital designs she may or must have had upon this confirmed old deaf bachelor. The wonder is that she had any social life at all, not that she sought the company of the greatest painter in London.

In 1767 she bought a house in Golden Square. When even Reynolds could ask no more than forty guineas a picture, Kauffmann must have worked all the hours of the day to find herself in such a position. Her father and her niece came to live with her.

The truth about Angelica Kauffmann's behaviour will never be known, because she did not choose to make it known. This indisputable fact of history accords ill with gossiping reports of flamboyant and injudicious behaviour. One is more inclined to accept Boswell's laconic judgment: 'musician, paintress, modest, amiable'.[6] Despite the éclat of her career, there is remarkably little first-hand notice of her behaviour from the people in the circles that she is said to have frequented. During the period when Fuseli is said to have courted her she was preparing her first allegorical paintings. Portrait painting was a well-charted realm for women painters. Kauffmann was embarking on historical compositions expressing a range of movement and emotion beyond anything that a portraitist could be called upon to show. No English painter had yet attempted it. The dignity and restraint of the neo-classic manner she had learned in theory from Winckelmann: now she was to embody it and make of it a fashion. It is not easy to reconcile such a serious aim with a frenetic and foolish life of flirtation and a suburban obsession with marriage. The venom of Kauffmann's rejected suitors is perhaps best explained by her simple failure to care for them.

As long as Angelica Kauffmann refuses suitors her behaviour is relatively easy to understand. Her marriage is quite incomprehensible. On the face of it, it was the same sort of marriage that Vigée-Le Brun was to make fifteen years later with a handsome, plausible, immoral man, apparently rich, whose riches were no more than an elevated life-style which his unlucky wife would have to finance. One can ill understand why Vigée-Le Brun affected to feel so very sorry for Kauffmann whose fate was in the end easier than her own, for Kauffmann's marriage was invalid. For Vigée-Le Brun there was no such release.

In both cases the marriage was secret, a circumstance which seems to suggest the women's complicity in their own misfortune. Vigée-Le Brun's friends knew the real character of the man she married; Kauffmann had the excuse that

all society was gulled by the bogus Count von Horn, just as she was. Perhaps Kauffmann saw marriage to a foreigner, which he desired as a protection from his enemies at home, as a mere formality which would put an end once for all to the speculation about her own affections. The marriage was never invalidated, although the bigamous 'count' was paid off and sent away. It simply increased her notoriety and with it her vulnerability. The collapse of her emotional life in disgrace and disappointment sealed off the avenues to maturity. Her art remained immobilised in girlishness. Her reticence increased; the range of her imagery narrowed.

Despite her public humiliation, the voices of envy still gave Kauffmann no quarter. Her professional association with the engraver Ryland, who was hanged for forgery in 1783, is still given out as a flirtation, although at the time Ryland had not only a wife but a mistress and an illegitimate child as well. Ryland's own behaviour compromised Kauffmann, for he made a great show of his admiration for her. Nathaniel Hone dragged her into his libellous painting depicting Sir Joshua Reynolds as a plagiarist, showing her as one of the nude figures dancing around St Paul's, a reference to the grandiose plans for redecoration of the church, in which she but not Hone had been included.[7]

Many people visited the house at Golden Square, but few repaid Kauffmann's hospitality as unkindly as Jean-Paul Marat, who boasted that he had seduced her. The truthfulness of the boast may be judged by the fact that the man to whom it was made, Antonio Zucchi, married Kauffmann a few months later.

This time the match was made in the proper manner. The settlement, which ensured that Zucchi had no claim upon Angelica's income, was duly witnessed, but the gossips were not to be silenced by a mere marriage. The *Morning Herald* unnecessarily contradicted the earlier view of Angelica's relationship with Reynolds;

> She has long refused many advantageous offers of various suitors and among them one from Sir Joshua Reynolds who at the same time that he admired her style of painting thought Angelica a divine subject to adorn the hymeneal temple.[8]

Antonio Zucchi was a distinguished painter; he made a remarkable husband who, while he expected his wife to accept the many lucrative commissions that came her way, was perfectly willing to undertake the selection and purchase of her materials, to arrange the dispatch of her finished work, and to allow her considerable freedom within the *cordon sanitaire* of his name. Roman society, unlike parochial London, was both incurious about sexual behaviour and capable of understanding sentimental friendship. Goethe found in Angelica Kauffmann a confidante in matters of taste and feeling; for her it was a passionate association which would not founder in a sea of innuendo. Gradually the crass image which the English had made faded away and the real Angelica emerged, wistful, tired and disappointed, still cherishing an impossible ideal of

love, but able at last to express her own 'simplicity, sincerity and sensitivity'. Goethe called her 'die Gute' and he may be allowed a better judge than Smith or Farington.[9]

In 1795 Zucchi died. He had left his wife in the care of her cousin, Anton Joseph Kauffmann, but she was seriously affected by the loss of her dis-interested protector. She was obliged to work as hard as ever without his benign influence ordering her affairs. Despite the fact that she was a popular heroine, loved and revered by the people who saluted her carriage as it passed through the streets of Rome, she was so tormented by the thought of the prying that would follow her death that she spent the last months of her life going through all her papers and destroying most of them.

The young Angelica was driven by a strong urge for fame. At first she was not sure whether singing or painting was the best way to arrive at it. She rejected the dubious life of a singer, but even as a a painter she discovered that there was no way that she could promote herself without offending against modesty. On the one hand she had to exert energies beyond those required of men in mastering her art and on the other she was obliged to project an image of retiring and delicate femininity. The contradiction attenuated her painting and hobbled her genius. The style that emerged was as popular as the female stereotype has always been, even while it has been denied any pretensions to greatness. A hundred years after Angelica sent her first picture to the Academy, however, the same clichés of painterly expression were still current.

As a colourist, Angelica Kauffmann was the equal of any of her contem-poraries. Her design is not calculated to astonish or confound, but to delight in its elegance, which it seldom fails to do. She was as deficient in draughtsman-ship as any painter whose training consists in drawing from plaster casts and copying old masters, but many painters commonly accounted great draw as badly. It is futile to object that she was not great, especially when it is not well understood how brilliant and influential she really was. In an age of silver, she was of the purest metal. It is to the endless discredit of the country of her adoption, that the study of her contribution to the British school is neglected, while the foolish prattle about her 'love life' is perpetuated. (See Pl. 10.)

Like Angelica Kauffmann, Elisabeth Vigée-Le Brun (1755–1842) was forced to exploit her personal charm to get her art education. She was obliged to gain entrée to the galleries and permission to work there by attracting some great name who would intervene to bend the laws on her behalf; then as a portrait painter in search of sitters from high society. From her early teens she was conspicuous, and her rash marriage with a libertine was not calculated to make her less so.

She was not a Swiss provincial however, but a sophisticated Parisienne, and for the most part she contrived to silence the gossips by her adroit manipulation of royal patronage and her strict attention to the appearances of propriety, which the more guileless Angelica might have neglected. The first rumours

were spread by anonymous letters, possibly written by the vicious Comte de
Brie, who is said to have tried to make her his mistress. The letters named
individuals among a veritable army of lovers, and did her little damage.[10] The
coupling of her name with that of Louis XVI's finance minister, the Comte de
Calonne, could have cost her her life.

When in 1785 she painted the portrait of Monsieur de Calonne, the critics
made several underhand remarks, including that she had showed herself 'maît-
resse de son sujet'. Sophie Arnould quipped that she had cut off his legs in the
picture so that he would have to keep where he was and remain faithful to her.
In a collection of contemporary letters sent to Russia from Paris between 1777
and 1792 it is said that the Comte de Calonne, who was certainly guilty of
massive misuse of public money, had chosen to pay Madame Le Brun by a New
Year's present of a handful of pistachio nuts, each wrapped in a three-hundred-
franc note. The nuts were accompanied by a gold étui, which when opened
proved to be already full of twenty-franc pieces, each likewise wrapped in a
three-hundred-franc note.[11]

The revolutionaries saw Calonne as one of the principal villains of the *ancien
régime*. Vigée-Le Brun's flight from Paris did nothing to dispel the gossip of her
illicit relations with him; Calonne's Aspasia was said to have fled to the arms of
another lover, the Comte de Vandreuil, whose portrait she had painted (with
five copies) in 1784. In 1793, Jean-Baptiste-Pierre Le Brun, who was living off
his wife's supposedly immoral earnings while she roamed Europe, to save his
own skin wrote a defence of her in which he pointed out that their many debts
and few possessions gave the lie to such calumny. As he was a known gambler
and wastrel, the argument was far from convincing.[12]

Vigée-Le Brun herself denied the story hotly, but her explanation of a scandal
which was well-known even among the common people was too detailed and
circumstantial to be reassuring, especially as it revealed a circumstance never
before mentioned, that her carriage had once stood all night outside the Palais
de la Finance. More convincing was her own declaration of distaste for
Calonne's *perruque fiscal* which he was obliged to wear when in formal dress,
but then formal dress was not always worn. She protested in her *Souvenirs* that
she was never a coquette, and there her own self-portraits give the lie.[13]

It is only to be expected that the favourite portraitist of Marie-Antoinette
would share in the revolutionary character assassination, most of which had
little regard for the rules of evidence. There is no doubt that Vigée-Le Brun
worked hard all her life, and owned nothing at the end of it; her reality was the
same as that of the revolutionaries after all, but malice constantly showed her as
a spoiled courtesan. The legend of her Grecian feast, which actually cost fifteen
francs, is a typical case of the working of calumny against the female artist for,
as she heard the story herself over the years in all parts of Europe, it changed
from a light-hearted *al fresco* romp in which the scantiness of the clothing and
the simplicity of the fare were the chief attractions, into a spectacular

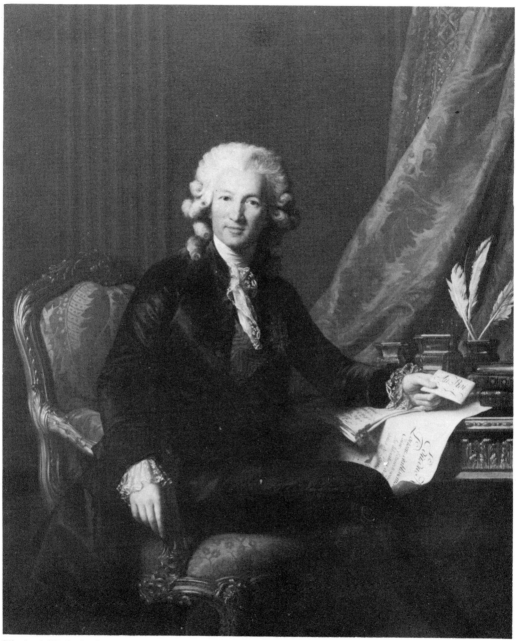

Elisabeth Vigée-Le Brun, *Charles Alexandre de Calonne*
This is the kind of official portrait which Vigée-Le Brun hated painting, in which
the sitter wears his *perruque fiscal* in a setting of rhetorical pomp. Sophie
Arnould said that she had cut off the feet so that he could not leave her: certainly
his expression is more urbane and intimate than grandiose.

extravagance costing forty thousand francs.[14] The true story of her earnings was that they went straight into her husband's pocket. They might well have included sums embezzled by the Comte de Calonne, about which Vigée-Le Brun need have known nothing.

As the wife of a known libertine, Vigée-Le Brun was probably at the mercy of his boon-companions, who must have known how exploited and neglected she was. The disgusting Marquis de Champcenetz, who joined the ranks of her detractors, was probably one such.

More pervasive still than the smearing of Vigée-Le Brun's character by imputations of immoral sexual behaviour was and is the libel that she and Adélaïde Labille-Guiard (1749–1803) hated each other, which is regularly aired, even by such scholars as Jean Cailleux, whose methods are impeccable until he has to deal with the subject of the rivalry of the two women. In an article published in 1969, he correctly describes the situation of the two women who were compelled to work under orders from the factions in the royal family, Madame Vigée-Le Brun for Marie-Antoinette and Madame Labille-Guiard for the Mesdames de France. Lamentably, he is not content with describing this confrontation as a function of their rôle as court portraitists, but assumes that it was also the result of their personal antipathy.

> The opposition between these two female painters had declared itself as early as 1783, on the occasion of their reception at the Académie.[15]

The women had been played off against each other since first they began to exhibit, mostly to the disadvantage of the less spectacular personality, Labille-Guiard. The opposition did not so much declare itself as find itself declared and provoked by others. Labille-Guiard insisted on being elected to the Académie in the normal way, for reasons unconnected with Vigée-Le Brun, and the Academicians, resentful of royal interference, made an issue of the fact for their own ends.

Cailleux compounds his libel by continuing:

> From this time onwards the opposition, indeed the hatred, that existed between the two women was never to end, and Madame Vigée-Le Brun in her *Souvenirs* takes every opportunity to complain of her rival.[16]

However tiresome Labille-Guiard found the adulation enjoyed by her younger, prettier rival, we have no good reason to suppose that she hated her. So far from taking every opportunity to complain of Labille-Guiard in her *Souvenirs* Vigée-Le Brun suppresses all mention of her by name. Only twice does she make references which might be construed as references to Labille-Guiard, when she simply complains of envy and calumny in terms which do not constitute hard evidence that she had ever been the victim of either. Writing of her acceptance of a commission to portray the Mesdames de France in exile in Rome, she says

I was not at all unaware that a woman artist who has always shown herself my enemy, I don't know why, had tried in every imaginable way to blacken me in the minds of these princesses; but the extreme goodness with which they treated me, assured me in a very short time that these calumnies had had very little effect.[17]

Any reading of Labille-Guiard's character places such ingenuous malice out of the question; Vigée-Le Brun was both vain and insecure enough to be readily convinced that her rival was working against her. Certainly she should have found in the other woman's steadfast, earnest and retiring character, an unspoken criticism of her own flightiness. The opposition between them was like the opposition between the Mesdames and their corrupt nephew, and like the contrast to be observed in their art. To believe Vigée-Le Brun, otherwise unreliable as in her description of her reception to the Académie Royale and her relationship with Catherine the Great, in the matter of Labille-Guiard's behaviour towards her is to trust to very shaky support.

Even though I was, I believe, the most inoffensive creature who ever existed, I had enemies: not only did some women hold it against me that I was not as ugly as they, but several did not forgive me for being the fashion and selling my pictures at better prices than theirs ...[18]

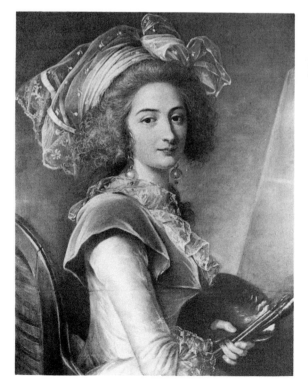

Adélaïde Labille-Guiard,
Self-Portrait, 1782
 When Labille-Guiard entered the Salon de Correspondance where this portrait was shown, the people present burst out clapping so striking was the resemblance. Pahin de la Blancherie notes that *'le hasard'* had occasioned this picture to be hung as pendant to Vigée-Le Brun's self-portrait.

Her own *Souvenirs* show only too clearly that Vigée-Le Brun was not at all the most inoffensive creature that ever existed, and the rest of her protestations may be taken with as much salt.

The most wounding and the commonest calumny that the woman artist has to bear is that some male artist is the author of her work. Menageot was said to retouch Vigée-Le Brun's work.[19] A vulgar pasquinade of 1783 accused Adélaïde Labille-Guiard of passing off François-André Vincent's work as her own.

> To Madame Guiard
> What do I see Oh Heaven! your friend Vincent
> Is no better than an idiot [anatomical expression]
> His love makes your talent
> Love dies and talent slumps
> Resign yourself (twice) proud Chloris
> Say your De Profundis
>
> Madame, when one is as attractive as you one does
> not lack a lover. As for me, I have two hundred ...
> I believe you, because twenty hundreds [Vingt cents – a pun on Vincent] or
> two thousand is the same thing. Note, Vincent touches up that woman, isn't
> that funny?[20]

We do not know what degree of intimacy existed between the estranged wife of Nicolas Guiard and her childhood friend and master, François-André Vincent. Madame Labille-Guiard was always chaperoned by her companions, Mesdemoiselles d'Avril and Capet. Her rôle as a teacher would have been compromised unless she was not only chaste but seen to be chaste. There can be found no grounds for disbelief that Madame Labille-Guiard's sexuality was very efficiently repressed. What the cost of such repression must have been in terms of her artistic, intellectual and emotional development is unfathomable. To a modern mind she is more to blame for such violence to herself than she would have been for any irregularity in her conduct, but at the time the penalties for illicit sex were high, not least in the field of professional recognition.

The idea of non-genital passion has been comprehensible to all ages but our own. The romantic sensibility of the eighteenth century sought the love that would last for ever, uncontaminated by cohabitation and reproduction. It seems probable that women artists were even more devoted to the neo-platonic ideal and its sentimental offspring than those who whiled away their afternoons reading poetic versions of it.

The women painters who became nuns were clearly rejecting domesticity and their sexual function for a life replete with spiritual satisfactions: the same decision may have been made by Adélaïde Labille-Guiard when she left her husband's house for her ladies' seminary. Her long association with François-André Vincent was certainly a love-affair, but the term was more varied in its

Marguérite Gérard, *The Bad News*
Life in the affluent household as depicted by Gérard was not all billets doux and lactation. The astonishing pallor of the recipient of bad news is nearly as important as the lustre of her satins.

application before the age of suburbia. At the risk of sounding perfectly ridiculous, I would venture to doubt also that there was any great measure of genitality in the relationship between Prud'hon and Constance Mayer. One has only to recall the importance of delicacy in the writings of contemporaries to see that Constance Mayer might well have waited for the death of Madame Prud'hon before consummating her love. It is a fundamental aspect of the psychology of the woman artist that while she flouts convention and defies gossip, she is also quite likely to be following a lofty rule of life, out of the range of any Victorian concept of decency.

When Anne-Marie Gérard married Honoré Fragonard, she brought her little sister, Marguérite, aged eight, to live and study with them, leaving their fifteen brothers and sisters at home in Grasse. The little sister quickly learnt to surpass her elder in the fashionable arts including that of painting in miniature. Madame Lecomte described the young woman as she grew up.

> Tall, slender, with a distinguished air, her accent gave away her origin; but in her pretty mouth, it was a little provençal brogue which suited her ravishingly; she was in every way an accomplished person, whom we loved very much and little Papa Fragonard adored.[21]

The Fragonard household is usually described as a *ménage à trois*: in fact, it was a *ménage* of much more than three. If Fragonard had enjoyed a sexual liaison with a sister-in-law twenty-nine years younger than himself, he must have done so not only with the complaisance of his meridional wife but also with that of her large family and his own children, so much closer to Marguérite's age than he. Gradually Madame Fragonard gave up painting, and took over the running of the household and the keeping of accounts. Though seventy, Fragonard had an insatiable need for affection and the forty-year-old Marguérite was happy to delight it with her fervid epistles, although if her brother-in-law, brought up in a more robust era, had attempted any unseemly familiarity, she would have rejected him out of hand.

> My good friend wishes to know if I am pleased when I say something which pleases him. Well, I confess to him that it is my only delight: my grateful and feeling heart is only happy when it is concerned with my friend and says every pleasant thing which he inspires. But when my way of expressing myself has pleased my friend, then I believe I love him better, knowing that I please him even more.[22]

In their elaborate pleonasms and unabashed abstraction, these hyperbolic letters are the fitting expression of a sentimental passion, which would have regarded sexual intercourse as a good deal less intimate than the commerce of souls. Fragonard can only have benefited from the physical love and care that he enjoyed with his wife and the adulation and titillation that was provided by his sister-in-law. The damage done by the relationship was suffered by her, distracted from the development of her own sexuality by a profound sublimated passion which lasted until Fragonard's death in 1806, when she was already forty-five.

By this time, Marguérite Gérard was famous in her own right, and not as an imitator of Fragonard whose work had not kept pace with changes of taste. Citoyenne Gérard refined her miniaturist technique which hardened into a glittering vehicle for a kind of neo-classical domestic genre painting so successful that even Fragonard himself tried to emulate it. Her subjects were mostly idyllic portrayals of family life, derived from those she had learned to paint with Fragonard, but her approach was completely original. Her cool narrative rendition of every detail was the antithesis of the broad rendering of a mood in Fragonard's rich *impasto*; although it is a far cry from the pomp and melodrama of mid-nineteenth-century narrative painting, in her high moral concern for setting the affluent domestic scene, her insistence upon the virtues of motherhood and the limitless joys of a happy and fecund marriage, Gérard carries the bourgeoisification of art to its limit. That she could have become famous as a pictorial moralist while living openly as an adulteress with her sister's husband exceeds all the possibilities of hypocrisy. (See Pl. 14.)

There are few women who have not had to face the accusation that their work is by another hand, since even Elisabetta Sirani was obliged to paint in the

presence of her patrons as the surest way of scotching such calumny. Thérèse Reboul, Madame Vien (1735–1805), ceased exhibiting at the Académie Royale because it was said that she did not paint her own pictures. Unfortunately, there was just sufficient evidence of masters painting the works submitted by their pupils to keep such suspicions alive to be levelled against women who were innocent of them.[23]

The modern version of this calumny is the easy assumption that is made about closely related male and female painters, that the man led and the woman followed, which accords her the status of an imitator, and assumes that differences in outlook are evidence of inferiority or incompetence. A superficial judgment would place Marlow Moss as an imitator of Piet Mondrian, with whom she spent a great deal of time in Paris between 1929 and 1938, but in fact the relationship between them was one of equals, and in the case of double-line compositions, Mondrian followed the lead set by Moss. Their careers diverged when Moss began to use relief in her paintings with superimposed white slats and collage. She was, as many women have been, interested in constructivism and the boundaries of painting and moved eventually to plastic constructions. It is arguable that she had a greater influence on subsequent developments in twentieth-century painting than Mondrian did.[24]

Even feminist art historians must begin with the developing tradition of masculine Western art, and so must argue from the men back towards the women. As the men are so much better known, the character of their work is more deeply stamped upon our consciousness and it is hard to discern what is genuinely original in retrospect. In making the kind of claim that was made just now for Marlow Moss, one feels a sensation of giddiness and fright as the well-known landmarks drop away. Most of what the feminist art historian discovers validates the claim of men to be the masters and bears out the general impression that women are followers, but this very fact makes it doubly important that when a woman has led part of the way, the fact be recognised, for it indicates a remarkable capacity for survival in women and the possibility of a cooperative relationship with men. Often the male artists have acknowledged the real nature of the relationship and have simply been disbelieved.

Amidst such optimism, it must also be remembered that for most artists, the very term *female* is pejorative. One has only to recall Paul Klee's characterisation of Schmoll:

> Is he a consumptive or a woman in disguise? I can add that he is really only a female painter. His intellectual and emotional world is completely feminine ... He is a pietist, a canting beauty worshipper, has no appreciation of the salt of truth, can't transgress anywhere with a sense of humour.[25]

V

Dimension

Nature can afford to be prodigal in everything, the artist must be frugal down to the last detail. Nature is garrulous to the point of confusion, let the artist be truly taciturn.

Paul Klee

It is probable, however, that both in life and in art the values of a woman are not the values of a man. Thus ... she will find that she is perpetually wishing to alter the established values – to make serious what appears insignificant to a man, and trivial what is to him important. And for that, of course, she will be criticised; for the critic of the opposite sex will be genuinely puzzled and surprised by an attempt to alter the current scale of values, and will see in it not merely a difference of view, but a view that is weak, or trivial, or sentimental, because it differs from his own.

Virginia Woolf, 'Women and Fiction', *Collected Essays*

In one of his least questionable utterances, Aristotle pointed out that the work of art must have dimension. While no one is minded to quarrel with such a self-evident proposition, no one can be dogmatic about its application. Aristotle clearly did not mean that fifteen square feet of painted surface is better *ipso facto* than two square feet, nevertheless there is implied in his statement an implication of due size, or significance. The very word *greatness* contains a strong element of pure bigness. Usually, the simple preference for size is expressed in other terms, as scope, profundity, scale, importance and the like.

The artist who undertakes projects of due scope, significance, grandeur or size, must have a masterful attitude not only to his subject, but also to the beholder whose attention he claims; insofar, such a concept of art may be called masculine. The demands for scope, profundity, importance and so forth are not strictly aesthetic demands; Kant was so troubled by the persistence of such demands of the work of art that he developed a dual vocabulary for the aesthetic judgment, which is concerned not simply with the beautiful, but also with the sublime. The quest for the sublime is an interested quest, for the sublime has a

psychological, social and moral function beyond that of beauty. While the thing of beauty exists unto itself, the sublime depends upon the impact caused by the shared apprehension of scale. A work of sublimity beggars human expectation by being immense beyond human power to realise. Sublimity is often found in natural phenomena, seldom in architecture, sometimes in painting and poetry. Michelangelo's *Last Judgment* may be described as sublime, simply because it cannot be 'taken in'. The spectator is overpowered, swamped in awe.

Great art, for those who insist upon this rather philistine concept (as if un-great art were unworthy of even their most casual and ill-informed attention), makes us stand back and admire. It rushes upon us pell-mell like the work of Rubens or Tintoretto or Delacroix, or towers above us. There is of course another aesthetic: the art of a Vermeer or a Braque seeks not to amaze and appal but to invite the observer to come closer, to close with the painting, peer into it, become intimate with it. Such art reinforces human dignity: the finest expression of this kind of art, which rejects sublimity as a form of barbarism, is a painting like Raphael's *Portrait of Baldassare Castiglione*, infinitely mellow, calm, reassuring and sophisticated. In the hyper-stimulated bursting world of maxi-media its cool tenderness is a reproach: most of the seekers after 'great art' have never heard of it.

A mere mortal who attempts the sublime must be activated by extraordinary motivations. The romantic theorists of art erected the artist as the usurper of the function of God, a genius bowing to no law but the inherent necessity of his own idea. This figure was but the Renaissance concept of the artist as a cultivated gentleman, aware of the history and significance of his images, taken to its logical (and absurd) extreme. The painter is now supremely an artist not because he understands the application of colour to a flat surface, but because of his personality, a heroic super-masculine concept which women should only adore, not imitate. A tide of overweening expectation fanned by nineteenth-century hyperbole swept away thousands of young men at the same time as it washed the princes of the art establishment in warm floods of congratulation.

The element of heroic maleness had always been present in the concept of the artist as one who rides the winged horse above the clouds beyond the sight of lesser men, a concept seldom applied to those who worked with colours until the nineteenth century. When the inevitable question is asked, 'Why are there no *great* women artists?' it is this dimension of art which is implied. The askers know little of art, but they know the seven wonders of the painting world. For the lover of painting there is another question, 'Why is women's work usually so small?' In output, format, pretension, women's work is small; the vast majority of women artists produced few works, in a small format and diffidently. To find a woman painting consistently in life-size or larger is to recognise an exceptional self-confidence which will dare to collar whole walls for works meant to encumber the future, conceived as monumental before they are begun. Such a work was Lavinia Fontana's huge *Stoning of St Stephen* for the

Elisabetta Sirani, *The Baptism of Christ*, 1658
Unabashed by the problems of painting semi-draped figures in foreshortened
postures, on such a huge scale, and to be viewed from far beneath, Elisabetta
Sirani included a self-portrait in the foregound, as the *santina* in pink with her left
hand raised.

church of San Paolo fuori le Mura, now destroyed.[1] Elisabetta Sirani was also
invited to contribute a monumental work to the new Certosa of Bologna.
Malvasia describes how she quickly dashed off a sketch for it in her characteris-
tic manner in brush and wash, reminding us that almost all monumental works
grow out of smaller sketches and preliminary studies, raising the whole ques-
tion of scale in another context.[2]

It is now taken as a truism by all teachers of art that the work of art has scale
proper to it, that is to say it cannot be reduced or enlarged without mitigation of
its intended effect. The scale cannot be imposed upon it by any external system
of laws, it can only be recognised in the work itself. A student who used to make
tiny sketches which he photographed and enlarged and eventually painted over
was constantly upbraided by his teachers who decried the procedure as dishon-
est, notwithstanding that the transference of cartoons to mural surfaces has
always been carried out in a similar although greatly more laborious way.

The question of scale in art is the more vexed because scale is subjectively
perceived. Figures which appear huge to a child will not seem so to a tall adult.
Titanic art may seem powerful to an eye used to perceive huge struggling forms
but coarse, bullying, even gross, to one nurtured on a different scale.

The patrons who approved designs for large commissions were probably acting on a concept of scale which they shared with the artists. Given a space of a certain shape and size they would stipulate a Rape of Proserpine, say, with six nymphs, attendant zephyrs, a landscape with water and an apparition in the heavens, and the painter worked more or less happily within the stipulated bounds. The idea of due bigness of individual figures and whole compositions changes subtly with the currents of changing taste. Portable paintings grow steadily bigger from the beginnings of the use of canvas until they rival the surfaces formerly covered in *affresco*: the figures grow bigger, more crowded, sometimes longer-limbed, sometimes more massive.

The identification of scale is one of the subtlest aspects of art-historical criticism, for museums are forced to favour works of manageable size. Large works are shown out of their architectural context and often smaller works represent not the intended major painting, but a finished preliminary study for it. The larger paintings often perished with the buildings that they decorated, while the preliminary works remained in the artists' possession and so found their way into museums.

For many painters the sketch represented the idea in its perfection: the large work was almost certainly a combined effort and unevenly realised. In translation from sketch to large canvas, spontaneous gesture often hardened into posture, and in the working up of the finish the rhythm was destroyed. Thus, while the sketches may be called minor, or misleading about the scale and impact of the finished work, they may also be aesthetically more satisfying than the commissioned work. Beneath the pomp and circumstance of major art, there beats still the pulse of another concern, a different aesthetic. If one is properly responsive to this concern, one may bring to women's work more appropriate expectations.

Women are capable of covering vast surfaces with paint. Sonia Delaunay's huge panel in the Musée d'Art Moderne de la Ville de Paris insists upon its own enormousness. The unity of the motif results in a massiveness of impact, a single deafening statement of her overriding idea of the rhythm of pure colour. Having laboured on this giant enterprise and expressed her idea in this form, she returned to her usual media, preferring the more malleable forms of textiles, décors, illustrations, soft-sculptures, collages, book-bindings. She was capable of bigness but unexcited by it. Her preference for intensive, scaled-down working is the tendency of women painters through the ages.

The Italian women painters of the Seicento worked unselfconsciously on a large scale because the rôle of the artist had not yet assumed its romantic superman aspect. They were able to be serious, committed painters, working broadly and brilliantly on a large scale, dealing with subjects of great dramatic impact and social importance, because they were not troubled by the incongruity of the concept of the artistic personality. There had been *terribili maestri*, but they were the exception rather than the rule. Art was still a normal activity:

women like Giulia Lama worked without truculence, broaching heroic subjects with confidence, which is not to say that they were free from persecution, but simply that they had vanquished the insidious enemy within. They shared the sense of scale of their time. Most women have not been able to.

The confidence to make grand gestures, to raise one's voice, as it were, derives from an image of oneself as entitled to make such a bid for attention. From their earliest childhood women had been rewarded for self-inhibition. A voice 'gentle, soft and low', an excellent thing in woman, was accompanied by small gestures, short paces, insinuating rather than impressive manners. In short, women lived on a different scale from men: they took up less room. They did not even claim working space of their own, much less the supportive activities which painting on a large scale requires. All the external aspects of the reduced scale of female life might have been overcome, if they had not been simply the outward manifestation of a subjective difference.

There is an alternative aesthetic which corresponds to the subjective difference in apprehension of due bigness. The vast mass of human artistic activity makes no claim to greatness, but rather to beauty. Women have always excelled in the production of the 'merely' beautiful, remarkable for fineness, delicacy, elegance, small work taking up little space, much time in its making and no duration in its observation. The scale upon which such work was executed would appal the women of today, whose gestures have far outgrown the circumference within which women of earlier ages lived. Women who stride in trousers and drive fast cars might well grow sick to their stomachs when they view the cut-paper work of Adèle Schopenhauer, seeing in it a cancerous ingrowth of futility, but the readiness with which they dismiss such phenomenal achievements represents in some part the extent to which they have adopted the masculine concept of scale and with it an alien estimate of worthwhile activity.

George Eliot gave voice to the capitalist contempt for smallness when she dismissed the artistic activity of women as 'ladylike tinkling and smearing'.[3]

The present writer acknowledges herself a victim of masculine education in that she is often disappointed by the smallness of women's work. The fact that Lady Butler's *Quatre Bras* is little more than three feet high, and *Scotland Forever!* only forty inches high seemed shocking at first, for on this scale the figures painted are virtually miniatures. The finished works are almost like sketches for non-existent monumental works, if it were not for their total finish. Enough rushing activity to make three paintings by Delacroix is primly confined in the size of a corner of one of his mighty canvases.

The aesthetics of smallness are still understood, even in this world where the model economy is one of continual, exponential expansion, if not by educated taste, then by the spontaneous judgment of the uneducated. Many a semi-literate museum attendant will pluck visitors by the sleeve to call their attention to some prodigy of littleness, such as a Properzia de'Rossi (1491?–1530)

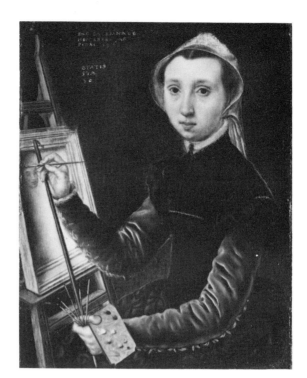

Caterina van Hemessen,
Self-Portrait, 'Ego Caterina De
Hemessen pinxit 1548 Aetatis Suae
20'
 This artist's small archaic portraits
painted on wood gained her a
considerable reputation in her
lifetime, although it seems likely
that her working life was short, as
we have no work dated after her
marriage in 1552, and none before
1548.

Crucifixion sculpted on a cherry-stone. The feminist sees the frustration of an artist driven away from carrying out her commissions for the basilica of San Petronio (see p. 209): the custodian sees something wonderful.

It is not simply the vulgar who are astonished by freaks of tininess. Karel van Mander was greatly impressed by the achievement of Anna Smijters, who painted a windmill, with its sails outspread, a miller bearing a sack, a horse, a cart and people passing by in a compass so small that it could be hidden by an ear of wheat.[4] Vasari was astounded by Properzia de'Rossi's cherry-stones.[5]

Sheer smallness is prodigious perhaps, but as irrelevant to an aesthetic judgment as hugeness. Squinting at a Properzia de'Rossi cherry-stone is not an aesthetic experience until the oddity of the minute scale is overcome and the composition is comprehended. When size, either large or small, cannot be realised by the beholder, the ensemble cannot be understood. Generally speaking, one translates huge or minute works of art into another scale and then proceeds to judge them aesthetically. Most works of art are neither huge nor minute, but some are ambitious, profound, important and others light, elegant, exquisite. Art historians concern themselves primarily with the former, connoisseurs with the latter.

Some painters take what might be called an expansive attitude to art; others struggle to concentrate matured perceptions into single statements tersely expressed. In both categories we find mainly men; but in the latter category,

Caterina van Hemessen, *Christ and St Veronica*
In view of the fact that this must have been painted *c.* 1550, it is not only small and carefully restricted in the range of feeling it expresses, but archaic. It has been suggested that it is based upon a print.

until the nineteenth century, most women painters were to be found. The difference is epitomised in the career of the two Johns, Gwen and Augustus. Augustus' marvellous facility in drawing, together with his fairly cavalier attitude to paint, led him into ever broader and looser compositions. Gwen's genius drew away from a virtuoso beginning with subtle modelling and bottomless colours built up in layers of fine glazes, to the relentless suppression of all such superficiality. She painted her paintings less and less, leaving the ground showing through, never touching the canvas twice in the same place, risking failure with every move. While her brother spread himself very thinly, she withdrew into a single drop, forever compressing and concentrating her art and her feelings to one inner end, the intense, energetic but utterly circumscribed life of a mystic. A Gwen John painting, however small and diffident in its colour scheme and apparent subject, is a sharp point of concentrated feeling, haunting and challenging in its modesty.

Gwen John's personality as a painter has long been obscured by the misleading comparison with Vuilliard, whose interests are far more sensual. In fact, Vuilliard represents the commoner preoccupations of the painter who thinks small; his aim is to delight. Like him, thousands of women created delicious small art objects, gentle, unassuming and flawless. The giants of nineteenth-century art would have roared through their beards, indeed, did roar through

their beards, if anyone attempted to apply to them the criteria of taste. If they did not want an art which blended with other arts and deemed pusillanimous, pettifogging and bourgeois art which did not drain all colour and meaning out of its environment, others did. Berthe Morisot's (1841–95) rejection of the bullying role of the artist is reflected in her simple subjects and limited palette, delighting particularly in shimmering effects of white on white, focused by her deft handling of linear details in black, with occasional spice of viridian or ultramarine or dark brown. Later in her career, she lengthened her dabbing strokes and used more strident chemical colours, but still limited them, using a rapid dazzling technique of sketching on to canvas, ignoring the picture-frame, working from a nucleus within it. It is well known that Morisot influenced Manet to take up *plein air* painting but no one has yet explored the relationship between what Morisot was doing in the 1880s and Monet's *Nymphéas*. Among his masterpieces in the Musée Marmottan, a perfect pastel sketch of a little girl by Morisot insinuates its quiet voice into the trumpeting chorus.

Berthe Morisot's work was no less revolutionary than that of her male contemporaries in the impressionist movement, but it consistently earned higher prices at auction. Its greater acceptability is directly related to its gentleness. Her work relates to the other arts of living; it implies a social

F. P. d'Heudicourt, *Louis XIV*
This small picture contains a woman's treatment of an extremely grand subject, for it is not only an equestrian portrait of the Sun King, but a picture of a siege by his infantry and cavalry as well. In fact it probably represents a miniature version of a larger painting.

environment, a continuum within which art is happy to co-exist with music and conversation and children. This is what it means to be called *minor*; it is descriptive of male and female artists, but in female artists it is often called feminine.

For Mary Cassatt (1855–1926) the decisive influence came from her acquaintance with Japanese art, entirely different in conception from the monumental notions of the European art establishment of the nineteenth century. The exhibition of Japanese arts at the Palais des Beaux-Arts had revealed the lightness and grace of the alternative aesthetic, beside which the pompous works of recognised artists seemed all the more laboured, explicit, heavy and lustreless. Mary Cassatt had worked in dry-point before, but now she undertook the series of colour prints which are among her most prized achievements. She drew outlines on copper in dry-point, laid in a soft ground over the parts that she wished to colour, and applied the colours all at once, by a technique that she called 'à la poupée', working with rags tied over little sticks. She and her printer then ran the plates by hand through the press.[6]

In that 1891 series of colour prints, Mary Cassatt showed most decisively her departure from the ways of the other impressionists: her designs are as deceptively simple and self-effacing as a *haiku*, but behind each line, as we know from some of the studies which were exhibited in the same year, lies a whole drama of contemplation and decision, for the whole must be comprehended by the artist before a single line is drawn on the plate, and there is no possibility of a *pentimento*. The other artists responded to the subtle mastery that she displayed in this work, Degas with a momentary slackening of his relentless gibing ('I will not admit that a woman will draw so well', 'No woman painter knows what style is'),[7] and the public responded too.

It must not be thought that Mary Cassatt's choice of the minor medium of colour print-making represented any slackening of interest or industry on her part. Rather the industry was more exacting, in physical and mental terms. The work of print-making sometimes took as long as eight hours a day, and that was after the hard work was done, the identification and orchestration of the image.

In her autobiography, *The Magic of a Line*, Dame Laura Knight explains the aesthetic of economy which was the ruling principle of her artistic career.

> The true aesthetic quality I believe to be found in uncluttered simplicity. On the ceiling of the famous Altamira cavern, there exist works of art defying comparison ... The search for technical skill holds danger: mere skill of hand work alone necessary as it be, can by very pride of its possession kill truth. What matter how much canvas can be cleverly covered ... To the true artist is given the use of eye, hand and heart in so perfect a coordination as to enable freedom of individual expression. This, being no mere imitation of subject matter, speaks of the big in small ... a smallness that may be held in one hand. As in the fourteen lines of a sonnet, a few strokes of the pencil can hold immensity.[8]

Like Mary Cassatt, Laura Knight was attracted to media which permitted no *pentimenti*, where each stroke was final and unalterable. Her drawings and aquatints are much finer and more suggestive than her finished oil paintings, and upon them her enduring reputation will eventually rest. Similarly, Elizabeth Stanhope Forbes worked in the fragile medium of water-colour, leaving grander genre and history compositions in oils to her better-known husband. Often the simplicity of her work seems slack and spurious, but occasionally, as in her pastel *The Kiss*, some greater intensity swells the small statement.[9]

It would be futile to argue that the choice of a small format and a minor medium is quintessentially feminine. Men have outnumbered women in all the minor modes too; the greatest artists have been the most aware of the enduring value of perfect works and have often been absorbed in the special concerns of minor modes. Leonardo himself, having solved the initial problems of conception of monumental works, was no longer interested in carrying them out, leaving behind him a maddeningly incomplete and fragile oeuvre. 'Getting it right' is the deepest ambition of any artist; monumental ambitions are subsequent and sometimes inimical.

The tendency of women to work in the minor modes and in a minor key is not simply a matter of their inferiority as artists, then. Such modes are presented to them both as eminently suitable for women and as impeccable sources of artistic satisfaction. While working in a small format may indicate a failure in a more 'significant' mode for a man, it is free of any such wounding implications for a woman.

The Japanese Arts Exhibition of 1890 was in many senses the occasion of a rediscovery of the charms of smallness, for Western painting has not long concerned itself with grandeur. Portable paintings had their beginnings in miniature painting; the greatest artists of their time worked willingly in the tiniest scale, and there is some evidence that their smaller works were more highly prized. Lievina Teerlinck was handsomely rewarded by the Tudor monarchs for her miniatures, for which she earned forty pounds a year, more than Holbein, who also worked in larger format. Mary Beale, a century later, had her son trained as a miniaturist rather than a portraitist like herself, and he only took up portraiture on a larger scale when his eyes became too weak to work in miniature.[10]

> The Regent diamond or the Koh-i-Noor is small in comparison with the paving-stones on our highways and almost infinitesimal in juxtaposition with the boulder on the mountainside, but they are certainly not insignificant, and the power and light condensed within their small circumference may be justly compared with the force, life and truth, concentrated by the hand of a master on an inch or two of paper, vellum, or ivory, bearing the same sort of relation to the larger panels and canvases that the gem does to the rock.[11]

J. L. Propert's argument by analogy is neither fair nor conclusive, but in fact miniature paintings were often prized more highly than the gems which were used as their setting. Mademoiselle de la Boissière (*fl.* 1701–25) furnished portraits of the Bourbon monarchs for costly boxes; one given to the Comte de Baudry, ambassador to the Grand Ducal court of Tuscany, cost 5772 francs; Madame Maubert got one hundred and twenty francs apiece for her portraits of the King, and Mademoiselle Brisson, miniaturist to Louis XV, two hundred.[12]

It has not been possible to deal with the important contribution made by women to miniature painting in the scope of this book. The number of women painters mentioned here could be equalled by as great a number of women like Anna Seghers, Susan Penelope Rosse, Anne Marie Strésor, the Sedelmayr sisters, Maria Vittoria Cassana, Marianne Haid, Sophie Clémence de la Cazette, Mrs Mee, Sofia Giordano, Francesca Schöpfer, and Madame Mirbel who chose to work in a tiny format.

VI
Primitivism

Nor can I, like fluent sweet tongu'd Greek
Who lisp'd at first, in future times speak plain
By art he gladly found what he did seek
A full requital of his, striving pain
Art can do much, but this maxim's most sure
A weak or wounded brain admits no cure.

Anne Bradstreet, c. 1646

When the Altona Museum in Hamburg ran a competition called 'Ships and Harbours' for Sunday painters, it got an enormous and enthusiastic response. No fewer than 11,300 people sent entries, forty per cent of them women. Of the hundred and fifty works which won prizes and were exhibited the following year, slightly more than half were by women. In no other field would or could female artists have given so good an account of themselves.[1]

The paintings were all in the style known as 'naïve', in which forms are simplified into stylised structures alternating hard-edged masses of vivid colour with complex linear detail, in settings representing a sort of earthly paradise where innocence reigns and the sun sheds a diffuse and shadowless light. They exuded the kind of egregious sentimentality which the collectors of naïve works find charming and the lovers of painting spurious.

The vogue of naïve art is already enormous and still growing. There is a bitter irony in the fact that in the century when some art-teaching has been experienced by every child in the Western world and true naïveté thereby rendered impossible, the richest patrons, media magnates, film stars, oil barons and politicians, should be most interested in this art which is a rejection of the great European tradition. The innocence of twentieth-century naïve painting is

feigned, because information about art and art history is so widespread that it is impossible to ignore. Twentieth-century naïve painters do not paint the only way they know how, they deliberately adopt a set of conventionalised motifs and with them mix a commercially successful bromide.

The exceptions to this rule are those naïve painters who are seriously disturbed, of whom there are relatively few. The mystic, psychopathic or extremely neurotic painter may reject sophisticated painting because he is unable to make use of its highly developed language to express his inner preoccupations. His lack of technical expertise may join with his obsession in producing a kind of stylised image which is not at all acceptable in the way that the doll-figures of pseudo-naïve painters are. Such naïve painting is not reassuring, although it may be decorative. Some of it has been called 'ugly' art or 'outsider' art: it is certainly extremely disturbing, especially when the work of any one such artist is seen in quantity and the relentlessness of the obsessions is communicated to the appalled viewer.

Such a painter was Aloïse Corbaz (1886–1964), who was committed to a psychiatric clinic in 1918, when she was thirty-two, and remained there until

Aloïse Corbaz, *Porteuse de rose avec Napoléon*
The roses are drawn in the manner of embroidery patterns, a frequent element in the visual language of female primitives. Other elements in the painting, less easy to identify, are possibly more significant: the recurrent circular forms arranged in chains, for example, and the leaping leaf-shapes.

her death. Her art is a timeless re-working of the images of a courtship which she never experienced, in which the woman is a preposterously voluptuous concatenation of circular and oval shapes, gazing narcissistically at the beholder out of lake-like blue eyes while she is overwhelmed by a male profile. The details of clothing and background are all transmuted versions of the soft-core pornography of opera, novelette and popular history, such as provide the décor of the masturbation fantasies of many conventally educated young women: what makes her work remarkable is the intensity of its obsessive rhythm, what Jean Dubuffet, who collected it for the Galerie de l'Art Brut, called the 'uniform vehemence' of her pencilling.[2] It is in the semi-conscious motifs that she used to fill her picture space, the anxious proliferation of forms without literal content that we can best discern the pressure which throws up the repetitive image of the loved sex object, the mere depiction of which relieves some of the anguish of Aloïse's own emotional and sexual frustration. The inauthenticity of the recognisable images, surfacing in this swirling tide of semi-automatic squiggling, is not the result of self-censorship or any calculated manipulation of the perennial public taste; it is rather Aloïse's helpless fealty to the insidious archetype which invaded her mind and laid it waste. (See Pl. 30.)

Some of the same pressures can be seen in the work of the English medium, Madge Gill (1884–1961), who, like Aloïse Corbaz who worked on scraps of paper and sewed them together, covers whole rows of calico and paper with coherent productions which she never views as a whole. Like Aloïse, she often draws her own versions of commercial archetypes of womanhood, but her approach is more angular. Where Aloïse ignores depth, Madge Gill manipulates the illusion of depth. Equally fascinated by the mythical feminine, she places her in jagged, dizzying settings like halls of broken mirrors.[3] (See Pl. 32.)

Aloïse Corbaz and Madge Gill may both represent cases of strongly motivated women artists whose tensions may have stemmed in part at least from the alien nature of recognised painting. Certainly a creative and decorative impulse is as strong as the impulse to recreate the obsessional image, for it is always reproduced in varied compositions, and the activity does not cease once the beloved image is recognisable.

The art of Aloïse Corbaz has been called 'the only truly splendid manifestation, in painting, of the strictly feminine pulsation'. Certainly, Aloïse is speaking in her own voice, and therefore may be regarded as demonstrating something of what female genius might be like if once it could emancipate itself from the cultural institutions of men, but it must be remembered that Aloïse was so severely damaged a person that the direction of her life was taken over by others. If hers was the strictly feminine pulsation, it was also the pulsation of a creature severely wounded and alienated from herself. It was also, importantly, a response to the enculturation of women: the self-generated aspects of her work, the unconscious imagery of the unreadable forms, has not yet been

Madge Gill, *Women*
The images culled from women's magazines are transmuted in Gill's work by the
intensity of the emotion with which she filled them.

analysed, and any analysis would of necessity produce unverifiable conclusions.
While we may conclude that the woman artist must escape from society, the
escape must not take the form of ostracism, which has its own destructive
consequences.

Most often, it is religion which offers to women the nearest escape route from society: like Aloïse's escape into the Clinique de la Rosière, it is the acceptance of an other-directed way of life and perpetual infantile status, while religious archetypes offer their own version of Aloïse's mythical commminglings. Women in the cloister might often have painted out their fantasies, especially if these were so vivid or persistent that they caused neurasthenic symptoms and rumours of saintliness, but they would always have been disguised in the garments of orthodoxy. The first known mystic female artist was clearly mentally and emotionally disturbed, but her painting gives depressing evidence of the power of the confessional in reinforcing self-censorship.

A daughter, Caterina, was born in 1566 to the noble de'Pazzi family in Florence. At the age of sixteen she entered the Carmelite convent of Santa Maria degli Angeli where she took the name of Maria Maddalena and proceeded to live a life of the most uproarious holiness, which greatly amazed and edified all her sisters in religion. She slept rarely, went barefoot, clad in a single thin shift in all seasons, and was so attached to her diet of bread and water that she vomited whenever her mother superior prevailed upon her to eat anything more substantial. Her time was spent either in ecstatic communion with God or racked by the most terrible torments; all such vicissitudes were faithfully recorded by her confessor, Father Vincenzo Puccini. Among a host of more predictable prodigies he records:

> Being in ecstasy with her mind alienated from her senses and rapt in God, her eyes fixed on heaven, she sewed and did needlework, cut gold [leaf?], painted devout images on paper. The nuns seeing such a marvellous thing, and it seeming impossible to them, in order to determine whether she needed light for such activities, used to bandage her eyes and close the windows of the room where she was working, and make her stay in the dark, and thus in the dark, with her eyes bandaged, she continued the work and the painting which she had in hand, with her usual mastery and perfection, as if she was working in the usual way. And so in trances she carried out much work and many holy pictures which have been preserved as miraculous.[4]

Visionary painters there have been in every age. In the twentieth century we have become interested in the creativity of mental disturbance from a more worldly perspective. Mediums like Felicia Bodmer[5] and Laure Pigeon (1882–1965)[6] may have executed automatic drawing in the same manner that Maria Maddalena de'Pazzi did, but it is seldom asserted that they actually worked blindfolded or in the dark.

Writing in 1677, the Father Provincial of the Reformed Carmelites of Touraine, whose concern was to debunk Puccini's credulous account of common religious mania (which must have been a constant peril in an enclosed order), remarked that the automatic painting was the only noteworthy circumstance of the poor nun's wretched condition, which he considered to have been

much worsened by her superiors' superstitious attitude, so that she died prematurely after a life of horrifying extremes of mania and depression.

Her paintings were used to decorate the basilica of St Peter's at her canonisation. The eight works preserved in the convent of Santa Maria Maddalena at Trespiano, near Florence, do not show a soul moved by a powerful interior vision, but an obedient nun rather clumsily illustrating some of the mysteries of her religion with images of the most conventional kind. Orlandi was impressed by the painting known as *The Press*, an emblem of the Redemption, showing Christ in a winepress. He stands bent under the cross bars of the press which are tightened by two screws, with His feet in a basin of blood. He holds an urn from which He fills a cup borne by a female figure with loose hair in a formal, long-sleeved white gown, St Maria Maddalena's usual way of representing the soul. Orlandi was clearly impressed by the profundity of the emblem, but there is no evidence that it was of St Maria Maddalena's invention.[7]

The existence of three drawings in two versions is rather evidence that her designs, which are crudely rendered in poor quality ink and coloured with gouache, were copied either by the author or by some other hand. In one case the designs are of identical dimensions but reversed. The fact that certain details are recognised in one and not the other seems to indicate that not all the copies were taken from the original. Perhaps the miraculous works had to be replaced with the passage of time. Given the poor quality of the materials the saint used, such an eventuality is only to be expected. One version of an ambitious composition, showing the *Madonna and Child with Sts Francis and Catherine*, has been pierced as if for a cartoon, perhaps for needlework.

The only aspect of St Maria Maddalena's work which might suggest personal experience is her depiction of the soul as a young woman in a white gown, as in her *Allegory of Profession*. Professing nuns are usually dressed as brides, and the repeated use of this sub-sexual motif may be significant. The rest of St Maria Maddalena's work is predictable, derivative holy picture-making, complete with Latin mottoes. So eclectic in fact is Suor Maria Maddalena that in her *Allegory of Profession* she depicts love as a young Eros in a gown embroidered with flowers 'as it were a mead', with a crown, a cross-bow and parti-coloured wings, an image more indebted to Cesare Ripa's *Iconologia* than divine inspiration.[8]

A hundred years later a nun of the Canadian order of the Sisters of Notre Dame, born Marie Barbier, called Marie de l'Assomption in religion, was credited with the authorship of a miraculous image of the Child Jesus, which, when hung over the oven, prevented the bread from burning, and was thrown into the fire when the convent burned, and survived.[9] This is certainly a genuine naïve painting: we may perhaps believe that Marie de l'Assomption maintained a constant dialogue with the Child Jesus in her imagination, so spontaneous and original is her version of Him.

In the Shaker communities of North America, women were encouraged to

give permanent graphic form to their mystic visions. The only sister whose name has come down to us so far is Hannah Cohoon who brought her two children to live with her in the Shaker community at Hancock in Massachusetts, known to the faithful as the City of Peace, in 1817. In the inscription to her *Tree of Life* she explained how the design had been communicated to her:

> I received a draft of a beautiful Tree pencil'd on large sheet of plain white paper bearing ripe fruit. I saw it plainly, it looked very singular and curious to me. I have since learned that this Tree grows in the Spirit Land. Afterwards the Spirit showed me plainly the branches, leaves and fruit, painted or drawn upon paper. The leaves were check'd or cross'd and the same colours you see here. I entreated Mother Ann [*Lee, the founded of the Shakers, who was in constant spiritual communication with the sect members*] to tell me the name of this tree which she did Oct. 1st 4th hour P.M. by moving the hand of a medium to write twice over Your Tree is the Tree of Life.[10]

Another painting, in water-colour, depicts one of her own visions in which she saw the elders of the community feasting upon cakes at a table underneath huge mulberry trees full of birds, and drinking from a stream which flows to the right

Hannah Cohoon's inspiration is no more original than that of her Catholic counterparts, for the depiction of an earthly paradise with trees in flower and fruit is a standby of primitive art in Europe. Séraphine also painted mystical vegetation, drawing perhaps from a similar fount of undigested imagery.

The career of Séraphine Louis (1864–1942) demonstrates what the genuine visionary painter of the age of irreligion may expect. She had grown up a shepherdess, and become a servant: her fortunes threw her in the path of the collector of primitive paintings, Wilhelm Uhde, whose house she cleaned when he came to Senlis in 1912. He saw a still-life of apples in a neighbour's house and was astonished to discover that Séraphine was the artist.[11] He supplied her with the materials that she had never had and encouraged her to paint until the war drove him out of France. When he returned, he did not scruple to collect all of Séraphine's work, as if she had been under contract to him. Her first exhibition was held at the Galerie des Quatre Chemins in 1927.

Her works are the portraiture of paradise, as she dreamed of it every day of her dark, laborious life. She painted locked in her small room, under an altar of the Blessed Virgin where a lamp burned continually. Rapt in the contemplation of the happiness of the blessed, she produced astonishing paintings, exploding nucleic forms of sensuous fruit and flowers in rhythmic alternations, like an overwhelming chorus of delicious voices. Her manipulations of rough and smooth, of fluttering linearity with juicy masses are masterpieces of innocent voluptuousness. (See Pl. 31.)

Her happy working days were not to last. In 1930, afraid that the Depression might leave him with Séraphine's pictures on his hands, Uhde ceased buying. Séraphine, who had always felt that the world was against her, became

completely overwhelmed by anxiety and suspicion. The vision of paradise receded. The psychiatric ward of a geriatric hospital claimed her. Uhde used to say that death was merciful and had claimed Séraphine in 1934. In fact she lingered on, friendless and desperate, until 1942.

For painters like Elena Lissia (1906–75) and Gertrude O'Brady (b. 1904) the visionary element was crucial. Gertrude O'Brady painted sixty pictures between 1944 and 1949 and then stopped. Elena Lissia did not begin painting until the priest gave her Holy Viaticum on Good Friday 1955.[12]

Any doubt that many female artists never even get to the point of considering themselves entitled to paint is dispelled by the many examples of women who began furtively, like Hel Enri, (b. 1873)[13] the mother of the constructivist Berlewi, who began by using the left-overs of her son's palette. Maria Sanmarti, the mother of the painter Antoni Clave (1886–1959),[14] painted in her own untutored style. Marcel Gromaire was immensely proud of the work of his grandmother, Reine Mary-Biseaux.[15]

Women artists who do not feel that they are entitled to think of themselves as such could not have been inspired to emulation by the fortunes of women who struggled clamorously to assert themselves, like Mathilde Poulevarie (1876–1956, whose real name was Jeanne Castets) who claimed to be in communication with Goya, Velazquez and Rembrandt, to the perennial dismay of the Bordeaux Salon des Indépendants. When she died her work was auctioned off for the frames and canvas.[16]

The fortunes of eccentric women who insisted on being artists despite their ignorance of the art world and of technical matters show that to the struggle of finding one's own visual language were added disastrous social and emotional tensions. It is impossible to decide whether it was the impossibility of successful socialisation which led to the survival of the artistic talent or whether the imperiousness of the talent unfitted these women for happy domestic existence. The explanation of all lies in the women's work, but until now it has been imperfectly understood.

The naïve art of today would shudder at the excesses of Séraphine and Aloïse. So far from being obsessive, naïve painters boast that they are 'Sunday' painters, even though many of them are making vast fortunes. In Brazil and Yugoslavia in particular, women have been drawn into an immense bonanza of inauthentic primitivism.

In socialist countries naïve art is acceptable precisely because of its implied rejection of painting as developed in the culture of the upper classes since the Renaissance. Primitive painting is seen as a continuation of peasant art and enduring evidence of a great popular aesthetic tradition. In fact, peasant art hardly concerns itself with portable paintings, which account for a very small proportion of peasant artistic activity, which is largely a matter of decorating useful objects. The carved and painted motifs used by true peasant artists are variously ornamental, emblematic and didactic: they are usually taken over

from a common stock and modified according to the individual's purpose. The knitted pattern in an Aran sweater is both a non-representational pleasing elaboration of the garment, and a key to recognising the fisherman should he be washed up drowned. The painter of a Sicilian cart may borrow his motifs from a neighbour whose cart has pleased him, altering them slightly to distinguish his cart from another's.

Once the cart-painter is encouraged by an astute dealer to transfer his designs to two-dimensional spaces with frames around them, he is being invited to parody himself as well as to make a lot of money for himself and others. We may easily understand why the women of Uzdin were encouraged to cease their laborious embroidery and express their decorative sense in portable paintings, and we need not be surprised that they principally paint the events of a peasant life which is dying out, complete with the wonderful embroideries that they themselves have given up. Part of the motivation behind the persuasion to abandon their embroidery is the greater esteem that portable paintings enjoy, not in peasant art, but in the aristocratic artistic tradition that even socialist governments cannot wholly defy. When the spectacular woven blankets of the Navajo women were shown recently in London, they were stretched taut on the walls so that they resembled abstract paintings. Critics raved over the result, although what they saw bore as little relevance to the kinetic structures that the women envisaged as a cadaver strung out on a fence does to the flying bird. So have the women of Uzdin been persuaded to abandon dense and highly wrought embroidery for crude painting.

Even while one rejects this concept of a peasant tradition as a justification for twentieth-century naïve art, it is nevertheless proper to observe that women by virtue of their inability to plunge into the mainstream are often genuine primitives, even when they have had a modicum of training. Their attraction to the highly censored and conventional forms of *faux-naïveté* is another aspect of the timidity of oppressed peoples. Moreover, the imagery of *faux-naïveté* is most often the imagery of paradisaical domesticity which women have been brought up to revere. Each *faux-naïf* painting shows a place for everything and everything in its place, usually confined by a linear outline, as if painting were a version of good housekeeping. It is small wonder that women with decorative sense and graphic talent choose this guaranteed popular form in which to avoid revealing themselves. The spurious innocence of the chosen form coincides with the enforced denial and suppression of female libido. The childishness of modern naïve art is no more spontaneous than the lifelong infantility of women.

For a brief period in the early nineteenth century in America, primitive peasant traditions and bourgeois notions of art interacted fruitfully. For immigrant peasants making good in the new country, the old joy in decorating their environment died hard, but they had new gentlemanly ideas of how that should be done. Itinerant professionals painted thousands of beguiling stock portraits;

women everywhere stencilled wallpapers, embroidered garments and pictures, and in an ecstasy of super-efficiency used every last little bit of fabric in rag rugs and patchworks of astonishing beauty. Unlike their peasant forbears, the American artists painted a great number of portable pictures, on silk and velvet, as well as on paper and canvas and under glass. They made great use of stock motifs, often taken from prints, passed from hand to hand.

In the application and combination of designs and motifs, many women were able to express their own aesthetic sensibility. In this new world where nearly all the pictorial activity was primitive to a degree, they did not need to feel any inferiority in working out their own concepts, whether they did so by painstaking if clumsy brushwork, or with sponges and rags dipped in colour, or in the amazing scrolls of calligraphic drawing, or in cut paper and appliqué tinsel.

Most of the surviving work is anonymous, but occasionally women, like the professional portraitist Deborah Goldsmith (1808–36), may be identified.[17] In

Deborah Goldsmith, *The Talcott Family*, 1832
 One may see a parallel to the ceaseless and pettifogging industry of women's
 lives in the obsessive patterning of all the surfaces in paintings like this one.

Eunice Pinney, *Two Women, c.* 1815
 While clearly not a portrait, this picture of two female members of a family, the
 mother and the non-mother, gives a curiously dynamic impression of their
 relative power.

her famous portrait of *The Talcott Family* there is a number of interesting
indications that, beneath the self-censorship of a highly derivative concept of
pose and composition, the painter had her own view of things: the woman's
body contains the baby within her silhouette, but the little girl cannot be got to
sit on her father's knee; she bobs within the circle of his immensely long arm
like a cork, while his left foot appears to be resting on the dog. The hand with
which he moors his wife might as well be pushing her off her chair. A similar
kind of unease can be felt in Eunice Pinney's (1770–1849) *Two Women* (Connec-
ticut 1815).[18] Like Goldsmith, she displays the primitive concern with
pattern-making in the importance that she gives to the lozenge pattern on the
carpet and the careful arrangement of the composition absolutely symmetri-
cally about the central spindle of the table and the candlestick. A tension
between the two women, the large complacent mother and the slighter
apprehensive other is heightened by the tipped tabletop under the candlestick
seen at eye level and the oddness of the candle flame seen between the pale
windows.

Susan Merrett, *Fourth of July Picnic at Weymouth Landing, c.* 1845
The primitive painter often uses diagrammatic picture-making as an alternative to
a verbal record of events: the conventions of representation derive from
map-making and topographical drawing, as well as popular prints.

The American women artists of the early nineteenth century portrayed not
only people but landscapes and their own version of the *bambocciate* of
seventeenth-century Rome, of which Susan Merrett's *Fourth of July Picnic at
Weymouth Landing* (Massachusetts, *c.* 1845) is the most famous example.[19] More
often the preferred landscapes were those of romantic fantasy now well fuelled
by the kind of education that young ladies might expect from their seminaries:
Betsy Lathrop's version of neo-classicism owes as much to fashion plates as it
does to a nodding acquaintance with Gothic architecture and the iconography
of the paladins.[20] The attenuated sensibility of romanticism could be worked
out in the streaming tears, waters and willow leaves of memorial pictures, the
making of which seems to have been a duty of unmarried womanhood.

It is to be expected that women who have been schooled in the arts of
decoration from their earliest years should transfer this concern to their paint-
ing: lace-making and embroidery are essentially forms of abstract pattern-
making, and for many women the function of portable paintings was still
basically abstract. From their portfolios we know that young women studied
colour-making, experimenting with different forms of application, so building

up their deceptively simple compositions with a great deal of forethought. Emma Cady's water-colour study of fruit carefully contrasts the bland soft textures of the fruit with the gritty mica which she has applied to the glass bowl and the cold mottling of the shelf on which they stand. In its suppressed detail, single unrepeatable lines and carefully uninflected negative space, the painting brings us, as much women's work does, close to the concept of minimal art, for tact and control are all-important.[21]

Most of the interest in American primitive painting is simply antiquarian, although some attempts have been made to find an essentially female aesthetic in the works of women in these unique circumstances. However it must be borne in mind that, however simple and innocent their paintings may now seem, these women were subject to constant bombardment by information about decoration, if not about painting as such. Their work is heavily derivative, of fashion plates, drawing cards, stencils, commercially and individually produced, and all kinds of reproductions, from good quality engravings to coarse polychromes.[22]

Genuine primitivism derives from genuine ignorance. Women painters, like primitive painters, were often obliged to work from lay figures, stock models and borrowed motifs. Because they did not study anatomy, they had little concept of the dynamic interaction of figures in groups, and so were particularly prone to repeat formulae in their posing. Having no understanding of the mechanisms of movement, they could rarely paint figures in action, but were obliged to render them in static poses, like a series of individual portraits.

Barbara Longhi (1552–1638) is a fascinating example of the enduring archaism of much of women's work. She was the daughter of Luca Longhi, a Ravennate mannerist (1507–80), and the sister of the painter and poet Francesco Longhi (1544–1620). While her brother seems to have remained a dilettante, Barbara's output was considerable, all small pictures, remarkable for their purity of line and soft brilliance of colour. The relationship between father and daughter is horribly muddled: both were provincials heavily dependent upon Roman and Bolognese schools. Barbara must have had to copy many of her father's works, and probably often assisted him; nevertheless the works that are emerging as hers are characterised by the expression of feeling through patterning, rather than in the conventional rhetoric of sixteenth-century Italian painting. Verisimilitude and depth are sacrificed to another sort of intensity, which could with truth, despite Barbara's extensive familiarity with contemporary painting, be called primitive.[23]

Such is not the case for the many women who were attracted to neoclassicism of the most rigid and prescriptive kind, who saw in the rules a safeguard and a guarantee of correctness. The shortcomings of their training could be masked by a study of plaster casts and a repetition of classical motifs. Lavinia Fontana's drawing of the *Presentation of the Virgin* solves all its problems of group composition by representing the figures as a stylised frieze, their heads

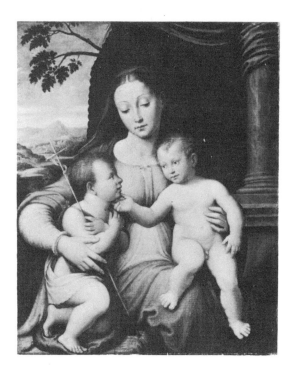

Barbara Longhi, *Mary with Christ and John the Baptist*
A backward member of a provincial school, Barbara Longhi brings to her extremely conservative picture-making a simplicity and intensity of feeling quite beyond her mannerist father and her dilettante brother.

touching the upper line and their feet the lower. Angelica Kauffmann and Maria Cosway both executed drawings of the most arid correctness, as did the female pupils of David and Gérard, finding in the censorship of neo-classicism a protection for their tremulous artistic personalities.

The pre-Raphaelite movement attracted women for similar reasons. The archaic postures, with bodies obscured by period costumes, backgrounds simplified by patterning, were well within the competence of women whose training had been strong on patterning and portraiture and weak on construction, movement and dynamic. Eleanor Fortescue-Brickdale (1871–1945), Marianne Stokes (1855–1927), Maria Spartali-Stillman (1844–1927), Mary Young-Hunter (1878–1936), Catherine Hueffer (not. 1869–74), Lucy Rossetti (1843–94) and the much ridiculed Anna Lea Merritt (1844–1930) whose *Love Locked Out* owes a good deal to Holman Hunt's *Light of the World*, all found reassurance in the deliberately limited scope of pre-Raphaelitism.[24]

At the Slade, Evelyn de Morgan's (1850–1919) drawings had won her the coveted three-year scholarship, but after one year she resigned it. She did not wish to continue drawing nudes in charcoal, for she was attracted to a kind of art in which her brilliant draughtsmanship was of little or no consequence. She

has been described as a second-rate follower of Burne-Jones whose attenuated figures appear rather more softened and glamorised in her work, and to be sure she was every inch a latter-day pre-Raphaelite, but the unavoidable evidence is that she worked very much alone. Most of her work could not be mistaken for Burne-Jones, despite the fact that the signature on her *Aurora Triumphans* in the Russell-Cotes Gallery in Bournemouth was changed from E.P. (her maiden name was Pickering) to E.B.J.[25]

At first Evelyn de Morgan worked hard and exhibited regularly in order to finance her husband's ceramic factory, which had already consumed her independent fortune, but when her husband gave up designing 'glorious pots', she had no need to sell her work. She got out and about for the first time in years, visited cubist and futurist exhibitions which she likened to the Emperor's new clothes. 'If that is what people like now,' she said, 'I shall wait until the turning of the tide.'[26] The tide never did turn. Evelyn de Morgan went on painting in her old manner, and each finished painting was turned to the wall. When she

Kate Bunce, *Musica*
Voluptuous surface-patterning in a single plane, statuesque posture submerged in detail helped to make painting more like embroidery, typical of the Birmingham School of Decorative Painting.

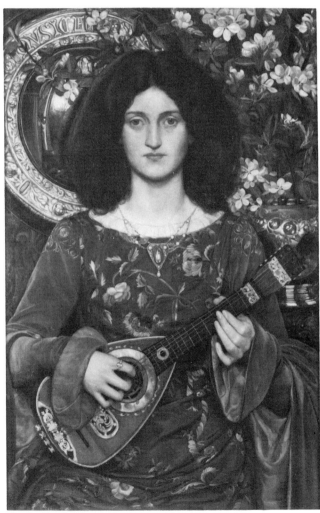

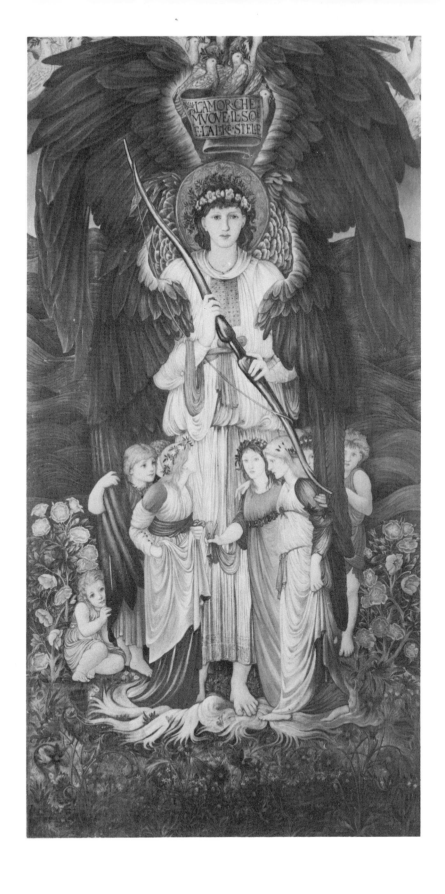

died they were all auctioned off to raise money for soldiers blinded in the First World War. She had painted 'all day long and nearly every day for forty years' without advancing or developing at all.[27]

An angry admirer said after her death:

> Her fame must now wait ... upon the future operations of speculative dealers, as happened with Millet, Corot, M. Maris and their fraternity. Some day, perhaps not far distant, when a big corner has been made, the doubtful Gainsborough and dubious Hals will be removed from the galleries of docile millionaires and replaced by de Morgans, where they will hang, let us hope, as a standing rebuke to the buyers and their motives for buying ...[28]

If the Evelyn de Morgans that were auctioned off were to appear on the art market she would in fact fetch good prices, because so many people who do not like or understand painting do like pre-Raphaelitism. Many a fashionable dealer in bad art would dearly love to corner Evelyn de Morgan and when the moment is ripe gradually let the paintings into the salerooms. What Evelyn de Morgan and her supporters took for fastidiousness was in fact vulgarity.

The fact that so many gifted women strangled themselves in arch-conservatism is not some sort of secondary sexual characteristic working its way out, as if women are of necessity born with corsets on the mind. It comes of the very insecurity that these women felt upon entering into competition with men who seemed to have made all the running so far. They were not the peers and companions of the men in the schools where they studied in different rooms, in a more repressive atmosphere. Ellen Clayton records that Augusta Walker was *expelled* from the South Kensington Schools for *whistling*; although the students went on strike for her, she was never reinstated.[29]

Rosa Bonheur, who managed to divest herself of actual corsets, was at the height of her fame still so uncertain of herself that, as she herself has said, she 'painted every grass blade twice over'.[30] There is no doubt that the talent revealed in her sketches, one of which was exhibited at the 1977 'Women Painters' exhibition, is economical, assured and thoroughly painterly, while the finished works tend to be laboured, the paint surfaces deadened by too much handling. Another painter who divested her work of personality by painting out every brushstroke was Angelica Kauffmann. A preparatory colour sketch exhibited at Bregenz in 1968 was a revelation. Energetic, broad, loose and free, it seemed almost impossible that it had been painted by the same hand as the finished work. Women's preference for hard, flat surfaces and static forms and composition may in many cases be taken for a kind of protective posture, an artistic flinch. Until we have done the spade-work and put together the works and their preparatory sketches (many of which are passing as the work of better-known painters), this must be no more than a hypothesis.

Evelyn de Morgan, *Love which moves the Sun and the Other Stars*
 The iconography of this study is sixteenth-century, the manner of its treatment post-pre-Raphaelite. The static composition and careful sweetness rob the picture of all vitality.

VII

The Disappearing Oeuvre

The Newport Historical Society, Rhode Island, gambled and lost. Three years ago, the society found that a painting it owned by Jane Stuart, daughter of the American artist, Gilbert Stuart, had another painting underneath it. The top paint was removed – but the painting below is not a Gilbert Stuart.

New York Times, 1978

Paintings do, in the normal course of events, perish. Panels decay as wood decays. Canvas rots, tears, sags. The stretchers spring and warp. As colour dries out it loses its flexibility and begins to separate from its unstable ground; dry colour flakes off shrinking or swelling wood and drooping canvas. Micro-organisms feed upon the organic substances in the paint. Exposed to light, many pigments fade, yellow or darken. Glazes change colour, harden and become opaque. Waste gases from heating systems and car exhausts precipitate corrosive substances on to the surface of paintings. Sharp dust sifts on to them continually; each dusting scrapes the tender painted surface. What decay leaves undone, restoration often completes.

Even a painting as valuable, as well cared for, as Mary Cassatt's *Woman Sewing in the Garden* in the Jeu de Paume was, when this writer last saw it, suffering some paint loss to the dense fine brushwork of the face, which cannot be restored without a radical alteration of its whole surface. If a painting by Cassatt, who was a consummate technician, could suffer such a fate in such circumstances, we cannot marvel that so many works by women less well known and not as well trained have simply rotted away. The vast majority of

women painters before Mary Cassatt were not admitted to the society of artists and could not share their expertise, nor did they have the advantage of the commercially manufactured stable pigments which so simplified the painter's work in the nineteenth century.

The story of the technique of oil painting is that of a never-ending search for truly stable media and permanent colours. The greatest artists took regular flights into the unknown, risking months of work in their constant search for better media. The minor artists lagged behind, unaware of the shared knowledge of the great *ateliers*. One of the penalties of being a minor artist is impaired capacity for survival, and women suffered gravely from it.

Allowing that much of women's work perished as a direct consequence of their inadequate technical preparation, there are still too few works by women to be seen. The preservation of paintings is a costly business and can only be feasible where the value of the work justifies it. The face value of most of the work of minor artists would not pay the rental on its storage space, let alone the wages of the people who must watch over it. When collections are menaced by war, fire or flood, the most valuable works are conveyed to safer storage, the rest must be left to fend for themselves. When massive restoration, as in Venice and Florence after the floods of 1966, is to be undertaken, the most important works are dealt with first.

Important works of art are those which are considered to be by important artists. There are no intrinsic criteria as reliable as the authentication of the painting as the work of an artist who is well known, great, important and so forth. The same painting, when found to be not the work of a great author but by a minor figure, may lose almost all its value. In 1913, H. E. Huntington paid a hundred thousand dollars for a Romney, which was eventually shown to be not by Romney, but by Ozias Humphrey. Huntington's attitude was typical of collectors: 'If it's not a Romney,' he said, 'I don't want it at any price.'[1] In 1944, his Romney was sold as an Ozias Humphrey for £63. His closeness to Romney could not take the value of Ozias Humphrey upwards: instead he bore the stigma of a fake Romney. Such a philistine cult of personality is not typical of private collectors alone. In 1927, the Louvre paid one and a half million francs for two Watteaux: they lost nine-tenths of their value when the original designs by Quillard were found.[2] Even the Louvre was powerless to launch Quillard as a new, perhaps better, Watteau. Any dealer leafing through a portfolio longs to find a drawing by Watteau and would therefore tend to find it in any unsigned (and perhaps signed) drawing by Quillard.

Major artists must accumulate an oeuvre; minor artists must lose theirs. The style of the major artist is known, therefore approximations to it are recognisable: the minor artist's style is known only in reference to these milestones which may be extremely misleading. A major artist might have been influenced by an artist now considered minor, but scholars will almost invariably assume that the greater influenced the less, that what came after came before, unless

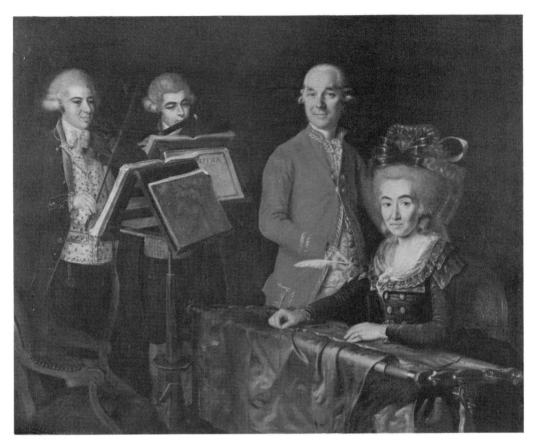

Isabelle Pinson, *Family Group*
 A student of this name exhibited in the Salons from 1796 until 1812. She may
 have been a contemporary of Adélaïde Labille who was, like her, a student of
 Vincent, and a professional portraitist long before her Salon career.

documentation is found to prove the fact. Great artists are products of their own time: they do not spring forth fully equipped from the head of Jove, but are formed by the circumstances acting upon them since birth. These circumstances include the ambiance created by the other, lesser artists of their own time, who have all done their part in creating the pressure that forces up an exceptional talent. Unjustly, but unavoidably, the very closeness of a great artist to his colleagues and contemporaries leads to their eclipse. The obliteration of minor personalities is a disservice to art history, and many a scholar, finding traces of such a buried individual, sets about to sift the surrounding documents and to question attributions of related works in search of a new hero. So Roberto Longhi went in search of Artemisia Gentileschi in 1916, accumulating for her an oeuvre which he himself was obliged to halve when he revised his essay in 1961.[3] In retrospect there were clear stylistic differences among the works he ascribed to her hand, as there are in the works still ascribed to her: the clinching evidence was documentation positively giving works ascribed to her by Longhi to other painters, more minor and male.

Judith Leyster, *Still Life*
The existence of one still life of this quality entails the existence of many more by
the same hand, but so far this is the only work in the genre attributed to Leyster.

There are other women for whom scholars and art-dealers are anxious to
amass a greater oeuvre. The select band includes Louise Moillon, one of whose
paintings fetched the staggering price of $120,000.[4] A Clara Peeters fetched
£39,900[5] at Christie's in London in 1973, a Rachel Ruysch £31,500.[6] In almost
every major sale the locution 'M. Caffi' or 'Caffi' and sometimes the confident
attribution 'Margarita Caffi' appears on murky and ill-preserved flower-pieces.
Most second-rate neo-classical canvases of the eighteenth century have

appeared on the market as 'A. Kauffmann' at some stage in their career and almost any French eighteenth-century female portrait has been called a Vigée-Le Brun self-portrait at some time. Obscure Cremonese portraits are often called Anguissolas, especially if they are not painted well enough to be called Campi. A palette was added to an undistinguished portrait by a follower of Pourbus in the Palazzo Pitti and it was called a self-portrait by Lavinia Fontana. The attributions of works to notorious females has the added advantage of the interest that collectors feel for such freaks of nature, an interest which unscrupulous dealers swoop to gratify: in this writer's view several of the female self-portraits in the Grand Ducal collection in the Uffizi are forgeries.

Unfortunately, prejudice against women means that women painters generally accumulate the worst rather than the best of other people's work. Lesser-known women have suffered the worse fate of having their best work attributed to others.

The most remarkable case of a disappearing oeuvre (until the next one comes along) is probably that of Judith Leyster. We know now that she was born in Haarlem in 1609/10, almost thirty years after Frans Hals. She witnessed the baptism of one of Hals' children in 1631, in 1633 was listed as a member of the Haarlem guild, and in 1635 had three male pupils, a good index of her standing as an artist.[7]

In 1636, she married Jan Miense Molenaer (1610–68) and went to live with him in Amsterdam. She bore him three children and died in 1660. Her earliest known works show the influence of the Utrecht *Caravaggisti*, those dated about 1629–30 the influence of Frans Hals. Probably later is a series of smaller domestic genre scenes, which are extremely original, looking forward to the restrained manner of Ter Borch and Metsu. Several flower and bird paintings appear in the inventory of her husband's possession made at his death, and to these may be related the magnificent *Still Life* sold in London in 1976 by the Brod Gallery.

By 1627, Judith Leyster was famous enough to be mentioned in Ampzing's description of the city of Haarlem; by 1661 she had so far been forgotten that De Bie does not mention her in his *Golden Cabinet*. Her eclipse by Frans Hals may have begun in her own lifetime, as a consequence of her marriage to Molenaer perhaps, for Sir Luke Schaub acquired the painting now known in the Louvre as *The Jolly Companions* as a Hals in Haarlem in the seventeenth century.[8]

If Judith Leyster had not been in the habit of signing her work with the monogram JL attached to a star, a pun on the name her father had taken from his brewery, Leyster or Lodestar, her works might never have been reattributed to her: few paintings can boast of a provenance as clear as that of *The Jolly Companions*. As a result of the discovery that *The Jolly Companions* bore Leyster's monogram, the English firm which had sold the painting to Baron Schlichting in Paris as a Hals attempted to rescind their own purchase and get their money back from the dealer, Wertheimer, who had sold it to them for

Judith Leyster, *The Jolly Companions*, 1630
How two experts can have decided that this small picture on wood was a
masterpiece of Frans Hals is now quite incomprehensible.

£4,500 not only as a Hals but 'one of the finest he ever painted'. Sir John Millars
agreed with Wertheimer about the authenticity and value of the painting. The
special jury and the Lord Chief Justice never did get to hear the case, which was
settled in court on 31st May 1893, with the plaintiffs agreeing to keep the

Anna Quast, *Still Life with Butterfly*, 1640
 Annette Sphinters married the dissolute Peeter Jansz Quast in 1632. Until this
signed work appeared on the market this century, she was not recorded as a
painter. The existence of this very competent still life, quite unlike her husband's
bibulous productions, suggests a considerable talent and output, necessitated
perhaps by her husband's profligacy and early death.

painting for £3,500 plus £500 costs. The gentlemen of the press made merry at the experts' expense, for all they had succeeded in doing was in destroying the value of the painting. Better, they opined, to have asked no questions.[9] At no time did anyone throw his cap in the air and rejoice that another painter, capable of equalling Hals at his best, had been discovered. Many collectors must have had the uneasy suspicion that the painter of one such masterpiece must have painted more: all Hals' works were suddenly suspect.

In fact, *The Jolly Toper*, acquired by the Rijksmuseum in 1897, which bears her monogram and the date 1629, had been sold as a Hals at the Hôtel Drouot in 1890.[10] In 1874, the Kaiser-Friedrich Museum had bought another Leyster *Jolly Toper* as a Frans Hals.[11] Another version of *The Jolly Companions* sold in Brussels in 1890 bore Leyster's monogram crudely altered to an interlocking FH. A most un-Hals-like group of children has also been attributed to Frans Hals. Even when these attributions have been corrected, Judith Leyster's work is still far too fragmentary. One of her earlier works, a *Laughing Man with Wineglass*,[12] has been rescued from Gerard Honthorst: a methodic examination of Hals, Honthorst and Molenaer might yield much more, indeed might reveal the contours of an artistic personality strong enough to have influenced all three.

The tendency nowadays is for extreme caution in attribution. Scrupulous scholars like R. H. Wilenski are including more and more 'unknowns', so wary are they of inventing the identities of artists, even by assigning groups of paintings to one hand. At the very time when women might benefit from some reverse discrimination in winning back the great mass of dubious attributions to men, such attributions are ceasing to be made. Without signature or documentation all attributions are taken to be insecure; upon such insecurities nothing can be built. Further work on Judith Leyster has in fact cost her attributions, leaving her agreed oeuvre smaller now than it was in 1926, when Juliane Harms confidently assembled a bare thirty-two paintings under her name.[13]

What we know about Judith Leyster is tantalising: she was as good as Hals in some ways, and yet perfectly distinct from him. Even in the works that most resemble his, the composition is more intricate, the subject more involving, less simply euphoric, the brushwork more sensitive, less exuberant. The essential difference in her character can be grasped immediately from her self-portrait, in which she swings away from a canvas showing a half-finished figure of a fiddler, as if to greet a welcome interruption. Her expression is not jocular, but kindly and slightly quizzical, as if she were consulting the beholder for an opinion. As in another female portrait attributed to her, one is aware of the constriction of her rigid bodice, the knife-edge of her collar, the pressures acting upon the woman,[14] much as one is aware of the woman's helpless embarrassment in the much-discussed Proposition of 1631.[15] (See Pl. 6.)

The few paintings we have cannot represent the achievement of Judith

Leyster's thirty years as an artist. No one who was not working regularly could have achieved the excellence of the works that we have: moreover Judith Leyster was not the kind of painter who painted a picture a year and that a masterpiece. Her work is not laboured or elaborated, but swift and brilliant. If not as allusive and flashy as Hals, she was nevertheless a painter of spontaneous, vigorous effects even in the works of smaller format on wood. To find the rest of her work, the archives of seventeenth-century Haarlem, Vreeland, Heemstede and Amsterdam must be sifted through and through to find the smallest clues to documentation, a very expensive and time-consuming business; but worse, every possible attribution must be examined, scientifically, usually only to be refuted. Not only must Leyster originals be separated from Leyster copies, but what is much more difficult, false Hals, Honthorsts, Molenaers, and possibly dozens of others must be weeded out as scientifically as possible. The process could be catastrophic: the value of thousands of Dutch paintings could be destroyed in the search for the truth about another artist who cannot earn anywhere near as much either in the salerooms or as a drawcard on a museum wall.

There are many pitfalls lying in wait for the scholar who embarks on a search for a little-known artist. The only way that he can survive the tedium and disappointment is by falling in love with his subject and so seeing signs of the beloved presence in the most unlikely places. Maddened by the invisibility of

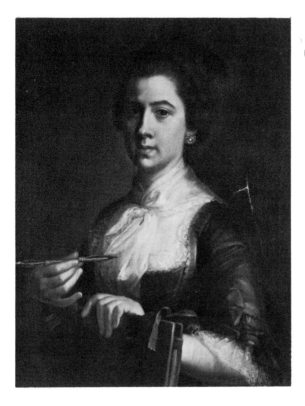

Unknown, *Self-Portrait*
This portrait is catalogued by the Uffizi as being by a painter called Teresa Arizzara. No such person is listed in any of the usual art references.

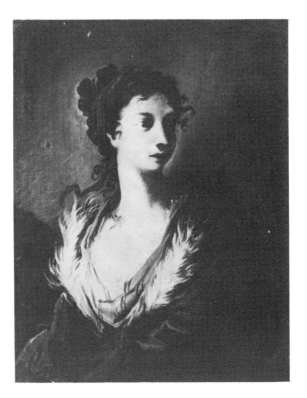

Unknown, *Self-Portrait*
 This truly wonderful portrait is
 listed in the documentation of the
 Grand Ducal collection in the
 Uffizi as the self-portrait of an
 artist called Rosalba Fratellini.
 Giovanni Fratellini was called the
 Tuscan Rosalba, but no secure
 attribution can be made on that
 ground. The approach and
 execution of this work, which
 would have to be years earlier
 than that reproduced on p. 27, are
 far more sophisticated and
 assured.

Judith Leyster, one Dr Robert Dangers came to the conclusion that she was the lover of Rembrandt and the author of more than thirty paintings usually attributed to him. The story as he told it was seductive: Molenaer was an addict of tavern life and prostitutes, a conclusion easily drawn from his work, and Rembrandt was attracted by the genius of a woman who could offer him a kind of spiritual companionship lacking in his life with Saskia. The case that he makes out for Leyster's authorship of the famous portrait of Rembrandt and Saskia, that Rembrandt toasts the painter while Saskia squeezes a tight smile to hide her jealousy, is superficially convincing because of the complexity of the interaction of the portrayed and the beholder, which often characterises Leyster's work, but Dangers' case is too flimsy to uphold it. When he opines that the portrait of the boy known as Titus is a portrait of Rembrandt's son by Leyster and bears her monogram in his hair, we realise that we are in fantasy land.[16]

Nevertheless, Dangers' instinct in going for Leyster's work to the vast output attributed to Rembrandt, and more properly to be assigned to his workshop, is correct. There are more Leysters in the world and they are more likely to be of such a standard than the sloppy Hals copies which now bear her name in the salerooms. Nothing daunted by his piratical raid on Rembrandt, Dangers also gave Leyster five Frans Hals, four Dous and a Vermeer. It is up to feminist art historians now to have as much courage and a good deal more common sense.

In 1922 a David was purchased, under the terms of a bequest, for the Metropolitan Museum in New York for two hundred thousand dollars. It was (and is) a fascinating portrait of a young female artist, seated so that the light from a cracked window falls on to her drawing. Through the window in the diffuse light of outdoors one sees a couple on a parapet, painted in a few strokes which effortlessly suggest the woman's compliance and the man's masterliness, while a gulf yawns between their world and the bare *atelier* where the young woman studies her subject, the viewer, so intently. Maurois called it 'a perfect picture, unforgettable'; others pointed out that it was more informative than David's portraits usually are, while the use of indirect light was unlike his severely classical approach to the portrayal of character. There is in fact a slightly surreal, semi-allegorical cast to the work, a little too much Gérard in its elaborations. Moreover, judging by an engraving of the 1801 Salon, it seems that the painting was exhibited then, when we know that David boycotted the exhibition. No mention is made anywhere of an exhibit by him, and one of the two entries which might relate to this painting appears under the name of Constance Marie Charpentier, née Blondelu.[17]

The admission that the Metropolitan David might not be a David at all was finally made in 1951; the picture was not taken down for David's name to be removed from the frame until 1977. Professor Sterling of the Metropolitan found nothing to rejoice at in the matter; in finding that the painting was feminine, he also found that he did not like it so much after all.

> Its poetry, literary rather than plastic, its very evident charms, and its cleverly concealed weaknesses, its ensemble made up from a thousand subtle artifices, all seem to reveal the feminine spirit.[18]

The portrait of *Mademoiselle Charlotte du Val d'Ognes* does not seek to charm, nor does it seek to portray the sexual vitality of its sitter. Charles Sterling's dislike of the painting derives from his perception of it as a fake David; he expects from it the wrong things. If he would be content to see it as challenging and disturbing, a different kind of portrait, a feminist portrait perhaps as Maurois dimly understood when he called it the 'merciless portrait of an intelligent, homely woman', he might accord it praise of a different kind.[19] (See Pl. 16.)

The attribution to Madame Charpentier is not secure. Of her thirty works sent to the Salons between 1795 and 1819 we know only one other, which can be related to the portrait rather by its weaknesses than by any evidence of the same originality. Until her other works are brought to light the personality of this artist remains unknown and her achievement a mystery.

If the case of the Metropolitan 'David' is still dubious, the case of the Frick 'David' is not. In the same album of engravings in which the Metropolitan portrait was found, Georges Wildenstein found among the pictures in the 1804 Salon, the Frick portrait, unmistakable because of the sitter's unusual posture, his body in profile seated with his legs crossed, plucking at the strings of a violin

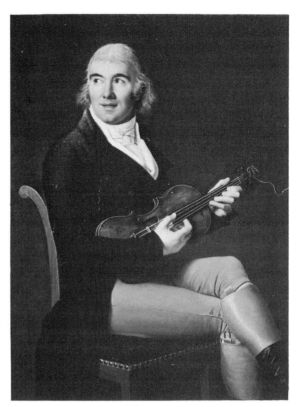

Césarine Davin-Mirvault, *Portrait of Antonio Bartolomeo Bruni*
The authentification of this splendid portrait has not improved the visibility of its author. The documentation of her life is sparse, and her oeuvre a mere handful of works, none so distinguished as this one.

held under his arm while looking over his shoulder towards the light source so that his face is seen frontally. It was clearly identified as the portrait of Antonio Bartolomeo Bruni by Césarine Davin-Mirvault.[20]

Césarine Davin-Mirvault was born in 1773, and studied with Suvée, David and Augustin. Versailles has two other portraits, *Asker Khan* (1810) and *Marshal le Fevre, Duke of Danzig* (1807). A portrait of a lady, signed and dated 1817, is also known, as well as genre subjects. She established a school of painting and drawing and had many pupils.

The swallowing up of these two women in the personality of David is a direct consequence of the enormous esteem in which David was held in the nineteenth century: as the element of hero-worship subsides and *catalogues raisonnés* are attempted, we may expect the work of lesser artists working in his shadow to be identified.

The correct attribution of the paintings of Leyster, Charpentier and Davin-Mirvault has so far had only negative effects. The paintings have lost value because the notoriety of their true authors did not equal that of their suppositious authors. Until reverse discrimination is practised and women artists become more highly saleable than men, this situation will prevail. With the change in attribution comes a change in aesthetic as well as commercial valuation, because the woman painter is marked by the stigma of imitation, when she

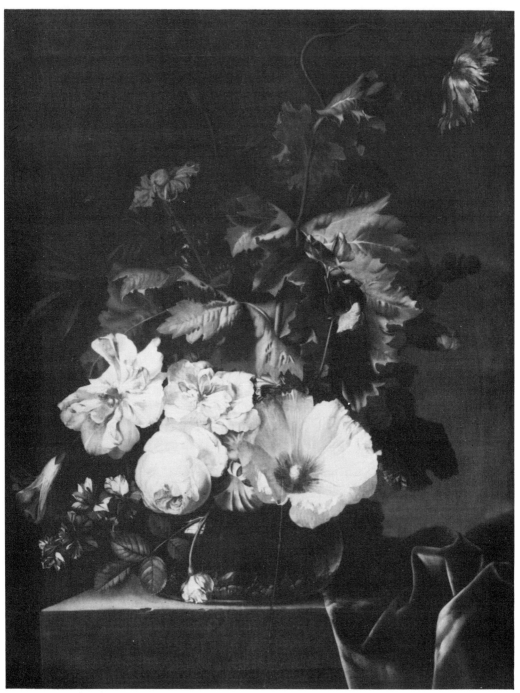

Jacoba Nikkelen, *Flowers*

Jacoba (1690–?) was the daughter of the landscape and game painter Jan van Nikkelen, to whom many of her works in Düsseldorf were ascribed. Her obvious mastery of her chosen genre has not sufficed to keep her work together under one name.

almost certainly did not imitate at all. The most insidious way of stealing a woman painter's work from her is to take for granted that she played some subservient rôle to her male colleagues and to regard her individuality as simply failure to copy correctly. The superficial archaism of women's work reinforces the impression of inept imitation and lagging behind.

The artistic personality of Giulia Lama has had to be reconstructed on the evidence of a Venetian guidebook of 1733, which mentions three altarpieces by her, two of which, the *Crucifixion* in San Vitale and the *Madonna in Glory with Two Saints* in Santa Maria Formosa, may still be seen.[21]

In the Grand Ducal collection in the Uffizi is a rather clumsy self-portrait which seems to show her at about forty, although it is so unflattering in its execution and so poorly preserved that any reliance upon it as an indicator of age is ill-advised.[22] A much better portrait of her, in the Thyssen collection at Lugano, is given to her exact contemporary and probable teacher, Piazzetta. It shows the artist at work in the traditional posture, looking away from the canvas towards her subject in a fierce, rapt way, her thick eyelids drooping over slightly prominent eyes. It is not the portrait one paints of an admiring pupil: the character that emerges is as strong as Piazzetta's own. The long, swift strokes of his brush can hardly suffice to convey the self-contained energy of this simple figure caught up in creation.

Both portraits show what the only known biographical comment about her maintains, that she was far from being a conventional beauty. She lived in great retirement, and died unmarried as far as we know.

One look at the *Crucifixion* in San Vitale (the church has now become a commercial art-gallery, but the old altarpieces can still be dimly seen behind the display screens), and it is obvious that Giulia Lama was no Sunday painter. She was a highly trained professional carrying out large original commissions with daring and self-confidence. A handful of works could by no stretch of the imagination have been her whole output: she is no *bottega* assistant or copyist either. It is to the credit of the scholars, Fiocco, Pallucchini, Goering, Donzelli and Ruggeri, who began the search for Giulia Lama, that so many of their early attributions have been seen to be correct. It had been assumed that she was a second-rate follower of Piazzetta although, even on the basis of the known works, the assumption was unjustified. The *Crucifixion* offers none of the superficial sensual and picturesque charm of Piazzetta. The palette is colder; the lines of the composition saw back and forth between the figure of Christ strung in agony between his arms, electrified by the cold light, and the appalled and terrified observers. The earth heaves beneath them, even the planes in which the figures stand lurch painfully in the viewer's vision as he follows the narrative movement of their gesturing arms.

The changing taste of the Settecento could not stomach this violent chiaroscuro and the perversely insubstantial lines of bodies which are emotions rather than forms. To the *accademici* it seemed the antithesis of art. If Piazzetta's realism

was unacceptable, Giulia Lama's stripped down version was incomprehensible.

Properly studied, Giulia Lama's work emerges as beyond Piazzetta's. If his style and technique were congenial and she learned from him, which is as yet unproved, she went her own way with what she learned. To reassemble her scattered oeuvre, the scholars found that they had to plunder not only Piazzetta, but Federico Bencovich, the young Tiepolo, Domenico Maggiotto, Francesco Capella, Antonio Petrini, Jan Lyss and even Zurbarán.[23]

The discovery of two hundred drawings, probably from Giulia Lama's bequest, has further clarified the character of this exciting painter. She drew from the life, nude males and females, and in her flowing economical lines and swift understanding of weight and mass, we find all the sensual receptivity that she represses for emotional effect in the finished paintings. The drawings can often be matched to known paintings, thus strengthening Lama's claim to them and our understanding of the way she worked. A beginning has been made, and Pallucchini may write enthusiastically in the light of his own discoveries:

> It is today my conviction that Giulia Lama does not yet enjoy her rightful place in the picture of the development of Venetian painting of the eighteenth century ... Without doubt, Lama begins with the dramatic chiaroscuro of the early Piazzetta, but she does not accept the commitment to naturalism inherited from the Venetiani *tenebrosi*, as the implicit sensuosity of her palette reveals ...[24]

Now at last, Giulia Lama may emerge from the seclusion that she chose to protect herself against the Venetian art world, to take her rightful place in the history of art.

The rediscovery of Giulia Lama began with a known self-portrait and an old guidebook which led to altarpieces still *in situ*. For literally thousands of women artists we have not even that beginning, but only names when no names were signed, or initials which might be shared with twenty others. Occasionally we know the names of paintings, like Justina Van Dyck's *Crucifixion with angels collecting the precious blood*,[25] or the name of a sitter. We may only have the words, 'was also a painter' to go on, as upon Antonia Uccello's tombstone, while every year that goes past destroys more of our heritage. If anything is to be salvaged, women by the thousand must begin to sift the archives of their own districts, turn out their own attics, haunt their own salerooms and the auctions in old houses.

The most promising place to begin the search for the vanished works of women painters is the art market, where Pallucchini found six of his new attributions to Giulia Lama. Doubtless, a good deal of women's work is rotting in storage in European museums, but the practical difficulties in the way of a researcher are enormous. The greater part of museum holdings are not exposed on the walls of the public rooms; how·adequately stored they are and how accessibly is dependent upon the museum administration and the funds at its

Giulia Lama, *Crucifixion*

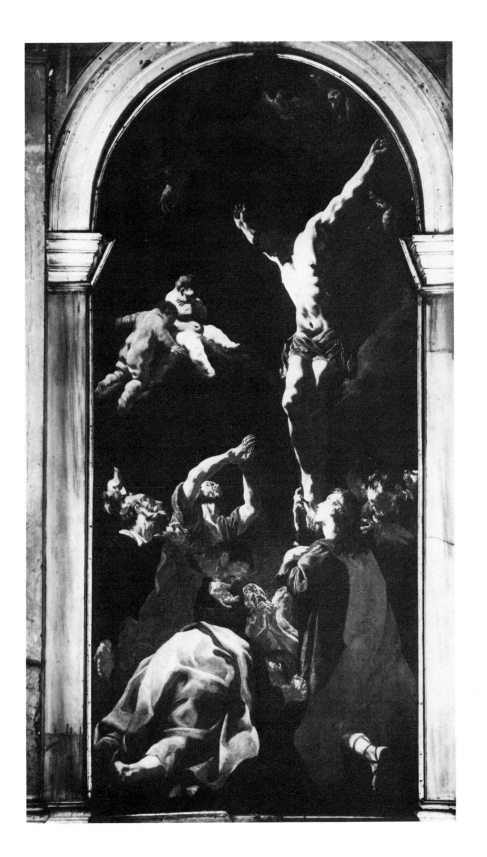

disposal. All European museums suffer from both chronic lack of funds and a surplus of paintings which they can neither afford to keep in a decent state of preservation nor sell off to try their own fate on the market, where dealers and collectors, sometimes too zealously, will undertake the work of preservation and restoration. As far as little known minor artists are concerned, museums are graveyards where they will lie buried until they rot.

This harsh judgment is not a criticism of museum administrators, but rather of the bureaucracies upon which they are dependent. Even a gallery as well organised and thoroughly documented as the Pinacoteca Nazionale in Bologna is obliged to crowd twice as many paintings into its storeroom as the rolling screens are meant to hold, so that the screens may not now be moved, and the would-be student must squeeze into the foot or so of space between them to squint at the paintings, holding up a light bulb to see by. Many more museums have not even the notional facilities which exist there, but simply stack unhung paintings in disused spaces, corridors, cellars and under the eaves. Whether the humidity is controlled, the temperature even, the traffic vibrations at a minimum is all a matter of chance.

Minor artists generally fare better in museums like the Palazzo Pitti where everything is hung pell-mell and cheek by jowl; however the tendency these days is to clear the walls and hang only the pearls of the collection, which are the principal drawcards. When paintings vanish into storage it is sometimes quite impossible to get them out. Letters may go unanswered, visits prove fruitless, as detours on other journeys are met with the demand that one return tomorrow, Friday or next week. Asking the museum to photograph the painting is an expensive and time-consuming affair, and the photograph is never good enough to base an attribution upon. Very few museums can afford

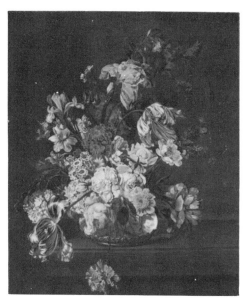

Cornelia van der Mijn, *Flowers*
We do not know how much success
Cornelia van der Mijn enjoyed with
compositions like this, itself rather
uncertain in technique and spreadeagled
in design.

Aleida Wolfsen, *Portrait of a Lady*
In between producing Peter Goury's eight children, Aleida Wolfsen (1648–90) painted enchanting small portraits like this one. In 1910 the Women's International Art Club exhibited a male portrait at the Grafton Galleries in London; another female portrait dated 1686 is in the Hermitage in Leningrad. The rest has disappeared – in the direction of Netscher, who may have been her teacher.

to compile exhaustive catalogues in which the provenance of their minor, unexposed works is discussed, and fewer still will permit a student to browse through the whole study collection or all the stored paintings on the off chance that there is something significant, a painting related to a known drawing, a repeated motif, a recurring colour, some telling aspect of brushwork.

The feminist who wishes to uncover the whole figures of Leyster or Lama or Charpentier must steep herself in the art of the period, so she must first spend by far the greater part of her time studying the men to whom the woman's work is supposed to have been related. Having a bare handful of the woman's work to go on, she is severely hampered in her building-up of a concept of the woman's style and characteristic preoccupations, but with patience, thoroughness, scrupulosity and an indispensable amount of luck, she may succeed in taking the process of rediscovery a step further.

If dealers become aware that their rooms are full of women in search of Leysters and Lamas, Leysters and Lamas will appear, and their prices will go up. Flimsy trails of evidence will be forged into iron chains of coincidence. No temptation will be greater than to allow oneself to believe in false attributions, to see what has so long been sought in a place where it is not. Nevertheless, the emergence of a specific market for women's work must have good results in the end, for only in response to a demand for their work will the search for women artists be undertaken on the kind of scale and at the kind of level where

it is useful. The connoisseurs will have to be ruthless in rejecting false and injurious attributions: they will have to know more, not less, than the dealers about watermarks, pigments, canvas and stretcher constructions, drawing techniques and the skills of forgers. They will also have to see through skying and foxing and cracking and centuries of smoke-blackening and fly-dirt, which is where the luck comes in.

The conception of art history as a succession of giants standing alone in an unpeopled landscape is fundamentally philistine. The seven wonders of the world are not the only things worth looking at in it, neither can one hope to understand the greatness of, say, Chardin, if one does not know of the existence of Vallayer-Coster. More and more art historians are trying to compile views of the great art periods as complex structures of interacting influences. An exhibition like the 'Angelika Kauffmann und ihre Zeitgenossen' which was seen, alas, only in Bregenz and Vienna, is typical of the best trend in contemporary art history, in that it demonstrated the rôle played by Kauffmann in the development both of neo-classicism and of history painting as a genre.

However discouraging it is to reflect that the feminist art historian must do more, not less work than those historians who are interested in the major male figures, and for less result in the long run, the rewards of the research are enormous. Each painting or drawing rescued from oblivion and obliteration means another spring of hope and self-esteem for the women working now, a fresher understanding of the difficulties and a better chance of solving them.

Madame Chassaignac, *Général Lejeune*
Who is the lady who so romantically
depicts the young soldier? She appears in
no art lexicon.

VIII

The Cloister

I fold today at altars far apart
Hands trembling with what toils? In their retreat
I seal my love to-be, my folded art.
I light the tapers at my head and feet,
* And lay the crucifix on this silent heart.*

Alice Meynell, 'The Young Neophyte', *Collected Poems*

According to every schoolboy, Western culture only survived the Dark Ages because it was protected and nurtured in the monasteries. Nineteenth-century pre-Raphaelitism has assisted feminism in embroidering a vision of women in religion as escapees from the indignities of female servitude and the tribulations of their reproductive destiny, to develop their intellects and creative abilities in luxurious calm. In the convents, no obstacle barred them from the understanding and practice of any art they chose, while the anonymity of the cloister protected them from the rapacity of the market place.

The harsh historical reality is that monasticism cannot be understood in isolation from the society which produced it. Convents existed in the real world and were dependent upon the economic and political systems of their day. They were never paradisaical enclaves to which women of all classes might escape at will, but controlled establishments in subjection to both religious and secular powers.

The first female monasteries were aristocratic institutions founded by women of royal families who secured for them the status of baronies. The abbesses exercised powers like those of bishops. From her position of landed

Ende, *Explanatio in Apocalypsam*
The earliest illuminations signed by a woman are those in a manuscript of the
Apocalypse, preserved in Gerona Cathedral. In 970 a woman signed her
completed work 'En Depintrix et Dei Aiutrix'. Her male collaborator is also named,
and it is by comparing his other known works with the Apocalypse that the
attribution to Ende, as she is generally known, is strengthened, for the best work
in the Apocalypse is clearly not by his hand.

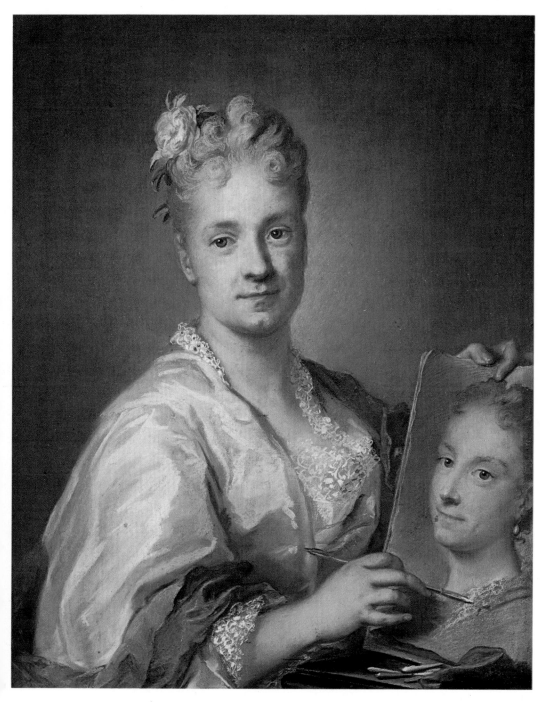

Pl. 9 Rosalba Carriera, *Self-Portrait, Holding Portrait of Her Sister*, 1715

Pl. 10 Angelica Kauffmann, *The Artist Hesitating Between the Arts of Music and Painting*, c. 1794

Pl. 11 Anne Vallayer-Coster, *The White Tureen*, 1771

Pl. 12. Adélaïde Labille-Guiard, *Portrait of the Painter François-André Vincent*

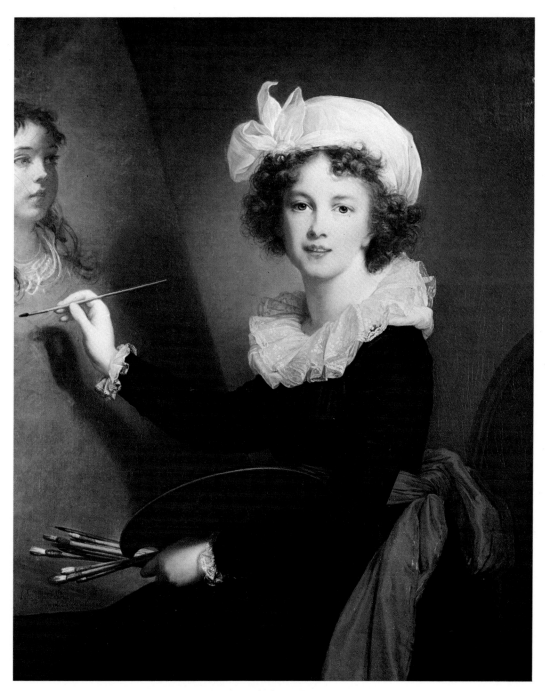

Pl. 13 Elisabeth Vigée-Le Brun, *Self-Portrait*

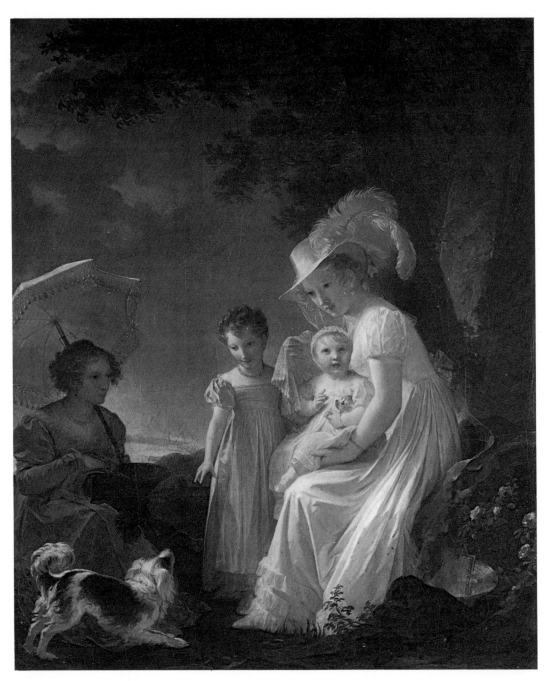

Pl. 14 Marguérite Gérard, *Summer*

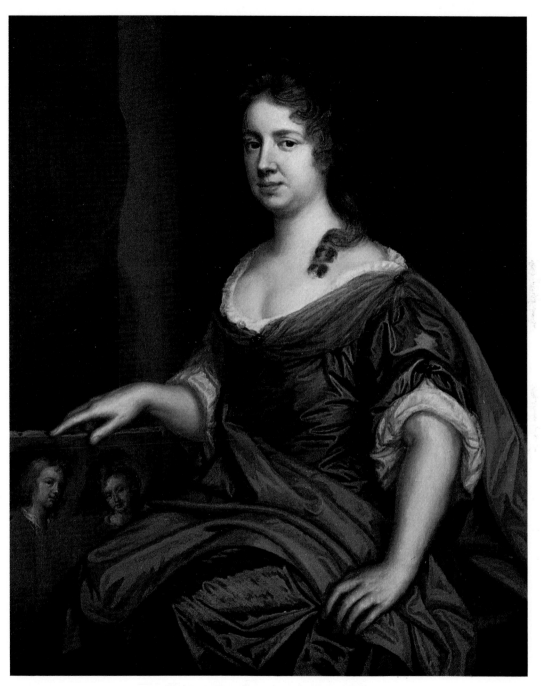

Pl. 15 Mary Beale, *Self-Portrait*, 1666

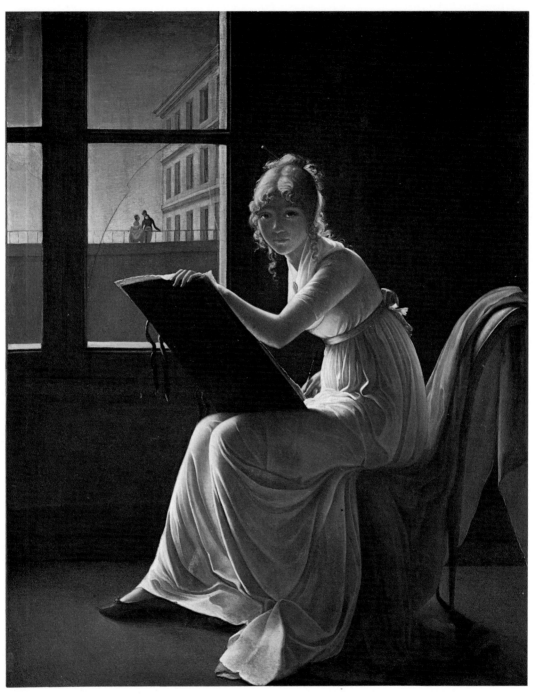

Pl. 16 Constance Marie Charpentier, *Mademoiselle Charlotte du Val d'Ognes*

wealth (for monasteries have always depended upon mundane endowments for their daily bread) and spiritual power, an abbess could exert considerable influence upon secular affairs, but she could not hope to survive the collapse of the dynasty from which she came.

Of this first period of monasticism we know very little. It may well be that fourth-century manuscripts like the *Itala* of Quedlinburg were produced by communities of women: it is idle now to speculate whether they were or not. St Melania, who was praised for her calligraphic labours in the fifth century, may have been typical of the gentlewomen who chose celibacy. Eadburg, abbess of a monastery in Thanet in the eighth century, was skilled in writing in gold characters on dyed parchment:

> Often gifts of books and vestments, the proofs of your affection have been to me a consolation in misfortune. So I pray that you will continue as you have begun and write for me in gold characters the epistles of my master, the holy apostle Peter ...

This rather egregious begging letter was written to the abbess by St Boniface. What he was asking for were gifts of great price; if women like Eadburg were in the habit of doing such work only to give it away, we might be justified in suspecting that a good deal of the monastic art which has survived from the period is in fact women's work.[1]

Allard, Lord of Derain, had two daughters, Harlinde and Renilde, whom he educated in a convent at Valenciennes. The *Acta Sanctorum Bollandorum* says that there they mastered the arts of writing and painting, 'a task laborious even to men'. Their education completed, they declared their intention of renouncing the world, and their parents founded for them a nunnery at Maas-Eyck.[2] An evangeliary by them was discovered in the sacristy of the parish church Maas-Eyck by Martene and exhibited in the Brussels Exhibition of 1880 where it occasioned great comment because the style of their eighth-century illumination left no doubt that Byzantine influences had permeated as far West as Flanders, which in turn must be interpreted to mean that the nunnery at Valenciennes had a good selection of manuscripts from which they had been able to learn.

A legend about these two gifted women relates that one evening while they were working, a cloud overcame them and a demon blew out their wax-lights, which were miraculously lit by a breath direct from the Holy Spirit. To the minds of those who believed the legend at least there was still something prodigious in the idea of women carrying out this work.[3]

A superficial understanding of manuscript-illumination might see it as ideal women's work in that it is small, dainty, requiring no brute strength and much endurance and patience. The traditions of illumination evolved with vegetable slowness, as monastic workers gradually modified their sources and increased the range of iconographic reference, so little pressure was put upon the artist to intrude his own personality or to use the work to promote his own reputation.

Sex rôles prevail even in the service of God, for Catholic women may not aspire to ordination. Generally, men sculpted, painted, carved, and worked in metal and stained glass, while nuns wove, needleworked and embroidered the square miles of precious cloths used in the thousands of churches throughout Europe. There was so much of this kind of work to do that they had scant opportunity to compete with men as illuminators. The vast mass of their daily labour has rotted away, leaving only tantalising vestiges, themselves doomed to decay.

Most conventual artistic activity would nowadays be thought drudgery. The applications of millions of tiny stitches in huge copes, dalmatics and altar hangings was not so much the exercise of a woman's creativity as a religious duty carried out in expiation of the sins of the world. Most of the women working in this way would have had no hand whatever in the design, which might have been original but was more likely a copy of another, modified to fit the ecclesiastical function of the particular piece or its recipient or the materials available. Sometimes the nuns would have transferred a design from another art form, a missal cover, a reliquary or a monstrance. As they worked, they

Uota, *Evangeliarium*
It is clear from this important miniature that Uota, Abbess of Regensburg, seen offering her book to the Madonna and Child in Glory, was a highly cultivated woman. Her signature in monogram appears in the hemicircle below the central medallion.

probably prayed, meditated, or listened to a reading from a devotional book, just as they do in convents to this day.

Book-making was a more prestigious activity than needlework. The scribe had to be highly literate, usually in Latin: this was possibly more important than the quality of the hand he wrote. He was, unless he was the abbot himself, under orders from a superior who would be finding the money to pay for the parchment and the materials that he would use, black for the text and vermilion for the rubrics, and directing him which pages to leave blank and which capitals to leave for illumination, if, as was usual, they were to be carried out by another person. The addition of miniatures in precious pigments and gold greatly increased the cost of the book. The person who bore this expense might exercise a varying amount of creative control, from broad indications of what he expected where, to detailed descriptions of decorations, and it is to him that manuscripts are most often attributed. The donor (the German word *Stifter* gives a better idea of his ambiguous function) is often mentioned by name in a manuscript, the scribe sometimes and the illuminator almost never. The donor was the intellect behind the work, the scribe his educated servant, the illuminator a menial.

Manuscript-writing is if anything harder work than illumination. As Prior Petrus wrote at the turn of the tenth century:

> Only try to do it yourself and you will learn how arduous is the writer's task. It dims your eyes, makes your back ache, and knits your chest and belly together. It is a terrible ordeal for the whole body.[4]

It is impossible now to build any clear picture of the full extent and mode of women's participation in the art of book-making. What has survived is the tiniest fraction of an enormous activity, which may have survived because it was extraordinary, and therefore carefully protected from wear and tear. The provenance of the surviving manuscripts of the pre-Carolingian era is so problematical that it would be foolish to base categoric statements upon it. Manuscripts wandered from owner to owner as wars, suppressions and indigence dictated.

In view of the invisibility of women in the tradition of Western illumination, it is especially ironic that the first great school of the Carolingian renaissance should be called the 'Ada School', after a donor known to us only as 'Ada ancilla dei'. It is a disheartening sign of present trends in scholarship that the Ada School is more often nowadays called the Rhineland School, and the older speculations that Ada was a sister of Charlemagne who became a nun are considered unscholarly.[5] From the earliest times women have been important as donors of sumptuous manuscripts, like the *Dioscurides Codex* made for Juliana Anicia, a Roman lady living in Constantinople in the sixth century. We may not infer from the sex of the donors that they asked women to do the work:

it is unlikely that nuns would have had the facilities in their scriptoria to carry out such work which was usually done by monks. The interest of women in book-illumination is a reflection of the sedentariness of their lives rather than of their concern for women's work.

The *Lindisfarne Gospels* and the *Book of Kells* were prodigious in their own times: few were the monasteries and fewer still the nunneries which had the resources to carry out such work. The bulk of calligraphic activity was of a much humbler workaday kind. Nunneries would have had their gospels and service books and hymnals, and used them every day until they fell to pieces. Most of them would have been lettered in coarse, bold script on thick parchment, with only as much vermilion as was needed to help in the reading, cut out, scratched and scribbled over as the rubric changed, and carefully mended in silken herringbone stitch when the worn skins tore. In the twelfth century, the revised Benedictine rule advised religious to shun vain ornament: for most nunneries this was to make a virtue of necessity. The manuscript of Isidorus of Seville in the British Museum, upon which seven nuns worked before it was completed in 1134, is probably fairly typical of the vast mass of calligraphic labour done by women.[6] It is written only partly on vellum, in inferior ink and a tolerably correct text; the occasional diagrams are beautifully drawn. A sketch for a miniature of the Crucifixion has not been miniated, although Book VII has some rather rudimentary illuminated capitals. The whole adds up to a picture of hard work, undeveloped skill and paucity of means.

At the end of the eleventh century women were more visible in the Church than ever before. Female saints were proliferating, many of them sprung ready canonised from pagan tradition. The cult of the Blessed Virgin was growing. The life of one of the wives of the Frankish King Lothar, St Radegund, who exercised great power from her convent of Sainte-Croix, is thought to have been written and illuminated there at the end of the eleventh century. The theory that her nuns are responsible is based on the derivative nature of the illumination, which shows strong reminiscences of the Winchester School of the preceding century and is generally carried out with the unsteadiness that typifies the work of copyists.[7] The book presents a conundrum in that the text has been executed in a later hand on the versos of the illuminations and on blank sheets inserted between them. It is possible that the miniatures had been painted separately as a commission to one monastery from another which could only attempt the calligraphic part of the work. Whatever the truth, it is clearly unwise to place any reliance on this manuscript as wholly the work of the nuns of Sainte-Croix.

Similar ambiguity clouds the role played by Herrad, the Abbess of Hohenburg from 1167 until her death in 1195, in the making of the famous *Hortus Deliciarum*, a 'curious crossing of Western or Byzantine influences with ancient traditions as well as frankly new techniques', according to Jacques Dupont and Cesare Gnudi, who make it the only exception to the twelfth-century decline in

German illumination.[8] Herrad, who saw herself as the bee of God distilling honey from her reading as balm for the souls of her nuns, gathered together for them a selection of improving readings in a massive folio of three hundred and twenty-four sheets of parchment written in a fat neo-Gothic minuscule with full-page miniatures.

How Dupont and Gnudi have come to such a generous conclusion is difficult to say, for the great book was completely destroyed when the library which held it was burned down in the Siege of Strasbourg in 1870. All that remains are tracings made in 1818 which can give no indication of linear detail, depth, colour, decoration or stylistic vigour, although they give some account of the iconography of certain depictions.[9] The only ground for supposing Herrad herself to be the illuminator is the closeness of the illustrations to the text. In some cases the text is actually contained within the illuminations, all of which seems to have been carried out on blank parchment, without diapering or other background and with no attempt at a decorative border.

St Hildegard of Bingen (1098–1179) evidently worked in close collaboration with the maker of her book *Liber Scivias*, recording and illustrating each of her thirty-five visions. Unfortunately the earliest known version, made not at

Diemudis, *Initial S*
Although there is no doubt that this is a self-portrait of a lady called Diemudis, it cannot be the same Diemudis who is recorded as working at Wessobrunn from 1057 to 1130, and even she is quite likely to have been two people of the same name.

Gisele von Kerssenbroek, *Codex Gisele, Initial P*
This is one of the fifty-two miniatures in the book made by this Westphalian nun in the thirteenth century. She has signed the edge of the Virgin's coverlet and given us a portrait of her community beneath.

Bingen but at Trier, has been missing from the Wiesbaden Staatsbibliothek since the Second World War.[10] One of its miniatures shows St Hildegard, her head clasped by miraculous flames, sitting with a wax tablet on her knees and a stylus in her hand, while a monk, probably the scribe, watches her, waiting to copy her writings into the book he holds.

Both Herrad and Hildegard might have instructed nuns to commit their visions to parchment. A woman called Guda tells us that she wrote and painted a twelfth-century *Homeliary of St Bartholomew*, preserved at Frankfurt-am-Main, describing herself as *peccatrix mulier*, which might be taken to mean that she was a laywoman or beguine.[11] Another laywoman, Claricia, has left a charming portrait of herself as the tail of an illuminated Q, painted with more verve than refinement.[12]

An illuminated *Augustini Sermones* in the Grand Ducal library at Wolfenbüttel is well-documented as the work of Ermengarde, a nun in the convent of St Adrian at Lamspringe, in the times of Prioress Juditha and Prior Gerard, who is mentioned in sources dating from 1178 to 1214.[13]

A woman called Diemudis signed a missal with historiated initials, now in

the Munich Staatsbibliothek, written in the Wessobrunn script but for Salzburg use. She may be the same Diemudis who was Abbess of Nonnburg in Salzburg until her death in 1136, although she cannot be the same Diemudis portrayed in an initial in another Wessobrunn book, which dates from a century later.[14] A sixteenth-century source lists forty-five books by a Diemudis, who evidently accepted commissions from other religious establishments besides her own.[15]

In the twelfth century the character of monasticism underwent a great and fundamental change. Women of the middle classes became attracted to religious life which could no longer be simply a more durable sphere of influence for princesses than the rough and tumble of military courts. Old-style abbeys disappeared to reappear as priories and convents where devout women lived according to strict rules, expiating the sins of the world in the three-fold observance of poverty, chastity and obedience. They were still dependent upon secular powers for their endowments, although their income might be augmented by soliciting donations or through the dowries brought to them by the richer brides of Christ. Inside the convents the class system prevailed as outside. The prioress was invariably noble, while the menial work was carried out by women from the lower classes who would continue to be as illiterate as when they came to the convent. Usually, in order to be professed, a degree of familiarity with doctrine and religious writings was required, but not all the sisters were professed. In addition to the economic pressures which secular powers might bring to bear upon religious establishments, there was the duty of obedience which the women's houses owed to their superiors, not only in their own religious order, but to their confessors and counsellors, the ordained clergy, and to the ecclesiastical hierarchy. In the monastic pecking order, convents, unless they enjoyed the exceptional favour of a very powerful secular ruler, came low down. Male monasteries acquired secular power of their own: female monasteries remained dependent upon it. The princesses Hilda of Whitby and Radegund of Poitiers were more powerful as abbesses than they would have been as wives, but after the reforms of Cluny and Citeaux, the entry of a princess into a monastery signalled her retirement from public life.

The thirteenth century saw the rise of secular scriptoria. Book-making was becoming a luxury industry, carried out in close proximity to the sources of money and power. Princes, noblemen and merchants were becoming book-collectors and the nunneries could neither hope to compete with the secular patrons nor with the professional scriptoria. Nevertheless, although the mainstream of illuminating tradition had swept past them, they worked on. The noblewoman Agnese of the house of Meissen, abbess of the ancient and powerful foundation of Quedlinburgh, is reputed to have written and adorned many books including a gospel which is still preserved.[16]

Gisele von Kerssenbroek wrote and illuminated a manuscript now known as the *Codex Gisele* (dated 1300, the year of her death) in the Cathedral Library of Osnabruck.[17]

According to a later inscription, the Gradual of the Cistercian nuns of Seligenthal was begun in 1232 by a nun called Elisabeth under the first abbess, Agnes, Countess of Freyssing.[18] It is a huge book written in a large and none too even Gothic script on coarse parchment. The colours of the initials are rather limited for this period but for all their simplicity and narrowness of range, the historiated initials are considerably expressive and energetic in a fashion which must already have been considered somewhat archaic.

Women were also working as illuminators in the professional scriptoria. Maître Honoré, the founder of the great Parisian school of illumination which developed at the end of the thirteenth century, was assisted by his daughter, whose name we do not know, as well as by her husband Richard de Verdun. A list of professional painters in Cologne, made in the fourteenth century, mentions one 'Johannes illuminator et Hilla uxor eius'.[19] Jean le Noir, whose patrons included Yolande, Countess of Bar, and then both King John and King Charles V of France, worked with his daughter Bourgot, described as a 'female illuminator'.[20] In none of these cases was the woman in a position to accept commissions on her own behalf, and probably not even to design and complete whole miniatures. From the earliest times illumination had been divided into specialties, and as the intricacy and ornateness of the work intensified under Gothic influence, the fields of specialisation increased in number. The ground of the illumination was prepared in gesso, so that it stood out from the parchment as if it had been embossed; the backgrounds were often diapered, embossed and burnished, ornamental borders spread down the sides of the pages; miniatures began to feature landscape and architectural backgrounds. A single page might show three or four hands, and various forms of decoration.

We know that Thomasse 'illuminator and inn-keeper' was living in the rue de Foin in Paris in 1292, but we know of no work by her or any other of the eight female illuminators listed as living in Paris during the late thirteenth and early fourteenth centuries.[21] We do not know either what kind of work was done by Marie de Sainte-Cathérine, 'la poindresse', who lived and worked in Lille from 1342–47.[22] In Bologna a woman known simply as Donella was working as an illuminator in about 1271.[23] The rules of the Confraternity of St Luke, founded in Florence in 1339, stipulated that women would have to pay two-thirds of the sum paid as dues by male members, but no woman was recorded by name in any of the documents of the company.[24]

Dupont and Gnudi, both unusually gallant among modern scholars, are of the opinion that the person who illustrated the copy of Boccaccio's *De Casibus Virorum Illustrorum* presented by Jacques Raponde to Philip the Bold in 1403 must have been a woman, on the grounds that she chose to show the noble paintress Thamar seated at her easel painting a *Virgin and Child*, surrounded by her brushes, paint-boxes and shells, while an apprentice grinds the colour, and in another miniature we see Cratinus' wife, Cyrene, colouring a statue, and yet again, Marsia, palette in hand, painting a self-portrait from her own reflection

in a mirror.[25] The grounds for the assumption must be admitted as slight, but as
so many errors are made on the side of obscuring the women who worked in
men's studios, we might permit ourselves the luxury of believing that Dupont
and Gnudi know best. They are also convinced that Anastaise, the illuminator
praised by Christine de Pisan in the *Cité des Dames*, illustrated the copy of that
book that she presented to Isobel of Bavaria, which they take to be the one in the
Bibliothèque Nationale in Paris. When they go on to say that in the miniature of
Folio 2, the 'artist has expressed with charmingly feminine naïveté her desire to
strike a modern note, while keeping within the bounds of due decorum', one
might be excused for losing faith in their motives.[26] The grounds for attribution
of certain works to women are themselves so frequently sexist that women
were best advised to come to their own conclusions. What Christine de Pisan
said was simply,

> I know a woman named Anastaise who has such skill and cunning making
> vignettes for illustrated books and landscape scenes for tales, that in Paris,
> where all such things are well paid heed to, none fails to commend her, nor is
> there any other who so sweetly and delicately limns as she, nor whose work
> is more esteemed, so rich and rare are the books to which she has set her
> hand.[27]

The secular limners did not drive the nuns from the field. Convents con-
tinued to need and to produce hand-written books. In Italy the convent of Santa
Maria in Siena was accepting commissions for books for outside churches, like
that of the Augustinian monastery at Lecceto, which had eight of them in the
period 1375–80. The directress of the scriptorium was a nun called Giovanna
Petroni.[28]

In the fifteenth century the monastery of San Giacomo at Ripoli boasted a
bustling scriptorium; three of the nuns' names have come down to us. Angelica
Miniberti signed a *Collectarium*. The noble Angela de'Ruccellai also worked
there as a copyist. The one illuminator whose name we know was Lucrezia
de'Panciatichi who worked there at the turn of the sixteenth century.[29]

Maria Ormand or Ormani taught the arts of book-making in an Italian
Augustinian convent. A *Breviarium cum Calendario* is now in the Imperial
Library in Vienna.[30]

Another Augustinian nun, Laura de'Bossi, achieved a considerable reputa-
tion as a calligrapher and miniaturist in 1485–88 in Pavia.[31]

South German Dominican convents devoted an unusual amount of time and
energy to book-making, as a consequence perhaps of the reforms of the
fifteenth century. Of the dozen or so convents working at the time, the most
remarkable is that of St Katherine of Nuremberg where, in 1443, one
Kunigunda finished her *Novum Testamentum Germanicum*. She may have been
assisted by Margareta Imhoff, who worked with the famous 'Nun of Nurem-
berg', Margaretha Cartheuserin, on the Winter missal that she finished in
1452.[32] Until recently it was thought that Cartheuserin was not only the scribe

Unknown, *Book of Hours*
 The early-fourteenth-century
 Flemish Book of Hours from
 which comes this miniature of a
 nun working as a copyist is
 anonymous.

but the illuminator of the ten books that she has left us, but more careful scrutiny shows the work of several hands. We know the name of only one of the artists, Barbara Gwichtmacherin: the fact that she is a woman makes it seem likely that the illuminations were carried out by sister nuns of Cartheuserin's convent.[33]

The books were so famous that a Dominican monastery of Cologne offered four hundred thalers for each volume, but the offer was refused. If it had been accepted, the provenance of the volumes might have remained a mystery, for manuscripts were seldom signed, title-sheets were often scraped or taken out and the parchment rebound in the style of the new owners. We shall never know how many convents fallen upon hard times had to sell their treasures or how many of those treasures represented the highest achievement of mediaeval woman, transmitted to us now as examples of the achievement of monks.

In Augsburg, in the mid-fifteenth century, a secular illuminator called Clara Haetzlern was making a name for herself, but her name is all we know about her.[34]

In the British Museum is a curious example of women's work called *Das Leben und die Wunderwerke des Heiligen Franciscus*, a German version of the biography by Saint Bonaventure, written and illustrated by Sibylla de Bondorff, a Franciscan nun under the rule of Suzanne de Falckenstein, in 1478. It is

written in cheap ink on paper in a little quarto book of two hundred and forty-eight leaves and copiously illustrated in a manner that has been called childishly coarse.[35] The miniator's palette boasts few colours, all of them fairly crude, especially the blue and gold; the drawings for the miniatures are made in fine bistre according to extremely simple types, and are not childish but

Maria Ormani, *Breviarium cum Calendario*, 1453
 The lavish foliated decorations in this book show that the artist was both confident and competent. In her portrait Maria is described as 'handmaid of God, daughter of Orman and writer of the book'.

primitive. The whole book is a labour of deep love and reverence, and into it the Franciscan nun put enough joy and faith to make up for the harsh vermilion, crimson and green of her colours, and the irritating way that the colours, probably mixed with glue, gather themselves up on the paper and blur the dashing contours of her figures. Compared to the exquisite intricacies of the precious books of the fifteenth century, Sibylla de Bondorff's is a daub, but I am not sure that in the jaunty way in which she solves the problems of her narrative, with jostling angels, and smiling friars and splashy flowers bursting from the ground beneath saints' feet, that she has not made something of unique beauty and effectiveness in its own unassuming style. (See Pl. 1.)

For the art historian the existence of this book implies what we have all along suspected about art in convents. The cheapness of the materials, the predominance of enthusiasm and energy over skill and technical mastery add up to a picture of fine book-making as beyond the scope of most female foundations. However, this is by no means the whole picture: a nun from the Schillings-kapelle convent near Heimerzheim called Margaret Scheiffartz de Meirroede is responsible for the wonderful decorations of a hymnarium bequeathed to the Pest National Museum by Count Carl von Wickenborg. The text is surrounded by richly illuminated borders with strawberries and the like on a golden ground as well as the drolleries beloved of the fifteenth century, and far, one would have thought, from the preoccupations of the convent. The book also contains little genre scenes like the ones being popularised by the secular scriptoria, especially those in Flanders.[36]

Flemish illuminators were finding themselves in great demand, and as book-illumination was a family business, we may be sure that their womenfolk worked with them, although we cannot with certainty isolate their contribution. The sister of Jan and Hubert van Eyck is documented as having worked with them. Modern impatience with her claim to artistic fame has gone so far as to call her a 'self-styled artist' which would suffice for this critic at least, if it were true. The efforts of dealers to fudge the vanished oeuvre of Margarethe van Eyck are disingenuous and irritating, but that she lived and worked is true nevertheless.[37] The wife of Gérard David, Cornelia Cnoop, was a miniaturist and at least one attempt to attribute a major work to her is on record. Clara, the sister of the humanist Robert de Keysere, is probably the author of the seven little pictures in the missal that he wrote for Charles V's personal use.[38] The guild list of Bruges gives us the names of two other women illuminators, Berlinette Yweins and the wife of one Lantsheere, but of their work we know nothing.[39]

Another secular miniaturist of Bruges had the unusual distinction of founding a convent scriptorium. Her name was Marguerite or Grietkin Scheppers. (She is sometimes confused with Elisabeth or Betkin Scepens who was a student of Willem Vrelandt in Bruges in 1476, after whose death she ran his business with his widow, and was a member of the artists' guild from

Crucifixion with Our Lady and St John
This miniature was probably carried out by the nuns of the convent of St Katherine in Nuremberg in the mid-fifteenth century.

1476–89.[40]) Marguerite Scheppers illuminated a missal for the Carmelite convent of Notre Dame de Sion in 1503 *par charité*; the inventory of the convent, published in *Le Beffroi*, makes it perfectly clear that Marguerite Scheppers was a professional limner who offered her services free and 'she taught this type of work to one of the religious', Sister Cornelie van Wulfskerke.[41] This information was ignored by the scholars who annotated the Brussels Exhibition of 1927, who claimed that the nuns were taught by the calligrapher Pieter van Balle, who was working in the convent at the same time and may well have taught them calligraphy, and the miniaturist, Geeraard de Tollenaere, who had illuminated two antiphonals in the last years of the fifteenth century before his edifying death in the convent. Both were Carmelite monks and had connections with the convent scriptorium, but it was clearly Marguerite Scheppers who undertook to teach the nuns to master the techniques of illumination. She continued working with Cornelie van Wulfskerke on a *De Tempore* Gradual until her death in 1505, when it was finished by her pupil, who also illuminated

the companion volume *De Sanctis*. Sister Cornelie was a hard worker; as well as these works she painted miniatures and capitals for the missals written by Pieter van Balle, and in 1512, we read in the same inventory, she was at work on an antiphonal with her pupil, Marguerite van Rye, and the partnership worked again on a summer missal, and on small books of music, while another *De Tempore* Gradual is attributed to Sister Cornelie alone.

The last of the illuminators of Notre Dame de Sion was Catelijne del Meere, who was professed in 1522. In 1536 she illuminated a missal that the sub-prioress had decided to finish writing after the original copyist had died in 1510.[42]

The need for large-format hymnals and service books continued after the

Dorothea Deriethain, *Medlingen Gradual, Initial L, c.* 1500
 Costumes and attitudes in this historiated initial showing the miracle of the loaves
 and fishes are archaic, the drawing reminiscent of woodcuts of an earlier period.

invention of printing. During the High Renaissance, many women artists worked as miniaturists in convents. The fall of Constantinople meant little or nothing to the woman who wished to be an artist. One of the few openings for her was still the convent scriptorium.

After the death of her husband, Tommasina del Fiesco, or Fieschi or Fiesca, entered the convent of Santa Maria delle Grazie in Genoa and in 1497 moved on to the convent of San Giacomo e San Filippo where she engraved, painted and wrote mystical tracts.[43]

Dorotea Broccardi, a Poor Clare in the convent of San Lino at Volterra, was illuminating and floriating her *Libro dell'Ordine di Santa Chiara*, now in the Biblioteca Guarnacci in Volterra.[44]

At the same time, in Germany, Dorothea Deriethain was illuminating the Medlingen Gradual, now in the Munich Staatsbibliothek.[45]

Book-collecting remained popular long after the invention of printing had rendered hand-copying otiose, and women worked as miniaturists right through the sixteenth century. Some of them, like the daughters of Lucas Horenbout, Susannah,[46] and of Jan Sanders van Hemessen, Caterina, became famous in their own right, and belong more properly to the history of portrait-painting.[47] In the mid-sixteenth century the daughter of a doctor, Anna Seghers, made a name for herself in Antwerp,[48] and Francesca de Firenze delighted connoisseurs in Florence.[49] The daughter of the famous Angelus Vergecius was supposed to have executed the drawings in the delightful little books that he wrote, like the *Manuel Philes de Animalibus* in the British Museum: nowadays scholars make no mention of her in describing Vergecius' work.[50] Vergecius' work itself owes a lot to the styles of the printed books of his time, especially those of Aldus Manutius, and the illustrations might serve as drawings for a woodcut maker or engraver and, in fact, eventually did. They were tinted by hand and heightened with body colour, which in the case of the *de Animalibus* has turned black. In dealing with Miss Vergecius we are already dealing with the art of illustration.

Doubtless in Iberia the arts of book-illustration had been practised since the beginnings of Christianity there, but the first woman whose name has come down to us as an illuminator was Philippa, the daughter of the ill-fated Pedro, Archduke of Coimbra, and sister-in-law to Alfonso V of Portugal. For a year she worked at illuminating a book of homilies on the Gospels, which she bequeathed to the convent of Odivellas.[51]

A hundred years later, in Spain, a nun called Donna Angelica made the choir-books for Tarragona Cathedral.[52]

There is much evidence that convents continued to copy books and decorate them, long after the tradition had otherwise died out. Their work was distinct from the art of the miniaturist, because it was still a matter of decorating a text. To this day convents place a high value upon ornamental script and teach various forms of attenuated calligraphic ornament. The blackboards in convent

schools often bear a fancy inscription in a debilitated version of uncial script, and holy pictures may carry illuminated prayers on the back. Religious activities do not lose their *raison d'être* because they have no earthly point or aesthetic value. With the Gothic revival and the various recrudescences of religious sentiment in the nineteenth century, pseudo–Gothic profession plats (or diplomas) and mass books abounded. All the nuns of the convent of the Blessed Virgin Mary of Nazareth in Brussels signed a Canon Missae Ponteficialis in the mid-nineteenth century. Séraphine Francisco Dupon is the author of an illuminated profession plat now in the Royal Library in Brussels.

Outside the convents, illumination and calligraphy have to some extent been kept alive by the manuscript societies of which women are often the mainstay.[53] Many artistic women are happier to confine their works to books, to the single viewer that books demand, and to work in a medium in which they are not under pressure. The results are often exquisite, but they are the palest shadow cast by the great tradition.

IX

The Renaissance

I shall not live long . . . I believe the candle is cut in four and burns at every end. It is not that I boast of it . . . Leonardo da Vinci did everything, and did nothing very well. Michael Angelo — but Michael Angelo, when he had to paint, did no sculpture for thirteen years. I invoke the great names. Do not laugh, I know I am nothing; only when one cites Michael Angelo or Leonardo the argument is unanswerable.

Marie Bashkirtseff, *Journal*, 10 December 1883

As far as we know, the greatest period of Italian art, and perhaps the greatest period of all Western painting, which began with Giotto and culminated in the achievements of Raphael, produced no female master. We do not in truth know very much about the painters of the Trecento and Quattrocento at all; most of what is usually taken as known is in fact believed, on more or less convincing evidence. We are confronted with a great body of wonderful painting, a few names of illustrious individuals, and a very, very small number of paintings upon which the names of some of the individuals have been written. Sometimes these paintings are called 'signed': generally it would be more accurate to say that they are inscribed. In the days before print culture, a painter might expect to be recognised sooner by his inimitable style than by the letters which composed his name, a name that was usually a sobriquet in any event.

At this time, as at every other, women must have been using some form of graphic expression. Nevertheless, however today's woman might chafe at the universal assumption that all unidentified works have been carried out by a man named *anonimo*, there is very little she can do about it. Very few names have come down to us and almost no authenticated work. To distinguish particular

Mechteld toe Boecop, *The Last Supper*, 1547
Mechteld van Lichtenberg came of a noble Utrecht family but chose to marry a
painter, Egbert toe Boecop, and live and work with him in Kampen. Although the
influence of Jan van Scorel is discernible in this large and confident work, it is
more remarkable for the strong personality of Mechteld herself.

works as feminine in style and therefore to assume a female painter is to
compound the operations of sexism. One might as well argue that Fra Angelico
was a woman. Like most of the matters debated by art historians, Fra
Angelico's chromosomal make-up is beyond scrutiny.

While asserting that Fra Angelico was a woman might be a useful guerrilla
tactic, we must be reconciled to the probability that none of the surviving
anonymous paintings of the Trecento or Quattrocento is by a woman. In order
to survive the vicissitudes of time, a tempera painting must be expertly made.
The process began with the selection and preparation of the board which had to
be filled and primed before the pigments were ground and tempered and
applied. Earth colours, still named after the provinces of Italy which supplied

them, were easy enough to handle, but whites were difficult and blues expensive. The undertaking required time and help. Pigments ground too coarse would not adhere, pigments ground too fine lost their brilliance, egg tempera turned precious blues green. Each school devised its own methods of solving the problems of the materials, as well as its own visual language. Each master conducted his own experiments for increasing the range of tempera painting. pera painting.

A boy of the artisan class had to learn a trade: if he showed interest or aptitude, he might be put to learn the craft of painting in the *bottega* of a master while he was still a small child. At first he would carry out the most menial tasks, tending the fire and sweeping the floor, anything at all that the master might ask of him. He might have to sleep on the studio floor with other boys. Gradually he would be given more demanding jobs, grinding pigments, cleaning brushes, then mixing and tempering colours and preparing boards, transferring the master's drawing to the board, painting in the ground, then actually painting the skies, backgrounds, drapery. When the master accepted commissions he was usually required to guarantee that he would handle the design and the important details of the composition himself. Whether he acknowledged and promoted his apprentice was largely a matter of his temperament. The work which emerged from the *bottega* was mostly uninscribed: when a name appeared upon it, it was always the master's. No dishonesty was meant thereby; Giotto used to 'sign' works which had been mainly carried out by his assistants. The name was evidence of his creative control, a guarantee of quality.

It is not now an easy task to recreate the atmosphere of a *bottega*. The gentlemen artists who turned critics and historians in the sixteenth century did not go through this procedure. The painters of the fourteenth and fifteenth centuries were not given to writing about what they did, but to doing it. Apprentices are a traditionally volatile group, and we may be sure that discipline in the *botteghe* was harsh and punishments violent and spontaneous.[1] The guilds gave masters enormous power over their boys, and only the most exemplary cruelty occasioned a rebuke. Some pigments were expensive, especially ultramarine which was ground from lapis lazuli, and easily spoiled. A boy's mistake might ruin months of work. For the boys, daily frustration and weariness must have been almost more unendurable than the kicks and beatings. Most of the boys who went to work in *botteghe* never became masters. Those who did spent as long as ten years doing it.

However rocky the road, the way to become a painter lay through the *botteghe*. The guilds might or might not have been able to enforce their rulings that no one who had not served an apprenticeship might accept a commission; for practical purposes no one who had not served under a master for some period of time *could* accept a commission.

There is no evidence that any female was trained in an Italian *bottega* in the Trecento or Quattrocento. Even the daughters of the masters themselves seem

to have been kept away. Male apprentices were usually forbidden to marry; for women the long years of training would have left them old and unmarriageable, even if they succeeded in retaining a spotless reputation in the rough and tumble of the apprentice community. The painters' daughters who married their fathers' best pupils were probably prepared by education in a nunnery or almost as efficiently cloistered in their mothers' quarters. Childbearing was an essential, full-time, dangerous job in those days of high mother- and child-mortality, plague and sporadic warfare.

Against all probability, one woman is recorded as having accepted a commission in the Quattrocento. Her story was first published by Conrado Flameno in 1590, in his *Storia di Castelleone*, a tiny town in the Cremonese.

> Onorata Rodiana, gifted young woman, and a Castillionese, painting the palace of Gabrino [Fondulo] killed with a knife a courtier of his for an act of scant decency used towards her. She fled by night dressed as a man, abandoning her family and her homeland, saying, 'It is better to live honoured outside my homeland than dishonoured within it.' Gabrino was profoundly displeased, tried her, and instantly pardoned her, but already she unknown to all had entered the service of Oldrado Lampugnano as a cavalryman, and that was in the year 1423. She lived then with her name and her clothing changed under various captains and held various military offices. She came then with Conrado, the brother of the Duke Francesco Sforza, in the year 1452 to the aid of Castelleone besieged by the Venetians, where she behaved with her usual valour and the siege was raised, but she was mortally wounded and carried into Castelleone, and recognised with great amazement, shortly whereafter she died, saying, 'Honoured I lived, honoured I shall die.' She was buried in the parish church with due solemnity on the 20th of August, 1452.[2]

The coincidence of the heroine's name, Onorata, and her remarkably felicitous way of punning on it at the climactic points in her life-story are the hallmarks of legend. The legend is still very much alive in Castelleone, a thriving agricultural town with a new parish church built in the sixteenth century, in which there is to be found no trace of any earlier funeral monuments. The Palazzo Galeotti-Vertua is commonly thought to be where Gabrino Fondulo took up residence and some of the locals believe that a pair of unfinished wall-paintings in it are the work of Onorata.[3]

The context of Onorata's activities and her associations with Oldrado Lampugnano and Conrado Sforza fit in with known facts and dates. On the strength of Flameno's use of the term 'virtuosa' to describe her, and the simple but tantalising assertion that she was 'dipingendo il Palazzo' of Gabrino Fondulo, the name Onorata Rodiana or Rodiani is to be found in all dictionaries of artists.

In the 1420s large-scale mural decorations were almost invariably undertaken in *affresco*, a technique requiring considerable expertise and great confidence in handling materials. The wall had to be prepared by the application of a granular

Mechteld toe Boecop, *Adoration of the Shepherds*, 1574
The remarkable state of preservation of these large panels indicates that Mechteld
had a thorough grasp of the technicalities of colour application. She was not
afraid, either, to show naked limbs and torsoes, with effects more expressive than
realistic.

plaster or *riccio*, which was roughly finished, or, if the walls were already
plastered, the old plaster was chipped to provide a rough surface that the
painter's fresh *intonaco* would adhere to. Generally the painter supervised, and
even carried out the application of both the *riccio* and the smooth *intonaco* which
formed the basis of his painting, for the correctness of its composition was
crucial. The pigment was then applied to the fresh *intonaco*, which was only laid

upon the wall in *giornate*, sufficient, that is, to be painted in a single working day while fresh. The *sinopia*, the underdrawing in red chalk for the whole design, was got in on the *riccio*, but for the day's work the artist had to proceed by memory, and no *pentimenti* were possible, for all colour applied was instantly amalgamated with the plaster as it underwent the chemical process of setting.

Tempera was used in mural painting, but usually only for retouching *a secco* for linear details, most of which quickly discoloured and fell off. If Onorata had mounted her scaffolding to paint on dry plaster in tempera, as a nineteenth-century version of her story claimed,[4] we cannot be surprised that none of her works survived long enough to be noticed by any art historian. If she painted in *affresco* she must have undergone a long and arduous training, a circumstance even more remarkable, in the days when women were comparatively often to be seen in command of troops, than her serving under the *condottieri*.[5] Yet, however unlikely Flameno's story is, it is still not impossible that Onorata Rodiana did undertake decorations in a residence of Gabrino Fondulo, and some Cremonese archive, perhaps the record of her trial for murder, might yet come to light.

A woman's name appears upon a large tempera painting of *St Ursula and her Companions*, at present in the Accademia in Venice. On the pediment beneath the saint's feet is lettered CATERINA VIGRI + BOLOGNA 1456. In 1456 a real person of that name led her sister nuns of her own reformed version of the Poor Clares from Ferrara to Bologna where, after sheltering in various temporary accommodations, they founded the convent of Corpus Domini. In 1463 she died after a life of such exemplary asceticism and piety that she was canonised in 1712.[6] Her name is included in lexicons of art principally because her friend and biographer, Suor Illuminata Bembo, says that 'she loved to paint the Divine Word as a babe in swaddling bands, and for many monasteries in Ferrara and for books she painted him thus in miniature'.[7] All the sixteenth-century commentators take up this reference in saying that besides her '*diligentissime miniature*' she executed miraculous paintings of the Holy Child, which were sent to the sick and often cured them.[8] The chief source of biographical data about the saint is, of course, the Holy See, but no interest has ever been evinced by the Church in her artistic activities. The most recent official biography by Father Bergamini does not reproduce any of her work or even discuss the matter of her miraculous pictures but carefully catalogues all the clichés of sanctity, like the time she was called away from her baking to hear a visiting priest only to find when she came back after several hours that the bread was perfectly cooked and tasted wonderful; and the fact that her body refused to rot, although to the eyes of an unbeliever the grotesque cadaver preserved in the chapel of La Santa in Bologna is quite sufficiently decomposed.[9]

The reliability of popular tradition may be tested by recourse to the Poor Clares in Bologna, who when asked which pictures in the convent are by the saint gesture at all of them. When pressed they indicate a small picture in the

saint's chapel, of the *Madonna with Apple*.[10] The painting is unmistakably Bolognese, even to the traditional design on the infant's *fascie*, but the iconography belongs to an earlier period. The anomalies in the posture of mother and child compared with the insipid rendition of the mother's face, and the fact that the painting is on canvas with plentiful addition of burnished gold, seem to indicate that this painting is a more modern version of an old original since decayed or lost.

Another *Madonna and Child* in a completely different style is also attributed to the saint and has had considerable success as a votive object.[11] The treatment of drapery is rhythmic, the posing and drawing of the group freer and more suggestive while linear decoration is incised in the surface of the board. In feeling and approach it seems much closer to the Venetian School and to the other paintings attributed to the saint than the *Madonna with Apple*. The nuns at Corpus Domini also keep a miniature on buckled vellum of Christ the Redeemer in the white robes of his resurrection, resting one hand on a floating book upon which is rather unevenly lettered 'In me all grace, in me all [?] and truth, in me all hope, life and virtue', while the other tiny hand is raised to show the Precious Blood trickling from his wounds. The background is inferior blue, the figure archaic with a huge head and tiny linear features. In two medallions in the upper corners a beautiful Annunciation is limned, effortlessly contained within the tiny circular space, conveying all the elegance and energy that is lacking from this laboured portrait of Christ.[12] It is possible that the larger picture was painted over a page of calligraphy, which had been decorated by an earlier and better artisan. From any examination of these three works, Caterina Vigri appears to have been not one painter but four.

When we come to examine the works attributed to Caterina Vigri outside her convent, the number of styles this remarkable painter exhibited actually grows. The Pinacoteca Nazionale of Bologna has a painting of *St Ursula* which has been attributed to Caterina Vigri but is very different from the one upon which her name appears in Venice.[13] The convention of representation is different, for the saint here is represented as encompassing her myriad of tiny followers with the hem of her cloak; the figure is extremely decorative and decorated but basically static. While the Venice *St Ursula*, although sharing some of the conventional motifs, shows five figures of equal size, in various curving and expressive postures; at their feet kneels a tiny nun in a white habit and black veil, not the habit of a Poor Clare.[14] Also attributed to Caterina Vigri, on the grounds of a superficial resemblance and her name lettered upon one of the frames, have been four pairs of female saints from the church of San Giovanni in Bragora in Venice.[15] The pictures all have something in common in the treatments of dress and hair and ornamental patterning, but the differences within this area of broad similarity are such that one would be obliged to believe that the painter had been completely re-educated between finishing one and starting another, and that completely different materials were available for each. This fact, combined

with the remarks that Suor Illuminata makes about Caterina's basic indifference to aesthetics as an end in themselves, leads one irresistibly to conclude that her simple breviaries and her tiny devotional pictures of the Christ Child were all she ever undertook.

The Venice *St Ursula* was X-rayed in 1941 and another largely indecipherable inscription appeared underneath the Vigri one. Moschini justly points out that in the case of minor artists attributions are more readily believed, but he overlooks the fact that however minor she might have been as a painter, Caterina Vigri was a major saint.[16] Her cultus exactly suited the counter-Reformation temper and became enormous. To this day devout Bolognese kneel before her grim remains and beg her intercession. Ignorant priests may have sought to satisfy public demand by identifying some of their more mysterious female saints as St Caterina Vigri (notably all three attributions are pictures of female saints, which nowhere is it said she painted) or they might even have sought to enhance the value of disprized works they held by saying that they were actually by Caterina Vigri.

Upon a pretty painting of *The Madonna and Child Enthroned* in the Pinacoteca Malaspina of Pavia appears the following inscription, 'opus reverende Domine Andriole de Baracchis hujus Monasterii abatisse 1489'. The composition is archaic: the Madonna looms over the tiny nuns clustered before her while any lingering illusion of depth is banished by the old-fashioned manner in which the background is underpainted in vermilion and filled with gold. The modelling of the haloes of mother and child and the angels behind them in gilded low-relief further emphasises the flatness of the picture plane. Donna Andriola has been called 'a mediocre and slavish follower' of her Pavese contemporary, Bergognone,[17] but any comparison of their styles makes it at once clear that she is not concerned to follow the better known painter anywhere. Despite superficial similarities in their chosen modes of representation, Donna Andriola's concerns are fundamentally different: the idealisation of Bergognone's slightly bloated forms is no more than a sweet, non-corporeal lyricism in her version of the mother and child, while her rendition of lesser figures is almost Gothic in its eschewal of all glamour. Her self-portrait in severe black wimple, holding a gilded crosier, might have been painted a hundred years before. Her palette is old-fashioned too: where Bergognone luxuriates in new cool blues and subtle tertiary shades, she continues to use the warm, reverberant jewel colours of a more formalistic epoch. She is oblivious to painters' fashions. Her object is to glorify God by beautifying her convent. (See Pl. 2.)

Another painting by her, an *Entombment*, is remarkable not only for the gallant attempts at rendering a foreshortened group of angels at its summit, who are engagingly miming woe at the sight of the dead Redeemer beneath them, but also for the expressiveness of the head of the virgin, painted in an angular emotional style which is by now quite unattainable for more sophisticated painters.

Andriola de Baracchis, *The Entombment*
Despite the shortcomings of the drawing and the extreme formality of the
composition, this panel exudes passionate religious feeling as well as a strong
aesthetic sense, both more typical of an earlier period.

Suor Barbera Ragnoni, *Adoration of
the Shepherds*
Some of the muddle in this
painting may be a result of crude
attempts at restoration, as the
panel is badly split. The least
interference is to be found in the
figures of the shepherds, painted
with wit, delicacy and firmness.

The inscription on *The Madonna and Child Enthroned* is part of the original
composition: Donna Andriola seems to have fulfilled the duties of both painter
and mother superior at the same time. Her monastery still exists, although it
was turned into an orphanage in 1790; the street is still called Via San Felice after
it. In the *sala capitolare* are frescoes thought by some to be further examples of
the work of Andriola de Baracchis.

The inscription on the Madonna may or may not be slightly later in date than
the painting itself, but there is no reason to believe that it does not state the
simple truth. What the words 'Suor Barbera Ragnoni', lettered across a painting
of the same period in the Pinacoteca Nazionale of Siena, might indicate is still a
mystery.

The original painting showed an *Adoration of the Shepherds*, with St Jerome,
set in a charming landscape in the Tuscan manner, with a meandering river

spanned by a strange bridge with a tower upon it. The Virgin is more delicate than the figures usually associated with Pacchiarotto, the artist whose disciple Suor Barbera is usually said to have been, while the shepherds and St Joseph are painted with quite remarkable virtuosity and insight. The ox rather unfortunately placed at the centre of the composition degenerates into a sort of brown curtain behind the manger where his leg ought to be, while the Infant is quite unlike the young of any earthly species. Generally, the parts of the painting that have not been interfered with show highly defined, clearly modelled figures, built up on green underpainting by the accretion of minutely modulated brush strokes as in miniature painting, while the feeling is closer to Pinturicchio than any Sienese artist of the end of the Quattrocento.

At some point, this small tempera painting has fallen into the hands of a barbarian, who had horribly transmogrified St Jerome into a senile St John in his coat of skins, holding, instead of St Jerome's stone, a crudely lettered scroll saying ECCE AG [nus dei]. The same hand has tinkered with various parts of the painting, possibly in oils, and may be responsible for the unconvincing architectural background as well as various sepia blears and smudges around the Virgin's head, the repainting of the figure of the Divine Child, and the striding letters across the bottom of the painting which spell out the nun's name. It is to be hoped that Suor Barbera was the original painter, whose work can be rescued by restoration, but as the provenance of the painting is unknown, until the massive *carteggi* of the convents of Siena have been thoroughly sifted we cannot be sure that she ever existed.[18] Various women of the Ragnoni family were members of the community of Santa Marta at the end of the fifteenth century, but I have not yet found one called Barbera or one who painted. The tendency among modern art historians is to suppose that Suor Barbera was the ignoramus who ruined a pretty painting by Pacchiarotto or Bernardino Fungai, which may be the case, and may not. The unevenness of the original in the treatment of the animals and the child may well be the marks of a convent miniaturist's attempt at something bigger.

We cannot really wonder at the invisibility of women in this, the greatest period of Italian art, even though Burckhardt, in his *Civilisation of the Renaissance* has asserted it as a fact 'that women stood on a footing of perfect equality with men'. 'There was no question of "women's rights" or female emancipation, simply because the thing itself was a matter of course.'[19] Reading Flameno's uncondescending and completely unsurprised account of the career of Onorata Rodiana one might see some superficial justification for this view, but it is actually highly inaccurate. The debate about the nature of women, and their ultimate capacity for development was an inevitable aspect of Renaissance individualism. Male self-interest, spelled out in humanist discussions of marriage and education, prompted the continuing subjection of women as wives and mothers. The realities of most women's lives were as brutal as ever they had been, however noble women might rule over their courts of flatterers, and

however independently they might express themselves in courtly debate. The idea of the virago, the woman soldier, the almost divine embodiment of the highest Platonic values, was a cherished fantasy, given humorous form by Ariosto, but however a man might dream of a heroic relationship with a superwoman, he had no intention of fathering her, educating her or of marrying her. The lives of most women were unchanged by the atmosphere of freedom and innovation that reigned in the courts of the tyrants, and for the noblewomen themselves, painting was still a craft practised by menials at their behest, and not a becoming exercise of the '*altissimo ingegno*' of a cultivated woman. She might describe and indeed demand certain forms of decoration for environments that she designed herself but she was unlikely to embark on the hard work of actual application of her aesthetic ideas.

In the fifteenth century there was no separation between art and craft and it is partly this unceremonious and intimate relationship with materials which provides the unique durability and strength of great Italian painting. Painters usually found themselves sharing their representation in the craft guilds with artisans in all kinds of related fields, from paper-making to pharmacy and glazing. For a noblewoman to enter such a tightly organised social structure, even as a dilettante, was not only unthinkable, it was impossible. It was almost as impossible for men of noble families. Condivi tells us that Michelangelo's father beat him in order to blunt his determination to join the ranks of artists with the sons of butchers and tailors.

Where painting was a family business, and women might without scandal get a modicum of training we do find that they practise as artists: in 1454, an eighth of the membership of the Bruges guild were women and in 1480, they were a quarter of the total,[20] while Antwerp records only one woman member from 1453 to 1500.[21] The guilds that accepted painters also accepted allied tradesmen; it may well be that the women's contribution was trifling or menial, but it is certainly a very different situation from the Italian one.

When the noble Cremonese, Amilcare Anguissola, sent two of his daughters to learn painting in the house of Bernardino Campi in 1546, he was setting an extraordinary precedent. In his *Discorso* of 1774, Lamo gives a curious reason for this, saying that Amilcare was hoping, 'through the nobility and worth of his daughters to render noble and highly esteemed in this city, the profession of painting'.[22] Campi is praised for avoiding roughness in his correcting of his female pupils, as well as for eschewing flattery. The presence of his wife in the household was doubtless of great importance, and she is mentioned by Sofonisba Anguissola with respect and affection, although no authority has seen fit to record her name or the date of her marriage.

By the time Sofonisba and her sister Elena went to live in Campi's house the moment of the High Renaissance was over. Raphael and Leonardo were dead. The Sack of Rome had shockingly exposed the rottenness of church and state and the frenzy of religious reaction known as the Counter-Reformation had

begun. Michelangelo had finished his *Last Judgment* in the Sistine Chapel and the tide of mannerism was flowing at its fullest when Sofonisba and her sister began to learn how to paint likenesses in oils on canvas.

Sofonisba Anguissola seems to have been regarded as something of a child prodigy. She certainly drew remarkably well as can still be seen from the unusually finished drawing which was famous in her own lifetime, of a boy bitten by a *gamberetto*.[23] The painting described by Vasari, of three of her sisters playing chess,[24] also exhibits an unusual kind of vivacity and an original concern for catching the atmosphere of daily life. The dubious appeal of

Sofonisba Anguissola, *Bernardino Campi painting the portrait of Sofonisba herself*
This painting, badly bituminised and falling apart, seems to be Sofonisba's painterly joke. The head of Campi is subtly expressive, in her own best manner, while her version of his version of herself is blank and moon-faced, larger than life.

low-life genre painting came to Italy in the sixteenth century with the Dutch painters Honthorst and Terbruggen, but Sofonisba's approach to genteel genre seems to have been entirely original. The art she learned from Bernardino Campi was very much more sedate, the useful art of official portraiture to the history of which she belongs.

Some explanation of Amilcare Anguissola's real motives in having his daughters trained as artists might be found in the fact that Sofonisba is the eldest of no fewer than six daughters, for whom dowries had to be found. Their younger brother Asdrubale was not taught painting, but all the girls were encouraged to develop as many accomplishments as they could. We do not know if Anguissola paid Campi or what he paid him for the three years that his daughters lived and studied in his house, but it seems clear that they were not apprenticed in the regular fashion but were treated as paying guests in the household. Campi seems to have had no other students at the time. The investment was a wise one. Sofonisba was not only enabled to earn herself a handsome living, but she also taught her sisters, Lucia, Europa and Anna Maria.

Lucia, her most gifted pupil, died in 1565 leaving only one signed, dated picture, a portrait of Pietro Maria, doctor of Cremona,[25] but recent researches have tended to verify the judgment of sixteenth-century commentators that she was more gifted than her teacher and to ascribe some of the work usually attributed to Sofonisba to her.[26] Her mature technique is remarkably spare and expressive with an original painterly manner quite unlike her sister's more formal and old-fashioned compositions. Anna Maria has left a rather clumsy *Holy Family with St Francis* in the Pinacoteca at Cremona,[27] while Europa, who enjoyed the protection of Antonio Campi, seems to have actually carried out commissions for the church of Santa Elena in Cremona.[28]

Amilcare Anguissola did set a precedent. Ten years or so after the Anguissola girls began to study with Bernardino Campi, Alessandro Allori accepted Lucrezia Quistelli della Mirandola as his pupil, and Orlandi goes so far as to say that 'with her talent spread abroad in many pictures and portraits she won the right [*meritó*] to enjoy as her husband a knight of noble blood'.[29] In fact she married Count Clemente Pietra. In her case, training as a painter certainly functioned in lieu of a dowry. Titian agreed to instruct the granddaughter of his friend Paolo di Ponte, Irene di Spilimbergo, perhaps for some similar motive, for she and her sister had been orphaned of their father and been sent to live in their grandfather's house when their mother remarried. She painted three pictures, *Noah entering the Ark, The Deluge* and a *Flight into Egypt*, according to Count Maniago in whose family the pictures were for a time preserved.[30] As a result of going from her warm bedchamber into the loggia of her Venetian home to begin painting early on a cold morning, she fell ill and died at the age of eighteen. Her death occasioned a public show of mourning by the *accademici* of Venice. A collection of poems written by every eminent Venetian contemporary on the occasion of her death was published in 1561. In the introduction it is

Lucia Anguissola, *Pietro Maria, doctor of Cremona*
This painting is the only authenticated work of Lucia Anguissola, and a poor basis for further attributions for, as she notes in her signature on the arm of the chair, she was 'adolescent' when it was painted.
Nevertheless, the portrait has dignity and character.

said that 'having been shown a portrait by Sofonisba Anguissola, made by her own hand, presented to King Philip of Spain, and hearing wondrous praise of her in the art of painting, moved by generous emulation, she was fired with a warm desire to equal that noble and talented damsel [*valorosa donzella*]'.[31]

Irene threw herself into her work, in the space of a month dashing off such excellent copies of Titian's works that everyone who saw them was amazed. She was deemed 'worthy to be the wife of a prince until death eloped with her'.[32]

In 1559, the year of Irene di Spilimbergo's death, Sofonisba was called to the vice-regal court of Milan whence she was escorted to the royal court in Madrid with great pomp and ceremony and a bevy of attendants. Among them may have been one of her sisters, as well as the Milanese craftswoman Caterina Cantoni who specialised in life-size portraits in needlework, which could be viewed with equal effect from both sides. Sofonisba worked there for more than twenty years.

We know almost nothing of what Sofonisba Anguissola accomplished there. She was well-paid, in the customary manner with rich gifts rather than a regular stipend; most but not all of the work that she has left is portraiture and is discussed in detail in that chapter (pp. 251 ff). As a court portraitist she probably had to do a good deal of copying of her own work, as well as recording the

Sofonisba Anguissola, *Husband and Wife*
 Despite the simplicity of the composition, the feeling of this portrait of a couple is
 both complex and intense.

minutiae of the trappings of state. She can have had small opportunity for the
kind of vivid sympathy that appears in her portrait of husband and wife in the
Galleria Doria Pamphili in Rome.[33] In 1580, when according to van Dyck's
computation[34] she must have been already fifty-two, the King of Spain offered
to find her a suitable husband. As an unmarried woman she had all along been a
ward of the King; her only escape from this filial rôle was as the ward of a
husband. She asked her royal patron if she might marry an Italian, whereupon
the King produced a Sicilian, as the next best thing, with the Hispano-Italian
name of Fabrizio de Moncada, along with a dowry of twelve thousand ducats.

When he died, four years later, she was recalled to Spain, but she begged permission to visit Lombardy, her homeland, which had as little in common with Sicily as Spain. She never did arrive in the Cremonese, for she married Orazio Lomellino, the captain of the ship taking her from Palermo to Genoa, and seems to have spent the rest of her long life in one or other of the two places.

Victorian commentators are somewhat outraged at what they take to be an improper predilection for senile marriage.[35] Life for an unattached foreign woman in the Spanish court cannot have been easy. Although all authorities repeat that she bore herself with irreproachable dignity and reserve, she might well have quailed at the thought of going back to drudgery and dependence upon the royal whim. Her long employment at the Spanish court may have been less a matter of choice than commentators usually suppose. Marrying Lomellino may have been less an indication of how 'buoyant' she was in her private life than how keen a sense of self-preservation she had.

The circumstance of Europa Anguissola's church commissions is recorded without comment, but it is in its way no less remarkable than Sofonisba's career in Spain. Women had executed paintings for churches before; Suor Plautilla, born Pulisena, the daughter of the painter Luca Nelli, had entered the Dominican convent of Santa Caterina di Siena in Florence in 1537, when she was fourteen, and there she carried out large works like the *Last Supper* from a cartoon by Bronzino, at present in the Refettorio of Santa Maria Novella in Florence.[36] The painting is vast, and although it reveals clearly that Suor Plautilla is no Bronzino, it also shows that she was perfectly capable of working a fully finished painting on a huge scale. The colours are harmonious, balanced, rich and warm, the feeling solemn and dignified, if undramatic. The painting of the table, which she may have been able to observe in a way impossible with her thirteen figures, is quite remarkable; the sureness of her touch in dealing with the sparse, simple shapes and textures of the paschal meal (except for the lamb which is rather unfortunately placed under the Redeemer's nose, although he has just said the words of consecration and is handing bread to Judas) reveals a talent which would have profited by more systematic training.

An earlier painting, the *Deposition*, in the museum of San Marco in Florence,

Suor Plautilla Nelli, *The Last Supper*
Only in her painting of the supper table does this nun's personality emerge through Bronzino's design.

was the subject of considerable merriment when it was first seen by the public.[37] The design is said to have been by Andrea del Sarto, but it appears to have been a much less prescriptive design than the one Bronzino supplied for the *Last Supper*, and a much more challenging composition. On the left rises a precipice with a tortuous road leading up to the three crosses and various small figures and groups of figures. Beyond lies the shell-pink city of Jerusalem, on the right a knoll is crowned by a basilica, an ambitious landscape setting even for del Sarto. The foreground is dominated by the dead body of Christ, supported by St John. The tradition is that Suor Plautilla, in search of a model for the figure of Christ, availed herself of the corpse of a defunct sister and the other sisters jokingly used to say that 'Nelli instead of *Cristo* did *Criste*'.[38] Clearly, Suor Plautilla's art did suffer from the enclosed nature of a nun's life, quite different in this respect from the lives led by those male Dominicans who were painters. The figure of Christ is a pewter dummy with plucked eyebrows, but the figures of the women grieving over him are, despite the tackiness of the medium that she learned from Fra Paolino di Pistoia, expressive in a dramatic but non-rhetorical fashion by now quite unusual in religious painting. In their white wimples they might as well have been sisters of her community and she painted them with complete confidence and understanding. They express their grief not in extravagant postures, but in huddled weeping, their eyes reddened and dashed with tears, the Gothic tortuousness of their simple drapery echoing this intensity of feeling. Behind them stand a bearded lady who must be Joseph of Arimathea, and Nicodemus, a strange figure in hook-on beard and Assyrian toque. The whole work is a kind of monument to the High Renaissance, undertaken in the sincerest spirit of emulation, revealing by how much the moment for such work was past, and how far this gifted woman, instructed in the art of painting at the instance of her mother superior, Camilla de'Rucellai, was estranged from the living current of art and unable to find her own graphic language in a waste of eclecticism.

Suor Plautilla did not lack commissions. She painted a huge picture for the monastery of San Luca in Pistoia, of the *Madonna and Child, with Sts Thomas, Augustine, Mary Magdalen, Catherine of Siena, Agnes, Catherine of Alexandria and Lucy*, which was received much more kindly than her *Deposition*, but which is now lost.[39] Two ladies of Florence both owned *Annunciations* by her hand. She was reputed to be more successful in small works, like a predella of *St Zenobius* which she carried out for Santa Maria del Fiore. An *Adoration of the Magi* may yet be mouldering in a storeroom of the Uffizi. The Gemäldegalerie in Dresden used to have a *Temptation of St Antony*, from an original by Fra Bartolomeo.

The revival of the graphic arts in monasteries was one manifestation of the spirit of the Counter-Reformation. The iconoclasm of Protestant reformers had no parallel in sixteenth-century Catholic thinking, but it was realised that church art had wandered away from its central concerns, in that, however orthodox the iconography of its treatment of the central events of religion, the

emphasis and feeling was unmistakably anthropocentric. The turbulence of mannerism gave vivid expression to human doubt and rebelliousness as well as attesting the higher forms of spiritual experience. As ecclesiastical art for every day, the works of Rosso and Pontormo had fairly obvious shortcomings: they were if anything too individual and too great to lead a workaday soul by the most direct route to God. While the church reformers accepted much of the classicism and eclecticism of the sixteenth century, they might well have yearned to do for painting what they had managed to do for music, to restore humility and devoutness, so that the art form did not interpose itself between God and man. The convent *pictorie* were the ideal places to create a self-forgetful church art, if such art were ever to be possible again. Given the nuns' vow of poverty, they were also the cheapest places.

For women attracted to painting, the convents offered the only chance of avoiding the trials of family life. The women of the Alberti family, which had been producing painters for two hundred and fifty years, preferred to renegue on their dynastic duties and become convent painters. A *Pietà* for the high altar of the church of the Buon Gesù in San Sepolcro is by either Clara or Elisabetta Alberti.[40] Brigida Franciotti entered the convent of San Giorgio in Lucca in 1523 and worked there as a painter and sculptor.[41] At the convent of San Rocco in Ferrara, Suor Ippolita Tassoni painted a *Christ Carrying the Cross* and an *Entombment* in about 1540.[42] A mid-sixteenth-century painting of the *Madonna and Child with Angels and Saints* in the Pinacoteca Comunale in Spoleto is attributed to Ginevra Petroni.[43] Suor Plautilla is reputed to have trained other nuns, like Suor Prudenza Cambi, and the five daughters of Francesco Traballesi, of whom we know only Agata by name, Maria Ruggieri and a Sister Veronica.[44] Their principal activities may not have been very different from the holy picture industry as it is still practised. At San Vincenzo al Prato, the nuns used to paint 'Angels which were carried throughout all Italy, with much veneration, as much because they came from this holy monastery where there were a hundred and fifty noble handmaids of God'.[45]

We know nothing about the way in which the laywoman Europa Anguissola secured her church commission, whether or how much she was paid. Antonio Campi had taken over her training and it may have been he who contrived it, for he certainly designed both the pictures that she painted for the church of Santa Elena in Cremona (suppressed and destroyed in 1808). It seems likely that these are the same works to be seen in the parish church of Vidiceto outside Cremona.[46] The Pinacoteca of Cremona has a *Madonna of the Scodella* painted on copper by Europa Anguissola, apparently left to the gallery by the family of Europa's mother, Bianca Ponzone.[47]

There is no record either of how the other Cremonese painters reacted to Europa's entry into their field, and whether the guild brought any pressure to protect the interests of its members. Guild power was by now breaking down. The sixteenth century saw the gradual widening of the rift between art and

craft, a process which was abetted by patronage which demanded the right to recognise talent and to create *maestri* on a level on which the guild authorities were powerless. Painters themselves were aspiring to a position of greater esteem and insisting on the nobility of their profession. Although technical expertise was hardly less important or easier to acquire, discussions of painting laid small emphasis upon matters that dirtied the hands and devoted themselves to discussions of decorum, iconography and the mathematics of composition as part of their attempt to raise painting to the status of a liberal art.

The tyrants of the fifteenth century had been willing and able to override the guilds in their exercise of private connoisseurship, and the artists were only too glad to be able to dictate the modes of their own composition rather than fulfil the stereotyped demands of public art with a defined political and religious function. The great Florentine mannerists were forced, in the isolated condition in which they found themselves, to be more and more parasitic upon their own personalities and private fantasies.

The Counter-Reformation had little use for troubled genius working out the obsessions of individualism, however staggering its vision. What was needed was a public art, accessible to all, expressing religious orthodoxy in a decorous and sympathetic manner. Sumptuous and heroic celebration of human spiritual sublimity was not required in the great re-edification plan. Idiosyncratic visions led to heresy, to the kind of mystic experience which was characterising the non-conformist sects among the Protestant rebels: the Papacy looked beyond Florence where the enlightened patronage of the Medici had created the modern type of artist to its favoured possession, Bologna, where the religious art which was to dominate Europe for three hundred years was developing. An unprecedented number of women painters was involved in that development.

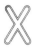

X

The Magnificent Exception

Across the broad continent of a woman's life falls the shadow of a sword. On one side all is correct, definite, orderly; the paths are straight, the trees regular, the sun shaded; escorted by gentlemen, protected by policemen, wedded and buried by clergymen, she has only to walk demurely from cradle to grave and no one will touch a hair of her head. But on the other side all is confusion. Nothing follows a regular course. The paths wind between bogs and precipices; the trees roar and rock and fall in ruin.

Virginia Woolf, 'Harriette Wilson', *Collected Essays*

Great genius is the exception that makes the rule. It is always and everywhere gratuitous; the wonder is not that genius does not appear on earth more often but that it ever appears on earth at all. Like most other women painters, Artemisia Gentileschi was the daughter of a painter, but she was not his collaborator. At one time she wished to be the wife of a painter, but she was saved from this fate against her own will. The retired life of women was an impossibility for her and so she lived aggressive, independent and exposed, forcing herself into the postures of self-promotion, facing down gossip, and working, working with a seriousness that few other women ever permitted themselves to feel. (See Pl. 3.)

When Anna Jameson saw the masterpiece of Artemisia Gentileschi in the Palazzo Pitti in 1822, she was thoroughly appalled. This 'dreadful picture' she called it, 'a proof of her genius and of its atrocious misdirection'.[1] The painting depicts an atrocity, the murder of a naked man in his bed by two young women. They could be two female cut-throats, a prostitute and her maid slaughtering her client whose up-turned face has not had time to register the change from lust to fear. The strong diagonals of the composition all lead to the focal point,

Artemisia Gentileschi, *Judith beheading Holofernes*
The apocryphal Jewish heroine had been depicted in many ways but never as a brutal, cold-blooded killer.

the sword blade hacking at the man's neck from which gouts of blood spray out, mimicking the lines of the strong arms that hold him down, even as far as the rose-white bosom of the murderess.

The excuse for such portrayal is, of course, the apocryphal story of Judith and Holofernes, which might equally well justify the portrayal of Jewish beauty (as

it did for Rembrandt) or of a mistress's careless cruelty (as it did in the luscious version of Cristofano Allori). Artemisia Gentileschi's choice of depicting the act of decapitation itself had been made before, by Elsheimer and of course by her father's erstwhile friend, Caravaggio.[2]

Artemisia's treatment of the same subject clearly refers to Caravaggio's painting, but in no spirit of emulation; rather she has decided to outdo her predecessor. The composition is swung around and tightened into a terrible knot of violence. The tension away from the act which divides Caravaggio's canvas is abandoned, for all the interest centres upon the ferocious energy and application of dark, angry Judith, who plies her sword like a peasant woman slaughtering a calf, in a claustrophobic oval of light filled with restless see-saw movement. There is no concession to decorative effect in the composition: the warm transparency of Artemisia's palette and her delicate chasing of linear effects, the rippling of the tufted hem of the bed-covering, the tinkle of blood against Judith's jewelled forearm, the sprouting of Holofernes' hair through her rosy fingers, are all expressions of callousness. The spectator is rendered incapable of pity or outrage before this icon of violence and hatred, while he is delighted by such cunning. The painting was, in its own time, both notorious and inconspicuously exposed.

The facts of Artemisia's life are gradually emerging from the fog of inattention which has obscured them for three hundred years.[3] Her birth is recorded in the baptismal register of San Lorenzo in Lucina in Rome, as having taken place on 8th July 1593. We may be sure that this is the Artemisia who grew up to be the great painter of the war between the sexes, and not some elder sister who died in infancy, because of her father Orazio Gentileschi's claim in a letter of 1612, that he had been training his daughter to follow his profession for three years. None of his three sons was to become a painter.

This birthdate, earlier than was thought before the entry was discovered, reinforces Artemisia's claim to be the painter of the *Susannah and the Elders* in the collection at Schloss Weissenstein in Pommersfelden which is inscribed ARTE GENTILESCHI 1610. The palette is her father's, but the design and the figure of Susannah are Artemisia's. Only she could paint female figures which had a skeleton as well as flesh and skin texture. Susannah's pelvis is not the invention of voluptuous fantasy, but something observed and understood. Her body is not displayed in Susannah's conventional posture of self-caressing, to excite the observer: she sits heavily, crumpled against the cruel stone of the coping, turning her face away from implication in the tangled drama of the two men conspiring to destroy her. Her useless hands do not so much defend her, as draw her into ruinous complicity with her enemies. The daring of the composition, with its tight lozenge of busy movement crushing the naked vulnerability of the innocent female body, is clearly derived from Gentileschi *père*'s boldly asymmetric approach but the shallowness of the spatial arrangement is more typical of Artemisia.

Artemisia entered public life in 1612, when her father brought an action against his friend and collaborator, Agostino Tassi, for raping his daughter and taking away paintings from his house, including a 'rather large *Judith*'. The records of the trial are preserved in not quite legible condition in Rome but as they consist only of the depositions at the trial and not the deliberations of the justices and their final verdict, it is not easy to discover what was deemed then to be the truth of the matter.[4]

Apparently, Tassi went to great lengths to see Artemisia, who was kept, as most Roman women of marriageable age were kept, in seclusion. He contrived to get a sight of her, and then to visit her with the connivance of her chaperone, one Tutia, of whose son Artemisia was painting a portrait. He visited her on a second occasion and, despite her spirited resistance during which she drew blood from her assailant, he overpowered her and raped her.

In his complaint, Orazio said that the offence was repeated *più e più volte*, which has occasioned some sneering at him and his unfortunate daughter. What Orazio was anxious to establish was that Tassi deflowered his daughter under promise of marriage, that she understood herself to be betrothed when in fact she was dishonoured – in Orazio's term *assassinata*. Her father's letter to the Grand Duchess of Tuscany, beseeching her to counteract the effects of Lorenzo's intercession on Tassi's behalf, made it clear that at the time of the defloration neither he nor Artemisia knew that Tassi already had a wife. The *nozze di riparazione* were then, as now in Southern Italy, the acceptable sequel to the ravishment of a virgin, a survival of the ancient custom of marriage by capture. The man and woman involved in such violent wooing might continue in intimacy until a marriage ensued. The fact that Tassi took paintings from the house indicates that he was allowing himself the privileges of a prospective member of the family and one entitled to dowry.

It is not easy to disentangle the chronology of these events. Artemisia may have been only fifteen when Tassi raped her, as Gentileschi suggested in his deposition, and the offence may have been committed before Tassi was arraigned on an accusation from his sister Olimpia that he was committing incest with his wife's sister. However, Orazio explained to the Grand Duchess that he himself had helped Tassi to beat that rap, so by then he must have known that Tassi had a wife. He could only have supposed that Tassi would marry Artemisia if he believed the rumour, which was also repeated in court, that Tassi had arranged for his wife's murder. By the time he wrote to the Grand Duchess, he seemed to have considered that Tassi's wife was living, for he called her, her sister (Tassi's mistress) and Tassi's three sisters, prostitutes. He claimed also that Tassi had a brother who was hanged and another brother banished for procuring sodomites.

The unavoidable conclusion is that the society of artists among which Tassi and Gentileschi moved was lawless and unsavoury. Once she was deflowered by Tassi, Artemisia was exposed to the intrigues of this group, for Tassi took

her on picnics in the Campagna in company with his sister-in-law and her notoriously obliging husband. The only way he could escape the *nozze di riparazione* was to make a whore of her, and his drinking companions were only too willing to oblige. One in particular, Tassi's hanger-on, a repellent individual called Cosimo Quorli, tried to arrange a gang rape.

Orazio Gentileschi was an old hand at litigation. He must have known that patronage was more relevant than guilt or innocence and yet he wilfully exposed his daughter to torture and the risk of disgrace. It would have to be proved that she was a virgin before and that she had not become a whore since Tassi had deflowered her. She was subjected to the thumbscrew in front of Tassi, to whom she cried out, 'This is the ring and these the promises you gave me.' She did not alter her story but Tassi and his friends, some of whom were subjected to torture, were equally resolute in insisting that she was a whore. After five months of sleazy revelations the trial ended and Tassi was released from gaol.

During the trial, Artemisia had had one champion, who protested against the frivolous and cynical way that Tassi and his cronies had ruined her life. He was a Florentine, Giambattista Stiattesi, a very intimate friend of Tassi's, to judge from some erotic poems produced in evidence as having passed between them. A month after the trial ended, Artemisia was married in the church of Santo Spirito in Saxia to one Pietro Antonio di Vincenzo Stiattesi. Of her married life we know very little.

The abortive trial had left Artemisia nothing but her talent. It also removed the traditional obstacles to the development of that talent. She could no longer hope to live a life of matronly seclusion: she was notorious and she had no chance but to take advantage of the fact. She was probably in love with her rapist, for Tassi's charm is evident in the loyalty that he excited in all kinds of people.[5] He was a dashing figure, handsome and black-bearded, often to be seen on horseback and sporting a golden chain in defiance of the sumptuary laws. Artemisia did not choose to dwell upon her disappointment. She refused to deal in pathos and the softer emotions, and, as a result, alienated all those critics and historians of art who nurture the usual presuppositions about women. She developed an ideal of heroic womanhood. She lived it, and she portrayed it. It was not as crassly misunderstood in her own lifetime as it has been ever since.

One man of culture and discrimination who was not repelled by Artemisia's notoriety was Michelangelo Buonarroti the Younger, who commissioned her to paint an emblematic figure of *Inclination* as a ceiling decoration for the Casa Buonarroti.[6] The design was a naked woman 'of most beautiful, very lively and proud aspect, holding a compass, a bright star shining above her like a guide'. The commission was a recognition of Artemisia's proficiency in the depiction of the female nude: the *concetto* was probably invented by Michelangelo who had no reason to repent his act of academic gallantry, for the painting she furnished was universally admired. By the next generation, sensibility had

altered so much, that Michelangelo's heir, Leonardo, had the nudity of *Inclination* covered by Baldassare Francheschini, Il Volterrano. Artemisia's allegory became a coquettish semi-draped ornamental figure.

Artemisia and her husband had been in Florence since 1614. It seems that Artemisia was associated with the Accademia del Disegno, which allowed her and her husband to run up bills for painting materials. In 1616 she matriculated and in 1620 we hear of her petitioning the Grand Duke Cosimo II for permission to return to Rome for family reasons.

Perhaps the Grand Duchess Maddalena had responded to Orazio Gentileschi's appeal by prompting the extension of grand ducal patronage to his daughter. Artemisia's use of her uncle's name, Lomi, which Orazio had abandoned for his mother's name, Gentileschi, would seem to separate her from her father. Artemisia's return to Rome might have been occasioned by the news that her father was leaving Rome and her younger brothers. However, to assume that father and daughter were estranged is as unjustifiable as to assume that father and daughter worked and travelled together, failing more significant evidence.

The paintings by Artemisia in the Grand Ducal collection all date from this period. The *Judith and her Maidservant* in the Palazzo Pitti is clearly derived from a lost painting by her father, perhaps the 'rather large *Judith*' which was confiscated from Tassi by the Tribunale del Governatore, of which at least two copies exist, one in the Statensmuseum in Oslo and another in the Bernaldo de Ourios collection in Madrid. Perhaps Artemisia's hand can be seen in the ornamental details of the Oslo canvas, which are typical of Artemisia's Florentine period and untypical of her father at any time.

The Pitti *Judith and her Maidservant* squeezes the composition of the Oslo version, by moving the women closer together, so that Judith's right hand rests on the maid's right shoulder rather than her left. The emphasis now falls upon the complicity of the two women; the lyrical flow of the drapery in the Oslo version becomes the tortuousness of implication. The treatment of still-life elements like the basket and the bloody napkin is less indulgent. The inclusion of crackling decorative detail in the embroideries on Judith's robe, her jewels and the pommel of her sword are annoying but typical of Artemisia's work in this period. Another version of this painting, in the Galleria Corsini in Rome, perhaps more successful, shows these details considerably modified.

To this period belongs the *Judith beheading Holofernes* (now in the Uffizi) and the sumptuous *Penitent Magdalen* in the Pitti. In the latter, we may see the same translucency of colour and deep, smooth finish upon which the linear effects sparkle like filigree, that characterise the *Judith beheading Holofernes*, which is alas, not so well preserved. The simplicity of the Magdalen's pose and the flush of her tear-stained features are ironically contrasted with the irrelevant opulence of her rose-pearl shoulders and heavy gold gown.

By this time Artemisia had developed her own dramatic language, which is

not that of elevated emotion, but of irony and detachment. There is no less feeling in her work than in that of any of her contemporaries but the feeling is of a different kind, not always recognised as such. It is discriminating, intelligent and passionate, rather than soft or self-indulgent. The effects she strove for were grand ones: the predominant theme, a celebration of human and especially female potential, was profoundly alien to the prevailing artistic temper.

It has often been noticed that Artemisia's female figures are strong rather than charming; one is often puzzled by the impression of massiveness conveyed by Artemisia's spatial organisation and her exaggeration of certain features, especially the size of hands. The women are unconsciously voluptuous, engrossed as they are in their own activities. The splendour of their garments and the glowing of their skin is a thematic irrelevance relished by the less heroic spectator almost guiltily. The conflict is deliberately evoked.

While living in Florence Artemisia seems to have borne at least one daughter. In the census of the *quartiere* of Santa Maria del Popolo in Rome in 1624, four people are listed in Artemisia's modest household, the painter, two servants and a six-year-old girl called Palmira. The next year only a six-year-old called Prudentia is listed, and the next only Palmira. Rather than assume that this is one child with two ages and two names, we might as well assume that Artemisia had two daughters, neither of whom lived with her all the time. Stiattesi is not mentioned: he may have remained in Florence.

Baldinucci lists other works carried out by Artemisia in her Florentine period, an *Aurora* and a *Rape of Proserpine*. The *Lucrezia* in the old Durazzo-Adorno collection is probably another work from this period, although the languid Odalisque equipped with an asp and labelled *Cleopatra* (in the Palazzo Rossi *deposito*) is not a good Artemisia if it is an Artemisia at all. Many other works, including the small fruit pieces mentioned by Baldinucci, must have been lost.

The existence of the Bologna portrait known as *The Portrait of a Condottiere*, inscribed on the back 'Artemisia Getilsca faciebat Romae 1622', not only indicates that she had set up her studio in Rome and was accepting commissions by 1622, but that she is a portraitist of the first rank. This remarkably well-preserved and little-known painting shows her characteristic transparency of medium together with a subtlety of lighting which suggests an influence far from Roman Caravaggism, closer to the mood of Velázquez.

The subject is no *condottiere*, but a bright-eyed, rosy, little man, perhaps newly dubbed a knight of San Maurizio e San Lazzaro. The insignia of knighthood sit oddly upon him: his plumed helm is half as big as he is. His air of glowing self-satisfaction is rendered by the painter with slightly satirical compassion, effortlessly suggested by the contrast of the virtuosity of the painting in the grand manner with the brashness of the subject. He stands splay-footed, one hip flung out in a highly unmilitary posture while one large pink hand floats irresolutely above his sword-pommel. In his gleaming face and hands shines the

personality of a good and useful man, alive inside the meaningless formality of ceremonial armour.

The only other work we have from this period is also of staggering quality, the great *Judith and her Maidservant* which passed from the collection of the Brancacci family to the Detroit Institute of Arts. Artemisia need no longer labour to impress, for mastery is evident in all she does. It is an old-fashioned device to use a candle-flame as the only light source, but Artemisia avoids all the cliché effects of Elsheimer and Honthorst. The darkness about her effortlessly posed figures is deep and resonant. The horror of Holofernes' head is irrelevant: the subject is a spiritual one, the steadfast moral courage of women carrying out an atrocious duty in calm readiness, their heads turned in unison to the unseen threat. In a perfectly coordinated piece of narrative, one is impressed primarily by spiritual values, and only secondarily by the range of colour and tonal effect.

The *Esther and Ahasuerus* in the Metropolitan Museum probably dates from Artemisia's Roman period. It is not easy to assess the effects of this remarkable composition, which ought to be hung at eye-level, for the museum authorities

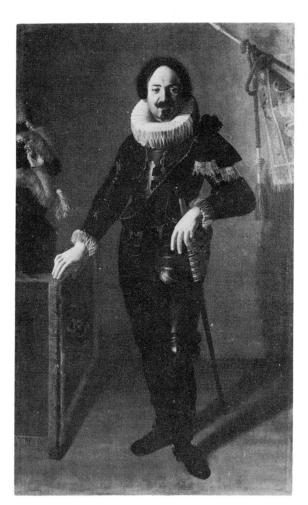

Artemisia Gentileschi, *Portrait of a Papal Knight*, 1622
Artemisia is recorded as a successful portrait painter, but this masterpiece is the only portrait which has survived.

have hung it far over the heads of visitors. It has been described as an unusual painting for Artemisia because it shows a male figure dominating the action, but in fact it depicts a man outnumbered by three women, to whom he is being passively drawn across an echoing space. The claw-feet of the king's throne are

Artemisia Gentileschi, *Judith and her Maidservant*
 Gradually Artemisia abandoned the rhetorical element in the Judith story and concentrated upon the concept of female heroism.

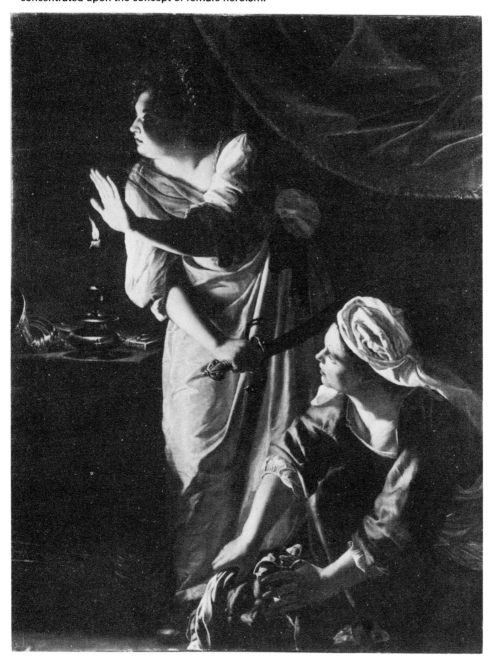

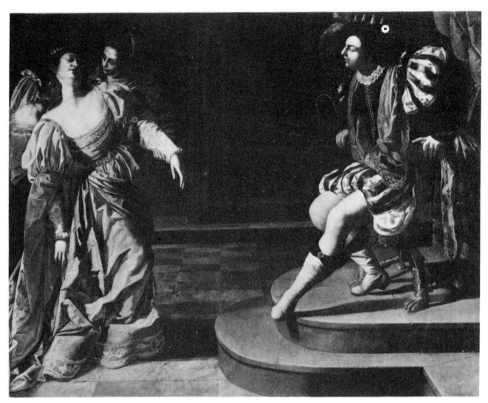

Artemisia Gentileschi, *Esther and Ahasuerus*
 The perspective of this composition is clearly meant to be viewed at eye-level or lower. In the Metropolitan Museum in New York it is hung high over the heads of passers-by who, even if they do notice it, cannot get any just impression of its effectiveness.

nearly as big as his tiny feet in dandified boots trimmed with fur and jewels; neither foot has any purchase upon the ground. The sleepy energy of the fainting Esther, monumental in old-gold, mocks the frill and flutter of this popinjay peeping into her heavy face sideways from a distance like a bird.

In 1612, Artemisia had testified that she could neither read nor write. Legend has it that she became a woman of culture, just as we are told that she was a great beauty, in flat contradiction of her father's images of her, as well as her own. Her surviving letters are garbled in syntax, tending to heap clauses in apposition, as if she was dictating.[7] Their clumsiness with honorifics does not bear out the claims made by her chivalrous biographers, while her occasional vivid colloquialisms smack more of the habits of speech of the *popolino* than elegant raillery. In a letter of 1647, she confesses that she is dictating: her letters taken as a group show quite different systems of orthography. Short of a proper calligraphic analysis we shall never have reliable evidence of the standard of literacy that she reached.

If her learning had been deficient, Artemisia would have found it virtually impossible to hold her own in Rome with the learned painters of the Bolognese

school. Their painting represented an alien ideal of refinement as well as sentiments of delicacy and piety for which Artemisia felt scant sympathy. It was her friendship with the young Giovanni Francesco Romanelli, perhaps, which prompted a series of elegant allegorical figures which seem to have been painted during her last years in Rome. Baldinucci tells us that Romanelli and she used to spend much time in 'most agreeable discussions of art' at her studio.[8] A portrait of a woman painter in the Palazzo Corsini in Rome is sometimes described as a self-portrait by Artemisia. Its condition is so poor that a positive attribution is impossible, but in view of the fact that the sumptuously dressed paintress is crowned with laurel we may be reasonably certain that the painting is not a self-portrait. It could be an allegorical portrait of Fame painting the image of a painter, for a man's face on the woman's canvas is unusually important in the composition. It could be a likeness of Artemisia for the features as far as they may be described do correspond to the foreshortened version of Artemisia's face in the Hampton Court self-portrait. A self-portrait as Fame is not impossible but it seems *a priori* more likely that this is a flattering portrait of Artemisia by someone else, perhaps Romanelli, whose portrait of Artemisia was attacked by his wife with a bodkin, so annoyed was she by his incessant panegyrics about the older woman.[9] It is possible that Romanelli and Artemisia painted reciprocal portraits, and that the face on the canvas is Romanelli's own.

At some time between 1626 and 1630 Artemisia left Rome for Naples, from where she wrote to Cassiano del Pozzo speaking of works she had undertaken for the Empress. She arrived with her family in Naples as a celebrity and is said to have lived there magnificently and to have enjoyed the patronage and protection of all the local grandees, most significantly of the Viceroy, the Duke of Alcalà, who had acquired a painting of hers in 1626.

The prevailing cultural influence in Naples was that of Inquisitorial Spain, which was even more alien to Artemisia's genius than the influence of Guido Reni and the Carracci. José Ribera, Lo Spagnoletto, who had been living and working in Naples since 1616, became her friend and seems to have been the most important influence upon her later career. Nevertheless she repeatedly solicited commissions from the Grand Duke of Tuscany, the Duke of Modena and Cassiano del Pozzo. They might have provided a market for allegorical figures like the *Fame* of 1632: otherwise almost all her Neapolitan paintings were conventional church pieces, the like of which she had never before undertaken.

The earliest known painting from the Neapolitan period is an *Annunciation*, at present in Capodimonte, inscribed as most of the known paintings of this period with her name on a painted scrap of paper fluttering in a corner, AERTIMISIAE GENTILESCHA F. 1630. The subject of the painting has, typically, become an interchange between two female figures; the active one, ostensibly the Angel Gabriel, sweeps into the canvas from the left in an attitude of commanding earnestness, flinging her left arm upwards so that it dwarfs the

Artemisia Gentileschi, *The Annunciation*
Despite the wings, the angel is another of Artemisia's heroic women, the Virgin as passive and helpless as Bathsheba; her large hands are humbly accepting.

passive virgin. The billowing, lambent draperies convey an impression of enormous energy, which leaves the dove representing the Holy Spirit looking utterly unworthy of such heroic attention. The dark background is bituminous and meaningless, the cherubic masks ridiculous. What this grand ruin represents is possibly a masterpiece disfigured as a result of Artemisia's unorthodox approach.

The allegorical figure of *Fame* dated 1632 shows that Artemisia's technique was undergoing some fundamental changes. The figure is an elegantly posed three-quarter length; the flesh tones are rendered with a powdery shimmer while the liquid treatment of the highlights of the drapery is broader than anything else we have from Artemisia's hand. Instead of the skilful building up of tones in transparent layers which we see in the *Annunciation*, we have an illusionistic use of this *impasto* which, considerably modified and refined, was to become the basis of Artemisia's Neapolitan style. The painting may have been a rush commission from one of the many foreign visitors to Naples, the illustrious but untraceable 'T. Rosiers', and very rapidly painted. It is to be regretted that Artemisia did not see fit to paint or could not find a market for as many of these beautiful figures as Ribera found for his stock pieces of philosophers, savants and other interesting old men.

The self-portrait as *The Art of Painting* also belongs to this transitional period. In painting an allegory with herself as a model, Artemisia was making her own mocking obeisance to the gallants who misrepresented hard-working women painters as muses incarnate. Although she dressed herself in Pittura's gown of '*color cangiante*', hung the gold mask medallion about her neck and showed her coarse black hair disordered by divine afflatus, she was careful not to imply that her art was effortless or spontaneous.[10] One arm holds the brush to the canvas high above her head, while she bends round the stretcher to fix her subject with an intense scrutiny. The violent foreshortening of her features was a calculated flout to those who called her beautiful. (See the frontispiece.)

A word must be said here about the fascinating portrait of a woman in the Prado which has in the past been erroneously attributed to Artemisia.[11] Although the solid and creamy style of painting is not Artemisia's, the features, especially the strong, casually dressed black hair, correspond to her preferred type. She sits at a table like the conventional still-life platform, upon which lie three parti-coloured pinks, watched over by a white mourning dove dappled with black. In her strong hands she holds a rook (?) which pecks her finger. Her

Artemisia Gentileschi, *St Januarius with the Lions*
 The types Artemisia has chosen are those which may still be seen in the streets of Naples. Once again she has chosen to familiarise her subject.

gown has immense sleeves worked in red and white stuffs, repeating the parti-colour motif of the pinks, in the colours of guilt and innocence, red and white. She gazes at the spectator with an expression both sad and challenging, above these emblems of ruined virtue. The iconography of such a painting would be tasteless and impudent unless it was the invention of the woman herself. My guess would be that the Prado portrait is a version by another *Caravaggesco*, perhaps Cecco del Caravaggio, of an early self-portrait by Artemisia. Her own references indicate that she painted a number of self-portraits. Women who painted were frequently called upon to depict their freakish selves, in preference to less sensational subjects.

In 1635 Artemisia sent to Cioli a *St Catherine* and a work by her daughter. In 1636 she travelled to Pisa to sell property to raise a dowry for 'una mia figlia'. In 1637 she asked Cassiano del Pozzo to help her marry off a daughter, in the same letter that she asked for news of the life or death of her husband. Yet again we hear of Artemisia marrying a painter daughter, in 1649, to a Knight of the Order of St James. Of their work and their lives we know no more.

In 1635, Francesco Gentileschi, who seems to have been employed as an agent by both father and sister, brought Artemisia an invitation from Charles I to visit England. We do not know when she was able to make the journey; it is believed

Artemisia Gentileschi, *The Adoration of the Magi*
 Both halves of this composition are typical of Artemisia's mature technique, but, as far as one can tell, for the surface of the painting is very bituminous, they fail to coalesce. One realises with a shock that the Infant is standing on the hand of the figure in the foreground.

by modern scholars that she helped her ailing father finish the decoration of the Queen's House at Greenwich. In 1639 he died.

Artemisia did not stay long in England where she seems to have excited ignorant gossip of the most repellent variety. Baldinucci has her working in Naples in 1642 and it may have been at this time that she carried out an important commission for the new basilica at Pozzuoli. For such ambitious subjects she was able to call upon assistants like Viviano Codazzi and Domenico Gargiulo to paint architectural and landscape details. *St Januarius with Lions* required the depiction of heroic male characters, rather than heroic action, as well as lions and the architecture of the amphitheatre. In the figure-painting Artemisia follows the models of Lo Spagnoletto rather than the alien Bolognese as familiarised in Naples by the work of the Cavaliere Massimo Stanzione. Her figures are intense, small-boned and round-headed *latini*, responding to the miracle of St Januarius (San Gennaro) in as mundane a fashion as Neapolitans do to this day.

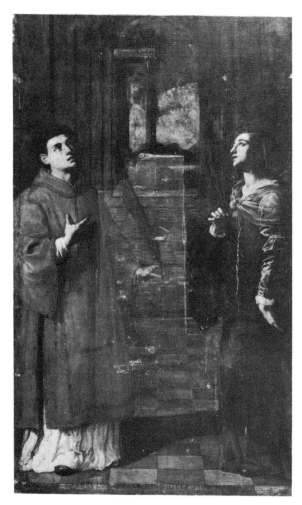

Artemisia Gentileschi, *Sts Proculus and Nicaea*
The perspective in this painting was probably painted by Viviano Codazzi, who often worked with Artemisia. Her lack of interest in perspective might have something to do with her unpleasant experience with her perspective teacher, Agostino Tassi.

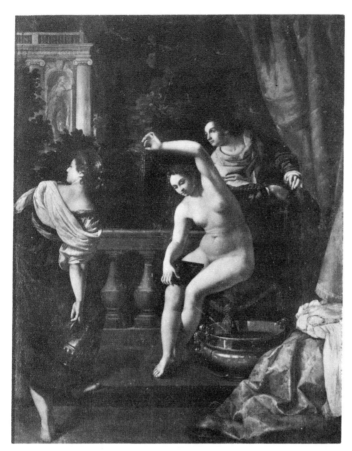

Artemisia Gentileschi, *David and Bathsheba*
In this version, Artemisia has again chosen the figure of a waiting woman to dominate the composition. The virtuoso painting of draperies and the bowl give credence to the report that Artemisia also painted still-life compositions.

The spiritual dimension is signally lacking too, from the curiously composed *Adoration of the Magi* in which the mother and child, although apparently in the same plane as the two large figures of kings in the foreground, are dwarfed and bounced out of the picture by them. A restoration of 1954 has done little to clarify the confused middle ground of the painting, which may represent a work begun before Artemisia left for England and fudged later into its present state. The figures of the Magi reveal the same worldly consciousness that created the *Papal Knight* and *Ahasuerus*, but the whole is less than the sum of its parts.

The other surviving work from Pozzuoli is a monumental altarpiece of *Sts Proculus and Nicaea*. The saints, simply posed and brilliantly painted, are shown as architectonic figures against the background of a long colonnaded cloister leading to a glimpse of landscape. The design, in which the eye is led irresistibly to the void, as Artemisia's name flutters on a tiny scrap of paper in the distance, is like another of Artemisia's comments upon her subject matter. Her saints are human, their situation one of earthly deprivation. Their uplifted eyes see nothing.

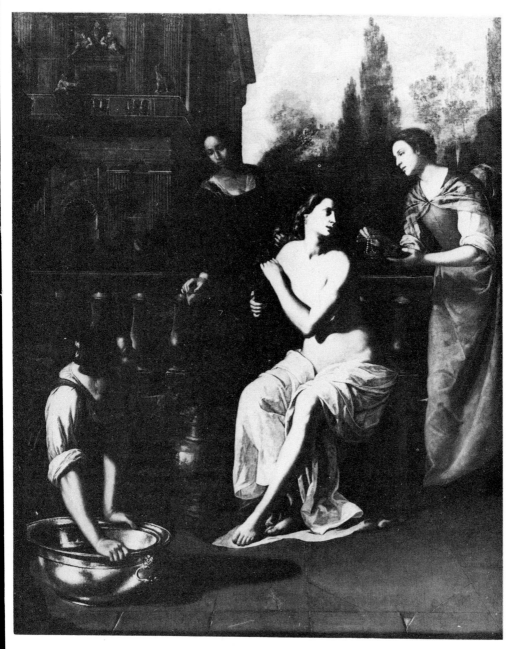

Artemisia Gentileschi, *David and Bathsheba*
The vulnerability of the figure of Bathsheba, innocent in her nakedness, is
beautifully underlined by the lazy power expressed in the strong arms of the
servant with her beaten metal dish.

The last years of Artemisia's life are illuminated by her letters to her Sicilian
patron, Don Antonio Ruffo. They make painful reading: Artemisia complains of
poor health, of her poverty, of Ruffo's disgraceful practice of cutting the agreed

price for her work, of the behaviour of her models, of her *Galatea* being ruined on the sea voyage. She is obliged to flatter her patron, although she might be excused for feeling for him nothing but contempt. Her railing against the poor esteem in which her finished work was held (for it was not hung but stood against the wall) completes the picture of an exhausted woman obliged to court provincial patronage, while struggling to paint the heroic subjects which fired her imagination. Ruffo is only concerned to get a genuine original, and at a bargain price. Artemisia boasts that she is not obliged to copy her own work, but the truth is that her last four works are all versions of the same picture in which she availed herself of the assistance of Codazzo and Garginlo, Lo Spadaro.

The *Bathsheba* paintings are elegant, rather than energetic, but there is still something in them of Artemisia's insight into magnanimous womanhood. Bathsheba is clad in nakedness like truth; in the handsomest version she sits simply without a hint of coquetry, turning her head to the woman who brings her jewels. She is taller, more dignified than the figure that the young Artemisia painted of Susannah, but the feeling is similar if more diffuse. The three women who wait upon her are dwarfed by the stern building where David stands plotting the ruin of the unconscious woman's life. The composition is elegant, the mood elegiac, the light so low as to suggest impending night.

Another product of Artemisia's last years is the picture that she painted as part of a series of five undertaken by Massimo Stanzione of the life of John the Baptist. She deals with the birth of the Baptist almost as a genre subject without angels or supernatural manifestations. The fine, intense characterisation is like that of *St Januarius*: the simple figures are bathed in warm, tremulous light and languid energy expressed through the rhythm of repose and alertness in figures posed without any hint of theatricality. Not one of the figures in this deceptively simple and spacious composition is unambiguous; one wonders helplessly what the four women are saying about the prodigiously recollected baby they lower into his bath, and whether tired Elizabeth knows or cares what Zachary is committing to his paper. (See Pl. 3.)

The date of Artemisia's death is usually taken from insulting epitaphs published in 1653. The circumstances of her dying are unknown.

The tiny nucleus of authenticated work can represent but a small and possibly unrepresentative part of the work of forty years. No fewer than six large canvases by Artemisia's hand used to be known in Parma, others are documented as in the collections of many noble connoisseurs, the Prince Ruffo of Messina, the Prince Scilla, the Marchese del Vasto, Dr Luigi Romeo, Girolamo Rondanelli, the Barberinis. The existence of such documentation, and of many copies and a couple of engravings indicates that Artemisia enjoyed a considerable reputation, which was not based entirely on non-aesthetic considerations.

Almost as disheartening as the disappearance of documented works by Artemisia is the attribution to her of works by dozens of other painters both

good and bad; the best among them are Orazio Borgianni, Alessandro Caroselli, Cecco del Caravaggio, Alonso Rodriguez, Rutilio Manetti and Antiveduta Gramatica. She was famous enough in her own time to have her name inscribed on works by inferior painters, and to see her work copied. As she was not primarily a literary painter, her paintings cannot well be recognised by their subject matter, or by inadequate reproduction of dirty and poorly preserved works. Only when the development of her technique is thoroughly understood will we be able to assess for example what Massimo Stanzione learned from her and she from him. The general impression among modern scholars is that Artemisia's importance was overrated: until we can distinguish the outlines of her achievement we really have no way of knowing.

For the women of today, Artemisia represents the female equivalent of an Old Master. She is the exception to all the rules: she rejected a conventional feminine rôle for a revolutionary female one. The price she paid was enormous: we shall never know how much of her potential was expended in fruitless friction, truculently defending her independence, exacting respect from patrons who condescended doubly to a woman dependent upon their support. The shortcomings of her education affected her all her life until eventually she was obliged to capitulate to refined taste, but her approach to her painting was always thoroughly individual. Even in shop works she solved problems of composition in her own direct way. Her mastery and originality is best seen in her application of the colour itself, the enormous range of saturation and intensity that she was able to manipulate, which is what Massimo Stanzione tried (in vain) to learn from her. These most painterly qualities are those that are soonest obscured and most often destroyed. If we are to give Artemisia her just meed of praise, rather than hypocritical flattery and undeserved neglect, then we must create such a climate of interest in her work that the costly, tedious, meticulous authentication of all possible attributions is undertaken and brought to a proper conclusion.

XI

The Bolognese Phenomenon

Artists wrestled here!
Lo, a tint Cashmere!
Lo, a Rose!
Student of the Year!
For the easel here
Say Repose!

<div style="text-align: right">Emily Dickinson, c. 1859, Complete Poems</div>

In 1600 the secretary of Cardinal Bernierii wrote to a Bolognese woman painter, Lavinia Fontana, inviting her to come to Rome. Her fame may have been bruited in Rome by Pope Gregory XIII, who was one of her most fervent admirers. He himself was Bolognese and a member of the Buoncompagni family who had always been proud to honour Lavinia Fontana with the marks of the highest esteem. When she travelled to their country estates in the Emilia, they would mount a formal reception, with soldiers lining the streets, firing salutes, as if she were a princess.[1]

She was not a princess, nor even of noble blood, but the daughter of Prospero Fontana, a painter and teacher, who was repeatedly elected to be *massero* of the goldsmiths' guild to which all Bolognese painters had to belong.[2] Bologna was the one place in Italy where the guilds still held undisputed sway; every Bolognese had to be a member of one or another, even if he came of noble blood. Here as nowhere else the new concept of the gentleman artist might be reconciled with his public duty. Prospero Fontana ran a cultivated household, where visiting artists and intellectuals were entertained. When the sculptor Jean de Douay (1524–1608), known as Giambologna after his real name Jean Boulogne, came to Bologna, he stayed in Fontana's house.[3]

Bologna was a university town which had always prided itself upon its capacity to produce female prodigies. Women learned in philosophy and the laws, like Bettisia Gozzadini and Novella d'Andrea and Bettina Calderini, Milanzia dall'Ospedale, Dorotea Bocchi, Maddalena Bonsignori, Barbara Arienti and Giovanna Banchetti wrote, taught and published.[4] Novella d'Andrea, Christine de Pisan tells us, lectured at the university behind a screen, 'to avoid distracting the students with her personal charms'.[5] The eminence of such women does not by any means indicate that Bologna was a feminist city. The emergence of occasional individuals points instead to the treatment of clever women as isolated prodigies, like the two towers leaning in opposite directions which are the landmark of a city which has always delighted in paradox. The matter of Novella d'Andrea's screen reveals egregiously enough that all the students to whom she was talking were men.

In 1512 Emilia became one of the papal states. The years that followed were years of expansion and consolidation, made possible now by the Bolognese version of the *pax romana* which spared them the wasteful strife which plagued other Italian cities. It was in no sense a sleepy place, for the students, a cosmopolitan crowd drawn from all over Europe, specialised in uproar and direct action to an extent which would perplex today's authorities. As a boom town, the city had its fair share of lawlessness, besides the prostitution which inevitably accompanied enforced celibacy of the university community.

Grandiose plans for the development of the city were being carried forward. San Petronio, of which only a small portion was ever built, was intended to be the biggest church in Italy after St Peter's, surrounded by its own complex of *piazze*. A woman, Properzia de'Rossi, had succeeded in winning a commission to provide sculptures for the façade. Although she had already carried out work for the church of the Madonna del Barracano, it seems that she was obliged to submit test pieces, which were accepted, but she achieved very little and eventually withdrew or was driven away from undertaking anything more.

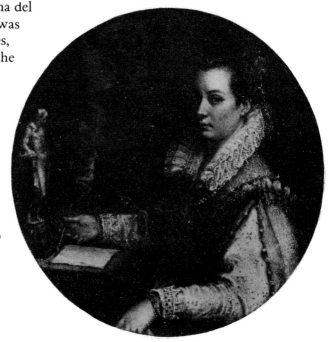

Lavinia Fontana, *Self-Portrait*
The artist shows herself as a prosperous artist and scholar: two antique bronzes stand on her work table, and a collection of *gessi* or plaster casts is dimly shown in the background.

Only four years after her last recorded payment for work on San Petronio she died, still young, in the Ospedale della Morte, apparently poor and friendless. Vasari was of the opinion that she was destroyed by male persecution; nevertheless Bologna continued to pride itself on having produced her.[6]

Properzia de'Rossi seems to have had no protectors or family; twice she ran into trouble with the law and in one complaint she was described as a courtesan.[7] The young man who was named with her in the complaint, a member of the noble Malvasia family, married among his peers some years after her death, and on such slender evidence has been built the tale of a beautiful sculptress whose heart was not eased by professional success but broke with unrequited love. Her interesting, chastely *classicheggiante* relief of Potiphar's wife snatching at the skirts of fleeing Joseph is vulgarly construed to be a hopelessly indiscreet self-portrait and the clue to the whole mysterious affair.[8]

Lavinia Fontana's life provided no such grist to the mill of gossip which surrounded the artist community. Her father's eminence and influence in guild affairs would have been sufficient to protect her from slander and the grosser forms of exploitation, even if he had not had the wisdom to find her the right husband. Orazio Sammachini, Fontana's friend and colleague, handled the negotiations with the *consigliere* from Lucca whose son had been chosen. 'If she lives a few years,' he wrote in 1577 when Lavinia was already twenty-five, 'she will be able to draw great profit from her painting, as well as being god-fearing and of purest life and handsome manners.'[9] The newly-weds were to take up their residence in Prospero's house, at his expense, and work as painters; all they earned was to be his in return. In the next eighteen years Lavinia underwent eleven full-term pregnancies: Sammachini's conditional clause was quite appropriate.

Malvasia tells us that Lavinia's husband was not gifted as a painter, although in his marriage document he is described as such. 'As he toiled away without success, people used to make fun of him and so he was put to paint only the busts in those portraits that she drew and to dress them, and so they said he had to content himself with being a tailor as heaven did not wish him to be a painter.'[10] Whatever the rest of the world may have thought of her husband, Lavinia Fontana was happy to sign his name to her work; she seems to have been equally happy to live and work in her father's house for twenty-five years.

As a painter who presented decorous figures, inspired with true if manageable religious feeling, free from sumptuosity and vain gestures, Lavinia Fontana had as many church commissions as she could handle. Her father's pupils, the Carraccis, were forging the eclectic, neo-classical Bolognese style into a

Lavinia Fontana, *Birth of the Virgin*
For more than one female painter, the Birth of the Virgin provided an excuse to paint a genre scene of female life. Here a dark-eyed little girl, her eyes gleaming with excitement, holds the swaddling bands, while another bathes the new-born child by the fire, and another holds a cloth to air. Others give the mother food, put warming pans in her bed and the like. The supernatural events are less important than the expressions of deep joy on the faces of these calm and busy women.

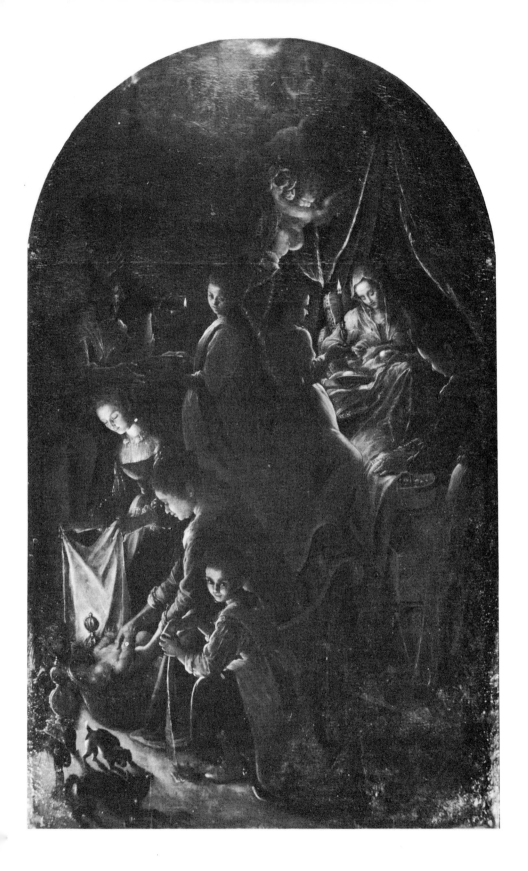

dignified, fluent statement of religious orthodoxy. Lavinia, although she might not attend the life drawing-classes run by the Carracci at the Accademia degli Incamminati in the house of Ettore Ghislieri, was right at the heart of things. To the traditional elements of her father's style she added the delicacy and ambiguity of Denis Calvaert; she loaded her brush with a thinner medium and her canvases began to assume, with their own stillness and elegance, a Titian-esque transparency. She was perforce an eclectic painter, but eclecticism was a feature of the Bolognese School and an acceptable path to prestige.

A letter from an agent in Bologna to Monsignore Ratta implies that patrons had to insist when commissioning works from Prospero Fontana that they were to be by him and not by 'madonna Lavinia',[11] and it seems likely that the relative smallness of her output might be partly explained by her work in her father's *bottega*. There were other patrons, however, especially for portraits, who wished to favour her in particular among the painters of her father's circle. The fact that she was ever able to sign works in her own name implies a certain measure of support from her menfolk; many of her contemporaries were not so fortunate.

Lavinia Fontana's Roman commission was the result of the success of a painting of *The Triumph of St Hyacinthus* which she sent to the church of Santa Sabina in Rome.

The Papacy was probably the only patron who would have allowed Lavinia Fontana to delay until her father had died and her smaller children had grown

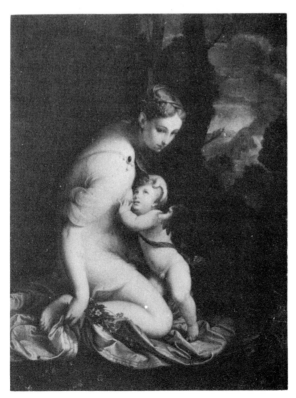

Lavinia Fontana, *Venus and Cupid*
All the subtle charm of Lavinia Fontana's work is evident in this understated depiction of mother love.

before moving her household to Rome to take up her appointment. She herself
was middle-aged and past the zenith of her powers but she plunged into her
new duties, accepting a commission to paint a huge *Stoning of St Stephen* with
many figures and a *gloria in alto*, even though she had to ask for larger quarters in
which to work on it, for it was more than twenty feet high.[12] When it was
hoisted into place in San Paolo fuori le Mura it was decreed a failure.[13] Posterity
may not now make its own decision for it was destroyed in a fire in 1823.[14]

In the Galleria Borghese in Rome there is a boudoir piece by Lavinia Fontana
of *Minerva disrobing*. The original painting has been widened by the addition of
canvas panels at the sides; it was perhaps originally intended as a mural decora-
tion. It is unusual because Minerva is represented quite naked. Her armour has
been discarded and lies about the room. A *putto* plays with her helmet. The pose
is undemanding and quite unprovocative: Minerva stands with her left
shoulder turned to the beholder and her left leg stretched behind her. The face
she turns over her shoulder is sweet but unexpressive. The gown she lifts
without looking is painted with the same delicate touch and loving attention to
detail that we see in Fontana's portraits, and contrasts oddly with the blankness
of the treatment of the figure. The allegory of the goddess of war assuming her
feminine rôle after a hard day at the battlefield, expressed in her usual harmoni-
ous understated manner, may have been Lavinia Fontana's answer to gossips
like Malvasia who stereotyped her family life. Her representation of the female
nude is lucent and graceful, although modelled so discreetly that it is defined
only by the edges of an area of pearly colour. Her careful inclusion of Minerva's
owl and the silhouetted leaves of an olive tree are less certain indications of the
picture's academic and neo-classical temper than the simplicity of its composi-
tion and the careful regulation of its mood. In the Gabinetto di Disegni in
Florence there is a sketch for a *Presentation in the Temple* which is actually a frieze
of classical figures, all carefully draped, standing in profile as high as the
picture-frame, which reveals how closely Lavinia Fontana had taken the neo-
classicism of her eminent contemporaries to heart. She, perhaps more than any
other Bolognese painter of her era, faithfully carried out the theories of Agos-
tino Carracci, such to her was the prestige of the academy which she was not
allowed to join. A little familiarity might have bred some salutary contempt.

Lavinia Fontana's overriding concern with the quality of feeling generated by
the interplay of broad areas of colour, patterned and defined by rhythmic use of
linear detail, is visible in another boudoir piece, the *Venus and Cupid* at the
Hermitage. There is no hint of display in the posture of the scantily draped
figure, which is in fact so modest that one is rather struck by the vulnerability of
Venus' exposed thigh and the ordinariness of the knees she kneels upon. The
viewer of the pretty lady kneeling to suckle her greedy baby in a dark landscape
feels that he is guilty of a certain prurience. In both allegories she has subdued
sensuality and infused her own kind of understated sweetness.

Lavinia Fontana seems to have been content to be regarded as a prodigy and

the muse incarnate. Although she ran workshops in both Bologna and Rome, she did not make a point of teaching women. She did teach one of her sons to carry on the family tradition but he did not outlive her. Posterity can only guess at the heartbreak which lies behind the death of almost all her children before herself; one of her surviving daughters somehow managed to wound herself in the eye with a needle when she was still a little girl. Romeo Galli says that a woman called Gozzardini, a family which had patronised Lavinia, was her pupil and executed commissions for the church of San Giovanni in Monte.[15] Whatever the truth, as an independent master who achieved great fame and considerable riches, Lavinia Fontana's example did work in favour of women painters in succeeding generations whether she cared or not. (See Pl. 4.)

Lodovico Carracci, encouraged perhaps by Prospero's success in educating Lavinia to be his helper and the prop of his old age, chose a woman among his students to be his particular helper. Her name was Antonia Pinelli; all commentators are agreed that it was the modesty and sagacity of this particular female which so endeared her to one of the most influential painters of her time, modesty so pervasive that she never attempted to undertake any kind of painting without consulting her master and working from his designs, while she showed her gratitude by always helping him.[16] In fact she seems to have been an extra pair of hands for Carracci, especially in executing private commissions. In 1613 while she was still young she painted an altarpiece of *St John the Baptist* from a design by Carracci in which she portrayed herself in a feathered hat, as well as the man she was to marry, Giovanni Battista Bertusi.

A painting of a *Guardian Angel*, now in the Convent of San Guiseppe dei Cappucini is an example of the depths to which Counter-Reforming delicacy could sink. Well might reformers have worried about the frankly erotic angels of painters like Caravaggio with their muscular young limbs and sidelong glances; the solution emerged rather quaintly in the seventeenth century in the depiction of angels which were, as doctrine had always maintained, neither male nor female. Antonia Pinelli's angel is a sumptuous creature with spreading hips, clad in a provocative crimson tunic which is slit and coyly buttoned over the thigh and leaves one shoulder bare, revealing a vague nacreous bulge which is not quite a bosom, while the diaphanous shift underneath froths around the angel's dainty ankles. The effect is not obviously heretical or even sensuous, but vaguely and elaborately indecent, sickly and modish. Besides these two works we know only an altarpiece for the church of San Francisco in Ricciardina, a village near Budrio, and a *Birth of the Virgin* for the church of Santa Maria in Regola in Imola. She died childless in 1644.[17]

Guercino also had his female pupil, the sister of Antonio Domenico Triva, Flaminia. She became her brother's assistant, working with him in Venice and at the court of the Elector in Bavaria, where she died in 1660. There is no known work attributed to her; her life and work seem to have been completely swallowed up in her brother's.[18]

The Bolognese School of painting had developed late. During the High Renaissance and mannerist period it had been unremarkable among the schools of Italy. In the late sixteenth century the Bolognese School became the first in Italy, and its influence extended deep into Spain and the Lowlands. The Carracci family brought the Bolognese style to its apogee. Agostino Carracci was concerned to place the teaching of art on a level with philosophy and the laws. Annibale developed his own eclectic vision of an ordered intellectual universe from the Schools of Venice and Rome. Lodovico anchored them both to Bologna and it was to them that the most influential painter of the seventeenth century, Guido Reni, turned in his search for a purer style and an escape from the *sordidezza* of the *bottega* of Denis Calvaert. He joined them in 1592, left in 1600 to return in 1614 and die in Bologna in 1642.

Guido was the incarnation of the gentleman painter. Gentle, fastidious and deeply religious, he embodied all that academicians and reformers could ask in his life and in his work. Modern taste is not now attuned to the originality of Guido's expression of piety because it became the foundation of clichés that are still current in religious art and have in their turn obscured the freshness of Guido's sentiment, but he was greatly loved and honoured by his contemporaries all over Europe. The qualities that he sought in painting were qualities that any woman might feel free to express without fearing that she might have been de-sexed by paint or that unbecoming immodesty and self-promotion were required of artists male or female. He taught no women, unless one believes De' Dominicis' prattle about his relationship with Artemisia.[19] (Maddalena Natali is sometimes called his pupil, but she was not born until 1657.)[20] However, he inspired many women, one of whom was great.

Like most of the painters of his generation, not all of them in Bologna, Giovan Andrea Sirani was an imitator of Guido. He was a successful painter, probably because much of his work was indistinguishable from his master's, upon whose death he was called upon to complete his unfinished work. In 1638 he became the father of a daughter, Elisabetta. Count Malvasia noticed that the child had ability and prevailed upon her father to let her work:

> It was I, I may well say, who willed absolutely that her father, otherwise in this reluctant, tried her with brushes: I who encouraged her always to the worthy enterprise, I, in short, who saw myself considered worthier than any other for all conference and council in the weightiest matters and for the most important works . . .[21]

We may infer from the fact that Malvasia had to exhort him to train his daughter that Giovan Andrea Sirani was unusually intolerant. The precedent had been repeated so many times that it must by now have seemed to any man with Giovan Andrea's knowledge of the art world a distinctly wise move to capitalise upon the talent of a daughter, unless he had his own ideas about the rôle of women. Nearly a century before, the Neapolitan painter Giovanni

Filippo Criscuolo had been taking his little daughter Mariangiola, of whom he was very fond, to watch him and his brother at work. She had not been slow to imitate them, and then to learn, and then to assist them. She had found a painter husband and gone on to carry out her own work for the proliferating churches of Naples.[22] Luca Longhi's daughter Barbara was born in the same year as Lavinia Fontana, and although her fame did not spread far from Ravenna she developed her own Counter-Reformation icons, subtly stylised in a way only superficially redolent of intellectual mannerism.[23] The delicate and other-worldly curves of the necks and arms of her madonnas and saints are no more bodily than the curling of their garments. The range of tone, colour and feeling is deliberately narrowed down to a single, uncluttered statement of civilised piety. The warmth and subtlety of her rose-gold palette eventually pierces the veil of inappropriate expectation and has won for Barbara Longhi the esteem of connoisseurs.

The Veronese painter Paolo Farinato, who seems to have had less regard for his unmarried daughter Vittoria (b. 1565) than for any of his sons or grand-children, nevertheless gave her enough training to enable her to copy paintings. Annunzio Galizia's daughter Fede had been famous from 1595 for works in almost all genres.[24] Filippo di Lorenzo Paladini's daughter Arcangela had been called to the Grand Ducal Court of Tuscany when she was only sixteen,[25] while Nicolas Regnier or Renieri, (also known as 'Il Mabuse') had taught his four daughters, Anna, Angelica, Clorinda and Lucrezia to earn a living for themselves in Venice.[26] Two of Tintoretto's daughters had become nuns, but the eldest, the delight of his old age, he dressed as a boy so that she could come into the *bottega* and anywhere else that he went, and her he taught to paint.[27] Quintilia Amalteo,[28] Cecilia Brusasorci,[29] and the five daughters of Guglielmo Caccia[30] were all women whom Giovan Andrea might be expected to have heard of. Perhaps his reluctance had something to do with the description of the two painter daughters of Enea Salmeggia, Il Talpino, 'who refused to apply themselves to all those humble exercises to which for the most part the sex is condemned from its greenest years'.[31]

Malvasia was a person of importance, a director of the Accademia del Nudo, an influential nobleman and a discriminating collector. He did not waste his words and Giovan Andrea had no cause to regret his advice and interference, for his daughter proved a very apt pupil. Giovan Andrea found his hands increas-ingly afflicted with an arthritic ailment which eventually prevented him from working altogether, by which time Elisabetta was supporting the family.

At sixteen she was astonishing the inhabitants of Bologna with her virtuos-ity. Detracting tongues said that her father was passing off his work as hers in order to exploit the publicity value of an infant female prodigy,[32] so patrons sometimes insisted on watching her at work. She became inured to working in public and to making a display of facility. 'More remarkable and beyond comparison was the velocity of the woman, of Elisabetta, in the working of her

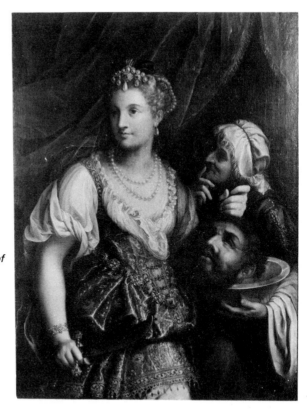

Fede Galizia, *Judith with the Head of Holofernes*
This painting has been overpainted in parts, possibly more than once, but one may discern Galizia's hand in the virtuoso treatment of jewels and draperies.

canvases, to such an extent that wielding the brushes she seemed gaily to be playing rather than painting.'[33] Women painters were, alas, still freaks, as those who suspected Giovan Andrea well knew. A trait which would have earned ridicule for a male painter (Luca Giordano was called '*fa presto*')[34] was treated as evidence of the prodigious nature of female talent. The image of Elisabetta flirting with her canvas might well have been a figment of Picinardi's bombast-ridden brain, but that she worked with astonishing celerity can also be deduced from the list of a hundred and fifty pictures which she left, a list which is significantly and verifiably incomplete. Once it was established that she could work fast, she had to work fast; for one thing, her father wanted the money.

> On the thirteenth of May his most serene Highness Cosimo Grand Duke of Tuscany was in our house to see my paintings, and I in his presence worked on a picture of the Lord Prince Leopold, his uncle, in which alluding to the three particular virtues of that great house, there is Justice assisted by Charity and Prudence, sketching in really quickly the whole of the baby suckled by Charity, etc. he ordered me to make a Blessed Virgin Mary for himself, and I did it at once and in time so that on the day of his return to Florence he had it with him.[35]

Unlike most painters, for example Lavinia Fontana who often apologised for work delayed and not done, Elisabetta seems to have filled every commission that came her way. Her father took every penny of cash that she earned, as if she were apprenticed to his *bottega*, while gifts were stored in a cupboard and duly exhibited to all visitors to the house. Perhaps they were meant to serve as her dowry, but Giovan Andrea made no recorded attempt to find his busy daughter a husband. There would be no such interference with her output. In fact, she produced even more work than he thought. When she needed to make a present or show her thanks, she gave the only things she could, paintings. When her mother needed money, Elisabetta painted works on the sly for her to sell on her own account.

Malvasia was present when, in 1657, Elisabetta Sirani was invited to join the most respected Bolognese artists, her father, Canuti, il Bibiena and Rosso Napoletano, in providing one of the enormous pictures in the series of the life of Christ which adorn the nave of the church of San Girolamo at the new Certosa of Bologna.[36] She jumped up and instantly dashed off a water-colour sketch of her proposed design, a sketch which Malvasia kept, and therefore should yet come to light, to silence those who assume that a composition so ambitious must have been planned by her father.[37] Christ and St John, the Holy Ghost and God the Father in Glory hold the centre upstage, as one would expect, but they are hemmed in on all sides by lay figures who seem, in the tradition of earlier frescoes, to be largely indifferent to what is going on. Much is made of the homely detail of towels to dry the faithful who are being immersed, and one of the most visible figures, for the painting hangs high in the dim vault of the church, is a comely young man drawing on his hose in the foreground. She was given two years to complete the painting and a thousand lire. Within a year it was hung and she was famous.

She worked from dawn to dusk (when she retired to pray), every day except Sunday and still found time to charm, entertain and play music for her guests and patrons. She also opened her studio to other women desirous of learning to paint and established a veritable school.

It was not perhaps the first of its kind, but it seems to have been on an unprecedented scale. Mariangiola Criscuolo had female pupils, because 'some ladies who knew her sent their daughters to her to be taught, not so much in the skilful application of painting, as much as that they should learn from her example the devout Christian life'.[38] De' Dominici names a certain Luisa among these pupils, who devoted herself to painting, but cannot give any further information about this Luisa or any other pupil.

Chiara Varotari is often credited with founding a school: she was an advocate of women's rights who wrote a tract called 'Apology for the female sex'.[39] She refused to marry and preferred to live with her brother, and work with him in Padua and Verona. Her fame was widespread, and an *Adoration of the Shepherds* may be seen in the Oratorio di San Carlo Borromeo in the church of Sant'Anna

de'Lombardi in Naples. It is actually a genre scene with a special feeling of sweetness and joy which shines through the dirt. One shepherd subdues his offered goat, a woman kneels with a basket of doves. Despite many disembodied hands and speaking impressions, it is a stable, peaceful picture, redolent of the simple devoutness of an earlier generation. Her self-portrait, rather a challenging affair in the alert sideways posture of the head, and utterly inept when it must be joined to breast and shoulders, used to hang in the Grand Ducal collection of self-portraits in the Uffizi.[40] Caterina Tarabotti came from Vicenza to work with the Varotaris, and painted history pictures in her home town.[41] Another pupil, Lucia Scaligero, worked in parish churches in Venice at about the same time that Elisabetta was active in Bologna. Many princesses sought her as a *damigella d'onore* but she preferred to stay in Venice and marry a countryman.[42] Her daughter, who also painted, became a nun at Santa Maria Maggiore.[43] In 1656, when Elisabetta Sirani was still only eighteen, she painted a portrait of Ginevra Cantofoli, a woman twenty years older than she who painted in miniature. With Elisabetta's help and encouragement and using her designs, Cantofoli began to undertake works on a larger scale, altarpieces and historical paintings. In 1569 she had the signal honour of seeing her altarpiece of St Thomas Villanuova carried in solemn procession around the streets of Bologna before it was formally blessed and installed in the church of San Giacomo Maggiore where, poorly preserved and badly disfigured by a spreading black stain, it hangs to this day.[44]

Considerable collaboration with her pupils, many of whom must have been ignorant of the basic rudiments of drawing, might explain some of the inconsistency of Elisabetta Sirani's work. The self-portrait in the Pinacoteca Nazionale of Bologna seems to be far too clumsy for her and might conceivably reflect a counterpart to the portrait of Ginevra Cantofoli that she painted in 1656, that is, a portrait by Cantofoli of her. On the other hand, it bears no particular resemblance to the figure that she herself claimed was a self-portrait in the *Baptism of Christ*. The Brera portrait of Ginevra Cantofoli is said to be a self-portrait of unknown provenance.[45]

Elisabetta's studio must have been a crowded and rather confusing place. As well as the *maestra* herself, there were her two younger sisters who eventually gained enough proficiency to carry out altarpieces for themselves. Anna Maria Sirani's work is not only to be found in the province around Bologna, but also in Massa Carrara and as far away as Malta. In the church of the Servi in Bologna there is an *Ecce Homo* by Barbara Sirani which, however *pastoso* and confused its execution, is based on a very simple and elegant design which makes telling use of the diagonals of Christ's bound hands, his sceptre and the droop of his head and shoulders; the assuredness of the design compared to the tentativeness of the painting leads irresistibly to the conclusion that the design is by Elisabetta. The drawing of the Three Persons of the Trinity, which is to be found among the hopeless muddle of drawings attributed to Elisabetta Sirani in the Gabinetto

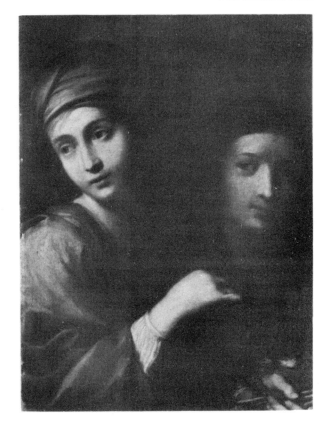

Ginevra Cantofoli?, *Self-Portrait
in the Act of Painting a
Self-Portrait*
 It is recorded that Elisabetta
Sirani painted a portrait of
Ginevra Cantofoli in 1656: in
this writer's view this is that
portrait of Cantofoli, painting
Sirani herself. The so-called
self-portrait of Sirani in the
Grand Ducal collection in the
Uffizi is either a juvenile effort
by one of her pupils or a copy
of a lost original.

di Disegni in the Uffizi, may be a study for Barbara's altarpiece in the church of
the Santissima Trinità fuori del Castello. Oretti lists ten paintings by Anna
Maria and nine by Barbara among others which he does not specify.[46] The
inference is that the women earned their living by painting at least until their
marriages.

If Malvasia is right, as well as women of her own age like Lucrezia Bianchi
(who later worked for the Duchess of Modena),[47] Veronica Franchi, Caterina
Mongardi and Veronica Fontana (who became a famous maker of woodcuts
and the illustrator of Malvasia's *Felsina Pittrice*), Elisabetta Sirani also accepted
into her studio girls who were very little indeed, like the daughter of the painter
Bibiena, who had died in 1664 when she was nine years old and Camilla Lauteri
may have been six when Elisabetta died and Teresa Muratori who was only
three. Two noblewomen seem also to have taken some instruction from
Elisabetta, Caterina Pepoli and a member of the Panzacchi family. Lucrezia
Forni, Teresa Maria Coriolani and Vincenza Fabbri are also listed among
Elisabetta's pupils.[48]

By some trick of history, the works by which Elisabetta Sirani is best known
are not those which reveal her intelligence or her seriousness. Until recently the

Pinacoteca Nazionale of Bologna exhibited a motley collection of uneven work which was dutifully praised by chivalry[49] and then as dutifully by feminism.[50] No attempt to present a *catalogue raisonné* of her whole oeuvre, notwithstanding the great help offered by her own list and Oretti's additions to it, has ever been made. No museum curator, faced with a mass of muddled work and dubious attribution, has considered it his duty to search out a really good painting by Elisabetta Sirani, since her work generally came under the heading of repellent curiosities, like poor Properzia de'Rossi's minutely sculpted cherry-stones. It is the more astounding then to come across paintings by Elisabetta Sirani which are full of warmth and life and tenderness, with a human glow which owes nothing to Guido Reni. Paintings like the beautiful *Madonna and Child* which was exhibited in the Emilian seventeenth-century exhibition in Bologna, or the *Madonna and Child with Sts Romeus and Francis*, hidden in the Sacristy of the Bologna Metropolitana, or the *Madonna* in possession of Alarico Mazzanti in San Marino or the *Madonna* auctioned at Christie's on 28th July 1976, may represent the achievements of Elisabetta Sirani's maturity, and they may not. A painter who was working on so many different levels, who had no time to elaborate any composition, was necessarily liable either to hit or to miss effects. Sometimes Sirani's compositions fall apart, sometimes the swiftness of her execution creates a harmony which is effortless. Some of her better known works also present a curiously slick and bland appearance which has nothing in common with the sureness of her painterly touch in the good canvases and must be the result of extensive retouching, as in *The Madonna of the Dove* where St John offers a rather clumsy sugary bird to the Infant. The ugly Infant in this painting seems a very unusual production from the brush of the woman whose *putti* and Christ children can be the prettiest ever painted.

The best canvases of Elisabetta Sirani are the ones in which she least resembles her father. It was probably no easy matter to disentangle herself from her father's style and preoccupations, for her father probably saw her, in view of his own disability, as an extension of himself. In fact, she was a much more spontaneous and instinctive painter than he could ever have been. At times, as in the two *Sybils* exhibited as part of the new acquisitions exhibition in Bologna in 1973, she seems to be completing a series devised by her father and applying his own neo-classical aesthetic, but her real genius is thoroughly baroque, in the liveliest and most unpretentious manner, her only reference to the truth of her own feeling.

In the spring of 1665 she fell ill of severe stomach pains, which abated, but she grew thin and depressed, although work continued at the old pace or even faster. On 24th August when all Bologna was celebrating St Bartholomew's Day and she was at work as usual finishing a picture for Eleonora Gonzaga, the pain which she had felt for some weeks before became so intense that she staggered downstairs to her sister and collapsed. Twenty-four hours later she was dead. Giovan Andrea made a complaint to the Legate and a maidservant

was tried for poisoning, but probably Elisabetta died of chronic ulceration of the stomach and duodenum which had come to a climax after considerable occult bleeding.[51] Malvasia, who never quite recovered from the bereavement, thought that the poison might have been generated in her, 'because of the extravagance of the workings of the matrix in this woman in particular so lively and spirited: mostly because of having to conceal the yearning for a husband proposed to her and by her father refused'.[52] For Malvasia's greensickness, we would nowadays read the cumulated effects of strain through overwork and relentless auto-repression. Giovan Andrea's dutiful daughter had no sense of self-preservation. She had worn herself out at the age of twenty-seven. She was buried in the vault of the Guidotti family in San Domenico, where the bones of Guido Reni had lain since 1642. Since then she has been known as his imitator and her work has been misunderstood as a result.[53]

Three months later a memorial ceremony for Elisabetta Sirani was held in San Domenico. It was an extraordinary affair; every *accademico bolognese* had made his contribution in the form of an *impresa* and great fun must have been had sorting out the elliptical Latin. Picinardi, prior of lawyers at the university, wound an elaborate oration around the ears of his listeners who sobbed luxuriously. As usual, Bologna felicitated itself mightily on having produced a female prodigy; no voice was raised lamenting that they had failed to keep her alive long enough to reach artistic maturity. It was all the fault of *Invida manus*. Grotesque rumours were abroad, and art historians have made sure that their poison survives: some modern sources continue the defamation of the character of Ginevra Cantofoli, calling her (at the age of forty-seven) Elisabetta Sirani's rival in love and accusing her of murder.[54] *Nil nisi bonum* does not apparently apply to women.

Although Elisabetta herself had come to such an untimely end, her example continued to inspire the young women of Bologna. Lucrezia Bianchi continued her studies with Lo Stringa and painted many works for the Duchess of Modena 'and many others presented to various ladies of Rome and many have been carried to England'.[55] Veronica Franchi took no other teacher that we know of, but embarked as a dilettante on rather ambitious subjects, a few church pieces, but principally subjects like *The Rape of Helena, Lucrece and Artemisia, Cleopatra, Galatea among Tritons*, and even a *Lot and his Daughters*. Oretti names another picture of 'una guerriera'.[56] Perhaps the Signora de' Franchi wished to abandon the self-abnegation of Elisabetta for the rebellious independence of Artemisia. Caterina Mongardi was taken as a student by Filippo Briccio and, as well as private commissions in Bologna, carried out an altarpiece for the church of the Olivetani in Imola.[57] Lucrezia Forni became the student of Domenico Maria Canuti and painted pictures for the churches of the Gesuiti and Santa Caterina di Strada Maggiore in Bologna, and many devotional canvases with large figures in landscapes for the Grimaldi, the Albergati and the Papazzoni families (of which no more is known).[58] Teresa Maria

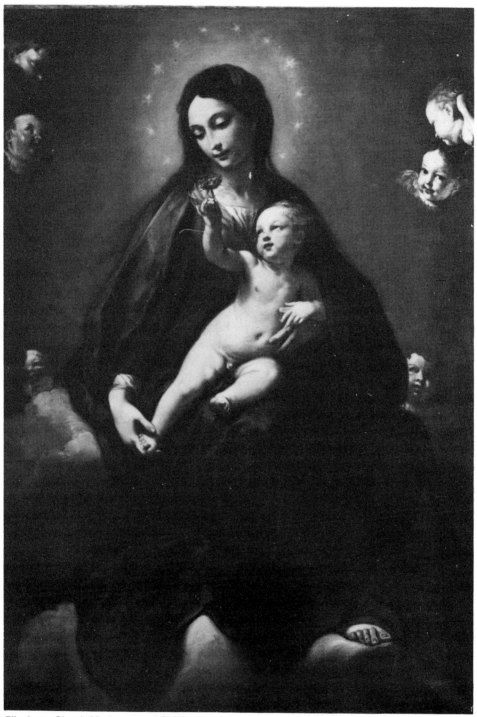

Elisabetta Sirani, *Madonna and Child*
This painting is rescued from mere prettiness by the bravura of the technique. Her contemporary, Murillo, might well have envied her combination of monumental composition with fluid detail and tender feeling. A preparatory study is preserved in the Gabinetto di Disegni of the Uffizi.

Coriolani became a nun, and of her considerable output there remains now only a little etching of the *Madonna and Child*.[59]

Maria Oriana Galli was taken as a pupil by Carlo Cignani and, after his death, by Franceschini. She worked with her brothers at the imperial court of Vienna and married the landscape and architectural painter Gioacchino Pizzoli.[60] Oretti describes a huge altarpiece for the church of the Madonna del Sasso near Bibbiena, of *Sts Job, Francis of Paola, Dominic, Philip Neri, Joseph, Homobonus, Antony of Padua, with the Holy Trinity in Glory*, and several works for the Castello of Bibbiena.[61] Zanotti merely remarks, typically, that she painted 'badly, very badly'.[62] Camilla Lauteri also went on to Carlo Cignani and received high praise for a *Death of St Joseph*[63] that she painted for the church of San Gregorio dei Padri del Ben Morire, but it disappeared from its place before the end of the seventeenth century.[64] An altarpiece of *St Antony of Padua* for the church of Sant'Andrea, at the villa of the Giavarina family at Cadriano, gave further indication of her powers and Oretti at least believes that she would have had excellent success, if she had not died at the age of twenty-two.[65]

Malvasia is probably over-eager in naming Teresa Muratori as a product of Elisabetta Sirani's school. She was taught after Elisabetta's death by Taruffi. Her early work of *St Catherine receiving a blow from her executioner* disappeared from San Niccolo degli Albani to be replaced by what Crespi thought was a much inferior work.[66] When Taruffi died she went to Pasinelli and painted for the church of St Helena *A Dead Man being resuscitated by the true Cross*; then she went to Giovan Gioseffo dal Sole and painted a *St Benedict resuscitating a dead boy* which may now be seen in the church of Santo Stefano in Bologna, although the sacristan stoutly maintains that it is a picture of San Mauro. It is an expertly composed altarpiece: the treatment of perspective is exactly adapted to the situation of the canvas, and the conventional architecture background deepens the effect of an experience taking place on a higher plane which we are privileged to glimpse as groundlings in a theatre might do. The effect of the painting is hardly enhanced by the holes in it and the mantle of dust that it wears; there may have been more to it than mere competence once upon a time.[67] In the church of the Madonna della Galiera we may see the companion piece, a *St Thomas*: a stone drapery almost mannerist in its refusal to indicate a body beneath, out of which a hand emerges for all the world as if it meant to take an unpardonable liberty with the person of Christ, and a head which gazes at him searchingly. The action is anchored in the foreground by a pair of massive pillars while a colonnade provides depth and establishes the viewer's inferior situation. The painting is flaccid and slippery, but in that it reflects the time as well as the artist: she is the product of Taruffi, Pasinelli and dal Sole, and by her works it may be known, as Zanotti sourly remarks in his marginal notes in a copy of Orlandi's *Abcedario* in the Accademia di San Luca.[68] The death of Elisabetta Sirani deprived not only her pupils, but the development of religious painting, which became more and more stagey, hollow and pietistic, the

product of a dissociated sensibility. Elisabetta's piety was a form of love of life: her best canvases are vivid and joyful, spontaneous expressions of true faith and simple devotion.

Women continued to work and accept public commissions in Bologna, but they could no longer rely upon the special treatment extended to prodigies of nature. The more numerous they became, the more apparent were the effects of their exclusion from the mainstream of art education. An antagonism began to develop between the directors of the academies, like Zanotti (who was only too aware that the painting produced by the methods they had struggled so long to establish was far from great), and the women who continued to win commissions, especially from religious houses and private paintings. The academies were producing feeble painting, and equally feeble painting which had never been taught in the academies was creating an effete fashion in civic art. Zanotti saw himself as combating effeminacy and dishonesty on all levels: his bitterness at the decline of Bolognese painting is somehow less offensive than Oretti's indiscriminate clucking.

Vincenza Fabbri might congratulate herself every year when her picture of *St Ansanus* was exhibited by the Accademici Corristi.[69] Maria Elena Panzacchi invented her own version of the *bambocciate*, '*graziose figurette* in genteel motion, carrying out distinct activities in the pleasantest imaginable landscapes, which were all the rage with gentlemen and princes'.[70] Count Ercole Bevo addressed two sonnets to her in 1687.[71] She could also paint portraits from memory, and was of noble birth, both valuable attributes for a fashionable painter.

Lucia Casalini Torelli, another product of Taruffi and dal Sole, busied herself painting all kinds of devotional subjects for patrons all over the Emilia, as well as portraits of every known individual in public life. She was made an *accademico d'onore* of the Clementina to Zanotti's disgust.[72] He notes with rancour that her repainting of the Fontana *Crucifixion* in the church of the Madonna del Soccorso ruined it.[73]

The egregious Oretti is quite incapable of Zanotti's sharpness. He is more than happy to list all Torelli's activities, noting with wonder that she painted to the end of her days (in 1762) and 'always without spectacles'.[74] In his extremely derivative manuscript notes on Bolognese paintings, Oretti makes very few original observations, but among them is a regret voiced for the first time by any historian of art. Of Ersilia Creti he says, 'Her marriage at an early age and her continual occupation with her family have taken her away from the exercise of this noble art.'[75] Zanotti merely remarks in his marginalia that she married a chemist and instead of producing pictures produced babies.[76] She too was an honorary member of the academy. A *Reclining Venus* by her used to be in the Dresden Gemäldegalerie.[77]

In recounting the career of another female pupil of Pasinelli, Maria Caterina Locatelli, Oretti says again, 'we would have seen many more praiseworthy products of her talent, if domestic necessities had not taken her away from such

noble undertaking'. She had worked privately for some time before she ventured to accept a public commission for the church of the Madonna dell'Aiuto at San Colombano, to provide for the façade of a chapel, a *St Antony with St Teresa* and various cherubs. The painting was soon replaced by another by a later artist and 'very bad'. Thus disappeared the only known work of Maria Caterina Locatelli.[78] It is Crespi who speaks up for the more productive Francesca Fantoni, the niece of Giovanni Gioseffo dal Sole. 'She would have done much more, if she had only been able to attend to painting, from which, to her chagrin, she was distracted by her domestic duties.'[79]

Lavinia Fontana had been able both to bear her children, eleven of them, and earn a handsome living for them as a painter. It would be tempting to base an assumption about changes in family life upon the fortunes of these married women of the next century, but the cases are not numerous enough to justify any such conclusion. Too much rested with the individual husband and the earning capacity of the individual artist. The conjugal felicity of Lavinia Fontana was not only a personal triumph but a piece of uncommon good fortune. For a brief century women in Bologna were encouraged to play a public rôle as artists. The astonishing thing is not that the century came to an end, but that it ever happened at all. The reaction against 'matrism' was not slow in coming, and a parallel phenomenon, in the initial welcoming of women to the royal academies and their subsequent exclusion, could be seen all over Europe.

XII

Still Life and Flower Painting

My heart, being hungry, feeds on food
 The fat of heart despise.
Beauty where beauty never stood.
 And sweet where no sweet lies
I gather to my querulous need,
Having a growing heart to feed.

Edna St Vincent Millay, *Collected Poems*

The French call it 'nature morte', their own version of the pejorative name given by Pliny to still-life painting, 'rhyparography' or the depiction of rubbish, low on the low list of *picturis minora*. The English term is derived from the Dutch word *Stilleven* used by Houbraken to describe the new genre in the Groote Schouberg at the beginning of the seventeenth century.[1] Platonists and Aristotelians alike were unable in the sixteenth century to separate the aesthetic function of painting from other concerns, public, moral and political; the narrative content of painting and its subsequent didactic power were its justification. They could find little to say for still life.

Women did of course try their hands at painting the great subjects, but mostly they came to them secondhand, through other paintings and the accepted forms of pictorial expression. These they manipulated well or ill, as the case was, but that any woman should possess the confidence to develop her own mode of seeing and commenting upon the great actions of the religious past or of mythology was in itself prodigious and therefore rare. The depiction of all great subjects required the figuring forth of human beings in action and reaction, with physical and psychological verity; more crippling than the

227

exclusion of women from the higher areas of art training were their exclusion from experience of the world beyond their families and their emotional subjection to others.

Despite the obvious appeal of still-life painting for women, few can have been motivated to undertake it in the sixteenth century, for the genre did not exist. There was no demand for it, and in fact no independent concept of it; while women who painted copies of religious and history paintings did well, it was hardly to be expected that a woman would struggle to master the difficult techniques of painting in order to sit down and labour over depictions of homely objects which would have no more place in the esteem of the cognoscenti than a dog in a tragedy.

That the critics had no time for still-life painting did not mean that the painters did not either. Caravaggio is recorded as saying that it took as much skill to paint flowers as figures.[2] He was obviously right, but the consideration was unimportant: the Renaissance concept of the artist as a philosopher placed a low premium on skill *per se*. An aristocratic art does not simply display painterly skills, but uses them deprecatingly in the service of great ideas.

In the twentieth century we have grown up in the light of Manet's statement that still life is the touchstone of painting.[3] In it we expect to perceive the essence of painterliness, an exquisite sense of colour values, of the dynamic interaction of colour and form, and responsiveness to the hues and surfaces of experience, especially of perception. As a working painter Caravaggio had grasped all this, although he would have seen no need to verbalise it. One understands more of the reality in which his *Boy bitten by a Lizard* lives in the contrast of his contorted face with the globe of water and the glossy leaves and blossoms which glow so steadily before him. Caravaggio's still life was monumental, sensuous and exquisite; his commitment as a painter shows as clearly in his *Basket of Fruit* in the Ambrosiana (Milan) as in many of his more sensational works, but if still life had claimed more than a tiny part of his attention he would have fallen into obloquy as a painter of trifles.

When Suor Plautilla painted her *Last Supper* for the convent of San Marco, she had of course to give most of her time and energy to the painting of her lay figures of Christ and the Apostles, but the most successful part of her painting, as we have seen earlier, is the table around which they sit. In the careful disposition of the homely objects of the Last Supper, the cunning interplay of surfaces, especially the creases of the white starched cloth, she creates an expressive intensity which is quite lacking from the human figures of which she had no subjective experience. In carefully separating each object, giving it its own full weight and its own accent, she solved the superficial problem of presentation in a manner typical of archaic still-life painting (see p. 185).

Fede Galizia, the daughter of a miniaturist from Trento, was, like Suor Plautilla, a successful painter of portraits and religious and historical subjects, but in her work we may detect the same contrast of confident dealing with the

inanimate and timidly derivative figure-painting, as in the *Judith* in the Galleria Borghese (see p. 217). The shimmering surfaces and crisp lines of Judith's garments and the cleverly painted jewels are all that is interesting in the work. Judith's face is a vacant mask staring insipidly above the liveliness of her attire. Drapery painting is in itself a form of still-life painting; drapery painters were a subordinate group employed by the masters, even though, in portraiture especially, recording the magnificent habiliments of the sitters was often more important a part of the portraitist's function than catching a genuine likeness.

Among the small number of authenticated works of Fede Galizia, there is a remarkable still life, signed and dated 1602, when the painter was twenty-four years old. It is a small panel, showing a dish of fruit glowing in warm, focused light, against a mysterious background. The globes of fruit swell softly against the hard edges of the dish and its metallic sheen vibrates against the velvetiness of their skin. Beneath and to one side stand a pear and a half. The hard enamelled skin of the pears indicates another extreme of the picture's frame of sensuous reference, while the sheerness of the face of the cut pear dramatises the whole composition. As if to alert us still more to the frailty of these beautiful objects, the pears are balanced by a blowzy rose, lightly subsiding on the other side of the edgeless surface upon which they all exist. The picture is astonishing not

Fede Galizia, *Still Life with Peaches and Jasmine*
This unusual still life, crowned with *Jasminum nudiflorum* and snapdragons is attributed to Fede Galizia by virtue of its similarity to her signed work which is in another class altogether. The compressed perspective is also untypical. Careful restoration might reveal a solution to the conundrum.

Orsola Maddalena Caccia, *Flowers*
The exaggerated symmetry of this
arrangement is rendered stranger by the
absence of stalks and leaves to some of the
flowers and the shadowless Chieranthus
beside the insubstantial vase. It is a
haunting, disturbing picture and the birds
simply heighten the effect.

only because of an immense sophistication expressed in arrogant simplicity, but
because of the grandeur of these humble objects suspended in an atmosphere of
timeless stillness.

The existence of the signed example has encouraged scholars to attribute to
Fede Galizia a group of still-life paintings which are otherwise quite unplace-
able.[4] The identifying characteristics are usually soft and intimate illumination,
near focus and shallow perspective, and meticulous balancing of all values with
their opposites. Her claim to some of these is sometimes contested by Panfilo
Nuvolone, but on the evidence of his signed work in the Galerie Saint Lucas in
Vienna, this writer should say that Galizia's is the better claim. His attitude is
truly baroque: his fruit is explosive, disintegrating and airy. Her concentrated
and optimistic sensuality is anachronistic and alien to the sophisticated painters
of the mainstream. Three still lifes in the Pinacoteca Civica of Cremona have
her tender thoughtfulness. In others, which may represent later work, there is a
clever diffusion of the light; to the nearer source on the left is added a light from
the right illuminating the background so that the fruit are counterpoised with
their lit faces against the dark. The objects are detached from their two-
dimensional realm and float as three-dimensional shapes, the way that

Cézanne's objects were to do three hundred years later. Fede Galizia's still life is the expression of reverent contemplation: and as such displays the essence of painterly genius. Her reputation is either great (Charles Sterling used one of her paintings as the frontispiece to his *History of European Still-Life Painting*) or completely obscured (Giuseppe Delogu did not see fit even to mention Fede Galizia in his book on Italian still life).[5] It is worth mentioning here that the great Artemisia Gentileschi is said by De' Dominici to have painted small fruit pieces which were greatly admired. None is now traceable to her.

Orsola Maddalena Caccia, whose three flower pieces in the Municipio di Moncalvo (Asti) are the earliest Italian flower paintings, is not mentioned by Delogu either. Like Suor Plautilla, Suor Orsola responded to the inanimate shapes in her paintings in a more lively and creative manner than she could to the religious personages she had learned to paint from her father. After her father's death, her painting deteriorated rapidly as she reworked the clichés of decorous expression until they were threadbare, while her perception of objects remained as fresh as ever.[6]

Giovanna Garzoni, *A Dish of Broad Beans*
 Because she worked in watercolour on vellum, Giovanna Garzoni is usually
 mentioned as a miniaturist. This writer was unable to trace the album of insects,
 fruits and flowers which was said to be at the Accademia di San Luca to whom
 Garzoni left all her considerable fortune amassed after a successful career as an
 (unmarried) artist.

Elena Recco, *Still Life*
 Taught by her father Giuseppe Recco, Elena had such success as a still-life painter
 that she was called to the court of Carlos II of Spain. Her few known works are
 scattered, and most have been attributed to her father.

Both Orsola Caccia and her contemporary, Giovanna Garzoni, seem to have
known of Flemish flower painting more by repute than direct experience.
Giovanna Garzoni was already a rich and successful painter of portrait minia-
tures, when she painted a series of octagonal gouaches of flowers and fruit in a
precise, miniaturist technique which owed nothing to the flower paintings
which were becoming the rage. Her choice of blooms, tulips, and Delft vases to
show them in might be Dutch, but her light backgrounds and rigid arrange-
ments were her own. The paintings, which are preserved in the Uffizi and the
Pitti, were possibly intended for some ornamental scheme. Another group are
simple still-life compositions and studies of birds, fruit and insects.

 Flowers did not inspire Italians as they did Northerners, although Mario
Nuzzi, *detto* Mario dei Fiori, enjoyed great fame and popularity in his lifetime. It
used to be thought that one of his pupils, Lauro Bernasconi, was a woman called
Laura. Elena Recco, daughter of Giuseppe, still-life painter of Naples, was more
typical of Italian interests although she is the sole female heir of Fede Galizia.
She painted fish in the highly esteemed manner of her father, possibly copies of
her father's work. Of other Italian women active in the sphere of still-life
painting in the seventeenth century we know of only Anna Vaiani, Bettina

Pl. 17 Aimée Duvivier, *Portrait of a Young Pupil of David*

Pl. 18 Rosa Bonheur, *The Horse Fair*

Pl. 19 Elizabeth Butler, *Scotland Forever!*

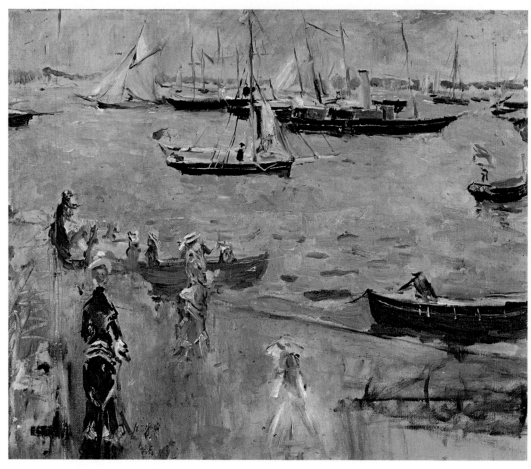

Pl. 20 Berthe Morisot, *Seascape, Isle of Wight*

Pl. 21 Mary Cassatt, *The Bath*, c. 1891

Pl. 22 Cecilia Beaux, *Portrait of Fanny Travis Cochran*, 1887

Pl. 23 Suzanne Valadon, *Woman in White Stockings*

Pl. 24 Gwen John, *A Corner of the Artist's Room in Paris*, 1907–9

of Milan, Colomba Garri and her daughter-pupil Ruffina Castellano,[7] and Margarita Caffi (*fl.* 1662–1700).

Margarita Caffi's is a name often taken in vain by art-dealers, for it is blithely affixed to any second-rate Italianate flower piece or still life which bears the marks of the influence of Mario dei Fiori. Signed examples are relatively rare. An early one, dated 1662, recently passed through a London gallery.[8] It shows an interesting preoccupation with emotive values of flower painting; the flowers are hardly individuated as species except in their general shapes. The whole composition is infused with light and movement so that it swirls and explodes like nebulae against a dull, absorbent background. The values in such painting are not those we normally associate with flower painting in this period; the excitement of her approach in these flickering compositions was perhaps more contagious before her pigments deteriorated. She enjoyed considerable fame, and apparently the patronage of the court at Innsbruck.

In France, Louise Moillon (1609–96) was bringing her own version of the seriousness of Fede Galizia's approach to the painting of fruit. She was closer to the Dutch influence, the favoured shapes in her still lifes were smaller, more jewel-like and the colour values more linear and translucent than Galizia's, but, like her predecessor, she inclined to deceptively simple compositions. The vividness of her registration of the intensity and glow of each sphere of fruit is

Margarita Caffi, *Flowers*, 1662
Despite the facts that her working life spanned forty years – her latest works are dated 1700 – and that authenticated works may be found in Milan, Barcelona, Madrid and Innsbruck, almost nothing is known of Margarita Caffi's life.

not vitiated by submerging it in a kaleidoscopic plethora, but rhythmically iterated in simple, distinct groupings. Often her baskets and boxes seem to be suspended in some luminous medium, because of her indifference to perspective and chiaroscuro; she was unusual in the intensity of her preoccupation with certain unfashionable elements in painting, in her case the relation of pure colour to shape, a virtual primitive.

Until Michel Faré's researches traced her life as a member of a Protestant painting family in Paris,[9] Louise Moillon had been confused with the painter of four Flemish still lifes in the Grenoble museum. The nucleus of signed work by her shows that she painted in a manner which might be expected of François Garnier's step-daughter, and, even if the beautiful Grenoble paintings may not be claimed for her, her contribution to French still-life painting was important. Her current popularity on the art market has resulted in flattering prices. (See Pl. 7.)

More than thirty years before Louise Moillon's death, the daughter of Jacques Duchemin, who had sent her to Baudesson to learn to paint flowers, was admitted to the newly founded Académie Royale. Her *morceau de réception* was *A Vase of Flowers placed upon a Table*. Still life had been accepted in France. Cathérine Duchemin is called in the record 'demoiselle Girardon'. She was in fact married to the sculptor, who became Chancellor and Rector of the Académie. Florent le Comte tells us that after her marriage she stopped painting. Tradition has it that the glass of poppies which she is painting in the portrait of her by Sébastien Bourdon is by her hand. (It is almost certainly not by Bourdon.[10])

In 1669 two more women presented themselves for admission to the Académie. They were the daughters of Louis de Boullongne, *peintre des bâtiments du roi* and one of the founders of the Académie. Geneviève was represented by a big painting of a vase of flowers and a carpet of damask, Madeleine by a bunch of poppies and some asparagus leaves. They were unanimously elected. The sisters exhibited in 1704, but Geneviève had moved to Aix-en-Provence with her husband, the sculptor Clérion. Madeleine lived with her younger brothers, Louis and Bon, both painters and academicians, painting still-life trophies as *sovraporte* for the apartments of the King and Queen. She seems to have been the only named practitioner of this art; the four examples still surviving in Versailles are very competent architectural compositions, but lacking any other works from her hand, they will not suffice to assure her reputation. The pictures exhibited by both sisters at the Salon of 1704 may yet turn up. At the Chiquet de Champrenard sale in 1768, a flower piece of a garland enclosing the Holy Family by Geneviève de Boullongne is recorded.[11]

The other female academician in Paris was a painter of flowers and birds in gouache, called Cathérine Perrot, whose place is properly with those women who painted the gouaches and water colours which were the basis of flower and botanical prints and books. The English collector R. H. Ward found a still life of

Madeleine de Boullongne, *Trophy of Arms and Musical Instruments*
This piece was intended as the kind of decoration called a *sovraporta*. Pieces of
canvas have been added to build the painting out into a rectangular shape. The
original composition was much tighter than this rather dull horizontal
arrangement.

black and white grapes signed on the back by one of the twenty-four children of
the painter Claude Vignon, called Charlotte, whose date of birth (1671) is all we
know of her.[12] The painting is unusual in that it has a curious swinging
perspective, the grapes are seen quite steeply from above, disposed rather
sparsely in a footed dish. Their stalks are displayed outward, so that the
composition sprays out like a Catherine wheel from an incised circle in the
centre of the dish.

Marie Blancour is known only as the author of an attractive flower piece
acquired by the National Gallery of London in 1964.

Like Louise Moillon, the Spanish-born still-life painter, Josefa de Obidos,
painting long after Zurbarán, returned to superseded decorative values of pure
colour and line. Her father was the Portuguese painter Balthasar Gomes
Figueira who returned to his homeland with his family after Josefa had learned
painting in Spain. She is principally known as a painter of portraits and religious
subjects and was a member of the Academia of Lisbon with the name Evora.
Her still-life painting is represented by a basket of flowers in the Espirito Santo
collection in Cascais and a pair of paintings in the Museu-Biblioteca at San-
tarem. Her experience as a professional painter makes her style of still-life
painting even more interesting; her choice of a stylised manner would seem to
be deliberate.[13]

Still life was not long to be left to women. The success of the Dutch easel painters in creating a new market for works of art inspired their colleagues in Italy, Spain and France to emulation. The middle-class collectors had no use for altarpieces and not much more for vast canvases full of incests, martyrdoms, riots and rapes; a small, exquisite still life or flower piece was much more likely to appeal to the nascent consumer society, and so it came to pass. Jan Breughel, who was first taught to paint by his grandmother, raised the painting of flowers from mere incidental decoration to an end in itself. The immediate but durable appeal of his compositions started a new craze; soon the thoughtful women studying the play of surfaces in subtle compositions were swept into oblivion by an avalanche of fish, fruit, fowl, flesh, cups, trenchers, rugs, musical instruments and, of course, flowers. The conspicuous activities of the pioneers were buried in the explosion of the baroque still life; nevertheless women continued to work, if less independently than before.

One of 'Velvet' Breughel's followers was the great still-life painter, Clara Peeters, of whose life too little is yet known.[14] Her surviving works number twenty-four, twenty-two of them still lifes, two pure flower pieces. Most often her canvases are display pieces in the manner of Floris van Schooten, in which precious objects, both natural and man-made, are individually set out, each with its own highlight and separate emphasis, inter-reacting contrapuntally

Josefa de Obidos, *Still Life*, 1676
 The object of this exercise seems to be to excite the taste-buds: sweetmeats of all kinds, comfits, cashews, petits fours and friandises are carefully displayed in a pictorial celebration of luxury. The ebullient decorations give no hint of impending surfeit, until we notice the upturned vessel in the foreground, and the scatter of broken petals and fragments of food.

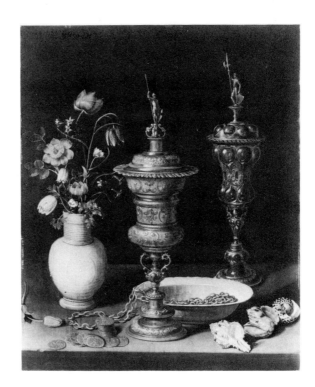

Clara Peeters, *Still Life*, 1612
Clara Peeters' still lifes are the
first known Flemish examples of
this kind of painting. We do not
know how she came by her
technical skills.

rather than forming a harmony. (See Pl. 5.) The unusual composition of the still life in the Staatliche Kunsthalle, Karlsruhe, indicates that Clara Peeters may have been a more original talent. It shows three tall vessels, a pottery vase of anemones, hyacinths, tulips and a snakeshead lily, and two gilt cups with covers standing about a Chinese celadon bowl out of which hangs a golden chain. The natural beauty of the flowers is counterbalanced by a group of exotic shells. The composition is deceptively simple, for cunning asymmetries weave among the elegant verticals, creating a nervous vortex in their stillness. On the shiny bosses of the furthermost cup, Clara Peeters has carefully painted her own reflection in miniature, six times, in the flare of light from a window.

A smaller piece, in the Rijksmuseum, of fish, eels, mussels, oysters, shrimps and shells, also shows a glass of flowers: the composition is bolder and more unified than her larger works; there is a curious alternation of broad massive shapes. Well balanced and painted with tentative and unsettling detail, Clara Peeters' work is yet to be untangled from the toils of inept restoration and outright forgery, before we can assess the full extent of her subtle mastery.

Properly speaking, flower painting is a species of the genus still life, but from the beginning flowers assumed the importance of an independent genre. Painters have always painted flowers, but for the early Renaissance painter the flower was subordinate to the whole composition, offering at most a symbolic comment upon it, for all the flowers have been incorporated in the iconography of religion, from Dante's vision of heaven in the form of a rose to the columbine called after the Holy Ghost. Generally speaking the flowers were wild flowers,

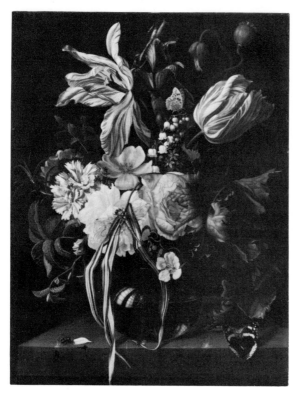

Maria van Oosterwijk, *Flowers and Insects*, 1669
Maria van Oosterwijk worked very slowly, building up her marvellously finished compositions, but she worked religiously every day. Such well-made paintings are unlikely to disintegrate: it is possible that her work passes under other names, perhaps names as illustrious as Jan Davidsz de Heem and Willem van Aelst.

or very simple cultivars, as much prized for their scent as for their shape and hue. The stylised shapes of foreign blossoms were familiar from imported textiles, and exercised their own influence upon the decorative use of flower shapes in painting. The Renaissance man's interest in the created world could not ignore the riches of botany, and so the first attempts to classify plants came to be made. Painters like Leonardo and Dürer studied flowers as specimens, as they might have studied a hand or a horse's head.

The arts of hybridisation were not new, but they began to be practised on an unprecedented scale. Perdita might quail at planting nature's bastards, but for less bloody-minded people the new, larger blooms were triumphs of horticultural art. Ambrosius Bosschaert painted his flower pieces, not only as a botanical record, but as a celebration of that art. The introduction of new flowers, like the dahlia from Mexico and the fritillary from Persia and from Turkey the tulip, represented a splendid collaboration between man and nature. The artist contributed his own matchless skill in mixing and applying colour, in composing his piece, in conferring relative permanence upon the flowers, placed in the subjectively received world in which he and the flowers lived and died. Moreover the painting might cost less than the blooms depicted so vividly in it.

In view of their enculturation it is not surprising that women came to concentrate more and more upon flower painting and less upon the other forms of still life. Many of them practised the ancillary arts of botanical illustration or

flower painting for textile and porcelain manufacturers. Women of exceptional self-confidence still took on the male masters of easel flower painting in oils in competition for the congested art market.

The first Dutch flower paintress was probably Margaretha van Godewijk, who also embroidered flowers and landscape. Of her paintings we know little.[15] Maria van Oosterwijk, the daughter of a Dutch Protestant minister, went to Antwerp in 1658, when she was twenty-eight, to study with the famous flower painter Jan Davidsz de Heem. Later she worked at Delft, Amsterdam and The Hague. Louis XIV, Jan Sobieski, the Emperor Leopold, William III of England and the Elector of Saxony were all her patrons.[16] The paintings in the British Royal Collection are close to the style of her master, but gradually she began to develop her own motifs, like the sunflowers which are otherwise rarely seen. Her compositions gradually became more open and daring, with bolder contrasts of texture and shape. Houbraken says that another still-life painter, Willem van Aelst, sought her hand in vain. Certainly, her growing interest in asymmetrical forms might reflect his influence (unless his reflects her influence upon him). She died, unmarried, in 1693. Geertje Peeters, her maid, was also her pupil.[17] Her one signed work in the Fitzwilliam Museum in Cambridge is an interesting composition, ostensibly symmetrical except that the small pedestal of the vase hangs over the edge of the table with only a stalk of variegated grass and a drooping stem of *Cineraria Marittima* to balance it.

The sister of the well-known marine painter Simon de Vlieger, Eltje, was an

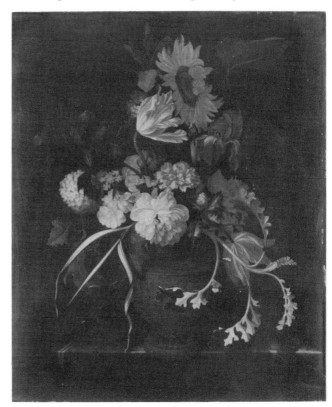

Geertje Peeters, *Flowers*
It is unbelievable that this should be the only extant work by Geertje Peeters, even if it were a copy of a painting by her teacher Maria van Oosterwijk, whose hallmarks, the striped grass and the sunflower, appear in it.

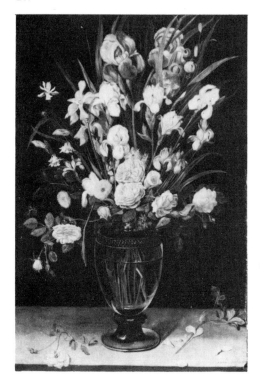

Anna Janssens, *Flowers*
Although this fine panel by Anna Janssens
was first published fifty years ago, we still
know only that its author was the wife of
'Velvet' Breughel, produced eleven children,
and was listed as a member of the Antwerp
guild in the 1640s and again in the 1660s.

elegant flower painter whose style looks forward to that of Elliger and Lach-
tropius, both of whom were considerably younger than she. There are notices
of her work from 1634–51.[18] In 1645, we find the first mention of a flower
painter called Anna Janssens, wife of Jan Breughel II, and mother of his eleven
children.[19] Her father, a painter of historical and religious subjects, had been a
teacher and collaborator of her husband. She chose to paint in the manner of
Velvet Breughel, her father-in-law: her one known work shows clear signs of
their influences.

Of the many women practising flower painting in the Lowlands in the
second half of the seventeenth century we still know far too little. Of Helena
Rouers, we know only a rather archaic flower piece dated 1663, in the Royal
Museum of Fine Arts in Copenhagen.[20] Of Elizabeth Neal, an Englishwoman
who came to study flower painting, we know only the name.[21] Of Sara
Saftleven, the daughter of one of the Herman Saftlevens and wife of Jacob
Adriaensz Broers, we know only some poorly preserved studies of flowers in
Rotterdam.[22]

Jan Philip van Thielen, the only pupil of the great Daniel Seghers, taught
flower painting to his three daughters, Maria Theresa, Anna Maria and Fran-
cesca Catherina. The family, of the *seigneurs* de Couwenbergh was a noble
Catholic one, and it seems that the three daughters of the painter became nuns at

a convent near Malines, where an aunt of theirs was prioress. A piece by Maria Theresa, showing a garland of flowers around a bas-relief of the Holy Family, is in the town hall at Malines, but other work by the sisters is now untraceable.[23]

Mathias Withoos, the most important follower of van Schriek, is usually credited with the training of his two daughters Maria (1657–1705) and Alida (1659–1715), but it is clear from the rare examples of their work which survive that they preferred to paint in the style of Maria van Oosterwijk, even to the extent of including the sunflower as apex of the composition.[24]

The daughter of the flower painter Samuel Hoffmann, Magdalena, came to Amsterdam to study flower painting and married and settled there.[25]

The women who painted flowers were eligible for guild membership, even though they may have practised their art in the cloister; in 1688 Catharina Ijkens was made a *Meisterin der Gilde*; the entry records her as 'spiritual daughter and nun'. She painted copies of Seghers, and original compositions in his style.[26]

So many women working in the genre, free from the embarrassment of being regarded as prodigies and the strain of conflict with their sexual destiny in the professional atmosphere of the guilds, created a unique concatenation of circumstances which allowed the emergence of a woman artist of the first magnitude. She was born in 1664 to Frederick Ruysch, professor of anatomy and botany in Amsterdam, and Maria Post, daughter of the architect who designed the Dutch royal country residence, the Huis ten Bosch. At the age of

Helena Rouers, *Flowers*, 1663
 Of this painter nothing besides this work is known. The assurance of the composition compared with the unsteadiness of the drawing of the flowers in details might be grounds for supposing this work to be a copy of a lost work, perhaps by Marrel or Bosschaerts the Younger.

Katharina Treu, *Still Life*

fifteen Rachel was apprenticed to the sophisticated flower painter, Willem van
Aelst. He was the originator of the asymmetrical spiralling composition which
Rachel Ruysch developed to its most successful expression. Her taste in choos-
ing and balancing blooms, colours, light and backgrounds was perfect; the
finish of her painting soft, clear and flawless. As the creator of pictures of perfect
beauty she was heaped with commissions and honours, but her poise never
altered. She never succumbed to flattery and demand, but continued to work as
fastidiously as ever. In 1701, she became a member of the guild in The Hague,
together with her husband, the portrait painter Juriaen Pool, to whom in the
course of a married life of fifty years she was to give ten surviving children.
From 1708–13, she was court painter in Düsseldorf. In 1716, on the death of her
patron, the Elector Palatine Johann Wilhelm, she returned to Amsterdam
where she continued to work until her death in 1750 at the age of eighty-six.[27]

The range of her painting was relatively great. While keeping her soft,
diffused light from the left, she varied her compositions of all kinds of com-

bined shapes, simple and sumptuous, in dozens of permutations of warm and cool colour, even painting flowers in architectural settings and the slightly sinister woodland subjects of flowers and creeping things in van Schriek's strange version of the *vanitas* genre. Each painting, whether an asymmetrical spray of simple blooms or a dizzy interaction of multifarious shapes and contrasting colours, is completely successful. (See Pl. 8.)

Rachel Ruysch was not a token woman, unfairly singled out for praise at the expense of other women. In the shelter of her undeniable achievement many other Dutch women were able to realise their talents and obtain due recognition, without flattery or false standards. Agatha, the sister of Herman van der Mijn, a successful portrait painter who also painted still lifes and flowers, came with him to England in 1720 and exhibited flowers and still life at the Free Society of Artists. Herman's daughter, Cornelia van der Mijn (1710–72), one of eight children who followed their father's profession, also settled in London.[28]

Another pupil of Herman van der Mijn, Jacobea Nikkelen, followed in Rachel Ruysch's footsteps to Düsseldorf. Other women who went as painters to the courts of Germany were Katharina Treu (*c.* 1743–1811), Gertrude Metz (1746–after 1793) and Maria Helena Byss (1670–1726).[29] The flower and fruit pieces of the patrician Catharina Backer (1689–1766), who married Allard de la Court van der Voort, were famous in her own time.[30]

Rachel Ruysch, although she influenced many of her contemporaries, seems to have had no pupils besides her younger sister, Anna Elisabeth (*c.* 1680–1741), one of whose few signed works is a copy after Mignon.[31] Little is known of her.

The sixty-odd years of Rachel Ruysch's working life spanned the climax and the beginnings of the decline of Dutch flower painting. Tradition has it that when Velvet Breughel painted his first flower piece, he did so for a woman who could afford the painting but not the flowers. As the development of demotic horticulture gathered steam, more and more people wanted the real thing or visual guides to its varieties. The flower portrait flourished at the expense of the compositions which subordinated the quiddity of the blooms to an aesthetic purpose. Flower painters were more often constrained to practise botanical draughtsmanship than commissioned to paint portable flower pieces. Madeleine Basseporte spent her whole career painting portraits of flowers for the vast collection known as the *vélins* of the King of France.[32] Decorative flower painting flourished as never before, but more as a source of motifs for the royal porcelain manufactures and the silk factories of Lyons than as an end in itself. Flower compositions retreated from canvases to decorate walls, carpets, laces, brocades, curtains, tapestries, coaches, and cups and saucers. In such a plethora of floralness, the burning flower pieces of Rachel Ruysch must soon have appeared supererogated. Their absorption and solemnity were foreign to the blasé quest for elegance.

When she persuaded the jealous Jan van Huysum to accept her as his only

student, the Dutchwoman Margareta Haverman secured the key to success in the French capital. Six years later, in 1722, she used it, when a flower piece earned her unanimous election to the Académie. In circumstances now beyond investigation, it was decided that her *morceau de réception* was by her master and she was struck off.[33] Nevertheless the cognoscenti continued to patronise her until her death in 1795, as well they might, for her surviving works show her to have mastered the style of van Huysum beyond any necessity of a cheap fraud. A comparison of her work with that of her better-known successor, the German van Spaendonck, who came to Paris in 1766 when he was twenty, shows that she was his link with van Huysum. Van Spaendonck was to teach many women, among them the Marquise de Grollier, Thérèse Baudry de Balzac, Henrietta Geertruida Knip, Madame Peigne, Madame Vincent and Melanie de Comoléra.[34]

The flower portrait and the flower motif were replacing the flower piece as a branch of still-life painting, when one of the greatest still-life painters of France, Anne Vallayer-Coster, undertook to paint flowers and other objects with all the painterly seriousness of a past generation.[35]

She was the daughter of a goldsmith of the royal factory at Gobelins, who had moved his family to Paris in 1754, when she was ten. We do not know who was her first master. Madeleine Basseporte was a friend of the family, for she stood godmother to Anne's sister Simone, but the younger woman's concerns were far removed from those of a patient water-colour painter of flower portraits. In 1770, Anne Vallayer, as yet unknown and without sponsor, presented two still lifes as reception pieces to the Académie Royale de la Peinture et de la Sculpture. When they saw her paintings, one of the *Attributes of Painting*, and another a group of musical instruments, the honourable Academicians elected her unanimously at once. Both paintings are now in the Louvre.

Her moment of success was saddened by the death of her father. Her mother took over the family business while Anne continued to work for the support of the reduced family. Her youth, good looks and agreeable manners were no obstacle to popularity, but she did not allow foolish and public praises to turn her head. In 1775 she exhibited her first still lifes with flowers; in 1779 she began to enjoy the patronage of Marie-Antoinette; in 1781 she was granted a studio in the Louvre and was married to Jean-Pierre Silvestre Coster, a rich and respected member of a powerful family from Lorraine.

Her cool, chaste compositions, which to us might signify the surfacing of the abiding concerns of still-life painting as the flood of rococo exuberance subsided, appealed equally to neo-classical tastes and temper. Many of her compositions might remind us of Louise Moillon, in their single-minded consideration of simple shapes, a single basket of plums, a twig of *orangier* in a glass, a rumpled white cloth. This reverent sensuality is evident even in her early work, like *The White Tureen* of 1771 (see Pl. 11). Her roses trembled in cool grey light; her flower paintings had more of the feel of flower-ness than

Margareta Haverman, *Still Life,* 1716
The use of the stone niche in which to set her flowers does not prevent Margaret Haverman from developing a marvellous play of spangling light effects by counterpoising fine filigree shapes against darker masses. The composition is highly unusual: one can only regret that either inadequate technical training or poor conservation have caused so much colour loss.

Barbara Regina Dietzsch, *Flowers*
This painter also carried out
flower studies in body colour on
black paper. The flatness and
linearity of her technique may be
explained by the fact that many
such studies were taken for
engravings.

anything before painted, however they might have disappointed those whose
first fealty was to horticulture.

She survived the upheaval of the French Revolution, despite the undeniable
fact of her royal patronage. The new fashions in politico-sentimental art left her
unmoved, still absorbed in the sort of contemplation that was to engross
Cézanne seventy years later. Her still lifes continued in the tradition of Oudry,
Desportes, and Chardin; each explored and articulated the conditions of its own
successful existence. In her work we find a clear expression of the deep joy
which great still life communicates.

As a profoundly serious still-life painter, Anne Vallayer-Coster was a
woman in a man's world; we do not know what she thought of the contem-
poraries who admitted her to the confraternity, and made of her an honorary
man. Her life was determinedly private, dignified and hard-working.
Occasionally she attempted other genres, but for the usual reasons her success at
figure painting was limited. The real drama in her life lay in the objects she
immortalised.

The passion for flower painting had spread not only down the Atlantic coast
but inland to the courts of Prague and Vienna and Nuremberg, where many
distinguished Dutch and Flemish artists worked. Nuremberg, the seat of the
archducal court and of a flourishing publishing industry, provided work for a
number of distinguished women flower painters, like Anna Katharina Fischer,
Anna Barbara Murrer (1688–1721), and Amalia Pachelbin (1688–1723).[36]

The distinguished Dietzsch family numbered two women painters among its members. An elder daughter of Johann Israel, Barbara Regina Dietzsch (1706–83), mastered the art of flower painting in gouache, mostly for engravers. Her work was exact and linear, as one might expect of designs for engraving, but in her more ambitious flower pieces she exhibited a conservatism of approach which was fairly antiquarian. For all its charm, it showed that flower painting had begun to prey upon its own history; except in the hands of great masters, the genre was in decline. Margaretha Barbara Dietzsch (1726–95) painted, like her elder sister, flower portraits for engravers.[37]

Maria Caterina (1747–1794) and Elisabeth Christina Höll (1749–1800) both painted, Elisabeth Christina flowers and birds. Maria Caterina trained her daughter, Ursula Magdalena Prestel (1777–1845), to paint and engrave flowers and she accompanied her mother to England when Maria Caterina left her husband in 1786.[38]

With the growth of British wealth and influence in the eighteenth century, more and more European artists and craftsmen found their way to London. The daughter of a Swiss gold-chaser and enameller, Mary Moser (1744–1819), began to exhibit flower paintings at the Society of Artists while she was still a

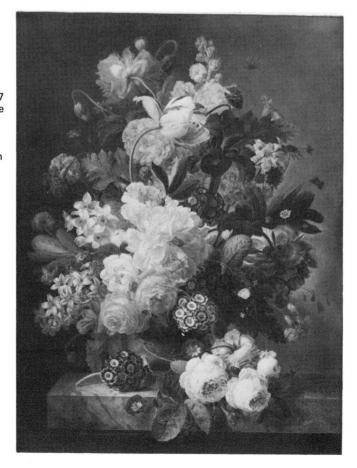

Melanie de Comoléra, *A Vase of Flowers*

Melanie de Comoléra is first recorded working at the Sèvres porcelain factory in 1816. In 1827 she became flower painter to the Duchess of Clarence, later Queen Adelaide. The inscription on this painting shows that she held the same post under Queen Victoria.

Mary Ensor, *Spring Flowers and a Starling by a Wall*, 1864
Victorian flower painters often attempted to portray flowers in their natural habitat in freer, more spontaneous compositions.

child. The sisters of Henry Fuseli, Elisabeth (1744–80) and Anna (1749–72), both painted flowers and insects.[39]

Mary Moser was not so much influenced by any native Swiss school of her own time as by the older Dutch masters whose glowing colour against dark backgrounds is typical also of her work. From the outset her approach was bold and luxurious; it is not surprising, especially in view of the fact that her father had been appointed first Keeper of the Royal Academy, that she was elected a founder member at the age of twenty and she exhibited there from 1768 to 1790. She painted professionally until, at the age of fifty-three, she married the widower of a friend; after which she worked only as an amateur and in other genres. At the climax of her career she was paid the princely sum of nine hundred pounds for painting the walls and ceiling of a room in Frogmore at Windsor, a room which is now sadly in need of restoration and closed to the public. Of a lifetime's work only a handful of paintings is now known. One of the pieces in the British Royal Collection shows that if she was the first significant British flower painter, she was also one of the best.[40]

The story of the fifty-odd women exhibiting flower pieces in London alone in the second half of the eighteenth century belongs more properly to the story of painting as genteel accomplishment. Part-time practice of flower painting

was enormously widespread; it took only a nod or a nudge in the right quarter and ladies flocked to exhibit. Flowers were chosen as a fit subject for people who were not meant to take their artistic activity too seriously, and commercially manufactured paper, pencils and water-colours were not smelly or messy or in any way unfeminine. There is no point in adjoining here the names of all those ladies whose fame is assured in the annals of the Society of Artists and the Royal Academy.[41] There were exceptions to the general sway of amateurism and frivolity in flower painting, of whom Mary Moser was one.

Mary Moser's success with Queen Charlotte was paralleled in her own time by the appointment of Diana Gili[42] as flower painter to the court of Savoy, and of Elisabeth Félicité Gillet who was made a member of the St Petersburg Academy in 1774.[43] The Danish flower painter Madeleine Margrethe Baerens enjoyed the patronage of both the Danish Queen Juliane Marie and Catherine II of Russia. She cast her net wide, for in 1790 she exhibited at the London Royal Academy and to the Paris Salon of 1794 she sent no fewer than twenty-one paintings.[44]

Masters like van Spaendonck, van Dael and Redouté were happy to take women as students, whether they were unusually highly motivated amateurs or willing to make designs for books or manufacturers, but in the nineteenth century the serious still life was to become something which painters of other subjects attempted from time to time. The tradition in which painters like Maria van Os (1780–1862) and Maria Snabilé (1776–1838) grew up was spent.[45] Their prim, pretty paintings are faint echoes of past glory. It was not until the impressionist revolt that still life was to come into its own as a genre again, and then few women could be found who practised it as seriously as Cézanne, Braque or later Morandi. (A discussion of the work of Georgia O'Keeffe is outside the scope of this book.)

The women still-life painters of the nineteenth century were, perforce, academic and eclectic in their approach. The Victorian flower painters, like Melanie de Comoléra (*fl.* 1816–54), Emily Stannard (1803–85) and her niece, Eloise (1829–1915), and Anne Feray Mutrie (1826–93) created somewhat choked, ornate compositions, lit with the rather lurid glow of the new chemical colouring agents. Some, like Eloise Stannard and Mary Ensor, took still-life painting into the open air, and painted dense clumps of woodland vegetation, starred with flowers and full of the tapestry of green on green so beloved of Millais.[46]

The work of these women, who gathered up the strands of three hundred years of fascination with flowers, may be decadent, but like much that is decadent it is often full of charm. The self-deprecating attitude of the painters is one of the sources of this charm, to which buyers at auction seldom fail to respond. Every year produces its own crop of little-known names or initials affixed to delicious small paintings, the only trace of women who would have been deeply embarrassed to hear the bidding for their work.

XIII

The Portraitists

The invisible woman in the asylum corridor
sees others quite clearly,
including the doctor who patiently tells her
she isn't invisible –
and pities the doctor, who must be mad
to stand there in the asylum corridor
talking and gesturing to nothing at all.

Robin Morgan

Since the Renaissance, all European art has been portraiture, in that the artist has not expressed in his work the rejection of worldly experience, but rather its exaltation as a means of cognition. At the lowest level, portraiture provides us with recognisable effigies of individuals, at its highest it provides us with insights into the human spiritual condition. We cannot now judge whether Leonardo's *Mona Lisa* is a useful Identikit portrait, for the subject cannot even be identified by name, let alone by her long decayed features, but to the minds of men it has conveyed an essence of alien, challenging femaleness which has not lost its pungency after five hundred years.

The greatest portraits are those painted by the greatest painters. The greatest portrait by a woman is *The Portrait of a Papal Knight* by Artemisia Gentileschi (which has been discussed earlier on pp. 195–6). Because Artemisia Gentileschi was a painter skilled in portraying humanity in the drama of interaction, her portraits of individuals resound with significance beyond the fashionable likeness, indicating energy and sensibility beyond the bounds of individual circumstance. She was not confined by portraiture, but turned her sophisticated vision upon the individual for a space.

For most women, portraiture was not one of the multifarious media of well-developed painterly genius but the outer limit of their capacity, a calling followed by constraint. Painters who have been allowed only to learn how to prepare canvases, apply and mix paint, and to paint draperies, skies and ultimately hands and faces, must, if they continue to paint figures, paint more or less formal portraits, and so they did.

When Amilcare Anguissola allowed his daughter to paint portraits for the public eye, it was precisely because portrait painting did not imply any unbecoming breadth of experience. Her approach was modest, respectful to the point of ceremony and as such it was popular in a way that more impudent observation would not have been. Such portraiture is eminently useful, especially for a court like that of Spain, where effigies of the monarch were needed by the gross. She was capable of more than the icon of pomp and circumstance; her calm perception did not preclude an uncondescending sympathy, most remarkably conveyed by her studies of her own family. Her simple compositions are weighty and still for the most part, occasionally stirred by some deeper feeling. Heads are turned to show the lobe of the ear, hands are always visible, clothing dark and unextravagant, while the rosy colouring of the Cremonese school, of which her known works provide otherwise typical example, is muted.

From the same standpoint, and using much the same range of imagery,

Sofonisba Anguissola, *Portrait of her sister, Lucia*
This writer would class this charming small portrait among Sofonisba's best work if it were not for a sneaking suspicion that it is by Lucia herself and does not represent her. The style is close to the wonderful *Portrait of a Boy with Sword*, as far as one can judge in so different a format.

Sofonisba's sister, Lucia Anguissola, created something closer to great portraiture. Her slightly more mannered style conveys greater intensity of emotion, especially in her portraits of children which have a limpid, listening, responsive look which adumbrates the agony of childhood better than any sentimental portraiture has ever done. The callow sophistication of the youth in the wonderful portrait in the Walters Gallery, Baltimore, is truer to the spirit of youth than any emblem of innocence. What such a painter might have produced in maturity is beyond imagination. In Baldinucci's words, 'death took her before her time'.

Many were the portraits in the style of the master which issued from the *bottega* of Jacopo Robusti Tintoretto, but as modern criticism attributes fewer and fewer to his daughter Marietta, we can form little idea of her relative proficiency or, for that matter, of any degree of independent vision she may have had.

Lavinia Fontana executed many church commissions but her greatest success was in portraiture. Inside the gorgeous trappings of rich patricians, her disabused eye saw the human creature struggling with the hollowness of pomp and

Sofonisba Anguissola?, *Portrait of a Boy with Sword, Gloves and Dog*
This wonderful portrait is certainly Cremonese and the extreme restraint of the palette is more typical of Sofonisba than her Cremonese contemporaries, but the astonishing blend of style and sympathy suggests a more independent and individual talent. It may be one of the works which earned Lucia Anguissola a reputation for greater ability than her sister.

the universality of fear and pain. Her compassionate and unflattering assessment of the individual found its just counterpoise in the extreme formality of her compositions where every pleat and tuck, every point and every gem is minutely recorded. The result is hieratic, ironic and fundamentally disturbing.

Cecilia Riccio (1549–93), daughter of Il Brusasorci, was famous for 'lifelike portraits in bizarre attitudes'. Quintilia Amalteo, Chiara Varotari, Arcangela Paladini, Lucia Casalini Torelli, and Giovanna Fratellini were all professional portraitists.[1] Maddalena Natali (b. 1657), the daughter of Carlo Natali, accompanied her brother to Rome and supplemented the household income by painting portraits of the clergy, of which a signed example dated 1675 has been described, but is now destroyed.[2] Angela Beinaschi is another woman who painted portraits while her menfolk undertook more ambitious commissions in Naples and in Rome.[3] An engraved portrait of Latino Latini dated 1675 is all we know of the work of Caterina Angiola Bussi from Viterbo.[4]

Anna Metrana was said by Orlandi to be one of the most famous paintresses of the time (*c.* 1704), especially in the art of portraiture, 'having in this excelled her mother, herself a great painter', but nothing more is known of her outside this single mention.[5] Another Torinese, la Clementina, M. G. B. Clementi (1690–1761) is represented by a life-size portrait of Carlo Emmanuele III dated 1754 in the Pinacoteca of Turin, and another in Besançon.[6]

Women outside Italy were also successful as portraitists in the sixteenth and seventeenth centuries. The Fleming Catherina van Hemessen began her career as her father's assistant and painted religious groups like his, but all the signed examples of her work are small, restrained portraits typical in their abstracted, introverted expression, limited colour range and restricted lighting of the Flemish portrait tradition as it was to develop.[7] Her technique was that of a miniaturist, expanded into the small portrait on wood; the larger format increases the religious sense of solemnity in these austere little works, and even in the rare instances that they look towards the beholder, their expression is meditative, innocent of arrogance or display. In 1554, the painter married Christian de Morien who held the post of organist in the Antwerp Cathedral. The partnership was unusually successful in that Mary of Hungary, sister of Charles V, took them both to Spain and on her death in 1556 provided for them for life.

Gertrude van Veen's (1602–43) likeness of her father Otto, Rubens' teacher, was considered good enough to be engraved, as was Anna Françoise de Bruyns' likeness of her uncle and teacher, J. Francquart. Her uncle presented her to the Infanta Isabella of Spain for whom she carried out commissions, including a series of *Fifteen Mysteries of the Rosary* as a present for the Pope. According to Houbraken in *De Groote Schouburgh* she was the best woman painter of her time but beyond the engravings from her portrait we have no evidence of this ability.[8] She married I. Bullart, author of *L'Académie des Sciences et des Arts*, and went with him to Arras in 1629, when she was about twenty-four.

Micheline Wautier, *Portrait of a Man*, 1646
The fluent brushwork, relaxed posture and confident use of chiaroscuro to give emphasis to this gentleman's poker face show Wautier to have been an experienced professional. Yet only four works are known, one only by an engraving.

Micheline Wautier is the author of a rather good masculine portrait in the Musée Royale of Brussels, painted with a swiftness and accuracy which suggests regular professional practice, but besides this, and two religious half figures in Vienna, documented as her work in the Archduke Leopold's inventory of 1659, and the engraved portrait from her painting of Don Andrea Cantelmo in armour (1643), no other work is known.[9]

(Anna van Cronenburch, hitherto considered the most distinguished Flemish woman portrait painter of the seventeenth century, has been discovered to be identical with Adriaen van Cronenburch.)[10]

Catelijne Pepijn, the daughter of Rubens' rival, was named *Meisterin der Gilde* in 1654.[11] A portrait of N. van Couwerven, Abbot of St Michel, dated 1657, is in the Antwerp museum and another signed portrait of Abbot J. C. van der Sterre of the same date and from the same place, the Abbey of Tongerloo, is recorded.

Adriana, daughter of the history and portrait painter, Johannes Spilberg, and later wife first to the painter Breckvelt (1684) and then to Eglon van der Neer (1697), is reputed to have excelled in portraits, mostly in crayon, sometimes in oils.[12] She was born in Amsterdam in 1652, travelled to Düsseldorf in 1661, but no work is known in either place.

Adriana Spilberg's contemporary, Aleida Wolfsen (1648–90) is more fortunate in that a signed example of her work is preserved in the Gemeente museum in The Hague and another in the Hermitage. She was probably a student of Caspar Netscher. She married the painter Pieter Soury, to whom she bore eight children.[13] The Dutch portrait painter, Margrete van Huyssen, is known only by two signed portraits dated 1688 and 1706.[14] A woman by the name of

Catelijne Pepijn, *Portrait of the Abbot of St Michel*, 1657
We are indebted to the Abbey of Tongerloo for any indication of this highly competent painter's style. The rest of her work has probably been redistributed among her contemporaries.

Dorothea Henneberger is recorded as a court painter in Munich around 1590, but so far we know only her name.[15]

The first Englishwoman to set up as a professional painter may well have been Mrs Joan Carlile. In 1654, she and her husband moved from their country home to Covent Garden, the artists' quarter of London. By 1658 Mrs Carlile had made a name for herself, and so was mentioned by William Sanderson as a 'virtuous' artist in oil colour. She was the daughter of a higher civil servant but unfortunately we have no information about the circumstances in which she was enabled to gain the rudiments of a painter's training. Her painting production is known to us only by a handful of dubious examples, among which the best documented is a painting known as *The Stag Hunt*.[16] Another attempt to portray an occasion rather than an individual is the family group of the Baron of Helmingham. Various individual portraits have been attributed to her, besides the three mentioned in her will: the portraits of a princess and Lady Bedford and a painting of 'the little Saint Katherine and Mercury'.

Until recently this painter was known as Anne Carlile because of a mistake in Buckeridge's *Essay towards an English School*, in which it is recorded that Charles I once presented her and Sir Anthony van Dyck with more than five hundred pounds' worth of ultramarine.[17]

Another Englishwoman was Mary Beale (1632/3–97), the daughter of a clergyman and enthusiastic amateur painter. She probably had her first lesson

from her father's friend, Robert Walker. By the time she was twenty-seven, she was already receiving favourable notice and her house in Covent Garden was the resort of up-and-coming churchmen, artists and littérateurs.[18] Many of these were to be her sitters, some, like Tillotson, more than once. A self-portrait of this period (see Pl. 15) shows a vigorous expressive style, especially in the treatment of the drapery, as well as an interesting dignity and reserve not to be found in the female portraits by her contemporary, Sir Peter Lely. The colours are warm and harmonious, the skin tones fresh without being voluptuous. The artist rests her strong right hand on an unfinished canvas showing the heads of her two sons. A portrait of her husband, companion piece to the self-portrait, is remarkable in the sense of domestic sensuality that it conveys.

In 1665 the Beales left London, just in time to escape the Great Plague. In 1670, they moved to a house in Pall Mall and Mrs Beale's clientèle increased rapidly, partly because of the help she had from her husband. In 1677 she had eighty-three commissions, all carefully recorded in her husband's notebooks, but with Lely's death and the change of fashion her popularity waned. Despite

Joan Carlile, *The Stag Hunt at Lamport*
A case has been made for this as a conversation piece: it is rather a group portrait and the organisation suggests figures posed before a backdrop rather than social interaction. It is possible that the same figure occurs in both groups, and that there is some attempt at making the picture an allegory of Spring, with the lady of the house in the title role.

Sarah Curtis, *Portrait of Dr Hoadly*
Sarah Curtis turned Mary Beale's
training to good account judging
from this portrait of Dr Hoadly,
later Bishop of Hereford and
Salisbury, whom she married,
whereupon she gave up painting.

her industry her willing drudgery in painting replicas of her own and Lely's work, and her husband's loving support, the household was always in financial straits. Often the painter had to resort to cheap materials and the survival of her work was thereby threatened.

Mary Beale taught another woman, Sarah Curtis (d. 1743), to paint portraits. She is known to have carried out at least three portraits, two of which, of Whiston and of Burnet, were engraved. Her portrait of her husband, Dr Hoadly, who was to become Bishop of Winchester, Hereford and Salisbury, hangs in the National Portrait Gallery. After her marriage in 1701 she gave up painting.[19]

Walpole mentions another woman active as a painter in England in the seventeenth century, Mary Moore, by whose hand there is a copy of a portrait of Cromwell, Earl of Essex, in the Bodleian Library, Oxford.[20]

The taking of a likeness in colour had always been a laborious business, of sketching the whole composition and refining the portrayal of details. The gradualness of the method was reflected in the static poses of the sitters, their lofty and unfocused gaze. The Dutch genre painters tried hard to catch the velleities of expression in oils, but their laughter was often petrified, their open mouths dark holes in stiffly contorted cheeks. A new medium was needed to lighten and electrify the portrait. The names of various women are mentioned in the development of the medium of pastel, like Marianne Haid, later Madame Werner (1688–1753),[21] but the exploration of the possibilities of pastel portraiture was advanced most by the work of Rosalba Carriera.

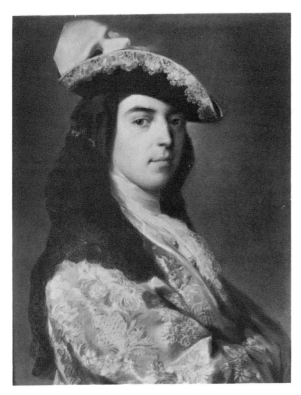

Rosalba Carriera, *Charles, 2nd Duke of Dorset*
Young men on the Grand Tour hastened to sit for Rosalba when they got to Venice, as we may guess from this rather enigmatic portrait of a young English nobleman in full *ridotto* kit.

Painters had always used chalks for preliminary sketches, but chalks are properly speaking natural substances and their range limited to black, white and red. Crayons bound together the pigments with wax or oil: the texture was not conducive to extensive use. The development of pastel, in which the pigments were mixed with filler and bound with gum, made it possible to take fully coloured and modelled likenesses in the shortest time. The colour range was enormous, the versatility of the medium considerable. The use of coloured papers made it possible to achieve a variety of delicate nacreous effects. The sitters were not incommoded, the price was not exorbitant, and it was not necessary to spend long hours in the artist's smelly studio.

The possibilities of the medium were first fully explored by Rosalba Carriera (1675–1757). She was the daughter of a poor Venetian public official and a lacemaker, for whose lace she drew the patterns. From this work she graduated to decorating snuff-boxes and painting miniatures. Her wonderful miniature portraits on ivory gained her admission to the Accademia di San Luca in 1705 but, when a friend sent her the new pastels to try, he changed the course of her life.[22] She had many royal patrons and many invitations to transfer her household from Venice, but it was only when her sister's family were bound for Paris that she consented to accompany them in 1720. She took Paris by storm. Pastel portraits became the rage and the oil painters were obliged to strive for a dancing lightness in their own works. (See Pl. 9.)

Her portraits vary from simple head studies to carefully composed half-

figure groups. She eschewed pompous detail and concentrated instead upon the expressiveness of the countenances she observed. It was an art perfectly attuned to the temper of the Enlightenment, warm, elegant, lively and unassuming. Her character chimed with her style, happily, for a society portraitist must also be sociable. She gauged with perfect taste how to dress and how to comport herself in order to enjoy the full pleasures of patronage and as a result she went about in the best society and was greeted with great courtesy and important marks of recognition, such as her unanimous election to the Académie Royale de la Peinture in October 1720.[23]

Rosalba's success in Paris was not a matter of gallantry but of taste. Four women had been elected to the Académie Royale in the 1660s. Another, Elisabeth Sophie Chéron, was unanimously elected in 1672. She had begun life as the daughter of the miniaturist Henri Chéron, and the sole support of her brothers and sisters when he abandoned his family. She earned her living as a miniature portraitist in water-colours and enamel, as well as pastel but, not content with success in the minor mode, she attempted not only full-sized portraits, of which three besides her *morceau de réception*, a self-portrait, are known, but religious and genre pieces.[24]

Although Mademoiselle Chéron was treated as a prodigy her achievement was, even then, not unique. Professional women portraitists had been known in France since the sixteenth century when Marguerite Bahuche[25] worked in Fontainebleau with her husband, Jacob Bunel. When he died in 1614 she was allowed to keep his apartment in the Louvre. Her contemporary Elisabeth Duval, daughter of a *peintre du roi*, was famous for portrait drawings.[26]

Rosalba's success in Paris owed more to the 'matrism' of French society under Louis XIV than it did to the eminence of women like Sophie Chéron. By 1720 women were conspicuous in public life, which was conducted as much in their salons as in the corridors of power. As Vigée-Le Brun said, 'Women ruled then: the Revolution dethroned them.'[27] Femininity was not a disadvantage, for grace, delicacy and lightness were required qualities for all in the *haut monde*. The unsurpassable shimmer of Rosalba's record of polite society was the model as much for men as for women, and Rosalba's influence was as marked upon the work of men as of women.

Marie Cathérine Frédou was in her teens when Rosalba was working in Paris.[28] She married the engraver Jean Charles François and her work is now known mainly through his reproductions. In 1911 a portrait by her of Giacomo Reycend and his wife was shown in Florence. Rosalba may have actually taught Madeleine Basseporte to make pastel portraits; however she soon abandoned the genre and became flower portraitist to the King. In 1736 we hear of a woman, Monique Damiche, earning her living as a portrait painter in Strasbourg.[29]

Françoise, daughter of the painter Antoine Du Parc and granddaughter of the sculptor Albert Du Parc, studied with Van Loo in Marseille, but her work is

much closer to the genre portraiture that we associate with Chardin except that she concentrated upon the depiction of individuals rather than telling an idealised story of humble life.[30] She and her sister Joséphe Antonia moved to Paris, perhaps after their parents' deaths, where the younger woman, who also painted, died. Then it seems that Françoise Du Parc went to England where she may be the same as the Mrs Dupart who exhibited figure paintings in London in 1763 and the 'Duparc' who exhibited in 1766. In 1771 she was back in Marseille, where she was admitted to the Académie in 1776 and died, aged fifty-two, in 1778.

The development of Du Parc's style is a mystery. There is no record of her having worked with Chardin; although the opacity of her medium, the solidity of the *impasto* and subtlety of her lighting resembles his work. Her concern with the representation of unassuming types, who are not subordinated to some notion of homespun morality or sentimental depiction of the simple life but shown as independent personalities, is unusual in her own time and may in some measure account for her eclipse. When she died she left forty-one paintings, of which only the four she bequeathed to the town of Marseille are still known. Other attributions will remain dubious until more of her life and work is known.

Another Frenchwoman about whom too little is known is Charlotte Mercier, from whose work Ravenel engraved four *Ages of Life*. She was the daughter of the portrait painter and engraver, Philippe Mercier, and his wife, Dorothy, who exhibited water-colour flower pieces and miniatures as an amateur in London where Charlotte died in 1762.[31] Before that, in 1757, she was noted on her own account as a pastel portraitist.

The life and career of Marie Anne Loir, another unmarried Frenchwoman who earned her living painting portraits, is still largely unknown.[32] She was a favoured pupil of Jean François de Troy, who went to Rome as director of the French Academy in 1738, seven years before the first notices of Marie Anne's work. She may have studied under de Troy with her brother, Alexis Loir, who went to Rome in 1739. In 1747, de Troy claimed to be still in communication with her, and on his death in 1752 he left her a watch and a gold snuff-box.

Her best-known work is a portrait of Gabrielle-Emilie le Tonnelier de Breteuil, the famous Marquise du Châtelet, who introduced the work of Leibnitz and Newton to the French and was Voltaire's longest love and closest friend. It is not known how this portrait may relate to the portrait exhibited by Nattier in the Salon of 1745: it has too much flair and energy to be a mere copy. The depth and brilliance of the Marquise's black eyes cannot be eclipsed even by the overpowering ultramarine of her velvet dress: the impact of her personality is more significantly rendered by her tense, energetic figure than the iconography of mathematics and true love duly disposed about her in the grand manner. Even if Loir was basing her portrayal upon Nattier's, it is clear that her

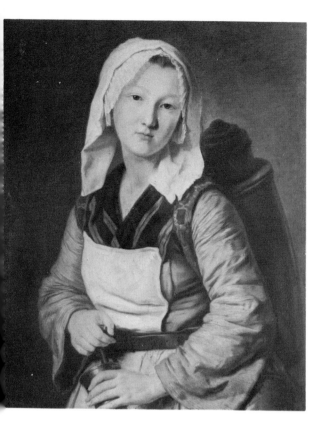

Françoise Du Parc, *The Infusion-Seller*
The young woman gazes impassively at the artist as she works her herb-mill which crushes the dried leaves. There is neither subjection nor coquetry in her demeanour – none of Du Parc's contemporaries could have resisted the temptation to make the picture tell their version of the young woman's story.

own response to the appeal of the eccentric marquise informs the work more directly.

Like Du Parc, Loir seems to have found the provinces more congenial than competitive Paris. In the 1760s she was working for patrons in Pau where her brother Jérôme had settled. In 1762 she was elected to the Académie Royale of Marseille. A portrait is noted in Toulouse in 1779. A clearer view of her life must await more systematic research and a careful examination of doubtful attributions to Nattier and Tocqué.

For young artists anxious to make their mark in Paris there were the open-air Expositions de la Jeunesse held during the Fête Dieu, from six in the morning until midday, on the hangings which decorated the route of the procession. If it rained the exhibition was postponed until the Petit Fête-Dieu a week later, and if it rained then too it was postponed till the following year.[33] It provided a valuable opportunity for unknown painters to catch the eye of a patron, and women were not slow to avail themselves of it.

In 1760 Cathérine Elisabeth Allais showed work at the Exposition de la Jeunesse.[34] Her father, the sculptor, had sent her to study with the distinguished portrait painter Aved. In 1769 we find her making an unsuccessful bid to join

the Académie Royale. From 1779–87 she sent pastel portraits to the Salon de la Correspondance and there her known career ended.

In 1769 Madame Doré, sister-in-law of the painter François-Hubert Drouais, exhibited *A Girl holding a Rose* at the Exposition de la Jeunesse.[35] Two portraits dated 1763 have appeared on the art market at different times and in different places. Another relative and pupil of Drouais, Cathérine L'Usurier, painted portraits in his style.[36] The Louvre has an oval portrait of Drouais, inscribed '*Aetatis suae XV Lusurier pxit*'; her portrait of D'Alembert in the Musée Carnavalet is dated 1770. She died in 1781, aged only twenty-eight. Another of Drouais' pupils, Pauline Chatillon, Madame Gauffier, became famous for painting Italian peasant genre subjects.[37]

In 1768 and 1773 we hear of a Mademoiselle Rameau exhibiting oil and miniature portraits among the 'Pupils of Painting'.[38] Mademoiselle Médard brought portraits to hang in 1769, 1770 and 1772.[39]

For all those who could not gain entry to the Académie, there existed the Académie de Saint-Luc, founded in 1751, membership of which entitled them to earn a living as painters. It had no fixed address and its exhibitions were somewhat irregular as a result, but the part it played in fostering female talent, before the vindictive Académie Royale caused its abolition by royal decree in 1776, was considerable. It was the survival of the old craft guild to which varnishers, frame-makers and gilders were admitted. One of its rules waived the requirement of a five-year apprenticeship for the wives and daughters of masters; another stipulated that women who were not daughters of masters might not enter the guild until they were eighteen. Of its four and a half thousand members, one hundred and thirty were women, mostly portraitists in oils, pastel and miniature.[40]

A Mademoiselle de Saint-Martin, who had exhibited there since 1751, became a member in 1761.[41] Marie Elisabeth Ozanne was *agréée* in 1763 as a portrait painter.[42] Madame Cledat, painter in pastel and *en cheveux*, exhibited in 1768 and 1770;[43] and it was there that the two great female portraitists of the eighteenth century made their débuts.

The greatest female exponent of the pastel portrait after Rosalba was Adélaïde Labille. After learning the art of miniature from François-Elie Vincent and contracting an ill-starred marriage with Nicolas Guiard, she became in 1769 one of the select group of artists to be taught by the irascible Quentin de la Tour.[44]

Another of his female students, Marie Suzanne Giroust, wife of the Swedish painter Roslin, was attracting favourable notice.[45] In 1770 she was elected to the Académie, only to die of breast cancer less than two years later. Her *morceau de réception* was the portrait of the sculptor J. B. Pigalle, at present in the Louvre. Six pregnancies interrupted Madame Roslin's development as an artist: of her brief working life a handful of works survives.

Another of La Tour's pupils was Mademoiselle Navarre, Madame Labille-

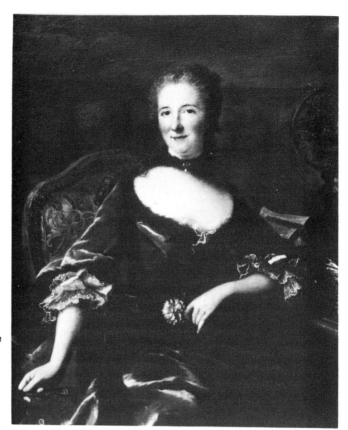

Marie Anne Loir, *Portrait of the Marquise du Châtelet*
A fascinating study of a fascinating woman, whose nose Loir does not shorten one jot, this picture may be related to the portrait of the Marquise by Nattier.

Guiard's senior by twelve years and a member of the Académie de Saint-Luc, where she exhibited pastel portraits 'of the greatest truthfulness', of which one, signed and dated 1774, was exhibited at the Delft Antique Dealers' Annual Fair in 1923.[46] It corroborates the contemporary judgment that 'its composition is very well finished, its lights are generous and have much effect'. Madame Charrière, another of La Tour's pupils, had been his model Belle de Zuylen.[47]

Mademoiselle Navarre had taken part in the exhibitions at the Hotel d'Aligre in the Rue St Honoré in 1762 and 1764. Madame Labille-Guiard joined her at the Salon de la Correspondance in 1774 with a life-size pastel portrait and a miniature self-portrait. She was a slow and earnest worker. Her proficiency in miniature earned her a living while she steadily deepened her range in pastel portraiture; there were no children of her marriage and soon the marriage itself seems to have become a dead letter. In 1779 a legal separation was announced.

After the suppression of the Académie de Saint-Luc, artists who wished to live by their work were compelled to seek admission to the Académie Royale; to do this, Adélaïde Labille-Guiard had to master yet another medium for, since 1749, only oil paintings had been considered as *morceaux de réception*. For her training she turned to her childhood friend and son of her first master,

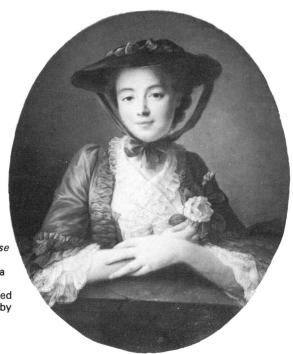

Marie-Jeanne Doré, *Girl holding a Rose*
At the Exposition de la Jeunesse in
1769 Mademoiselle Doré exhibited a
picture called *Girl holding a Rose*,
which is probably the one reproduced
here. It was formerly thought to be by
her brother-in-law Drouais.

François-André Vincent (see Pl. 12). She continued to work in pastel: a wonderful pastel self-portrait exhibited at the Salon de la Correspondance (a short-lived *défi* to the Salons of the Académie) in 1781 ironically shows her painting in oils. When she appeared in the room where the work was hung the spectators burst into spontaneous clapping. Despite the facility of the medium and the characteristic lightness of the effects, she had rendered even more faithfully than the glimmer of silk and velvet and the froth of lace the impression of an earnest, recollected personality, whose will and courage are overlaid by patience and steadfastness. The depth of the impression made by her steady dark eyes is still remarkable.

The next year she showed her pastel masterpiece, a portrait of the sculptor Augustin Pajou at work, in his shirt-sleeves, on a bust of his teacher Jean-Baptiste Lemoine. It has been suggested that the composition may have been inspired by Madame Roslin's portrait of Pigalle, but any comparison serves only to impress us more with the vigour of Labille-Guiard's treatment. Energy flows through the sculptor's strong arm and sensitive fingers, while the face he turns to the beholder is both masculine and distinguished, kindly and intent. Despite his powdered wig and gentlemanly air, the portrait looks forward to Revolutionary portraiture with its emphasis upon character and sensibility rather than rank.

Adélaïde Labille-Guiard was already making a speciality of teaching young

women: three of her students, Mesdemoiselles d'Avril, Capet and Frémy, had shown work at the Exposition de la Jeunesse of 1781; Victoire d'Avril showed once more in 1783 and then apparently accepted the rôle of Labille-Guiard's housekeeper. Of Mademoiselle Frémy's subsequent career we know nothing further, beyond a portrait exhibited at the Salon de la Correspondance. Marie-Gabrielle Capet became one of the most distinguished miniature painters of her day, working in Madame Labille-Guiard's *atelier* until her death.[48] Her most ambitious work was a posthumous portrait of her teacher, shown painting a portrait of Vien (as she had indeed twenty-five years before) while Marie-Gabrielle changes her palette, and François-André Vincent, Joseph Vien and his wife, and Vincent's student, Monsieur Merimée, look on. It was exhibited at the Salon of 1808 but its present whereabouts is unknown.

At the Exposition de la Jeunesse of 1783, Labille-Guiard's nine pupils '*du sexe*' were the star attraction, but not all of their names have been transmitted to posterity.

Marie-Thérèse de Noireterre became a good miniaturist: one of her works secured her selection to the Society of Artists in London, but in the latter part of her career she turned to illustration. Jeanne Bernard painted portraits until her marriage to Vincent's pupil, Laurent Dabos, after which she turned to genre subjects like her husband's. A Mademoiselle Verrier who exhibited work in 1786 became Madame Maillard, but of her career as a painter we know nothing more. Mademoiselle Alexandre is known only as an exhibitor in the Expositions de la Jeunesse of 1784 and 1786. In 1788 Labille-Guiard was ordered by the

Marie Suzanne Roslin, née Giroust, *Portrait of the Sculptor Pigalle* This virtuoso pastel portrait, in which the artist has gloried in the challenge offered by watered taffeta and Valenciennes lace, won for Marie Suzanne Roslin nomination to the Académie Royale de la Peinture et de la Sculpture in 1770.

Mademoiselle Navarre, *Portrait*,
1774
 By choosing a pose of recollection
 and repose, and turning her
 subject's eyes levelly upon the
 beholder, Mademoiselle Navarre
 invests her with the same kind of
 dignity that we see in the portraits
 of Françoise Du Parc.

King's aunt to take one Pomponne Hubert as a pupil for a pension of twelve hundred livres a year; the sum was reduced to eight hundred livres in 1790 and continued to be paid until 1792, but of the result of Mademoiselle Hubert's training we know nothing. Count Doria names two other women, Mesdemoiselles Lambert and Gordrain, but of their work nothing is known.[49]

In 1782 Labille-Guiard had been working upon a series of portraits of members of the Académie Royale, of which the Pajou portrait is one. Her success was so brilliant that it was inevitable that her name should come up before the Academicians for inclusion among their number. She angrily rejected the advice that she should leave it to her powerful friend, the Ministre des Arts, to propose her rather than risk the ballot.

> She forcefully rejected this indirect method, declaring that she wanted to be judged and not protected; that if her talent was not found worthy of the academy, she would work without respite to perfect it; that she would respond to refusals by new efforts; and, in order to succeed in vanquishing all pretexts, she openly attacked the obstruction which women almost always encounter in their progress to fame [gloire] so that they never win any success which is at all impressive, without someone at once trying to deprive them of some part of it.[50]

She had nothing to fear from the ballot: her portrait of Pajou was demanded as a first *morceau de réception* and the whole series of artists' portraits was

Adélaïde Labille-Guiard, *Portrait of the sculptor Pajou, modelling the bust of J. B. Lemoyne*, 1782
'Come and see the portrait masterpiece of Madame Guiard,' wrote the periodical *Les Peintres Volants* in 1783, 'what a virile, speaking physiognomy! How the accurately drawn arm seems to be in relief and stand out from the canvas [*sic*].' Pajou was a friend of the painter's family and one of her earliest and most loyal supporters.

exhibited at the Salon of the Académie Royale. The second *morceau de réception* was a portrait of Amedée van Loo exhibited in 1785.

As if to challenge the dissidents among the Academicians, Labille-Guiard prepared, for the Grand Salon of 1785, an important life-size self-portrait with two of her pupils, the faithful Mademoiselle Capet and Mademoiselle Rosemond, who had shown work at the Place Dauphine in 1783, 1784 and 1786. In 1788 she married a pupil of the engraver J. G. Wille and died the same year; Labille-Guiard has immortalised her as an artist, standing behind her teacher's chair, clad in a simple muslin painting-dress, her uncurled hair bound by a green ribbon like a harbinger of the women artists of the Revolutionary period. There may be a touch of loving irony in this, for Madame Labille-Guiard shows herself in full sail, corseted and sumptuously gowned in her favourite French grey-blue with yellowish *reflets*, trimmed with lace and bows. The mahlstick balanced across her satin knees and the cloth held in her left hand, let alone the palette so close to the loose bow hanging at her bosom, seem odd accoutrements for a lady of fashion, while her extravagant hat trimmed with ostrich feathers and ospreys and blue taffeta bows, seems an odd accessory for a hardworking painter, indoors at that. The warm, supportive personality of Marie-Gabrielle Capet, who cared for her teacher's widower Vincent after her death, and watched over Labille-Guiard's work until her own death in 1818, after which it was dispersed and its attribution muddled, is well caught in the air

of unmixed admiration with which she regards the canvas upon which the artist is working. The most striking qualities of this interesting painting are the dignity and authority which came to be the distinguishing marks of Labille-Guiard's work.

These were the qualities perhaps which prompted the Mesdames de France to commission portraits from Labille-Guiard. Royal patronage was the apogee of success for a portrait painter, but it was not an unmixed blessing. The creator of spirited artist-portraits could hardly have been thrilled at the chance of portraying the King's aunts, who regarded themselves as the bastions of royal dignity which was ill-served by their nephew's family. Still less could she have welcomed the tiresome necessity of painting numerous copies of every portrait. In many ways the next years must have seemed well-paid drudgery.

Labille-Guiard strove still to increase her range: in 1788 the Comte de Provence commissioned a vast group portrait of the *Reception of a Chevalier de Saint-Lazare, by Monsieur, the Grand Master of the Order*. It was her masterpiece, fourteen feet high and seventeen feet wide, for which she was to be paid three thousand livres: she worked on it for two and a half years. During the Reign of Terror, on 17th August 1793 she was commanded to give up the canvas and all the studies for it that they might be burned. She had no choice but to obey.

The Revolution brought good as well as ill to Labille-Guiard. She lost her royal patrons, but she painted an impressive series of portraits of *enragés*, for which her talents were better adapted. In 1793 she was at last able to divorce Nicolas Guiard; in 1795 she was given a pension and an apartment in the Louvre, where she moved with Mesdemoiselles d'Avril and Capet. One of the finest works of this period is a portrait of Citoyenne Capet at work on a miniature, a fitting tribute to a great friendship. She showed work for the last time in 1800, when for the first time she signed herself Madame Vincent, for she and François-André were married on 8th June. She was already ailing; in May 1803 she died.

Nothing could contrast more with the gradual progress of Adélaïde Labille-Guiard than the meteoric rise of Elisabeth Vigée-Le Brun. Her training in oils had begun in 1766 when she was eleven, when the painter Davesne taught her how to manage a palette.[51] When she was thirteen, after the death of her father whose dearest ambition seems to have been to see his daughter become a better painter than he was himself, the supervision of her development was undertaken by his friend, the history painter Doyen. Even at this age she was painting from life. Accompanied by her friend, Mademoiselle Bocquet, she drew in the *atelier* of Briard at the Louvre. She was advised by Joseph Vernet, but she had no master properly speaking. Her style developed along lines suggested to her by study of the collections of the noblemen and connoisseurs who were only too pleased to allow the pretty girl the run of their galleries, where she industriously copied works by Rubens, Van Dyck and Greuze.

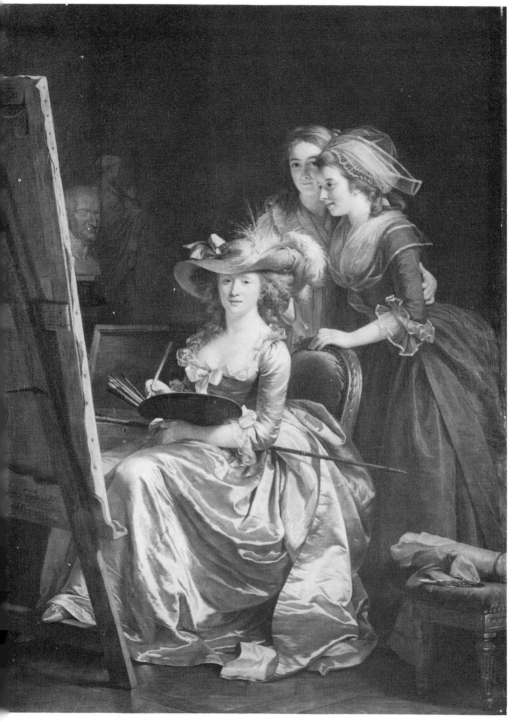

Adélaïde Labille-Guiard, *Self-Portrait with two of her pupils, Mesdemoiselles Capet and Rosemond*, 1785

The odd custom of showing an artist at work in formal dress is not so much an indulgence of the artist's personal vanity as a courtesy to her beholders; we may be sure that Madame Guiard did not ruin her satins by putting her mahlstick across her skirt in real life.

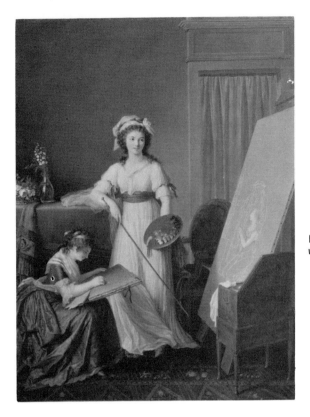

Marie-Victoire Lemoine, *Self-Portrait
with Elisabeth Vigée-Le Brun* (?)
This picture is still something of a
conundrum: even the
identification of the figures has
been challenged. It is by
Marie-Victoire Lemoine as we
know from the records of the
Salon of 1796, when it was simply
called *Interior of the Atelier of a
Woman Painter.*

By 1772 she was already earning a great deal of money, but it was not enough
to pay all the expenses of her mother's household and her brother's education.
Her mother had married again in 1768 a rich but avaricious jeweller, who took
everything Marie-Louise Elisabeth earned and kept her and her mother on very
short rations.

Her success as the portraitist of the ladies of the *haut monde* was in no small
part due to the charm of her person. Two years after her first exhibition of
works at the Académie de Saint-Luc in 1774, she married the personable but
dissipated art dealer Jean-Baptiste-Pierre Le Brun. By her own account he
seems to have been more interested in her as a source of finance for his illicit
pleasures than as a wife. Under the guise of managing her affairs he fixed the
high prices of her pictures, pocketed the proceeds and kept his wife very
meanly. In order to increase their income he suggested that she take pupils.

> I consented to what he desired, without taking the time to reflect, and soon
> there came to me several misses whom I showed how to do eyes, noses,
> ovals, whose work I had to retouch incessantly, which took me away from
> my own work and irritated me sharply.[52]

The only pupil whom she mentions by name is Marie-Guilhelmine Leroulx
de la Ville, whom she calls 'Emilie', the name by which Dumoustier had

addressed her in his *Lettres sur la Mythologie*. She had begun to work in Vigée-Le Brun's *atelier* some time in 1781, and her public career began in 1784 with the sending of three pieces, including a portrait of her father, to the Exposition de la Jeunesse. In 1786 she attracted a good deal of attention with a self-portrait in a white dress. By this time she was already a pupil of Louis David, who had taken her with her younger sister and a Mademoiselle Duchosel (another, perhaps, of Vigée-Le Brun's despised students), to work in his *atelier* while Vigée-Le Brun's ramshackle studio was being rebuilt.

If Vigée-Le Brun was a reluctant teacher there was at least one of her female contemporaries who was anxious to be known as her pupil. Marie-Victoire Lemoine (1754–1820) sent a picture to the Salon of 1796, in which she showed herself sitting on a low stool at Vigée-Le Brun's feet working on a sketch. The figure of Vigée-Le Brun is close to the sketch of her with Marie-Guilhelmine Leroulx de la Ville made by David.[53] The painter wears her favourite fly-away muslin turban and leans upon a piece of furniture covered with a tasselled cloth, a palette and brushes in her left hand and a mahlstick in her right. On the easel is an unfinished painting of the kind of monumental neo-classical subject that Vigée-Le Brun, who did occasionally paint Bacchantes and allegorical subjects, never attempted, of a priestess presenting a kneeling figure to an effigy of Athene the goddess of wisdom.

The painting is not successful: the figures and objects are represented in a curiously compressed spatial arrangement: the figure of Lemoine in what ought to be the foreground is too small and there is no relationship between it and the figure of Vigée-Le Brun. The frigidity of the neo-classical interior suggested only by a curtained doorway with a pediment and some jumbled pieces of furniture wedged among the legs of the women and the easel is not redeemed by the smattering of flowers. The picture does not have the merit of verity for it does not depict the interior of Vigée-Le Brun's shabby studio, nor is it a likeness of the artists who were both in their forties. It is rather a propagandist gesture and forms perhaps part of the background to the petition of artists and savants which made possible Vigée-Le Brun's return to Paris after her flight in 1791. Marie-Victoire, who never married and signed her work simply Lemoine (so that her works may not now be known from the works of Jacques Antoine Marie Lemoine), continued to exhibit spasmodically until 1814.

It was perhaps because she was inimitable that none of Vigée-Le Brun's pupils seems to have been able to carry on where she left off. Jeanne Elisabeth Gabiou,[54] the only other student to have made a name for herself, was more significantly influenced by Greuze and the eminently imitable David than she was by Le Brun.

Many good painters have been too impatient and egotistical to make good teachers. For all her affected nonchalance and spontaneity, Vigée-Le Brun was a serious and committed painter. She was no mere recorder of countenances and fashions, but strove to create timeless images in the manner of Raphael and

Domenichino. The uniformity of *la grande tenue* with its unbending corsetry and blank rouged faces under powdered hair frustrated her completely. She struggled with her sitters to break down the vapidity of the ceremonial portrait to make her portraits human documents. In 1783 her portraits of the Queen and the Comtesse de Provence *en gaulle* caused a sensation. The malicious said the Queen had been painted in her nightdress. Vigée-Le Brun herself presented the kind of image that she loved to paint; uncorseted, in loose painting gown of muslin and flowing shawls, she kept her brown hair unpowdered under the straw hats and eccentric flowing headgear that she affected.

In some of the twenty-odd self-portraits (see Pl. 13) we can trace Vigée-Le Brun's absorption in painterly problems. One, dated *c.* 1781, is inspired by Rubens' *Straw Hat*, which she had seen on a journey to Amsterdam with her husband. With considerable daring she undertook to paint herself outdoors in a hat, with the same play of direct and indirect light that Rubens rendered so deliciously. It was a completely original experiment beyond the range of most of her contemporaries, but she brought it off. The taste for open-air portraits was well established, but Vigée-Le Brun developed her own style of interaction between the human subject and its surroundings. Her figures are not simply posed against the landscape backdrop, but sparkle in the fresh air. Freshness was her favourite sort of sensuous appeal: no painter ever surpassed her in rendering the glow of happy young women.

Another self-portrait showing the young mother in a version of Renaissance dress, loosely clasping Julie Le Brun who turns her head to follow her mother's gaze, deliberately alludes to Raphael in the loose spiral of its composition and the direct emotional challenge of the eyes of mother and daughter. Although the picture is unmistakably not Raphael, for all its effects are self-conscious and distanced by the careful intervention of depth and negative space within the picture frame, the rhythmic composition throbs with a life of its own.

The best-known portrait of Vigée-Le Brun and her daughter is a typically witty comment upon the neo-classical convention which was to reign supreme in French art through most of Vigée-Le Brun's long life. She painted the figures as a symmetrical pyramid festooned with arms, every line carefully counter-balanced to give an impression of movement in immobility. It was a perfectly well-judged performance and became deservedly famous although it lacks the shimmer of Vigée-Le Brun at her brilliant best.

It was perhaps Vigée-Le Brun's egotism which enabled her to achieve such independence from the tyranny that fashion usually imposes upon portraitists, and especially female portraitists. She gloried in extravagant compliment and saw nothing embarrassing in being identified as La Peinture personified. At no time did she express any concern for the artistic aspirations of her own sex. The only other woman painter mentioned by name in her *Souvenirs* is Angelica Kauffmann, about whom Vigée-Le Brun speaks with a characteristic mixture of flattery, condescension and malice.

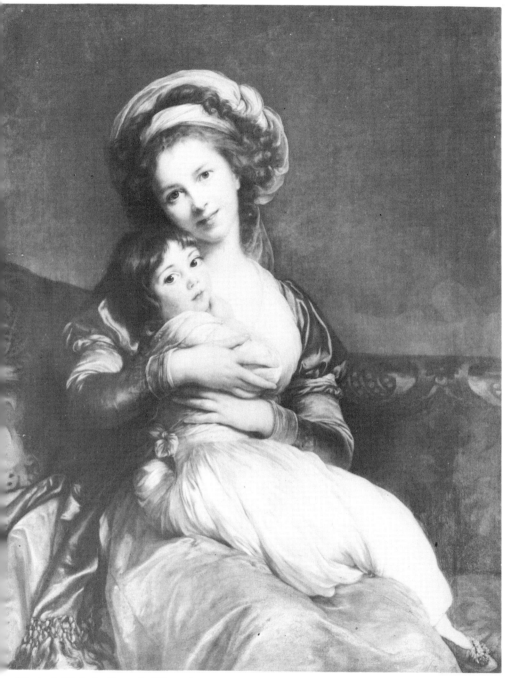

Elisabeth Vigée-Le Brun, *Self-Portrait with Her Daughter*
In her costume and the pose, loosely based upon the *tondo* called the *Madonna of the Chair*, Vigée-Le Brun audaciously recalls Raphael.

I found her very interesting, apart from her fine talent, for her mind and her range of knowledge. She is a woman who could be fifty years old, very delicate, her health having been affected as the result of the misfortune which she had to marry for the first time an adventurer who ruined her ... Her conversation is sweet; she is prodigiously well-informed, but not at all enthusiastic which, given my little knowledge, did not at all electrify me ...[55]

From 1779 Vigée-Le Brun had enjoyed the patronage of Marie-Antoinette, whose direct intervention led to her election to the Académie Royale without scrutiny in 1783, an intervention which was necessary because Jean-Baptiste Le Brun dealt in paintings, an occupation with which Academicians might have nothing to do. It was a sad coincidence that a woman who needed fear no rivals male or female had to resort to the patronage of a queen who was steadily becoming more and more unpopular in order to get what was hers by right. The Academicians resented the interference and made a great show of electing Adélaïde Labille-Guiard in the proper manner.[56] When she came to discuss the matter in her autobiography, Vigée-Le Brun gave a very misleading account of the events. The patronage of the tragic Queen was to cost Vigée-Le Brun dearly, but it is perhaps to her credit that she remained loyal to her all her life.

In 1791 she had to flee Paris as they conducted her royal patroness thither from Versailles under armed guard. She was to produce some of her best work in exile in the years that followed in Rome, Naples, Vienna and St Petersburg where every noblewoman, except the Empress herself who did not like Vigée-Le Brun's style, not surprisingly to anyone but Vigée-Le Brun, besought a portrait from her hand. Her Russian portraits are astonishing in the breadth of their imagery and the originality of their composition. She responded to the melancholy and exoticism of her new environment in an extraordinary burst of energy which she never again equalled.

In 1802 she was able to return to Paris as a result of a petition signed by two hundred and fifty-five artists and savants, and presented to the Directoire. Paris under the consulate was not the Paris that she knew and loved. She did not respond to her new patrons with real fervour; she distrusted David and shrank from envious gossip. She recorded with pride that David, who had never praised any work of hers to her face, had been heard by her husband to say that a portrait that he had sent to the Salon of 1791 had been painted by a woman, while Vigée-Le Brun's portrait of Paisiello, hung *en pendant*, was painted by a man. She visited England, where she was shocked by the painters' habit of exhibiting unfinished work and offended by an ignorant and supercilious letter in a newspaper. She travelled to Switzerland where she painted Madame de Staël as Corinna. Her unease communicated itself in the hollowness of the neo-classical composition: her moment had passed. Grace, beauty and joy seemed to her to have been crushed out of life by the horrors of the Revolution, in which her erstwhile fellow-pupil, Anne Rosalie Bocquet, now Madame

Filleul, had perished on the scaffold for wasting the nation's candles at a celebration of the wedding of the daughter of their old friend, Joseph Vernet.

Her formal royal commissions had never been those that gave her painting its true scope: her art had looked forward to a new aesthetic reign of nature, but when it came it was so anti-feminine and authoritarian that she lost her confidence. Yet, of all her generation, she was the only one whose art had celebrated from its very birth the new qualities of the human spirit that the Revolution had striven to liberate. She continued to paint until her death in 1842 but she allowed herself many distractions, among them her Salon and her *Souvenirs*. Her nieces were the companions of her old age; one of them, Madame Tripier-Le Franc, was a successful portraitist herself, especially of dramatic artists, and is known to have copied some of her aunt's works and may be the author of some of the more dubious works attributed in the salerooms to Vigée-Le Brun.[57]

The portraiture of the Revolutionary period, however strongly indebted it may have been to the innovations of Vigée-Le Brun and her absorption in the sensibility of her sitters, rather than fashion and rank, had little use for the lyricism of her approach. The typical diffused light of the *atelier* which lends such a surreal air to the best neo-classical portraits must have seemed harsh and cold to the old lady; nevertheless it is perhaps because of her unquestioned eminence in the genre of portraiture that so many women practised it in the Revolutionary period with such confidence. It is arguable that the portrait of *Mademoiselle Charlotte du Val d'Ognes*, formerly attributed to David and almost certainly the work of Constance Marie Charpentier, is the finest example of the neo-classical portrait. The work of Césarine Davin-Mirvault, also misattributed until recently, embodies the finest qualities of portraiture in this period, simplicity, directness of emotional appeal, and a compelling quality of glamour. About these women too little is yet known; about their contemporaries and colleagues even less is known.[58]

One of the first of the *citoyenne* portraitists was Aimée Duvivier (*fl.* 1786–1824), granddaughter of Nicolas Duvivier, inspector of the royal Savonnerie. She exhibited at the Expositions de la Jeunesse, but came into her own at the Salon of 1791 and Les Artistes Libres. It seems that she then abandoned the Salons, but evidently continued to paint portraits and to earn a good living by them.[59] (See Pl. 17.)

The female portraitists trained by Regnault form an interesting group about whom too little is known. Marie Marguerite Françoise Jaser, Madame Rouchier (1782–1873),[60] Blanche Lucie Hoguer, Madame Thurot (1786–after 1839),[61] Adélaïde Binart who married her fellow student Alexandre Lenoir,[62] Mademoiselle Boucher (*fl.* 1802),[63] Sophie Clémence de la Cazette (1774–1854),[64] Rosalie de la Fontaine (*fl.* 1806–19)[65] and Adèle de Romance (*fl.* 1793–1824),[66] all exhibited portraits in the Salons of the Directoire and the Consulate. Adèle de Romance, Madame Romany, became famous as an

interpreter of the personalities of actors and dancers for reasons which are apparent in her engaging portrait of the legendary Vestris. No fewer than six of her works are preserved in the Musée de la Comédie Française.

Of other portraitists working and exhibiting at the same time we know even less: Eulalie Cornillaud, Madame Morin, born in Nantes and a pupil of Lethière, is known only by her portrait of Madame Récamier; she exhibited in the Salons from 1798 to 1800.[67] Others are known only by the *livrets* of the Salon: Caroline Delestres (exhibited 1795–1803), Esther Pottier (exhibited 1799–1804), Eugénie Persuis (*fl.* 1803–8). Julie Philipault, pupil of Madame Hersent, won medals in 1814 and 1817.[68] The importance of the work only recently reclaimed for women whose artistic personalities were quite unknown justifies the suspicion that the work of these Frenchwomen may have reached a high point of excellence. The ground is worth prospecting.

France was not the only country where female portraitists were making a name for themselves. In Italy a nucleus of women trained by Rosalba, of whom we know only a tiny proportion, Felicità and Angioletta Sartori, Antoinette Legru[69] and Marianna Carlevaris[70] among them, was carrying on the precedent set by Rosalba.

Rosalba's elder contemporary, Giovanna Fratellini (1666–1731), began her artistic career as a miniaturist, but soon expanded her range to include enamel painting, pastel work and portraits in oil. Her self-portrait in the Uffizi shows considerable energy and charm, as well as a cunning use of a coloured accessory as a way of adding decorative interest without glamourising the worn features of her hard-working subject.[71] The picture contains a small tragedy: the painter son on whose miniature portrait she is working was to die before her.

Fratellini's pupil, Violante Beatrice Siries, went to Paris in 1726 to study under the experts in the grand manner, Hyacinthe Rigaud and François Boucher.[72] She worked in many media and many genres but her greatest success was in portraiture, in which she succeeded Fratellini to Grand Ducal patronage. She in her turn taught other women, for example Anna Piattoli (1720–88).[73]

In Bologna, Bianca Giovannini Fontana was practising as a portraitist until her death in 1744.[74] Maria Caterina David (b. 1765) was working in Genoa,[75] Maria Domenica Scanferla in Padua.[76]

The first female member of the Stockholm Konstakademie was a portrait painter, Ulrika Friedrika Pasch (1735–1796), although more important perhaps is the fact that she was the Rector's sister.[77] In the German states it was probably the enviable success of the Lisziewskas that inspired emulation. Henriette Pesne was their exact contemporary, and she undertook to do something rarely attempted by women, *Gegenstücke* showing the King and Queen of Poland in full figure upon horseback. Such daring implies a good deal of experience, but what that experience consisted in will not be clarified until this woman is identified properly. She was the daughter and granddaughter of painters, and

married the *Oberküchenmeister* at the court of Berlin, J. B. Joyard.[78] Christina
Maria Elliger was the direct descendant of three generations of painters work-
ing for the Electors of Brandenburg.[79] Ludowike Simanowitz (1761?–1827)
was only one of the portraitists in the circle of Goethe and Schiller.[80]

In eighteenth-century England portraiture was the most readily understood
form of painting: the greatest of the male painters gave themselves to it and
women had difficulties in competing with them for the most distinguished
patronage. At the most workaday level, many women daubed away at portraits
for the provincial middle classes, while in another world aristocratic ladies
made good pastel portraits of each other for fun. Angelica Kauffmann painted
portraits when perhaps she would rather have been developing her history
paintings. Women who wished seriously to compete at this level had to find
dedicated teachers who would help them to work methodically, and none
existed. The private academies that were founded to teach drawing and paint-
ing in the eighteenth century admitted women only as models and house-
keepers or members of the royal family.

One woman did manage to compete with the best artists of her time in the art
of portraiture. Catherine Read, the fifth of thirteen children of a Scots laird,
probably had her father's Jacobite sympathies to thank for the fact that she
found herself in Paris in the late 1740s, but it was her own initiative presumably

Eulalie Morin, née Cornillaud, *Portrait
of Madame Récamier*, 1799
 Eulalie Morin was born in Nantes,
 and studied with Lethière. Her salon
 career was short but her
 achievement considerable.

that got her into the *atelier* of Quentin de la Tour to learn the art of the pastel portrait.[81] By 1751 she was in Rome studying oil painting with Louis Blanchet. How these travels were managed is a mystery; the Abbé Grant perhaps stood *in loco parentis* for he is the only source of commentary upon her career as the first unmarried female travelling art student.

> At the rate she goes on, I am truly hopeful she'll equal if not excel the most celebrated of her profession in Great Britain ... were it not for the restrictions her sex obliges her to be under, I dare safely say she would shine wonderfully in history painting too, but as it is impossible for her to attend public academies or even design or draw from nature, she is determined to confine herself to portraits ...[82]

When she returned to England she was indeed able to steal commissions away from Hudson, Allan Ramsay, Francis Cotes and the rising Reynolds. To quote the good Abbé again, 'All the fine ladies have made it as much the fashion to sit to Miss Read, as to take the air in the park.'[83] From 1761–65 she executed, as well as portraits of all the most celebrated beauties of high society, portraits of Queen Charlotte and the Princes. Her work was engraved by all the best engravers, usually in more than one format: for a brief period in the late 1760s and early 1770s she was the best-known portraitist in England, but changes of style were pressing hard on her heels: after 1772 no more of her works were engraved. We may only glimpse the personality of this remarkable woman through the eyes of Fanny Burney, alas, but reading between the lines one is impressed by the difficulty of the life of a spinster portraitist in the world of fashion.

> Mamma took us with her to Miss Reid [*sic*] the celebrated paintress, to meet Mrs Brooke the *celebrated* authoress of *Lady Julia Mandeville*. Miss Reid is shrewd and clever when she has any opportunity given her to make it known; but she is so very deaf that it is a fatigue to attempt conversation with her. She is most exceedingly ugly, and of a very melancholy, or rather discontented humour.[84]

Visits were made to painters' studios while they were at work; a society paintress had to be welcoming and submit to being watched and talked to while at work: Miss Read's deafness may have been the result of inattention or of the unwelcome fact that fires were not usually allowed in studios because of the inflammability of the artist's materials. Painting in winter was a cold and hazardous business: Miss Read may have come by her deafness that way. Pert Miss Burney could not brook Miss Read's absorption in something other than herself

> ... she is absent, full of care ... added to which she dresses in a style the most strange and queer that can be conceived ... The unhappiness of her mind I have heard attributed to so great and extraordinary an unsteadiness not only of conduct but of principle that, in regard to her worldly affairs, she is governed by all who direct her and therefore acts with inconsistency and the most uncomfortable want of method ...[85]

Miss Read's odd dress might have been devised for painting and the worrying muddle in her management of her affairs might have been explained by her single status, for she was obliged to give the management of her money to some male who might do pretty much as he liked with it, a circumstance in which a busy woman might well find herself dithering uncomfortably. One person must have loved Catherine Read; her niece Helen Beatson came to live with her when she was a very little girl and learned drawing. A portrait by her aunt shows her at five handling a pencil in a very competent way. In 1775 the two women went to India, where the fifteen-year-old Helen married Charles, later Sir Charles, Oakley, Governor of Madras. Catherine Read died there in 1777.[86]

Catherine Read's initiative in finding teachers on the Continent was beyond the wildest dreams of her female contemporaries. Mrs Grace (born Hodgkins or Hodgkiss), like Catherine Read, availed herself of the opportunity supplied by the yearly exhibitions of the Society of Artists, which was formed in 1761, to show her work. She had had no 'regular instruction' (i.e. no instruction at all), but she managed to realise 'twenty thousand pounds' from her work as a portraitist.[87] Edward Edwards says that her works were 'heavy in their colouring'; Walpole said of a self-portrait exhibited at the Society of Artists, simply, 'Bad'. Until we find one of her works we cannot agree or disagree.

At the Society of Artists and the Free Society, and later at the Royal Academy, women seeking to make a living by painting could show their work to future clients and publish their names and addresses. Many of them tried to make a mark for themselves as portraitists: Mrs Elizabeth Carmichael, Mrs Eliza Hook, Mrs Gilchrist, Miss Frances Dickson, Mrs Forbes and Mary Bertrand all exhibited for a few years and faded away.[88] Catherine Read had found in Europe the training that was inaccessible in Britain, but foreign women coming to England to practise as portraitists could find no toe-hold. Besides Mrs Dupart or Du Parc, Antoinette Perotti (1719–76), an Italian, and the Frenchwoman Mary de Villebrune (*fl.* 1771–82), all tried to make an impression with portraits at the Royal Academy, to no avail.[89]

The explanation of the absence of good English female portraitists at the time when France was producing a group of brilliant women in the field is simply that in England portrait painting was not a secondary medium, considered as the inferior of history painting and all its branches. Women portraitists in England were competing for room at the top.

XIV

The Amateurs

I could not live for art – it would not be what I am put in the world to do. I do not despise art, but I should feel it was not given for that.

Louisa, Marchioness of Waterford

The rise of amateurism in painting was the result on the one hand of the development of techniques of drawing and applying colour which were not noisome or messy and, on the other, the emergence of a leisured class. The women of the upper classes had always been, perforce, a leisured class: music-making, needlework and praying were their usual pastimes. Queen Isabella of Spain sewed her husband's shirts with her own hand, but less heroic ladies undertook daintier work: they might spend years upon a pair of ruffles, taking up the work from its tiny box beside them and laying it down at will. It was a function of their labour that it be grotesquely time-consuming and totally useless.

The graphic arts were not specifically outlawed for women: one of the reasons why they preferred needlework was that there were few other ways of making a durable image. When she was eleven years old, Marie de'Medici, future wife of Henri IV of France, engraved her own portrait on wood and signed it.[1] The scratching out of an image on wood was not much more difficult than drawing it in chalk and much neater and more permanent. The very concept of drawing a fluid image comes from the availability of drawing

280

materials: painters used to sketch designs on prepared paper with metal styli: such a design lasts as long as the surface on the paper. Pen and ink and sometimes brush and wash were used: water-colour was born out of these beginnings. Meanwhile for ladies yearning to make images, engraving was as manageable a medium as any other. Hundreds of gentlewomen practised the art of engraving both from the designs of others and their own, until the ubiquity of water-colour put colour within the reach of those who could or would not spend long hours in a studio making messes and smells.

The artistic career of the mystic Anna van Schurman (1607–78) can be viewed as a gifted woman's search for a medium. First she clipped intricate, dainty shapes of flowers and insects out of paper, then she mastered the art of tapestry flowers in a few hours.[2] Graduating to the figure, she was obliged to make effigies of herself and her family carved in boxwood and ivory. She modelled a self-portrait in coloured wax and when a clumsy aunt dropped it and smashed it, she learned the techniques of engraving on glass and copper and miniature painting. Gerard Honthorst conducted a sort of school at Utrecht for the daughters of the Queen of Bohemia, Elizabeth, Anna and Louise, where Anna van Schurman too is said to have studied. One essay at a self-portrait in oils is documented, but one alone. Eventually she abandoned the frivolous practice of making graven images for more pressing religious duties.

The Renaissance ideal of the artist as an intellectual favoured the practice of graphic arts by women, for the participation of women, the objects of platonic devotion, in artistic activity demonstrated beyond any possibility of doubt that

Anne Killigrew, *Portrait of James II*
The King is represented as the young hope of the Nation, bedecked with flowers, as if he were a meadow, attended by Pomona and Venus.

soul was more relevant to art than body, and that brains were superior to brawn. This spirit prompted men of taste and discrimination to see in women's work qualities that were not there, to take the desire for the performance. To some such feeling we must attribute the welcoming of women as founder members of the academies. The presence of ladies guaranteed refinement, and refinement seemed more essential to the principles upon which the academies were founded than energy or dedication.

Older than public academies and more lively, if more frivolous, were the private academies. The idea had grown up in the Renaissance of creating environments where patricians, using pseudonyms, might enact their fantasies of Arcadian life, making music, writing and performing plays, addressing poems on the inevitable subject of love to one another, and hatching schemes for decorations and monuments. In some cases they fulfilled a useful function in the communities which harboured them. More often they simply coruscated for a space and died away, as the nobility returned to more workaday pursuits of war, diplomacy and politics. The Academia de San Fernando in Madrid sprang from such a root. More aristocratic than artistic, it featured from the beginning more women (and fewer enduring productions) than any of the

Isabella Maria Louisa de Bourbon, Duchess of Parme, *A View of Grottaferrata, near Rome*
 At twelve years old this artist, who is also known by signed engravings, married the Infante Don Felipe, son of Philip V. It is perhaps a pity that a woman so gifted should have had so little opportunity of developing her talent.

academies founded later. The Marquesa de Santa Cruz, Doña Mariana Valdestein, became its Honorary Director in 1771: her own productions consisted of copies, and portraits in oil and miniature.[3]

The Queen of Spain, the Parmesan Elisabetta Farnese, called Isabella, as the widow of Philip V was admitted to the Academia de San Fernando.[4]

Doña Mariana de Silva Bazán y Arcos Meneses y Samaniaga, Condesa de Oropesa, Huescar y Arcos, became an honorary member of the Academia in 1766 and was later appointed Director.[5] When the newly formed Academy of St Petersburg sent a blank invitation to the most distinguished academician to join its ranks, Doña Mariana was elected.[6]

Nowadays the term 'amateur' implies lack of skill and seriousness, as in 'amateurish'. The word 'commercial' has assumed all the pejorative meaning of 'professional', which has come to mean 'serious', 'dedicated' and so forth. For those pioneers struggling to raise painting from the status of a craft to the dizzy eminence that it now occupies as one of the crowns of human pursuit, it was important that the activity be exalted *in se* and not as a livelihood. To work without payment was a privilege; great art was priceless. This attitude was sometimes reflected in the way that artists were paid. Often it was not a fixed price for each figure, full-length at one rate, half at another, or a little extra for expensive pigments; the artist was rather given rich presents, a pension and free lodgings, and made a member of the King's household. He might even scorn to sell his work, an attitude which still prompts artists to keep their best works for themselves.

In writing of Anne Killigrew, lady-in-waiting to Mary of Modena, Duchess of York, and 'Excellent in the two Sister-Arts of Poesie and Painting', Dryden lays all the emphasis upon painting as an exercise of imagination; facility of technique is assumed.

> Her pencil drew, whate'r her Soul design'd,
> And oft the happy Draught surpass'd the Image in her Mind.
> The *Sylvan* Scenes of Herds and Flocks,
> And fruitful Plains and barren Rocks,
> Of shallow Brooks that flow'd so clear,
> The bottom did the Top appear;
> Of deeper too and ampler Flouds,
> Which as in Mirrors, shew'd the Woods;
> Of lofty Trees with sacred Shades,
> And Perspectives of pleasant Glades,
> Where Nymphs of brightest Form appear,
> And shaggy Satyrs standing neer,
> Which them at once admire and fear.
> The Ruines too of some Majestick Piece,
> Boasting the Pow'r of some ancient *Rome* or *Greece*,
> Whose Statues, Freezes, Columns broken lie,
> And though deface't, the Wonder of the Eie,
> Where Nature, Art, bold Fiction e're durst frame,

Her forming Hand gave Feature to the Name.
So strange a Concourse ne're was seen before,
But when the peopl'd Ark the whole Creation bore.[7]

Dryden's celebration of Mistress Killigrew's creativity, second only to that of God himself, is couched in terms of a classical education as well as invented landscapes. Her scenes with sacred groves and nymphs and satyrs are allegorical as well as fantastic: her understanding of their function raises her above the throng of the King's artisans. The Stuarts could be reminded of the artistic excellence of women whenever they looked at the little picture sent by Princess Louisa, daughter of Elizabeth, Queen of Bohemia, to her uncle Charles I, 'a landscape wherein the Angel is conducting Tobias with a fish under his arm, the angel being in a red and white habit, a little dog following'.[8]

Elizabeth Pickering, daughter of Dryden's cousin, Sir Gilbert, not only painted altarpieces for several churches near Oundle in Northamptonshire and portraits for friends but, on the death of her husband, 'occupied herself in painting and gratuitously instructing young girls in needlework and other feminine arts'.[9] Of her long life (1642–1728) no physical trace has been uncovered. Anne Killigrew died of smallpox in 1685, aged twenty-five. Of a dozen or so documented works only two are now known.[10]

Although earlier, isolated examples of noble paintresses like Marguerite, Grand Duchess of Austria (1480–1530), who painted portraits[11] and Philippa, the daughter of the fifteenth-century Archduke of Coimbra, who presented the convent of Odivellas with a Homeliary that she had illuminated herself,[12] can be found, the spread of painting as an accomplishment for noblewomen outside convents was a phenomenon of the academic movement in the seventeenth century. The European ruling class was international: ideas spread through it with remarkable rapidity. Princess Sophie Hedwig of Denmark and Norway (1677–1735), Sophie, Electress of Hanover (1630–1714), Marie Eleanore, Princess Radziwill (1671–1756), Ernestine, Princess of Nassau-Haudemar (d. 1669),[13] all practised painting in the seventeenth century. Eleonore Christine, Countess of Ulefeld (1621–98) had Karel van Mander for her teacher.[14]

Sophie Albertine, Princess of Sweden (1753–1829), was an associate of the Accademia di San Luca in Rome.[15] Christiane Louise (1754–1815), Countess of Solms-Laubach and later wife of Prince Friedrich Carl Ludwig von Hohenlohe-Kirchberg, became an honorary member of the academy of Kassel in 1782.[16] The Berlin Academy of Fine Arts boasted among its members of the Countess of Keyserlinck (1729–91) and the Electress Augusta of Hesse-Kassel, the daughter of King Friedrich-Wilhelm II of Prussia.[17]

Royal women were not simply elected to the academies as a way of currying favour: their presence (in spirit for they never attended the meetings) was an illustration of the refined intellectual temper of the Enlightenment, most strikingly illustrated in the attitude of Goethe to the practice of the arts by ladies of his acquaintance. The Goethemuseum in Weimar is full of the work of female

Amelia Curran, *Percy Bysshe Shelley*, 1819
The artist's technique is fairly rudimentary, nevertheless the perhaps rather stylised features of the sitter are now everyone's image of Shelley.

amateurs of whom the most famous perhaps is Countess Julie von Egloffstein (1792–1869).[18] Goethe wrote verses for the landscapes and genre scenes of Adele Schopenhauer (1797–1849), sister of the misogynist philosopher: two albums of her work, formerly belonging to Ottilie von Goethe, the dear friend of the mother of art criticism Anna Jameson, and to Sibylle Merteus Schaffhausen, are in the Goethemuseum. The singer, Corona Elise Wilhelmine Schrödter, is represented by two self-portraits in the Goethemuseum.[19]

The earlier lady amateurs are principally remembered for their portraits, which provided the designs for many important engravings: some of the most famous countenances in Europe have been transmitted to posterity through a woman's eyes: the adored features of Shelley are known to us only by a small canvas painted by the amateur Amelia Curran in 1819.[20] A clumsy likeness of Jane Austen by her sister Cassandra is the only ground for the widespread belief that she was in reality plain.[21]

The facility of the pastel portrait made it a favourite hobby of ladies in the eighteenth century; many of them acquired such proficiency in the medium that they ran the gauntlet of public exhibition at the academies. The Countess Tott, Albinia Countess of Buckinghamshire, Lavinia Countess Spencer, Lady Ann McGill, Mary Hamilton (Lady Bell), Lady Diana Beauclerk, Lady Lyttelton, Suzanne Keck (Maid of Honour to the Princess of Wales), Miss Georgina Shipley and Lady Beechey all successfully practised portrait-making in pastel.[22]

Viscountess Templetown,
Woodscene
 A lady's sketchbook could contain
 quite exquisite vignettes brought
 to a high degree of finish. The
 sureness of this composition is,
 however, rather unusual.

Very little of their work, which despite new fixing methods was still relatively fragile, has survived.

A subject more interesting than the faces of the *haut monde* and its children was beckoning to women: interest in it had been stimulated by the Romantic movement and the cult of the picturesque. As the European drawing-room, and particularly the English drawing-room began to open out into the countryside, ladies of leisure began taking views in water-colour.

English interest in landscape was born of the enthusiasm for Claude, which was spread by connoisseurs who, like the Countess of Hertford, travelled in Europe, bought paintings and prints, devised gardens and decorative schemes which embodied Claudian principles.[23] Women were among the first in England to wed the concept of beauty in landscape to the topographical concept of portraying actual landscapes. Lady Diana Spencer's *View of Windsor* (1723) was painted at a time when most English landscape painting was still either a variant of map-making or mere fantasy.[24] Lady amateurs were among the first who by diligent study of prints (a typically ladylike pastime) began to imitate the Claudians, and to some extent the Dutch landscape painters. Susannah Drury[25] and Susannah Highmore[26] are recorded as painting landscape in 1750. Lady Amabel Polwarth's views in Lord Grantham's park date from *c.* 1765.[27]

The interest of the gentry in the portrayal of landscape provided employment for the first English landscapists. Richardson, Jervas, and the Frenchmen

Chatelain and Liotard all found work teaching amateurs.[28] Goupy taught, besides the Royal Princes, Mrs Delaney.[29] Bonneau was brought to London 'from the Spa by some ladies'.[30] Later Paul Sandby, Girtin and Gainsborough would all teach women.[31] Crome taught Richenda Gurney,[32] the sister of the prison reformer Mrs Elizabeth Fry.

Elizabeth Evelyn Sutton (1765–after 1789), daughter of the first Baronet of Norwood Park, Sophia Hume, Countess Brownlow (*c.* 1775–1814), and Viscountess Templetown (d. 1829) all made names for themselves as landscapists. Lady Margaret Arden (1762–1851) was the pupil and the patron of David Cox. Lady Elizabeth Foster, touring Europe in the 1780s with the Duchess of Devonshire, painted views to accompany the Duchess's poems.[33]

Where the grandees went, those aspiring to rank and distinction were bound to follow. By 1800, the numbers of drawing-masters employed by the gentry had increased to hundreds; art teaching had become a profession in itself, much securer than risking oneself to the vagaries of the art market. More than seventy women sent landscapes to the London exhibitions between 1762 and 1800.[34] This great body of work is now dispersed; only if collectors catch a similar craze for eighteenth-century water-colour landscape painting will enough of this production be uncovered and assembled for any clear idea of its worth to be formed. If we may judge from some of the random samples that have been preserved, like Amelia Hotham's riverscape of 1793 in the British Museum,

Amelia Hotham, *River scene* 1793
 In this swift sketch, the amateur artist conveys her grasp of Claudian principles, as well as her thoroughly English appreciation of more subtle effects.

some women achieved a very high standard indeed, in a medium which gave the most fitting expression to their 'tender sences quiet and apt'.[35] In the rather grandiose conception of Miss Hotham's swift sketch we may see a conservative element, but the tact and deftness of her rendition of the bright distant prospect is the more remarkable because Turner was as yet only fifteen years old.

The ubiquity of ladies desiring to 'take views' became something of a plague to artists who found such work uncongenial, either because of their prejudices about the sex in general, or their bad experiences of spoiled, silly and peevish students. The aged Richard Wilson, 'asked out of pity to dinner by Beechey, first enquired, though starving, "You have daughters, Mr Beechey, do they draw?"' and only accepted when he found that they did not.[36] Girtin, by contrast, claimed that Amelia Long, Baroness Farnborough (1762–1837), was his favourite pupil.[37]

The interest of amateurs in painting gave the necessary stimulus to the full development of the resources of water-colour. Water-miscible colour had been used from the earliest times, but it was opaque, often laid on with glues to bind it to the surface, and thickened with body colour. Artists had used washes of dissolved inks and vegetable dyes to stain their sketches, but the colours were unstable and the range limited. Amateurs were not willing to labour for hours to prepare colours and surfaces before painting a stroke; this work was done by tradesmen, colourmen who supplied prepared canvases, boards and papers and ready prepared colours. The demand from the gentry was for water-colours, for the same reasons that Peacham had given on behalf of gentlemen painters a hundred years earlier.

> Painting in oyle is done I confesse with greater judgement and is generally of more esteem than working in water colours; but then it is more mecanique and will robbe you of over much time from your more excellent studies, it being sometimes a fortnight or a moneth ere you can finish an ordinary peece.... Beside oyle nor oyle colour, if they drop upon apparell, wil not out; when water colours will with the least washing.[38]

It was water-colour that Alexander Browne undertook to teach to Mrs Samuel Pepys, perhaps the earliest amateur lady water-colourist in England.[39] By 1766, the date to which the British firm of Reeves traces its origin, colour-making had to some degree been industrialised. New chemicals and new ways of preparing them in bulk were devised by professionals, who gradually organised themselves and rationalised production and distribution. The take-over of colour-making by specialists was the last step in the separation of painting from the craft guilds.

Not all the work carried out by noble amateurs was small and delicate. Albinia, Countess of Buckinghamshire (1738–1816), undertook the decoration of her own house, Hobart House in Grosvenor Place.[40] Lady Diana Beauclerk (1734–1808), born the daughter of Charles Spencer, second Duke of Marl-borough, married in 1757 to the Viscount Bolingbroke, divorced and remarried

in 1768 to Dr Johnson's harum-scarum friend Topham Beauclerk, was not only an expert in 'soot-water' designs of delightful cupids, and in illustrative drawings and a supplier of designs to Wedgwood, she also undertook decorative schemes. In her own house at Twickenham she decorated a room with 'a row of lilacs in festoons on green paper ... In each panel of the surbase ... a sprig or chaplet of geranium, of ivy, or periwinkle'.[41] The room was destroyed in 1785–86. She also decorated another house, Devonshire Cottage in Richmond, in a similar fashion.

Frogmore, at Windsor, one of the houses of George III, seems to have been taken over by his daughters. Princess Elizabeth was an indefatigable artist: she made stupendous decorations for her sister's birthday in 1798, painted the Red Japan Room, the Black Japan Room and a long narrow room. At Buckingham House (now Palace), she made an 'Apartment' in Japan-work, no longer in existence, and at the Queen's Cottage in Kew she decorated an upper room with convolvulus and nasturtiums twining around trellised bamboo canes. In 1818 she married Friedrich IV of Hesse-Homburg and her activities were curtailed.[42]

Unfortunately Frogmore was grossly transmogrified in the Victorian era, when hideous shrubberies were planted all about it and a megalomaniacal Mausoleum built in the grounds. The interior is no longer kept up; even Miss Moser's room is closed to the public. The Hermitage, which Princess Elizabeth designed and had built at a cost that her indulgent father grumbled about, has just been restored. The artistry of these Georgian ladies was meant to enhance life, not to clutter the future: they would not have minded the replacement of

Lady Georgina North, 'Just then, Clarissa drew ...' *The Rape of the Lock,* 1831
A present-day North tells me that one of her great-aunts copied all the family's most valuable paintings which were then sold without public fuss. Amateur noblewomen may have more to do with art history than anyone is prepared to acknowledge.

Louise Rose Julie Duvidal de Montferrier, Comtesse Hugo. *The Drawing Class in Edinburgh 1830, including Mademoiselle, afterwards Duchesse de Parme, the artist, Duchesse de Gontout, and the Duchesse d'Angoulême*
Like many another talented French noblewoman, Louise Duvidal de Montferrier was educated by the famous Madame Campan at Ecouen. She was trained by Gérard and Mademoiselle Godefroid, and showed her work at the Salons from 1819 to 1827. After her marriage to Abel, the brother of Victor Hugo, she seems to have given up painting for exhibition.

their own light-hearted works with new decorations, if only those new decorations had not been so dreary and self-important.

The craze for Japan-work involved many a lady in extremely complex and messy operations. Charlotte Boyle, Lady Henry Fitzgerald (1769–1831), decorated the walls of a room at Boyle Farm, Thames Ditton, with wall panels of grotesques, divided by pilasters of glass in black and gold, which she signed and dated, C. Boyle 1786.[43] The work, called black Japan-work, was carried out in lampblack and gold-leaf applied to glass with isinglass.

What the noblewoman lacked in hard training she sometimes made up for by spontaneity and daring in her designs. Walpole was proud of his Beauclerk closet where he kept seven drawings made by Lady Diana to illustrate his *Mysterious Mother*. Lady Georgina North plunged in where wise men would not have trod, in making graphic representations of the sylphs in Pope's *Rape of the Lock* in 1831, and pointed the way for the great illustrators of fairy tales of the

nineteenth century, for her fairies were no mere miniature nudes, like those of Fuseli who had died in her mother's house in 1825, but tiny pert people with personalities and peculiarities of their own.[44]

The most civilised person in the most civilised era of English culture was Mary Granville, later Mrs Pendarves, known to history by the name of her second husband as Mrs Delaney. She was a cultivated, vital, interested and interesting person, who worked as a leaven in the society of her day, stimulating all her friends to artistic and intellectual activity, noting, appreciating and criticising all that happened around her.[45] Although not rich or beautiful, she became the centre of a brilliant circle of charming and clever women whose only enemies were sloth and self-importance. Her activity was prodigious: apart from her wonderful letter-writing, she worked at the making and sticking of pincushions, Japan-work, pastel portraits, copies of great masters, designs in shell-work, lustres, candelabra, cornices and friezes in cut-paper on wood, chenille work, cornices made of shells painted over like fine carving, upholstery, quilt-making, embroidery, cross-stitch carpets, miniature playing-card painting, chimney boards and finally, when she was pensioned by the King and living in a cottage where the royal family visited her almost every day, her prodigious paper mosaic.[46]

She had begun it in 1774, when she was seventy-four; by the time she died in 1788, she had finished almost a thousand examples of flower portraits built up in cut paper. She worked without sketches, simply cutting the shapes she wanted out of paper that had been collected from every conceivable source, some of it dyed and painted by her to the exact hues of the flowers that she was portraying. The flowers were built up more like sculptures than mosaics, for the pieces of paper were cunningly laid over each other to give an exact image of the shape of the flower head and the way that it and the leaves were attached to the stalk. It was a totally original method for which she could have had no teacher: the lack of proper artistic training is only evident in her placing of this marvellous structure upon her page, painted dull black by herself.

Although these gentlewomen did not allow themselves to attach too much importance to their work, they imposed the highest standards of taste and execution. Mrs Delaney's friends, the Duchess of Portland, her daughters Lady Betty and Lady Harriet Bentinck, Laetitia Bushe, Lady Ann McGill, Mrs Forth Hamilton, and Lady Mary Andover,[47] all kept each other up to the mark, exchanging information about media and techniques, lending and borrowing books of prints and patterns. The result was not high art, but an art made for living, refined and unassuming, as the ladies themselves were. In smashing the delicate structures they left behind, Victorian pomposity, for all its worship of the artist, reveals itself as philistine.

XV

The Age of Academies

In consequence of this defeatism, woman is easily reconciled to a moderate success; she does not dare to aim too high. Entering upon her profession with superficial preparation, she soon sets limits to her ambitions. It often seems to her meritorious enough if she earns her own living . . .

Thus, of the legion of women who toy with arts and letters, very few persevere; and even those who pass this first obstacle will very often continue to be torn between their narcissm and an inferiority complex. Inability to forget themselves is a defect that will weigh more heavily upon them than upon women in any other career; if their essential aim is the abstract affirmation of self, the formal satisfaction of success, they will not give themselves over to the contemplation of the world: they will be incapable of re-creating it in art.

Simone de Beauvoir, *The Second Sex*, 1949

In France the waning of absolutist power, which culminated in the abolition of the Académie Royale, had been signalled by the spread of provincial academies, which understood their function in terms distinct from those which defined the Académie Royale; they were not devoted to the ideal of censure, repression and exclusion of art unbecoming the stature of the King, but to the encouragement of the arts in their regions. They accepted water-colours, wax models, embroideries and copies and duly promoted those who showed the most expertise. Women were not excluded from exhibiting, or from the prizegiving. Amateurs of both sexes were encouraged to exhibit.

In 1772 the academy at Dijon gave a prize to one Anne Dubois, for a copy of Greuze's *Little Girl with a Spaniel*.[1] The Académie Royale de Toulouse had no fewer than one hundred and eleven women on the books between 1751 and 1791.[2] Women began to run private art schools where other women might learn artistic skills, if they could not afford the private drawing masters who taught

the richer amateurs who displayed their finished work at the academies. The problem of the disproportion between the male and female population which results from war was intensified in the nineteenth century, when more and more women bred to lives of domestic ease were forced to turn their slender accomplishments into a means of gaining a livelihood. Painting was one of the more respectable alternatives. Greuze's pupil Geneviève Brossard de Beaulieu ran an art school in Lille until 1793;[3] Reine Knapp taught art at the same time in Mons.[4]

The champions of the academies saw no *a priori* reasons why women should be excluded, except the old bugbear of the life class, which even male students did not get into until many conditions had been satisfied. The very reasons why women's presence in the life classes was anathema were also the justification for women's inclusion in the academic community. Modesty, purity, delicacy, grace were all characteristics upon which the eighteenth-century academicians placed a high value. Moreover, the idea was beginning to take hold that artistic ability was primarily a way of seeing and responding, and no mere technical skill. The stereotype of women then as now was that of a group characterised by their receptivity. Moreover the old academies were dependent upon royal patronage, which was often only to be had through the women of the royal households, the men being occupied with matters military and sporting.

The new academies welcomed women into the ranks more willingly at their inception than they were to do later. Joachim von Sandrart, author of the *Teutsche Academie* and founder of the academy at Nuremberg, was married to a painter and cameo-maker.[5] He lived to see his great-niece Susanna Maria (1658–1716) carrying out engraved illustrations for his works.[6] The tradition of the family workshop in Nuremberg merged with the neo-classical ideal of cultured family life: the academicians were proud to show that their women-folk took part in cultural activities and practised the arts. Johann Daniel Preissler taught his daughter, Barbara Helena (1707–58), as well as his four sons; one of those sons, who became Director of the Nuremberg Academy in 1742, saw that two of his daughters were trained as artists.[7]

The neo-classical ideal could only be followed by those who were happy to bring about the Golden Age in their own homes, so that all members of the family were constantly engaged in improving pursuits. Daniel Chodowiecki, Director of the Berlin Academy from 1797, had left us a picture of the artist in his studio, with his wife, three daughters and two sons.[8] The eldest daughter, Jeannette, is turning over the leaves of a print book, from which as a young artist she will make her first copies. One of the boys is watching the other draw, and either learning from him or offering hints. Suzette (1763–1819), the middle daughter, was to become a member of the Berlin Academy as Madame Henry in 1789 and portraitist to the Prussian royal family. The baby, Sophie Henriette (b. 1770), made a name for herself as Henriette Lecoq.[9] Under Chodowiecki's influence, women like Johanna Louisa Knorre (1766–1834),[10] Friederike and

Philippine Sieburg and Elisabeth Sintzenich were encouraged to exhibit at the yearly salons in Berlin in the 1780s and 1790s.[11]

Goethe personifies the neurotic conflicts which beset the women painters of the Romantic era. The uncouth descendant of a Frankfurt tailor, he saw in gifted women the inner sensitivity which was the condition of aesthetic response in the world as seen by Winckelmann. In the course of his own development, he came under the influence of several remarkable women, his mother Frau Aja, Karoline the Landgravine of Darmstadt, and through her daughter, Luise, who married Karl August of Saxe-Weimar, the redoubtable Anna Amalia.[12] All his life he patronised women artists, willingly sitting for the seemingly interminable series of portrait drawings which familiarise his features to all Europe, giving women prizes, finding them commissions and patrons, and eventually failing them. Angelica Kauffmann, deeply scarred already, was wounded by the way in which Goethe simply forgot to continue an intense friendship. Corona Schrödter, daughter of an oboist in a military band, whose musicianship, artistry, beauty and eloquence in four languages took sneering aristocratic Europe by storm, was a more helpless victim of his charm and fickleness.[13]

Goethe could cope with gifted women only as long as their sexuality did not intrude. Body and soul were never more irrevocably divided than they were in this famous sensualist, who rejected all his spiritual passions for marriage with the incurious Christiane Vulpius. Schiller despised this aspect of Goethe's character and endeavoured to live a more integrated life, as Shelley may be said to have done, despite Byron's influence.

In a manner which might be compared to Goethe's relations with women, the academies alternately encouraged young and virtually untutored female talent beyond its deserts, and ignored and obstructed women who sought recognition as serious artists. They were satisfied with token women gracing their yearly exhibitions, and frequently awarded them prizes within their own limited categories and sometimes even in competition with men, but they seldom offered serious instruction to women and never the travelling scholarships which were the most highly coveted boosts to a painter's career. Women themselves were often too grateful for academic recognition, sheltering thankfully within the pale of received ideas and avuncular care, while their male contemporaries formed rebellious 'brotherhoods' which made a point of eschewing effeteness and the company of women along with the stultifying disciplines of the old royalist academies. They formed bohemian groups which treated women as bohemian groups everywhere have done.

The achievements of the German women who worked under the aegis of the academies in the eighteenth century is not easy to evaluate. Most of their work has perished. One cannot but be moved by the bare facts of a career like that of Katharina Treu (*c.* 1743–1811), one of the three artist daughters of a Jewish artist turned Christian.[14] Her sister Maria Anna (1736–86) gave up painting when she married; another sister, Rosalie (1741–1830), married a painter named Joseph

Dorn and continued working until her death.[15] Katharina received commissions from the Cardinal Franz von Hutten, became *Kabinettmälerin* to the King in Mannheim in 1769, and *Professorin* at the Düsseldorf Academy in 1776. As well, she travelled to London, where she fulfilled commissions, and taught both her daughters, Franziska (1785–after 1817) and Elisabeth (not. 1812) König to paint.

Johann Heinrich Tischbein, named Director of the Academy in Kassel by Wilhelm VIII, saw his daughter, Amalie, made an honorary member of the Academy in 1780.[16] His nieces, great-nieces and great-great-nieces were all painters. In Dresden, the potential of women was illustrated by Caroline Friedrich, who taught many women, among them her nieces, Alexia and Augusta Tettelbach, and Caroline Richter; she had been made a *Pensionarin* of the Dresden Academy in 1774.[17]

Since Winckelmann, Rome had been the Mecca of German artists. Anton Raphael Mengs went there first in 1741; in 1752 he settled there with his sisters, Theresa Concordia and Juliane, who had both been Court Painters to the Electors of Saxony. Juliane became the nun, Sister Maria Speranda, and worked in her cloister; Theresa married the painter Anton von Maron and stayed in Rome, where she taught women like Apollonie Seydelmann, who became a member of the Dresden Academy in 1792.[18] The Electress of Saxony herself, Maria Antonia Walpurgis, was a member of the Accademia di San Luca.[19]

The academies of the *ancien régime* were sometimes no more than playthings

Maria Antonia Walpurgis, Electress of Saxony, *Self-Portrait*, 1772
 The good humour and self-confidence of this amateur artist shine out of this competent portrait. She was skilled in poetry and music as well as painting, and honorary member of the Dresden and St Luke Academies.

Rosina Christina Lodovica Matthieu, *Peter III of Russia with Catherine II and her son Paul*, 1756
Little is known of this painter who may have been the daughter of Anna Rosina Lisziewska.

of the ruling families, striving to remove from their courts the taint of provincial barbarism. They depended upon royal whim for a place to meet, funds to continue and to finance art training and scholarships. The ladies of the ruling families had to be accommodated and flattered. In Sweden, virtually every member of the royal family and the nobility who could or would put brush to paper was duly received into the Konstakademie in Stockholm. Most of their work is of no more than archival importance, but women like Christina Charlotte Cederström (1760–1832), who divorced her first husband who would not let her paint, or the Queen Mother's Lady-in-Waiting, Marianna Ehrenström (1773–1876), may have achieved more.[20] It would be equally interesting to study the women who exhibited at the annual exhibitions at St Anna in Austria in the 1840s, in order to see just what kind of excellence could be achieved by women, cooperating and encouraging one another as a group; however it must never be forgotten that they were not allowed to think of themselves primarily as artists.[21]

The Revolution in France and the Napoleonic upheavals changed fundamentally the environment in which the academies had their being; although the Congress of Vienna restored the boundaries of Europe in 1815, it was clear that aristocratic patronage of itself could no longer ensure legitimacy. The academies were taken over by the state, run on regular allowances and accountable to the public. While on one level they became more democratic, it became harder for women to join the academies as members. What happened in France when the Académie Royale was dissolved and reconstituted as a state academy

is the best documented example of the struggle that women had to be admitted to the confraternity of Revolutionary and post-Revolutionary artists.

On 23rd September 1790, Adélaïde Labille-Guiard addressed a meeting of the Académie Royale on the subject of the admission of women artists, limited by royal arbitrariness to four in number.[22] She proved to their satisfaction that the only acceptable limit was no limit at all, and the motion was carried. There was a snag, however, for Madame Guiard went on to argue that no woman, however gifted, could succeed as a professor at the academy or in holding any administrative position, therefore women ought to be rewarded with honorific distinctions as *conseillers* or advisory members only. The women who had been admitted to the Académie Royale had never made use of their voting privileges and Madame Guiard's suggestion simply recognised the custom. Her motives are now beyond scrutiny: she did win for women the right to exhibit their work at the Salons, but the Ecole des Beaux-Arts, run by the Académie Royale and pledged to give free art training to all who sought it, was closed to them. They might not compete for the coveted Prix de Rome.

A jury of forty members selected the paintings to be hung in the Salon of 1791: twenty of them were academicians, twenty were not. The result was an exhibition of seven hundred and ninety-four paintings by two hundred and fifty-eight artists, of whom a hundred and ninety were not members of academies and twenty-one were women.[23]

Naturally Madame Guiard showed at this first open Salon, with her students Marie-Gabrielle Capet and Jeanne Dabos. Madame Duchâteau, the pupil of Joseph Vernet, showed two landscapes. The minor genres, flower painting, miniature and enamels, gouaches and water-colours were accepted as they had formerly been only at the Expositions of the Académie de Saint-Luc, de la Jeunesse and the Salons de la Correspondance. The Académie, although free and open, still wished to keep its monopoly.

For Marie Geneviève Bouliar (1762–1825), 1791 was the beginning of a salon career, the first of hundreds of such careers not only in France but all over Europe. She was to exhibit regularly for twenty-five years. She had the courage to try subjects far more ambitious than the portraiture she had learned from Duplessis. In 1795, she won a Prix d'Encouragement for the idealised portrait of the *hetaera* Aspasia.[24] The giving of the prize represented one of the shortest-lived enthusiasms of the Revolution, for free love and unfettered womanhood, the full intellectual and sexual development of the individual. Bouliar, who never married, chose to paint her scandalous subject with all the attributes of womanly grace and beauty, with one snowy breast exposed. The painting technique is hard and dry, the carefully painted drapery that of a lay figure, while the garland of minutely painted flowers that snakes around the back of the figure and smothers the globe bearing the constellations at Aspasia's left drains any conviction out of the central figure. Bouliar's real talent and her feminism are better illustrated by the sympathetic spontaneity of her portrait of

another working woman, Adélaïde Binart (1761–1839), who made her début as a painter in the Salon of 1795.

The appearance of women at the Salon of 1791 was no mere flash in the pan. At the Salon of 1793, the number rose to thirty.[25] Throughout the eighteenth century enlightened masters had been receiving women into their *ateliers*, although this necessitated teaching them separately from the men working with the master. Drouais, Aved, Vernet, Vien, Bachelier, Duplessis, Greuze, Vestier, Leroy de Liancourt, Suvée, Lethière and Meynier all claimed women as pupils: probably they did no more than advise them or correct their work from time to time. When the two most influential painters of their generation, David and Regnault, decided to give serious art training to women, the idea of the female artist took on a new kind of substance.

David's career as a teacher of women began when he took into his *atelier* at the Louvre three young women, Marie-Guilhelmine Leroulx de la Ville, her younger sister and Mademoiselle Duchosel, while Vigée-Le Brun's ramshackle quarters were being rebuilt, as a favour to the Leroulx family. When news of the presence of young ladies in the Louvre came to the ears of the Directeur-général des Bâtiments he reprimanded David severely. David, stung by the accusation of impropriety into remembering all his own sufferings at the hands of the Académie Royale, defended himself angrily.[26] The artistic training of women became a revolutionary cause. That very year, he had Marie-Guilhelmine send to the Exposition de la Jeunesse, a history painting, *Clarissa Harlowe at the Archers*. David's women pupils would not only paint, they would paint the most ambitious subjects. The public, of course, opined that he painted them himself.

After the Salon of 1791, Marie-Guilhelmine Leroulx de la Ville continued to work in the manner of David, although the conduct of her personal life took a markedly anti-republican turn. She married the Comte Benoist, who was obliged to flee France in 1793, because of his part in a plot to restore Louis XVI.[27]

In 1800 she exhibited her famous *Portrait of a Negress* which was later acquired by Louis XVIII for the Louvre. In 1804, she won a gold medal and founded an *atelier* for women, of which nothing is now known. Under Napoleon she was given the monopoly of portraits commissioned for the *départements*. The influence of David in her work gradually waned: after 1795 she ceased painting classical subjects, devoting herself to portraiture and then to sentimental genre scenes.

Much of the Comtesse Benoist's work has disappeared, but from what remains we may judge that despite the slick, cold finish that she learned from David and the rather hollow rhetoric of paintings like *Innocence between Vice and Virtue*, she also absorbed some of the enduring values that David stood for. Her masterpiece, *Portrait of a Negress*, relies entirely for effect upon the proud posture of the subject's head and the impenetrable look that she bends on the

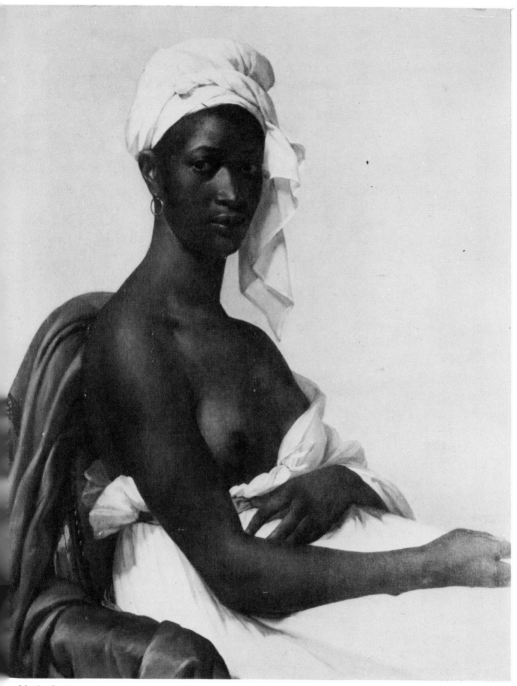

Marie-Guilhelmine Leroulx de la Ville, Comtess Benoist, *Portrait of a Negress*, 1800
 The daring of this composition is accentuated by the use of a luminous ground.
 Inferior portraits of Negresses, like the one in the National Gallery in London, are
 attributed to her by analogy.

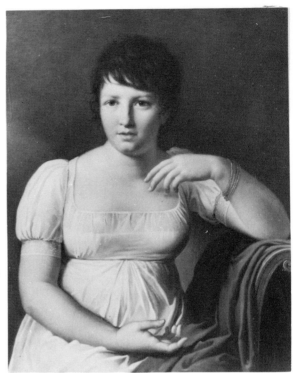

Louise Marie Jeanne Mauduit,
Madame Hersent, *Portrait of Pauline
Bonaparte*, 1806
> A pupil of Meynier and evidently
> also of her husband, himself a
> pupil of Regnault, Louise Mauduit
> graduated from portraits to
> history and genre paintings, one
> of which, *Louis XIV visits Peter the
> Great*, was acquired for the Royal
> Collection in Versailles. She
> exhibited in the Salons from 1810
> to 1824 and seems to have had
> women pupils of her own.

observer, slightly beneath her. The white cotton draperies emphasise the darkness of her polished skin: every detail works towards the central theme, the still dignity of the alien woman.

David's other female pupils also did him credit, the more so perhaps because they did not make an independent name for themselves. Two of them produced masterpieces that until very recently were taken for works by David himself, Constance Marie Blondelu (later Madame Charpentier) and Césarine Mirvault (later known as Madame Davin-Mirvault), who set up a painting school for women.[28] Angélique Lavol (1776–1855), like more and more of her contemporaries, painted not only portraits but attempted ambitious historic groups like *The Death of Astyanax* (Salon, 1802), and *Alexander mourning the death of the wife of Darius* (Salon, 1804), and mythological subjects like *The Death of Adonis*.[29] She married the archaeologist Antoine Mongez, and executed three hundred and eighty figure drawings for his *Dictionary of Archaeology*. Another pupil, Nanine Vallain, made her début in 1793, as Madame Pietre.[30]

David also taught the hapless fiancée of Ingres, Julie Forestier. Little is known of the history paintings she sent to the Salon from 1814–19 but a good portrait of the poet Gaillard is to be found in the Chartres museum.[31]

In 1814, when he was in exile in Brussels, David taught the seventeen-year-old Sophie Frémiet (1797–1867), who was to marry the sculptor François Rude. She in turn became an important teacher of women.[32]

While some of Regnault's pupils did not depart from the lucrative and well-trodden path of portraiture, others, encouraged and supported by their teacher, attempted the grandest subjects. At her second Salon in 1795, twenty-year-old Pauline Desmarquets, Madame Auzou (1775–1835) exhibited an antique group, *Daphnis and Phyllis*.[33] Sophie Guillemard (1780–after 1819) began to exhibit in 1801 with subjects like *Alcibiades and Glycerion* and *Joseph and Potiphar's Wife*.[34] Blanche Lucie Hoguer Madame Thurot, had the great success of seeing her Salon piece, *Sully draws the portrait of Henry IV* lithographed by N. H. Jacob.[35] Another Regnault pupil, Victorine Angélique Amélie Genève, Madame Rumilly (1789–1849), exhibited genre pictures as well as portraits at the Salons for thirty years, with an occasional classical subject, as *Venus and Cupid*.[36]

Another influence perhaps stronger than that of David and Regnault was at work upon these women, however. Since 1789 or earlier, the sister-in-law of Honoré Fragonard, Marguérite Gérard, had rivalled the three female *académistes* in reputation.[37] She had evolved, probably from observing Dutch masters like Metsu and Ter Borch, a kind of small-scale elegiac genre painting depicting morally improving versions of middle-class life. She had converted the sentimental moralism of her brother-in-law, which had been simply the excuse for vaguely erotic depictions of the *folies bergères* for an aristocratic market, into the visual statement of a crisp republican concept of the good life, personified in fecund women who breast-fed and educated their own children in affluent and tastefully furnished surroundings.

Paintings like *The Nursing Mother* now strike us as rather disingenuous in their combination of covert erotic appeal and self-conscious moralising, but the new innocence of the nineteenth century loved to see itself in the image that Gérard held up. The influence of her sister, the miniaturist Anne-Marie Fragonard, was probably more important than Fragonard's own in the development of Marguérite Gérard's style of small genre painting which is based upon an amplification of miniaturist technique. The surfaces, especially those of the pale satins that Gérard loved, are carefully built up in glazes, almost like enamel, so that no brushstrokes may be seen. Gérard was of course very close to the beloved Frago, from whom she had learned a more painterly, impressionistic style. She continued to paint in both the new, cold manner and the old loose, allusive way (as in the portrait of *An Architect and his Family* in the Baltimore Museum of Art) at the same time. Meanwhile, Frago, sensible that his popularity was waning, tried in vain to catch the rising spirit.[38] It has been traditional to assume that dubious works are by Marguérite Gérard assisted by the old master: only a systematic study will clarify the situation and reveal just how often a puzzling attribution may be explained by the ageing Fragonard's attempt to imitate his successful relative.

The appropriateness of moralising domestic genre for women artists was not lost upon their teachers. Elegiac genre has been called a *sous-ordre* of the school

of David, by critics unaware of the importance of Marguérite Gérard's rôle. As it could be developed from the traditional resources of the portrait and the portrait miniature and necessitated no inconvenient study of the nude, for the posed draped subject was far more appropriate when the subject was feeling rather than acting, the emerging women painters turned more and more to this genre in preference to struggling with monumental history pieces. Pauline Desmarquêts, as Madame Auzou, quickly grasped the spirit of Gérard and turned in the late 1790s to the depiction of interior scenes with young women reading and playing musical instruments. In the 1800s she developed her themes further and won a *médaille de première classe* in 1808.[39] Her most significant achievements, and subjects which became famous through engraving, were scenes from recent history, painted to celebrate the restoration of the monarchy. She also attempted another genre which Angelica Kauffmann and Marguérite Gérard had both tried before her, and which was to become the rage, scenes from non-classical history, or 'period genre' in subjects like *Diana of France and Montmorency*, which was engraved by Normand.

Eugénie-Marguérite-Honorée Lethière Charen, Madam Servières (1786–after 1824), won medals at the Salons of 1808 and 1817. Her specialty

Pauline Desmarquêts, Madame Auzou, *Marie-Louise takes leave of her family*
 Although Madame Auzou was well-trained and experienced, this painting is badly *craquele* because of imperfect technical preparation. The drawing of the figures with their tailor's dummy proportions is mannered and unconvincing. Madame Auzou's success belongs in the realm of fashion rather than art.

became that of 'period genre'. Her painting of *Inez de Castro and her Children at the feet of the King of Portugal* is now preserved in the Trianon at Versailles, while *Matilda makes Malek Abdel promise to become a Christian* from the Salon of 1812 was engraved by Madame Soyer.[40]

The entry of women into free competition with men in the art world did not simply coincide with the 'bourgeoisification' of art; women actually contributed to the process. Because they had never learned the arcane iconographic language of aristocratic art, women naturally chose simple expressive scenes and homely virtues to depict. The loftier, spiritual reaches of art had been closed off by a *cordon sanitaire* which only madmen would breach. Virtue was now ubiquitous and utilitarian, a matter of behaviour, and behaviour could be shown. There was no need to show tortuous, naked forms any more: art put on its clothes and sat down.

The style of genre developed by Jeanne Elisabeth Gabiou, Madame Chaudet, later Madame Husson, shows her own unique blend of the influences of her three teachers, Vigée-Le Brun, Greuze and David.[41] Subjects like *Little Girl teaching her dog to read* might strike us as repellently cute, but, compared with the tainted appeal of Greuze, it is pure limpidity, for it had been fired in the crucible of David's notions of the responsibility of art: the amusement was genuinely, deliberately innocent. Irony was deliberately eschewed: a sneer is as unwelcome as a snigger. Little girls weeping for naughtiness at school or lunching with their dogs inhabit the bland and sinless world that the adult bourgeoisie invented for its children in the nineteenth century, along with nursery rhymes, fairy tales and pantalettes. Hundreds of women collaborated in building up its imagery.

In 1798, Pauline Chatillon, wife of the sculptor Gauffier, initiated a new craze by exhibiting the portraits of two farm girls from Terracina. Her career was cut short by death three years later in Florence. It was her successor, Antoinette Cécile Hortense Lescot, wife of the architect Haudebourt, who was to develop this last variation on the genre theme.[42] While living in Rome, she had become fascinated by the customs and costumes of the *popolino* and began painting exotic subjects of local colour, for the French market. The moralising element was as pervasive as ever: Rousseau's noble savage exhibited homely virtues not naked but resplendent in national dress. Madame Haudebourt-Lescot's work became tremendously popular. Her fame evidently reached America, for a painting by James Peale in the eighty-first year of his life (1830), which was rather egregiously supposed, when it appeared on the market recently in New York, to represent members of his family, is in fact a copy of Haudebourt-Lescot's *A Good Daughter*, probably based upon the engraving by S. W. Reynolds.

Exotic genre became so popular in the nineteenth century that anyone with a modicum of artistic talent could make a good living by travelling to remote spots and portraying the inhabitants. Many men followed Madame

Haudebourt-Lescot into the field. She shared her triumphs at the Salon (two second-class medals and a first) with Jean-Victor Schnetz.

Despite all the restrictions which continued to hem women about in the nineteenth century, more effectively than considerations of decorum bound the aristocratic women of the Enlightenment, a new kind of female artist was coming into being. In the eighteenth century a woman already reassured by royal patronage might risk her fortunes in Paris, as Anna Dorothea Lisziewska Therbusch[43] did; but she ran the same risk of having to flee leaving her debts unpaid if she could not secure royal patronage. The women who travelled from court to court in Germany and Austria and Czechoslovakia, like Katharina Treu[44] and Barbara Krafft,[45] were travelling to take up appointments, but in the nineteenth century we find intrepid young women setting out to find the kind of art instruction that suited their talent, often quite alone and very far from home. It is astonishing that their parents allowed it, and argues a power of motivation which few female artists, with magnificent exceptions, had ever exhibited before.

When Anna Rajecka (1760–1832) went to Paris as a pensioner of King Stanislaus August in 1780, she pioneered a fashion that was to become an epidemic in the nineteenth century.[46] The daughter of the painter Rajecki, she studied with Louis Marteau, but the King's munificence enabled her to go to Paris. After her marriage in 1788, she returned to Warsaw as Madame Gault de Saint-Germain, making pastel and miniature portraits of the royal family and the Polish aristocracy. Marianna Walpurgis Krauss[47] (1765–1838) studied in Rome with Hackert, and Karoline Lauska Ermeler (1794–after 1844)[48] studied in Rome after her husband's death. All of these may claim to be the pioneers of

Marie Ellenrieder, *St Felicitas and her Seven Sons*
Marie Ellenrieder's fealty to the Creed of the Nazarenes may be inferred from this remarkable work which found favour in the eyes of Queen Victoria. This was how the Victorians saw Raphael and this version of piety and the High Renaissance is what Ellenrieder derived from her years in Rome.

study travels for women, but only Caroline Luise Seidler has left us a body of work and a memoir telling us how it was. She was the granddaughter of a Prussian aristocrat who fled to Saxony to escape military service. He and his ten children were obliged to live by their very cultured wits, and Luise grew up in an atmosphere of diffuse and unremitting artistic and intellectual activity. Nevertheless, her father was loath to expend any of their limited funds on art lessons for Luise, who earned the money herself, and then so quickly exhausted her teacher's prints and models that she was obliged to work alongside him from life. This his wife put a stop to, and in Luise's own words

> I was once more given up to myself in art, and abandoned to my own instinct.[49]

When she was twenty she fell in love with an officer in Bernadotte's regiment and became engaged to him. He was transferred to Spain without warning and Luise learned later that he had died of fever there. The vicissitudes of her family necessitated her move to Dresden where she saw the famous picture gallery. Few people were admitted to work there, and all had to pay an entrance fee, but she managed to persuade a Professor Vögel to teach her gratis. Writing in her old age she comments wryly on her good fortune in finding the galleries empty, for 'now the masterpieces are so thickly barricaded with easels and scaffolds that one cannot enjoy a view of them',[50] evidence of how commonplace art education had become in her lifetime.

Dresden was a stimulating place for not only did she meet the painters, Caspar David Friedrich, Kersting and Gerhard von Kügelgen, but she became an intimate friend of the capricious Goethe, who genuinely exerted himself to further her career. In these sad and troubled years, the friendly households where she found lodgings were forever breaking up, but Seidler kept working, carrying out commissions in Dresden and Weimar, borrowing paintings from friends to use as models. In 1814, her fortunes seemed at their lowest ebb. Her mother had died and Seidler herself was ill. Goethe came to the rescue with a commission to execute an altarpiece from someone else's design, but Frau von Heygendorff Jagemann, herself an artist, went one better; she begged four hundred thaler from the Archduke August, so that Seidler might go to Munich to study for a year, something which was only possible because the Archduke himself was an eccentric, asking in return only a portrait of Christ as Vishnu:

> How happy was I in the event! Now could I liberate myself from oppressive, indeed overwhelming domestic circumstances; the beginning of an independent existence had been placed in my hands. An artist's life of freedom beckoned to me with all its magic; with its troubles, but with its rewarding, delightful undertakings as well.[51]

Seidler admitted that her powerful patrons, for to the commendations of the Archduke were added those of Goethe and the Duke of Gotha, opened many doors for her and she was careful to note that Marie Ellenrieder before her had

Barbara Krafft, née Steiner, *Portrait of a Man*
The daughter of a Czech painter, Barbara Krafft exhibited for the first time at the Vienna Academy, where she became a member, in 1786. In the last four years of her life, in Bamberg, she painted one hundred and forty-five portraits but only a handful of works is now known.

had to plead with Langer to be allowed to study at the academy. Encouraged by her success so far, she made bold to ask the Archduke August for another four hundred thaler to go to Italy, and her request was granted. There she met the painter, Elektrine Stuntz, who had been sent to Rome by the parents of the

Baron von Freyburg to get her out of the way of their son who was in love with her. He prevailed upon them, and Elektrine and the young Baron were married, but Seidler remarks sadly that the demands of her art and of childbearing destroyed Elektrine's health.[52]

Seidler's natural inclination had been leading her towards the Nazarenes ever since she had seen the German masters for the first time in Nuremberg on her way to Munich. In Rome, where she teamed up with Marie Ellenrieder, living 'a truly poetic maiden life' with her in 1832–3, she visited the *ateliers* of Cornelius and Koch, and was helped by Overbeck. When she returned to Germany at the end of 1823, it was to take up the post of curator of the Weimar gallery and to teach the Princesses Maria and Augusta. In 1837 she was named Painter to the Court of Saxony. Notwithstanding her evident distinction and the liveliness of the personality evinced in her *Memoirs*, very little of her work seems to have survived.

When the Nazarenes mounted their attack on academic orthodoxy, 'expression from Raphael, colour from Titian and grace from Correggio', they called themselves at first the Brotherhood of Saint Luke, making no secret of the fact that, unlike the mother institution, the Academy of Vienna, they accepted no female members. Two distinguished women had been honoured by the Academy, the Berlin-born daughter of a Polish artist, Anna Dorothea Lisziewska Therbusch (1721–82), who was already a member of the Académie Royale in Paris and the Accademia in Bologna, and Barbara Krafft (1764–1825) who painted religious pieces for churches in Prague, portraits in Salzburg and was named city painter in Bamberg in 1821.

The guiding principle of the Nazarenes was the rejection of the Cinquecento for the Quattrocento, with a greater emphasis upon line, the subduing of colour in the service of clear, spiritual expressions of piety. They rediscovered Dürer and eventually Raphael by another route. It was a movement which was bound to appeal to women, for it showed them a way in which they could overcome the shortcomings of their training and the demands of modesty. Dozens of German women, especially in Catholic Bavaria, had carried on the tradition of religious painting. Marie Elisabeth Hayer (d. 1699), Margareta Maddalena Rottmayr (d. 1687), Placida Lamme (d. *c.* 1692), a gentlewoman of the name of Denisch (*c.* 1750), Katherina Kreitmayer (d. 1726), Margareta Antonia Hölzl (*fl.* 1767), Theresia Hermann (*fl.* 1781) and Marie Luise Melling (1762–99) are just some of the women who worked independently as church painters in the seventeenth and eighteenth centuries, without the recognition of any academy, most of them trained within the families of whom they were often last, unmarried descendants.[53]

Marie Ellenrieder, Luise Seidler's friend, was born in Constance in 1791. Swiss women, like women all over Europe, were inspired by the example of Angelica Kauffmann to take themselves seriously as artists, which required that they leave Switzerland and travel in search of instruction. Anna Maria Reinhard

(1753–1826), the insect, fruit and flower painter, left her birthplace Winterthur for Düsseldorf and Amsterdam.[54] Anna Margarethe Hollerbach studied flower and fruit painting in Basel, Frankfurt and Wetzlar.[55] Anna Barbara Steiner (1757–1818) visited Italy with her husband, the painter Johann Konrad Steiner, in 1796.[56] Marie Ellenrieder presented herself to the Munich Academy in 1813, and, thanks eventually to the intercession of a bishop, was able to study there for three years with the arch-classicist Peter Langer.[57] Six years later she was in Rome, where she was clearly influenced by the work that the Nazarenes were doing, although, ten years after the death of Pforr, the movement had passed its flowering and become a mere convention. Like Seidler, she did not become a Salon painter, but worked instead for the Grand-Duchess Sophie of Baden, in much the same way that many women of earlier epochs had been able to carve out careers in the provincial courts of Germany. The women who would follow the example of Ellenrieder and Seidler did for the most part become Salon painters, competing no longer for royal commissions but for the prizes awarded by the public academies.

By the turn of the century the nineteenth-century pattern was already set: the great age of academicism, with its attendant revolts, each to be co-opted and absorbed into the academic process, had begun. In vain did Jacques-Louis David cry

> In the name of humanity, in the name of justice, for love of art, and above all for love of youth, let us wipe out these deathly academies![58]

Already the nineteen academies of art which existed in 1700 had become two hundred; by the end of the nineteenth century there would be more than two thousand. To the emergent middle classes, an interest in art was the outward sign of their capacity for refinement. The new republicans would bring pictures into every home, by stimulating artistic activities on an unprecedented scale. Obviously, they would not spend money on encouraging an art which was alien to them and contrary to their interest. The extravagances of break-away aesthetic groups frightened and disgusted them, until they acquired authority and became the new orthodoxy, losing their energy on the way. The values that the public patronised in the art of the nineteenth century were tangible ones: pictures had to be comprehensible, recognisable, informative and conducive to the practice of civic virtue.

Middle-class patrons were grateful for guides in their selection of paintings. While the academies awarded prizes and the courts still commissioned grandiose works unsuitable for the private parlour, some other form of responsible public patronage had to be arrived at. The answer came from Germany, where in 1814 the first Kunstverein (art union) was set up in Berlin.[59] The Kunstverein let the public into the academy, by arranging exhibitions, buying paintings to be raffled among its members, distributing prints of prize-winning works and arranging lectures. The idea caught on at once. In 1818, Karlsruhe set up its own

Kunstverein, then Hamburg, Munich, Dresden and Düsseldorf. Edinburgh, London, Dublin, Manchester, Birmingham, and other British cities followed in the 1830s.

In 1839, after the collapse of the American Academy of Fine Arts, the American Art Union was set up in New York. In its manifesto, we may see spelled out the aesthetic of the middle-class patron: 'Truth, purity above all, as well as American simplicity and freshness.'[60] The union meant to 'be most indulgent in-its decision, and administer both words of encouragement and the more substantial assistance of pecuniary support' both to the masters and to 'the young, the rising and the unknown artist'. Women were not excluded from this process, but it was some time before they began to put any great pressure on the system.

In order for art to become respectable, it had to become the expression of a morality higher than that of commerce. Artists were elevated to a higher order of humanity and the art establishment was quick to assume a kind of moral and intellectual superiority which caused the more impressionable members of society, many of them women, not only to heed and respect them, but to *revere* them. They in turn enjoyed great wealth and all the psychological pleasures of enormous prestige. In vain did young, rebellious artists cry out against what they saw as hypocrisy, as the art princes tirelessly promoted their own cronies and disciples. Ill-tempered carping did not reach their ears. Among those whom they chose to honour and reward were many women, whose fealty to their styles and doctrines had found grace in their eyes.

The results of the process have been rather biliously summed up by George Moore:

> To the ordinary mind there is something specially reassuring in medals, crowns, examinations, professors and titles; ... we unfortunately hear no more of parents' opposing their children's wishes to become artists. The result of all these facilities for art study has been to swamp natural genius and to produce enormous quantities of vacuous little water colours and slimy little oil colours ... art has become infinitely hybrid and definitely sterile.[61]

The pendulum of taste is once more swinging towards the painters of the nineteenth-century academic establishment, partly because there are simply not enough impressionist paintings to keep the market fuelled, but even so the reputation of the hundreds of women to whom the academies yearly awarded prize after prize is not keeping pace. To explain this fact, which is not simply a matter of anti-feminist sentiment, we must look more closely at the motivation of the female artist as well as at the disabilities which she still had to overcome.

XVI

The Nineteenth Century

For the higher percentages of women in art lately may tell us more about the state of art than about the state of women. Are we to feel cheated that women have taken over in a capacity soon to be automated out? (Like 95 Percent Black at the Post Office, this is no sign of integration; on the contrary, undesirables are being shoved into the least desirable positions . . .) . . . art is no longer a vital centre that attracts the best men of our generation . . . the animation of women and homosexuals in the arts today may signify only the scurrying of rats near a dying body.

Shulamith Firestone, *The Dialectic of Sex*, 1972

The explosion of the art market may have found the masculine art establishment unprepared. There was suddenly room at the top and perhaps the male artists could not themselves fill it: meanwhile the pressure from women upon the art establishment was growing. Spinsterhood was a fate that every woman feared: after the inroads upon the male population made by the Napoleonic wars it was perfectly apparent to most middle-class people that redundant female relatives had to have some respectable way of earning a living. Some alternative had to be found to the ill-paid, lonely and humiliating work of governessing. More and more women were finding that what they had learned in the way of genteel accomplishment and pleasant pastime was having to become their livelihood. Industrial and applied art had long been considered proper fields of female employment for women of the lower classes: now women of a higher class were seeking art education of a more pretentious kind. At the same time, few of them believed that the practice of art was in itself superior to a life of wedded bliss. Most of them tried to keep their options open, as more serious students of art often angrily testified. The contradiction in their

Emily Mary Osborn, *Nameless and Friendless*, 1857
Notwithstanding the fact that this painting was known to be by Osborn, through engravings made at the time of its original exhibition, a preparatory drawing for it, now in the Ashmolean, was falsely signed Millais.

attitudes may be seen perhaps in the character of *The Tenant of Wildfell Hall*, who was obliged to turn to her beloved playthings, her art materials, in order to earn a living when she left her vicious and debauched husband.

> The palette and the easel, my darling playmates once, must be my sober toil fellows now. But was I sufficiently skilful as an artist to obtain my livelihood in a strange land, without friends, and without recommendation? No; I must wait a little; I must labour hard to improve my talent and to produce something worth while as a specimen of my powers ... either as an actual painter or a teacher.[1]

Before her marriage, Mrs Huntingdon had attempted very ambitious subjects, and in oils; her attitude to art seems on the one hand deeply committed to excellence, and on the other, perfectly capable of eschewing the struggle once for all. When her problems are solved by the death of her husband and her inheritance of another estate, we hear no more of her artistic ambitions. In fact,

Mrs Huntingdon is in no doubt that it is more blessed not to have to earn a livelihood at all. The modern concept of a *career* as something greatly preferable to a *life* is something she would not have understood.

Some of the difficulty in reconciling Mrs Huntingdon's apparently contradictory attitudes can be found in the persisting notion that the acquisition of mere technique is not the main purpose of artistic development. In the two kinds of female artist depicted in *The Marble Faun*, by a man who married an artist, we may see the sources of some of the special pleading that women's art occasioned in the nineteenth century. Hilda had shown amazing talent as a child, producing

> scenes delicately imagined, lacking perhaps the reality which comes only from close acquaintance with life, but so softly touched with feeling and fancy that you seemed to be looking at humanity with angel's eyes.[2]

Hilda's artistic ability resides in her sensitivity to beauty, which is so great that once she sees the masterpieces of Europe she can no longer be bothered to follow her own inspiration, but labours to copy the achievements of others.

> She was endowed with a deep and sensitive faculty of appreciation; she had the gift of discerning and worshipping excellence in a most unusual measure. No other person, it is probable, recognised so adequately and enjoyed with such deep delight ... She saw – no, not saw, but felt – through and through a picture; she bestowed upon it all the warmth and richness of a woman's sympathy ...[3]

Once she had seen the works of the great masters she became powerless to respect her own vision:

> Reverencing these wonderful men so deeply, she was too grateful for all they bestowed upon her, too loyal, too humble in their awful presence, to think of enrolling herself in their society. Beholding the miracles of beauty which they had achieved ... all the youthful hopes and ambitions, the fanciful ideas which she had brought from home, of great pictures to be conceived in her feminine mind, were flung aside, and ... relinquished without a sigh. All that she would henceforth attempt – and that most reverently, not to say religiously – was to catch and reflect some of the glory which had been shed on canvas from the immortal pencils of old.[4]

The idolatrous tone of such a passage is typical of the art enthusiasm of the age of philistinism. Artists never before or since had been so unintelligently praised by so many. The result was enormous riches and prestige for the few whose works impressed the crowds who came thronging to the exhibitions, most of whom were only capable of criticising the literal content of the paintings, on the premiss that every picture tells a story. Just so, Hawthorne contrasts with his dovelike Hilda the headstrong and evil though talented Miriam, whose experience of life enables her to draw the strong chiaroscuro of

Pl. 26 Vanessa Bell, *Portrait of Duncan Grant Painting*, c. 1915

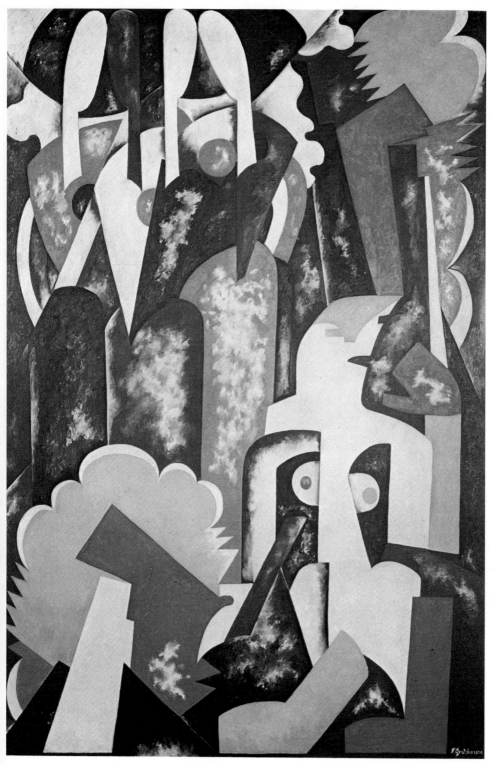

Pl. 27 Natalia Goncharova, *The Bathers*, 1912–13

Pl. 28 Alexandra Exter, *Still Life*, 1914–15

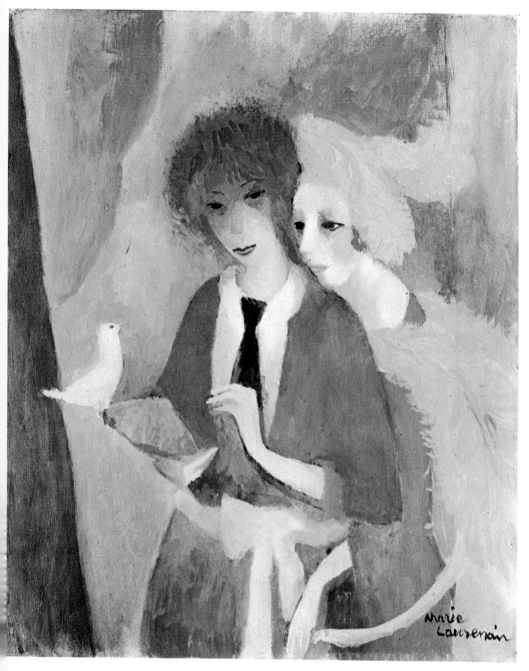

Pl. 29 Marie Laurencin, *Woman with Dove*, 1919

Pl. 30 Aloïse Corbaz, *Mysterious Temple*

Pl. 31 Séraphine Louis, *Tree of Paradise*

PL. 32 Madge Gill, *Women*

the human tragedy. In his description of Miriam's work, Hawthorne reminds us, perhaps deliberately, of Artemisia, in terms which bring to mind Mrs Jameson's horror. Hilda's jealously guarded innocence causes her to cast Miriam, the tainted genius, off and win the woman painter's highest reward, marriage with a more committed male artist, the sculptor Kenyon.

What Hawthorne assumed about the relation of artistic ability to sex was assumed not only by men in the nineteenth century, but by women too. A report in the feminist paper, *Revolution*, in 1868, revealed that of the hundred and sixty women enrolled at Cooper Union, only twenty planned professional careers.[5] The rest were educating their sensibility by the kind of palpitating contemplation of male greatness that Hawthorne's Hilda went in for.

Hawthorne's irritatingly hyperbolic way of writing about art as some sort of archangelic pursuit remains typical of much art criticism throughout the century. Clara Erskine Clement and Walter Shaw Sparrow writing in the first decade of the twentieth century are still praising women painters in terms which seem irritatingly irrelevant. The double standard in life becomes the double standard in art and many a woman followed these enthusiastic pointers towards insipidity. Both use the words that infuriated Marie Bashkirtseff when Julian used them to praise a sculpture, 'charming', 'delightful', 'winning',

Marie Amélie Cogniet, *Atelier for Young Women*
 Léon Cogniet is first recorded as a teacher of women in the 1830s. Besides his sister Marie Amélie, and his wife Caroline Thévenin, others of his pupils made names for themselves: Emma Blanche, Sophie Bourgeois, Madame Carton, Henriette Cappelaere and Amalie Lindegren.

'exquisite', 'appealing', 'a most pathetic scene, wonderfully rendered', and so forth. These words are balanced by others like 'successful' and 'popular' which give a clearer idea of the cultural environment in which these female art students moved.

> Women are proving just now not only that the domain of art should be open to them as freely as it is to men, on the grounds of right and reason, but also that they are specially gifted by their delicate sensitiveness, their quickness of comprehension, their initiative faculty, and lastly, by all the phases of their natural temperament, and by their intelligence to endow art with the elements of expression and beauty proper to womankind.[6]

This was written about French women painters by Léonce Bénédite; Ralph Peacock takes up the same strain in referring to women painters, explaining their susceptibility to influence as another aspect of that wonderful feminine character:

> Lady Alma-Tadema has produced work so extraordinarily good in itself that it is easy to believe the similarity of her technique to that of Sir Lawrence Alma-Tadema to be merely one of the happy chances of her life. A very similar thought arises in connection with the work of the late Miss Margaret Dicksee. It is easy to influence technique, but first causes are not set in action by human hands. If one who did not know her may say so, there is written on the canvases Miss Dicksee has left behind the evidence of a most lovable nature.[7]

It would be tedious to give further examples of this kind of writing, which abounded in art publications of all kinds and especially those which, for crackbrained reasons of chivalry, particularly dealt with women. As long as they were writing about fully developed artists, these twaddlers could do little harm, but the sad fact is that this kind of mentality had surrounded women artists from their first emergence as students.

Well might George Moore gnash his teeth and write:

> Women astonish us as much by their want of originality as they do by their extraordinary power of assimilation. I am thinking now of the ladies who marry painters, and who, after a few years of married life, exhibit work identical with that of their illustrious husbands – Mrs E. M. Ward, Madame Fantin-Latour, Mrs Swan, Mrs Alma-Tadema.[8]

Moore overstates his case: there were women whose work was different from their husbands but, more significantly, he does not see that the women were loved for their very faculty of emulation. The masters chose them to reward and to marry because they were extensions of their amazingly indulged egos. Of Evelyn de Morgan it was once said:

> She is a long way ahead of all the women and considerably of most of the men. I look upon her as the first woman artist of her day – if not of all time.[9]

The statement is completely untenable, except perhaps by the man who uttered it, G. F. Watts, the painter under whose influence she was at the time.

In 1853 A. M. Howitt wrote a book about her experiences as *An Art Student in Munich*. She and a friend had gone there without even knowing that they would not be admitted to the academy (even though Ellenrieder and Seidler had studied there fifty years before) or that 'the higher class of artists receive no pupils'. Summoning up all their courage, they approached the highest of all, von Kaulbach.

> I told him how earnestly we desired really to study; how we had long loved and revered his works; how we had come to him for his advice, if not his instruction, which we heard was impossible. I know not how it was, but I felt no *fear* – only a reverence, a faith in him unspeakable.[10]

Such an appeal got them invited to come and draw every day. The whole book is a celebration of the work that von Kaulbach was doing, under the adoring eyes of his female students, whose work he may have occasionally criticised, but Howitt describes no teaching of any sort. Judging from her bubbling descriptions of Bavarian life and customs, Howitt enjoyed herself, otherwise one would be tempted to opine that she had wasted her time. She does animadvert on the isolation of the female students, which continued to plague them for a hundred years:

> ... there is one feature of Munich life, from which you, unfortunately, as a woman have been cut off – the jovial, quaint life of the artists among themselves. This is a great pity, for you would have so much enjoyed it – the life of the artists, I mean, in their *Kneips* with their festivals and odd usages.[11]

There are many artists who have recorded the fact that they learned more from their fellow-students than from their teachers. The confraternity contained within itself the antidote to the master's personality and provided a counterbalance to the school situation. The women's only significant contact was with the master; the broader landscape of art was obscured by his dominant figure.

The single most important factor in the emergence of American women artists in Boston in the 1860s was the art school run by William Morris Hunt. Feminists might be impressed to learn that Hunt gave up his own favourite studio in the Mercantile Building in Boston to his forty female pupils, taking for himself one that was smaller and not so well lighted, and that he ignored the critics who said that 'he gave to schoolgirls what was meant for mankind', but the note of feverish adulation which his female biographers strike unconsciously over and over again causes one to wonder whether all these egregious females were not after all grossly imposed upon. The women were set to draw from the model in charcoal.

> The class went on for three years but his own work made such demands upon his time that he appointed Miss Helen M. Knowlton, one of his pupils

as teacher, while he would come in every day or two and correct the work. During these short and inspiring visits, Miss Knowlton, for her own use in teaching, would step behind a screen and write down hastily all the brilliant, witty remarks with which he went from one easel to another ...[12]

One of his pupils, a prominent Boston socialite, can be got to say:

His presence was full of inspiration, his criticism, vigorous and unsparing, was always helpful, and, in the best sense, sympathetic.[13]

When we actually consult Miss Knowlton's recollection of her idol's remarks, they hardly bear out the claim of brilliance and wit. Miss Knowlton (who spent a good deal of her life publishing Hunteries of one sort and another) quotes with a straight face:

To a pupil who was in tears because she could not paint like an expert, he said:
'I'll tell you what you had better do. You had better go and hem a handkerchief.' And it was said in a spirit of kindness and help, knowing that to a nervous woman the needle is sometimes her best resort.[14]

Strange to relate, though the project was often mooted, Hunt never did open a school for men.

As soon as art schools opened their doors to women, the modern phenomenon of the women being the student body while the men are the painters emerged. More than half of the pupils of Hubert von Herkomer, for example, were women. Few teachers relished the impression of dilettantism which such disproportion conveyed. Herkomer speaks of his female pupils with thinly veiled contempt.

Indignant letters were sent to me by ladies unconnected with the school who gathered from garbled accounts that I insisted on women standing at the easel without a chance of sitting down to work. As a matter of fact I merely said to them on that point, 'Stand to your work if you possibly can.'[15]

Herkomer boasts of the devotion of his students, complains that women students always made messes around them and worked in an atmosphere of confusion. More sinister is his insistence that when a woman married she was no longer eligible for his school. He cites examples, proud of his own intransigence in the matter:

The wife's last appeal was, 'But I am so fond of drawing; what am I to do if I cannot study?' That was easily answered: 'Devote your life to the happiness of your husband and children.'[16]

Even when a young widow with children to support was brought to him by her mother, he refused to accept her, apparently on the grounds that women who chose marriage would either practise art as a sort of second string or be bad wives and mothers. His memoirs are suffused with an amazing arrogance: at no

time did he ever find that he was not the sole mediator between his hapless pupils and Art or, if he did, he chose to forget it utterly.

Some women must have felt scepticism and rebellion in the face of such absurd pretension, but if they did, history has no record of it. Marie Bashkirtseff speaks of Julian and Robert-Fleury, her teachers at the Académie Julian, in a friendly, slightly patronising way, which seems warranted, but even an artist as arrogant in her own way as Cecilia Beaux invests Tony Robert-Fleury with a sick glamour: she describes him as:

> a young middle-aged and very handsome man ... his eyes, grey and deeply-set, smouldered with burnt-out fires ... The class, although accustomed to him, was in a flutter.[17]

Robert-Fleury came to criticise the women's work *once a week* and for this attention they seem to have been pathetically grateful. Cecilia Beaux was drawing an *académie*, a full-length figure, when Robert-Fleury bent over her

Marie Bashkirtseff, *The Académie Julian, c.* 1880
Some impression of the crowded conditions can be got from this rather glamorised representation of a life class, in which the women are managing to use oils, palettes, mahlsticks and all, while studying their rather woebegone model for a Del Sarto John the Baptist. Above hang the best studies.

and began speaking in a French she could not at first understand. The excitement of her fellow-pupils helped to bear in upon her the fact that he was quoting Corneille.

> He rose not having given me any advice, but bent his cavernous eyes on me with a penetrating but very reserved smile and turned to the next ...[18]

Cecilia Beaux does not elaborate upon who her comrades were in the packed studio in the Rue de Berry or at the Passage des Panorames, except to remark that very little talent was evident. Painting was impossible because of the overcrowding. All they got in fact was practice and access to the model. She notes with glee that Robert-Fleury took up a work of hers and remarked without viewing the others that hers was the best. The greatest accolade was to be hung on the wall, a rare honour. Every week the best student got first choice of place for the new pose on Monday morning.

A whole book could be written about the hundreds of women who joined the Robert-Fleury fan club at the Académie Julian: they came from all over the world, as far away as the U.S.A., Canada and even Australia. They were luckier than many women because neither Robert-Fleury nor Julian dictated style or treatment. Some were lucky enough to get criticisms from such giants as Gérôme, Bouguereau, Boulanger and Carolus-Duran. Others, richer and more demanding, became private students. All around them, public art schools to which women were admitted were opening.

It is too much to expect that people whose whole life-style was filial would see through the nineteenth-century art establishment, especially when it was invested with sexual glamour. The emotional reactions caused by the presence of the master by his female pupil's easel cannot now be easily imagined: all the repressed libido of the art student drove her towards adoration and its concomitant, emulation, and at the same time it undermined her self-confidence, made her avid for praise and reassurance. Hundreds of women entered into hundreds of competitions and won hundreds of medals and prizes, with paintings which are now quite forgotten. It was an arid path and one that led nowhere. Artistic energy had escaped by forcing its own way in defiance of the establishment: the wonder of it is that any women had the confidence to lead the way into the breach, not that most of them remained dependent upon academic recognition and popular acclaim.

One by one the barriers against women in art education fell: each new advance was hailed as the beginning of a millennium which would bring women artists to the fore in numbers equal to their proportion of the population. In 1861, Laura Hereford had gained entry to the Royal Academy schools by sending in the application papers and the required drawings under her initial so that the committee did not realise that she was a woman:[19] when the fact was discovered they found also that there was no specific rule excluding women from the academy schools, and so she had to stay. In the ten years that followed,

forty young women passed through as probationers. The victory was, as most of the women's victories, Pyrrhic. Already, many young artists were being exhorted to eschew the stultifying discipline of the academy schools, but women were too exhilarated by this victory to heed the warning. Likewise, they later struggled to join the Slade, where Tonks took out all his insecurity upon them, reducing them to tears with his sarcastic animadversions. Stella Bowen has an amusing account of how she happened not to go to the Slade.

> I went first for an interview to the Slade but was completely crushed by the aspect of the Professor who received me. I don't know whether it was the famous Tonks or the famous Brown, but he was eight feet tall and conceived it as his duty to put the fear of God into me. I knew well enough that I could never draw under his eye of wrath, so when he asked me what day I was coming to start work I stammered that I was not sure that I was coming at all – and took a bus to the Westminster. Here they told me that they didn't believe in grief and tears, that they never had any suicides amongst the students . . .[20]

When the entry to a school is in itself a victory, it is more than ever likely that the teaching will be over-valued and failure to please one's teachers construed as evidence of genuine lack of ability. Men also suffered at the hands of arrogant teachers, as Matthew Smith did at the Slade, as indeed did any insecure member of a minority group at the school. The power of such haphazard persecution to throw a student off course depended very much on the student's personality structure. Women, by their conditioning, were ill-equipped to withstand it. More insidious than the teachers' contempt was their praise. At all the art schools women consistently bore off the honours. Louise Jopling noted gleefully in 1880 that there was talk of limiting the number of women at the Royal Academy Schools because they carried off all the prizes from the young men.[21] It was not immediately apparent to the delighted Jane Mary Dealy and Emmeline Halse[22] that genuine artistic ability existed in inverse proportion to the ability to carry off prizes, especially from the Royal Academy Schools. Women easily confused this kind of success with genuine artistic achievement. In such a situation it is very likely that the wrong women were encouraged, for true artistic ability often presents itself in a truculent aspect which does not find favour with paternalist teachers.

One of the characteristics which women were expected to bring to their art was purity. The nineteenth-century art-lover did not, as earlier patrons had done, appreciate bohemianism and loose manners even in male artists, although many of the giants of academic art made covert advances to the repressed erotic desires of the public. Nevertheless the life class was considered the *sine qua non* of art education. 'To the pure all things are pure.' Life classes for women could be found, as when in Paris in the 1860s, where Chaplin ran an all-woman class in an *atelier* below his own, one of his ex-students, a Miss Besley, provided a nude model at seven o'clock in the morning.[23] Heatherley's school provided

models.[24] Frank Dicksee conducted an evening life class, and so on.[25] Ladies were not permitted even at Herkomer's school to work in the same life class as men, but much more significant than that prohibition was the way in which women were expected both to see and to render the nude. It had been said that women were not sensual enough to be great artists: the fact was that female sensuality was repugnant to accepted taste and inaccessible to most female artists. Henrietta Rae was one woman who insisted on painting nude female subjects and met with surprisingly little hostile criticism when she began to exhibit in the 1880s, but when one looks at her boneless, pink and hairless creations, lyrically swathed with tulle and surrounded by roses, it is immediately obvious how the female artist has had to blinker herself.[26] Rae's most successful painting, of *Eurydice sinking down to Hell*, is a typically hollow piece of rhetoric which was nevertheless rewarded with an Honourable Mention in Paris in 1889 and the medal at Chicago.

In painting as she did, Henrietta Rae was unconsciously parodying her teacher Sir Lawrence Alma-Tadema, the Victorians' favourite purveyor of sex-objects, duly justified by antique and exotic settings and irrelevant and pompous literary references. She was too lady-like to grasp the real nature of Alma-Tadema's appeal; at her hands the marvellous orchestration of surfaces and tactile values became a romantic veiling over a vacuous idyll of smirking damsels and hothouse flowers.

Despite the fact that hundreds of women were winning golden opinions from the art establishment, there are indications that other women were dissatisfied. Some, disgusted by the critics' double standard, signed their work with men's names, Rosarius (Rosa) Brett, Antonio (Antonia) Brandeis; others hid behind their own names, like Claude Marlef and Dewing Woodward, noting with glee how often their work was taken to be by a man.[27] Even mild Evelyn de Morgan, who as Evelyn Pickering won the Slade Scholarship, noted with glee that the male students were puzzled to know who this chap Evelyn Pickering was.[28]

The paradox tormented women then as it does now. Louise Jopling-Rowe[29] might lecture that 'There is no Sex in Art', especially as in her art there was indeed no sex, but it is obvious that sexuality is an important part of any personality and the artistic personality above all. If women were to paint as sexless creatures they were foredoomed to ineffectuality. Over all women artists loomed the figure of Rosa Bonheur: Lady Butler was called the English Rosa Bonheur, Marie Collaert the Flemish Rosa Bonheur and Barbara Bodichon, the Bonheur of landscape.[30] It was thought that Bonheur had eschewed her sexuality altogether and become great as a result. To many women this simply seemed too difficult, although for a time cows and sheep were studied in female life classes as a solution to the problems of modesty. (Many women painters and sculptors of animals depicted them without genitals.)

Many women must have wondered if there was a female art and truly female imagery, while painstakingly working on parodic versions of the fashions set by the male art pundits. Most accepted the idea that truly female art was feminine, delicate, dainty, small and soft-voiced, and concerned itself with intimate domestic scenes, especially mothers and children. They did not often see that the qualities men welcomed in women's art were the same that they reviled in their own, and that by acting out their sex rôles they were condemning themselves to the second rank. To some the cultivation of feminine qualities did appear as deliberate enticement to weakness and dishonesty, but few of them could see any way out of the impasse. More often, women boasted of keeping their feminine rôle sacrosanct and placing husband and children above their work. Almost no woman dared to say loudly and publicly that she was as good as the male artists who had inspired her as a young student.

There is evidence that women artists in the nineteenth century considered themselves a group with particular problems. Women's prizes, like the Dodge Prize, the Mary Smith Prize, the Bashkirtseff Prize, went some way to compensate women for the prizes and scholarships for which they were not eligible.[31]

Travelling scholarships for women seem to have been pioneered by the Swedish government which sent two women, Sophie Adelsparre (1808–62) and Amalie Lindegren (1814–91) to study in Paris in the 1850s.[32] The real problem was finding women to take them up. Chaperonage continued to be a problem until well into the twentieth century. Women of good family were taken to school by coach, or attended on foot by maids and footmen. Outside the school they were isolated in their families instead of carrying the lessons of the schoolroom into a stimulating studio environment.

One way of dealing with the problems was to band together in self-help groups; associations of women artists came and went all over the civilised world. Some, like the National Association of Women Painters and Sculptors in America, had very wide membership and for a time ran their own academies and arranged annual exhibitions with scholarships and prizes.[33] The Union de Femmes Peintres et Sculpteurs in Paris also held annual exhibitions from 1881.[34] The Künstlerinnenverein in Munich, the Vienna Verein der Schriftstellerinnen und Künstlerinnen, the London International Society of Women Painters, the Women's Art Club of Canada, the American Women's Art Association in Paris, were all formed to serve women artists.[35] It is not now easy to trace their development and decline or the degree of success they had in pursuing their aims, for their documentation seems to have perished.

Exhibitions of women's work were not arranged only by the women's organisations. All major exhibitions made some space for women, usually small and fairly inconspicuous, but sometimes on a large scale. Such a venture was the Woman's Pavilion at the Centennial Exhibition in Philadelphia in 1876, which was granted in recognition of the services of women in raising funds for the Centennial celebrations; in fact all that was granted was a position in the

Exhibition grounds as a consolation for the fact that the organisers had failed to keep the allotted space for women in the main building.[36] The funds for the building had still to be raised. Against all probability the building was erected and the exhibit opened by the Empress of Brazil. It was meant to give a picture of women's activities the world over, and not simply of women artists, but most of the art schools teaching women in the United States sent exhibits: the Women's Art School of Cooper Union in New York, the Lowell School of Design at M.I.T., the Pittsburgh and Cincinnati Schools of Design were all represented. Emily Sartain won a second medal for her painting *The Reproof*, already premiated at the Salon of 1875. She was to be the first principal of the Philadelphia School of Design for Women, now the Moore School (where students sleeping in the dormitory named after her do not know who she was).[37] Eliza Greatorex, the first female associate of the National Academy of Design since 1869, exhibited eighteen of the original drawings for her *Old New York from the Battery to Bloomingdale*. Another exhibitor was Alice Donlevy, founder of the Ladies' Art Association of New York in 1867.

The Women's Pavilion at the Centennial Exhibition did not attract all the women artists however. Many women, aware of the real feelings that male artists harboured in relation to their female competitors, refused to abandon open competition and preferred to vie for space in the Memorial Hall.[38] The women's organisations were beset by the problem that to the more successful women artists they seemed mere backwaters, harems in which women could be segregated and ignored, and the verdict of history would seem to prove them right.

As a result of agitation by Susan B. Anthony, a Woman's Building was proposed for the Columbian Exhibition at Chicago in 1893. It was to be built from a prize design by a woman and decorated exclusively by women. The prize (or fee) of a thousand dollars was ridiculously small, and the first and most famous woman architect in the U.S.A., Louise Bethune, quite properly refused to take part. Despite painful contradictions – for the organising committee was very anxious that no taint of feminism or radicalism should cloud their endeavours – the building came into being and was duly decorated by other women, including Mary Cassatt who contributed murals for the Rotunda along with Mary Fairchild Macmonnies. These two were also in the gallery of honour together with Cecilia Beaux, Ida Waugh, who had studied in the Académies Julian and Delecluse in the 1880s and went on to win the Norman W. Dodge prize for a portrait before dying in 1919 and fading into relative obscurity, and Enrilda Loomis France who has slipped into utter obscurity.[39]

It was not only in the New World that women were becoming so conspicuous. Exhibitions of women's work were being organised all over Europe as well. In Florence there were yearly exhibitions of women's work in the 1890s, which seem to have gone by the name of the Beatrice exhibition 'dell'arte femminile'.[40] Paintings by the women of Saxony were exhibited in Dresden in

1892,[41] while in the same year women artists of Berlin were exhibiting there.[42] More women artists showed at the Women's International Exhibition in London in 1900.[43] The apogee of all such exhibitions was that of *Les Femmes Artistes de l'Europe*, held at the Musée du Jeu de Paume in 1937, which went on to the Metropolitan Museum in New York.[44] The retrospective section with Marie Bashkirtseff, Marie Blanchard, Louise Breslau, Mary Cassatt, Lucie Cousturier, Beatrice How, Jacqueline Marval, Berthe Morisot, Jeanne Poupelet and Vera Rockline was uncommonly well chosen. The English section consisted of fourteen artists, the Belgian nineteen, the Finnish eight; the French *invitées* numbered twenty-four, and twenty-one others had been '*admises par le jury*'. Sixteen Dutchwomen, fourteen Hungarians, twenty-one Italians, eight Norwegians, no fewer than twenty-eight Poles, twelve Rumanians, nine Swedes, fifteen Swiss and nineteen Czechs exhibited. There was, moreover, an Ecole Internationale in which women like Cecilia Beaux, Romaine Brooks, Alexandra Exter and Natalia Goncharova were included – five hundred and fifty works from fifteen countries in all.

Ever since the 1850s observers have been claiming that all the obstacles in the way of women artists have melted away. Every woman who seized a prize or a scholarship or sold a work to a national collection or sat upon a hanging jury stoutly believed that hundreds of women would follow her into the breach in the defences of the male establishment. The history of art however remained virtually unaffected. Anna Lea Merritt's *Love Locked Out* which was bought for the Tate by the Chantrey Fund, and opened the way for the acquisition of more women's work, is a laughing stock. Rosa Bonheur, whose example justified all the struggles of nineteenth-century women artists, is no longer regarded as a great master or even as a good painter. In her recent book, *Nineteenth-Century Painters and Painting*, Geraldine Norman has to stretch a point to include six women, one of whom is Vigée-Le Brun, in more than seven hundred entries.[45] Besides Bonheur, Cassatt and Morisot, she includes the Danish Anna Ancher (1859–1935) and the Norwegian Harriet Backer (1845–1932).

The reason why Mrs Norman has not included more women is not that she is a lunatic anti-feminist but that she actually considers that their contribution does not merit inclusion even in a book which attempts to give a true picture of the main pre-occupations of nineteenth-century artists rather than concentrating on the breakaway groups which advanced furthest and fastest. In her view the rest of the hundreds of women working as painters in the nineteenth century are minor members of schools founded and demonstrated by male artists, and have simply been sifted out in arriving at the seven hundred-odd artists whose achievement is in her view significant. Ancher and Backer were both significant figures in provincial schools. Of the two hundred-odd English female artists listed in Christopher Wood's *Dictionary of Victorian Painters*, itself selective, for the number might easily be doubled, not one has merited inclusion in a work on a wider scale.

The narrower and more provincial the view taken by any exhibition or study, the more women appear in it, as we draw closer and closer to the school situation in which the women studying art outnumber the men. Even in the jubilee exhibition at the Royal Academy of *British painting from 1953–1978*, out of three hundred and ninety-two paintings hung, only forty-six were by women.[46]

There is no point in denying the situation or in pretending that it is purely the result of a male chauvinist interpretation of the facts. It would be possible, perhaps, without doing violence to Geraldine Norman's intellectual position, to quadruple the number of women she includes, but twenty-four is not much better as a showing out of seven hundred than six. It must be borne in mind however that concepts of relative importance are often mistaken. The case is often over-simplified: it is not always the woman who follows the man's influence. She is often the innovator, but it is the man who recognises the innovation for what it is, commandeers it and establishes it as his own. The assessment of importance is not based upon the assessment of talent, which is imponderable.

In the last analysis the external obstacles are less insidious and destructive

Anna Lea Merritt, *Love Locked Out*, 1889
Many Victorian women painters used children as models and invented all sorts of elaborated justifications for the practice, fitting wings on and making them angels, or calling them Love, as in this case.

than the internal ones. Poverty and disappointment do not afflict the work itself as effectively as do internalised psychological barriers. All women are tortured by contradictory pressures, but none more so than the female artist. The art she is attracted to is the artistic expression of men: given the present orientation of art history she is not likely to have seen much women's work and less likely to have responded to it. She certainly would not, unless she grew up in a very strange environment, be able to say that she responded primarily to women's work. If she does she is probably not referring to painting, but to textiles or some other 'minor' art in which women have not been inspired, led, influenced, taught and appreciated by men.

A woman knows that she is to be womanly and she also knows that for a drawing or a painting to be womanish is contemptible. The choices are before her: to deny her sex, and become an honorary man, which is an immensely costly proceeding in terms of psychic energy, or to accept her sex and with it second place, as the artist's consort, in fact or in fantasy. To live alone without emotional support is difficult and wearing and few artists have been able to survive it. To find emotional support in another woman is only possible for some women, most of whom have been continually distressed and oppressed by social pressures. The lesbian is more tortured than any other woman by the suspicion that she is a sort of mock-male: she more than another will be teased by the alien tradition of representing women as sex objects, as the 'other'.

For all artists the problem is one of finding one's own authenticity, of speaking in a language or imagery that is essentially one's own, but if one's self-image is dictated by one's relation to others and all one's activities are other-directed, it is simply not possible to find one's own voice. Time and again, women painters' work, however competent, fails to survive fashion. As the superficial predilection for a certain kind of treatment ebbs away, the paintings are seen to be hollow, posturing, empty and absurd. In their anxiety to feel the right feelings and give evidence of having lovable natures, many nineteenth-century women painters falsified their own perceptions and over-stated emotional experiences which they did not actually understand.

Feminism cannot supply the answer for an artist, for her truth cannot be political. She cannot abandon the rhetoric of one group for the rhetoric of another, or substitute acceptability to one group for acceptability to another. It is for feminist critics to puzzle their brains about whether there is a female imagery or not, to examine in depth the relations between male and female artists, to decide whether the characteristics of masculine art are characteristics of all good art and the like. The painter cannot expend her precious energy in polemic, and in fact very few women artists of importance do.

The point is, after all, not to question irritably whether women artists are any good in order to reject them if we find that they are not as good as another group, but to interest ourselves in women artists, for their dilemma is our own. Every painting by anyone is evidence of a struggle, and not all such struggles

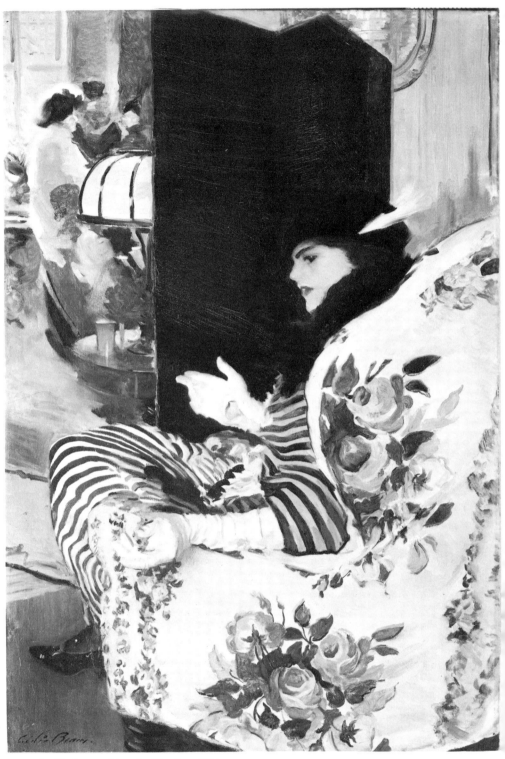

Cecilia Beaux, *After the Meeting*, 1914
This picture, of her friend Dorothy Gilder, caused a sensation in 1914. To the
glamour of the society portrait are added the excitement of vivid patterning, and
the illusion of movement and atmosphere.

are conclusively won. There are more warring elements in women's work than in men's, and when we learn to read them we find that the evidence of battle is interesting and moving, like the trampled grass of Lady Butler's *Quatre Bras*. Many women artists in our own day are journeying inward, away from inherited statement to an inner truth, as Gwen John did, to the point where all posture and surface appeal is bleached away. Others take the surrealist road, hoping in dream imagery to find the same kind of truth. Others strive for truly gratifying forms, to which they may respond more deeply than in words, beyond consciousness. Others turn to photo-realism in the search for a way out of hypocrisy. To the deadening pull towards passivity is added the pressure of politics which would drag the artist in another direction until her soul lies dismembered.

Most of us, despite our schools' insistence that anyone can draw, are not artists: it is to our advantage to become the women artists' audience, not in a foolishly partisan way so that anything a woman does is good in our eyes, but to offer the kind of constructive criticism and financial, intellectual and emotional support that men have given their artists in the past. The first prerequisite is knowledge, not only of women's work but of the men's work to which it relates, and not in vague generalisations but precise examples. The young Californian women who came to the 'Women Painters: 1550–1950' exhibition in Los Angeles were often disappointed to see how closely the women's work related to that of the men, whom they knew more about, and many of them lost interest right there. That should have been the starting point, for understanding how women artists sometimes led men, were plundered and overtaken, is an important part of recovering our history. At a recent exhibition at the Victoria and Albert Museum a small cubist gouache by Alexandra Exter, dated 1914–15, was accompanied by an unusually generous note, pointing out how much more advanced her work was than what Braque and Picasso were doing at the same time. Unfortunately on the postcards that were being sold showing this work her name was rendered *Alexander* Exter.[47] (See Pl. 28.)

There is then no female Leonardo, no female Titian, no female Poussin, but the reason does not lie in the fact that women have wombs, that they can have babies, that their brains are smaller, that they lack vigour, that they are not sensual. The reason is simply that you cannot make great artists out of egos that have been damaged, with wills that are defective, with libidos that have been driven out of reach and energy diverted into neurotic channels. Western art is in large measure neurotic, for the concept of personality which it demonstrates is in many ways anti-social, even psychotic, but the neurosis of the artist is of a very different kind from the carefully cultured self-destructiveness of women. In our time we have seen both art and women changing in ways that, if we do not lose them, will bring both closer together.

List of Illustrations

The author and her publishers make grateful acknowledgment to the owners and photographic agencies listed here for their permission to reproduce pictures.

Dimensions are given as height first.

37 Constance Mayer, *The Dream of Happiness*. Oil on canvas, 51⅞ × 71⅜ in, 132 × 182 cm. Musée du Louvre, Paris (photo: Giraudon).

38 Constance Mayer, *The Happy Mother*. Oil on canvas, 76⅜ × 56¼ in, 194 × 143 cm. Musée Jaquemart-André, Paris (photo: Bulloz).

44 Adrienne Marie Louise Grandpierre-Deverzy, *The atelier of Abel Pujol*, 1822. Oil on canvas, 37¾ × 50¾ in, 96 × 129 cm. Musée Marmottan, Paris (photo: Routhier).

45 Anna Lea Merritt, *War*, 1883. Oil on canvas, 40½ × 55 in, 102·9 × 139·7 cm. Bury Art Gallery, Lancashire.

48 Sylvia Gosse, *The Printer*, 1915–16. Oil on canvas, 40 × 30 in, 101·6 × 76·3 cm. (photo: Anthony d'Offay).

50 Paula Modersohn-Becker, *Self-Portrait*, 1906. Oil on canvas, 24 × 19¾ in, 61 × 50 cm. Kunstmuseum, Basel.

51 Laura Knight, *The Nuremberg Trial*, 1946. Oil on canvas, 72 × 60 in, 182·9 × 152·4 cm. Imperial War Museum, London.

55 Dora Carrington, *The Mill at Tidmarsh*, 1918. Oil on canvas, 25¼ × 37¼ in, 64·2 × 94·6 cm. (photo: Anthony d'Offay).

58 Madame Achille Fould, *Rosa Bonheur in her studio*, 1893. (photo: Witt Library, London).

61 Romaine Brooks, *Una, Lady Troubridge*, 1924. Oil on canvas, 50⅛ × 30⅛ in, 127·3 × 76·4 cm. National Collection of Fine Arts, Smithsonian Institution, Washington D.C. Gift of the Artist.

63 Gwen John, *Chloë Boughton Leigh*, c.1907. Oil on canvas, 23 × 15 in, 58·5 × 38·0 cm. The Tate Gallery, London.

65 Suzanne Valadon, *Family Portrait: André Utter, Suzanne, Grand'mère and Maurice Utrillo*, 1912, signed and dated. Oil on canvas. Formerly Collection Pomaret, present whereabouts unknown © S.P.A.D.E.M.

66 Frida Kahlo, *Frida and Diego*. Oil on canvas, 39 × 31 in, 99·1 × 78·8 cm. San Francisco Museum of Art, Gift of Albert M. Bender.

69 Unknown, *Marsia from Boccaccio's De Casibus Virorum Illustrorum*. Ink on vellum, 2⅞ × 2¼ in, 7·3 × 6 cm. Bibliothèque Nationale, Paris.

70 Mary Moore, *Thomas Cromwell, Earl of Essex*. Oil on board, 23¾ × 19 in, 60·4 × 48·2 cm. Bodleian Library, Oxford.

71 Arcangela Paladini, *Self-Portrait*. Oil on canvas, 20½ × 16⅜ in, 52 × 42 cm. Galleria degli Uffizi, Florence.

73 Elisabeth Sophie Chéron, *Self-Portrait*. Museé Nationale du Château de Versailles.

74 Elisabeth Sophie Chéron, *Self-Portrait*. Oil on canvas, 28 × 22⅞ in, 71 × 58 cm. Musée Magnin, Dijon (photo: Witt Library, London).

76 Marie Bashkirtseff, *The Painter's Sister-in-Law*, 1881. Oil on canvas, 36¼ × 28¾ in, 92 × 73 cm. Rijksmuseum, Amsterdam.

79 Mariana Valdestein, Marchesa de Santa Cruz,

Self-Portrait, 1772. Oil on board. Galleria degli Uffizi, Florence.

79 Anna Bacherini Piattoli, *Self-Portrait*. Oil on canvas, 9 × 6 in, 23 × 15 cm. Galleria degli Uffizi, Florence.

81 Angelica Kauffmann, *Design*. Oval, 52 × 59 in, 132 × 150 cm. Royal Academy of Arts, London.

83 Elizabeth Thompson, Lady Butler, *Quatre Bras*, 1815. Oil on canvas, 38¼ × 85 in, 97·2 × 216·2 cm. National Gallery of Victoria, Melbourne.

85 Henriette Ronner-Knip, *Three to One*. Oil on canvas, 32¼ × 50¼ in, 82 × 127·5 cm. Rijksmuseum, Amsterdam.

86 Maud Earl, *The Ace of Hearts* (photo: Christie's).

89 Giulia Lama, *Self-Portrait*. Oil on canvas, 28¼ × 23¾ in, 72 × 60 cm. Galleria degli Uffizi, Florence.

92 Angelica Kauffmann, *Lady Elizabeth Foster*. Oil on canvas, 50 × 39⅞ in, 127 × 101·5 cm. The National Trust, Ickworth.

97 Elisabeth Vigée-Le Brun, *Charles Alexandre de Calonne*, 1784, signed and dated. Oil on canvas, 59 × 50½ in, 149·9 × 128·3 cm. Windsor Castle, Reproduced by gracious permission of Her Majesty The Queen.

99 Adélaïde Labille-Guiard, *Self-Portrait*, 1782. Pastel on blue paper, 28¾ × 22⅞ in, 72 × 58 cm. Collection héritier Monsieur Raymond Flobert, Paris.

101 Marguérite Gérard, *The Bad News*. Oil on canvas, 25⅝ × 19¼ in, 65 × 49 cm. Musée du Louvre, Paris (photo: Bulloz).

106 Elisabetta Sirani, *The Baptism of Christ*, 1658, signed and dated. Certosa, Bologna (photo: Villani).

109 Caterina van Hemessen, *Self-Portrait*, inscribed 'Ego Caterina De Hemessen pinxit 1548 Aetatis Suae 20'. Tempera on panel, 12¼ × 9⅞ in, 31 × 25 cm. Kunstmuseum, Basel.

110 Caterina van Hemessen, *Christ and St Veronica*. Couvent des Pères Rédemptoristes, Brussels (photo: © A.C.L.).

111 F. P. d'Heudicourt, *Louis XIV*, inscribed. Water and bodycolour on paper on panel, 10 × 8¼ in, 25·5 × 21 cm. (photo: Witt Library, London).

116 Aloïse Corbaz, *Porteuse de rose avec Napoléon*. (photo: Third Eye Centre).

118 Madge Gill, *Women*. Borough of Newham, London (photo: Eileen Tweedy).

124 Deborah Goldsmith, *The Talcott Family*, 1832. Watercolour, 14 × 18 in, 35·5 × 45·7 cm. Colonial Williamsburg Center, Abby Aldrich Rockefeller Folk Art Collection.

125 Eunice Pinney, *Two Women*, c. 1815.

126 Susan Merrett, *Fourth of July Picnic at Weymouth Landing*, c.1845. Watercolour and collage, 26 × 36 in, 66 × 91·4 cm. The Art Institute of Chicago, Bequest of Elizabeth Vaughn.

128 Barbara Longhi, *Mary with Christ and John the Baptist*. Oil on canvas, 34⅞ × 28 in, 88·5 × 71·0 cm. Gemäldegalerie Alte Meister, Dresden.

129 Kate Bunce, *Musica*. Oil on canvas, 29½ × 19½ in, 73·7 × 48·8 cm. City Museums and Art Gallery, Birmingham.

130 Evelyn de Morgan, *Love which moves the Sun and the Other Stars*. Tempera, 84 × 43 in, 213·5 × 109·3 cm. (photo: Sotheby Parke Bernet).

134 Isabelle Pinson, *Family Group*, inscribed 'Pinson pinxit 1789'. Oil on canvas, 28 × 35½ in, 70·8 × 89·8 cm. Bowes Museum, Co. Durham.

135 Judith Leyster, *Still Life*, monogrammed. Oil on canvas, ⁻26¾ × 24⅜ in, 68 × 62 cm. American private collection (photo: Brod Gallery, London).

137 Judith Leyster, *The Jolly Companions*, 1630, monogrammed and dated. Oil on wood, 26⅝ × 21¾ in, 68 × 55 cm. Musée du Louvre, Paris (photo: Giraudon).

138 Anna Quast, *Still Life with Butterfly*, 1640, signed and dated. Oil on panel, 28¼ × 22⅜ in, 72 × 57 cm. English private collection (photo: Brod Gallery, London).

140 Unknown, *Self-Portrait*. Oil on canvas, 25¼ × 20½ in, 64 × 52 cm. Galleria degli Uffizi, Florence.

141 Unknown, *Self-Portrait*. 28¾ × 23¼ in, 73 × 59 cm. Galleria degli Uffizi, Florence.

143 Césarine Davin-Mirvault, *Portrait of Antonio Bartolomeo Bruni*. The Frick Collection, New York.

144 Jacoba Nikkelen, *Flowers*. Oil on wood, 19¼ × 14½ in, 49 × 37 cm. Gemäldegalerie der Akademie der bildenden Künste, Vienna.

147 Giulia Lama, *Crucifixion*. Chiesa di San Vitale, Venice (photo: Eileen Tweedy/Witt Library, London).

148 Cornelia van der Mijn, *Flowers*. Oil on canvas, 29⅞ × 25⅛ in, 76 × 64 cm. Rijksmuseum, Amsterdam.

149 Aleida Wolfsen, *Portrait of a Lady*. Oil on canvas, 18⅞ × 15½ in, 48 × 39·5 cm. Haags Gemeentemuseum, The Hague.

150 Madame Chassaignac, *Général Lejeune*. Oil on canvas, 45¼ × 30¼ in, 115 × 77 cm. Musée de l'Armée, Paris.

152 Ende, *Explanatio in Apocalypsam*. Fol. 167v. Ink on vellum, 15¾ × 10¼ in, 40 × 26 cm. Gerona Cathedral (photo: Mas).

154 Uota, *Evangeliarium*. Parchment, 15⅛ × 10⅞ in, 38·5 × 27·5 cm. Staatsbibliothek, Munich (photo: Marburg).

157 Diemudis, *Initial S*. Clm. 23036. Staatsbibliothek, Munich (photo: Marburg).

158 Gisele von Kerssenbroek, *Codex Gisele, Initial P*. Parchment, 10¾ × 14⅞ in, 27 × 37 cm. Cathedral Library, Osnabruck (photo: Marburg).

162 Unknown, *Book of Hours*. MS.B. 11.22 fol. 100. Watercolour on tempera, miniature. Master and Fellows of Trinity College, Cambridge.

163 Maria Ormani, *Breviarium cum Calendario*,

1453. Parchment, 6⅞ × 5⅛ in, 17·6 × 12·9 cm. Osterreichische Nationalbibliothek, Vienna, fol. 89.

165 *Crucifixion with Our Lady and St John*. Cent. III. 86 fol. 120v. Miniature. Stadtbibliothek, Nuremburg.

166 Dorothea Deriethain, *Medlingen Gradual, Initial L*, *c.*1500. Staatsbibliothek, Munich (photo: Marburg).

170 Mechteld toe Boecop, *The Last Supper*, 1547, signed and dated. Oil on panel, 72 × 79 in, 183 × 201·5 cm. Municipality of Kampen (photo: Rijksmuseum).

173 Mechteld toe Boecop, *Adoration of the Shepherds*, 1574, signed and dated. Oil on panel, 78¾ × 66½ in, 199 × 169 cm. Municipality of Kampen (photo: Rijksmuseum).

177 Andriola de Baracchis, *The Entombment*. Oil on panel, 24¾ × 20⅜ in, 63 × 52 cm. Pinacoteca Malaspina, Pavia.

178 Suor Barbera Ragnoni, *Adoration of the Shepherds*. Tempera on panel. Pinacoteca Nazionale, Siena (photo: G.F.N.).

181 Sofonisba Anguissola, *Bernardino Campi painting the portrait of Sofonisba herself*. Oil on canvas, 43⅜ × 43¼ in, 111 × 109·5 cm. Pinacoteca Nazionale, Siena (photo: G.F.N.).

183 Lucia Anguissola, *Pietro Maria, doctor of Cremona*. signed. Oil on canvas, 37¾ × 29⅞ in, 96 × 76 cm. Museo del Prado, Madrid (photo: Mas).

184 Sofonisba Anguissola, *Husband and Wife*. Oil on canvas, 28¼ × 25½ in, 72 × 65 cm. Galleria Doria Pamphili, Rome (photo: G.F.N.).

185 Suor Plautilla Nelli, *The Last Supper*. Chiesa di Santa Maria Novella, Florence (photo: Mansell Collection).

190 Artmesia Gentileschi, *Judith beheading Holofernes*. Oil on canvas, 70¼ × 67¾ in, 169 × 162 cm. Galleria degli Uffizi, Florence (photo: G.F.N.).

196 Artemisia Gentileschi, *Portrait of a Papal Knight*, 1622. Inscribed and dated. Oil on canvas, 81⅞ × 50⅜ in, 208 × 128 cm. Pinacoteca Communale, Bologna (photo: Villani).

197 Artemisia Gentileschi, *Judith and her Maidservant*. Oil on canvas, 72½ × 55¾ in, 185·2 × 141·6 cm. The Detroit Institute of Arts, Gift of Leslie H. Green.

198 Artemisia Gentileschi, *Esther and Ahasuerus*. Oil on canvas, 82 × 107¾ in, 208·3 × 273·8 cm. The Metropolitan Museum of Art, New York.

200 Artemisia Gentileschi, *The Annunciation*. Oil on canvas, 101⅛ × 70½ in, 257 × 179 cm. Museo di Capodimonte, Naples.

201 Artemisia Gentileschi, *St Januarius with the Lions*. Pozzuoli Basilica, Naples (photo: G.F.N.).

202 Artemisia Gentileschi, *The Adoration of the Magi*. Pozzuoli Basilica, Naples.

203 Artemisia Gentileschi, *Sts Proculus and Nicaea*. Pozzuoli Basilica, Naples.

204 Artemisia Gentileschi, *David and Bathsheba.* (photo: G.F.N.).

205 Artemisia Gentileschi, *David and Bathsheba.* Oil on canvas, 98½ × 76½ in, 250·2 × 194·3 cm. Columbus Museum of Art, Ohio, Schumacher Fund Purchase.

208 Lavinia Fontana, *Self-Portrait.* 28 × 18½ in, 71 × 47 cm. Galleria degli Uffizi, Florence (photo: Mansell Collection).

211 Lavinia Fontana, *Birth of the Virgin.* Chiesa della Trinità, Bologna (photo: Villani).

212 Lavinia Fontana, *Venus and Cupid.* State Hermitage Museum, Leningrad (photo: Society for Cultural Relations with the U.S.S.R.).

217 Fede Galizia, *Judith with the Head of Holofernes.* Oil on canvas. Galleria Borghese, Rome (photo: G.F.N.).

220 Ginevra Cantofoli?, *Self-Portrait in the Act of Painting a Self-Portrait.* Oil on canvas, 25¼ × 19⅝ in, 64 × 50 cm. Pinacoteca di Brera, Milan.

223 Elisabetta Sirani, *Madonna and Child.* 72¾ × 51⅛ in, 185 × 130 cm.

229 Fede Galizia, *Still Life with Peaches and Jasmine.* Collezione Campagnano, Florence (photo: Villani).

230 Orsola Maddalena Caccia, *Flowers.* Municipio di Moncalvo (Asti) (photo: Villani).

231 Giovanna Garzoni, *A Dish of Broad Beans.* Tempera on parchment, 9¾ × 13½ in, 24·8 × 34·3 cm. Palazzo Pitti, Florence (photo: Villani).

232 Elena Recco, *Still Life.* Oil on canvas, 41¾ × 66¼ in, 106 × 168 cm. Fürstlich Fürstenbergische Sammlungen, Donaueschingen.

233 Margarita Caffi, *Flowers,* 1662, signed and dated. Oil on canvas, 23¼ × 18⅞ in, 59·1 × 48 cm. Formerly in the collection of the Leger Galleries Ltd, London.

235 Madeleine de Boullongne, *Trophy of Arms and Musical Instruments.* Oil on canvas, 45⅝ × 59 in, 116 × 150 cm. Musée Nationale du Château de Versailles (photo: Musées Nationaux, Paris).

236 Josefa de Obidos, *Still Life,* 1676, signed and dated. Oil on canvas, 33 × 63 in, 84 × 160 cm. Museu–Biblioteca de Santarem (photo: Royal Academy of Arts, London).

237 Clara Peeters, *Still Life,* 1612, signed and dated. Oil on wood, 23⅜ × 19¼ in, 59·5 × 49 cm. Staatliche Kunsthalle, Karlsruhe.

238 Maria van Oosterwijk, *Flowers and Insects,* 1669, signed and dated. Oil on canvas, 18⅝ × 15⅛ in, 47·3 × 38·5 cm (photo: Richard Green Gallery, London).

239 Geertje Peeters, *Flowers.* Oil on canvas, 31⅛ × 26⅜ in, 79 × 67 cm. Fitzwilliam Museum, Cambridge.

240 Anna Janssens, *Flowers,* signed. Oil on canvas, 39¾ × 26⅜ in, 100 × 67 cm. Private collection.

241 Helen Rouers, *Flowers,* 1663, signed and dated. Oil on canvas, 21¾ × 18⅛ in, 55·5 × 46 cm. Statens Museum for Kunst, Copenhagen.

242 Katharina Treu, *Still Life,* signed C. Königin.

Oil on copper, 20⅛ × 17¼ in, 51 × 44 cm. Hessisches Landesmuseum, Darmstadt.

245 Margareta Haverman, *Still Life,* 1716, signed and dated. Oil on canvas, 31¼ × 23¾ in, 79·4 × 60·3 cm. The Metropolitan Museum of Art, New York, Purchase 1871.

246 Barbara Regina Dietzsch, *Flowers.* Gouache on Parchment, 20⅞ × 18⅛ in, 53 × 46 cm. Alte Pinakothek, Munich.

247 Melanie de Comoléra, *A Vase of Flowers.* Oil on canvas, 35½ × 27⅞ in, 90·2 × 70·8 cm. Fitzwilliam Museum, Cambridge.

248 Mary Ensor, *Spring Flowers and a Starling by a Wall,* 1864, signed and dated. (photo: Christie's).

251 Sofonisba Anguissola, *Portrait of her sister, Lucia.* (photo: G.F.N.).

252 Sofonisba Anguissola?, *Portrait of a Boy with Sword, Gloves and Dog.* Oil on canvas, 54 × 28¼ in, 137·2 × 71·8 cm. Walters Art Gallery, Baltimore.

254 Micheline Wautier, *Portrait of a Man,* 1646, signed and dated. 23¾ × 22¼ in, 63 × 56·5 cm. Musées Royaux, Brussels (photo: © A.C.L.).

255 Catelijne Pepijn, *Portrait of the Abbot of St Michel,* 1657. Oil on canvas, 51⅛ × 41⅛ in, 130 × 105 cm. Koninklijk Museum voor Schone Kunsten, Antwerp (photo: © A.C.L.).

256 Joan Carlile, *The Stag Hunt at Lamport.* Oil on canvas, 24 × 29⅛ in, 61 × 73·6 cm. Private Collection (photo: The City of Birmingham Museum and Art Gallery).

257 Sarah Curtis, *Portrait of Dr Hoadly.* Oil on canvas, 49 × 39 in, 124·5 × 99 cm. National Portrait Gallery, London.

258 Rosalba Carriera, *Charles, 2nd Duke of Dorset.* Pastel, 25 × 19 in, 63·5 × 48·2 cm. Knole (photo: Witt Library London).

261 Françoise Du Parc, *The Infusion-Seller.* Oil on canvas, 28¾ × 26¾ in, 73 × 68 cm. Musée des Beaux-Arts, Marseille (photo: Lauros-Giraudon).

263 Marie Anne Loir, *Portrait of the Marquise du Châtelet.* Oil on canvas, 39¾ × 31½ in, 101 × 80 cm. Musée des Beaux-Arts, Bordeaux (photo: Bulloz).

264 Marie-Jeanne Doré, *Girl holding a Rose,* signed. Oil on canvas, 15 × 24 in, 68·6 × 61 cm. Victoria and Albert Museum, London, Jones Bequest.

265 Marie Suzanne Roslin, née Giroust, *Portrait of the Sculptor Pigalle.* Pastel on paper, 35¾ × 28¾ in, 91 × 73 cm. Musée du Louvre, Paris (photo: Bulloz).

266 Mademoiselle Navarre, *Portrait,* 1774, signed and dated. Pastel, 24¼ × 19⅞ in, 61·5 × 50·5 cm.

267 Adélaïde Labille-Guiard, *Portrait of the sculptor Pajou, modelling the bust of J. B. Lemoyne,* 1782, signed and dated. Pastel, 28 × 22⅞ in, 71 × 58 cm. (photo: Giraudon).

269 Adélaïde Labille-Guiard, *Self-Portrait with two of her pupils, Mesdemoiselles Capet and Rosemond,* 1785, signed and dated. Oil on canvas, 83 × 59½ in, 210·8 × 151 cm. The Metropolitan Museum of Art, New York, Gift of Julia A. Berwind, 1953.

LIST OF COLOUR PLATES

71 × 57 cm. Galleria degli Uffizi, Florence (photo: Scala).

Plate 10 Angelica Kauffmann, *The Artist Hesitating Between the Arts of Music and Painting*, c.1794. Nostell Priory, by kind permission of Lord St Oswald (photo: J. Arthur Dixon).

Plate 11 Anne Vallayer-Coster, *The White Tureen*, 1771. 19⅜ × 24½ in, 50 × 62 cm. Private collection, Paris.

Plate 12 Adélaïde Labille-Guiard, *Portrait of the Painter François-André Vincent*. Oil on canvas, 28¾ × 11¼ in, 73 × 59 cm. Musée du Louvre (photo: Giraudon).

Plate 13 Elisabeth Vigée-Le Brun, *Self-Portrait*. Oil on canvas, 39 × 31⅞ in, 99 × 81 cm. The National Trust, Ickworth, Suffolk.

Plate 14 Marguérite Gérard, *Summer*. Musée de Perpignan (photo: Giraudon).

Plate 15 Mary Beale, *Self-Portrait*, 1666. Oil on canvas, 43 × 34½ in, 109·2 × 87·6 cm. National Portrait Gallery, London.

Plate 16 Constance Marie Charpentier, *Mademoiselle Charlotte du Val d'Ognes*. Oil on canvas, 63½ × 50⅜ in, 160·5 × 128·5 cm. The Metropolitan Museum of Art, Bequest of Isaac D. Fletcher, 1917.

Between pp. 232 and 233

Plate 17 Aimée Duvivier, *Portrait of a Young Pupil of David*. Oil on canvas, 50 × 37¾ in, 127 × 96 cm. Musée Marmottan, Paris (photo: Routhier).

Plate 18 Rosa Bonheur, *The Horse Fair*. Oil on canvas, 47¼ × 100¼ in, 120 × 254·6 cm. National Gallery, London.

Plate 19 Elizabeth Butler, *Scotland Forever!* Temple Newsam House, Leeds.

Plate 20 Berthe Morisot, Seascape, *Isle of Wight*. Private collection, Paris (photo: Giraudon).

Plate 21 Mary Cassatt. *The Bath*, c.1891, signed. Oil on canvas, 39 × 26 in, 88 × 66 cm. The Art Institute of Chicago, Robert A. Waller Fund.

Plate 22 Cecilia Beaux, *Portrait of Fanny Travis Cochran*, 1887. Oil on canvas, 35½ × 28½ in, 90·2 × 72·4 cm. Courtesy of the Pennsylvania Academy of the Fine Arts.

Plate 23 Suzanne Valadon, *Woman in White Stockings*. (photo: Giraudon) © S.P.A.D.E.M.

Plate 24 Gwen John, *A Corner of the Artist's Room in Paris*, 1907–9. Oil on canvas, 12½ × 10½ in, 31·8 × 26·7 cm. Sheffield City Art Galleries.

Between pp. 312 and 313

Plate 25 Gabriele Münter, *Meditation*, 1917, signed and dated. Oil on canvas, 26 × 39⅜ in, ·66 × 100 cm. Städtische Galerie im Lenbachhaus, Munich, Gift of Johannes Eichner.

Plate 26 Vanessa Bell, *Portrait of Duncan Grant Painting*, c.1915. Oil on canvas, 9¼ × 15¼ in, 23·5 × 38·75 cm. Anthony d'Offay.

Plate 27 Natalia Goncharova, *The Bathers*, 1912–13, signed. Oil on canvas, 90½ × 59⅜ in, 230 × 152 cm. Grosvenor Gallery, London © A.D.A.G.P.

Plate 28 Alexandra Exter, *Still Life*, 1914–15. Gouache, 13 × 9¾ in, 33 × 24·75 cm. Victoria and Albert Museum, London.

Plate 29 Marie Laurençin, *Woman with Dove*, 1919. Musée d'Art Moderne, Paris (photo: Musées Nationaux) © A.D.A.G.P.

Plate 30 Aloïse Corbaz, *Mysterious Temple*. Coloured crayon, 23¼ × 16⅜ in, 59·1 × 42·2 cm. (photo: Third Eye Centre).

Plate 31 Séraphine Louis, *Tree of Paradise*. Musée d'Art Moderne, Paris (photo: Bulloz) © A.D.A.G.P.

Plate 32 Madge Gill, *Women*. Borough of Newham, London (photo: Eileen Tweedy).

Acknowledgments

In addition to the acknowledgments of all those institutions which have cooperated in supplying illustrative material, my particular thanks is due too to those who made it possible for me to write this book at all. These are hard times for libraries and museums, for the funds available have not kept pace with the increase in the volume of work they are expected to cope with, amid which the demands of scholars are a small and irritating irrelevance.

My especially warm thanks goes to the Witt Library of the Courtauld Institute of the University of London, whose staff seem to manage the impossible and do it with a smile. The London Library too seems to adhere to standards of courtesy which larger institutions can no longer afford. The staff at the Victoria and Albert Museum, although so far below strength that the library must close on Fridays and for lunch at short notice and can do no photocopying at all, remained civil and helpful under very trying conditions, many of which stem from the fact that the building was falling down around their ears. My best wishes go to the British Museum staff; it is to be hoped that their industrial action produces a better deal for themselves and the readers.

Although not quite in the category of homes from home, the Bibliothèque Nationale in Paris, the Bibliothèque Royale in Brussels, the Biblioteca Nazionale in Florence, the Biblioteca Comunale in Bologna, the Accademia di San Luca in Rome, the Frick Art Reference Library in New York and the Archivio di Stato in Rome all deserve my special thanks.

At a time when most museums leave letters unanswered, those who welcome the prying stranger who needs to turn the storerooms upside down and ask awkward questions about out of date inventories are a distinguished minority. To M. Vindry of the Musée Fragonard in Grasse, Dr Borghini of the Pinacoteca Nazionale in Siena, Dr Riccomini of the Pinacoteca Nazionale di Bologna, M. Algieri of the Musée Calvet in Avignon, the young administrators of the Museum at Pau, the women of the Detroit Institute of Arts, the Sisters of the Convent of Santa Maria Maddalena dei Pazzi at Trespiano, the Padri Carmelitani in Rome, my sincere thanks.

The Rijksmuseum, Amsterdam, the Gemeente Museum in The Hague, the Frans Hals Museum, Haarlem, the Museum Boymans van Beuningen, Rotterdam, the Koninklijk Museum in Antwerp, the Museum for Schone Kunsten, Ghent, the Louvre, Musées Marmottan, Cognacq Jay, Carnavalet in Paris, the National Gallery of Australia, Canberra, the Walker Art Gallery, Baltimore, the Museo Nazionale di Capodimonte, Naples, the Uffizi, the Accademia, the Museo di San Maria Novella in Florence, the art galleries of Cremona, Pavia, Parma, Ravenna all let me take up their time and disrupt their routine, for which I am grateful.

There are hundreds more people who unlocked doors, opened windows, searched for lights, brought things to stand on, parish priests, sacristans, caretakers, housewives, custodians of small church collections who were fiercely interested in what they had and proud of it: to all of them my special thanks and the hope that we shall meet again.

Special thanks too must go to the Fine Art Society of London, who gave me the run of their office and records, the staff of Christie's and Sotheby's, who dealt patiently with every query, however muddled, Mr Anthony d'Offay and the Brod Gallery, and indeed all the picture dealers of London, and a few in other parts, who were all descended on at one time or another.

Lastly, but equally fervently, I should like to thank the people who kept me alive during the eight years it has taken to wrestle this huge topic into what shape it has; first of all, those who gave me work, which, while it kept me away from this book, also gave me the money to roam Europe and bury myself in libraries, and, of course, Tom Rosenthal of Secker & Warburg, who must often have wondered whether he would see any return on his advance. What they made possible was the time of my life.

Notes

INTRODUCTION

1. M. Tourneux, 'Une Exposition Rétrospective d'art féminin', *Gazette des Beaux-Arts*, 1908, pp. 290–300.

2. Giorgio Vasari, *Le Vite de' piú eccellenti architetti, pittori e scultori italiani, da Cimabue insino ai tempi nostri* . . . (Florence, 1568), Vol. II, p. 74.

3. Caius Plinius Secundus, *Historia Naturalis*, Book XXXV. The Latin text existed in MS before its publication in 1469, and was regularly republished in Venice, Parma and Paris. Cristoforo Landino's Italian version, which appeared in 1476, went through many editions.

4. Ludovico Ariosto, *Orlando Furioso*, Canto XX, 11.9–10. The stanza from the best-known Italian poem of Vasari's time continues: 'and whoever is well-versed in history is aware of their fame, yet undimmed. If the world has for a long time been without such knowledge, bad influence cannot last forever; and perhaps the honours due to women have been obscured by writers' envy or ignorance.'

5. Vasari, *op. cit.*, Vol. II, pp. 73–4, Vol. III, pp. 561–3.

6. Carlo Ridolfi, *Delle Maraviglie dell'Arte* (Venice, 1648), Vol. II, p. 11.

7. Karel van Mander, *Het Schilder Boeck* (Haarlem, 1604). Sandrart modelled his *Teutsche Academie* quite closely upon Vasari; he was concerned that more women should paint: 'liebt nicht nur die Kunst; sondern mahlet auch selbst', he exhorted. To Vasari's and Pliny's women he added Marietta Robusti, Lavinia Fontana, Anna van Schurman, Susanne Mayr and Artemisia Gentileschi. See also p. 293.

8. In the first volume of Houbraken's *De Groote Schouburgh* (The Hague, 1718) there were four women, in the second (1719) seven and in the third (1721), eleven.

9. J. V. Beverwijk, *Van de Wtnementheyt des vrouwelicken Geslachts* (Dordrecht, 1639), p. 290. Mechteld van Lichtenberg married Egbert toe Boecop some time before 1547, the date of her first known work. Her latest work is 'The Four Evangelists' of 1577 in the Museum at Zwolle. Her daughter, Cornelia, was her pupil. A signed male portrait is noted by Bredius in the possession of the Baron van Boecop in Ede (Thieme and Becker).

10. For example, the Mengs family was Jewish, but apparently converted. The Chéron family were Huguenots, but Elisabeth Sophie renounced her religion in return for royal patronage.

11. Camilla Gray, *The Great Experiment: Russian Art 1863–1922* (London, 1971), *passim*.

12. See Tatiane Loguine, *Gontcharova et Lationov: Cinquante ans à St. Germain-des-Près* (Paris, 1971), *passim*, and Mary Chamot, *Gontcharova* (Paris, 1972), *passim*.

13. See Yakov A. Tugendhold, *Alexandra Exter* (Berlin, 1922), *passim*.

14. Gray, *op. cit.*, pp. 184, 186, 193 and P1. 144.

15. *Ibid.*, p. 246.

16. *Ibid.*, p. 294.

17. *Ibid.*, p. 192.

18. See Robert Joseph Fanning, *Käthe Kollwitz* (Karlsruhe, 1956).

I FAMILY

1. See pp. 180–2.

2. See pp. 218–21.

3. C. H. & C. Immerzeel, *De levens en Werken der Hollandsche en Vlaamsche Kunstschilders* . . . (Amsterdam, 1842), Vol. I, p. 181; Christiaan Kramm, *De Levens en Werken der Hollandsche en Vlaamsche Kunstchilders . . . van sen Vroegsten tot op onzen Tijd* (Amsterdam, 1857–64) p. 336; also *L'Art Flamand*, Vol. III, Book 1, 'Les Biset, Louis et Anne de Deyster, les Van Hellemont et les Van Orley'.

4. On p. 72 of *Delle Maraviglie dell' Arte*, Ridolfi identifies a portrait of Marco de' Vescovi 'con lunga barba' and his son Pietro in Casa Tintoretti, which used to be assumed to be the one attributed to Marietta in the Vienna Kunsthistorisches Museum. The Vienna Kunshistorisches Museum, the Louvre, the Galeria Doria-Pamphili, all have Venetian female portraits which have been called self-portraits of Marietta Robusti.

5. Vasari, *op. cit.*, Vol. II, p. 217. Robert Simon pointed out the death certificate to Ann Sutherland Harris, 'Women Painters 1550–1950' (Los Angeles, 1976), p. 20.

6. U. Thieme and F. Becker, *Allgemeines Lexikon der bildenden Künstler von der Antike bis zur Gegenwart* (37 vols, Leipzig, 1907–50). Hereinafter referred to

as Thieme-Becker, citation presumed to be the artist named unless otherwise indicated.

7. Vittoria Farinato is mentioned in G. Trecca, *Note per la biografia dei pittori veronesi*, Atti dell' Accademie d'agricoltura scienze ecc. di Verona, Ser. IV, Vol. XI. (1910) p. 7, and in Zannandreis, *Le vite dei pittori veronesi* (1871), p. 159.
Rosalia Novelli is mentioned in A. Gallo, *Elogio storico di Pietro Novelli*, the *Guida Istruita per Palermo* 1858 and *Bolletino d'Arte* 10 (1916), 38, App. 2.
Ersilia Creti, see p. 225.
Faustina Maratta married the poet Tappi. Her temple was marked by acid thrown by a jealous lover. See Bellori, *Vite de' pittori moderni . . .* (Pisa, 1821), Vol. II, p. 236.
Michelangela Lanceni became a nun in the convent of Santa Caterina della Ruota in Verona (*Ricreazione pittorica di Verona*, 1720).
8. Juan Augustin Ceán Bermudez, *Diccionario Histórico de los más illustres Profesores de las Bellas Artes* (Madrid, 1800), p. 319.
9. Ceán Bermudez, *op. cit.*, Vol. I, p. 191.
10. Jose Parada y Santin, *Las Pintoras españolas: boceto histórico – biográfico y artístico* (Madrid, 1902), pp. 23–6.
11. G. K. Nagler, *Neues Allgemeines Kunstlerlexicon* (Munich, 1835), Vol. XVIII, p. 246.
12. Frans Joseph van den Branden, *Geschiedenis der Antwerpsche Schilderschoole* (Antwerp, 1883), p. 743.
13. Thieme-Becker (Frans Xaver Verbeeck).
14. J. Lopez Rey, *Goya and his Pupil, Maria del Rosario Weis*, reprinted from the *Gazette des Beaux-Arts*, May–June, 1956. We shall never know how many women were forced not only to work in the manner of more highly valued male artists, but ultimately to forge works. The crude facts behind a fate like Rosario Weiss's may be filled out from the better-known story of Claude Latour, who, under the alias of Zezi de Montparnasse, forged Utrillos for the dealer, Jacques Marisse. He paid her from a hundred to three hundred francs a picture, and sold them for as much as seventy thousand francs.
When Utrillo was called to give evidence at Claude Latour's trial in 1947, he said, again and again, moved perhaps by the sincerity of Latour's flattery, 'I might possibly have done it myself.' (Frank Arnau, *Three Thousand Years of Deception*, London, 1961, pp. 326–7.) One is reminded of the story so ingenuously told by Clayton, of Dupré taking copies of his work from the hand of Mary Louise Kirschner, 'J'aurais pu m'y tromper moi-même.' (Ellen C. Clayton, *English Female Artists*, London, 1876, Vol. II, p. 214.)
15. Marco Boschini, *La Carta del Navegar Pitoresco*, (Venice, 1660), p. 527.
16. Bernado De'Dominici, *Vite de' pittori, Sculptori e Architetti Napoletani* (Naples, 1742), Vol. II, p. 544. Although De'Dominici cannot be relied upon for details, where he is the only source he cannot be discounted absolutely.
17. Potsdam-Sanssouci, Kulturhaus Hans Marchwitza, 'Anna Dorothea Therbusch 1721–1782', Exhibition Catalogue by Gerd Bartoschek, 1971. Self-portraits by Anna Rosina Lisziewska may be seen in Hanover and Cassel.
18. Francina Irwin, 'Lady Amateurs and their Masters in Scott's Edinburgh', *The Connoisseur*, December, 1974, p. 234.
19. Clayton, *op. cit.*, Vol. II, p. 291, Anna Klumpke, *Rosa Bonheur, sa Vie, son Oeuvre* (Paris, 1908); Roger

Miles, *Rosa Bonheur, sa Vie, son Oeuvre* (Paris, 1900); Theodore Stanton, *Reminiscences of Rosa Bonheur* (London, 1910).
20. Anna Lea Merritt in her 'Memoir' to Henry Merritt's *Art Criticism and Romance* (London, 1879) describes the way in which she was called home to the United States several times during what was supposed to be her training.
21. Girolamo De Renaldis, *Della Pittura Friulana* (Udine, 1798), p. 74.
22. Thieme-Becker.
23. Cornelis de Bie, *Het gulden Cabinet* (Antwerp, 1661), p. 588; Kramm, *op. cit.*, Vol. IV, p. 1263; Van den Branden, *op. cit.*, pp. 1047, 1050, 1053.
24. Thieme-Becker.
25. Charles L. Chéron, 'Mémoires', *Réunion des Sociétaires des Beaux-Arts*, No. XII, 1887, pp. 349ff.
26. Los Angeles Country Museum of Art, 'Women Painters 1550–1950' Exhibition Catalogue by Ann Sutherland Harris and Linda Nochlin, 1976 (hereinafter referred to as 'Women Painters 1550–1950'), pp. 221–2. Baltimore, Maryland Historical Society, 'The Peale Family', Exhibition Catalogue, June, 1975; *The Kennedy Quarterly*, Vol. I, No. iii, 'The Fabulous Peale Family', Fig. 71.
27. Lodovico Guicciardini, *Descrittione dei Paesi Bassi* (Antwerp, 1581), along with Lievina Teerlink, Susannah Horenbout, Anna Smijters and Cornelia David.
28. Simone Bergmans, 'Le Problème de Jan van Hemessen, Monogrammatiste de Brunswick', *Revue Belge de d'Archéologie et de l'Histoire d'Art*.
29. Parada y Santin, *op. cit.*, pp. 43–9.
30. See p. 202.
31. Joachim von Sandrart, *Teutsche Academie der Bau- Bild- und Malerey-Künste* (Nuremberg, 1675–9).
32. Thieme-Becker. A landscape by Ursula Reinheimer (née Prestel) may be seen in the Städelsches Kunstinstitut, Frankfurt-am-Main.
33. Giovanna Fratellini, see pp. 78, 276.
Mary Beale: see the exhibition catalogue 'The Excellent Mrs. Mary Beale' by Elizabeth Walsh and Richard Jeffree, Geffrye Museum, London, 13th October–21st December 1975, for a full notice of her life and bibliography.
Cornelia Lamme: Kramm, *op. cit.*, Vol. V, p. 1465; Nagler, *op. cit.*, Vol. XV, p. 160; also the Catalogue of the Ary Scheffer Museum, Dordrecht.
34. Suzanne Valadon, see pp. 64–7.
Anna Carbentus: Humbert Nogera, *Vincent van Gogh: A Psychological Study* (London, 1967), pp. 16f., 19.
35. In the foreword to his edition of Sacrobosco's *Sphaera Mundi* (Florence, 1571). She is also mentioned by Pascoli, in his *Vite de'Pittori Perugini* (Rome, 1732), p. 75, and other sources.
36. Thieme-Becker.
37. Luigi Napoleone Cittadella, *Documenti risguardanti la storia artistica ferrarese* (Ferraram, 1868), p. 155.
38. *Oud Holland* (1896), Vol. XIV.
39. Alfred Wurzbach, *Niederlandisches Künstlerlexikon* (Vienna, 1906–11), claims that Maria was the daughter of Jan van Huysum: other sources list the three, Francina Margarete, Anna and Magdalena, as his daughters and make no mention of Maria. The whole family is shrouded in mystery.
40. They were the three daughters of Parrocel des Batailles: Jeanne Françoise Pallas, Mme Lefebvre de

Valsenreaux (1733–1829) flower and animal painter; Marie, called Marion (a male *nom de pinceau*), portrait and history painter (d. 1824); and Thérèse (1745–1835), the miniaturist.
41. 'The Ode on the Ghent Altarpiece of the Mystic Lamb' was not published until 1908, in Weale's *Jan and Hubert van Eyck*, p. lxxvii.
42. M. van Waernewijk, *Histoire van Belgis of Kronyke des Nederlansche Oudheid* (Ghent, 1568), p. 119.
43. Fra Bartolommeo, *Le Vite de' Pittori . . . Veronesi*, 1758; G. Da Re, 'Religie Sui Brusasorzi' *Madonna Verona* (1910); Zannandreis, *op. cit.*, p. 150, attributes the Santa Cecilia in the Galeria Comunale to her.
 A portrait by her of G. B. Calderari is lost.
44. Chiara Varotari, see pp. 218–19.
 Marie Schalken: Kramm, *op. cit.*, Vol. I, p. 1455; Nagler, *op. cit.*, Vol. XV, p. 134.
 Davina or Damina Damini or Damiani is mentioned by Ridolfi, *op. cit.*, Vol. II, p. 52, as the wife of Alessandro Languidis, and 'valorosa pittrice'.
45. Jeanne, sister of Charles Natoire, who became Director of the French Academy in Rome, accompanied him there in 1851, dying in Castel Gandolfo in 1776. Theresa Concordia Mengs (1710–1808), was the sister of Anton Rafael, the founder of German neo-classicism. She and her sister went with their brother to Rome where they settled. Juliane Charlotte (d. 1789), entered the convent of the Belvedere as Sister Maria Speranda; Theresa married her brother's pupil Anton von Maron.
46. Clayton, *op. cit.*, Cap. xi, *passim*. C. R. Leslie and Tom Taylor, *Life and Times of Sir Joshua Reynolds* (London, 1868), pp. 91–3, 120–2.
47. Leslie and Taylor, *op. cit.*, p. 92.
48. *The Letters of Samuel Johnson*, ed. R. W. Chapman (Oxford, 1952), Vol. III, p. 70.
49. Frances Reynolds, 'Commonplace Book', in the possession of Mrs A. T. Copeland Griffiths, in 1958, as the descendant of Mrs Gwatkin.
50. From a draft found among her papers, quoted by Clayton, *op. cit.*, Vol. I, pp. 210–11.
51. R. R. M. Sée, *English Pastels 1750–1830*, states without qualification that Frances Reynolds was the greatest female pastel portraitist of her time, not excluding Angelica Kauffmann and Maria Cosway. He reproduces her portraits of the Palmer sisters to bear out his point.
52. Pamela Askew's excellent discussion in 'Women Painters 1550–1950' (pp. 125–9) is the source for this abridged account.
53. Antonio Orlandi, *L'Abcedario Pittorico* (Venice, 1719), p. 268.
 A. Baudi di Vesme, *L'Arte in Piemonte dal XVI al XVIII Secolo* (Turin, 1963), Vol. I.
 Vittoria Moccagatta, 'Guglielmo Caccia, detto il Moncalvo', *Arte Lombarda*, Anno VIII, Secondo Semestre, 1963, pp. 185ff.
 As well as her four sisters, Orsola Maddalena taught the Bottero sisters, Laura (who succeeded her as Mother Superior) and Augusta (1651–1719).
54. A quotation from *Edvard Munch* by Rolf Steversen, giving a first hand account of the conversation appeared in the *Feminist Art Journal*, Winter 1973, p. 14, by Howardena Pindell.
55. Mary Ann Flaxman exhibited at the Royal Academy from 1786 to 1819 with a degree of success. Maria Flaxman is chiefly known for her designs for the thirteenth edition of Hayley's *Triumphs of Temper* (1803) wrongly attributed by the *Dictionary of National Biography* to Mary Ann.
56. Exhibition Catalogue of the Musée Marmottan 'Monet et Ses Amis' (Paris, 1971), pp. 60–1.

II LOVE

1. Lucas de Montigny: Obituary of Greuze, *Le Moniteur*, March, 1805, quoted in John Rivers, *Greuze and his Models* (London, 1912), pp. 266–8.
2. Edmond Pilon, *Constance Mayer* (Paris, 1927), quotes Mme Amable Tastu as his source, p. 16.
3. Pilon, *op. cit.*, p. 74.
 Author's translation.
4. Delécluze, M. E. J., *Louis David; son Ecole et son Temps* (Paris, 1855), p. 74.
5. Pilon, *op. cit.*, p. 52, citing Guiffrey and Charles Clement. See also 'Women Painters, 1550–1950', pp. 213–14.
6. Pilon, *op. cit.*, pp. 86ff. This account is based upon that of Charles Gueuette and may well be sentimentalised.
7. Delécluze, *op. cit.*, p. 308.
8. De'Dominici, *op. cit.*, Vol. II, pp. 96–100. In *Paragone*, No. 287 (1974) *The Drunkenness of Noah* in the Calabresi Collection (Rome) is attributed to Anella. In *Paragone* No. 227 (1969) Roberto Longhi attributed *The Isaac Blessing Jacob* in the Majetti Collection to her.
9. Giuseppe Sigismondo, *Descrizione di Napoli* (Naples, 1788–9), Vol. II, p. 301; Luigi Catalani, *Chiese di Napoli* (Naples, 1845), Vol. I, pp. 122, 127, and Vol. II, pp. 143, 145; De'Dominici *op. cit.*, p. 99.
10. G. A. Galante, *Guida Sacra* (Naples, 1872), pp. 167f, 356, 378, 444.
11. Susanna Gaspoel, Mevrouw van Steenwijk, is noted by Sandrart (*op. cit.*, Vol. II, p. 299), Immerzeel (*op. cit.*, Vol. III, p. 112) and Kramm (*op. cit.*, Vol. V, p. 1569). Works signed Susanna van Steen may be seen in the Provinciaal Overijssels Museum at Zwolle and the Lakenhalle in Leyden.
12. 'Madame Boucher' is a common saleroom attribution; the Museum at Amiens has an authenticated *Diana bathing* by her.
13. Sonia Delaunay did not exhibit after her first exhibition with Wilhelm Uhde until 1955. The situation is described in a conversation between Fay Lansner and Arthur Cohen in *The Feminist Art Journal*, Vol. 5, no. 4, Winter 1976–7, pp. 5–10.
14. Cunningham, *Lives of British Painters* (London, 1836), vi, 1; Smith, *Nollekens and his Times* (London, 1828), Vol. II, p. 392.
15. For a list of works by her see Clayton, *op. cit.*, pp. 333–5, and the entry under her name in the *Dictionary of National Biography*.
16. Quoted in Liselotte Erlanger in 'Gabriele Münter: A Lesser Life?', *Feminist Art Journal*, Vol. 3, no. 4, Winter 1974–5, p. 12, 11; *cf.* Johannes Eichner, *Kandinsky und Gabriele Münter vom Ursprungen Moderne Kunst* (Munich, 1957), and Hans Konrad Röthel, *Gabriele Münter* (Munich, 1957), and Peter Lahnstein, *Münter* (Ettal, 1971).
17. Munich, Städtische Galerie, exhibition catalogue, *Gabriele Münter 1877–1962*: this quotation is from Münter's own notebooks, dated 28th January 1959.
18. Marie Marguerite Froissé, Mme Oudry, is now known, if at all, for engraved portraits of her husband and her son who also painted.

Apollonie de Forgue, Frau Seydelmann, was, like her husband, expert in making sepia copies of old masters.

19. Francina Irwin, *op. cit.*, p. 237.

20. Marie Bashkirtseff, *Cahiers Intimes*, edited by Borel (Paris, 1925), Vol. IV, *passim*, especially for the latter part of 1881.

21. Caroline Thévenin (1813–92) exhibited at the Salon from 1835 to 1855.

22. Adrienne Louise Grandpierre-Deverzy, like Caroline Thévenin, had considerable success painting her husband's *atelier*, which she did three times. One version is in the Musée Marmottan; another in the Musée des Beaux-Arts at Valenciennes. See 'Women Painters 1550–1950', pp. 219–10, 349.

23. Evidently Laura Epps was Alma-Tadema's second wife: the Anna Alma-Tadema who began to exhibit in 1885 at the Royal Academy was either very young, if the daughter of Laura, or her step-daughter. A remarkable self-portrait shows her to have been both plain and an original talent. (Walter Shaw Sparrow, *Women Painters of the World*, London, 1905, p. 156.)

24. See L. Birch, *Stanhope Forbes and Elizabeth* (London, 1906).

In an article in the *Studio* of June, 1903, A. L. Baldry discussed the work of Mary Young-Hunter and her husband as if they had but one pair of hands and one brain between them.

Louise Howland King was Kenyon Cox's student at the National Academy of Design.

Mary Draper, who married the London landscapist Albert Stevens, specialised in portraying gardens.

25. Elizabeth Du Bourg's salon career did not take off until she was in her fifties, although she had been a regular exhibitor since 1868 (ten years before her marriage). See Shaw Sparrow, *op. cit.*, p. 240.

Alice Preble Tucker confined her efforts to water-colour seascapes and portrait miniatures with considerable popular success.

The Chicago Tribune named Mrs Henry A. Loop 'the leading portrait painter among our lady artists' in 1876, the year that she was elected an associate of the National Academy of Design. (Clara Erskine Clements, *Women in the Fine Arts*, Cambridge, Mass., 1904, pp. 103–4, 215–17.)

26. Henry Merritt, *Art Criticism and Romance* (London, 1859), from the Memoir by Anna Lea Merritt, p. 7.

27. *Ibid.*, p. 61.

28. Enid Bagnold, *Autobiography* (London, 1969), p. 73.

29. *Ibid.*, p. 77.

30. London, Michael Parkin Fine Art, Exhibition Catalogue, *The Sickert Women and the Sickert Girls*, 18th April–18th May 1974.

31. Denys Sutton, *Walter Sickert* (London, 1976), p. 83.

32. Wendela Boreel, as reported in conversation with Michael Parkin in Exhibition Catalogue, *The Sickert Women and the Sickert Girls*.

33. Sutton, *op. cit.*, p. 190.

34. Marjorie Lilly, *Sickert, the Painter and his Circle* (London, 1971), p. 114.

35. Charlotte Haenlein's note included in the Catalogue, *The Sickert Women and The Sickert Girls*, explains that Sickert drifted into the habit of letting Lessore and Gosse do all his preparatory work.

36. Wendela Boreel, *loc. cit.*

37. Paula Modersohn-Becker, *Briefe und Tagebuchblätter: Herausgegeben und biographisch eingeführt von S. D. Gallwitz* (Munich, 1920), p. 226.

38. Raine Maria Rilke: 'Requiem für eine Freundin', *Gesammelte Werke* (Leipzig, 1930), Vol. II, p. 326. The translation (from Petersen and Wilson, *op. cit.*, pp. 110–11) is rather clumsy. The original runs:
Und sahst dich selbst zuletzt wie eine Frucht,
nahmst dich heraus aus deinen Kleidern, trugst
dich vor den Spiegel, liessest dich hinein
bis auf dein Schauen; das blieb grosz davor
und sagte nicht: das bin ich; nein; dies ist.

39. Modersohn-Becker, *op. cit.*, p. 225.

40. Laura Knight, O.B.E., R.A., *The Magic of a Line* (London, 1965), p. 74.

41. *Ibid.*, Cap. XXXIII, *passim*.

42. Hayden, 'Frida Kahlo: her Life, her Art', *Artforum*, XIV, no. 9, May 1976, pp. 38–44.

The Frida Kahlo Museum: a catalogue with notices Juan O'Gorman, Lola Olmedo de Olvera and Diego Rivera (Mexico City, 1968).

43. No full-length monograph or *catalogue raisonné* of this artist's work has ever been compiled. European students find her work difficult of access even in reproduction. The Frida Kahlo Museum is no better run than most and private owners are difficult to track down.

44. In a review of Michael Holroyd's biography of Augustus John, Diana Holman Hunt said that at the time Augustus John fell in love with her, Ida Nettleship 'was more susceptible to girls' (*The Connoisseur*, Vol. 187, no. 753, November 1974, p. 219). Further conversation with her has revealed that this judgment is based entirely upon her reading of Holroyd. My own reading of Ida's and her friends' correspondence gives a rather different impression. She was attached to her girlfriends, to be sure, but she was passionately susceptible to men, the more so for being unable to get at them.

45. Michael Holroyd, *Augustus John: A Biography*, Vol. 1 'The Years of Innocence' (London, 1974), pp. 75–251.

46. *The Dictionary of National Biography* (Matthew Smith). In his Obituary Notice for Gwendolen Salmond in *The Times*, 1st February 1958, Augustus John said 'in what I have called the Grand Epoch of the Slade, the male students cut a poor figure: in fact they can hardly be said to have existed. In talent as well as looks the girls were supreme. But these advantages came to nought under the burdens of domesticity....'

47. Edna Clarke Hall continued working after her marriage, but progress was slow and output small. The series of illustrations for *Wuthering Heights* now in the Tate, were the work of more than ten years. She exhibited at the Redfern Gallery in 1929, 1930, 1932 and 1941 and at the City of Manchester Art Gallery in 1939.

48. Stella Bowen, *Drawn from Life, Reminiscences* (London, 1941), pp. 82–3.

49. *Ibid.*, p. 160.

50. Carrington, *Letters and Extracts from her Diaries*, chosen and with an Introduction by David Garnett with a biographical note by Noel Carrington (London, 1970), *passim*.

51. *Mark Gertler: Selected Letters*, edited by Noel Carrington with an introduction on his work as an artist by Quentin Bell (London, 1965), p. 37 (Letter of 2nd July 1912).

52. *Ibid.*, p. 144.

53. Carrington, *loc. cit.*, p. 467.
54. No full length study of either of these artists, let alone of their fruitful collaboration has yet been made. General references include 'Vanessa Bell: A Memorial Exhibition of Paintings', London, Arts Council Gallery, introduction by R. Pickvance, 1964; and London, Anthony d'Offay Gallery, *Vanessa Bell Paintings and Drawings*, introduction by R. Morphet, 1973.
55. Stanton, *op. cit.*, p. 102, from a letter of 7th July 1889, to Mme Auguste Cain.
56. *Ibid.*, pp. 38, 42–3.
57. *Ibid.*, p. 84.
58. *Ibid.*, pp. 97–8, 102.
59. *Ibid.*, p. 269, Letter of 1st January 1899, to Princesse Stirbey.
60. Karen Petersen and J. J. Wilson, *Women Artists: Recognition and Reappraisal from the Early Middle Ages to the Twentieth Century* (New York, 1976), p. 68.
61. Cornelia Otis Skinner, *Madame Sarah* (London, 1967), is the only one of Bernhardt's biographers who gives Abbéma any space, although she judges her far too harshly. (See p. 84.)
62. Meryle Secrest, *Between Me and Life: a Biography of Romaine Brooks* (London, 1974), *passim*.
63. London, Fine Art Society. 'Gluck: Exhibition of Paintings', 30th April–18th May 1973. Foreword by Martin Battersby. Obituary, *The Times*.
64. Judith E. Stein, 'Profile of Cecilia Beaux', *Feminist Art Journal*, Vol. 4, no. 4, Winter 1975–6, pp. 25–8.
65. Philadelphia, Pennsylvania Academy of Fine Arts, 6th September to 20th October 1974, 'Cecilia Beaux, Portrait of an Artist', Exhibition Catalogue by Frank Goodyear, Jr.
66. Fidière, *op. cit.*, p. 20 (Anne-Marie Strésor).
67. Four of the Lunettes by Ortensia Fedeli are still visible in the church of the Convent of Santa Agata in Florence.

Isabella Fiorentini, Suor Aurelia, directed the *Pictoria* in the Convent of San Domenico in Lucca. There the nuns modelled and coloured figurines. Work may be seen in the Church of the Immaculata Camaiore, and the Museo di Villa Giunigi, Lucca.

Ippolita degli Erri (see p. 28).

Angela Airola painted frescoes for the convent of San Bartolomeo dell'Olivella in Genoa and a canvas for the church of the Pauline Friars Minor.

Luisa Capomazzo painted for the churches of Naples: no extant work is attributed.

Caterina Ginnasi, the niece of a Cardinal, was told that she would be her uncle's sole heir if she turned her house into a convent. Filippo Titi (*Ammaestramento*, Rome, 1686, p. 131), tells us that she painted all the pictures in the convent church, Santa Lucia delle Botteghe Scure, after designs by Lanfranco, but the church has now disappeared (De' Dominici, *op. cit.*, Vol. III, pp. 90–3). She is often quoted as saying that 'the needle and the distaff were the mortal enemies of the paintbrush'.

Maria De' Dominici studied with her brother, the painter Raimondo De' Dominici and Mattia Preti. Her work is known by engravings (De' Dominici, *op. cit.*, Vol. II, p. 382).

Maria Chiara Baldelli is recorded as the painter of two works in the convent of Santa Giuliana in Perugia.

Michelangela Lanceni, see p. 16.

Giacinta Sacchetti has signed pictures, dated 1734, of the life of the Virgin in the Chapel of Santa Maria a Cellaio in Naples (G. A. Galante, *Guida Sacra di Napoli*, Naples, 1872, p. 67).

Plautilla Bricci was first noted by Filippo Titi in his *Ammaestramenti . . . nelle Chiese di Roma* in 1686. Her other recorded work has perished. Two other women artists are associated with her, Maddalena Corvina and Anna Angelica Allegrini.
68. Patt Likos, 'The Ladies of the Red Rose', *Feminist Art Journal*, Vol. 5, No. 4, Fall 1976, pp. 11–15.
69. Kingston, Ontario, Queens University, Agnes Hetherington Art Centre, *'From Women's Eyes': Women Painters in Canada*, Exhibition Catalogue by Dorothy Farr and Natalie Luckyi, pp. 38, 40–1.
70. Quoted in French by Augustus John (from papers in his possession) in his introduction to the 'Gwen John Memorial Exhibition' Catalogue, Matthiesson Ltd., London, 1946. Author's translation, pp. 6, 5.
71. R. Beachboard, *La Trinité Maudite* (Paris, 1953), pp. 34–5.
72. John Storm, *The Valadon Story* (London, 1958), p. 190. The observer was André Utter.

III THE ILLUSION OF SUCCESS

1. Vasari, *op. cit.*, Vol. III, p. 562.
2. *Rime di diversi nobilissimi et eccellentissimi autori in morte della Signora Irene delle Signore di Spilimbergo* (Venice, 1561), pp. 26, 121. Author's translation.
3. *Ibid.*, p. 178, *cf.* p. 158. Author's translation.
4. *Ibid.*, p. 56. Author's translation.
5. Marcello Oretti, *Notizie de Professori di Disegno* (Biblioteca Comunale di Bologna, MSS B.129) Pt. II, p. 13. Author's translation.
6. Giovanni Luigi Picinardi, *Il Pennello Lagrimato: Orazione* (Bologna, 1665), p. 17.

The actual phrase, almost untranslatable, is 'leggiadramente scherzare'.
7. Boschini, *op. cit.*, p. 526. Author's translation.
8. Jean Baptiste Fermel'huis, *Eloge funèbre de Madame Le Hay, connue sous le nom de Mademoiselle Chéron, de l'Académie royale de peinture et de sculpture* (Paris, 1712), p. 5 (quoting the Registers of the Académie Royale).
9. Octave Fidière, *Les Femmes Artistes à l'Académie Royale de Peinture et de Sculpture* (Paris, 1885), p. 15.
10. Her *Livre de Principes à Dessiner* was published in Paris in 1706. See also Antoine Joseph Dézallier d'Argenville, *Abrégé de la vie des plus fameux peintres* (Paris, 1762), Vol. IV, pp. 238–42.
11. Walter Shaw Sparrow, *Women Painters of the World from the time of Caterina Vigri 1413–1463 to Rosa Bonheur and the Present Day* (London, 1905), *passim*.
12. Kathleen, Lady Scott, Lady Kennet, *Self Portrait of an Artist* (London, 1949), p. 190, cf. pp. 142, 164.
13. Marie Bashkirtseff, *Journal*, 22nd December 1883: translation from *The Further Memoirs of Marie Bashkirtseff* (London, 1901), p. 84.
14. Giovanni Luigi Picinardi, *op. cit.*, pp. 11–12.
15. Hamerton, quoted in C. E. Clement & L. Hutton, *Artists of the Nineteenth Century and their works* (Boston, 1879), p. 72.
16. *Cf.* Théophile Gautier's statement that only three women in Europe painted, Rosa Bonheur, Henriette Brown and Elisabeth Jerichau (*cit.* Clayton, *op. cit.*, Vol. II, p. 107).
17. Much of Rosa Bonheur's success is thought by Jeremy Maas to have been the direct consequence of

the flair and sagacity of her dealer, J. J. E. T. Gambart (*Gambart, Prince of the Victorian Art World*, London, 1975, *passim*).
18. Thieme-Becker is still the most informative source. See also A. Baudi di Vesme, *L'Arte in Piemonte dal XVI al XVIII secolo* (Turin, 1966), Vol. II.
19. Her married name was Blok (Houbraken, *op. cit.*, Vol. II, pp. 293–4). She may be the author of the small gouache *Bird Concert*, signed Anna M. Cortens, exhibited at the Winston-Salem Fine Arts Centre in their 'Women' show in 1972. Then the property of Herbert E. Feist, the picture has since appeared on the London art market.
20. Thieme-Becker.
21. See p. 27. Also Thieme-Becker.
22. Mrs E. M. Ward, daughter of a painter and wife of another, ran classes for women at Chester Studios. She had two more votes for admission to the Academy than any other woman of her time. Her *Memories of Ninety Years* was published in 1924.
Mary Severn was the pupil of her father and George Richmond, then, in Paris, of Ary Scheffer. Her husband, Charles T. Newton, keeper of antiquities at the British Museum, literally worked her to death at thirty-four, producing illustrations for his books and lectures.
Josephine Swoboda's portraits of Queen Victoria and Princess Louise are in the Royal Collection.
Emily Mary Osborn (see p. 311) is the author of two pictures bought by Queen Victoria, *My Cottage Door* and *The Governess*.
Sara Biffin, miniaturist, born without hands and feet, was patronised by George III, William IV and Queen Victoria.
Maud Earl, see p. 86.
Gertrude Massey described her experiences in *Kings, Commoners and Me* (London, 1934).
23. Alan Bird, 'British Artists in Russia', *Anglo-Soviet Journal*, Vol. XXXV, Nos. 1 and 2, p. 20.
24. Jane Mary Dealy became Mrs W. Llewellyn Lewis and a member of the Royal Institute. She worked as an illustrator and several of her exhibited works were engraved.
Emmeline Halse is the sculptor who executed the reredos in St John's Church, Notting Hill, among other works.
25. Virginie Demont-Breton, friend and artistic heiress of Rosa Bonheur, had enormous success in her lifetime; her work was acquired by the Museums of Dunquerque, Douai, Amsterdam, the Luxembourg, Lille, Antwerp and Calais, but nowadays almost nothing is to be seen.
Louise Breslau's work was acquired by the Luxembourg, the Museums at Carpentras and Lausanne, but she outlived her own reputation.
Katharine Augusta Carl's career as a portrait painter was transformed by an invitation to paint the Empress Dowager of China. One version of the portrait was exhibited at the St Louis Exposition and acquired by the U.S. Government (see K. A. Carl, *With the Empress Dowager of China*, London, 1906).
Cecile de Wentworth, born in New York, was educated in Paris and trained by Cabanel. For the honours which were showered on her, see *Who was Who*, Vol. I (Chicago, 1942), p. 1322.
Henriette Manckiewicz exhibited panels in mixed media in the style of Makart.
Madeleine Lemaire, 'l'impératrice des roses', had an enormous fashionable success and regularly entertained, in the most Bohemian manner, the *haut monde* of Paris in her tiny atelier. Jules Martin, *Nos Peintres et Sculpteurs* (Paris, 1897), p. 250.
26. Bregenz Vorarlberger Landesmuseum. 'Angelika Kauffmann und ihre Zeitgenossen', Exhibition Catalogue, 1968.
Peter S. Walch, 'Angelika Kauffmann und England', pp. 19–28.
27. 'Women Painters 1550–1950', pl. 61, p. 83. The portrait of Lady Hamilton was the cover picture of the *Connoisseur* for July 1965.
28. Quoted in Moulton Mayer, *op. cit.*, p. 89.
29. Elizabeth Butler, *An Autobiography* (London, 1922), p. 108.
30. *Ibid.*, p. 40.
31. *Ibid.*, plate facing p. 332.
32. *Ibid.*, p. 103.
33. *Ibid.*, p. 118.
34. From Academy Notes (1875).
The Works of John Ruskin, ed. E. T. Cook & A. Wedderburn (London, 1904), Vol. XIV, pp. 308–9.
35. Butler, *op. cit.*, p. 153. Mrs Annie Swynnerton (1844–1953) died without becoming an R.A. The Tate has six paintings, three acquired by the Chantrey Bequest.
36. Clara Erskine Clement, *Women in the Fine Arts from the Seventh Century B.C. to the Twentieth Century A.D.* (1904), pp. 121–3. Cf. *The Dictionary of American Biography*, ed. A. Johnson and D. Malone (London, 1931), Vol. VI, p. 296.
37. Helen M. Winslow, *Concerning Cats* (London, 1900), p. 175ff. On 23rd February 1977, a signed panel, 38 × 48 cm, dated 1893, depicting long-haired cats, was sold at Sotheby's for £6,200.
38. Maud Earl may be known from books illustrating her preoccupations, e.g. A. Croxton Smith's *The Power of the Dog* (London, 1911), with twenty illustrations by her, *My Dog Friends: Pictures in Colour from paintings by Maud Earl* (London, 1913), and *Whose Dog Art Thou? Nine photogravures after paintings by Maud Earl* (London, 1913).
39. Clement, *op. cit.*, pp. 150–1. See also *The Kate Greenaway Treasury*, introduction by R. H. Viguers (London, 1968).
40. See Jane Quinby, *Beatrix Potter: a bibliographical check-list* (New York, 1954), and Anne Carroll Moore, *The Art of Beatrix Potter* (London, 1955).
41. Sheila Smith, Countess of Birkenhead, *Illustrious Friends* (London, 1965), pp. 258, 286, etc.

IV HUMILIATION

1. Denis Diderot, *Salons; texte établi et presenté par J. Seznec et G. Adhemar* (Oxford, 1957–67), Vol. III, p. 250. Author's translation.
2. Letter of March 1728, from the Abbé Conti to Mme de Caylus, cited in Pallucchini, 'Per la Conoscenza di Giulia Lama', *Arte Veneta* (1970), pp. 161–2.
3. W. E. Gladstone, although deeply shocked at the inner life of a teenaged girl, reacted in a relatively tolerant way: a more common reaction was of the kind described by the artist, Elizabeth Rigby, Lady Eastlake (*Journals and Correspondence*, 1895, Vol. II, p. 300).
4. Giovanni Francesco Loredano and Pietro Michiele, *Il Cimiterio Epitafi Giocosi* (Venice, 1654), Epitaphs 39 and 40. Author's translation.

5. John Thomas Smith, *Nollekens and his Times* (London, 1828), pp. 285–6, and Joseph Farington, *Diary*, ed. James Greig (London, 1922–8), Vol. IV, p. 257.
6. Boswell's Journal for 18th February 1765, in *Boswell on the Grand Tour: Italy, Corsica and France 1765–1766*, ed. Frank Brady and Frederick A. Pottle (London, 1955), p. 53.
7. Moulton Mayer, *op. cit.*, Chapter 11, *passim*.
8. *Ibid.*, p. 103.
9. *Ibid.*, p. 143.
10. W. H. Helm, *Vigée le Brun, Her Life, Her Works & Her Friendships* (London, 1916), p. 18
11. *Correspondance inédite sur Louis XVI, Marie Antoinette, La Cour et La Ville, de 1771–1792* (Paris, 2e Empire). Quoted by Helm, *op. cit.*, pp. 67–9.
12. Jean-Baptiste-Pierre Le Brun, *Précis historique de la Vie de la Citoyenne Le Brun, peintre* (Paris, An. II, 1794).
13. Marie-Louise Elisabeth Vigée-Le Brun, *Souvenirs* (Paris, 1891) Vol. I, pp. 75–7.
14. *Ibid.*, pp. 67–71.
15. Jean Cailleux, 'Portrait of Madame Adélaïde of France, daughter of Louis XV', *Burlington Magazine*, March, 1969, Vol. CXI, No. 792, p. v.
16. *Ibid.*
17. Vigée Le Brun, *op. cit.*, Vol. I, p. 99. Author's translation.
18. *Ibid.*, Vol. I, p. 72. Author's translation.
19. Bachaumont, *Mémoires Secrètes*, t. 24, p. 11. Quoted in Anne-Marie Passez, *Adélaïde Labille-Guiard* (Paris, 1971), pp. 24–5. Cf. Vigée-Le Brun, *op. cit.*, pp. 71–2.
20. 'Supplément de Marlborough au Salon', reprinted in Passez, *op. cit.*
21. Pierre de Nolhac, *Fragonard 1732–1806* (Paris, 1931), p. 166.
22. *Ibid.*, pp. 168–9. Author's translation.
23. See pp. 216–18 and Picinardi, *op. cit.*, p. 17. Thérèse Reboul was the wife and pupil of David's teacher, Joseph Vien. She studied at the Accademia di San Luca in Rome, and exhibited flowers and birds at the Académie Royale from 1757–67. It was no more uncommon for teachers to paint part of their pupils' work, both male and female, than it was for pupils' hands to appear in work of their masters, but for women who had passed beyond pupildom the inference was insulting.
24. John Russell, 'Moss, Lanyon and some Modern French Painters', *Art News*, No. LVII, April 1958, p. 47.

New York, Marlborough-Gerson Gallery, 'Mondrian, de Stijl and their Impact', Exhibition Catalogue by A. Hammacher, 1964.

Zurich, Gimpel and Hanover Galerie, 'Marlow Moss; Bilder, Konstruktionen Zeichnungen', Exhibition Catalogue by Andreas Oostboek, 1973.
25. Paul Klee, *Diary* (London, 1965), 2nd December 1902, p. 19.

V DIMENSION

1. See p. 213.
2. See p. 218.
3. George Eliot, *Middlemarch* (Edinburgh and London, 1871), Vol. I, Book I, p. 109.
4. R. H. Wilenski, *Flemish Painters, 1430–1830* (London, 1960), Vol. I, p. 654.
5. Vasari, *op. cit.*, Vol. II, p. 74.

6. Ellen Wilson, *American Painter in Paris: A Life of Mary Cassatt* (New York, 1971), p. 139.
7. *Ibid.*, pp. 72, 107, 133, 140, 144.
8. Knight, *op. cit.*, p. 337.
9. Reproduced in L. Birch, *Stanhope Forbes and Elizabeth* (London, 1906).
10. Eleanor Tufts, *Our Hidden Heritage* (London, 1974), p. 43.

London, Geffrye Museum, 'The Excellent Mrs. Mary Beale', 10th January–21st February 1976. Catalogue by Elizabeth Walsh and Richard Jeffree, p. 15.
11. J. L. Propert, *A History of Miniature Art* (London, 1887), p. vi.
12. Mlle de la Boissière, see Thieme-Becker; Mme Maubert, see Propert, *op. cit.*, p. 144; Mlle Brisson, Schidlof, *Die Bildnisminiatur in Frankreich* (Vienna, 1911), p. 120 (Brizon).

VI PRIMITIVISM

1. Hamburg, Altonaer Museum, *Schiffe und Hafen: Laienmaler zeigen ausgewählte Arbeiten aus dem Weltgewerb deutscher Laien – und Sonntagsmaler . . .* Exhibition Catalogue, 1973.
2. Jean Dubuffet quoted by Roger Cardinal, *Outsider Art* (London, 1972), p. 167 and p. 184.

Aloïse Corbaz's work is mostly in the possession of Dr Jacqueline Porret-Forel and the Centre for the Study of Psychopathological Expression at the Lausanne University Psychiatric Clinic.
3. Most of Madge Gill's work is in the Newham Collection at the East Ham Town Hall. See Cardinal, *op. cit.*, pp. 41, 135–45 and 185.
4. Vincenzo Puccini, *Vita della Beata Maria Maddalena de' Pazzi* (Florence, 1639), p. 141. Cf. Lezin de Sainte, *The Life of Maria Magdalene of Pazzi* (London, 1687), *passim*.
5. Although I am assured by those expert in both art and the occult, that Felicia Bodmer was both artist and medium, if you will forgive the pun, she is not mentioned in references as either.
6. Laure Pigeon began to draw after being introduced to spiritualism. Her continuous line drawings are often moving and beautiful. Cardinal, *op. cit.*, pp. 91–3, 186.
7. Orlandi, *op. cit.* This composition is to all practical intents identical with the emblem as represented in fifteenth century MSS. See Régine Pernoud, 'La Fontaine de Vie, Thème Privilégié du Moyen Age Chrétien', *Connaissance des Arts*, No. 319, September 1978, p. 104.
8. Cesare Ripa, *Iconologia* (Milan, 1602), pp. 75 and 104.
9. The miraculous painting is in the possession of the Sisters of the Congregation of Notre Dame in Montreal. See 'From Women's Eyes', *op. cit.*, p. 9.
10. The original is preserved by the Shaker Community Inc., Hancock, Mass. It has been reproduced in Mary Black and Jean Lipman, *American Folk Painting* (New York, 1968), Fig. 161.
11. Wilhelm Uhde, *Fünf Primitive Meister* (Zurich, 1948), and 'Séraphine ou la Peinture Révélée', *Formes* 17, September 1931, pp. 115–17.
12. Anatole Jakovsky, *Peintres Naïfs* (Basle, 1976), p. 373 (Elena Lissia), and p. 436 (Gertrude O'Brady).

13. *Ibid.*, p. 287.
14. Ferrau Canyameres and Jordi Benet Aurell, *Maria Sanmarti* (Barcelona, 1954).
15. Marcel Gromaire, *La Vie et L'Oeuvre de Reine Mary-Biseaux* (Paris, 1931).
16. Jakovsky, *op. cit.*, p. 487.
17. Jean Lipman and Alice Winchester, *The Flowering of American Folk Art 1776–1876* (London, 1974), p. 281.
18. Black and Lipman, *op. cit.*, pp. 98–100, Figs. 98–103.
19. Lipman and Winchester, *op. cit.*, p. 281.
20. *Ibid.*, plates 101, 117.
21. Black and Lipman, *op. cit.*, p. 206–7, Fig. 190.
22. For example, Eunice Pinney's water colour, *Mrs. Clarke The Yorke Magnet*, of 1821 in the Abby Aldrich Rockefeller Folk Art Collection is based upon an engraving by Ackermann of Mary Anne Clarke, the mistress of the Duke of York, who faced trial in 1809, on charges of selling military commissions as a result of her activities. It is extremely doubtful that Eunice Pinney had any notion of the scandalous subject of her painting.
23. A. Martini, *La Galleria dell' Accademia di Ravenna* (Venice, 1959).
24. Eleanor Fortescue Brickdale won £40 in 1896 for a design for one of the lunettes in the Royal Academy Dining Room; in the same year she began to exhibit at the Royal Academy. In 1905, appeared her first illustrated book to be followed by many more over the next twenty years. Her paintings were acquired by many provincial galleries. In 1972 an Eleanor Fortescue Brickdale Exhibition was mounted at the Ashmolean Museum, Oxford.

Marianne Stokes (née Preindlsberger) was half of an artistic couple: her husband Adrian exhibited with her at the Fine Art Society from 1900. She was actually trained in Munich, often using gisso and tempera. See W. W. Meynell 'Mr and Mrs. Adrian Stokes', *Art Journal*, 1900, pp. 193–8; *Studio*, XXIII, 1901, p. 157, XLIII, 1908, p. 82, XLVI, 1909, p. 54; *Connoisseur*, LXI, 1921, p. 177, LXIII, 1922, p. 112, LXVI, 1923, p. 50, LXXIX, 1927 (obit.).

Maria Spartali Stillman was actually trained by Madox Brown and used as a model by Rossetti. (See W. M. Rossetti, *English Painter of the Present Day*, 1871; Percy H. Bate, *The Pre-Raphaelite Painters*, 1899, p. 112; J. Maas, *Victorian Painter*, p. 146, pl. p. 45.)

Mary Young-Hunter, see p. 45, Note 24. Also Shaw Sparrow, *op. cit.*, frontispiece, pp. 126, 130.

Catherine Hueffer and Lucy Rossetti were both daughters of Madox Brown. (Clayton, *op. cit.*, pp. 96–8, 116–24.)

Anna Lea Merritt, see also p. 46 and p. 324.
25. A. M. W. Stirling, *William de Morgan and his wife* (London, 1922).
26. *Ibid.*, p. 309.
27. *Ibid.* However Christopher Wood says in his entry under her name in the *Dictionary of Victorian Painters* (London, 1972) that most of her work is the property of the De Morgan Foundation. The apparent anomaly may be explained by the fact that most of the auctioned work was bought by members of the painter's family.
28. *Ibid.*
29. Clayton, *op. cit.*, Vol. II, pp. 156–7.
30. According to Virginie Demont-Breton, quoted by Stanton, *op. cit.*, p. 374.

VII THE DISAPPEARING OEUVRE

1. Françoise Duret-Robert, 'L'Art et l'Or; à quoi tient le prix des tableaux', *Connaissance des Arts*, No. 297, p. 109.
2. Jean Ferre, *Lettre ouvert à un Amateur d'Art* (Albin Michel, 1975), cit. Duret-Robert, *ibid.*
3. Roberto Longhi, *Scritti Giovenili* (Florence, 1961), Vol. I. 'Gentileschi Padre e Figlia', *cf.* the article as it appeared in *L'Arte*, Vol. XIX, 1916.
4. A still life of fruit, signed, on panel 71 × 107cm. sold at Sotheby Parke Bernet, 6th December 1973. However, on 8th July 1977, a picture of *Peaches and Grapes in a Bowl on a ledge* sold at Christie's for £90,000.
5. Described as a 'still life of lobsters in a Kraak porselein dish, a half artichoke and cherries on a pewter dish, bread, a rhenish stoneware jug and an engraved silver salt on a table, signed with the artist's christian name and the initial P', on panel 32. 4 × 45.7cm., *ca.* 1610, on 5th June.
6. Christie's, 23rd March, Lot 90.
7. The chief sources for Judith Leyster's life are well summed up in 'Women Painters 1550–1950', pp. 137–40.
8. Samuel Ampzing, *Beschrijvinge ende lof der stadt Haerlem'* (Haarlem, 1628), p. 370. *Cf.* Theodor Schrevel, *Harlemum* (Haarlem, 1648), p. 90. Juliane Harms, 'Judith Leyster, ihr Leben und ihr Werk', *Oud-Holland*, XLIV, 1927, p. 236. (No. 11 in her 'Bilderverzeichnis'.)
9. *The Times*, 31st May 1893. Lawrie and others v. Wertheimer.
10. Harms, *op. cit.*, p. 235 (No. 9).
11. *Ibid.*, p. 236 (No. 10).
12. *Ibid.*, p. 234 (No. 4).
13. Prima Fox Hofrichter is at present working on a catalogue raisonné at Rutgers University. 'Judith Leyster: A Preliminary Catalogue' was her Master's Thesis at Hunter College, New York.
14. The self-portrait is in the National Gallery of Art, Washington, D.C.; the other female portrait is in the Frans Hals Museum, Haarlem.
15. Prima Fox Hofrichter, 'Judith Leyster's Proposition – Between Vice and Virtue', *Feminist Art Journal*, Fall, 1975, pp. 22–6.
16. Robert Dangers, *Die Rembrandt-Falschungen* (Hanover, 1928).
17. Charles Sterling, 'A Fine "David" Reattributed', *The Metropolitan Museum of Art Bulletin*, Vol. IX, No. 5, 1951, pp. 121–32.
18. *Ibid. Cf.* Andrew Kagan, 'A Fogg "David" reattributed to Madame Adélaide Labille-Guiard', *Acquisitions Report 1969–70*, Fogg Art Museum (Cambridge, 1971), pp. 31–40.
19. *Ibid.*
20. Georges Wildenstein, 'Un tableau attribué à David et rendu à Mme. Davin-Mirvault: Le Portrait du Violiniste Bruni', *Gazette des Beaux-Arts*, February 1962.
21. Antonio Maria Zanetti, *Delle Pitture Veneziane* (Venice, 1733), pp. 73, 146.
22. See p. 89.
23. The work of rediscovery was begun by R. Pallucchini in 'Di una pittrice del settecento: Giulia Lama', *Rivista d'Arte*, 1938, p. 400. The discovery of the drawings made possible Ugo Ruggieri's monograph *Dipinti e Disegni di Giulia Lama* (Bergamo, 1973).

24. R. Pallucchini, 'Per la Conoscenza di Giulia Lama', *Arte Veneta*, 1970, pp. 161–2.
25. See p. 17.

VIII THE CLOISTER

1. Sister Maria Pia Heinrich, *The Canonesses and Education in the Early Middle Ages* (Washington, D.C., 1924), p. 150.
2. Lina Eckenstein, *Women under Monasticism* (Cambridge, 1896), p. 231.
3. *The English Correspondence of St. Boniface*, trans. and ed. Edward Kylie (London, 1911), Letter xv, c. 735, p. 90.
4. The closing lines of Prior Petrus's MS of Beatus of Liebana's 'Commentary on the Apocalypse', British Museum Add. MS. 11, 695, quoted in A. Grabar and C. Nordenfalk, *Early Mediaeval Painting* (New York, 1957), p. 168.
5. David M. Robb, *The Art of the Illuminated Manuscript* (South Brunswick, 1973), pp. 106–8 and 142.
6. BM. Harl. MSS. 3,099. The manuscript is signed by Sibilia, Vierwic, Gerdrut, Walderat, Hadewic, Imgart, Uota and Cunegunt.
7. Poitiers, Bibliothèque Municipal, MS. 250. *Cf.* Marius Vachon, *La Femme dans l'Art* (Paris, 1893), pp. 127–9; and Robb, *op. cit.*, p. 177.
8. Jacques Dupont and Cesare Gnudi, *Gothic Painting* (Geneva, 1954), p. 14.
9. C. M. Engelhart, *Herrad von Landsperg und ihr Werk* (Stuttgart, 1818).
Maria Heinsius, *Das Lustgarten der Herrad von Landsperg* (1944).
10. Dom L. Biallet, 'Les Miniatures du Scivias de Sainte Hildegarde conservé à la Bibliothèque de Wiesbaden', Fondation E. Piot, *Monuments et Mémoires* XIX, 1911, pp. 49–149.
A. Katzenellenbogen, *Allegories of the Virtues and Vices in Medieval Art* (London, 1939), *passim*.
A. Straub and G. Keller (eds), *Herrade de Landsberg, Hortus Deliciarum* (Strasbourg, 1879–99); G. Cames, *Allégories et Symboles dans le Hortus Deliciarum* (Leyden, 1971).
Hans Fegers, 'Die Bilder im Scivias der Hildegard von Bingen', *Das Werk des Künstlers*, I, 1939, pp. 109–145.
Herman Fischer, *Die heilige Hildegard von Bingen, die erste deutscher Naturförscherin und Artztin* (Munich, 1927).
André Grabar & Carl Nordenfalk, *Romanesque Painting* (Geneva, 1958), pp. 160–1.
Hiltgart L. Keller, *Mittelrheinische Buchmalerei in Handschriften aus dem Kreise der Hiltgart von Bingen* (Stuttgart, 1933).
Josef Schomer, *Die Illustrationen zu den Visionen der heiligen Hildegard als künstlerische Neuschöpfung* (Bonn, 1937).
11. Frankfurt-am-Main Stadt- und Universitäts-Bibliothek, MS. Barth 42.
Gerhardt Powitz and Herbert Buck, *Die Handschriften des Bartholomeusstifts und des Karmelitenklosters um Frankfurt-am-Main* (Frankfurt-am-Main, 1974), pp. 84–5.
Pietro d'Ancona & Erardo Aeschlimann, *Dictionnaire des Miniaturistes* (Milan, 1940), p. 101, pl. LI.
12. Walters Art Gallery, Baltimore, MS. 26, reproduced in Petersen and Wilson, *op. cit.*, p. 12.
13. C. P. C. Schoenemann, *Hundert Merkwürdigkeiten der Herzöglichen Bibliothek zu Wolfenbüttel*,

p. 36. (Catalogue), Herzögliche Bibliothek Wolfenbüttel, N. 44.
14. Wilhelm Wattenbach, *Das Schriftwesen im Mittelalter* (Leipzig, 1875), p. 375.
George Haven Putnam, *Books and their Makers in the Middle Ages* (London, 1896), p. 97.
15. Eckenstein, *op. cit.*, pp. 236–7. Georg Swarzenski, *Die Salzburger Malerei* (Leipzig, 1913), p. 62. E. F. Bange, *Eine bayerische Maleschule des XI und XII Jahrhunderts* (Munich, 1923), p. 128, n. 3. Rosy Schilling, *Die illuminierten Handschriften und Einzelminiaturen des Mittelalters und der Renaissance in Frankfurter Besitz*, ed. G. Swarzenski (Frankfurt-am-Main, 1929), p. 12.
16. Friedrich Ernst Kettner, *Kirsche und Reformations-Historie der Kayserlichen Freyen Weltlichen Stifts Quedlinburgh* (Quedlinburgh, 1710), p. 48.
17. D'Ancona and Aeschlimann, *op. cit.*, p. 93.
18. B. M. Add. MS. 16, 950.
H. Swarzenski, *Die lateinischen illuminierten Handschriften des dreizehnte Jahrhunderts in den Ländern am Rhein, Main und Donau* (Berlin, 1936), pp. 114–15, Abb. 395–413.
19. Wattenbach, *op. cit.*, p. 305.
Johann Jacob Merlo, *Kunst und Künstler in Köln* (Cologne, 1850–52), pp. 186–90; Françoise Baron, *Bulletin Archéologique du comité des travaux historiques et scientifiques*, N. S. IV, 1964, pp. 37–121.
20. Leopold Victor Delisle, *Le Cabinet des Manuscrits de la Bibliothèque Impériale* (Paris, 1868–81), Vol, I, p. 36.
21. Baron, *op. cit.*, pp. 37–121.
Robert Branner, 'Manuscript-makers in mid-thirteenth century Paris', *Art Bulletin*, Vol. XLVIII, 1966, p. 65.
22. J. Houday, *Etudes artistiques – artistes inconnues des XIVe, XVe et XVIe siècles* (Paris, 1887), pp. 4–5.
23. F. Filippini and G. Zucchini, *Miniatori e pittori a Bologna, documenti dei secoli XIII e XIV* (Florence, 1947), p. 15.
24. Filippo Baldinucci, *Notizie de' Professori di disegno* (Florence, 1681–1728), and T. Reynolds, 'The Accademia del Disegno in Florence, its Formation and Early Years', doctoral dissertation, Columbia University, 1974, p. 248, quoted in *Women Painters 1550–1950*, p. 15.
25. Paris, Bibliothèque National, MS. Fr. 12420, Fol. 101v, Fol. 86. See p. 69.
Dupont and Gnudi, *op. cit.*, p. 157.
26. *Ibid.* (Paris, Bibliothèque National, MS. Fr. 607).
27. Christine de Pisan, *La Cité des Dames*, Part I, Cap. XLI, p. 161.
Lucie Schafer, 'Die illustrationen zur den Handschriften der Christine de Pisan', *Marburger Jahrbuch fur Kunstwissenschaft*, Vol. X, 1937, p. 119ff.
H. Mantin, *Les Miniaturistes français* (Paris, 1906), pp. 85, 64.
28. Vincenzo Pautassi, *I Codici Miniati* (Turin, 1883), p. 63.
29. Zani, *op. cit.*, Vol. XIV, p. 248. The nuns also operated a printing press, issuing seventy books between 1470 and 1484. (See E. Miriam Lone 'Some Bookwomen of the Fifteenth Century', *Colophon*, September 1932.)
30. J. N. C. M. Denis, *Catalogus Manuscriptorum Bibliothecae Nationalis Szechenyiani-Regnicolaris*, ed. J. F. Miller, Vol. III, p. 3, 084, Cod. DCCCLVI.
31. Zani, *op. cit.*, Vol. IV, p. 225.

Andreas, *Cartas Familiares*, IV, 45. Andreas also claimed to have seen an illuminated *De Civitate Dei* of St Augustine dated 24th August 1472, by a Veronese copyist called Veronica, in the possession of the Abbate Berio of Genoa; Dario Morani, *Dizionario dei Pittori Pavesi* (Milan, 1948), p. 37.
32. John W. Bradley, *A Dictionary of Miniaturists, Illuminators, Calligraphers and Copyists* (London, 1897), Vol. I, p. 195.
33. See Christian von Heusinger, 'Spätmittelälterliche Buchmalerei im oberrheinischen Frauenklostern', *Zeitschrift für die Geschichte des Oberrheins* CVII (1959), 136–60.
 Karl Fischer, *Die Buchmalerei in den Beiden Dominikanerklosten Nürnbergs* (Nuremberg, 1928). Theodor Raspe, *Studien zur Deutschen Kunstgeschichte. Die Nürnberger Buchmalerei bis 1515* (Strasbourg, 1905).
34. Wattenbach, *op. cit.*, p. 408
35. BM. Add MS. 15, 710.
36. *Regi egyhazmüveszeti tiállitás* (Budapest, 1930), Nr. 603.
 Emma Baroniek, *Codices Manu Scripti Latini*, Vol. I, *Codices Latini Medii Aevi* (Budapest, 1940), p. 227.
37. See p. 29.
38. V. van der Haeghen, 'L'Humaniste Imprimeur Robert de Kaysere et sa soeur Clara', *Annales de la Société d'Histoire et d'Archéologie de Gand*, Vol. VIII, 1908.
39. J. B. de Laborde, *Recueil des Pièces Intéressantes pour servir à l'Histoire des Règnes de Louis XIII et de Louis XIV* (Paris, 1781), p. 82; Albrecht Kirchhoff, *Die Handschrifthändler des Mittelalters* (Leipzig, 1853), pp. 188–9.
40. *Le Beffroi: Arts, Héraldique, Archéologie* (Bruges, 1863–73), Vol. IV, pp. 294–318.
41. *Ibid.*, Vol. III, pp. 320, 322, Vol. IV, pp. 297–329.
42. *Ibid.*, Vol. III, pp. 307–21.
43. Raffaello Soprani, *Le vite de' pittori, sculturi e architetti genovesi* (Genoa, 1674), p. 15. In his revised edition of Soprani's work (Genoa, 1768) Ratti adds more information in a note (Vol. I, p. 25). She was born in 1448, died in 1534.
 Alizeri, *Notizie de' professori di disegno in Liguria* (1870–80), Vol. III, pp. 14–16. *Atti della Società Ligure di Storia della Patria*, Vol. VIII, p. 403f. Suida, *Genua* (Genoa, 1906), p. 89.
44. Thieme-Becker: Notice by Stefano Lottici.
45. Beda Kleinschmidt 'Zur Suddeutschen Buchmalerei des späten Mittelalters'. *Die Christliche Kunst* (1905–6), No. II, pp. 269–79, Beilage, Heft 12, III.
46. Guicciardini, *op. cit.*, p. 144; Karel van Mander, *Het Schilder Boeck* (*op. cit.*) Vol. II, pp. 73–4. Clayton, *op. cit.* See p. 75: Dürer's actual words are rather odd, referring rather to what the work cost: 'dafür hab ich ihr geben 1 fl. Ist ein gross Wunder dass ein Weibsbild also viel machen soll' (*Albrecht Dürer's schriftlicher Nachlass* ... Berlin, 1910, p. 102).
 Guicciardini tells us that Henry VIII lured her to England with great gifts and *provisioni*; she was married first to the King's bowman and keeper of the robes, and then to a sculptor by the name of Whorstley. She died 'ricca e honorata'.
47. See pp. 109, 110, 253.
48. Lodovico Guicciardini, *Descrittione di tutti paesi bassi* (Florence, 1567), p. 99.

49. Zani, *op. cit.*, Vol. IX, p. 57. *Cf.* the work of Cecilia Hermans in the Royal Library at Brussels, RBB 3063–4 (808).
50. BM, Burney MS. 97; *cf.* Philip Hofer and G. W. Cottrell Jr., 'Angelos Vergecios and the Bestiary of Manuel Phile', *Harvard Library Bulletin*, No. VIII, 1954, p. 331; *cf.* Esther Inglis, BM. Add. MS. 27,927; 19, 633; 22, 606, and Harl. 4, 324, Royal MS. 17. D. XVI and New York Public Library, Spencer Coll. Eng. MS. 1601.
51. Atanasy Raczynski, *Les Arts en Portugal* (Paris, 1846), p. 206. See p. 284.
 Saurina de Corbera, a nun in a Franciscan convent at Pedralbes, near Savia, painted a polyptych of the twelve apostles which was in the inventory of Queen Elisende (d. 1364), Sanpetre.
52. Zani, *op. cit.*, Vol. II, p. 117, N. 87.
53. Brussels, Royal Library, Catalogue des Manuscrits du Duc de Bourgogne (Brussels, 1842).
 The work of Elizabeth Howard (d. 1761) niece of the first Viscount Stafford who was a Dominican nun in Brussels and Bornheim (professed 1695) is interesting in the context (see G. C. Williamson, *History of Portrait Miniatures*, 1904).

IX THE RENAISSANCE

1. George Renard, *Guilds in the Middle Ages* (London, 1918), p. 11; *cf.* Giambattista Zaist, *Notizie Storiche de' Pittori Cremonesi* (Cremona, 1774), Vol. I, p. 288, on the gentleness of Bernardino Campi.
2. Conrado Flameno, *Storia di Castelleone, cit.* Zaist, *op. cit.*, Vol. I, pp. 29–30. (Author's translation.) *Cf.* Bartolommeo di Soresina e Vidoni, *La Pittura Cremonese descritta* (Milan, 1824), p. 120, and G. Graselli, *Abecedario biografico de' pittori cremonesi* (Cremona, 1827).
3. For example, the anonymous authors of *Castelleone tra Storia e Leggenda* (Castelleone, 1976), Preface by G. Pandini. See pp. 36–8 for their version of the story of Onorata.
4. Giuseppe Campori, *Racconti artistici* (Florence, 1852), p. 19.
5. When the First World War broke out, Stephanie Hollenstein, who had been training and working as a painter for ten years, trained as a nurse, only to discover that she was not fit enough to go to the front. She dressed as a man and calling herself Stephan Hollenstein enlisted as a *Sanitätssoldat*. She was sent to the Italian front where she won the *Truppenkreuz*. In 1916, she returned to the front, this time as an official war artist (Thieme-Becker).
6. Cesare Cittadella, *Catalogo istorico de' pittori e scrittori ferraresi* (Ferrara, 1782–3), Vol. V, p. 61ff.
7. Suor Illuminata Bembo, *Specchio d'Illuminatione*, quoted in Laura M. Ragg, *The Women Artists of Bologna* (London, 1907), p. 37.
8. E.g. Giovanni Sabadino degli Arienti, *Vita della Beata Catherina Bolognese de l'ordini de la diva Clara del Corpo de Christo* (Bologna, 1502), echoed in Malvasia, *op. cit.*, Vol. I, pp. 33–4.
9. Tiberio Bergamini, *Caterina La Santa: breve storia di Santa Caterina Vegri, 1413–1463* (Rovigo, 1970).
10. Reproduced Ragg, *op. cit.*, facing page 90.
11. Ragg, *op. cit.*, facing page 36.
12. *Ibid.*, p. 152. Girolamo Baruffaldi, writing in 1733, mentioned also the miraculous drawing of the Christ Child which the nuns of Corpus Domini

used to send out to the sick (*Vite dei Pittori e Scultori Ferraresi*, Ferrara, 1844, p. 387).

13. *La Pinacoteca Nazionale di Bologna a cura di Andrea Emiliani* (Bologna, 1967), No. 78, now attributed to Niccolo di Pietro.

14. Venice, Accademia delle Belle Arti, reproduced in Shaw Sparrow, *op. cit.*, p. 33.

15. Vittorio Moschini, *Bollettino d'Arte*, XXVIII, 1934–5, p. 156ff (and appendices).

16. *Ibid.*

17. Dario Morani, *Dizionario di pittori pavesi* (Milan, 1948), p. 18.

18. Siena, Biblioteca Comunale, Archivio.

19. Jacob Burckhardt, *The Civilization of the Renaissance in Italy* (London, 1960), pp. 240, 241.

20. Douglas Farquhar, quoted by Dorothy Miner in *Anastaise and her sisters* (Baltimore, 1974).

21. Philippe Rombouts and Th. van Levius, *Les Liggeren et Autres Archives Historiques* (Antwerp, 1864–7), p. 20. F. J. van den Branden, *Geschiedenis der Antwerpsche Schilderschool* (Antwerp, 1883).

22. Alessandro Lamo, *Discorso intorno alla scoltura e pittura* (Cremona, 1584), in Zaist, *op. cit.*, p. 35.

23. Now in the Museo Nazionale di Capodimonte, Naples.

24. Vasari, *Vite* (1568), Vol. III, p. 562.

25. E.g. Irene Kühnel Kunze, 'Zur Bildniskunst der Sofonisba und Lucia Anguissola', *Pantheon*, XX, 1962, pp. 83–96.

Marianne Haraszti Takács, 'Nouvelles Données', *Bulletin du Musée Hongrois des Beaux Arts*, XXXI, 1968, pp. 53–67.

Flavio Caioli, 'Antologia d'Artisti; per Lucia Anguissola', *Paragone*, 277, 1973, pp. 69–73.

26. See Orlandi, *op. cit.*, p. 269, and Filippo Baldinucci (Florence 1681–1728), *op. cit.*, Vol. II, p. 230, 'Notizie de' professori di disegno'. The Portrait of Europa in the Gallery at Brescia is tentatively given to Lucia. There is actually only one secure attribution and the distinction of another hand and style may be misled.

27. Thieme-Becker; A. Puerari, *La Pinacoteca di Cremona* (Cremona, 1951), No. 205.

28. Orlandi, *op. cit.*, p. 145 (cites Vasari and Baldinucci).

29. Orlandi, *op. cit.*, pp. 2, 271, *cf.* Vasari (ed. Milanesi, Vol. V, p. 80).

Girolamo Tiraboschi, *Notizie de' pittori eccellenti di Modena* (Modena, 1786), p. 306.

30. F. di Maniago, *Storia delle Belle Arti Friulane* (Udine, 1823), pp. 88–9.

31. *Rime di diversi nobilissimi et eccellentissimi autori in morte della Signora Irene delle Signore di Spilimbergo* (Venice, 1561), Sig Aa2r.

32. *Ibid.*, Sig Aa8v.

33. *Catalogo Sommario della Galleria Doria Pamphili in Roma (1965)*, No. 230 (Inv. 446), Sala III.

34. Van Dyck records that he visited her in 1624 in Palermo and drew a portrait sketch of her, in the Notebook preserved at Chatsworth; he believed she was then ninety-six. M. Fournier-Sarloveze, 'Van Dyck et Anguissola', *Revue de l'Art*, VI, 1899, pp. 316–20; M. Rooses, 'Les Années d'Etude et Voyage de Van Dyck', *L'Art Flamand et Hollandais*, VII, 1907, pp. 5f.

35. Raffaello Soprani, *Le vite de' pittori, scultori et architetti genovesi* (Genoa, 1674), makes no bones about the fact that the middle-aged Sofonisba offered herself to Lomellini in marriage and he 'like a generous man' accepted. This is the circumstance

which Victorian commentators and others find so baffling: in fact, it was a sensible course of action for a widow.

36. Vasari, *op. cit.*, Part III, p. 178. Orlandi, *op. cit.*, p. 328.

P. L. Vincente Marchese, *Memorie de' piú insigni pittori, scultori e architetti* (Florence, 1845), III, XV, p. 287.

37. Marchese, *loc. cit.*, p. 286.

38. *Ibid.*, p. 291.

39. *Ibid.*, pp. 292–3. The *Adoration of the Magi* is in fact in the Pinacoteca Nazionale at Parma (Bolaffi, *op. cit.*, Vol. VIII, fig. 161).

40. Lorenzo Coleschi, *Storia della Città di San Sepolcro* (Città di Castello, 1886), pp. 253–4.

41. Marchese, *op. cit.*, II, p. 299.

Tommaso Trenta, *Documenti per servire alla storia della patria: Storie delle Belle Arti* (Lucca, 1882), pp. 122–3.

Federico di Poggio, *Memorie riguardanti la Religione Domenicana*, Vol. II, lix, p. 265.

42. Cittadella, *op. cit.*, Vol. II, p. 305; Baruffaldi, *op. cit.*, Vol. II, p. 587.

43. Umberto Gnoli, *Pittura e Miniatura nell'Umbria* (Spoleto, 1923); G. Angelini Rota, *Il Museo Civico di Spoleto* (Spoleto, 1928).

44. Marchese, *op. cit.*, p. 294, *cf.* Serafino Razzi, *Istorie degli Uomini illustri dell'ordine de' Predicatori* (Lucca, 1587).

45. Marchese, *op. cit.*, p. 295.

46. One, the *Calling of St. Andrew*, is said to be signed although the parish priest was not of that opinion: given the dirt, gloom and other factors, it was not to be expected that a signature would be visible to the naked eye. The other, a *Deposition*, is clearly related.

47. No. 199, from an engraving of 1606 by Annibale Carracci; A. Puerari, *La Pinacoteca di Cremona* (Cremona, 1951), p. 152.

X THE MAGNIFICENT EXCEPTION

1. Elizabeth F. L. Ellet, *Women Artists in all Ages and Countries* (New York, 1859), p. 66, *cf.* Anna Jameson, *Visits and Sketches at Home and abroad* (London, 1834), Vol. II, p. 119, Vol. III, pp. 252–3.

2. Rome, Casa Coppi.

3. See especially R. Ward Bissell, 'Artemisia Gentileschi – A New Documented Chronology' *Art Bulletin*, L, 1968, pp. 153–68, upon whose work this chapter is based.

4. Rome, Tribunale del Governatore, Archivio Criminale, Sec. XVII, Vol. 104, fols. 270–448, *Pro Cura et fisces contra Augustinem Tassum Pictorem*.

5. Even modern commentators have a soft spot for Tassi. See, e.g. Rudolf and Margot Wittkower, *Born Under Saturn* (New York, 1963), pp. 162ff. They call Artemisia a 'lascivious and precocious girl', while revelling in Tassi's criminal excesses, *cf.* Bertolotti 'Agostino Tassi e i suoi scolari & compagni pittori in Roma', *Giornale d'Erudizione Artistica* (Perugia, 1876), Vol. V, pp. 193ff; Giovanni Battista Passeri, *Vite de' Pittori* (Rome, 1772) and Luigi Lanzi, *Storia Pittorica d'Italia* (Florence, 1792).

6. Alessandro de Morrona, *Pisa illustrata nelle arti di disegno* (Livorno, 1812), Vol. II, p. 269; Hermann Voss, *Die Malerei der Barock in Rom* (Berlin, 1924), p. 463.

7. Stefano Bottari and Giovanni Ticozzi, *Raccolte di*

Lettere (Milan, 1822), Vol. I, pp. 348–54; *Archivio Storico dell'Arte*, II, 1889, pp. 423ff.
8. Baldinucci, *Notizie de' professori di disegno*, Vol. IV, p. 294.
9. De' Dominici, *op. cit.*
10. See discussion in Michael Levey, 'Notes on the Royal Collection: Artemisia Gentileschi's Self-Portrait at Hampton Court', *Burlington Magazine*, civ, February 1962, pp. 79–80.
11. E.g. by Roberto Longhi in 1916 (*loc. cit.*).

XI THE BOLOGNESE PHENOMENON

NB All quotations from Italian sources translated by the present author.

1. Carlo Cesare Malvasia, *Felsina Pittrice* (Bologna, 1678), Vol. I, pp. 219–20. Hereafter referred to as *Felsina Pittrice*.
2. Ragg, *op. cit.*, p. 196. The most authoritative biography of Lavinia Fontana is Romeo Galli *Lavinia Fontana, Pittrice 1552–1614* (Imola, 1940), upon which this account is based.
3. *Ibid.*, pp. 198–9; Lodovico Frati, *La Vita Privata di Bologna* (Bologna, 1900), p. 210.
4. Picinardi, *op. cit.*, p. 4, *cf.* Ragg, *op. cit.*; *cf.* Luigi Crespi, *La Certosa di Bologna descritta nelle sue pitture* (Bologna, 1772), pp. 21–3. See also the *Dizionario Biografico degli Italiani*.
5. Eleanor Tufts, *Our Hidden Heritage* (London, 1974), p. 31, probably quoting Ragg, *op. cit.*, p. 2, who is, I believe, quoting an anecdote from Christine de Pisan's *Cité des Dames*.
6. Vasari, *Vite*. The available information is well summed up by Laura Ragg, *op. cit.*, pp. 167–87, especially Bianconi and Canuti, 'Descrizione di alcuni minutissimi intagli di mano di Properzia de' Rossi'. Virgilio Giuseppe Guizzardi, *Le Sculture delle Porte di San Petronio* (Bologna, 1834).
7. Michelangelo Gualandi, 'Memorie intorno a Properzia de' Rossi', *Osservatore Bolognese*, Nos. 33, 34, 35 (1851); also *Memorie originali riguardanti le Belle Arti*: Ser. V (1840).
8. The story of a real woman assumed the status of myth: see Felicia Hemans's poem, *Properzia Rossi*, for example.
9. Galli, *op. cit.*, p. 19.
10. *Felsina Pittrice*, Vol. I, p. 220.
11. In fact, Lavinia Fontana usually signed herself, after her marriage, Lavinia Fontana de Zappis.
12. Galli, *op. cit.*, p. 31.
13. Giovanni Baglione, *Le vite de' pittori ... dal pontificato di Gregorio XIII del 1572, infino a' tempi di Papa Urbano VIII nel 1642* (Rome, 1642), p. 136.
14. Galli, *op. cit.*, pp. 31–4, 51.
15. Galli, *op. cit.*, p. 86. Michelangelo Gualandi, *Nuova Raccolta di Lettere sulla Pittura ... con note e illustrazioni* (Bologna, 1844).
16. Orlandi, *op. cit.*, p. 64; Luigi Crespi, *Le Vite dei pittori bolognesi non descritte nella Felsina Pittrice* (Rome, 1769), Vol. III, p. 26; Cesare Malvasia, *Le Pitture di Bologna ...* (Bologna, 1686), pp. 299, 542.
17. *Felsina Pittrice*, Vol. I, p. 70; *Le Pitture di Bologna*, ed. Andrea Emiliani (Bologna, 1968), p. 171, Note 251/24.
18. Boschini, *op. cit.*, p. 528.
19. De' Dominici, *op. cit.*, Vol. I, pp. 300–1.
20. See p. 253.

21. *Felsina Pittrice*, Vol. II, p. 454.
22. De' Dominici, *op. cit.*, p. 329; Carlo Celano, *Delle Notizie del Bello, dell'Antico e del Curioso della Arta di Napoli* (Naples, 1692), Vol. V, p. 34.
23. See p. 127.
24. G. Trecca, 'Note per la biografia dei pittori veronesi', *Atti dell' accademia d'agricoltura ... di Verona*, Ser. IV, Vol. XI, 1910, p. 7. Zannandreis, *op. cit.*, p. 159. Fede Galizia was first noticed by Giovanni Paolo Lomazzo in his *Idea del Tempio della Pittura* (Milan, 1590), p. 163, then by Morigia in *La Nobiltá di Milano* (Milan, 1595), p. 282. The only full-length study is Stefano Bottari, *Fede Galizia, Pittrice 1578–1630* (Trento, 1965).
25. See p. 71.
26. See p. 18.
27. See pp. 14–15.
28. See p. 21.
29. See p. 29.
30. See p. 34.
31. Francesco Maria Tassi, *Vite dei pittori ... bergamaschi* (Bergamo, 1869), Vol. 1, p. 225. Chiara and Elisabetta Salmeggia left an imposing array of work (see A. Pasta, *Le Pitture notabili di Bergamo*, Bergamo, 1775).
32. *Felsina Pittrice*, Vol. II, p. 478.
33. Picinardi, *op. cit.*, p. 17.
34. It is said to have been Luca Giordano's father who constantly admonished him, 'Luca, fa presto'. The fact that he painted a huge altarpiece in a single day still excites astonishment and ridicule. Domenichino, on the other hand, defended himself angrily against the charge of facility.
35. *Felsina Pittrice*, Vol. II, pp. 473–4, quoting Elisabetta Sirani's own inventory.
36. See p. 106.
37. *Felsina Pittrice*, Vol. II, p. 479.
38. De' Dominici, *op. cit.*, Vol. I, p. 329. *Cf.* Celano, *Notizie* (1692), ed. Chiarini (1856), Vol. IV, p. 25; O. Giannone, *Giunte sulle vite de' pittori napoletani*, ed. O. Morisani (Naples, 1941).
39. Ridolfi, *op. cit.*, Vol. II, p. 83; Boschini, *op. cit.*, pp. 526–7.
40. See p. 29; Ridolfi, *op. cit.*, Part II, p. 83.
41. Boschini, *op. cit.*, p. 527; Luigi Antonio Lanzi, *La Storia pittorica della Italia inferiore* (Florence, 1792).
42. Boschini, *op. cit.*, p. 526; Francesco Sansovino, *Venezia Citta Nobilissima con aggiunta* 'sino al presente da G. Martiniori', App. 5, p. 23; Vittorio Moschini, *Delle Origine e delle vicende della Pittura in Padova* (Padua, 1826), p. 92.
43. Orlandi, *op. cit.*, p. 300. Her name in religion was Suor Maria Teodora: no works are known.
44. *Felsina Pittrice*, p. 487; *Le Pitture di Bologna*, p. 97; Orlandi, *op. cit.*, p. 182.
 In the 1841 edition of the *Felsina Pittrice*, the picture is said to have been replaced by another, by Fancelli. Moreover, the design of Cantofoli's work is here attributed to Elisabetta. In Emiliani's annotated edition of *Le Pitture di Bologna* (1686) only the description of the procession and installation of the picture (from Oretti, fol. 187 V) is included.
45. Francesco Malaguzzi-Valeri, *Catalogo della reale Pinacoteca di Brera*, 1908. It has also been suggested that the *Self Portrait* in the Pinacoteca Nazionale of Bologna is, in fact, the portrait of Elisabetta by her sister Barbara, described by Malvasia (*Felsina Pittrice*, p. 403).
46. Crespi, *op. cit.*, p. 74; Barbara married the luten-

ist Borgognini. Two ink and wash drawings by Barbara, funeral emblems for her sister, preserved in the Gabinetto di disegni in Florence, show what she could achieve on her own.

Crespi says Anna Maria died unmarried, Oretti (Vol. VII, fol. 113) that she married Giovanni Battista Righi.

47. *Felsina Pittrice*, p. 487.
48. M. Oretti, *Notizie de Professori di Disegno* Biblioteca Comunale di Bologna, MSS. B. 129, Part VII, p. 120. Oretti's *Notizie* are largely compiled from earlier and better known sources, but he does add his own observations, and updates the information from time to time.
49. The inventory of *c*. 1804–8, published in Emiliani's *La Pinacoteca Nazionale di Bologna* (1967), includes six paintings attributed to Elisabetta Sirani, one as a copy from Guido, another simply as a copy, and a lost full-length portrait. In 1871, the number had dwindled to three, of which two were queried attributions (*ibid.*, p. 66ff). The two pictures acquired in the Zambeccari Bequest were of subjects similar to those already in the gallery's possession. The present day catalogue, which is extremely selective, lists and illustrates only the painting of the Madonna and Child with St John and the dove, which, when this writer was last in Bologna, was not exposed. Although the staff were as helpful as humanly possible, no one knew what had become of the other works listed as by Sirani in the documents in their possession, let alone those listed by others.
50. When Laura Ragg was in Bologna, no fewer than fourteen pictures, Nos. 175, 176, 177, 178, 179, 180, 280, 379, 503, 554, 561, 565, 616 and 750 in the inventory of the time, were visible in the public rooms. Most of them would have been acquired on the art market prior to 1906, at low prices and with very dubious credentials. No more obvious case for a properly conducted investigation exists, in all the troubled annals of seventeenth-century painting.
51. Ragg (*op. cit.*, pp. 255 *et seq.*) gives a full account of the trial of Sirani's servant for poisoning. This writer's conclusion is based upon the evidence of the *post mortem* examination (see e.g. p. 311, *op. cit.*).
52. *Felsina Pittrice*, p. 480.
53. Ever since John Evelyn, Sirani has been called *Emulatrice del Sommo Guido Reni*, and Ragg (*op. cit.*, p. 288–92), while declaiming her deep dislike of Reni's work goes along with the general assessment. In fact, the passionate imitator of Reni was Elisabetta's father, in whose manner she did not always paint.
54. E.g. Carlo Villani, *Stelle femminili: Dizionario bio-bibliografico* (Napoli, 1915).
55. A *Madonna and Child* was noted by Campori (*Gli Artisti italiani e stranieri negli stati estensi Modena*, 1855, p. 78), in the possession of the Cappelli family in Modena.
56. Crespi, *op. cit.*, p. 76; Oretti, *op. cit.*, Part. VII, fol. 124.
57. Crespi, *op. cit.*, p. 158; Oretti, *op. cit.*, Part IV, fol. 26, Part VII, fol. 126.
58. *Felsina Pittrice*, p. 487; Oretti, *op. cit.*, Vol. VII, fol. 121–2. Her married name was Scarfaglia. The *Dizionario Enciclopedico Bolaffi dei Pittori e degli incisori italiani* (Turin, 1975), reproduces an interesting self portrait in the Galleria Pallavicini, Rome.
59. Crespi, *op. cit.*, p. 158.

60. Orlandi, *op. cit.*, p. 149; Crespi, *op. cit.*, p. 85. A. Ottani, 'Notizie sui Bibiena', *Rendiconto delle sessioni dell' Accademia delle Scienze dell' Istituto di Bologna. Sezione delle Scienze Morali* (Bologna, 1963).
61. Oretti, *op. cit.*, Part VII, fol. 130.
62. Zanotti was in the habit of recording his own sentiments in rather testy comments in the margins of his copies of books like *Felsina Pittrice* and Orlandi's *Abcedario*. These were never meant for publication, although the *Felsina Pittrice* did appear with his *postille* in 1841. As representations of what one *intenditore* really felt, but would not have said publicly, they are very revealing; this remark should be considered in the light of Zanotti's notice in the *Storia dell' Accademia Clementina* (Bologna, 1739), p. 118, and Vol. II, p. 213.
63. Malvasia in *Le Pitture di Bologna* actually praised the picture because '*si riconosce il gran colorito, e le maestre pieghe del . . . Cignani*' (1706), p. 123.
64. Crespi (*op. cit.*, p. 193) reported it as already missing. Cf. *Il Passeggiero Disingannato* (Bologna, 1686), p. 113.
65. *Ibid.*, cf. Oretti, *op. cit.*, Part VII, fol. 123, and Part X, fol. 499.
66. *Ibid.*, p. 155; *Le Pitture di Bologna*, pp. 111, 312.
67. Orlandi, *op. cit.*, p. 404; Malvasia, *Le Pitture di Bologna*; *Ristampata con nuova e copiosa aggiunta* by G. V. Cavazzoni Zanotti (Bologna, 1706), p. 312.

Oretti, *op. cit.*, Part VII, fol. 76, Part IX; other works still in existence are *Memoria del Padre Roberto* (Archiginnasio) and an *Annunciation* (Santa Trinitá).
68. Zanotti in Orlandi's *Abcedario*, p. 404; cf. the flattering mention in the *Storia dell' Accademia Clementina*, pp. 86–8.
69. Crespi, *op. cit.*, p. 76; Oretti, *op. cit.*, Part VII, fol. 127.
70. Orlandi, *op. cit.*, p. 311; Crespi, *op. cit.*, p. 155; Oretti claims that she died in 1737 (cf. Zani) at the age of seventy-nine, making her birthdate 1658.
71. Ercole Bevó, *Miscellanea Poetica*, 1687.
72. Zanotti's comment in the *Abcedario*, p. 149, is partly prompted by misogyny, one suspects, cf. *Storia dell' Accademia Clementina*, Vol. III, pp. 86–8.
73. *Ibid.* Oddly no portrait has survived but two altarpieces in Bologna are still attributed: *Blessed Ceslaus putting out a fire* (San Domenico), and *San Nicola de Tolentino* (San Giovanni Battista dei Celestini).
74. Lucia Casalina (1677–1762) married the church painter Felice Torelli; Crespi, *op. cit.*, pp. 246–7.
75. Oretti, *op. cit.*, Part VIII, fol. 179; cf. Crespi, *op. cit.*, p. 259.

Her married name was Lindri: Oretti says she was sixty-two when she died in 1777 (cf. Zani). Among her teachers is listed Maria Vaiani, the daughter of Alessandro Vaiani and wife of Jacques Courtois, who received 348 scudi for a painting in the Pope's private chapel (Missirini, *op. cit.*, p. 474).

It is interesting to compare Oretti in this respect with Ridolfi. 'Egli é peró vero che essendo questo infelice sesso allevato fra le ritiratezze delle case e privo dell'uso delle discipline n'esce molle ed inerte, e poco atto a nobili esercizii. Nondimeno ad onta degli uomini, trionfa armato di lusinghiere bellezze die loro voleri.' (*Le Maraviglie*, Vol. II, p. 259.)
76. Zanotti, MS. marginalia, *loc. cit.*, Vol. II, p. 118.
77. Thieme-Becker (Donato Creti). I am unable to discover if the picture is still in existence.
78. Maria Caterina Locatelli; Crespi, *op. cit.*, p. 139; Oretti, *op. cit.*, Vol. VIII, fol. 139; *Le Pitture di*

Bologna, Cat. 119; Orlandi Guarienti, *op. cit.*, fol. 365.

79. Crespi, *op. cit.*, p. 27.

XII STILL-LIFE AND FLOWER PAINTING

1. A. P. A. Vorenkamp, *Bijdrage tot op de geschiedenis van het hollandsch stilleven en de 17de Eeuw* (Leyden, 1934). *Cf.* Charles Sterling, *History of European Still-Life Painting* (Paris, 1959), p. 44.
2. Caravaggio on still life, as quoted in a letter from Vincenzo Guistiniani to Teodoro Amideni, 'it required of him as much craftmanship to paint a good picture of flowers as of figures' (Bottani, 1754, Vol. VI, p. 247).
3. Like most such dicta, this one cannot be proved to have ever been uttered, but it is certainly consistent with Manet's attitude to painting of all subjects, as it were, in the spirit of still life.
4. Stefano Bottari, *Fede Galizia, Pittrice 1578–1630* (Trento, 1965), *passim*.
5. Sterling, *op. cit.*, used the picture in the collection of Vitale Bloch; in 1965 it was recorded in the collection of E. Zurstrassen in Heusy, Belgium. A replica is in a Swiss collection (Bottari, *op. cit.*, plates 20 and 21). *Cf.* Giuseppe Delogu, *Natura Morta Italiana* (Bergamo, 1962).
6. See also pp. 33, 34.
7. Elena Recco was recorded by De' Dominici (*op. cit.*, Vol. II, p. 297), who described her as working for the Court of Spain. Besides two pictures from the collection of the Princes Fürstenburg, now in Donaueschingen, Nolfo di Carpegna. 'I Recco: Noti e Contributi', *Bollettino d'Arte*, Anno XLVI, 1961, Ser. IV, pp. 123ff., attributes to her a still life in the Museum at Nantes. Four *floreros* are listed in a 1794 inventory of the Palacio del Buen Retiro.

Anna Vaiani is probably the same person as that referred to in Chapter XI, Note 75. She was a member of the Accademia di San Luca and perhaps better known for engravings, see G. Albrizzi, 'Donne incisori nei secoli XVI e XVII', in *I Quaderni del Conoscitore di Stampe*, 1973.

The only ground for believing that Bettina of Milan ever existed is the entry in Zani's *Enciclopedia Critico Ragionata delle Belle Arti* (Parma, 1819–22), Part I, Vol. XIII, p. 261.

Colomba Garri and her husband seem to have had between them four daughters who painted. (De' Dominici, *op. cit.*, Vol. III, p. 567): only Ruffina painted flowers.

Margarita Caffi is said by Oretti to have married one of two brothers, students of Canuti – her works were 'ricercate e comperate a caro prezzo' even then. Zanotti claimed that she stayed in Bologna, citing Donato Creti as further evidence, but other sources infer that she worked for the Archdukes Maximilian and Leopold: the presence of works in Austria and Spain does not of course entail her sojourn there.

8. Sotheby's, London, 15th July, lot 90.
9. Michel Faré, *La Nature Morte en France: son Histoire et son évolution du XVIIe au XXe siècle* (Geneva, 1962), Vol. I, pp. 41–3 and 98–100.
10. Sydney Pavière, *A Dictionary of Flower and still life painters* (Leigh-on-Sea, 1962–9), gives her dates as 1630–98. Le Comte's actual words, according to Pavière, were 'quittant la maison de son père, elle y

laissa son pinceau et se fit un capital du soin de sa maison et de l'éducation de ses enfants'.
11. Faré, *op. cit.*
12. Cathérine Perrot's married name was Oury: she studied with Nicolas Robert, and herself taught Louise-Gabrielle de Savoie, wife of Philip V of Spain. (Paviere.) She published a *Traité de la Miniature* and *Leçons Royales ou la manière de peindre en miniature les fleurs at les oiseaux* in 1686.

Charlotte Vignon's painting on wood (27 × 40 cm.) in Ward's collection, is signed on the back. Another panel 22 × 35 cm. is recorded in a Paris collection.
13. Luis Reis-Santos, *Josefa D'Obidos* (Lisbon, s.d.).
14. Edith Greindl, *Les peintres flamands de nature morte* (Brussels, 1956), pp. 34–7 and 178–9.
15. Margaretha van Godewijk was first mentioned by van Balen, Vol. I, pp. 203, 209 (Houbraken, Vol. I, p. 316). Her self-portrait, engraved by Hoogstraten, may be seen in Van Balen, *Beschrijving van Dordrecht*. She is supposed to have studied with Nicholas Maes and Cornelis Bisshop. A wonderful landscape with figures apparently signed Godewijk is illustrated in Berndt, *op. cit.*, Vol. I, p. 44.
16. The principal source for details of Maria van Oosterwijk's life is still Houbraken, *op. cit.* An updated list of works may be found in 'Women Painters 1550–1950', p. 145.
17. Houbraken, *op. cit.*, Vol. II, p. 216. Despite the fact that she signed her work with a monogram, it has apparently been attributed to de Heem.
18. Eltje de Vlieger's last-known painting is dated 1651, the year, according to Kramm, of her wedding to Paulus van Hillegaert the Younger (though Thieme-Becker maintains that her niece Cornelia married him that year). Her works may be found in the Kunsthaus, Hamburg, the Amalienstift, Dessau, and the Mauritshuis, The Hague.
19. See p. 26.
20. Peter Mitchell, *European Flower Painters* (London, 1973), p. 220.
21. Cornelis de Bie, *Het Gulden Cabinet* (Antwerp, 1662), p. 558; Horace Walpole, *Anecdotes of Painting* (London, 1872, p. 263).
22. There is some confusion in her dates: Kramm (*op. cit.*) says she was the daughter of Herman Saftleven II and married in June 1671. Thieme-Becker opines that she was born in Utrecht in 1633 and was the daughter of Herman Saftleven III.
23. Maria Theresa, 1640–1706; Anna Maria, 1642–?; Francesca Catherina, *c.* 1645–?. De Bie, *op. cit.*, p. 247; Houbraken, Part II, p. 53, Part III, p. 105; M. C. Hairs, *Les Peintres Flamands de Fleurs au dix-septième Siècle* (1965), pp. 110, 243.
24. A picture by Maria is reproduced in R. Warner, *Dutch and Flemish Fruit and Flower Painters of the 17th and 18th Centuries* (London, 1928), pl. 113c. A flower painting by Alida is in the Museum at Montpelier.
25. Magdalena Hoffmann was in fact half Swiss: her husband was called Stuewarts. She is supposed to have sent her self-portrait as a shepherdess to Anna Waser (see p. 4).
26. There is some confusion as to which branch of the Ijkens family Catharina belongs to: she was born in 1659 according to Kramm (*op. cit.*, Vol. II, p. 466, Vol. IV, 1896), the daughter of Peter Ijkens the Younger, but if there are references to her dating from 1667–8 (see Hairs, *op. cit.*, pp. 111–12), she is more likely to be the daughter of Jan Ijkens. The Prado has two signed garlands.

27. Maurice H. Grant, *Rachel Ruysch, 1664–1750* (Leigh-on-Sea, 1956), is still the fullest discussion, however Grant's catalogue is far from selective and should probably be halved.
28. Agatha van der Mijn; see p. 30. Cornelia may be the Mrs Mijn who exhibited flowers and child portraits at the Free Society of Artists from 1764–72. She is represented in the Rijksmuseum. See p. 148.
29. Jacoba Nikkelen, see p. 144. She married the portrait painter Willem Troost.
Katharina Treu, see pp. 294–5.
Gertrude Metz: a Miss Metz, living at Mr Richter's, exhibited three still lifes at the R.A. in 1773.
Maria Helena Byss was one of a family of artists which had flourished in Solothurm since the sixteenth century, daughter of a painter and sister of three more. No works are at present attributed to her.
30. Kramm, *op. cit. De Vroedschap van Amsterdam*, Vol. II, p. 824. A signed flower painting dated 1712 was in the Hallwylska Collection.
31. Staatliche Kunsthalle, Karlsruhe, no. 378.
32. The distinction between flower painting and botanical illustration is not always an easy one to make. Insofar as the portrayal of species as a part of bookmaking is an activity distinct from easel painting, it is irrelevant to this book, and therefore, even the astonishing vision of Maria Sibylla Merian is excluded.
The contribution made by women to botanical illustration is significant, to say the least; Maria Moninckx, Clara Pope, Mary Lawrance, Margaret Miller, Pauline de Courcelles, Geneviève de Nangis Regnault, Miss Drake, Alice B. Ellis, Edith Bull, Sarah Bowdich and Agnes Arber are a few of the names that come to mind.
33. C. White, *The Flower Drawings of Jan van Huysum* (Leigh-on-Sea, 1964), p. 8.
34. The Marquise de Grollier (1742–1828) was called by Canova the Raphael of flowers.
Thérèse Baudry de Balzac (1774–1831) carried out illustrations for the *Annales de l'Histoire Naturelle*, and exhibited at the Salons of 1800, 1806, 1810, flower and still-life paintings.
Henrietta Geertruida Knip (1783–1842) painted in water colour from designs made by her father, Nicolaus Frederick Knip, before he went blind in 1795. After her father's death, she took lessons from Van Dael and changed her style, medium and subject matter completely.
Mme Peigne exhibited in the Salon of 1799.
Henriette Vincent née Rideau du Sal illustrated various books. Her *Etudes des Fleurs et des Fruits* were described by Dunthorne as among the most beautiful of all flower prints in their beauty and delicacy of execution.
Melanie de Comoléra exhibited at the Salon between 1817 and 1839, at the Royal Academy from 1826–54, and at the British Institution from 1830–2.
35. Marianne Roland Michel, *Anne Vallayer Coster* (Paris, 1970).
36. Anna Katharina Fischer, Frau Block (1642–1719), was already famous when she married the portrait painter and engraver, Benjamin Block in 1664.
Anna Barbara Murrer was the daughter of Johann Murrer, history and portrait painter of Nuremberg; no works are known.
Amalia Pachelbin, or Pachelbein, Frau Beer, has a flower piece in the Residenzmuseum, Munich, and

two water colours in the Küpforstichkabinett, Berlin.
37. Thieme-Becker. Their niece, Susannah Maria, made a name for herself as a bird painter.
38. Thieme-Becker (Prestel); see pp. 26–7.
39. Elisabeth Fuseli ought, according to Thieme-Becker, to be represented by a work in the Landesmuseum in Zürich. No work by Anna is recorded.
40. Peter Mitchell, *European Flower Painters* (London, 1973), pp. 182–3, pl. 257.
41. Information derived by analysis of data to be found in Algernon Graves, *The Royal Academy of Arts* (London, 1905) and *The Society of Artists of Great Britain 1760–1791 and the Free Society of Artists 1761–1783* (London, 1907) *passim*.
42. Zani, *op. cit.*, Vol. X, p. 32.
43. Thieme-Becker (Françoise Gillet) mentions also Elisabeth Félicité's sister, Sophie, who was received into the Academy as a portrait painter.
44. 1737–1808. She was made a member of the Royal Academy in Copenhagen in 1780 (Thieme-Becker).
45. Maria van Os, daughter and pupil of Jan van Os, had two painter sons. She is represented in the Rijksmuseum and the Gemeentemuseum, The Hague. Maria Snabille was born in Würzburg but married a Dutch painter, Pieter Barbiers, and settled in Holland (Mitchell, *op. cit.*, pl. 339).
46. Emily Stannard studied painting with her father, Daniel Coppin, won an award and went to Holland to study and copy Jan van Huysum. Her marriage to Joseph Stannard lasted only four years. She went on working in her widowhood, apparently signing both maiden and married names (H. A. E. Day, *East Anglian Painters*, 1969, Vol. III, pp. 223–33). Her niece, Éloise, daughter and sister of painters, began by painting in her aunt's style, although with a different palette and eventually moved to outdoor subjects.
Anne Feray Mutrie, with her elder sister, Martha Darley Mutrie (1823–85), attended the Manchester School of Design. Their work was highly praised by Ruskin (Academy Notes, 1855, 56, 57, 58).
Mrs Mary Ensor (not. 1864–74), lived and worked at Birkenhead in Cheshire. The picture illustrated is earlier than any before noted.

XIII THE PORTRAITISTS

1. Cecilia Riccio, see p. 29; Quintilia Amalteo, see p. 21; Chiara Varotari, see pp. 29, 218–19; Arcangela Paladini, see pp. 71–2; Lucia Casalina Torelli, see p. 225; Giovanna Fratellini, see p. 27.
2. Thieme-Becker (in entry for Natali family).
3. Angela Beinaschi was noted by Orlandi (*op. cit.*) who reported her as born in 1666, and living in Rome in 1704. Lione Pascoli, *Vite de' Pittori* (Rome, 1730–6), Vol. II, p. 223, praised her highly.
4. Thieme-Becker. Zani, *op. cit.*, Vol. V, p. 133.
5. Orlandi, *op. cit.*, p. 87.
6. The portrait of Carlo Emmanuele although signed and dated was early attributed to Van Loo (Thieme-Becker).
7. See also pp. 108–10, and Thieme-Becker.
8. The portrait of Gertrude van Veen's father is in deposit at the Royal Museum of Brussels. She married a merchant, Louis Malo. Anna Françoise de Bruyns' self-portrait was engraved by W. Hollar. As

well as by Houbraken (*op. cit.*, Vol. 1, p. 163), she is mentioned by Kramm (*op. cit.*, Vol. 1, p. 183), *int. al.* In all, she is supposed to have made two hundred and forty-five portraits.

9. The Vienna figures were for a long time attributed to Frans Woutiers, until von Egerth identified them from the Archduke's inventory (Thieme-Becker).

10. The signature Aaaa v. Cronenburch on the *Portrait of a Lady in a Dutch Dress* in the Prado was taken to read Anna van Cronenburch until the discovery of a legal document signed by Adriaen in that manner (R. H. Wilensky, *Flemish Painters 1430–1830*, London, 1960, Vol. I, p. 537, *cf.* the long entry in Thieme-Becker under the name Anna van Cronenburch).

11. Kramm, *op. cit.*, Vol. IV, p. 1269.

12. Attempts have been made to find secure attributions: a female portrait in the Städtliche Kuntstsammlungen in Düsseldorf has been attributed. K. Strauven, *Über Künstlerisches Leben und Werken in Düsseldorf bis zur Düsseldorfer Malerschule unter Direktor Schadow* (Düsseldorf, 1862), p. 4.

13. Other portraits are listed, a married couple in a private collection, in 1863, a female portrait of 1686 in the Hermitage, a male portrait exhibited by the Women's International Art Club at the Grafton Galleries in 1910 and two female portraits, one signed and dated 1670, in the Dutch Art Market. Walther Berndt, *Netherlandish Painting in the Seventeenth Century* (London, 1970), p. 322. A fascinating portrait of a boy in the Dessau Gemäldegalerie is attributed to Maria van der Laak: a group portrait of Princess Henrietta Catharina and her children at Wörlitz indicates that Van der Laak worked in the German courts.

14. Not to be confused with the female relatives of Jan van Huysum (see p. 28 and Note).

15. Lorenz von Westenrieder, *Beitrage zur Vaterländishen Historie* (Munich, 1790), Vol. III, p. 113.

16. Margaret Toynbee and Giles Isham, 'Joan Carlisle (1606?–1679) – An Identification', *Burlington Magazine*, No. 96, 1954, pp. 275ff.

17. William Sanderson (*Graphice*, 1658) called her simply Mrs Carlisle; Buckeridge's essay, included in Savage's translation of *The Painting and Lives of the Painters* by Roger De Piles supplied the wrong Christian name and Vertue and Edwards took up the mistake, therefore commentators did not realise that the painter Mrs Carlisle and the wife of Lodowick Carlile were the same person.

18. The main sources for information about the career of Mary Beale are her husband's notebooks of which only two, the one for 1677, in the Bodleian Library in Oxford (MS. Rawl 8°572), and another for 1681, in the National Portrait Gallery, are preserved. The exhibition Catalogue 'The Excellent Mrs. Mary Beale' by Elizabeth Walsh and Richard Jeffree (London, Geffrye Museum, 1975) is, until its authors publish their monograph, the most complete and authoritative source.

19. Horace Walpole, *Anecdotes of Painting in England* (London, 1828), Vol. III, p. 60, Vol. IV, p. 64. See also 'The Excellent Mrs. Mary Beale' (*op. cit.*), pp. 43–4.

20. Walpole, *op. cit.*, Vol. III, p. 273. Otherwise, Walpole's mentions of women are few.

21. She was born in Danzig in 1688, daughter of the painter, Andreas Haid: in 1705 she married the painter, Christoff Joseph Werner, and worked at the Court of Dresden from 1721. Contemporary sources refer to her as Damigella (Damsel) Haid.

22. Vittorio Malamani, *Rosalba Carriera* (Bergamo, 1910). Gabrielle Gatto, 'Per la Cronologia di Rosalba Carriera', *Arte Veneta*, Vol. XXV, 1971, pp. 182–93.

23. Rosalba has left her own account of her triumphant stay in Paris in her 'Journal', published first in Italian by Vianelli, and in French, translated by Alfred Sensier (Paris, 1865), but in both cases the 'Journal' was severely abridged, so that it might function as a record of Paris society at that time, when it was primarily a list of clients made for business purposes. See Vittorio Malamani, *Rosalba Carriera* (Bergamo, 1910).

24. See pp. 72–4.

25. E. Giraudet, *Les artistes tourangeaux* (Tours, 1885), pp. 11–12; J. Guiffrey, *Artistes parisiens du XVI^e et XVII^e siècles* (Paris, 1915), p. 81ff.

26. Henri Bouchot, *Les Portraits aux Crayons des seizième et dix-septième siècles* (Paris, 1884), p. 171.

27. Marie-Louise Elisabeth Vigée-Le Brun, *Souvenirs* (Paris, 1891), Vol. I, p. 107.

28. Thieme-Becker (François).

29. In his *Nécrologie* of Madeleine Basseporte, Palissot gave the most interesting account of why Basseporte gave up portraiture: 'Elle peignoit le pastel et fut bientôt connue par des portraits qu'on mit à côté de ceux de Rosalba; mais la crainte de manquer d'occupation, l'embarras d'avoir sans cesse de nouvelles connoissances à faire et d'autres inconvénients' led her eventually to accept the King's invitation and devote her life to portraying plants.

30. Joseph Billioud, 'Un peintre des types populaires: Françoise Duparc de Marseille (1726–1778)', *Gazette des Beaux-Arts*, Vol. XX, 1938, pp. 173–84, established her birthdate as 1726.

31. A signed pastoral portrait dated 1757 appeared on the art market in 1923. Samuel Redgrave, in his *Dictionary of Artists of the English School* (London, 1878), tells us that Mercier abandoned herself to a vicious life, and died in the workhouse of St James's Parish.

32. The best discussion is undoubtedly that in 'Women Painters 1550–1950', pp. 167–8.

33. Lancret and Chardin used to show their work in makeshift accommodation in the Place Dauphine, calling their shows the *Salon de la Jeunesse*. After the regular Salons were instituted, the *élèves de la peinture* continued the practice.

34. Bellier-Auvray.

35. *Apollo*, March 1972. One of the two paintings dated 1763, a female portrait, was with Fischer in Lucerne in 1930, the other, a female portrait, with Drouot in 1937.

36. *Gazette des Beaux-Arts*, Vol. XVI, No. 779, July–August 1927, p. 85. Another, *Portrait d'inconnu* in the Musée Carnavalet, is signed and dated 1776.

37. See p. 262. Her work was much engraved by Bartolozzi.

38. Bellier-Auvray; Louis Dussieux, *Les Artistes Français à l'Etranger* (Paris, 1876), p. 553. She is probably identical with the Charlotte Louise Rameau, who married Suvée in 1780, and exhibited once more in 1782.

39. Mlle Médard appears to be the author of a charming oval which appeared on the Paris art market in 1913, signed J. J. Medar, and dated 1771.

40. J. J. Guiffrey, 'Notes et Documents: les Expositions de l'Académie de Saint-Luc et leurs Critiques

1751–74', *Bulletin de la Société de l'Histoire de l'Art Français*, 1910, pp. 78–124 and 258–70; also *Les Livrets des Expositions de St-Luc*, ed. J. J. Guiffrey (Paris, 1872).
41. Bellier-Auvray; *Nouvelle Archive de l'Art Français*, Third Series, No. XIX, pp. 204, 206, 230, 236.
42. She was one of three sisters, in a family of engravers. See Charles Auffret, *Une Famille d'Art Brestois au dix-huitième siècle: Les Ozanne* (1891).
43. She is thought by some to have been a pupil of Greuze; *Revue Universelle des Arts*, No. XIX, 1868, pp. 53–5.
44. This and any other account of the career of Adélaïde Labille Guiard is deeply indebted to Anne Marie Passez, *Adélaïde Labille Guiard* (Paris, 1973).
45. Thieme-Becker, also Gunnar W. Lundberg, *Roslin liv och werk* (Malmö, 1957), Vol. 1, pp. 79, 80, 102, 125f., 140f. and 305; and *Mme. Roslin Konstnären husfru* (Idun, 1934).
46. *Burlington Magazine*, No. 27, November 1971, pp. ii–iii; the quotation is from the *Almanach Historique et Raisonné des Artistes*, 1776.
47. Belle de Zuylen was the preferred name of Isabella Agneta Elisabeth de Tuyl de Serooskertsen (1740–1805), a Dutch gentlewoman and *femme d'esprit*, an author in her own right, and the correspondent of Constant d'Hernanches and Benjamin Constant. Boswell wanted quite earnestly to marry her, but she disapproved of his way of discounting her criticisms of his work and eventually, unhappily, married her brother's tutor instead.
48. Arnault Doria, *Une Emule d'Adélaïde Labille-Guiard: Gabrielle Capet, portraitiste* (Paris, 1934): 'Gabrielle Capet' is a very popular saleroom attribution.
49. Doria, *op. cit.*, p. 6; Passez, *op. cit.*, pp. 19–22; 'Exposition de tableaux des élèves de la Peinture à la Place Dauphine, 1787', *La Revue de l'Art*, Vol. lxi, 1932, pp. 3–5.
50. J. Le Breton, *Notice Nécrologique sur Madame Vincent née Labille* (Paris, An. XI), p. 1, quoted in Passez, *op. cit.*, pp. 17–18. Author's translation.
51. Marie-Louise Elisabeth Vigée-Le Brun, *Souvenirs* (Paris, 1869), p. 7.
52. *Ibid.*, pp. 35–6. Author's translation.
53. Reproduced in Ballot, *op. cit.*, then in the collection of the Comte de Manneville.
54. See p. 303.
55. Vigée-Le Brun, *op. cit.*, pp. 156–7. Author's translation.
56. Le Breton, *op. cit.*, p. 4.
57. Eugénie Le Brun, Mme Tripier-Le Franc (1805–?), was one of the pupils of Regnault; she showed at the Salons before her marriage from 1819–24, and under her married name from 1831–42, specialising in theatrical portraits.
58. See pp. 142–3.
59. André Girodie, 'Biographical Notes on Aimée Duvivier', *Burlington Magazine*, No. 132, Vol. XXIV, March 1914, pp. 307–9. *Revue de l'Art Ancien et Moderne*, Vol. lxvi, No. 356, November 1934, p. 361.
60. Her first teacher was a local artist in Nancy where she was born; she then studied miniature painting with Aubry and Isabey, and then oil painting with Regnault. She showed as Jaser in the Salons of 1808, 1822, 1827 and 1831, and only from 1833–44 as Rouchier. A miniature of the Princess Caroline Amalie can be seen in Schloss Rosenborg (Thieme-Becker, Iaser).

61. See p. 301. She exhibited as Hoguer at the Salons of 1810, 1812, 1814, 1819, 1822, 1824, 1827, and as Thurot at the Luxembourg in 1830, and the Salons of 1831, 1834, 1835, and 1839.
62. Bellier-Auvray lists her in the Salons from 1795–1817; her portrait by Marie Geneviève Bouliar is in the Musée Carnavalet, Paris (*Women Artists 1550–1950*, plate 67).
63. In 1802, a Mlle Boucher exhibited at the Salon 'Une jeune fille occupée à peindre'.
64. She was born in Lyons, and exhibited portraits in oil and miniature in the Salons from 1806 to 1838.
65. Rosalie de la Fontaine is known only from Salon records: she exhibited general subjects as well as portraits.
66. The portrait of Vestris, which is in the Musée of Valenciennes, is reproduced in Sparrow, *op. cit.*, p. 170.
67. Bellier-Auvray.
68. Esther Pottier is represented in the Museum of Orleans, by a portrait of Marie Louise Bourbon-Conti, Duchess of Orleans.
 Madame Persuis was born Delaporte.
 Julie Philipault's *Racine reading Athalie before Louis XIV and Mme. de Maintenon* (1819) is in the Louvre (Cat. No. 1460).
69. For the Sartori sisters, see Manzani, *Artisti Friulani*.
 Antoinette Legru, Signora Perotti, settled in London in 1768. See p. 279.
70. Marianna Carlevaris is represented by pastel portraits in Ca' Rezzonico.
 Maria Molin is also thought to have studied with Rosalba. (Giovanni Mariacher, *Ca' Rezzonico, Guida Illustrata*, Venice, 1969, mentions a signed pastel female portrait.) Rosalba's three sisters, Giovanna, Angela and Nanetta, also worked with her.
71. See p. 27.
72. Violante Beatrice Siries (1709–83) enjoyed considerable fame in her own lifetime: upon her return to Florence she married a man called Cerrotti; and went on studying with Conti. In 1734 she was fulfilling commissions in Rome. In 1735 she painted a portrait of the family of the Emperor Charles VI, with fourteen figures. The Uffizi has no fewer than three self-portraits, none particularly well painted.
73. Anna Bacherini married the painter Gaetano Piattoli, and was the mother of the painter, Giuseppe Piattoli. See p. 79.
74. Bianca, sister of the painter Carlo Cesare Giovannini, married the noble Girolamo Fontana. She is unusual among Bolognese women painters in that she painted and engraved principally portraits, *cf.* Barbara Burrini, Eleonora Monti, Giulia de' Balli Casanova, Rosalba Bolognini, Anna Teresa Messieri, Ippolita Possenti, M. Buonaguardia, Anna Morandi Manzolini, Rosalba Salvioni, Isabella Sandri, Gentile Zanardi, Teresa Caterina and Claudia Felice Missiroli, Angela and Anna Maria Palanca, Rosa Agnese Bruni, Giulia Bonaveri, Rosa Alboni Nobili.
75. Thieme-Becker.
76. Thieme-Becker gives an impressive Bibliography; *cf.* also, Margherita Paoli, Costanza Paoletti, Angiola and Teresa Piola, Angela Veronica Airola, Anna Galeotti and Maria Maddalena Baldacci Gozzi.
77. Portraits by Ulrika Pasch may be seen in the

Museums of Norrkoping, Helsingfors, Gripsholm and of course Stockholm, where there are two self-portraits (*Svenskt Konstnarslexicon*).
78. For the Lisziewskas, see p. 19, and Note. *Kunstchronik*, NF 32, 1920/1, 858. Self-portraits by Dorothea Lisziewska Therbusch may be seen in the Grossherzogliches Museum, Weimar, and the Gemäldegalerie Staatliche Museum, Berlin. A self-portrait by Anna Rosina Lisziewska is in the Provinziaal Museum, Hanover.
79. Thieme-Becker.
80. She was born Reichenbach: the Duke Karl Eugen provided her with the wherewithal to study in Paris with Vestier: on her return, she married Simanowitz and was the friend of Schubert who dedicated many poems to her. Back in Paris she was patronised by Madame de Staël and Napoleon. Most of her surviving work is in the Schillermuseum.
81. Victoria Manners, 'Catherine Read, the English Rosalba', *The Connoisseur*, Vol. LXXXVIII, 1931, p. 379.
82. *Ibid.*, p. 380.
83. *Ibid.*, p. 381.
84. *Ibid.*, Vol. LXXXIX, 1932, p. 173, from Fanny Burney's Diary, 1774.
85. *Ibid.*, from Fanny Burney's Diary for February, 1775.
86. Astonishingly, Helen Beatson exhibited at the Royal Academy in 1779, aged eleven years (Graves, *The Royal Academy*, Vol. I, p. 152).
87. Clayton, *op. cit.*. p. 361.
88. While amateur exhibitors were decently screened from publicity, professionals had to use the exhibitions as advertising. Thus, Mrs Carmichael advised viewers at the Free Society in 1768 that she was at Mrs Regnier's in Newport Street. In 1769 she exhibited at the Society of Artists from another address; in 1771 she was back with Mrs Regnier. In 1773 and 1774 Mrs Eliza Hook informed the public that similar portraits could be got from her in Newman Street, while Mrs Gilchrist, who exhibited in 1774 and 1775, was in Poland Street. Miss Dickson's name appeared in more than one version, but her address in Brewer Street was consistent.
89. This may have been Françoise Du Parc (see p. 259–60). Mary de Villebrune could be found at Mr Bocquet's King Street Studio, Angelica Perotti at Mrs Gambarini's in Poland Street.

XIV THE AMATEURS

1. Bryan's *Dictionary of Painters and Engravers* (1904), New Edition, ed. George C. Williamson, Vol. III, p. 296. (It would be interesting to see in this context Valabrègue, *Les Princesses artistes*.)
2. Una Birch, *Anna van Schurman, Artist, Scholar, Saint* (London, 1909).
3. See p. 79; J. Parada y Santin, *Las Pintoras Españolas* (Madrid, 1903), pp. 58, 64.
 For the founding of the Real Academia de San Fernando, see Ceán Bermudez, *Diccionario Istorico de los mas ilustres profesores de las Bellas Artes en España* (Madrid, 1800), Vol. III, pp. 251–5, also Vol. II, pp. 305–6.
4. Elizabeth Armstrong, *Elizabeth Farnese, the Termagant of Spain* (London, 1892).

W. Stirling Maxwell, *The Annals of the Artists of Spain* (London, 1891).
 Palomino de Castro y Velasco, *Museo pitorico*, 1795/7, Vol. I, p. 187.
 Antonio A. Ponz, *Viage de España* (Madrid, 1787–94), Vol. X, pp. 123–4, 147–8.
5. Parada y Santin, *op. cit.*, pp. 56–8; F. Quilliet, *Dictionnaire des Peintres Espagnols* (Paris, 1816).
6. Ceán Bermudez, *op. cit.*, Vol. IV.
7. 'To the Pious Memory of the Accomplisht Young Lady Mrs. Anne Killigrew... An Ode', first published in *Poems by Mrs. Anne Killigrew* (1686), from the *Poems and Fables of John Dryden* (London, 1961), pp. 347–8, lines 106–26.
8. Abraham Vanderdoort, 'A Catalogue and Description of King Charles the First's Capital Collection...', ed. George Vertue (London, 1757), No. 71, p. 53. (No. 70, a picture of a falconer, was also by Louise Hollandine.)
 Louise Hollandine (1622–1709) was one of the group who studied with Anna van Schurman under Honthorst. She ran away from her mother's house at the age of thirty-six and became a Catholic and Abbess of Maubuisson. She had considerable talent and became very competent. In the Provinzial Museum, Hanover, there is a life size self-portrait; three more portraits are in the Kestner Museum in Hanover, and at Herrenhausen, there is a remarkable painting of a *Woman at her toilet* (reproduced in Jessica Gorst Williams, *Elizabeth, the Winter Queen*, London, 1976). Another self-portrait, cut down from three-quarter length, was in the possession of the Earl of Craven until 1969, when it was put up for sale at Sotheby's, reproduced in an Exhibition Catalogue of the National Portrait Gallery, London, 'The Winter Queen' (1963), No. 62, Plate VIb. Thieme-Becker records two portraits of Visitandine Abbesses and another of Marie de Medici.
9. Clayton, *op. cit.*, Vol. I, p. 39.
10. As well as the illustrated portrait of King James II, her *Venus and Adonis* is recorded by Thieme-Becker as in a private collection in Folkestone in 1915. An engraving by Blooteling from a self-portrait and a mezzotint by B. Lens from her *Venus and Adonis* are in the Paul Mellon Collection. See also Clayton, *op. cit.*, Vol. I, p. 68.
11. This almost legendary character was the daughter of the Emperor Maximilian, wife of the Infante Jean de Castile in 1494 and then of Duke Philibert of Savoy in 1501. A popular epitaph runs:
 Ci gist Margot, la gente demoiselle,
 Qu'eut deux maris et si mourut pucelle.
12. Atanasy Raczynski, *Dictionnaire historico-artistique du Portugal* (Paris, 1847). See p. 168.
13. Princess Sophie Hedwig: thirteen works by her are in the Danish Royal Collection at Rosenborg Castle.
 Sophie, Electress of Hanover, sister of Louise Hollandine, is thought to be the author of a portrait of George I as a child, erstwhile in the possession of the Earl of Craven at Coombe Abbey. A. W. Ward, *The Electress Sophia and the Hanoverian Succession* (London, 1909), p. 329f.
 Marie Eleonore Radziwill's self-portrait is still in the possession of her family.
 Princess Ernestine's works, a series of portraits, among them a self-portrait, may be seen at Raudnitz Castle.
14. Michel Rousseau de la Valette, *The Life of Count Ulfeld and of the Countess Eleonore, his wife* (London,

1695). *Memoirs of Leonora Christina . . . written during her imprisonment in the Blue Tower at Copenhagen . . .*, translated by F. E. Bunnett (London, 1872). Works by her may be seen in Rosenborg Castle, and in the National Museum at Frederiksborg.

15. Melchiorre Missirini, *Memorie per servire alla storia delle Romana Accademia di San Luca* (Rome, 1823), pp. 461–74.

16. Christiane Louise was encouraged by Chodowiecki who engraved her portrait of Andreas Böhm: it seems that her *morceau de réception* at Kassel was a self-portrait; in 1786 she exhibited two self-portraits in Berlin and a portrait as well as three pastel paintings.

H. Knackfuss, *Geschichte der Königlichen Kunstakademie von Kassel* (Cassel, 1908), p. 67. For Bibliography, see Thieme-Becker.

Daniel Chodowiecki: *Briefwechsel zwischen Chodowiecki und seinen Zeitgenossen*, ed. Charlotte Steinbrucker, Vol. I, 1736–1786 (Berlin, 1919), pp. 296ff.

17. Karoline Charlotte Amalia Truchsess von Waldburg was widowed by Count Heinrich Christian von Keyserlinck in 1761, married Count Heinrich Uexkuell-Gyllenband and was widowed again in 1787, the year that she exhibited *Adam and Eve* at the Berlin Kunstakademie. Her portrait of Kant was in the Majoratsbibliothek in Rautenburg.

Augusta of Hesse-Cassel, 1780–1841, took part in the exhibitions of 1810 and 1812.

Georg Kaspar Nagler, *Neues Allgemeines Künstlerlexikon* (Munich, 1835–52), Vol. VI, p. 162.

18. Portraits of the Grand-Duchess of Saxe-Weimar, and Queen Therese of Bavaria are known, as well as scenes of Italian life and biblical subjects. The Tsar and Queen Victoria acquired her work (Thieme-Becker). See also, Anna Jameson, *Visits and Sketches* (*op. cit.*), Vol. II, pp. 122–4.

19. Adèle Schopenhauer: one of her silhouette books was published in facsimile by H. T. Kroeber in Weimar, 1913.

Gedichte und Scherenschnitte von Adele Schopenhauer, H. H. Houben and H. Wahl (Leipzig, 1920). *Jahrbuch der Sammlung Klippenborg* (Leipzig, 1921), Vol. I, p. 177.

Der Kunstwanderer, 1921–2, p. 162.

Corona Schrödter: see p. 294. Weimar, Goethe Nationalmuseum, *Grosse Ausgabe des Führers*, ed. M. Schneffe (Leipzig, 1910), pp. 99, 102.

A water colour by the Abendgesellschaft at the house of Anna Amalia by G. M. Krause, gives a marvellous picture of this integrated society (reproduced in *Goethe Gedenkblätter Weimar*, Goethe National Museum, Weimar (Berlin, s.d.) p. 68).

Minna Stock, daughter of Goethe's teacher and her sister, Dora, who came to live with Minna and her husband, Christian Gottfried Körner, in Dresden, transformed the household into a centre of artistic and intellectual activity. It is now the Körnermuseum in Dresden, and a treasure-house of women's work, some of it professional, but most of it semi-professional or amateur, but it is not easy to tell from the quality which is which.

E. Peschl and E. Wildenow, *Theodor Körner und die Seinen* (Leipzig, 1898).

20. She was an amateur painter, who died unmarried in Rome in 1847. Her portrait of Shelley was exhibited in 1868.

21. National Portrait Gallery.

22. The Countess de Tott exhibited 16 works between 1801 and 1804 (Graves, *The Royal Academy*, Vol. II, pp. 313–14).

Albinia, Countess of Buckinghamshire, limited herself to portraying her own and her friends' children.

The work of Lavinia, Countess Spencer, is known from engravings by Gillray and Bartolozzi.

Maria Hamilton, Lady Bell, was an Honorary Exhibitor at the R.A. from 1816–20. Her pastel portrait of Mrs Wainwright is illustrated in R. R. M. See, *English Pastels* (London, 1911) facing page 233 (Graves, Vol. I, pp. 175–6).

Lady Lyttelton exhibited pastels as an Honorary Exhibitor at the R.A. in 1771, 1775 and 1780 (Graves, Vol. IV, p. 121).

Suzanne Keck began by exhibiting anonymously in 1769; it is worth noting here that the most prolific exhibitor at the R.A. in the early years was 'A Lady' or 'A Young Lady' (Graves, Vol. IV, p. 304).

Georgina Shipley exhibited as an Honorary Exhibitor in 1781 (Graves, Vol. VII, p. 115).

Lady Beechey, an Honorary Exhibitor is recorded by Graves as showing from 1795 to 1805 (Vol. I, p. 164).

23. Elizabeth Wheeler Manwaring, *Italian Landscape in Eighteenth Century England* (New York, 1925), pp. 58, 97.

24. A view of Windsor, dated 11th April 1723, by Lady Diana Spencer, later Duchess of Bedford (1710–35), was part of lot no. 122 on the twentieth day of the Strawberry Hill sale (17th May 1842).

25. M. H. Grant, *A Chronological History of the Old English Landscape Painters in Oil* (Leigh-on-Sea, 1950) Vol. I, p. 49.

26. Susannah Highmore, later Mrs Duncombe, is at present known by only one work, evidently a landscape with characteristic figures.

27. Amabel, Baroness Lucas and Countess de Grey in her own right (1751–1833), married Lord Polwarth, heir to the third Earl of Marchmont. She is better known by engravings, some of which are based upon her sketches at Grantham.

28. Manwaring, *op. cit.*, p. 88.

29. *Ibid.*, p. 90.

30. Joseph Farington, *Diary*, ed. James Greig, Vol. 1, p. 289 (1st August 1800).

31. Manwaring, *op. cit.*, p. 89.

32. *Ibid.*

33. Elizabeth Sutton: Grant, *op. cit.*, reproduces a landscape dated 1789 (Pl. 36), and comments that her work is clearly derived from Gainsborough's second manner, and as such, is very early (Vol. III, p. 18).

Viscountess Templetown: Clayton, *op. cit.*, Vol. I, p. 356.

Lady Margaret Arden: a series of water-colour landscapes was recorded in the Sotheran collection in 1929.

For Angelica Kauffmann's portrait of Elizabeth Foster, see p. 92.

34. Graves, *op. cit.*, *passim*.

35. Nicholas Hilliard, *A Treatise concerning the Arts of Limning* (1606); Hilliard is not speaking of women, but of the gentry.

36. Manwaring, *op. cit.*, p. 89. The story exists in two versions: the one quoted by Manwaring is from Thomas Wright's *Some Account of the Life of Richard Wilson* (1824) who himself is quoting a Mr Field. Farington, on the other hand, who heard the story from another source, says that upon hearing that the

ladies did in fact draw, Wilson turned on his heel and walked away hungry (*Diary*, 8th October 1809).
37. Grant, *op. cit.*, Vol. II, p. 169, and the *Dictionary of National Biography* (Long).
38. Henry Peacham's *Graphice or the Art of Drawing with Pen and limning with Watercolours* was so popular that it went through several editions, the later ones being given the new name of *The Gentlemanly Exercise*. *The Compleat Gentleman*, a companion volume appeared in 1622.
39. *The Diary of Samuel Pepys* (London, 1906), Vol. I, pp. 594, 606, 607, 614, 620, 622, 636, from 30th June 1665 to the 27th September. Pepys began by finding his wife's work 'curious' and ended by admiring it and showing it to his friends.
40. Clayton, *op. cit.*, Vol. I, p. 349.
41. Horace Walpole, *Letters*. Beatrice S. Erskine, *Lady Diana Beauclerk* (London, 1903).
42. In the Royal Library at Windsor, there are fifty-one vignettes by her, of ruins, *capricci* and similar subjects. In 1795, the Princess designed a series of pictures called 'The Birth and Triumph of Cupid' which were engraved by Tomkins, and in 1806, 'The Power and Progress of Genius' in twenty-four sketches. 'The New Doll' and 'The Seasons' appeared after her marriage. See Clayton, *op. cit.*, Vol. I, pp. 340–2, and Farington's *Diary* for 9th February 1794 and 9th November 1797.
43. Horace Walpole, *Letters*, ed. Mrs Paget Toynbee, Vol. XIV, p. 11. *Cf.* Mrs William Weddell, who designed a circular boudoir at Newbury Hall, in Yorkshire (*Country Life*, 26th June 1937, pp. 716–17, fig. 5).
44. Clayton, *op. cit.*, Vol. I, p. 403. Her distant relative, Marianne North, was the amateur botanical artist who endowed the North Pavilion in the Botanical Gardens at Kew, together with 848 paintings. She left her own *Recollections of a Happy Life* edited by her sister, Mrs John Addington Symonds (London, 1892).
45. C. E. Vulliamy, *Aspasia: The Life and Letters of Mrs Delaney* (London, 1937), *passim*.
46. British Museum Prints and Drawings Department.
47. Clayton, *op. cit.*, Vol. I, pp. 343, 351, 354, 353.

XV THE AGE OF ACADEMIES

1. Her prize seems to have been the beginning and end of her career, for this is the only mention of her in any source.
2. R. Mesuret, *Les Expositions de l'Académie Royale de Toulouse de 1751 à 1791* (Toulouse, 1972), *passim*.
3. Born in La Rochelle, she was a successful painter of portraits, historical and mythological subjects. She was granted a pension on the restoration of the monarchy. A portrait of Princess Libomirska is recorded, in the National Museum of Warsaw; two works are in Rochefort-sur-mer.
4. Devillers, *Le passé artistique de la Ville de Mons* (1885).
5. Esther Barbara Sandrart, born 1651.
6. Joachim von Sandrart had no issue of either of his two marriages. Susanna Maria was the daughter of his nephew, Jacob. She is mentioned in his *Teutsche Academie* (1675). She married first the painter Hans Paul Auer, then the bookseller W. M. Endter (Thieme-Becker).
7. Barbara Helena married her father's pupil Philip Oeding; her brother, Johann Justin, had his daughters Esther Maria and Anna Felicitas trained as painters. Anna Felicitas became well-known as Frau Zwinger.
8. Ludwig Kaemmerer, *Chodowiecki* (Bielefeld and Leipzig, 1897) p. 4, Ill. 3, engraving of 1771.
9. Jeannette Chodowiecka, Mme Papin (1761–1835), painted genre subjects in water colour and pastel: her son, the painter Heinrich Papin, was probably taught the rudiments by her.
Suzette Chodowiecka married a student of her father's who became librarian and supervisor of the Berlin Antique and Bronze Collection. She continued to exhibit until 1818. There is a painting of St Elizabeth in the Stadtmuseum, Danzig.
Chodowiecki's brother, Gottfried, who died in 1781, was exhibited as an amateur at the Berlin Academy in 1787 and 1788.
10. Née Wahlstab, she was the wife of the first professor of drawing at the Provinzial Kunstschule in Königsberg, Andreas Knorre. She exhibited principally miniatures and copies at the Berlin Academy in 1787, 1788, 1793, 1795, 1797, 1800 and 1810. Their daughter, Auguste, exhibited there in 1820.
11. Friederike exhibited pastel portraits and Philippine landscape drawings from 1788–93/4.
Elisabeth Sintzenich was the daughter of a Mannheim engraver. She sent her first picture to the Academy in 1795 when she was seventeen. It was said that the heads in her portraits were painted by others.
12. See pp. 284–5.
13. See p. 285.
14. See pp. 242–3.
She is represented in the Museums of Augsberg, Bamberg, Karlsruhe, Darmstadt, Düsseldorf, Mannheim, Spire, Stuttgart and Wurzburg. Her marriage, to the wealthy Jakob König, lasted only a few years before she was off on her own way again.
15. Thieme-Becker (Treu). For her daughters, Elisabeth and Franziska König see J. H. Jack, *Pantheon der Literaten und Künstler Bambergs* (Bamberg, 1821–5), Vol. II.
16. Amalie (1757–1839?), Frau Apell, posed for her father. Wieland wrote an Ode to her. Knackfuss, *op. cit.*
Johann Heinrich's niece Antonie, Frau Röntgen (1761–1826), painted landscapes and dead birds in Hamburg.
Betty, Frau Kunze, and Caroline, Frau Wilke, daughters of his nephew, Johann Friedrich August, painted, as did Margarethe and Louise, grand-daughters of his nephew, Johann.
17. (1749–1815) She was the daughter and pupil of David Friedrich for water colour, and learned oil painting from her brother Alexander. A still life dated 1799 is recorded in the Königlichebemäldegalerie in Dresden. Other works are in the Amalienstift, Dessau, the Berlin Kupferstichkabinett.
Gottfried Benjamin Tettelbach married a sister of Caroline Friedrich and had five children who were artists. Alexia (1775–96) died too young to accomplish much. Augusta (1785–after 1828) married the painter and drawing teacher Johann Amadeus Larius. Caroline Richter (1777–?) is the author of two nature studies in Dresden Gemäldegalerie, one dated 1807 (gift of the artist) and one 1809.

18. Theresa Mengs is represented in the Collection of the University of Wurzburg. The Accademia di San Luca, of which she and her husband became members in 1765, has a male portrait (no. 40). The Gemäldegalerie in Dresden has a pastel self-portrait (no. 178) and a companion portrait of her sister (no. 179), as well as two miniature copies after Correggio.

Their niece, Anna Maria Mengs (1751–93), married a Spanish painter, Manuel Salvador Carmona, and worked as an artist in Spain, where in 1790 she was received into the Academia de San Fernando. Appollonie Seydelmann, see p. 44.

19. (1724–80). A *Magdalen* in the Schleissheim gallery is recorded (Thieme-Becker).

20. For Cederström, see *Svenskt Konstnärslexicon* (Malmö, 1952), Vol. I, p. 297 (entry by Sven Sandström); Ehrenström, *ibid.*, Vol. II, p. 86 (entry by Gunnar Eckholm).

21. Caroline Murau, *Wiener Malerinnen* (Dresden, 1895).

22. Jean-Georges Wille, *Mémoires et Journal* (Paris, 1857), Vol. II, pp. 264–6. The vote was subsequently disallowed.

23. *Ouvrages de Peinture, Sculpture et Architecture . . . exposés au Louvre, par Ordre de l'Assemblée Nationale, au mois de Septembre, 1791, l'An IIIe de la liberté à Paris . . . de l'Imprimérie des Bâtiments du Roi* (list of artists, pp. 55–7).

24. 'Women Painters 1550–1950', No. 65, Catalogue, pp. 202–4.

H. Jouin, *M. G. Bouliar: Peintre de Portraits* (Paris, 1891): Her portrait of Adélaïde Binart, Mme Lenoir, is in the Musée Carnavalet (exhibited 'Women Painters 1550–1950', No. 67).

25. *Description des Ouvrages de Peinture, sculpture . . . sculpture . . . exposés au Sallon du Louvre Par Les Artistes composans la Commune-générale des Arts, le 10 Août, 1793 . . .* (Paris, 1793) (list of artists, pp. 75–90).

26. Archive National, O'1919, fol. 162.

27. J. Ballot, *La Comtesse Benoist, L'Emilie de Demoustier 1768–1826*.

28. See p. 143.

29. Her *Death of Adonis* (Salon, 1810) and *Orpheus in Hell* (1810) were engraved by Normand; *Perseus rescues Andromeda* was engraved by Soyer. The Museum of Angers has *The Seven Before Thebes* and *Mars and Venus*, Tours, a portrait of Ledru Rollin and Charenton, a *Crucifixion*. Exhibition Catalogue 'David et ses élèves', Paris, 1913, no. 198.

30. She continued to exhibit until 1810, attempting themes of the most ambitious order, both biblical and mythological. Her *Liberty* (1793–4) is in the Louvre (see 'Women Painters, 1550–1950', p. 47).

31. H. Lapauze, 'Le Roman d'Amour de M. Ingres' *Revue de L'Art*, 1910.

32. The Musée de Dijon has nine paintings by her including a self-portrait; *Chronique des Arts* (1867), p. 301; Devillers, *op. cit.*, pp. 69, 110; A. Perrault Dabot, *L'Art Bourgignon* (Paris, 1914), p. 705; *Kunstablatt* (1820), pp. 325f.

33. 'Women Painters, 1550–1950', pp. 211–12.

34. Bellier-Auvray.

35. She showed paintings in 1810, 1812, 1814, 1819, 1822, 1824 and 1827 as Hoguer, and at the Luxembourg in 1830, and the Salons of 1831, 1834, 1835 and 1839 as Thurot. She was born in 1786, at Versailles.

36. She exhibited at the Salons from 1808 to 1839.

37. See also pp. 101–2. 'Women Painters, 1550–1950', pp. 197–200.

38. Pierre de Nolhac, *Fragonard 1732–1806* (Paris, 1931), pp. 167–8.

39. 'Women Painters 1550–1950', *op. cit.*, pp. 211–12, Fig. 71.

40. Bellier-Auvray.

41. *Little Girl Teaching her Dog to Read* is in the Museum at Rochefort; a portrait of *Princess Laetitia, Countess Pepoli* is in Versailles; the Museum at Arras has *Dibutades or the Origin of Painting* which was engraved by Mme Soyer. Her *Girl Bemoaning the Death of a Dove* was engraved by Devilliers. *Little Girl lunching with her Dog* of 1812 was engraved by Mme Soyer, and was sold at the Dorotheum in Vienna in 1921.

A painting in Gabrou-Chaudet-Husson's manner in the Schloss Arenenberg of a *Girl Feeding Birds* is attributed to Henriette Amalie Chaudet, who may be related.

42. (1784–1845). She was a pupil of Lethière, whom she followed to Italy, where she met her husband. Her self-portrait from the Louvre (M 1719) was exhibited in the 'Women Painters, 1550–1950' Exhibition, no. 75 (see Catalogue, p. 218 and Bibliography, p. 349). There are works in the Galleries of Fontainebleau, Montpelier, Dijon, Versailles, Aix, Angers, Besançon, Cherbourg, Rouen and Toulouse. She had as pupils the greatest ladies of her time and had a considerable social success, being ugly but charming and innocent of affectation. She was named painter to the Duchesse de Berri, an important promoter of women's work: see *The Kennedy Quarterly*, Vol. I, No. iii, Fig. 71.

43. See pp. 88–9.

44. See pp. 242–3, 294–5.

45. See pp. 306 and 307. A self-portrait is in the Carolino Augusteum in Salzburg.

46. Her portrait of Alexandra z. Lubomirsky Stanislova Potocka is in Wilanow (Bellier-Auvray, Gault de St Germain).

47. She was a lady in waiting of Gräfin Franz von Erbach-Erbach and travelled in her train to Rome. Landscapes she painted there are in Schloss Erbach, and a sketch book is in the Museum at Buchen. Her married name was Lammerhirt (Thieme-Becker, entry by K. Noack).

48. She was the wife of the Bohemian musician Franz Ignaz Lauska, who died in 1825. She had been taught in Berlin by Kretschmar and exhibited in 1812. Her *Three Angels at Christ's Tomb* begun in Rome in 1829 was acquired by the King of Prussia. She exhibited at the Berlin Academy in 1826, 1832, 1834, 1839 and 1844, travelling to Rome again in 1842 (Thieme-Becker, entry by Fr. Noack).

49. Caroline Luise Seidler, *Erinnerungen und Leben*, ed. Hermann Uhde (Berlin, 1874), p. 34 (author's translation). Works by Seidler are not now easy to find. The Museum at Bremen has a signed *Allegory of Morning* (Inv. Nr. 1065–1972/13). A portrait of Fanny Caspars was advertised in *Apollo*, September 1972.

50. *Ibid.*, p. 54 (author's translation). Her companion and helper in these years was often Caroline Bardua, who was taught by Meyer and von Kügelgen and exhibited from 1822–40. Her authenticated works include portraits of Goethe and his wife and a good portrait of Caspar David Friedrich

in the Berlin National Gallery. (*Zeitschrift für die Bildende Künstr.*), Vol. LXIII, July, 1929, p. 35.
51. *Ibid.*, p. 159.
52. *Ibid.*, pp. 201–2. Elektrine Stuntz (1797–1847) the daughter of a landscape painter, had also contrived to get Langer to teach her. She married in 1823, the year after she had been received into the Accademia di San Luca. Thieme-Becker supplies a list of works, mostly in Munich.
53. Margareta Magdalena Rottmayr, daughter of the painter Kaspar Zehender, carried out many church decorations near her home in Laufen, Bavaria. She also trained her son Johann Franz Michael Rottmayr (1660–1730) (Thieme-Becker).
Placida Lamme was a nun in the Benedictine convent at Hohenwart. Felix Joseph Lipowsky, *Baierische Künstlerlexikon* (Munich, 1810).
Fräulein Denisch painted two pictures, an *Immaculate Conception* and a *Saint Norbert* for the Church of St Odilienberg in Lower Alsace. *Kunst und Altertum in Unterelsass* (1876), p. 234.
Katherine Kreitmayer was a nun working in her monastery at Altomünster near Eichach (Thieme-Becker).
Margareta Antonia Hölzl was the daughter of the painter Felix Hölzl; she painted portraits, historical compositions and pictures of the Blessed Virgin in Ingolstadt, *c.* 1767.
Theresia was the only woman painter in the fourth generation of an artist family in Upper Swabia. She was the collaborator of her father, Franz Ludwig Hermann, and worked with him in the Parish Church of Lindau, where the altarpiece of the *Annunciation* is ascribed to her. The convent at Ottobeuren had a *Holy Family* dated 1781.
Marie Luise was the daughter of Joseph Melling: she became a nun in the convent at Lichtendal-bei-Baden in 1786; her works were preserved there (Thieme-Becker).
54. On her return to Winterthur in 1784 she married Johann Kaspar Kuster, but was 'gezwungen, sich mer vorwiegend als Flachmaler zu betätigen'. Her works are in the Museum at Winterthur, Basel and Zurich (Thieme-Becker).
55. Thieme-Becker (Friedrich Christian Reinermann).
56. Anna Barbara Steiner also came from Winterthur (Thieme-Becker).
57. Klara Siebert, *Marie Ellenrieder* (Karlsruhe, 1915); M. Zündorff, *Marie Ellenrieder* (Constanze, 1940); W. Fischer and S. v. Blanckenhagen, *Marie Ellenrieder, Leben und Werk der Konstanzen Malerin ... mit einem Werkverzeichnis* (Constanze/Stuttgart, 1963). See also 'Women Painters 1550–1950', p. 50.
58. *Convention Nationale, Discours sur la Nécessité de supprimer les Académies, séance du 8 août, 1793.*
59. Geraldine Norman, *Nineteenth Century Painters and Painting: a Dictionary* (London, 1977), p. 126.
60. *American Academy and Art – Union Exhibition Record* ed. B. Cowdrey (1953).
61. George Moore, *Modern Painting* (London, 1893), p. 67.

XVI THE NINETEENTH CENTURY

1. Anne Brontë, *The Tenant of Wildfell Hall* (1848).
2. Nathaniel Hawthorne, *The Marble Faun or the Romance of Monte Beni* (Boston, 1860), p. 74. The character of Hilda was based upon that of Hawthorne's wife, Sophia Peabody Hawthorne, who married him in 1841, when she was thirty-one, and supplemented the family income by her painting in the early years. See Josephine Withers, 'Artistic Women and Women Artists', *Art Journal*, Vol. XXXV, no. 4, Summer 1976, pp. 331–2, and notes, p. 336.
3. Hawthorne, *op. cit.*, pp. 75–6.
4. *Ibid.*, p. 76.
5. Quoted by Josephine Withers, *op. cit.*, p. 331.
6. Leonce Bénédite 'Of Women Painters in France', *Women Painters of the World*, Walter Shaw Sparrow (London, 1905), p. 182.
7. Ralph Peacock, 'Modern British Women Painters', Shaw Sparrow, *op. cit.*, p. 70.
8. George Moore, *Modern Painting* (London, 1893), pp. 266–7.
9. A. M. W. Stirling, *William de Morgan and his Wife* (London, 1922), p. 193.
10. A. M. Howitt, *An Art Student in Munich*, written in 1853, edition quoted (London, 1879), p. 2.
11. *Ibid.*, p. 232.
12. Martha A. S. Shannon, *The Boston Days of William Morris Hunt* (Boston, 1923), p. 102.
13. *Ibid.*, p. 162.
14. Helen M. Knowlton, *The Art Life of William Morris Hunt* (Cambridge, Mass., 1899), p. 99.
15. Hubert van Herkomer, *My School and my Gospel* (London, 1908), p. 13.
16. *Ibid.*, p. 65. Widowed Louise Jopling and married Gertrude Massey were both refused by Herkomer, and lived to tell the tale. 'Go home and make puddings,' he told Mrs Massey (*op. cit.*, p. 13). The Kemp-Welch sisters studied with him as did Americans Louise Burnell and Ellen Condie Lamb, and Australians Josephine Muntz-Adams and Kate O'Connor.
17. Cecilia Beaux, *Background with Figures* (Boston and Newport, s.d., 1930), p. 118.
18. *Ibid.*, p. 119. *Cf.* Marian Hepworth Dixon, 'A Personal Reminiscence', *Fortnightly Review*, February 1890, on the Académie Julian.
Sir William Rothenstein, *Men and Memories* (London, 1931), Vol. I, p. 36–43.
H. Schleittgen, *Erinnerungen* (Munich, 1926), pp. 173–9.
L. Corinth, *Legenden aus dem Künstlerleben* (Berlin, 1908), pp. 50–68.
A. S. Hartrick, *A Painter's Pilgrimage through fifty years* (London, 1939), pp. 13–27.
Clive Holland 'Lady Art Students' Life in Paris', *International Studio* No. 21, 1904, pp. 225–31.
19. Louise Jopling, *Twenty Years of My Life* (London & New York, 1925), p. 6.
20. Stella Bowen, *op. cit.*, p. 45.
21. Jopling, *op. cit.*, p. 151.
22. Clayton, *op. cit.*, Vol. II, pp. 130–2, *cf.* Alice Elfrida Manly (*ibid.*, pp. 189–91) and Catherine Sparkes (*ibid.*, pp. 131–2).
23. Jopling, *op. cit.*, p. 5, *cf.* Clayton, *op. cit.*, Vol. II, p. 83, describing how Eliza Bridell Fox set up a life class for women, *c.* 1850, using an undraped model.
24. Gertrude Massey, *Kings, Commoners and Me* (London, 1934), describes how Leigh's school of Art ran the only nude life-drawing class which students could attend by simply paying (in 1850, Heatherley joined as assistant and in 1860 it became Heatherley's). When Massey studied there the women were not allowed to enter until the model

was posed, and had to leave the room when the professor entered, to file in when he left and read the critique which had been written on their work in their absence.

25. Arthur Fish, *Henrietta Rae (Mrs Ernest Normand)* (London, 1905), pp. 21–6. When Rae managed to win entry to the R.A. schools, it was to discover that drawing from the undraped model was not included in the female curriculum, even though she had already attended life classes at Heatherley's.

26. Rae exhibited her first nudes in the Academy Exhibition of 1855, and two more the next year, when there was some hostile reaction although she had done her best to show that nude painting was as pure as the driven snow.

27. Rosa Brett: London Tate Gallery, 'Landscape in Britain, *c.* 1750–1850', Exhibition Catalogue by Leslie Powis, p. 130, no. 316 (ill). Antonia Brandeis, Clement, *op. cit.*, p. 61. Claude Marlef, *ibid.*, p. 227. Dewing Woodward, *ibid.*, p. 367.

28. Stirling, *op. cit.*, p. 180.

29. Jopling, *op. cit.*, p. 307.

30. Butler, *op. cit.*, p. 141; Clement, *op. cit.*, p. 84; Christopher Wood, *Dictionary of Victorian Painters* (London, 1972), p. 145.

31. In default of published documentation of the prizes, one must surmise their existence from the documentation of the more eminent winners of them: the Dodge Prize was won by Cecilia Beaux, Matilda Browne (1899), Ida Waugh, and Amanda Brewster Sewell. The Mary Smith Prize was awarded every year by the Pennsylvania Academy of Fine Arts for the best painting by a woman; Emily Sartain won it twice (1881, 1883), Cecilia Beaux won it four times (1885, 1889, 1891, 1892), Carol H. Beck won it in 1899 and Jessie Wilcox Smith in 1903. Presumably the Bashkirtseff Prize was set up at the Académie Julian in memory of Marie Bashkirtseff; the only winner so far noted by this writer is Marie Perrier (1899).

32. Both Adelsparre and Lindegren worked in the atelier of Léon Cogniet. Even earlier, (Ary Scheffer had made a speciality of teaching women.

33. In 1867, the wood-engraver, Alice Donlevy, founded the Ladies' Art Association in New York, on analogy perhaps with the Society of Female Artists, founded in England in 1857, reorganised in 1869 as the Society of Lady Painters, and again in 1885, evidently because the sheer volume of work from amateurs desirous of exhibiting made all other functions impossible, and still in existence, as the Society of Women Artists, with no more than forty-five members, thirty-five associates and fifteen Honorary Members. The National Association of Women Artists in New York claims to have been founded in 1889, holds annual exhibitions and issues an annual catalogue. As of 1964, it had eight hundred members and one administrative officer. What relation it bears to the National Association of Women Painters and Sculptors, to which more than eighty of the women approached by Mantle Fielding when collecting data for his *Dictionary of American Painters, Sculptors and Engravers* and to the related institution, the National Academy of Women Painters and Sculptors, which fifty others said they belonged to, this writer cannot say.

34. The Union de Femmes Peintres et Sculpteurs offered its own prizes, known as *Les Palmes Académiques*; Pauline Delacroix-Garnier was Vice-President from 1894–1900.

35. Munich was not the only city with a Künstlerinnenverein; other German cities, for example, Berlin and Dresden, followed suit. The high point of such organisation came in the 1890s when the women trained in the boom-time began to face the difficulties of starting out as professional artists. The Women's International Art Club, founded in London in 1900, aimed at organising women artists on an international basis, with offices in New York, Toronto and Paris, but only women who had already exhibited in the official salons of their countries or the Paris Salon might apply. Women's Art Clubs came in all sizes, some were professional organisations, others gatherings of happy hobbyists; the names are not always stable, whether the Women's Art Club of Canada is the same or distinct from the Women's Art Association of Canada, is no more to be taken for granted than what the Ladies' Art Club of Glasgow might have in common with the Women's Art Club of New York, the Cleveland Women's Art Club, or the Cincinnati Women's Art Club or the Clubs of Women Art Workers. Whether the American Women's Art Association in Paris is the same or different from the Paris Women's Art Club however, it reflects the same necessity, the pressing need to organise, but then as now, the women who might have given the organisations real clout stayed away.

36. Judith Paine, 'The Women's Pavilion of 1876', *Feminist Art Journal*, Vol. 4, no. 4, pp. 5–12.

37. Patt Likos, 'Sexism at the First Women's Art College', *Feminist Art Journal*, Vol. 3, no. 4, p. 34.

38. Paine, *op. cit.*, p. 10.

39. Maud Howe Elliott, ed., *Art and Handcraft in the Women's Building of the World's Columbian Exposition* (New York, 1893).

40. The only publication I have been able to trace is an interesting indication of the activities: *La Donna Italiana descritta da scrittrici italiane in una serie di conferenze tenute all'Esposizione* with an introduction by A. Conti (Florence, 1890).

41. It would be interesting in this context to see A. Hirsch, *Die Bildende Künstlerinnen der Neuzeit* (1905).

42. The Künstlerinnenverein of Berlin not only ran an art school for women, but attempted to mount biennial exhibitions of women's work, at which special prizes were awarded.

43. The Women's International Exhibition at Earl's Court in 1900 may have resembled the Exposition Rétrospective d'Art féminin in that it was not publicised and published nothing on its own account.

44. Paris, Musée du Jeu de Paume, 'Les Femmes Artistes de l'Europe', Exhibition Catalogue, 1937. An interesting sidelight on the exhibition is given by Madeleine Bunoust's *Quelques Femmes Peintres* (Paris, 1936). It is depressing to realise how many of the women who cut figures in the art world then have since virtually disappeared, including, by the way, all the triumphant winners of the Prix de Rome, Odette Pauvert, Fernande Cormier, Renée Jullien, Madeleine Leroux, Irene Kaledjian, Alice Richter and Louise Cottin.

45. Geraldine Norman, *Nineteenth Century Painters and Painting: a Dictionary* (London, 1977).

46. London, Royal Academy, 'British Painting from 1953–1978', Exhibition Catalogue.

47. Naturally this writer informed the Museum

administration of the fact, but nothing was done. When, months later, the Museum was approached again, we were told that the work was *signed* 'Alexander' Exter. Further enquiries revealed that the masculine form related to a different work, and further enquiries still revealed that a mistake had crept into the Victoria and Albert Museum's official inventory as well. The appropriate action was eventually taken, six months after the original complaint.

Index

Italic figures indicate illustrations; plate references are given in bold type